God Is Beautiful and Loves Beauty

THE HAMAD BIN KHALIFA SYMPOSIA AND PUBLICATIONS ON
ISLAMIC ART ARE SPONSORED BY THE QATAR FOUNDATION FOR
EDUCATION, SCIENCE, AND COMMUNITY DEVELOPMENT

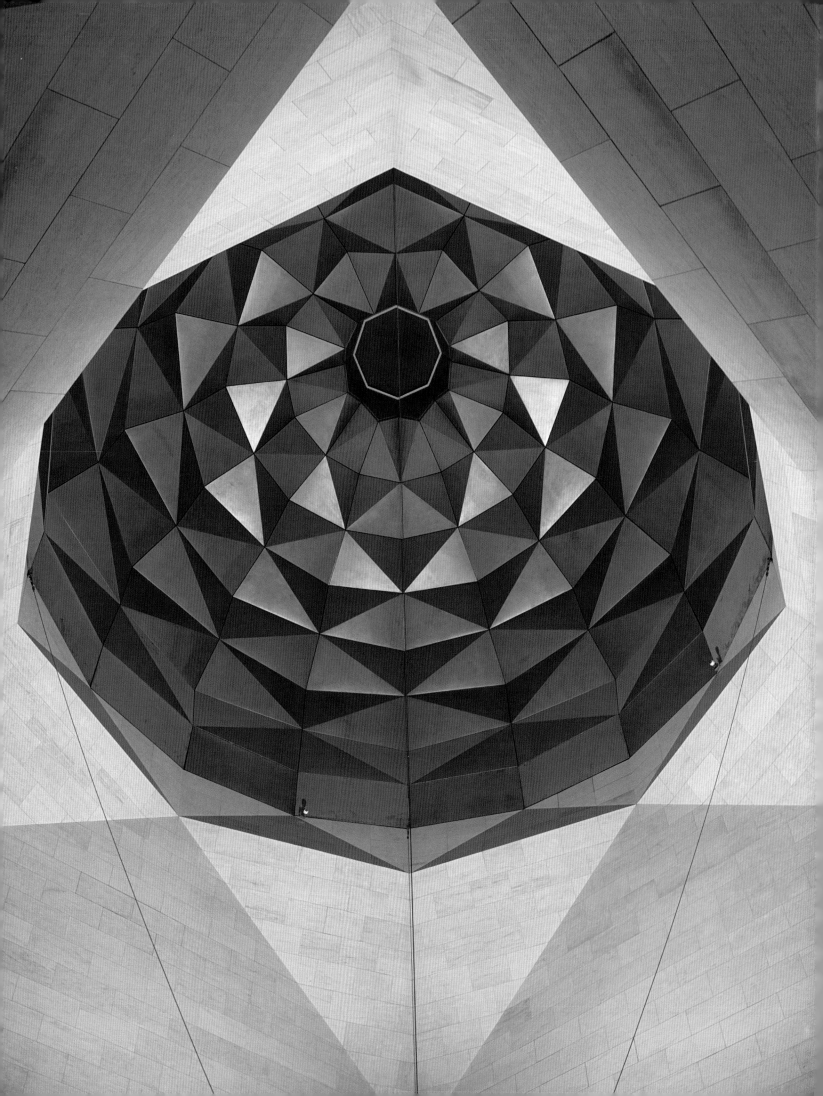

God Is Beautiful and Loves Beauty

THE OBJECT IN ISLAMIC ART AND CULTURE

Edited by Sheila Blair and Jonathan Bloom

YALE UNIVERSITY PRESS, NEW HAVEN AND LONDON

in association with

THE QATAR FOUNDATION, VIRGINIA COMMONWEALTH UNIVERSITY,

AND VIRGINIA COMMONWEALTH UNIVERSITY SCHOOL OF THE ARTS IN QATAR

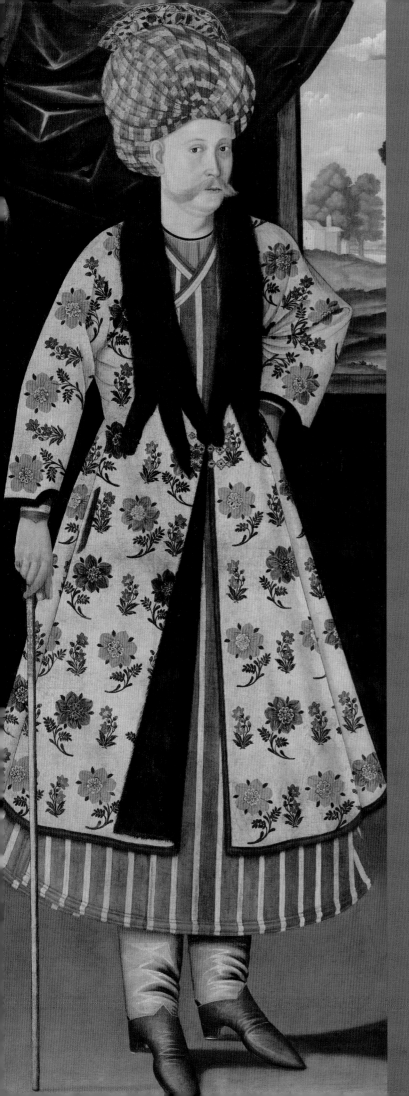

Designed by Sarah Faulks

Printed in China

Library of Congress Cataloging-in-Publication Data

Biennial Hamad bin Khalifa Symposium on Islamic Art (4th :
2011 : Qatar)
 God is beautiful and loves beauty : the object in Islamic art
and culture / Sheila S. Blair and Jonathan M. Bloom.
 pages cm
 Includes bibliographical references and index.
 ISBN 978-0-300-19666-5 (cl : alk. paper)
 1. Islamic art objects–Congresses. 2. Art and society–Islamic
countries–Congresses. I. Blair, Sheila, editor of compilation.
II. Bloom, Jonathan (Jonathan M.), editor of compilation. III.
Museum of Islamic Art (Qatar) IV. Title.
 NK720.B54 2013
 704'.088297–dc23

 2013005184

A catalogue record for this book is available from The British
Library

Pg. ii: detail of the dome in the Museum of Islamic Art, Doha.
Pg. iv: detail of *An Unidentified European Gentleman With a
Cane, circa* 1660–70. MIA, Doha (PA.2.1997).
Pg. vi: detail of glass candlestick once in the Rothschild
Collection, 1340–65. Collection of the Corning Museum of
Glass, Corning, New York, Clara S. Peck Endowment Fund
purchase (90.1.1.).
Pg. viii: detail of *Müfredat* exercises on the letters *ayn* and *fa*
in *thuluth* script, by Hafiz Osman, 17th century. MIA, Doha
(MS.726.2011).
Pg. x: medallion featuring a motif of a lion on Mongol silk-and-
gold textile. MIA, Doha (TE.202).
Pg. xii: detail of cast bronze fountainhead in the shape of a hind,
mid-10th century. MIA, Doha (MW.7.1997).
Pg. 390: earthenware dish decorated in black on a white
slip, eastern Iran or Central Asia, 10th century. MIA, Doha
(PO.24.1999).
Pg. 393: detail of the Sarre Ardabil animal carpet, mid-16th
century. MIA, Doha (CA.43.2002).
Pg. 395: detail from a folio from the Jahangir Album with
calligraphy dated 1541–42 and marginal decorations, *circa* 1604.
MIA, Doha (MS.158.2000).

Arabic table of contents and title page typography with
DecoType Nasta'liq, Naskh, and Ruq'ah using
WinSoft-DecoType Tasmeem.

Contents

ب عج عد عر عن عس عس عت عت عض عط

عف عق عك عل عم عم عن عن ع

لا عى ع ى ع فا ف ف فذ ف ف فس فـ

Foreword

التمهيد

Since 2004, when the first Hamad bin Khalifa Symposium on Islamic Art and Culture was held in Richmond, Virginia, this biennial gathering of scholars of Islamic art has become the preeminent international conference in its field. The volume you hold collects the papers that were delivered at the Museum of Islamic Art in Doha in 2011; like *And Diverse Are Their Hues: Color in Islamic Art and Culture* and *Rivers of Paradise: Water in Islamic Art and Culture*, which collected the papers delivered in 2009 and in 2007, this handsomely illustrated book of essays contributes to our understanding of the arts and culture of the Islamic world and attests to the impact in that field that has been made by Sheikha Mozah bint Nasser Al Missned and Sheikh Hamad bin Khalifa Al Thani.

In 1998, Virginia Commonwealth University School of the Arts was invited by Sheikha Mozah bint Nasser Al Missned to establish the founding campus in Qatar's Education City. The Hamad bin Khalifa Chair in Islamic Art History was subsequently endowed within VCU's Department of Art History, and the biennial Hamad bin Khalifa Symposium on Islamic Art was established at the behest of Sheikh Hamad bin Khalifa Al Thani. Drs. Sheila Blair and Jonathan Bloom are the inaugural holders of the Khalifa chair at VCU and have been responsible for chairing the Symposium since 2004.

I wish to extend my thanks and deepest appreciation to all of the scholars who have contributed essays to this publication and also to the many people in Richmond and in Doha whose work was integral to the Fourth Biennial Hamad bin Khalifa Symposium on Islamic Art where these papers were delivered, including Dean Allyson Vanstone (VCUQatar), Marisa Angell Brown, Andrew Ilnicki, Kim Seagraves, Teresa Engle Ilnicki, Dawn Waters, Nancy Scott, Ashley Burton, Mieke Kaan, Priya D'Souza, Markus Elblaus, Barry Parham, Jun Ocampo, Lolwa Abdulla, Jordan Gushwa, Eman Ali, Shaduli Valappil, Yousef Al-Alwadi, Liaqat Ali Hyder, and Mohamed Zakariya for his fine calligraphy.

The Museum of Islamic Art was exceedingly gracious in hosting the symposium on which these essays are based, and its staff was unstinting in responding to numerous queries and requests. The organizers would particularly like to thank Aisha Al Khater, Director; Dr. Franak Hiloowala, former Registrar; Marc Pelletreau, Head of Multimedia;

Samar Kassab, Photographer; and Galina Lasikova, Curator for Textiles, for making the collection accessible to our scholars on multiple occasions. Yale University Press (London), under the expert editorial care of Gillian Malpass, ensured the swift publication of this volume, and its handsome design is due, as with earlier volumes, to the thoughtful design of Sarah Faulks.

I also wish to thank Her Highness Sheikha Mozah bint Nasser, Chairperson of the Qatar Foundation for Education, Science and Community Development; Dr. Mohammad Fathy Saoud, its President; Her Excellency Sheikha Al Mayassa bint Hamad bin Khalifa Al Thani, Chairperson of the Qatar Museum Authority; His Excellency Dr. Abdulla Al-Thani, President of Hamad bin Khalifa University; and Sheikha Hind bint Hamad Al Thani, Vice-chairperson of the Qatar Foundation board, for their continued support and encouragement of our endeavors in Qatar and abroad.

Joseph H. Seipel
Dean, School of the Arts
Virginia Commonwealth University

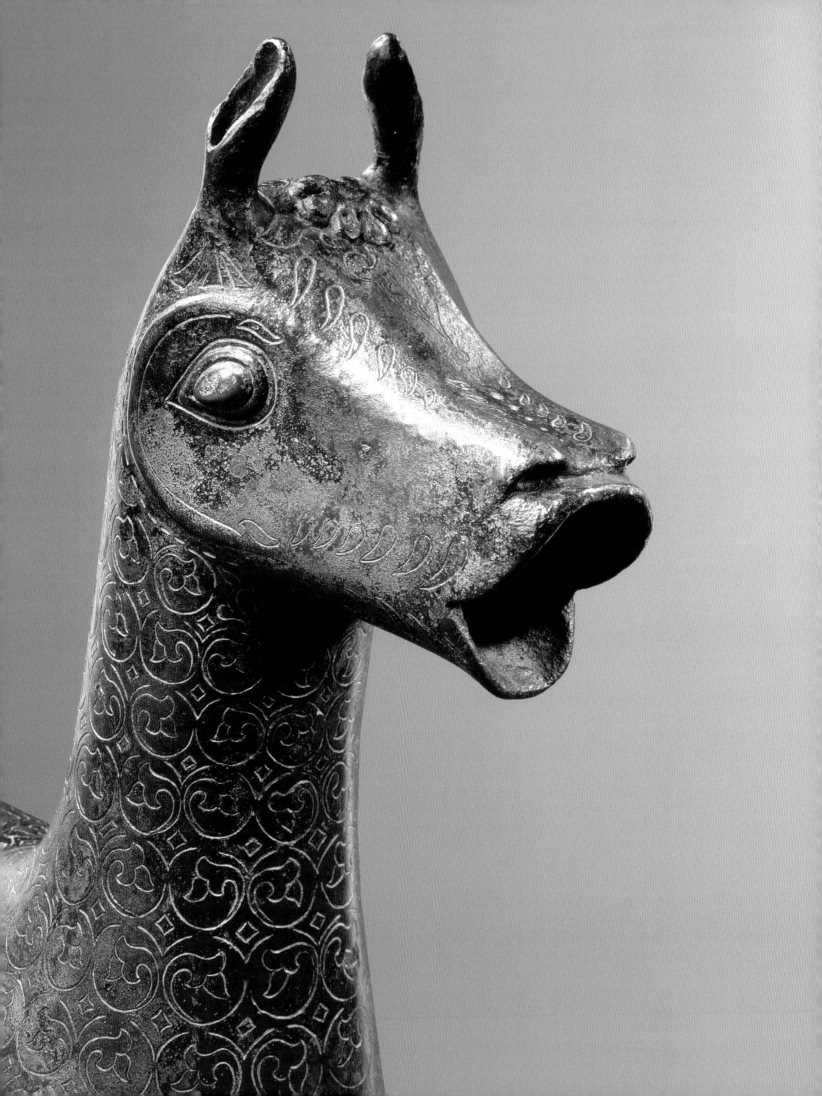

INTRODUCTION

The Object in Islamic Art and Culture

المقدمة : التحفة فى الفن والثقافة الاسلامية

Sheila Blair and Jonathan Bloom

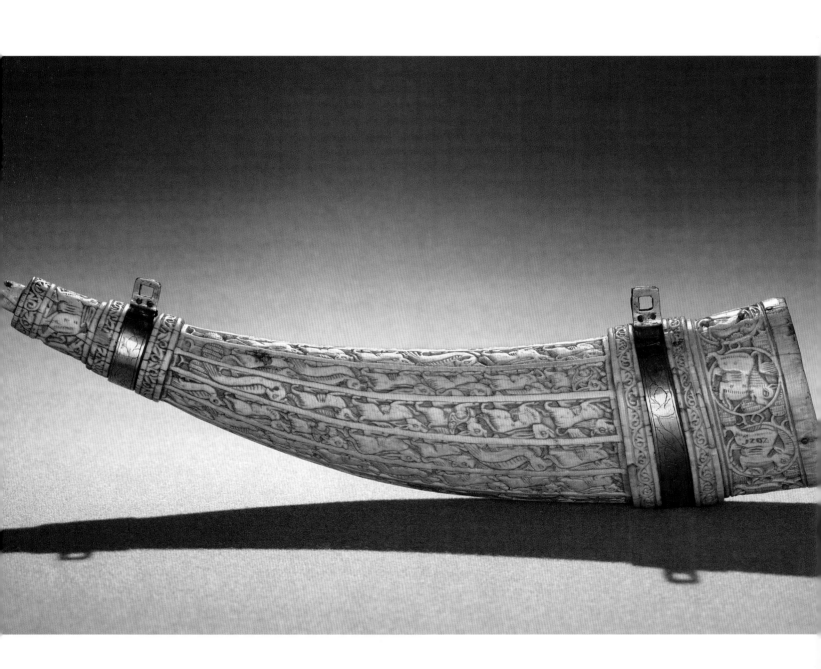

The Hamad bin Khalifa Biennial Symposia on Islamic Art and Culture are designed to address broad themes in Islamic art and make the latest research available to a wide audience. In our role as conveners, we have deliberately selected topics to fit the specific time and place of the event. The first symposium that we organized, held in Doha in 2007, addressed the topic of water in Islamic art and culture, a subject of increasing importance in such an arid region. The papers from it were beautifully published by Yale University Press as *Rivers of Paradise: Water in Islamic Art and Culture* (Blair and Bloom 2009) to coincide with the second symposium that we convened, held in Córdoba, Spain in 2009. It addressed the topic of color, a resonant theme given the brilliant interior of the major mosque in that city. Yale University Press again published the papers from it in an even more beautiful volume, *And Diverse Are Their Hues: Color in Islamic Art and Culture* (Bloom and Blair 2011). For the third symposium, held in Doha in 2011, we chose to address the art of the object, a topical subject in light of the stunning collection assembled there in the new Museum of Islamic Art (MIA), which opened in 2008.

Within the last generation, the object has been a topic of increasing relevance in both the social sciences and the humanities. A generation ago Arjun Appadurai's groundbreaking volume, *The Social Life of Things: Commodities in Cultural Perspective* (1986), set the stage from a theoretical perspective. That publication, a group of conference papers presented by five anthropologists, four social historians, and one archaeologist, focused on the relationship between people and things, how people define themselves with reference to things, and how the cultural meanings of things are constituted by their exchange (or their withdrawal from exchange). Most of the essays followed up on the term coined in the introduction by the anthropologist Igor Kopytoff of an object's "cultural biography," or under the archaeologists' rubric of an object's "life history." Such terms continue to resonate today, as seen in the title of at least one essay in this volume.

Oddly enough, Appadurai did not include in his conference art historians and curators, who have a long tradition of investigating certain kinds of objects from many different perspectives. While many art historians study particular classes of objects, such as paintings and sculptures, historians of Islamic art have long studied types of objects that historians of other art traditions have often considered merely "decorative" or "applied" art. The essays in this volume focus on many different examples that craftsmen have transformed into sublime works of art.

The title of our symposium, "God is Beautiful and Loves Beauty," derives from a well-known hadith, or tradition of the Prophet Muhammad, as recorded (no. 275) in the *Sahih* ("Accurate") of Muslim ibn Hajjaj (d. *circa* 875), one of the six major collections of hadith in Sunni Islam. Theologians understood both beauty and love as manifestations of God's unity. Although the Koran never actually calls God "beautiful," it often implies His beauty, as in the stunning metaphor of the Light Verse (24:35), "God is the Light of the Heavens and the Earth," and the prophetic tradition encapsulates the belief of many Muslims about the beauty of all God's creations.

The study of the object has become topical in the broader field of art history. Scholarly examples abound. To give but one that addresses a complementary place and

1 (*facing page*) Carved ivory oliphant (l. 49 cm), probably Sicily, 11th–12th century. MIA, Doha (IV.7.1999).

time: Sears and Thomas's collection of essays (2002), for which they invited eighteen prominent art historians to analyze a single work of medieval art. But the study of the object has broadened to include a much larger audience. The most popular is undoubtedly the series of programs broadcast in the first half of 2010 on BBC Radio 4 by Neil MacGregor, Director of the British Museum, entitled "A History of the World in 100 Objects." These were pithy, fifteen-minute presentations on objects drawn from the British Museum collection. They can be downloaded as podcasts at http://www.bbc.co.uk/ahistoryoftheworld/ or read in more traditional format in the volume that was published in 2010. To judge from recent figures (over 200,000 "hits" in the month of April 2012 alone), the program has reached an audience in the millions.

Within the field of Islamic art, the topic of the object is gaining traction as well. The second biennial symposium convened by the Historians of Islamic Art Association in October 2010 in Washington, DC was entitled "Objects, Collections and Cultures." The papers addressed a broad variety of topics that reflected the wide-ranging interests of the speakers, and many of them have been published in the latest issue of *Ars Orientalis* (Farhad and Simpson 2012).

This publication combines features from many of these other projects. Like Appadurai's volume or the journal issue edited by Farhad and Simpson, our work began as a series of conference papers. Like MacGregor's volume, this publication focuses on the objects in a single museum – the Museum of Islamic Art (MIA) in Doha – that chronicle the history of a major culture, the civilization that flourished under the religion of Islam. Like MacGregor, we have chosen our topics deliberately, and the careful reader will note that the essays span the history of Islamic art as collected in the MIA, from its beginnings in the seventh and eighth centuries under the Umayyads and Abbasids, as seen in the essays by François Déroche on the Tashkent Koran and Julia Gonnella on Samarra stuccos, to the age of empires in the sixteenth and seventeenth centuries, as seen in the contributions by Mohamed Zakariya on the Ottomans, John Seyller on the Mughals, and Eleanor Sims on the Safavids. The essays thus cover the extraordinary collection amassed in Doha, at a rate of roughly one essay per century.

But we did not want to leave the impression that Islamic art (and culture) petered out or died in the eighteenth century, although the MIA's collection focuses on the pre-modern period. Therefore, we invited the renowned architectural critic Paul Goldberger to give the keynote address on I. M. Pei's design for the building that houses the collection and to address the question of how a Chinese–American architect might create a work of Islamic art of today. In many ways, Pei's brief was not so different from that faced in the late seventh and early eighth centuries by the designers of the Dome of the Rock or the Great Mosque of Damascus, who used the materials and techniques of the late-Antique world to create architectural settings appropriate for the needs of the new culture and religion in Umayyad Syria. To further fill out the discussion of collecting and display in the publication, we invited Oliver Watson, the former Director of the MIA who had presided over its opening, to contribute an essay about the reasons behind the choice of the objects for the museum and the ways in which they were installed in the new building.

In addition to chronological parameters, we also selected our speakers and their objects to represent the geographical spread of classical Islamic civilization, from the Iberian peninsula to the Indian subcontinent. Modern scholarship has, of course, expanded the purview of Islamic art to other regions (pl. 2), such as West Africa, Southeast Asia, and China, and some of our speakers, such as Mohamed Zakariya, have mentioned works produced in these regions (pl. 253). Yet as these areas do not figure prominently in the MIA collections, we could not make them the main focus of this volume, much as we could not include material produced during the past two centuries.

We also selected our authors in order that their contributions cover the range of media so prominent in Islamic art. Three papers treat the so-called arts of fire: Aimée Froom on ceramics, Ruba Kana'an on metalwares, and Rachel Ward on glass. Two other contributions address different aspects of textiles, in economic terms arguably the most important form of Islamic art: Kjeld von Folsach on a magnificent set of gold and silk lampas-weaves and Michael Franses on an early animal carpet.

Four essays deal with the arts of the book, which played such a seminal role in the creation and dissemination of Islamic culture – François Déroche on an early Koran manuscript, Emilie Savage-Smith on what we learn is the earliest extant copy of al-Sufi's guide to the constellations, Mohamed Zakariya on a calligraphic album, and John Seyller on five little-known pages from the dispersed album compiled under the auspices of the Mughal emperor Jahangir (r.1605–27). Eleanor Sims takes up the related subject of figural representation in seventeenth-century oil paintings produced in Iran and the relationship of this medium with European art.

Again, we did not want to slight architecture, which created the physical setting in which so many of these objects were seen and understood, so in addition to Goldberger's keynote address on the building itself, we asked Julia Gonnella to investigate wall decoration from the ninth-century palaces at Samarra in Iraq and Antonio Vallejo Triano to examine the marble capitals from the caliphate of Córdoba in southern Andalusia, Spain.

We also selected the contributors to approach their individual subjects from different perspectives, so we invited not only art historians, but also historians of science, curators, artists, and archaeologists. The authors therefore applied different methodologies to their topics, approaches that often varied depending on the type of object and the time that it was created (and reused). In many ways, this book, therefore, can be "read" as a broad overview of the field of Islamic art, offering both beginner and specialist a way to sample this enormous field. Indeed, in our many years of teaching, we have often applied such a methodology to introductory surveys of Islamic art by focusing on the study of individual works that can illustrate some of the myriad facets of this very broad subject.

In all cases, we asked the contributors to select an object or a group of objects in the MIA and then develop the subject in the ways that they felt worked best. The authors readily met our challenge and broadened their analyses to incorporate discussions of many relevant fields, such as the interaction between Islam and neighboring

2 (pp. 6–7) Map showing the sites discussed in the book.

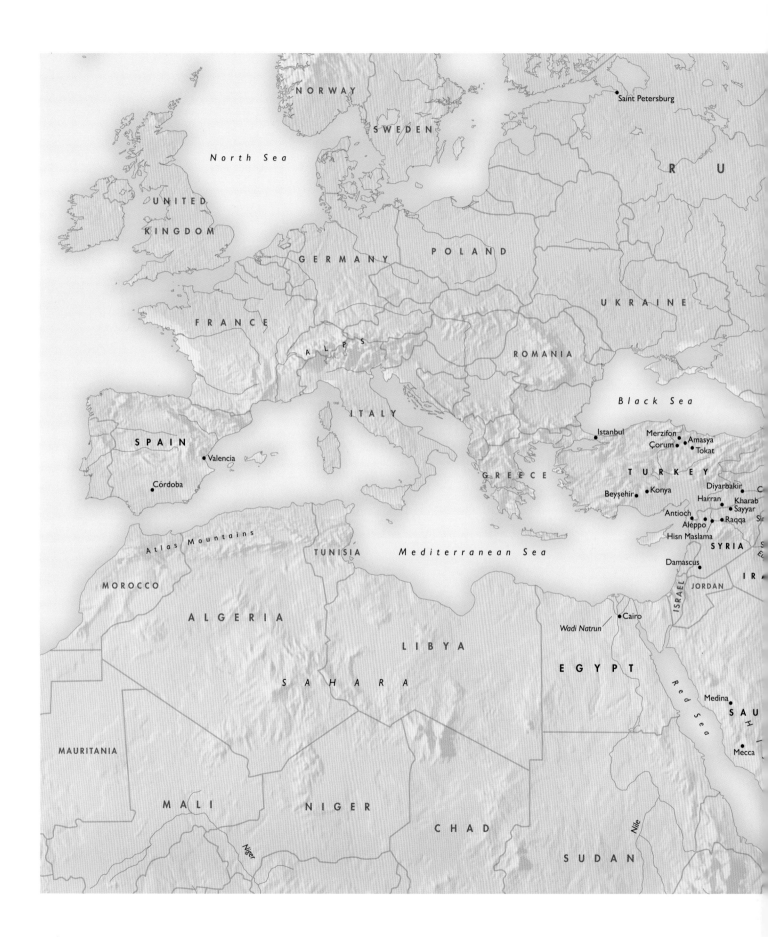

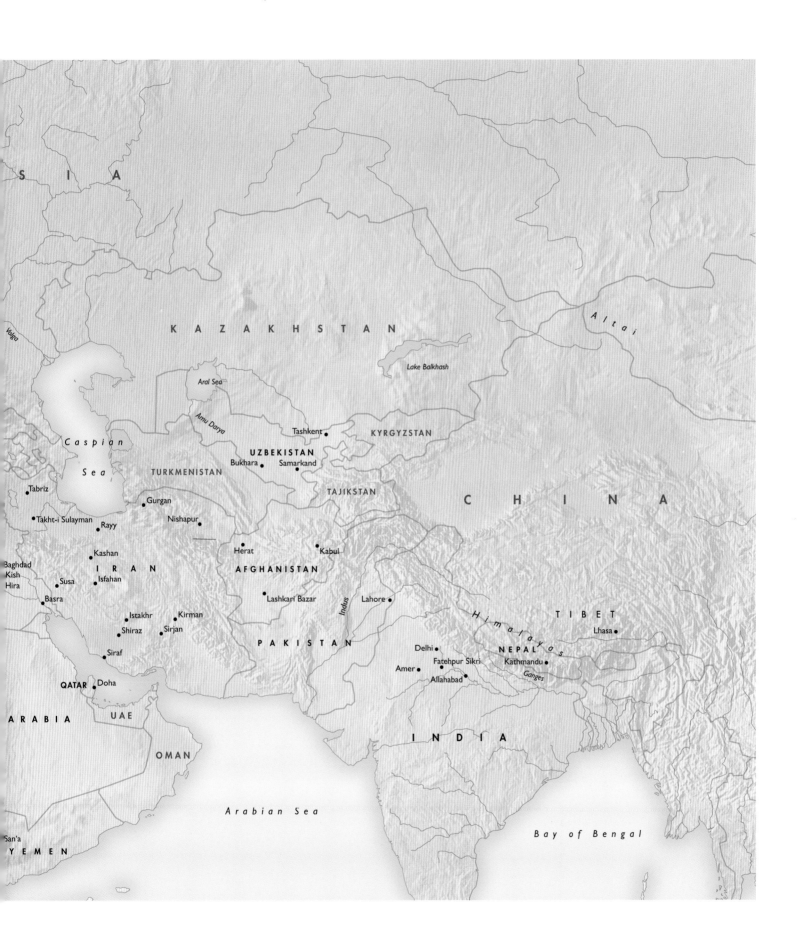

3 Jade amulet (w. 5.1 cm);
India, 1631–32. MIA, Doha
(JE.85.2002).

cultures to the east and west, questions of connoisseurship, the methods of collecting and displaying objects, and the problems of production, faking, and forgery.

Given the limitations of time (at the symposium) and space (in the publication), however, we had to omit discussion of many of the MIA's treasures, different types of objects, and other important periods in the history of Islamic art. For example, we did not ask anyone to discuss the MIA's important collection of Islamic ivories, including the oliphant (pl. 1) and the box (IV.4.1988). Similarly, we did not have any papers on their spectacular jewels and hardstones, such as the jade amulet made for Shah Jahan in 1631–32 (pl. 3) or the stunning amulet made from a Colombian emerald and carved for the Mughals in 1695–96 as the decoration for an armband (JE.86.2002). The MIA also has a particularly broad and fine collection of metalwork, ranging from the cast-bronze fountainhead from al-Andalus in the shape of a hind (pl. 4) to the spectacular inlaid candlestick made for the ruler of Fars, Abu Ishaq Inju (r.1341–56; MW.122.1999), as well as many famous Mamluk pieces such as an enormous tray made for al-Nasir Muhammad (r.1293–1341 with interruptions; pl. 5), quite apart from the remarkable collection of scientific instruments (for example, pls 36 and 116–18). We could go on and on, for the MIA's collection is truly extraordinary, placing it among the finest in the world. We have omitted subjects and objects not because we consider them any less important than the ones discussed, but because we wanted to balance periods and media, as well as scholarly approaches, so that the symposium and the resulting book would present a coherent overview.

Despite the broad chronological and geographic span of these essays and the differing media and methodologies used in them, several themes run through them all. One is the importance of the first-hand study of the object in whatever medium from whatever time or place. Architecture, for example, can be understood best when one is actually in the space. There was a telling moment in Paul Goldberger's memorable keynote address when he looked up from his text and admonished the audience, asking "Why am I talking about this through slides? Just look up." He was right: the enormous

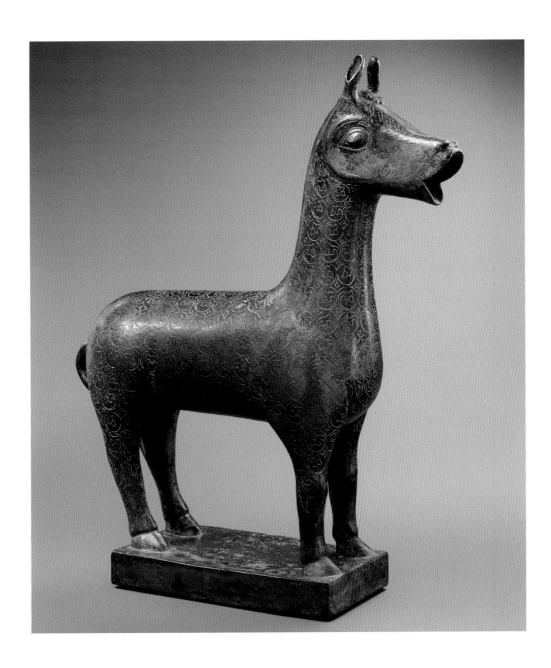

4 Cast bronze fountainhead in
the shape of a hind (h. 48.1 cm),
Andalusia, mid-10th century.
MIA, Doha (MW.7.1997).

triangular flaps supporting the dome overhead could be perceived far more clearly when seen from below than from a two-dimensional image.

The same is true for portable objects, be it the quires and pen strokes in a manuscript or the two types (wrapped and flat) of gold threads used in a Mongol textile. Rachel Ward makes the point that museums tend to photograph three-dimensional objects from their "best" side, but often the flaws or the undecorated back of an object can be equally telling. Many of us will not have the opportunity to handle these museum-quality objects, but at the very least we can look at them first-hand in a display, particularly in cases that allow the viewer to walk around the object or at the very least approach it closely. Such an approach to display was, as Oliver Watson points out, a deliberate decision in the installation design in the MIA, but not necessarily one followed in exhibitions of Islamic art in museums everywhere. Books like this one are wonderful armchair aids, but they are not the same thing as actually looking at objects, and, as Paul Goldberger points out, one of the key roles in the museum is the "experience of authenticity," an experience with "an almost holy aura" that "extends to the

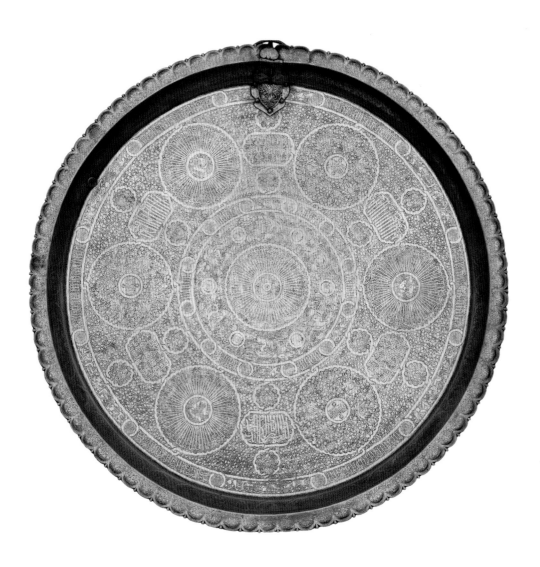

very core of museum's being." Such a fundamental purpose of the museum makes it
all the more important that the objects on display are both authentic and readily visible.

A second theme that runs through these essays is the enormous amount of time and
patience needed to really "study" an object. A prime example here is Emilie Savage-
Smith's word-by-word reading of the colophon in the copy of ʿAbd al-Rahman al-
Sufi's *Guide to the Constellations*. As she herself states in the essay, such a reading can
be quite tedious, but as all would agree, her presentation was mesmerizing and the
results extraordinary. The same could be said for many of the other essays, from François
Déroche's detailing of the letterforms in the pages of the Tashkent Koran to Eleanor
Sims's thorough enumeration of the sartorial details in Safavid oil paintings.

Such careful, first-hand examination often depends on traditional art historical
methods of connoisseurship. Most of the works encompassed within the rubric of
"Islamic art" are not dated, and many of our authors used the traditional technique of
stylistic analysis and grouping or seriation, be it of objects, images, or words. But these
essays show that such traditional methods should be combined with new and produc-
tive methods of scientific analysis, methods that are themselves rapidly changing.
Michael Franses notes, for example, that the techniques of carbon-14 testing used in
the 1980s are already outdated and that new methods are appearing that produce more
reliable and more precise dates. But in encompassing the new, we must not jettison
the old. Once again, Michael Franses has a telling example in that black-and-white

photographs are often more useful in showing carpet designs, although color photographs are necessary as well to convey other aspects, such as hue and texture.

A third theme that runs through all the essays is the importance of context, a concept that appears in them all, but in very different ways. In some cases, the authors are concerned with physical context, as in Antonio Vallejo Triano's essay investigating where marble capitals were used in Córdoba, not only in which building but in which location within any single building, for he shows that the choice of location is often significant. Such information about physical context is often difficult to reconstruct, as Julia Gonnella shows in the case of the stuccos from Samarra, but nevertheless essential to attempt.

Physical context is equally important for books, and we often need to study their codicology, or how they were actually made, as with François Déroche on the Tashkent Koran or John Seyller on the various parts of an album page. One can even deconstruct penstrokes, as Mohamed Zakariya does with individual pages of the Ottoman calligraphic album.

Physical context can also refer to the ways in which an object was seen in its original setting. Rachel Ward shows, for example, that the different viewpoints in looking at an enameled beaker, which was held in the hand, and in looking at an enameled lamp, which was seen from a distance when hanging overhead, affected the ways in which the craftsmen needed to affix the enamels and hence encouraged new techniques of production.

The context for an object can also refer to the historical setting in which it was produced, and one of the initial objectives in working on any single object is to localize and date it, sometimes, as in the cases of Emilie Savage-Smith and Rachel Ward, with new and surprising results. But the historical context can and often should incorporate the role of patronage, examining the role not only of the producer but also of the recipient. As Ruba Kana'an shows, the name inscribed on a ewer may indicate the person to whom it was given, not the person for whom it was made, and the role of gifts, a topic also of recent interest in Islamic art (see, most recently, Komaroff 2011 and 2012), appears several times in these essays.

And finally, context should not stop with the time that the object was made but should also encompass the continued way the object was used, up to and including its installation in the museum. Many of the essays touch upon this topic of "reception" or "afterlife." Perhaps the most revolutionary group of objects, discussed here by both Kjeld von Folsach and Michael Franses, are the textiles that have been discovered in Tibetan monasteries and appeared in increasing numbers on the art market since the Chinese occupation of the region in the 1950s. Such discoveries are reshaping our knowledge of material history, but our view is very much the product of modern political concerns. Many of the essays thus look at these objects not just as MacGregor did as "signals from the past," but also as objects that continue to have resonance and speak to us today with myriad voices. We urge readers to delve into this volume and enjoy these beautiful examples of visual art created in the Muslim lands over the past 1400 years.

p. 12: detail of the atrium in the MIA, Doha.

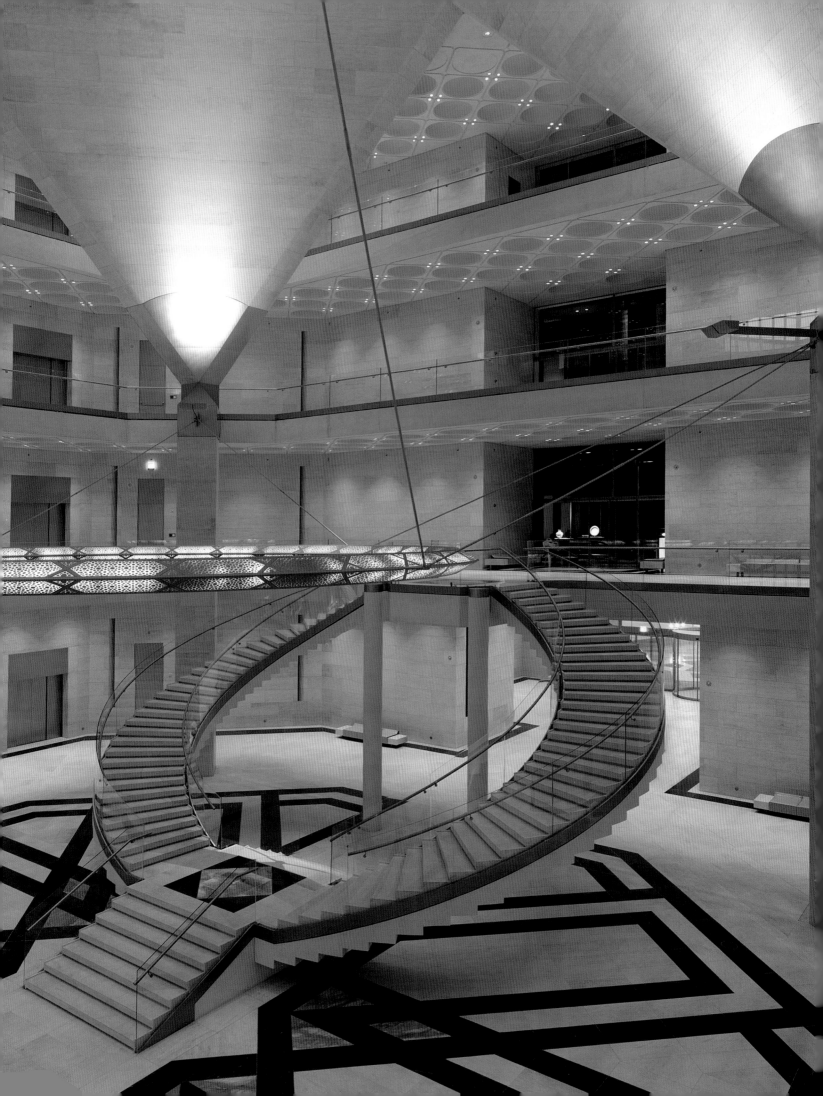

I

I. M. Pei and the
Challenge of the Modern

آی . ام ٖ پی و تحدّی الجدید

Paul Goldberger

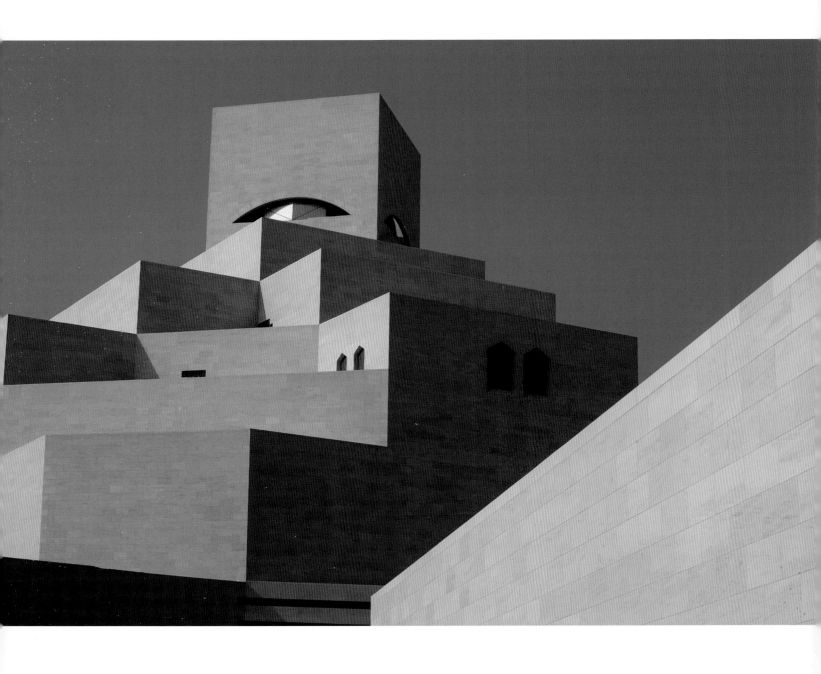

The Museum of Islamic Art (MIA) in Doha (pl. 6) is a key event – indeed, in some ways it represents the ultimate moment – within the career of I. M. Pei, one of the central figures in the architecture of the last sixty years. Yet even as it marks a critical point in the arc of Pei's late career, the MIA is equally a part of several entirely different narratives. It needs to be discussed within the history of the museum in contemporary culture, itself, of course, a rich and compelling narrative of its own, and one within which this museum aspires to play an important part. The MIA is also conceived as an attempt to evolve a contemporary expression of Islamic architecture, an effort that places it within another narrative, the extended quest by architects in the Middle East and the West to find common ground between modernism and Islamic tradition, a dialogue between Islamic and Western architecture that precedes this building by many years and will continue long beyond it. And finally the MIA must also be seen as part of a fourth narrative, the story of Qatar itself and its capital city Doha and the ambitious attempt to establish within Doha both a vibrant cultural life and a meaningful urbanism.

It is in the nature of architecture that buildings call for analysis in multiple ways: every building is at once an aesthetic object, a practical one, and a structural one. It is expected, in other words, to be beautiful, to be functional, and to stand up. This tripartite view of architecture, which has its roots in Vitruvius's never-surpassed definition of architecture as "commodity, firmness, and delight," stands as a reminder not only that no building's story is a single narrative, but also that its multiple narratives are braided together so tightly that none can be said to exist on its own.

An ambitious public building like the MIA also almost invariably needs to be considered in aspects beyond the three main categories of the aesthetic, the practical, and the physical. Any urban building is a physical object within a larger set of adjacent objects, and cannot be discussed entirely apart from its relationship to its context, which is to say the buildings that are around it. And there is also another meaning to context, a less physical one. Every building – and surely an elaborate museum of Islamic art created by a prominent Western architect of Asian descent for a rapidly growing Middle Eastern emirate – is also a political object with a particular meaning within its own culture and for other cultures.

So there is no shortage of ways in which to view this building, and Pei's, and Qatar's, intentions in bringing the MIA into existence – and also no shortage of ways in which these various narratives are inextricably intertwined and interconnected. I. M. Pei's career, for example, plays a key role in the broader story of the expansion of the museum in our time. And, in turn, the position museums hold in contemporary culture is closely tied to the cultural ambitions of Qatar, which like so many places today have been driven by the recognition that architecturally ambitious museums have become iconic presences for many cities and states, signaling their ambitions to the world.

Indeed, it is only a slight exaggeration to say that the museum has come to occupy a position in contemporary international culture not unlike the position once held by the cathedral, a building notable not only for its size and aspirations toward majesty, but also for its distinction from other cathedrals elsewhere. A city now aspires to be

known for its art museum, as it was once known for its cathedral, and frequently seeks a museum that is sufficiently different from other museums to serve as its identifying symbol. It might be added that museums are repositories of the past, as cathedrals are; they represent a set of more or less common values, as the cathedrals did when they were new; and museums can function as community centers as well as places of enlightenment, just as cathedrals did.

Of course it is the rise in visual literacy, not spirituality, that drives the contemporary museum, and the democratization of art. A more educated, more visually literate public has come to view the museum not as the province of the elite, but as a democratic right, open to all. The museum has come to symbolize not just the importance of art, but its accessibility.

It is also the case that in an age in which so many people spend most of their days communicating, working, and being entertained by computers, they begin to cry out for the experience of authenticity, which is the art museum's very essence. In the art museum, everything, whether a twelfth-century Iranian bowl or a seventeenth-century Indian carpet – or a twentieth-century Matisse – is real. When the current wave of technology was new, there was considerable fear that it could have the opposite effect, that it could destroy the power of the real, or at the very least compromise it by blurring the distinction between the virtual and the real. In fact, the opposite thing has happened. The real, by being rarer, became all the more precious. It takes on an almost holy aura – we are in the presence of the real thing, not the virtual image of it, and that aura, when everything is working as it should, extends to the very core of the museum's being.

Another value that has grown and not diminished in most technologically advanced societies today, both in the West and in the Middle East – and this is also contrary to many predictions – is good public space. The ability to work, shop, and be entertained by computer had threatened to make streets and town squares and retail shops obsolete, but the opposite has happened: technology has made public space its own kind of authentic object, all the more precious than it was. People, it turns out, want to walk on streets as well as to talk online. They want to be in real places, so long as those real places offer them something beyond what they can get through their computers.

Where these two phenomena coincide and the increased power of authenticity joins with the desire to be in truly special public places is, of course, the art museum. It is no accident that the art museum has become the most important public building of the age. It is both a temple to authenticity and a public gathering place – not to mention a place in which the very idea of immortality seems always to hover, offering the hope of some degree of transcendence from daily life.

It should not come as a surprise, then, that the last generation has sought to give art museums a more conspicuous architectural presence, and that we have come to think of them not just as containers for works of art, but also as works of art in themselves. While the notion of the museum as an ambitious and significant work of architecture is hardly new to our time – indeed, it might be said to have begun with the first important building constructed solely to serve as an art museum, Schinkel's Altes

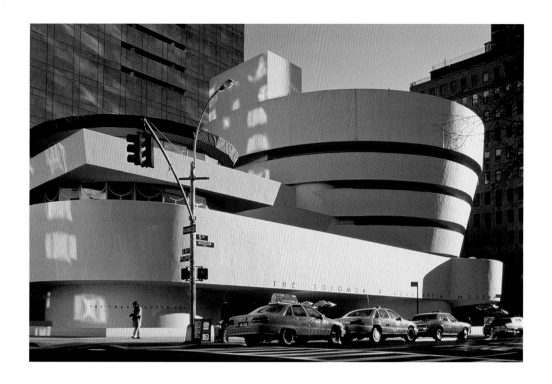

Museum in Berlin of 1830 – expectations for the museum have grown far larger, and become much more widespread, over the last few decades than ever before. The current view of the museum as an architectural event in itself begins, at least symbolically, with Frank Lloyd Wright's Guggenheim Museum in New York, completed in 1959, its round shape and spiral exhibition ramp for more than half a century as much of an attraction in New York City than any painting in its collection (pl. 7). In the years immediately following the opening of the Guggenheim, and perhaps to some extent in reaction to it, the modernist preference for showing art in simple, straightforward, orthogonal white rooms, an attitude exemplified by the Museum of Modern Art of 1939 by Edward Durell Stone and Philip Goodwin, remained fairly common, driven in part by the belief that such places were neutral environments that deferred entirely to art. That was something of a fallacy, of course, since no space is truly neutral, and the white, boxy rooms of the Museum of Modern Art, or of so many art galleries, while hardly as distinctive as the Guggenheim, nevertheless make a potent architectural statement.

But these simple modern spaces that we might refer to as classic modernism were hardly the only way of making museums, of course; the 1970s brought two of the greatest museum projects by Louis Kahn, the Kimbell Art Museum in Fort Worth and the Yale Center for British Art in New Haven (pl. 8), both magnificent, brooding buildings that reinterpreted the modern aesthetic as something no longer light, but heavy, solid, almost primal. At the same time, Richard Meier was beginning an active career as a museum architect by reinterpreting modernism in a different way, as light and picturesque, almost romantic, supremely elegant, and not at all neutral (pl. 9). And as museums became a more important architectural commission, the counter-reaction to the simple modern box grew, driven in part by the increasing democratization of art around the world, making museums more popular, as well as the gradual but steadily mounting doubts among both architects and clients that the straightforward, orthodox modernism of the International Style – the simple modernist box, that is – could provide the degree of popular attraction that they sought.

I. M. Pei and the Challenge of the Modern 17

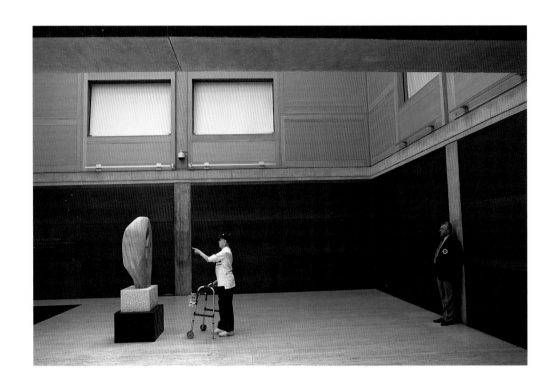

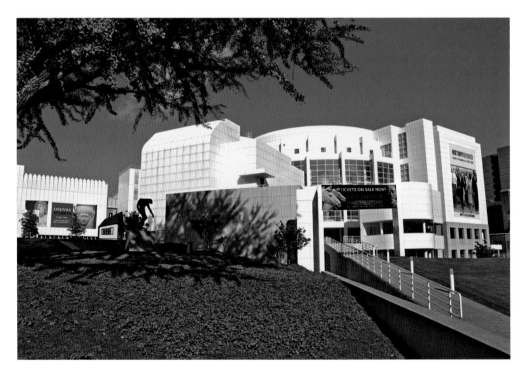

Surely Lina Bo Bardi, the Brazilian architect who designed the 1968 Museum of Art of Sao Paulo (pl. 10), and Renzo Piano and Richard Rogers in their competition-winning entry for the Centre Pompidou in Paris (pl. 11), completed in 1977, had a new model in mind. Both of these buildings somewhat disingenuously pretended to neutrality by virtue of their flexible, changeable interiors, but they were not, of course, neutral at all. They were powerful statements, as powerful, in their way, as the Guggenheim had been. Piano and Rogers turned modernism into hyper-modernism, exaggerating functional elements and turning them into what for all intents and purposes

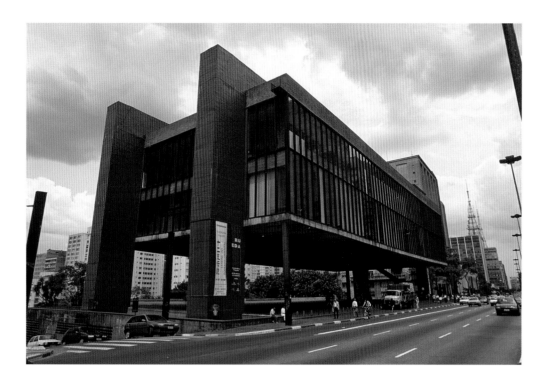

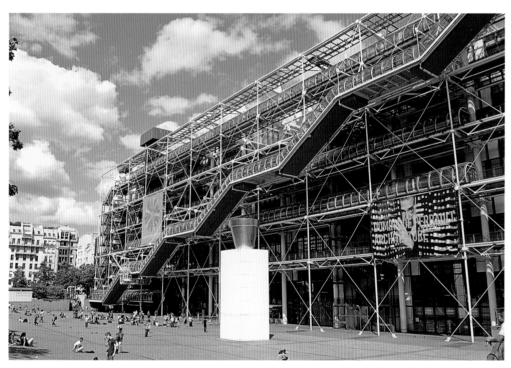

10 (*top*) Sao Paulo Museum of Art, Sao Paulo, designed by Lina Bo Bardi, completed in 1968.

11 (*bottom*) Centre Pompidou, Paris, designed by Renzo Piano and Richard Rogers, completed in 1977.

was decoration. The Sao Paulo museum exuded a Brutalist swagger. If the Pompidou was more fanciful and playful, both of these museums suggested that modernism was far from exhausted as a source of new, distinctive, and highly expressionist design.

All through the last two decades of the twentieth century, the museum seemed to expand exponentially as a vehicle for architectural expression. Renzo Piano built, and continues to build, museums at an astonishingly rapid rate, and many of them, including the Menil Collection in Houston, the Beyeler in Basel, and the very recent Modern Wing of the Art Institute of Chicago (pl. 12) are important further steps in the quest

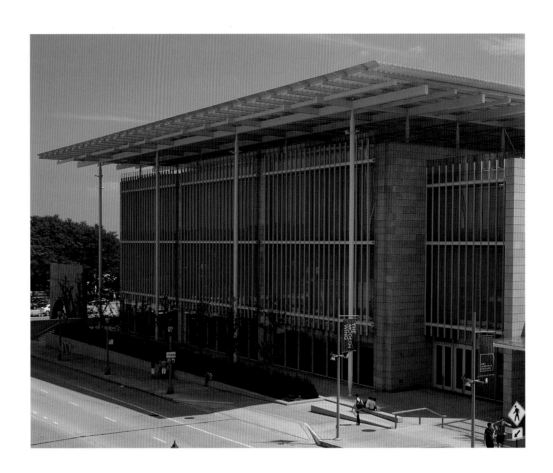

12 Art Institute of Chicago Modern Wing, Chicago, designed by Renzo Piano, completed in 2009.

to find a modernist expression that is at once light and substantial, and a vivid but not too assertive presence. And it is essential to mention two architects who chose other ways of breaking away from orthodox modernism: James Stirling, whose Neue Staatsgalerie in Stuttgart (pl. 13), completed in 1985, is perhaps the greatest post-modern museum built, an intense, extreme play on historical form that is almost an inversion of classicism; and Robert Venturi and Denise Scott Brown, whose Sainsbury Wing at the National Gallery in London (pl. 14), completed in 1991, represented a less playful, less cartoon-like, and highly mannered play on historical form. In neither of these cases did the architects use historical form to create what in any way could be considered a traditional building. Quite the contrary: they saw their museums as very much of the late twentieth century – it is just that to them, the spirit at the end of the century, with modernism no longer new or revolutionary, called for some degree of looking back and embracing architectural history, and making of it something of a collage. In that way, the sense of a collage or an assemblage, these buildings and the aesthetic they represented broke significantly from the modernist quest for a kind of platonic ideal, a pure and perfect object – a quest that I. M. Pei, for his part, very much continued to pursue.

Post-modernism did not fulfill its expectations for a number of reasons, not the least of which is that the slightly cartoon-like nature of many of its buildings did not seem convincing as a way of making architectural statements that would be permanent, important, and monumental, which we have always wanted our museums to be. But even more of a factor, surely, was the rise of a key figure in the architectural history of the museum at the end of the twentieth century, an architect whose impact now seems to be at least as significant as that of Kahn or Pei, Frank Gehry. Gehry's Guggenheim

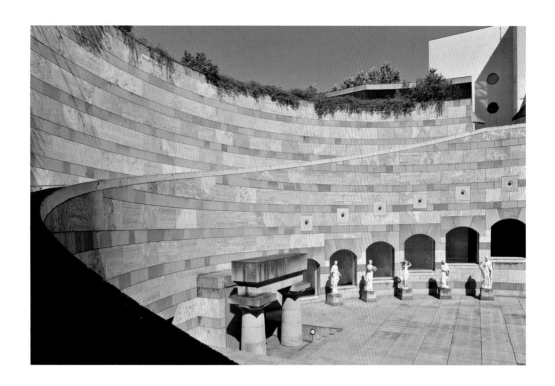

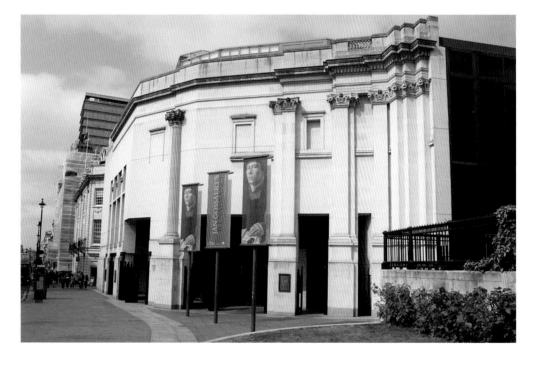

13 (*top*) Neue Staatsgalerie, Stuttgart, designed by James Stirling, completed in 1984.

14 (*bottom*) Sainsbury Wing of the National Gallery, London, designed by Robert Venturi and Denise Scott Brown, completed in 1991.

in Bilbao, Spain (pl. 15), completed in 1997 – paid for by the Basque government but built and managed by the same institution that built Wright's great Guggenheim in New York – is without a doubt the key museum of the late twentieth century. It is a building of great power, energy, and assertiveness, yet also of great beauty, and its curving titanium forms, in combination with elements of stone and glass, represented a truly new way of building that was less mannered than post-modernism, yet every bit as much of a break with classic modernism. It became wildly popular, one of the few buildings of great architectural ambition, depth, and complexity to excite the public imagination. There are not many such buildings: in the category of museums only

I. M. Pei and the Challenge of the Modern 21

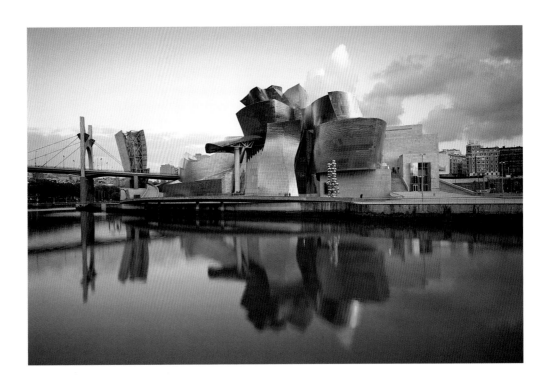

15 Guggenheim Museum Bilbao, Bilbao, designed by Frank Gehry, completed in 1997.

Wright's Guggenheim and two works of I. M. Pei, the East Building of the National Gallery of Art in Washington and the glass pyramid at the Louvre, have managed to be so worthy of extended critical analysis and so popular at the same time.

Pei had designed numerous other art museums of note before accepting the commission to design the MIA, and it is important to consider all of them not only within the context of contemporary museum design, but also within the larger framework of his exceptionally wide-ranging career. Pei has never been easily characterized. A committed modernist who was born in China and educated in the United States, he began his career not as what we might call an artist–architect, but in what might be considered the most commercial venue of all for an architect: as the chief of design within the office of a real estate developer, William Zeckendorf. In the early 1950s, Zeckendorf, unlike most of his colleagues, was eager to prove that it was possible to build commercial projects at large scale without sacrificing architectural quality. Pei shared Zeckendorf's unusual mix of idealism and pragmatism, and the two were so comfortable working together that the developer convinced him to work directly for him rather than begin an independent architectural practice.

It is not the sort of beginning that one would expect for an architect who would eventually become one of the leading designers of museums in the world. But as Pei was not a typical architect, Zeckendorf was hardly a typical developer. He was genuinely excited by architecture and the possibilities modern design held in the postwar years, and he envisioned himself less as a conventional client than as a true partner of his architect. The association with Zeckendorf lasted through the 1950s; in 1960, as Zeckendorf ran into the financial problems that would eventually result in his bankruptcy, Pei took the large architectural department he had built for Zeckendorf and turned it into an independent firm – making himself the rare architect to have opened his own practice with a staff of several dozen already in place.

Pei had done some notable buildings for Zeckendorf, mainly housing like Kips Bay Plaza in New York (pl. 16) and commercial towers like Mile High Center in Denver.

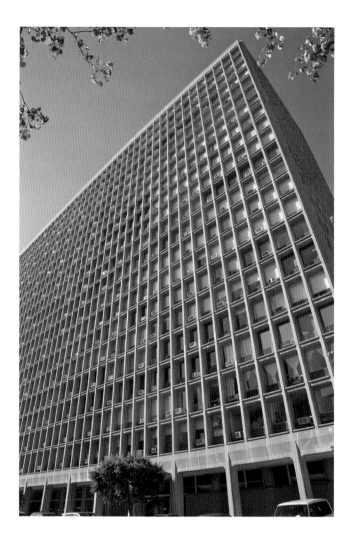

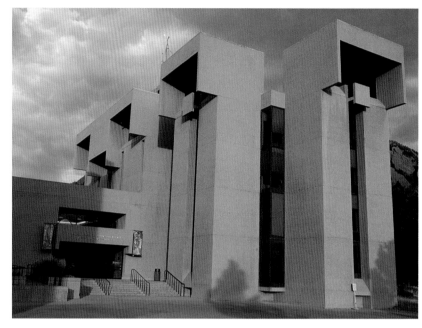

16 (*left*) Kips Bay Plaza South Building, New York, designed by I. M. Pei, completed in 1960.

17 (*right*) National Center for Atmospheric Research, Boulder, designed by I. M. Pei, completed in 1967.

There are elements of simple, direct geometries in most of these buildings, as well as a desire to move away from the light, transparent structures of the International Style toward something more sculptural and more defined by masonry. And once Pei was on his own, he began to move more assertively in these directions, beginning with the National Center for Atmospheric Research in Boulder, Colorado (pl. 17), completed in 1967, a project that has echoes of his contemporary Paul Rudolph and surely emerges out of a view of modernism as capable of possessing both traditional dignity and a new kind of sculptural energy. The influence of Le Corbusier is clear, as it is in the Luce Chapel in Taiwan (pl. 18), finished in 1963, a small religious building that seems to owe a debt to Le Corbusier's celebrated chapel at Ronchamp, which had been finished just eight years before. At more or less the same time, Pei also showed a willingness to learn from Frank Lloyd Wright, since the Newhouse Communications Center at Syracuse University (pl. 19), finished in 1964, very clearly uses the aesthetic of Wright's Prairie Houses, but then turns it into something altogether different – something civic, monumental, and, most un-Wrightian of all, symmetrical.

In his first years of independent practice Pei seemed to be looking at the entire range of modern architecture, treating it almost as a smorgasbord, picking and choosing from a wide range of different influences. He was seeking his own voice, and he hadn't fully found it, but what unites these early independent projects as well as most of his work for Zeckendorf was a desire to make modernism that was actively geometrical, yet solidly

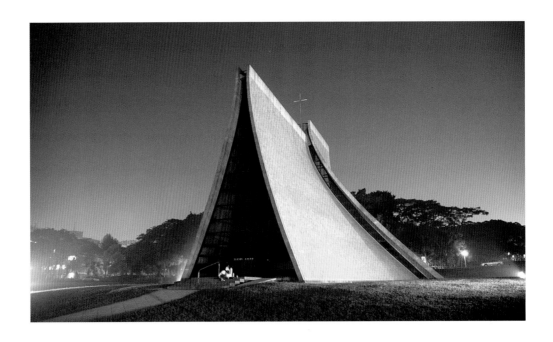

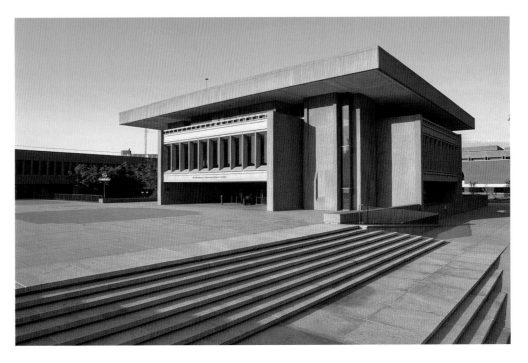

18 (*top*) Luce Memorial Chapel, Tunghai University, Taichung, designed by I. M. Pei; completed in 1963.

19 (*bottom*) Newhouse Communications Center, Syracuse University, New York, designed by I. M. Pei, completed in 1964.

monumental. He had relatively little interest in the notion of modernism as connoting lightness, as exemplified by the work of Mies van der Rohe; if anything, Pei's sensibility seemed more akin to the rough, heavy, powerful style influenced by late Le Corbusier that came to be known as Brutalism. But Pei did something quite unusual, even contradictory, here: he sought to make Brutalism refined, to keep its sense of mass and solidity but remove all its rough edges and make them smooth and elegant.

These qualities would remain paramount in his work as he moved on to other civic and cultural buildings, projects that we could well consider precursors to the MIA. Pei's first museums, the Everson Museum of Art in Syracuse (pl. 20), completed in 1968, the addition to the Des Moines Art Center, also of 1968, and the Herbert F. Johnson Museum at Cornell University, finished in 1973, are all different, but each in

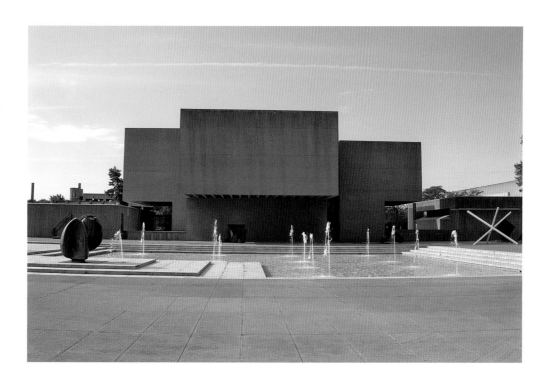

20 Everson Museum of Art, Syracuse, New York, designed by I. M. Pei, completed in 1968.

its way was an exercise in the use of blunt, direct modern geometric form to yield a powerful yet at the same time highly refined building. So, too, would Pei's other buildings explore different forms and influences and yet, however varied, would always be defined by an exercise in geometric shape-making that was at once blunt and elegant. The airline terminal Pei designed for National Airlines at John F. Kennedy Airport in New York, completed in 1970 and demolished, unfortunately, in 2011, can stand for a large group of buildings designed at roughly the same time as the early museums, most of which shared the airline terminal's quality of being both exceptionally massive and exceptionally refined.

If these general qualities prefigure the MIA in Doha, so do many more specific aspects of earlier projects. One of Pei's first independent commissions was the John F. Kennedy Library, originally planned for Cambridge, Massachusetts and eventually built in a revised design at Columbia Point at the edge of a University of Massachusetts campus that overlooked an outer section of Boston Harbor (pl. 21). Pei convinced the client to locate the library at the farthest point of the site, far from the other campus buildings, all the way out at a point at the water's edge – actually beyond the buildable portion of the site, so a tremendous amount of site work was required before any construction could begin. The final version of the building was heavily compromised, but it is still very much a Pei composition: a combination of basic geometric shapes, in this case a circle, a square, and a triangle, and an elaborate glass space frame looking out to the water and to the view of the city skyline in the distance. The Kennedy Library project was begun in 1964 and not finished until 1979; despite the distance of thirty years between its completion and the opening of the MIA, not to mention the enormous differences between these two buildings in terms of quality of materials and detailing, it is not difficult to see that they represent a very similar view toward siting: in each case the building is envisioned as a fairly simple geometric composition, set at the edge of the waterfront on a site created out of landfill, in deliberate isolation from other buildings and from the city center.

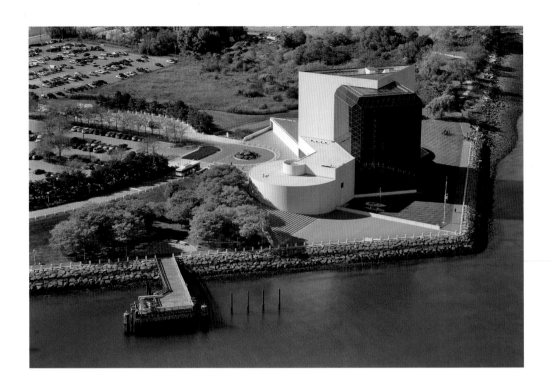

21 John F. Kennedy
Presidential Library, Boston,
designed by I. M. Pei, completed
in 1979.

Considerably more successful, and definitely an advance in terms of the quality of its details, was the East Building, Pei's addition to the National Gallery of Art in Washington (pl. 22), completed in 1978, a year before the Kennedy Library but designed many years after it. Here there is of course no waterfront site, but the themes of Pei's earlier museums remain: the East Building is a solid masonry structure of crisp geometries, in this case dictated by two adjacent triangles, with a large, light-filled atrium between them. Carter Wiseman, Pei's biographer, recounts that William Pedersen, the architect who began his career as one of Pei's chief design associates, grew concerned that the rigorous geometry of the triangles would compromise the functional success of the building, and yield galleries that were potentially awkward. He raised his concerns with Pei, who listened carefully and then responded that he remained absolutely committed to the overall form of the building. It was clearly of critical importance to Pei that a powerful and highly readable geometry be driving the design (Wiseman 2001, 165).

Indeed, as Pedersen predicted, the East Building has always been somewhat compromised functionally: its galleries are clearly secondary spaces, organized around a spectacular central atrium that is in every way the primary space of the building. While it would be an exaggeration to refer to the galleries as leftover spaces, it is difficult not to feel that they are subordinate ones. The atrium, unlike the great central halls of many classical museum buildings, including John Russell Pope's original National Gallery building next door, does not lead in a natural sequence to the galleries. It feels less like a prologue to the gallery spaces than a destination in itself.

Still, the East Building represented an important moment in the history of American museum architecture. It was surely the most monumental modernist museum built up to that point and probably, even with its shortcomings, the most widely admired. Its success underscored the extent to which modernism had become an accepted, perhaps even a conservative, style by the late 1970s. If an important new museum might also be an avant-garde architectural statement, as with Wright's Guggenheim twenty years earlier or Piano and Rogers's Centre Pompidou just the year before, the East Building

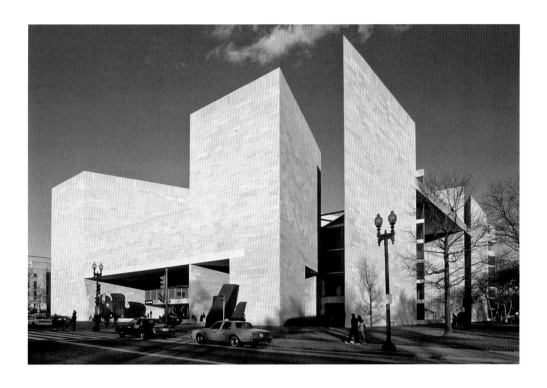

made a different kind of statement: it said that modernism could, in its way, be as monumental and self-assured as classicism and could project the same air of permanence. For all of its powerful diagonals, the East Building nevertheless seemed fixed and grounded, as if Pei had wanted to prove that his building – and modern architecture in general – could stand beside a classical building like John Russell Pope's with equal gravitas.

Two other museum buildings by Pei further set the stage for his work in Doha. In 1989, Pei completed his glass pyramid that now serves as the public entrance to the Louvre (pl. 23). It was at this point surely his most famous work, and a project that was highly controversial when it was proposed. Now it has been so widely accepted that it is difficult to understand why it provoked such strong opposition, though much of it, to be fair, was directed not toward Pei's actual design but toward the vast expansion and modernization of the Louvre to accommodate larger crowds, of which the pyramid was the most conspicuous symbol. Here again Pei uses modern elements and modern materials to create a simple, almost primal shape, exquisitely detailed and absolute in its geometry. In this sense the pyramid represents not a departure from Pei's previous work but an extension of it. What marks the pyramid as different is both the sense of overall lightness it projects and the extent to which it relies upon, and connects to, older buildings; the pyramid cannot be viewed or even conceived as a thing in itself, as the East Building, for all its connections to its older neighbor, can stand alone. Every image of the pyramid shows the Louvre behind it; the courtyard of the Louvre quite literally becomes part of Pei's architecture. Here, lightness and transparency become an act of architectural deference, as if Pei were ceding to the older sections of the Louvre the solidity and opacity he normally wants his museums to have. The intimate relationship between Pei's sleek glass pyramid and the eighteenth-century buildings of the Louvre is, of course, what many of the original critics had objected to, fearing that the juxtaposition would provoke an untenable clash. In fact, the opposite has turned out to be true: Pei's pyramid is remarkably comfortable beside the older

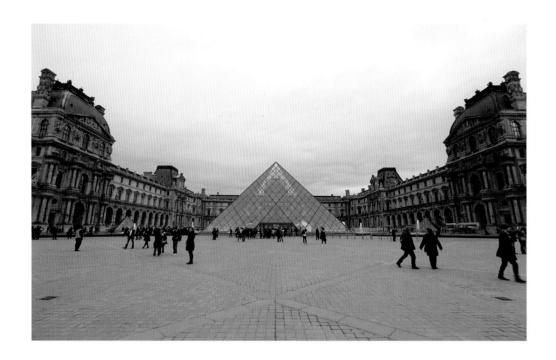

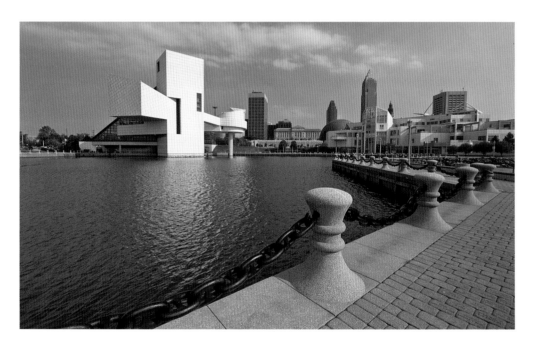

23 (*top*) Pyramid in the Louvre, Paris, designed by I. M. Pei; completed 1989.

24 (*bottom*) Rock and Roll Hall of Fame, Cleveland, Ohio, designed by I. M. Pei, completed in 1995.

wings of the Louvre, as Pei had predicted it would be, and might even be said to enliven them at no cost to their dignity.

If the Louvre project showed that Pei could be more comfortable with classical symmetry than anyone had expected, further setting the stage for the MIA, it provided another element that would prove beneficial in Doha. At the Louvre, Pei worked for the first time with Jean-Michel Wilmotte, the gifted designer whose collaboration with him on interior exhibition spaces was so successful that the architect invited Wilmotte to work with him again on the MIA, where Wilmotte would have a substantial impact on the design of the galleries.

Pei was to design one other museum that might be said to serve as a precursor in a different way for the MIA: the Rock and Roll Hall of Fame in Cleveland, Ohio (pl.

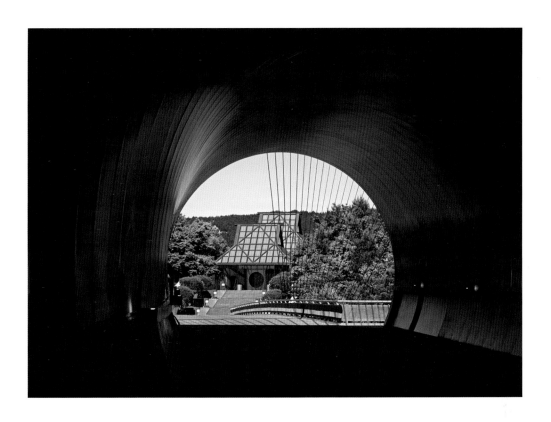

24). It was an unlikely project for Pei, who received the commission in 1986 in large part because he was thought to bring an air of established respectability to a new institution that was logically associated more with youth and irreverence. Pei characteristically immersed himself in the culture of rock and roll, even traveling to Memphis to visit Graceland, Elvis Presley's home, not, to be sure, in search of literal architectural inspiration but in quest of a greater understanding of rock and roll. In fact, the museum, which opened in 1995, has many of the characteristic Pei elements: bold dramatic shapes and a large, glass-enclosed central atrium. And like the Kennedy Library and the MIA, it has a prominent site along the waterfront.

By the time the Rock and Roll Hall of Fame opened, Pei was approaching the age of eighty and had largely withdrawn from his firm. He did not retire; he formed a partnership with his two architect sons with the understanding that he would accept only those commissions he considered meaningful to him. One was the Miho Museum outside of Kyoto (pl. 25), completed in 1997, which is reached via a dramatic approach through a tunnel and over a bridge, and which is a clear effort to reinterpret classic Japanese design; another was a museum for Suzhou (pl. 26), Pei's family's ancestral home in China, which opened in 2006 and which represented a similar effort to integrate traditional Chinese architecture into what was clearly a modern building. Both of these buildings possessed many of Pei's characteristic elements, underscoring the fact that Pei had no desire to imitate a traditional building directly.

But while he was never comfortable with direct historical quotation, he was gradually becoming more interested in modern buildings that made overt attempts to synthesize historic style, as he had first tried to do in a project much closer to home than Kyoto, Suzhou, or Doha: his design for the Four Seasons Hotel in New York City, a stone-clad skyscraper completed in the early 1990s that has an elaborate, setback top clearly evocative of classic Manhattan skyscrapers of the 1920s. The hotel tower

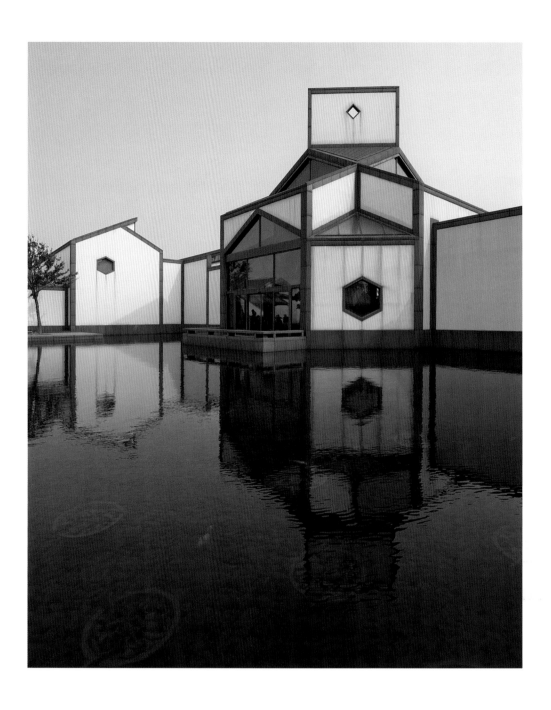

26 Suzhou Museum, Jiangsu, designed by I. M. Pei, completed in 2006.

represented a significant aesthetic distance from the stark and simple modernist build-ings of Pei's early years, but it would set a tone for all three of his late museums, where Pei sought, in three entirely different contexts, to create modern buildings that would similarly recall many elements of traditional style while copying none of them literally, and that would appear sympathetic to traditional buildings while being very much of the twenty-first century.

At Doha, Pei was to make what was perhaps his most ambitious attempt to create a modern building that would synthesize elements of traditional architectural styles, so as to conclude his career with a ringing declaration of his belief that modern and traditional architecture need not be seen as representing entirely opposite philosophies. The MIA was a key building-block in the program of the Emir, Sheikh Hamad bin Khalifa Al Thani, to establish Qatar as a major international cultural center, and it was intended to be the first in an extraordinarily ambitious series of museums overseen by

Sheikha Al Mayassa bint Hamad bin Khalifa Al Thani that would eventually include a national museum designed by Jean Nouvel.

The Islamic art museum project actually began some time before Pei was called to design it. In 1997, an architectural competition was held to select a design under the aegis of the Aga Khan's long-standing initiative to encourage contemporary expressions of Islamic architecture. The winner was the Jordanian architect Rasem Badran, who produced a scheme that philosophically if not architecturally had certain similarities to what Pei would design several years later. (Badran's competition design bore little resemblance to the building Pei would eventually create, but it represented a particularly engaging, not to say self-assured, synthesis of modernism and traditional Islamic motifs.)

Badran's project did not, however, go ahead. The state of Qatar had already become an active collector of art and artifacts from across the Islamic world. It was eager to invest in further acquisitions and it is possible that Badran, despite his distinguished reputation within the region, did not have the degree of international stature the nation sought. Whatever the reason for the abandonment of Badran's design, Luis Monreal, a member of the competition jury, suggested to the Emir that the project might appeal to Pei, whose prestige, it probably did not have to be said, would bring welcome attention to the country's already rapidly growing cultural stature. Pei was approached and he agreed to accept the commission, despite the fact that he had never designed a building in the Middle East – or perhaps because of it, since he has said that "I chose to do buildings in places I'd never been before – I enjoy learning about a place. I knew the East because I was born there, the West because I was educated there, but the Middle East I didn't know. My early education never revealed to me Islamic architecture as a major architectural invention" (Landin and van Wagenen 2009).

Pei was clear from the outset that at Doha he would try to do much the same thing that he had done in Kyoto and was in the process of doing in Suzhou: he wanted his building to stand as evidence that there need not be a contradiction between modernism and traditional culture, to show that it is possible to design a thoroughly modern building that absorbs and reflects the influences of traditional architecture. Islamic architecture, of course, is quite different from Asian architecture, and as Pei freely admitted, he could not claim any real familiarity with it as he began the design process. His Western education had taught him nothing about either the art or the architecture of Islam. At the start of the design process, for Pei, Islamic architecture was as unfamiliar as the culture of rock and roll had been.

But as he had prepared himself for the process of designing the building in Cleveland, Pei immersed himself in this new culture, and sought to understand not only its physical forms but also the minds of its creators. He began by reading a biography of the Prophet Muhammad, which revealed to Pei, he later said, "how little I knew about Islam" (Landin and van Wagenen 2009). And then he began to travel across the region, seeking, he said, to discover the "essence" of Islamic architecture (Jodidio 2008, 30). It was a journey that underscored the extent to which the architect was anything but casual in his attitude toward this project.

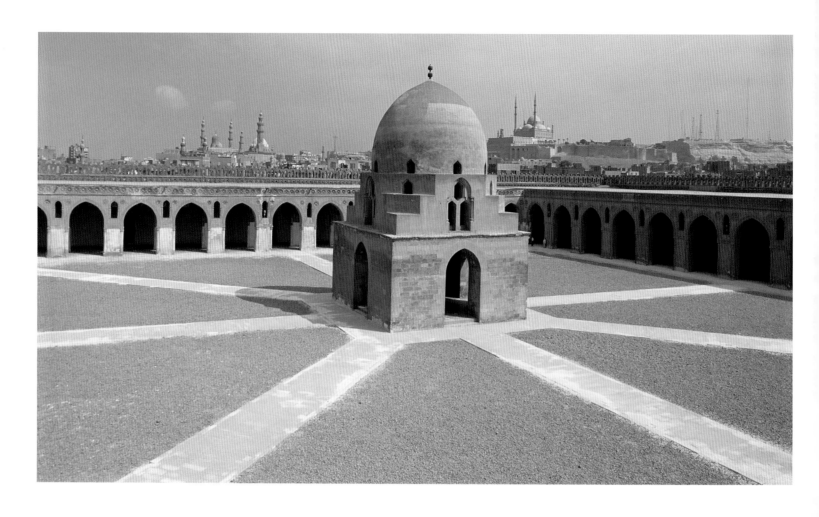

27 Courtyard in the Mosque of Ibn Tulun, Cairo, completed in 879.

Pei went to see the Great Mosque in Córdoba, which he later said he had previously assumed to be the high point of Islamic architecture, but which he now felt was too Spanish, perhaps even too Mediterranean. Similarly, the Jama Masjid in Fatehpur Sikri was too Indian. The Umayyad Great Mosque in Damascus felt too suggestive of Roman and Byzantine architecture. Nothing Pei saw seemed, to him, to reveal the essential qualities of Islamic architecture as a pure thing unto itself. In Tunisia, Pei found himself more attracted to ancient ribats, or fortifications, than to mosques – in the forts, he said, "sunlight brings to life powerful volumes and geometry plays a central role" (Jodidio 2008, 44–45).

In time, Pei's travels took him to Cairo, where he visited the ninth-century mosque of Ahmad ibn Tulun (pl. 27), the oldest mosque in Cairo to have survived intact, and there he found what he had been looking for – if Córdoba, as Pei said, was "too lush and colorful," Ibn Tulun was "severe and simple in its design," a place "where sunlight brings forms to life . . . an almost Cubist expression of geometry progression from the octagon to the square and the square to the circle. This severe architecture comes to life in the sun, with its shadows and shades of color" (Jodidio 2008, 46).

It is not difficult to see the connection between the high-domed fountain in the central courtyard of Ibn Tulun and the museum Pei would come to build in Doha (pl. 28), just as it is easy to see how the arcades in the courtyard he would design in Doha between the main building of the museum and its education wing were inspired by the arcades facing the courtyard of Ibn Tulun's mosque. Pei's attraction to the mosque in Cairo was genuine, and ran deep.

28 (facing page) MIA, Doha.

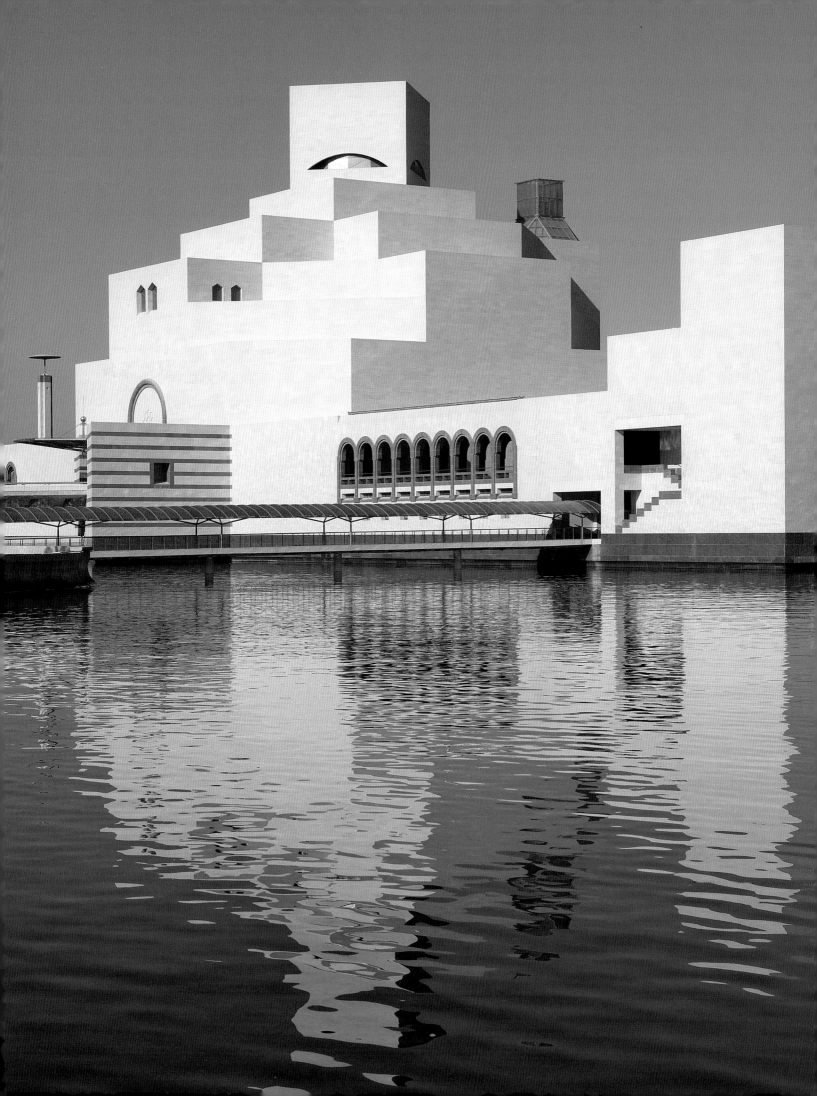

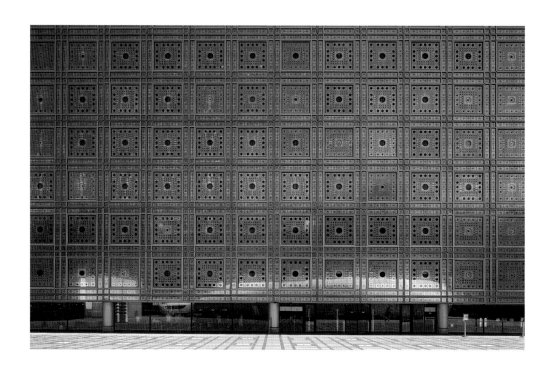

29 Institut du Monde Arabe,
Paris, designed by Jean Nouvel,
completed in 1987.

Still, every architect, like every artist of any type, sees what he wants to see. He or she sees what is relevant to the ideas and sensibility that they bring to any situation. As Frank Gehry looked at Los Angeles and saw the energy of chaotic, industrial sprawl, not the softness of pink Spanish Mediterranean houses, as Le Corbusier looked at pure architectural form against the landscape, not the architraves and entablatures of classicism, so I. M. Pei looked at Islamic architecture and saw its clear, strong, basic geometries – elements that connected to the aesthetic sensibility he brought to his exploration. He did not see the calligraphy, the decoration, or the way that geometries are often used in Islamic architecture to create delicate and intricate pattern and ornament. He once admitted to being uncomfortable with those examples of Islamic architecture that were too dependent on calligraphy and ornament – those that depended, in other words, on the things that did not align with his own aesthetic. So Pei's quest to seek the essence of Islamic architecture, while deeply earnest, was in every way colored by his own lifelong preferences for Western modernism, and his own reading of Western modernism as predominantly a composition of geometric forms and spatial volumes, not of decorative detail.

We might contrast Pei's view of Islamic architectural tradition with that of Jean Nouvel, who also has a presence in Doha in the form of a new cylindrical tower, and will eventually have an even more conspicuous presence through the new National Museum under construction not far from the MIA. When Nouvel designed the Institut du Monde Arabe in Paris (pl. 29) he, like Pei, sought to evoke Islamic tradition. But Nouvel saw precisely the opposite of what Pei saw. To Nouvel, it was not the solid, severe masonry forms but the intricate ornament and the exquisite decorative patterns that connoted Islamic architecture, and he sought to evoke this intricacy and filigree in an entirely new way by making it the inspiration for an ingenious system of sunscreens. He put these Islamic-inspired sunscreens behind a glass curtain wall, which is about as distant from Islamic tradition as one can get.

So it is not only Pei who seeks in Islamic precedent those elements that would allow him to make a work of architecture that is consistent with what he had done

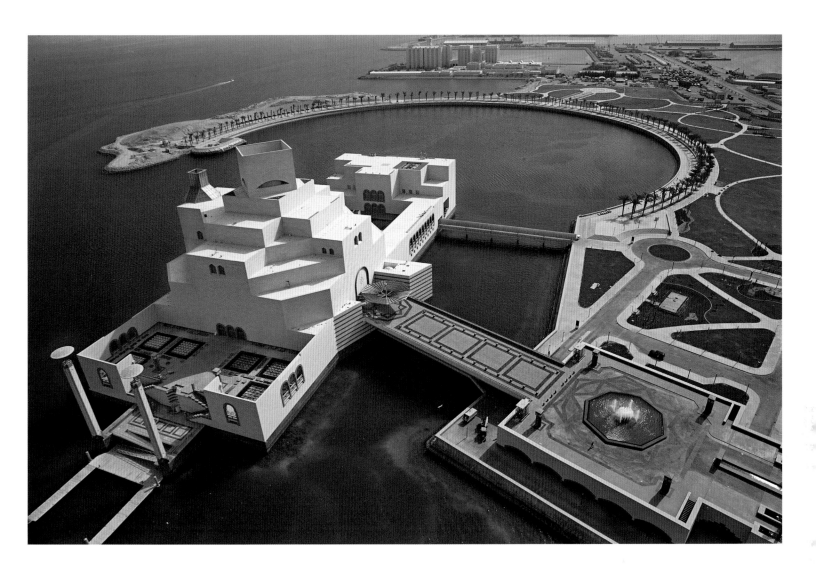

30 MIA, Doha.

before. But this inevitably means, of course, that the elements of the MIA that evoke Islamic precedent are somewhat limited, and cannot be said to be truly defining of the building as a whole. And in some cases, what Pei has cited as Islamic is a condition not limited to Islamic architecture – for example, Pei has spoken often of being inspired by the way the forms and volumes of traditional Islamic architecture are brought to life by the intense sun, and said that he envisioned his building also as very much a structure designed to be seen in bright sun, its crisp forms outlined against the blue sky. It is indeed so, but it is difficult to list this welcome but very general quality as evidence of strong connection to Islamic tradition. This is first and foremost a modern building – albeit a modern building designed with great sympathy to, and engagement with, Islamic tradition.

The connections to Pei's other work parallel, and at times overshadow, his desire to respond to Islamic tradition. The choice of the MIA's site is a good example. The building had been proposed for various sites along Doha's Corniche, all of which Pei rejected, fearing that large structures might in time overshadow the museum. He suggested a manmade island sixty meters away from the shore, to be connected by landfill, so that the MIA might stand wholly apart, and be seen against the water, not against other buildings (pl. 30). And thus the MIA occupies this spectacular, indeed unique, site, breathtakingly beautiful but set apart, with a formal, axial approach – a siting that

would seem to have more in common with the formal axes of Western buildings in the classical tradition than with Islamic ones, although the diagonal entry axis subtly but powerfully asserts its connection to modernism as well. While the MIA is vastly grander and more thoughtfully conceived than the Kennedy Library, its siting on land-fill, overlooking the water and as far away as possible from other buildings, surely evokes that of the Library or, to a lesser extent, the waterfront site of the Rock and Roll Hall of Fame.

A great central interior space, several stories high (pl. 31), is absolutely key to this building, as it is to almost every other Pei museum. There are elements here, like the side staircase details and the great dependence on natural light, that remind one of the atrium of the East Building of the National Gallery in Washington; the orientation to the water and the view of course evoke the Kennedy Library – or perhaps we might say the Kennedy Library as Pei might have wished it to be, without the many compromises that weakened that building.

While the symmetry of the Great Hall is not characteristic of Pei and neither, for that matter, is the dome or the fountain, one still has the sense that despite these factors, this space has more in common with other Pei work than not. It is a large, light-filled public space, defined largely by walls made of the same stone as is used on the exterior, with the galleries arrayed around it, in spaces that are clearly subsidiary to the central hall. Those words could certainly describe the central space of the East Building in Washington, and even though that space is asymmetrical and defined by diagonals, it is still very much a space where a clearly articulated geometric form is the determining factor.

The dome is not typical of Pei's work, but neither is it what one would call a traditional Islamic dome. If the fact of the dome is an acknowledgment of Islamic tradition, its specific design, with an interior of faceted stainless steel (pl. 32), is not, though it is unquestionably beautiful and eloquent as a way of mediating between Islamic tradition and modernist form, and of enhancing the play of light, which enters through a small oculus and then shimmers as reflected by the facets. On the exterior of the building the dome is, for all intents and purposes, non-existent, since it is surrounded by stone walls that combine to form a central tower, roughly square, that is the culminating element of the mounting sequence of masses that make up the overall volume of the building. The square tower is a dramatic break with the precedent of Ibn Tulun, which inspires the stepped-up, angular masses below but which of course culminates in a very visible dome. Pei's decision to cover the dome is partly, I think, a response to scale: his dome is fairly small, and is more of a punctuation mark at the top of the atrium, not a dome that covers the full breadth of the space, and if it were visible on the outside it would seem under-scaled, almost trivial. Still, these walls create a striking paradox: in search of a more modern appearance, Pei has created a set of false walls, indulging in the very sort of architectural cover-up that modernists have tended to criticize as characteristic of historicist architecture. In search of the "honest" appearance of modernism, in other words, he has made the building less honest.

Does this matter? I think not. I mention it not to be critical, but to point out the fallacy of so much modernist rhetoric. Pei is using a false tower as a kind of stage-set

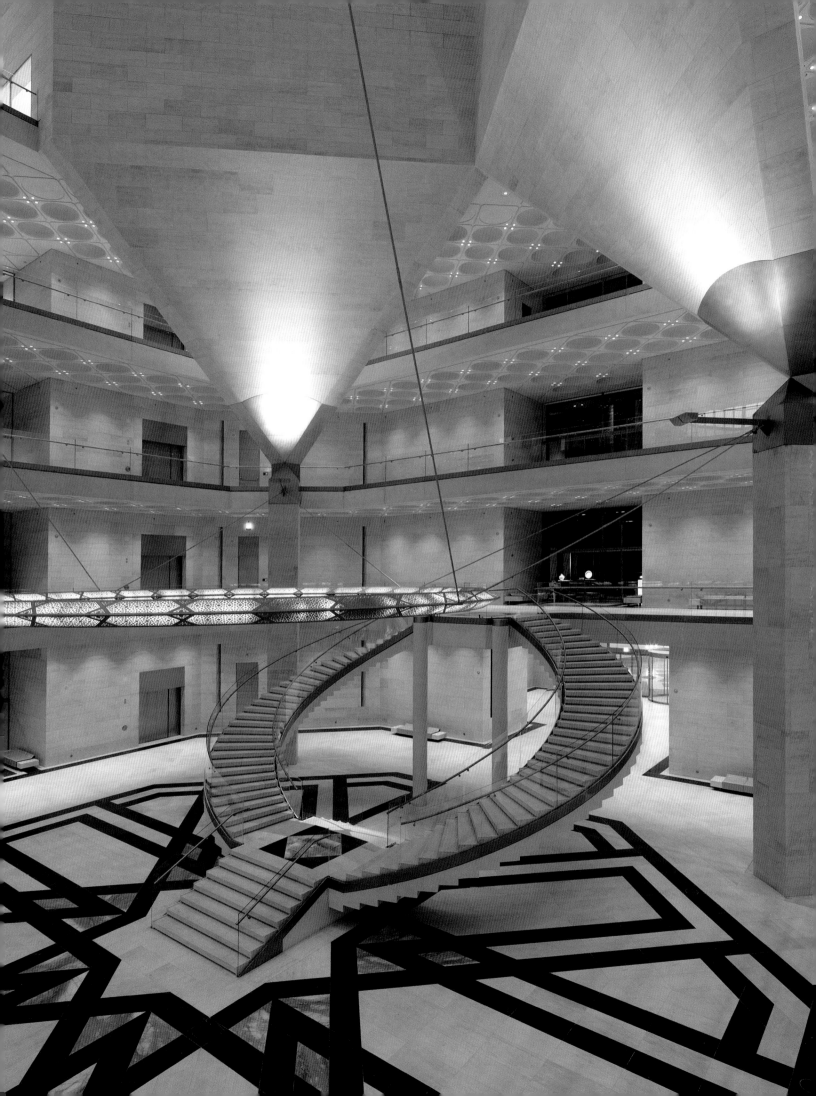

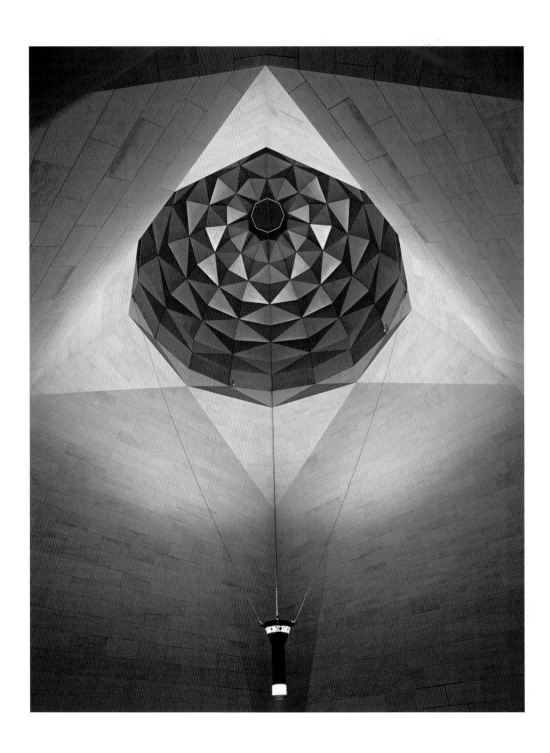

32 Detail of the dome in the
MIA, Doha.

here, denying the structural reality of the dome. But while this may be a contradiction of modernist doctrine, it offers instead something more meaningful than rhetoric, which is an exterior that is whole and complete as a composition in itself. Within the decision to shape the exterior this way, and to not express the dome, there is an implicit admission that composition and the visual pleasures it provides are more important than modernist doctrine.

Below the dome, the space becomes complex, and despite a number of elements that allude to Islamic decorative traditions, such as the patterns in the floor, the octagonal fountain, and the filigree pattern to the chandelier (pl. 33), the overall sense is of modernist space and structure. One of the most remarkable elements of this building, the unusual sequence of geometric forms within the structure by which the dome is

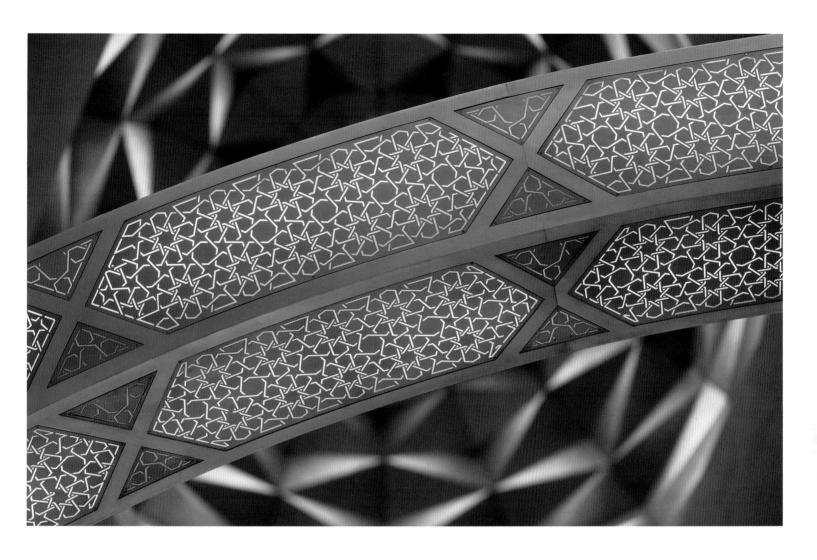

33 Detail of the chandelier in the MIA, Doha.

supported, Pei has described as "a geometric matrix [that] transforms the dome's descent from circle to octagon, to square, and finally to four triangular flaps that angle back at different heights to become the atrium's column supports" (Jodidio 2008, 63).

It is a good description, and from it we can infer the reality of this space, which is that while it makes use of several shapes that are common in Islamic architecture, it is in almost every way a modern interior space. The enormous V-shaped corner supports, which Pei refers to as the "triangular flaps," are emphatically modern; so are the thick trusses supporting the glass bridges that cross the atrium. Even the low-hanging chandelier, which evokes the intricate details of ancient lamp design to create a huge, floating circle of light, while admittedly not like anything Pei has done before, still has more in common with his modernist sensibility than with the ancient lamps that inspired it.

Perhaps the double stair, flying up from the very center of the space, is the one exception here; while it, too, has no precise precedent, it feels light in a way that is very much in accord with the delicacy and intricacy of Islamic design, the very elements that Pei most of the time chose not to see. Then again, it is hard not also to see some connection to Palladio and the Palladian tradition, a line of Western classicism that Pei has generally not pursued. The issue a critic might have with the stair is not its degree of connection to Islamic or Western precedent, however, but its placement in a position that means that the visitor sees the backside and underside of the stair

as he or she enters the museum, and not the exquisite way in which, from the other side, it appears to float upwards.

The atrium overall, then, is a curious combination of the modern and the traditional, which sometimes seem to relate very comfortably and other times less so. The symmetry of the main building suggests that the space will possess a repose that it doesn't fully have, in part because there is a lot going on with all of these stairs and bridges and structural elements, some modern, some less so; and in part because of the somewhat idiosyncratic structure supporting the dome, in which the triangular supports meet the columns on different floors, throwing the space a bit off balance. The serenity that Pei sought in the atrium is achieved more fully, I think, in the court-yard between the Museum and the educational wing, a space that is austere but pow-erful, with modern screens that provide shade and balance the modern and traditional aesthetic with particular ease, and a beautifully scaled, rhythmic series of open arches, providing a greater sense of connection between you and the water and the vista of the city than you get within the atrium. It is a space that is rather too open for com-fortable use in the intense heat, but it remains one of the most successful elements in the MIA (pl. 34).

It is somewhat paradoxical that Pei has succeeded so well in a section of the MIA in which, thanks to the arcades, there is a stronger feeling of Islamic tradition than in some of the other areas. But it is important to say again that this is not a building that can or should be judged by the standard of how it should be rated on the scale of traditional Islamic architecture. Its goal was something else altogether: to make a modern building that would acknowledge traditional architecture and learn from it, and then use that knowledge to make a work of modern architecture that would be different from any other.

But to what extent is that actually possible? Is there an inherent contradiction between Islamic architecture and modern Western architecture that will make any attempt to synthesize them inevitably a compromise? It need not be, in part because, as the architectural historian Marvin Trachtenberg has pointed out, many of the fun-damental elements of Islamic architecture are shared with the architecture of the West: domes, arches, columns, vaults, all elements that Pei chose to emphasize (Hyman and Trachtenberg 1986, 215). Surface decoration is far more essential in Islamic architecture than Western, of course, and here Pei was more hesitant to embrace precedent. But Islamic architecture does make much of monumental interior space, as Western archi-tecture, and particularly Pei's own work, do.

Pei succeeded, then, in creating a meaningful synthesis, in part because he was able to use so many architectural elements that Islamic and Western architecture have in common. While he may have used some of these elements in a more Western way than Islamic traditionalists would like, his goal was to make a modern building, as well as a building that will be a landmark in Doha, in Qatar, and in this entire part of the world. Pei has done this by continuing and extending the themes of his own work, as well as by pursuing, with the utmost sincerity, the traditions of Islamic architecture. Pei's career is one of continual searching for ways in which other places, other cultures,

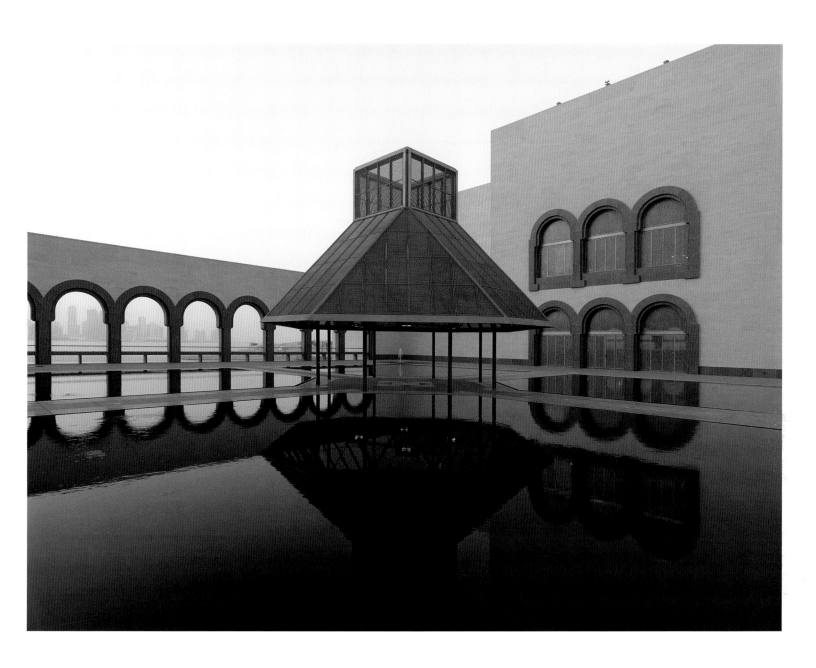

34 View of the courtyard in the MIA, Doha.

other traditions, can be integrated into his own modernist sensibility. "Architecture is form, space, light, movement, all of that. But more important is the place where you build," Pei has said (Landin and van Wagenen 2009). The museum at Doha, in that sense, is his capstone, the ultimate expression of this lifelong quest. Every architect is hired for two reasons: to solve a problem and to be true to himself. Pei achieved both of these things in the MIA – a building that brings the modern world to Islamic culture, and brings Islamic culture to the modern world.

p. 42: detail of the Introductory Gallery, MIA, Doha.

2

The Galleries of the
Museum of Islamic Art, Doha

اروقة متحف الفن الاسلامي في الدوحة

Oliver Watson

The Idea

The Museum of Islamic Art (MIA) in Doha is arguably one of few museums in the world conceived, planned, prepared, built, and installed in the ideal manner. Most museums, and certainly any museum of a certain age, have at some point or indeed on several occasions had to reinvent themselves as they adjust to new social and political circumstances, and as their trustees and directors respond to the fickle pressures of fashion and finance. Their raison d'être changes; different parts of the collection are forefronted, others dismissed; different activities and different audiences are sought; old spaces are coerced into new functions, new spaces attached.

Recently built and recently opened, the MIA in Doha has not had time nor need to rethink its mission, but even among other recently opened museums the ideal process from conception to delivery is nevertheless a rarity. The MIA is pristine: the crystal clarity of its exterior proclaims the clarity of the thought and ambition that brought it into existence. It started not with collections that needed housing, nor some muddled idea of civic necessity, but with a simple idea. This idea, perhaps not even explicit at the time, was educational: to promote an understanding of the high points of culture that Islamic societies have reached over the millennium and a half since the revelation of Islam and its expression in a Middle Eastern state in the seventh century CE. This idea could best and most easily be illustrated by art – by works of art chosen not simply for their aesthetic qualities, not only for their breathtaking craftsmanship, not just as markers of stylistic development and influence, but as reflections of the sophistication and high achievement of the culture – of the most cultured members – of the society that produced them. So a collection was built, and its astonishing quality, importance, and range, often remarked on, is something of which Qatar can be truly proud.

As the collection grew, a museum building was needed as the literal and metaphorical site where the collections could do their primary work in promoting the idea, so an architect was appointed, and subsequently a specialist gallery designer. Architect I. M. Pei chose to work with an old colleague, the distinguished French *architecte d'intérieur* Jean-Michel Wilmotte with whom he had collaborated on the interior of the Louvre pyramid. Gallery design and display program followed, in collaborative work between the architects, the designers, and the curatorial team. The design and selection of interior finishes, display cases, lighting systems, object mounts, text, and labels, are all crucial to the final impact, and each element must balance an aesthetic imperative with stringent technical requirements. All this work (in total the work of some years, it has to be said) in support of the original idea – an idea for which the audiences and the activities they engaged in would be the final, critical, and most demanding test. Would it work?

35 (*facing page*) Earthenware dish decorated in black on a white slip (diam. 42.5 cm), eastern Iran or Central Asia, 10th century. MIA, Doha (PO.24.1999).

The Collections

The collections of the MIA, brought together in less than fifteen years, are of astonishing quality, its best pieces (and there are many) matching or surpassing those in the older, more established, museums of Europe and the United States. However, they are

36 Planispheric astrolabe made by Ahmed ibn Husayn bin Baso (diam. 13.5 cm), Granada, 1309. MIA, Doha (MW.342.2007).

not just fine works of art, but all reflect in some way the cultural, educational, and scientific activities of the varied Islamic societies that produced them. The aim in collecting was to show the highest cultural achievements, and this led inevitably to the focus on works of the highest quality – in popular parlance "masterpieces." And in this, Qatar has achieved wonderful success. The works in the MIA were collected not to develop a narrative – the history of a particular material such as pottery or carpets – nor to illustrate the full visual complexity of a particular period, but instead rely on the power of individual objects to suggest and recreate complex social and intellectual pursuits.

Art works can involve and conjure up every level of society, and the activities that bind them. Take, for example, these three objects. The superb quality of an epigraphic dish (pl. 35) indicates an appreciation of craftsmanship among those of modest wealth for whom ceramics were made. The calligraphy – as fine as that found on any manuscript or building of the time – underlines the importance of literacy and the written word; its aphorism ("foolish is the person who misses his chance and afterwards reproaches fate") derives from the widespread interest in ethics and philosophy. The whole reflects the importance of generosity in social gatherings where discussion takes over from refreshment as the focus of an evening's entertainment.

An astrolabe (pl. 36) is an astonishing scientific precision instrument, where one's initial admiration of the meticulous skill of the craftsman in blending the beautiful and the functional gives way to awe at the learning that lies behind it: the centuries of observation and recording that led to such a profound understanding of the mechanics of the heavens, and how these could help in everyday activities such as pinpointing the time of prayer or the direction of Mecca, or the esoteric astrological predictions of a monarch's life.

A carpet (pl. 37) is the result of impressive contact and cooperation between a large number of different trades and craftsman – the silk farmer, the cotton grower, and the

37 The Sarre Ardabil animal carpet, wool pile on a silk foundation, probably Kashan, mid-16th century. MIA, Doha (CA.43.2002).

herdsman supplying the spinner who produces the woolen yarn; the dyer and his international network who source the precious dyes; the designer who details the pattern; the specialist who turns a drawn pattern into the program that the carpet knotters can follow. They work for the master weaver who commands the skill and resources to have the loom strung, the colored yarns assembled, the workmen ready. He schedules and prices the product. And finally there are the customers for whom the carpet speaks differently of luxurious display and of social gathering, of court ritual or community prayer, of international exchange by trade or contact by diplomacy.

Gallery Design

The overall design of the galleries in the MIA supports the vision of a collection of masterpieces, each capable on its own of telling many stories, each worthy of prolonged contemplation. Overall the galleries are dramatic, dark spaces richly paneled in textured wood and stone, with glass cases soaring into the darkness above, and spotlit objects commanding attention. There is space around and between the objects, allowing them to breathe, to signal their importance, to invite close inspection. In some galleries (pl. 38), the presence of the display cases is minimized, to suggest immediate and untrammeled access. Elsewhere, monumental tables of stone support the displays (pl. 39), inviting the visitor to rest, literally, during their study. While some objects are of imposing size, many are small, yet covered in minute intricate decoration. The visitor must be encouraged into close inspection, not allowed simply to walk past hoping for something more imposing or bigger. Size does not equate to quality or importance in Islamic art.

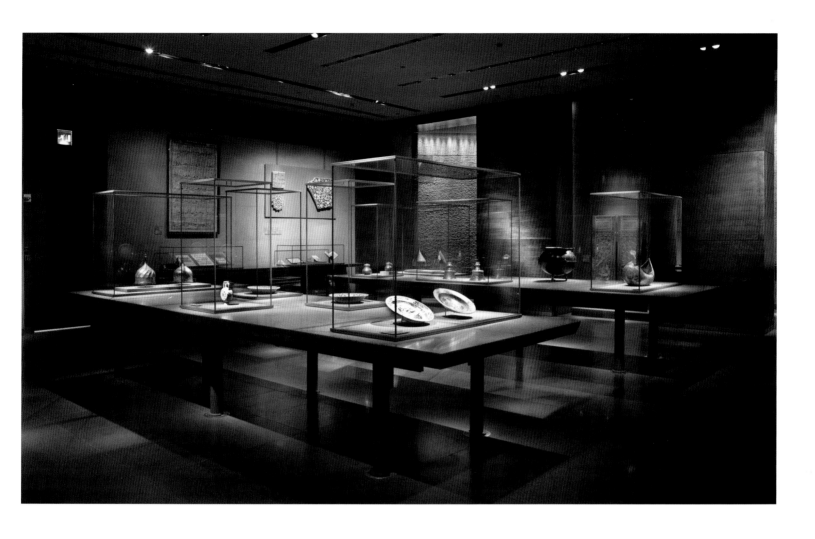

39 Timurid Gallery, MIA, Doha.

The galleries are not uniform in shape or atmosphere. As the visitor progresses from one to another along a stretch of four or five rooms, each has a distinct character, sometimes dictated by the space itself, as in the long double height spaces on the upper floor (pl. 40), which are followed by smaller more intimate spaces, sometimes by the nature of the objects on display (pl. 41), sometimes by the distribution of cases. This gives a sense of rhythm and change – one moves from the pattern gallery, with its wide variety of object types in rich colors and complex decoration, to the gallery of science, a quiet open space dominated by a single kind of object, or likewise from a crowded gallery full of small-scale sculpture to a spacious and restful room of much less busy character (pl. 42).

Gallery Layout

40 (*p. 50*) Seljuq and Mongol Gallery, MIA, Doha.

41 (*p. 51, top*) Mughal Jewelry Gallery, MIA, Doha.

42 (*p. 51, bottom*) Gallery in the MIA, Doha, with sofas for visitors to rest.

The galleries are on two floors, each with nine separate rooms. Planning had originally envisaged a purely chronological layout, starting from an introductory room to sequences left and right of the early periods in the Western and Eastern Islamic lands. Upstairs, the three great later empires of the Ottomans, Safavids, and Mughals were each to be given a double height space in which the large carpets might be displayed, with adjoining smaller spaces for more intimate arts such as miniature painting or jewelry. Case type and layout were designed to accommodate the collections,

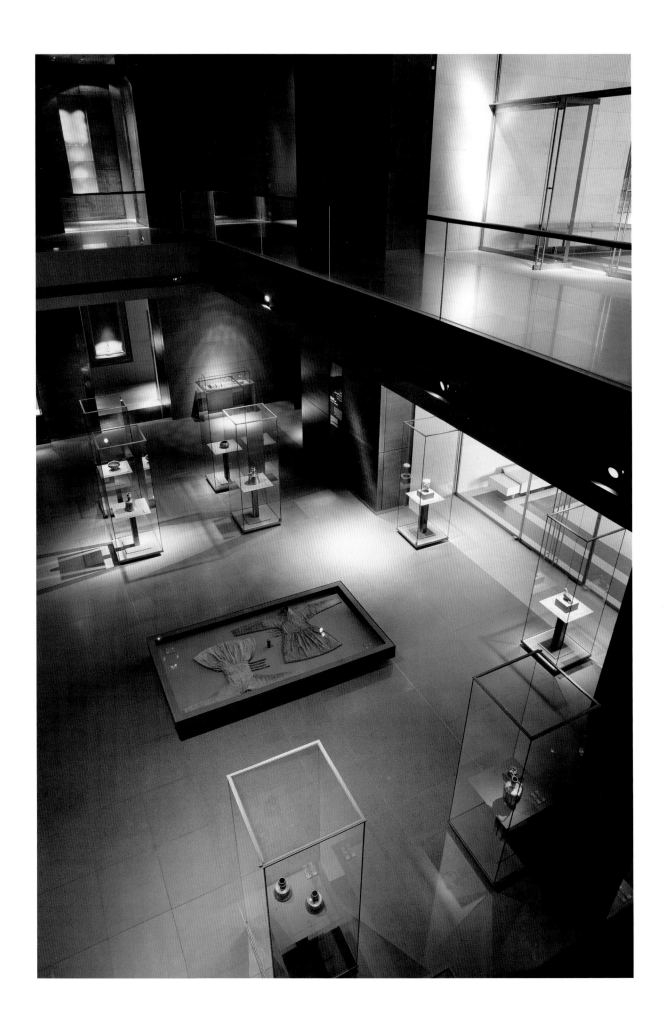

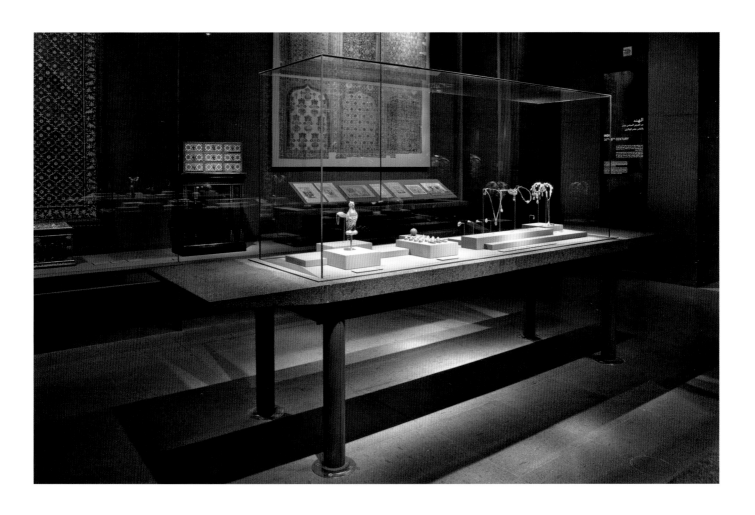

including special displays for several large, awkward, or sensitive objects. At a certain point in the process, however, a different approach was adopted by the then Director – with thematic galleries on the first floor, and a single chronological sequence on the floor above. The advantage was to allow for displays addressing topics deemed of particular interest to the general audience – in particular calligraphy, figuration, and science. The disadvantage was to deprive the later empires of sufficient space to show the large carpets, and to cram their riches in ceramics, tilework, textiles, jewelry, calligraphy, and arts of the book into two final rooms of modest size. It is unlikely, however, that the general audience would notice any such disadvantages. Some specialists in the field have expressed disappointment that the galleries – particularly those on the topic of ornament – promote a reductive and essentialist view of Islamic culture, one now generally rejected in favor of a diverse and dynamic set of Islamic cultures. The 1,400 years of art in three continents cannot or should not be reduced to a commonality of flower patterns, the arabesque, or geometry. From the curator's point of view, lack of space on the upper floors to show the wonderful carpet collection, the Iznik pottery, or the later manuscripts is probably a more pressing concern.

Labels and Gallery Texts

Nothing in the museum world raises more problems or more adverse comment than object labels: they are too big or too small, contain too little or not enough information, are too complex or too simple. Texts (by which I mean the larger wall panels explaining the function of the room as a whole) are similarly conflicted. In Qatar, the problem is compounded by the need for two languages, which doubles the label size automatically: Arabic of the host nation and English as an international lingua franca. It is here that modern technology provides an elegant solution. The MIA provides the barest minimum of information in physical text and labels (pl. 43) – just enough to locate oneself and the object in time and space – but provides a rich resource of further information on the multimedia guide. Here extensive text, maps, images and video, and commentaries by different experts can be located, in principle in many different languages, to suit the level of interest and knowledge of the visitor, whether a specialist from Europe with plentiful museum experience or a schoolchild from the subcontinent on her first ever museum visit. The multimedia guide can illuminate individual objects in depth, discourse on social or craft practices, guide the visitor on a particular trail of objects to tell a story. No longer need the display just tell a single story: numerous different stories can be woven through the same set of objects in one space. The possibilities are endless. The MIA guide initially addresses one hundred "stops" (objects, rooms, or topics) in Arabic or English, as well as tours specially for families or the visually impaired; further development is planned to cover many more objects and subjects, and in more languages to reflect the very international audience the MIA attracts. And all such information will in future be delivered via the web to provide a rich "virtual" visit.

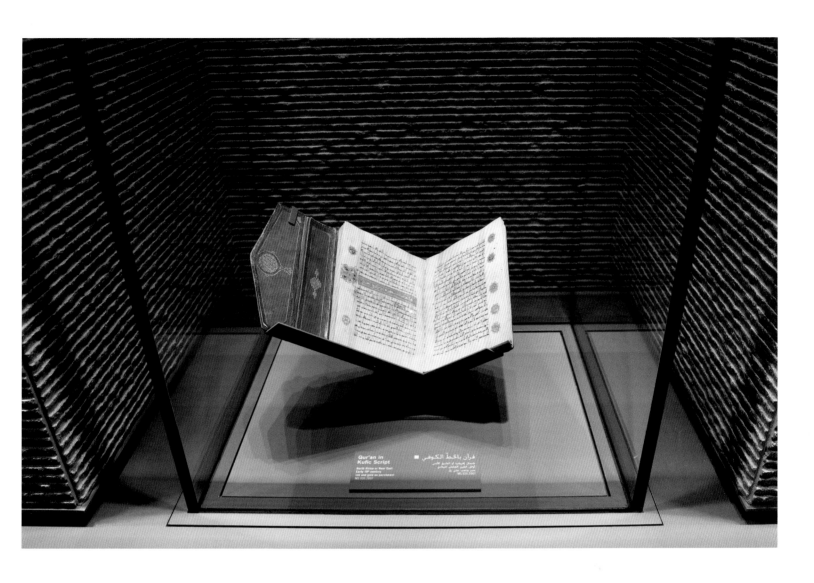

43 Koran manuscript and label on display in the MIA, Doha.

However, it is still true that the richest and most engaging way to visit a museum gallery is with a knowledgeable person. While the electronic guide can do this, it is often more satisfying in the presence of the real person, so the training of young people as museum guides has been a priority and a success story for the MIA.

Does It Work?

The most difficult questions to answer in the months leading up to the opening of the MIA in November 2008 were the standard ones from Western journalists: "What are your expected visitor numbers?" followed closely by "Who will your visitors be?"

A museum of the international profile of the MIA had never been opened in Qatar before, and the old National Museum had been closed for some years. While some expatriate communities resident in Qatar had plentiful experience of museums and museum visiting (particularly with the growth of Education City), a very large majority had limited or no museum experience at all. The potential audience in Qatar is extremely diverse, from the well educated, well traveled, and affluent to those of very modest experience and wealth. Would they come? Who would the "they" be? How

many of them? Would they enjoy it and learn from it? Would they come back again, and become regular visitors? Would museum culture become established in Qatar's society?

The main thrust of museum policy in the West over the last decade has been to develop the audience – not just in numbers, but also in demographic. The challenge, set by national paymasters of museums all over Europe and the West, was to widen "access" – meaning to bring in those who in the past would not have been natural or automatic visitors, usually for reasons of age or of economic, educational, or social status. These "non-traditional" audiences were therefore targeted – schoolchildren in particular, but also a spectrum of society wider than the educated middle classes of the past. To do this, it was thought necessary by the specialist museologists to develop new methods of display. "Context" was an early buzzword, followed by interactivity, by the need to cater for different learning styles – the kinesthetic or experiential, the visual or logical, the inter- or intrapersonal. It was often thought that traditional museum displays catered only to linguistic learners – in a minority – who were happy absorbing information from written labels and texts. So new displays concentrated on visitor-friendly environments, interactivities, games for children, fun stories, explanations, and quizzes: galleries had to be animated. The simple display of works of art, where the work of art was left to speak for itself, was abandoned (except, interestingly, for fine art paintings galleries) as horrendously old-fashioned.

So, in this measure, how do the MIA galleries rate? Let us be honest. To the contemporary museologist they also would appear horrendously old-fashioned, embodying the simplest traditional idea: works of art, in masterpiece mode, uncluttered by contextualization, animation, or interactivity. But the result is an enormous popular success, with 300,000 visitors in the first year (out of a population of less than 1.5 million) and 750,000 in the first four years. Visitors come from all sectors of society, from the wealthiest and best educated to the most modest. The schools program and the Education Department courses have been completely booked out since the opening. Visits last upwards of an hour and a half, and visitors, alone or in groups, are seen concentrating in fascination on the objects – looking hard at things in a way I have rarely seen in museums elsewhere. The masterpiece mode signals importance and invites and rewards attention.

Scientific audience surveys at the MIA have only just begun to determine exactly the demographic breakdown, the number of repeat visitors, and the number of Qatar residents versus tourists from the Gulf or further abroad. But the observations of the front-of-house staff have confirmed and continue to confirm the initial year's perception. This most traditional of approaches has been an enormous success even with the least experienced of museum audiences. We had expected to reach without trouble the traditional museum visitors whether resident in Qatar or visiting. Our observations, and attendance at MIA events such as the monthly lectures, confirmed our hopes. A personal encounter gave me reassurance that we were reaching also non-traditional audiences: chatting with a young Indian taxi driver as we drove past the Museum one night, he asked me what I did and exclaimed excitedly when I told him. I asked him

whether he had visited the Museum. "Oh yes sir!" he said, "three times already, and twice with my family!"

A study undertaken in the mid-1990s by Professor Glynis Breakwell of the Department of Psychology at the University of Surrey into the audience reaction to the new Glass Gallery at the Victoria and Albert Museum found a positive correlation between people's enjoyment of the physical space (how "beautiful" they found it) and how much they learned. An obvious conclusion one would think, but not a lesson whose prime importance has been widely recognized. In Doha, the MIA embodies this precept in a magnificently pure way. The beautiful display of beautiful objects is enough in itself to act not only as a source of enjoyment, but also as a powerful tool of education.

p. 56: detail of recto in the Tashkent Koran. MIA, Doha (MS 248, fol. 7a).

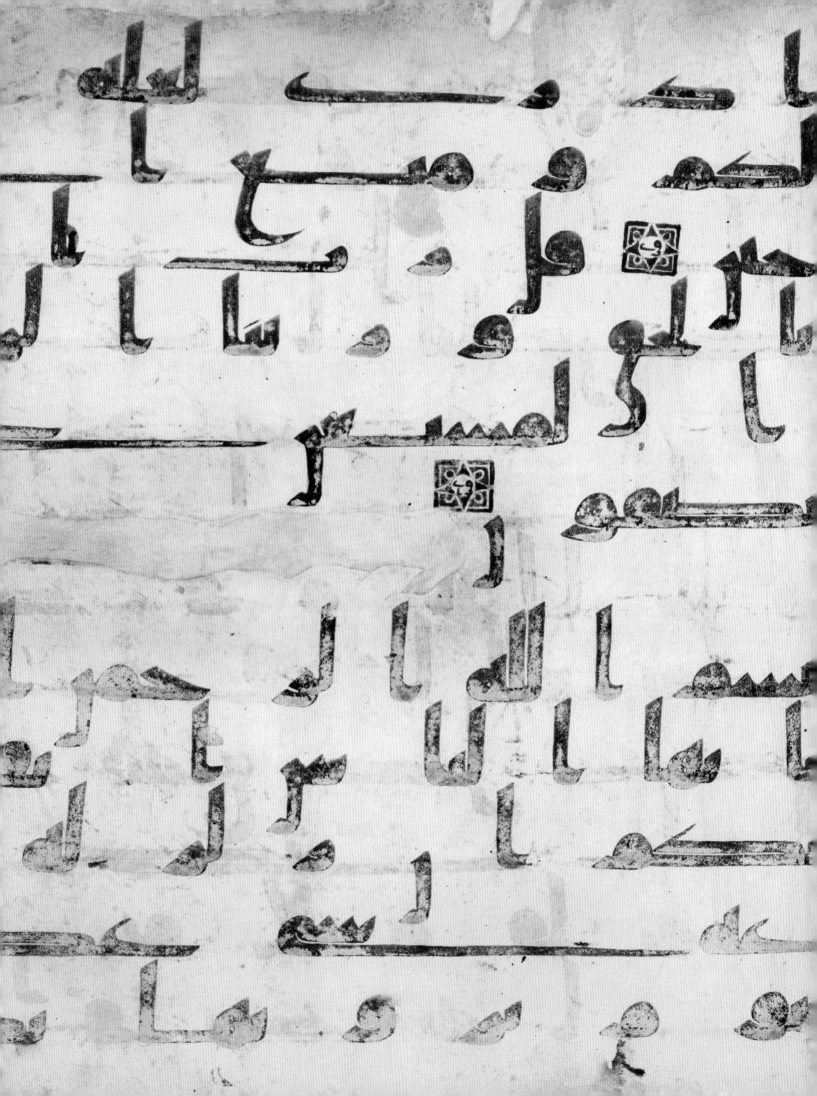

3

*Twenty Leaves from the
Tashkent Koran*

عشروه ورقة بمصحف تاشكند

François Déroche

In October 1869, in the aftermath of the Russian conquest of Turkestan, the general governor of the newly conquered province, General Constantin von Kaufman (1818–1882), sent the Imperial Public Library in Saint Petersburg (nowadays the National Library of Russia) a large copy of the Koran that had been acquired from local ulema in Samarkand (Shebunin 1891, 69–70; Jeffery and Mendelsohn 1942, 175–95). In spite of the soothing report the latter wrote for the Russian authorities about the worthlessness of this manuscript, one suspects that they did not part with it light-heartedly. Until that moment, it had been kept in the Khwaja Ahrar mosque in that city (pl. 44; Shebunin 1891, 69–70). According to a local tradition, this manuscript was the copy of the holy book that the third caliph ʿUthman had been reading when he was murdered in 656 and the pages were stained with his blood. It had been in Istanbul, so it was said, in the possession of the caliph of Rum (the Byzantine emperor), who either presented it to Khwaja Ahrar, a local holy man of Samarkand, or gave it as a reward to a disciple of the Khwaja (Shebunin 1891, 71–74). Another local informant, however, linked the manuscript with Timur (1336–1405), suggesting that the warlord had it brought to Samarkand (Shebunin 1891, 73). This outstanding copy of the Koran (pl. 45), with folios measuring 53 by 68 centimeters and twelve lines to the page, could naturally elicit such tales. The manuscript remained in the Saint Petersburg National Library until 1917, when the Soviet authorities decided to hand it back to the Central Asian Muslim community (Jeffery and Mendelsohn 1942, 177),[1] and it is now kept in Tashkent. I shall refer to it here as the Tashkent manuscript.

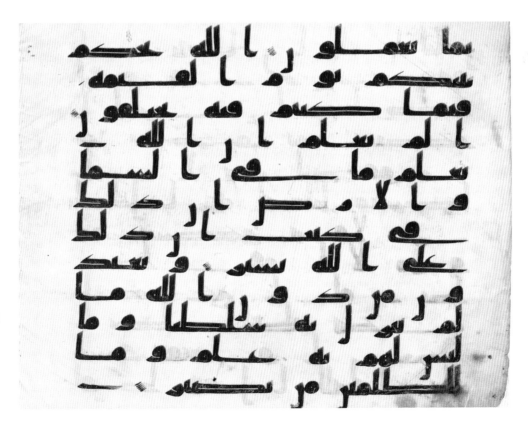

44 (*facing page*) Complex around the grave of Khwaja Ahrar, Samarqand, 1490s.

45 Verso of a typical folio of the Tashkent Koran. MIA, Doha (MS.248.10b).

While the manuscript was in Saint Petersburg, it was examined at least by 1890 by a Russian scholar, A. F. Shebunin, who published a documented study in which he dated it to the eighth century (Shebunin 1891, 123; al-Munajjid 1972, 50–52) and concluded that it derived from the Basra codex, one of the five copies of the Koran sent by the caliph ʿUthman to the major cities of the realm (Shebunin 1891, 124). A few years after Shebunin's study, a facsimile was made and published by S. I. Pisarev (1905). When Shebunin analysed the manuscript, it was already no longer complete: it then contained 353 folios, 69 of which were paper replacements (Shebunin 1891, 75–76). In addition, many of the parchment folios had been provided with new paper margins. The text stopped at Sura 43: 11 and was interrupted by many lacunae (Shebunin 1891, 78–80). There are conflicting reports about the number of folios now kept in Tashkent: according to a report made for UNESCO (http://www.islamic-awareness.org/Quran/Text/Mss/samarqand.html), there are about 250 folios, whereas Tayyar Altıkulaç (2009, 89) speaks of 338. Some more folios have therefore been removed since Shebunin saw the copy, and Altıkulaç (2009, 89) adds that fifteen were stolen in 1992. Before 1890 or perhaps even before 1869, however, some folios were already missing from the Tashkent manuscript. This is the case with the twenty folios of the manuscript examined in the Museum of Islamic Art (MIA) in Doha (MS 248 and MS 658), containing portions of text from Suras 21 to 23 and corresponding to a lacuna between folio 286b (ending with Sura 20: 135) and 287a (beginning with Sura 26: 63) of the copy as described by Shebunin.[2] During the last twenty years some folios, either stolen from the Tashkent manuscript or taken from it at an earlier date, have also appeared on the art market. In 1992, an auction house made a carbon-14 analysis of the parchment on a sample taken from one folio. It determined a date between 640 and 765 CE at the 68 per cent confidence level and between 595 and 855 CE at the 95 per cent confidence level (Christie's London 1992, Lots 225, 225A).

The folios now in the collection of the MIA cannot be properly discussed here without taking into consideration the whole manuscript. It is therefore necessary to

examine some technical aspects before trying to place it in its original context. The twenty folios in the MIA all originate from the same part of the manuscript and contain the following portions of text: folios 1–3 (MS.248.3–5): Sura 21: 36–58; folio 4 (MS.248.6): Sura 21: 69–76; folio 5 (MS.248.7): Sura 21: 111–Sura 22: 4; folio 6 (MS.248.8): Sura 22: 22–26; folios 7–10 (MS.248.9–12): Sura 22: 60–78; folios 11–12 (MS.248.13–14): Sura 23: 14–27; folios 13–15 (MS.248.15–16, MS.658): Sura 23: 41–60; and folios 16–20 (MS.248.17–21): Sura 23: 68–110. We know of four more folios belonging to the same sequence. Two of them fall between MIA folios 4 and 5: one with Sura 21: 79–82 is now in the Aga Khan collection (Makariou 2007, 106), while the other, with Sura 21: 103–111, was sold by Sam Fogg (2003, 12–13) and immediately preceded folio 5 in the MIA. Two more folios with Sura 22: 6–12 and 12–17, sold at Christie's in October 1992 (Lots 225 and 225A), followed this section of text very closely. The longest sequence in the MIA, that on folios 16–20, amounts to five folios.

The text in this manuscript is written on a rather thick parchment. Its hair side does not preserve any traces of the edges of the skin, suggesting that a fair portion of the sheets had been eliminated during the trimming process in order to achieve the nicest appearance. On the flesh side, some traces of the production process survive on many folios, mainly in the corners on the right-hand side close to the back of the volume, as may be seen, for instance, on the MIA folios 3a and 8a (pl. 46).

The uncommonly large size of this manuscript could be obtained only by using a entire leaf of parchment for each folio, thus avoiding the usual process of folding that is the basis of the codex. In other words, this copy is an *in plano*. In his publication, Shebunin already noted on the basis of his own examination that the parchment folios had been stacked one above the other in the same position, with the flesh side as the recto of the folios from the beginning to the end of the codex (pl. 47; Shebunin 1891, 75). Unless a mistake occurred during the production of the copy, which is the case for Shebunin's folios 3, 4, 11, 12, 236–39, and 309 (Shebunin 1891, 75, n. 2), every time the manuscript was opened, the reader would see a right page with the hair side and a left page with the flesh side, the former slightly yellowish with the script quite legible and the latter of a whiter appearance with the script fading away (pl. 48). The contrast is certainly more striking today than it was at the time the manuscript was produced.

47 Reconstruction of the folio preparation in the Tashkent Koran, showing sewing in the center over the stub, with a hair side in yellow on the right and a flesh side in white on the left.

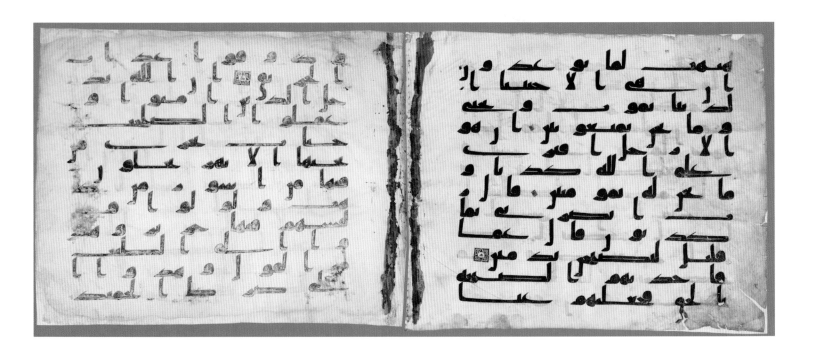

48 Double-page spread of the Tashkent Koran, with the hair side on the right and the flesh side on the left. MIA, Doha (MS.248).

Technically it would have been very easy to alternate the position of the sheets in order to get openings of the same nature, with hair side facing hair side and the converse for the flesh side, but this was not done.

One of the significant features of the Tashkent manuscript that Shebunin described is the stains, which were supposed to be the third caliph's own blood spilled on the manuscript when he was assassinated in 656. As the Russian scholar observed, the blood had been poured intentionally on the inner part of the folios, whence it spread more or less toward their center (Shebunin 1891, 76–77). This was also done on every other opening so that stains are found on folios 133b–134a, as well as on folios 135b–136a, whereas no blood mars folios 134b–135a.

Another feature of the Tashkent manuscript in 1890 was its state of disorder and the traces of many attempts at restoring it. In his publication, Shebunin described a copy made up of quires with eight or ten folios paired by their stubs. Typically, in a ten-folio quire folios 1 and 10 would be joined, then 2 with 9, and so on, in order to constitute bifolia, with a crease where the binder could sew them together (Shebunin 1891, 76). The Tashkent manuscript's compilation in quires seems to be confirmed by the fact that the recently stolen folios have a very narrow inner margin and no stub or line of prickings, probably because they were cut close to the fold, as the thief did not bother to cut the sewing thread itself in order to extract the folios.

The MIA folios exhibit a few original features. Since no sequence of folios exceeds five, it is not possible to reconstruct with certainty the way in which they were kept together. Nevertheless, four groups of folios (folios 7–10, 11–12, 13–15, and 16–20) are sufficiently close as to allow a few observations. First, the general appearance of the folios is that they are flat and show no sign of a crease on the left side of the rectos. Second, a line of prickings runs parallel to the edge of the folio, between the edge itself and a thick brownish smear (pl. 49). Observation of the lines of prickings found on the stubs (pl. 50) shows that the same pattern is repeated on all the folios, suggesting that as many as eighteen folios – fourteen actually present and four presumably missing (between folios 10–11, 12–13, and 15–16) – were pierced together, presumably

with a thin blade. On all the folios that could be observed, the holes are oriented in the same way at a slight angle to the axis. They clearly do not correspond to the stitching of a quire as it is usually done: they are very close to each other, far too numerous to have been used for a classical sewing operation, and not rectilinear as one would expect if they had been done in the central fold of a bifolio. Third, in addition to the main line of prickings, other holes can be seen between the latter and the edge of the skin, with one of them in the upper part of the folio having a π-shape. They are rather regularly spaced, between eight and nine centimeters. A last point: there is no bloodstain on any folio in the MIA.

Is the condition of the MIA folios compatible with Shebunin's account? We have here two different possibilities. The Tashkent manuscript might have been constructed or reconstructed according to the customary codex technique – that is, by folding the parchment folios near the edge in order to produce a stub on the back side, then by pairing two isolated folios in order to construct a bifolio, and finally by sewing together eight or ten such bifolios to get quires which could be bound easily (Déroche et al. 2006, 11, 65–67). Does this reconstruction correspond to the original state of the codex? The MIA folios provide the beginning of an answer. The fact that they exhibit neither the traces of a crease nor those of stitching suggests that they were separated from those that are still in Tashkent before the latter were bound according to the configuration described by Shebunin and retained because they were thought to preserve their original appearance or something very close to it. Did this happen while the manuscript was already in Central Asia or in the place where it had been kept until Timur took it, if we accept the local tradition mentioned above? I have been unable to find clues that could help us in figuring the history of this copy.[3] As we shall see, however, even in the second case it may have already been known as ʿUthman's *mushaf* (Koran manuscript).

One could also speculate that these eighteen folios (or more) all belonged to one half of a quire in which they were paired with folios of originally slightly larger width in order to have a stub on which the two parts would have been sewn together, thus

51 Brown smear near the right edge of the recto in the Tashkent Koran. MIA, Doha (MS.248.5a).

explaining the line of prickings left on the inner edge. These artificial bifolios would then have been sewn together, turned into normal quires, and bound. Such a presentation would have been largely similar to that of the Tashkent manuscript, although the number of folios per quire should have been at least thirty-six instead of eight or ten. Various objections can be raised to this explanation, and it should be discarded: the size of the quires would have made them difficult to handle, and the side stitching would have generated a bulge and would have been less resistant to handling.

How then can we explain the prickings? The manuscript is an *in plano*, in other words a book where every single folio is a sheet of parchment. Technically, it is not a codex, although it may look like one. The MIA folios give us only a part of the picture: the pricking was probably in preparation for the sewing that required the thread to go through the folios to hold them together. Are the additional holes part of the same operation, or do they correspond to a later restoration? It is difficult to decide. Another point remains unclear: were the folios grouped by sets of at least eighteen, the groups then being sewn and bound together, or did the thread go from the first to the last folio? Unfortunately, the break up of the manuscript means that this cannot be established.

The brown smear on the MIA folios (pl. 51) was apparently not found on the Tashkent manuscript when it was in Samarkand, as Shebunin did not notice anything of the kind when he examined it. Its presence would imply that the folios that were

20

15

10

5

2

1

362 sq. m.

124 sq.m.

18 sq.m.

2,5 sq.m.

1 2 5 10 15 20

52 Chart showing the comparative amounts of parchment used for early manuscripts of the Koran (green box = basic copy; blue = Codex Parisino-Petropolitanus; orange = Sana'a 20–33.1; red = Tashkent).

separated from the rest were rebound together in a rather crude way. It would be interesting to have an analysis performed in order to identify the material used. We can suppose that some glue was introduced, probably during a restoration, in order to enhance the cohesion of the folios, although this probably runs counter to the mechanics of the book, whose weight tends to separate the folios even when opened at a 45-degree angle on a lectern. Still, at that time the number of folios involved may have been fewer, and the glue may have been sufficient.

In its original state the manuscript was impressive not only for the two-dimensional size of the folios (58 × 68 cm), but also for their number. On the basis of the text found on the folios and on the assumption that the density of the script did not deviate considerably from what can be observed on the MIA folios, we can estimate that the copy contained about one thousand folios, which would have needed a flock of one thousand sheep to produce. In order to make further comparison with other manuscripts easier, this means that 362 square meters of trimmed parchment were required for the production of such a volume (pl. 52). One can speculate that the one thousand folios were not bound together in a single volume, but were divided into several volumes of a multi-volume Koran. We shall return to this point later.

The script of the MIA folios is rather homogeneous and suggests that the copyist was a professional (pl. 53). He could of course have relied on a comparatively recent technical tradition of large scripts exemplified by the Koran manuscript with an architectural frontispiece found in Sana'a (Dar al-Makhtutat 20–33.1) and dated to the beginning of the eighth century, where the use of a writing implement with a very broad nib can also be observed (von Bothmer 1987; von Bothmer, Ohlig, and Puin

1999, 33–46). The copyist or copyists of the Tashkent manuscript were working in dif-
ficult conditions owing to the size of the folios, with the page certainly held on a
slant, perhaps on some kind of board. This appears especially clear when one examines
the letters, whose bases look darker because of the fact that the ink applied on the
parchment drifted down before drying (pl. 54). Nevertheless, the broad nib of the
writing tool did not always allow the copyist to leave a regular stroke or immediately
achieve a satisfactory shape. He had therefore to re-ink the text in some places, a
process that sometimes may also have taken place at a later date, as is typically the case
for the bottom lines of text. This is especially true on the recto or flesh sides of the
parchment sheets: the ink could not adhere quickly and seep through, so that the script
looks quite faded (pl. 55) and in many places had to be re-inked by a later hand (pl.
56). When Pisarev prepared the facsimile of the folios in Saint Petersburg, he also had
to re-ink some of the folios, a process resulting in mistakes that were controversial in
Muslim circles (Jeffery and Mendelssohn 1942, 176).

 According to the practices standard at the time this manuscript was produced, the
text is evenly distributed on the folio without any distinction between the inter-word
spaces and those eventually found within a single word. As a consequence, dividing a

54 Detail of a verso of the Tashkent Koran, showing where the ink has drifted downward. MIA, Doha (MS.248.19b).

word at the end of a line is allowed (pl. 57), but the copyist would avoid breaking a word between two pages. The height of the script combines with the importance given to the horizontal component, underlined by the elongation or *mashq*[4] (Déroche 1992, 12; Abbott 1939, 24–28) of the letters *sad, ta'/za'*, and *kaf* and of isolated or final *ba', fa',* and *ya'* (pl. 58; Shebunin 1891, pls. VIII, IX). The latter form actually has two or three shapes, only one of which lends itself to elongation. The letter *dal*, in spite of its shape that is quite close to that of the *kaf*, is not elongated or only slightly. In addition to the application of *mashq* to the body of these letters, their connections can also be extended when required. Exceptionally, the horizontal tail of final *mim* can also be extended at the end of a line. Shebunin (1891, pl. IX) published a plate with a few spectacular examples of a single word occupying a whole line. There is no such occurrence on the folios now in the MIA, where in the most extreme cases we find two words on a line. Such elongation, however, did not preclude the copyist's use of dashes at the end of the lines in order to produce a regular left-hand margin (pl. 59). In some cases, there is actually no room for any letter and the device seems more a matter of aesthetics, but very often it may be quite long, suggesting that the copyist had not planned the distribution of the text very carefully. There seems to be no trace of any ruling, although it would have been difficult if not impossible to dispense with any system in order to write so horizontally and regularly.

The *alif* – as well as the other letters with a vertical stroke like *lam* – is upright, ending with a slight bevel. The lower crescent-shaped return is well developed, and its width varies somewhat according to the space available. Of the two ways of writing the teeth of the letter *sin/shin*, the only one present on the MIA folios looks like three equilateral triangles set one next to the other on top of the base line of the script. Shebunin also noticed two shapes for the letter *qaf*: only the sickle-shaped one appears in the folios kept in the MIA. He reproduced on his plate VIII (pl. 60) a shape of the

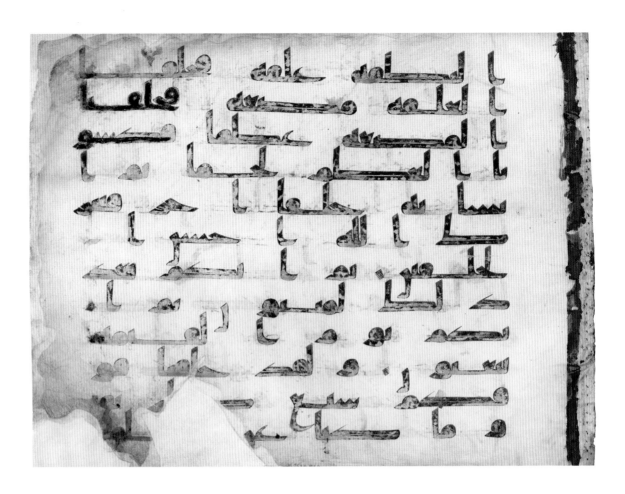

55 (*top*) Recto in the Tashkent Koran, showing how the ink did not adhere to the flesh side of the skin. MIA,Doha (MS.248.13a).

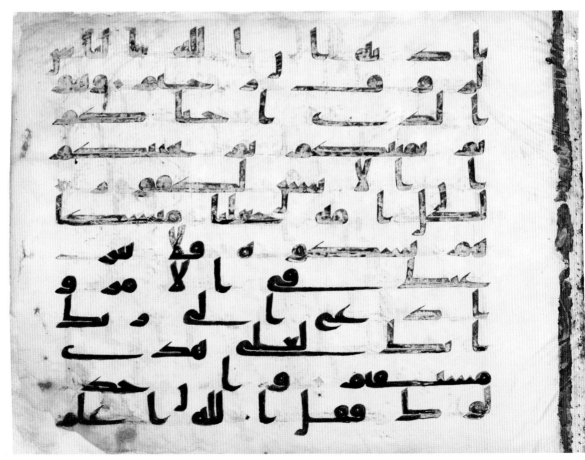

56 (*bottom*) Recto in the Tashkent Koran, showing later reinking at the bottom. MIA, Doha (MS 248.10a).

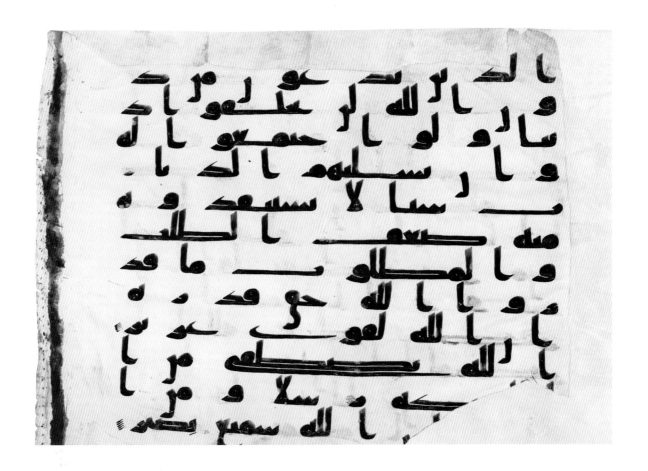

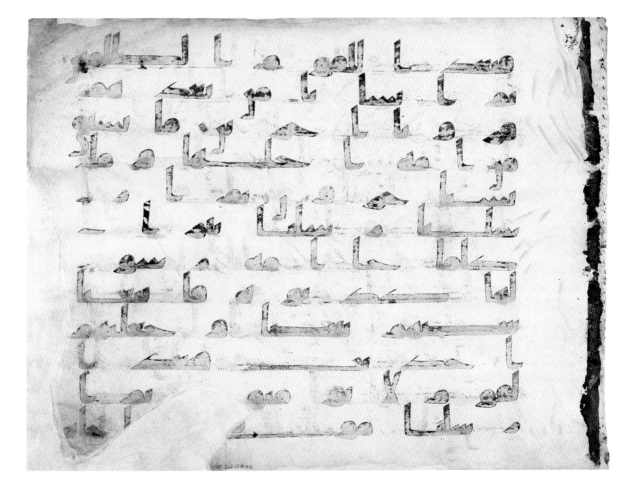

57 (*top*) Verso in the Tashkent Koran, showing how the copyist broke words between lines. MIA, Doha (MS 248.11b).

58 (*bottom*) Recto in the Tashkent Koran, showing *mashq* (the extension of some letters). MIA, Doha (MS 248.16a).

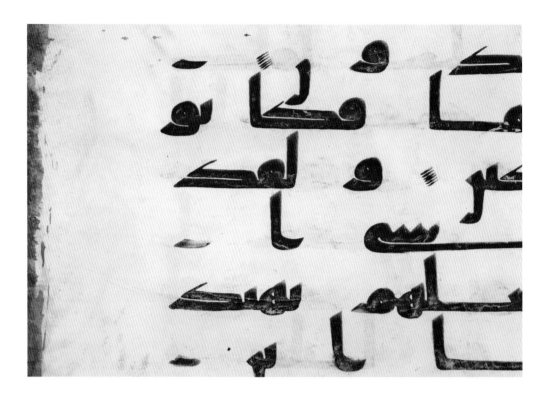

final *kaf*, which looks very close to that typical of the earlier tradition exemplified by *hijazi* or Umayyad copies (Shebunin 1891, pl. VIII; Déroche 1999, pls. 15, 16). In the MIA folios, there is no trace of such *kaf*, and all those present have their two parallel horizontal lines of the same length.

Although the initial *mim* is clearly circular, the final shape of the letter shows that the copyist considered that it was above the line (pl. 61), in contrast to that in the B group of scripts, as delineated by Déroche (1983). Within a word, it is quite exceptional to find a *mim* looking like a circle, as can be seen on folio 10b. The final and isolated *nun* are, however, slightly different, not unlike what can be observed in the B group (Déroche 1983, 37–39 and pls. IX–XI; Déroche 1992, 38–39; George 2010, 150–51). In both cases, the letter has two components, a short horizontal lower return and an upright body ending in a slight curve. The width of the latter is continuous when the *nun* is isolated, but when it is final, it becomes thicker above the base line and takes the shape of a triangle with a point oriented toward the left. The *ha'* is also related to the B group of scripts: although it rarely straddles the base line of the script as clearly as can be seen on folios 16b or 20b, its rounded lower part encroaches on the space below the line. This becomes especially clear when the letter is at the beginning of a word. The copyist used diacritical marks sparingly. Vowels signs are utterly absent.

The script of the MIA folios exhibits a distant relationship with the B group of scripts, but remains as a whole quite distinct. It may be the consequence of the size of the script itself, which imposed on the copyist an adaptation of the features of a script usually written in a smaller format. The variations that I have mentioned on the basis of Shebunin's description may actually derive from the solutions each copyist found when trying to achieve this goal. The dimensions of the copy – as far as the number of folios and the size of the script are concerned – implied the cooperation of various scribes whose contribution should be examined more closely. Such an analysis is unfortunately not possible with the folios in the MIA, since they originate

from the same part of the manuscript and may have been the work of a single copyist: their script looks rather homogeneous.

All the elements found on the MIA folios that can be subsumed under the rubric of illumination are found within the writing surface, with the limited exception of the vignettes, or small ornamental designs, at the ends of the headband. The verse separators can barely be considered as illumination since they consist merely of a column of oblique strokes, probably made by the copyist himself since the same ink has been used as that of the text (pl. 62). Groups of five verses are not singled out by a specific device, but decades or groups of ten verses are indicated in a more conspicuous way, with square ornaments containing a four-pointed star with a circle in its center. A red letter – or two when the number is higher than hundred – is written there on the white background and indicates the tens according to the *abjad* value of the letters (pl. 63a–b). The manuscript follows the old *abjad* sequence, with *sad* as the equivalent of sixty (Déroche et al. 2006, 96). This information is not present on the folios in the MIA, as in the only place where it could have been found, folio 7a, the ornament has been torn away. The illustrations in Shebunin (1891, pl. x) compensate for this loss and provide a fair number of examples. The decade ornaments are mainly done in green and red, but two of the loops connecting the branches of the star are in blue. The same device is also found at the end of Suras 21 and 22: the total number of their verses is indicated there, also in *abjad*.

On folios 3a, 14b, 15b, and 20b, the decade ornaments have been totally or partly torn away. They were probably the target of people looking for memorabilia or material for an amulet. The same thing happened to the band between Suras 21 and 22 on folio 5a (pl. 64). Only the vignette located in the outer margin remains. Although there are only eleven lines on that page, a narrow band of illumination was set somewhat clumsily after the last word of Sura 21: the final *nun* of *tasifun* located just above the

63a–b Details of the ornaments used to mark the end of ten verses in the Tashkent Koran. MIA, Doha (MS 248.6a and 11a).

two *lams* of *allah* in the *basmala* of Sura 22 did not allow the line to be used for calligraphy, so it was left blank, and the final *nun* of *al-mustaʿan* on the penultimate line of Sura 21 prevented the illuminator from using the remaining space.

A second sura ornament is found in the twelfth line of folio 10b (pl. 65). Although the lower right-hand corner of the folio has been torn away and the band of illumination has lost its marginal ornament, there is enough left to get a precise idea of the original. The composition relies on a simple pattern that the illuminator or illuminators of the Tashkent manuscript used extensively: a basic rectangular (preferably square) ornament that would be repeated mechanically, side by side horizontally. Here a network of lines in reserve, organized around a central circle, delimits areas colored in

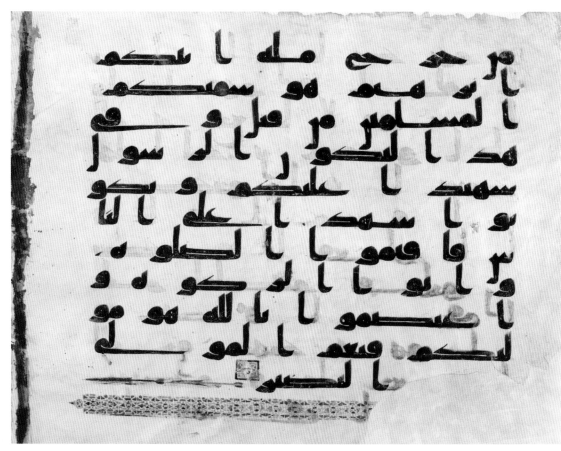

66 Detail of the band at the end of Sura 22, with the arrow used to fill the blank space. MIA, Doha (MS 248.12b).

red, blue, and green. As in the case of the decade ornaments, no gold has been used. The blossom vignette found to the left of the sura headband in the inner margin shows that the illumination was produced at a time when vignettes were found at both sides of the headband. These illuminations do not contain any information such as the title or number of verses in the sura. The place of the headband found between Suras 22 and 23, as well as the mention of the total number of the verses of a sura in an ornament found after the last word of the preceding sura, suggest that these illuminations were probably meant as a closing piece, a feature found during the early years of the written transmission of the Koranic text. In addition, folio 10b exhibits an interesting feature: the space left blank after the last word of Sura 22 has been filled by a decorative device in the shape of an arrow, its point oriented toward the inner margin (pl. 66), an element found in other early manuscripts. On the basis of the information provided by Shebunin, it turns out that the sura bands produced with modules were common in the manuscript.

The space usually left by the copyist for the decade markers implies some coordination with the illuminator, assuming that both text and ornaments were not the work of the same person. Nevertheless, the example of the band between Suras 21 and 22 suggests that the copyist did not always take into account the requirements of the illumination. This is by no means an isolated case, and Shebunin reproduced some examples of the somewhat awkward relationship between the possible two craftsmen.

Jeffery and Mendelsohn (1942) analysed the orthography of the Tashkent manuscript on the basis of Pisarev's facsimile and reached the conclusion (p. 145) that it could be dated to the ninth century. A few archaic features survive, although as a rule the copy reflects a more developed state than manuscripts such as the Codex Parisino-petropolitanus (Déroche 2009) or even the Umayyad fragments under the shelf number Marcel 13 in the National Library in Saint Petersburg (Déroche 2006, 227–64). The words *qala* or *shay'* are consistently written in the modern way, but on folio 15b (pl. 67), *bi-ayatina* keeps the old orthography with an extra tooth that is found in *hijazi* copies (Déroche 2009, 54).

At the beginning of this essay I mentioned the data related to the age of this manuscript. Shebunin's hypothesis of an eighth-century date contrasts with the conclusions

64 (*facing page, top*) Recto in the Tashkent Koran showing where the band between Suras 21 and 22 was cut out, leaving only the vignette in the margin. MIA, Doha (MS 248.7a).

65 (*facing page, bottom*) Verso in the Tashkent Koran showing where the band marking the end Sura 22 was torn away in the lower right. MIA, Doha (MS 248.12b).

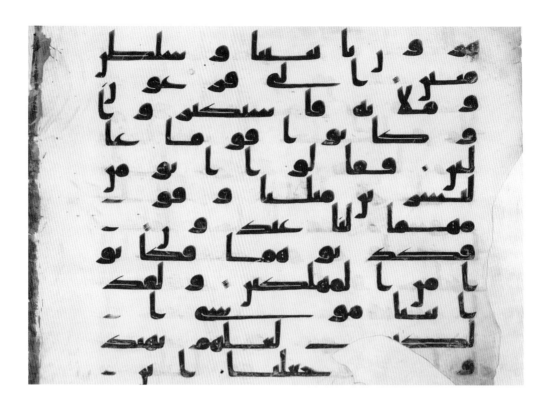

67 Verso in the Tashkent Koran, showing the old orthography for *bi-ayatina* in the middle of the first line. MIA, Doha (MS 248.16b).

of Jeffery and Mendelssohn, who favored a slightly later one, but received some support from the results of the carbon-14 analysis, which yielded a 68 per cent possibility for a date between 640 and 765 CE.

Some sources concerning this period may provide additional clues. A legal authority active in the second half of the eighth century, Malik ibn Anas (d.796), expressed his opinions about the *mushaf*s in which this group of twelve-line Koranic manuscripts apparently abide. For example, under the reference he called *ummahat al-masahif*, he conveyed his disapproval of vowel signs (Jahdani 2006, 274) and condemned multi-volume copies of the Koran (Jahdani 2006, 276). He also disapproved of illumination, according to a later commentator, either because it might distract the reader or because the Maliki school frowned upon the use of gold (Jahdani 2006, 275). It is actually surprising that a copy like this one that required such an enormous investment in the purchase of more than one thousand sheets of parchment is so poorly illuminated, without any gold. This could only be the result of a deliberate decision.

This huge and extremely expensive manuscript can be seen only as an imperial presentation copy produced at a time in the second half of the eighth century when rigorous views such as those expressed by Malik ibn Anas had the upper hand and the authorities needed to impress the Muslim community by an outstanding gift. Such a move could correspond to an account by Malik ibn Anas, transmitted by al-Samhudi (d.1505). According to this source (al-Samhudi 1984, 668), the Abbasid caliph al-Mahdi (r.775–85) ordered expensive copies of the Koran, which he sent to the major cities of the Empire, imitating a similar measure taken a few decades before by al-Hajjaj ibn Yusuf (661–714), who was himself emulating the third caliph ʿUthman. In the mosque of Madina, the Abbasid codex superseded the Umayyad one, which was put within its chest next to the minbar. On the basis of such evidence, I therefore suggest dating the Tashkent Koran to the second half of the eighth century, perhaps more precisely to the reign of the third Abbasid caliph al-Mahdi.

68 Large copy of the Koran kept in the Mashhad ʿAli in Cairo.

If big is beautiful, then this manuscript is undoubtedly beautiful. Awe, however, is the word that best describes the impression left by the remaining leaves of this monumental copy in Tashkent and others like it (pl. 68). It is based on the very simple but effective idea of magnifying God's word. From the sheet to the volume, all the components of the manuscript were extended to their utmost limit, based on the height used in the preparation of the parchment.

In the historical context of the beginning of Abbasid rule, assuming my suggestion about dating is correct, these copies had the last word. We should not forget that they could also answer the need to give full importance to the Koranic text vis-à-vis the other religions of the book. The technique was certainly the weak point of these manuscripts. Their size and weight, like this dinosaur, required a stronger composition or continuous repair, and apparently there were repaired many times in order to keep them together. They were nevertheless quite effective, and they remain so today.

Notes

1 The online catalog of Columbia University Library states that "General Ali Akbar Topchibashi retrieved the copy and sent it back to Tashkent, where it remains" (http://clio.cul.columbia.edu:7018/vwebv/holdingsInfo?searchId=4876&recCount=25&recPointer=0&bibId=8412746&searchType=7).

2 The MIA has a total of twenty-four folios from this manuscript. MS.248.1-2 containing text from Sura 3, verses 166–70 and 179–83 and MS.248.22–23 containing Sura 41, verses 15–20, 34–39 are not considered in this article.

3 According to the website 'Islamic awareness' (http://www.islamic-awareness.org/Quran/Text/Mss/samarqand.html), the folios sold on the market came from North Africa. Even if this is the case, it does not help us in figuring out where they had been before.

p. 78: detail of Samarra stucco panel in Style I/C. MIA, Doha (SW.86.1999).

4 Gacek (2006, 237) suggested that "this term may have also been used in the sense of a script or a style" and had thus various meanings.

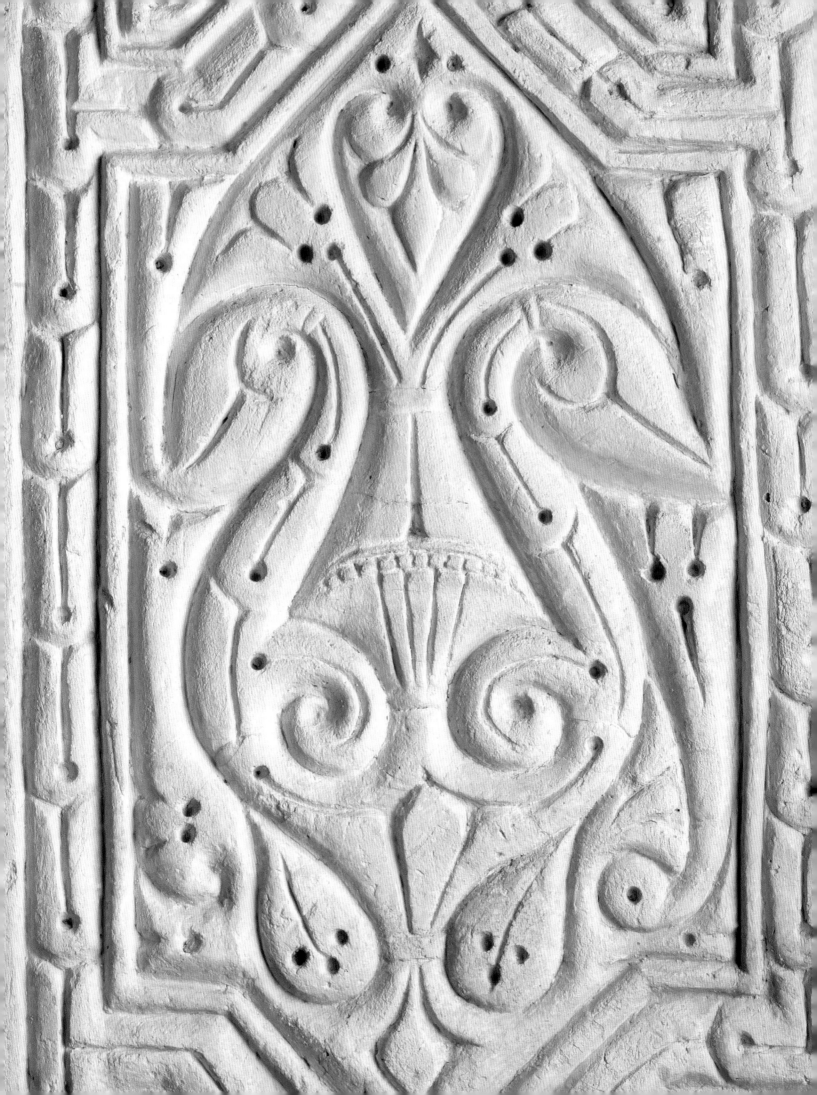

4

Three Stucco Panels
from Samarra

Julia Gonnella

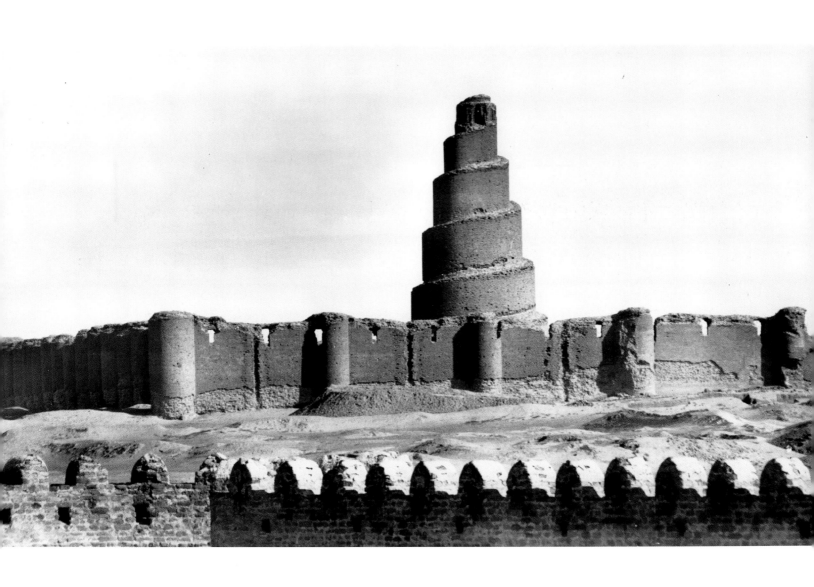

Its roofs of burnished gold are clad
in light which illuminates the gathering darkness,
And the eyes gaze, roaming in a brilliant place
whose heights are blazing, whose lower parts comely.

al-Bukhturi (820–897)

Few places in the world have captured people's imagination as much as the city of Samarra.[1] Staggering luxurious palaces, vast sumptuous pleasure gardens, majestic mosques of enormous size (pl. 69), game reserves, race courses, polo fields: all this belongs to the grand literary and archaeological lore of the extraordinary town that served as capital to the Abbasid caliphs between the years 836 and 892, a period of only fifty-six years. Afterwards, the caliphate returned to Baghdad. Samarra was more or less abandoned and, as the medieval historian Yaqut (cited in Meisami 2001, 69) put it, turned into "a ruin, a waste, at the sight of which the viewer takes fright." Despite its short-lived ascendancy, Samarra nonetheless became a paradigm of majestic power and extravagant taste. Its extraordinary size and overwhelming achievements became the focal point of all future imperial projects undertaken in the Islamic world.

Visually speaking, Samarra stucco often comes as something of an anticlimax; we always have to remind ourselves that it survived only piecemeal and never in its full contextual beauty. Even the three outstanding panels in the Museum of Islamic Art (MIA) in Doha (pls. 70–72) – all three extremely well preserved – betray nothing more than a minute detail, a section of what had originally been a very complex and truly remarkable interior design of the abandoned Abbasid capital. One should consequently remember that Samarra stucco panels are not so much objects, as otherwise discussed in this book, but rather "mementos," "reminders" of a more or less perished and forgotten architectural ornament that once decorated the celebrated palaces of the former caliphs and their retinue.

Despite its lack of visual prominence, Samarra stucco and its specific ornamentation represent one of the essential topics of the history of Islamic art. Its discovery and first publication by the German archaeologist Ernst Herzfeld (1879–1948) was groundbreaking for the entire discipline. Not only did Herzfeld (1923) produce one of first systematic archaeological catalogues of a coherent object group in the discipline, but he also set out its first major comprehensive stylistic interpretation. His succinct analysis of the three stucco styles, especially the famous "Beveled Style" (Herzfeld's First Style, later relabelled by K. A. C. Creswell as "Samarra C") with its characteristic slanted style of carving, profoundly influenced all future assessments of the development of Islamic art. Even now, one hundred years later, Herzfeld's analysis more or less forms the basis for countless handbooks and university courses, and "Samarra C" is still considered to represent the genesis of a remarkable stylistic revolution: the birth of the arabesque and a new taste for allover decoration (*horror vacui*); in short, the formation of a distinct new style under the Abbasids, which many people still consider the beginning of true "Islamic" art (Herzfeld 1923, 10; Haase 2007, 440; Grabar 2009, 248).

69 (*facing page*) Great Mosque of Mutawakkil with spiral shaped minaret, Samarra, 847–61, photo: Ernst Herzfeld, 1911–13.

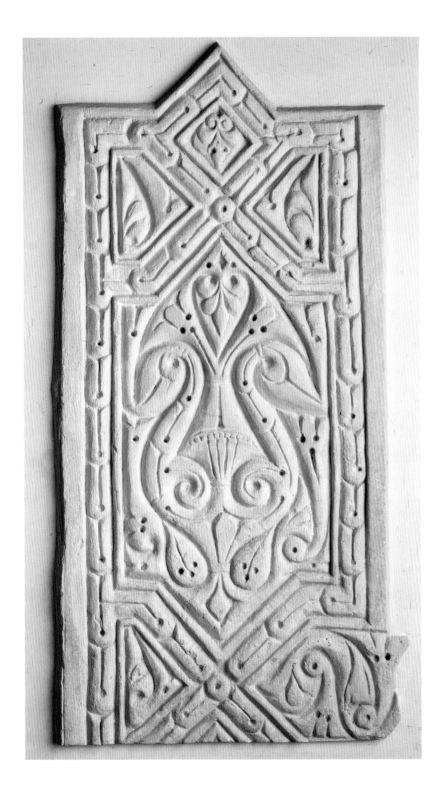

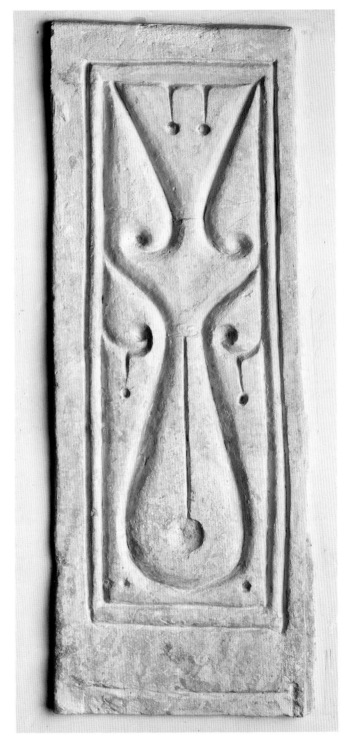

70 (*left*) Samarra stucco panel in Style 1/C. MIA, Doha (SW.86.1999).

71 (*right*) Samarra stucco panel in Style 1/C. MIA, Doha (SW.85.1999).

Today, however, new stucco finds from other Abbasid sites, especially in northern Syria,[2] re-examination of the large body of the Samarra stucco panels from Herzfeld's excavations in the Museum für Islamische Kunst (Museum of Islamic Art) in Berlin, and above all different interests and new ways of looking at objects and style call for a profound reconsideration of this entire group of material. For that reason, the following essay will not so much try to analyze the specifics of the entire ornamental program of Samarra stucco and its origins in traditional art historical manner, but rather will attempt to disentangle the narrative that has dominated the history of

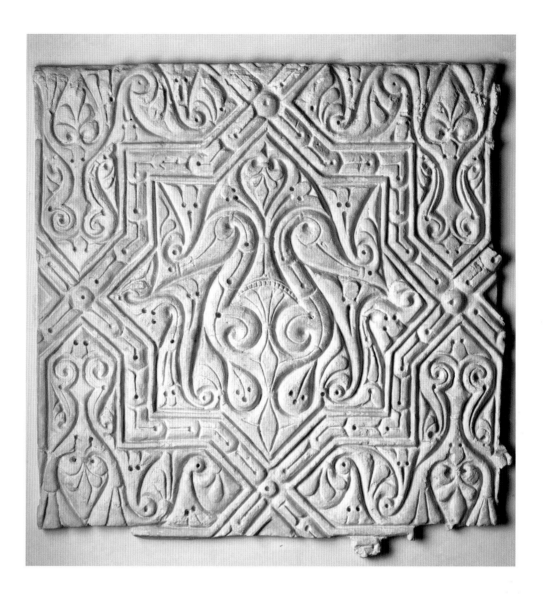

Samarra stucco decoration, touch upon the difficulties involved, and focus on strategies for studying this group in the future.

Samarra Stucco and Herzfeld's Excavations

In discussing the history of Samarra stucco, one has to start with Herzfeld himself and his excavations at the former Abbasid capital, which took place between the years 1911 and 1913 and which today have become nearly as legendary as the city of Samarra itself. Herzfeld's excavations certainly represent one of the first scientific archaeological enterprises on a purely Islamic site, marking the beginning of large-scale archaeological research on Islamic antiquities as a whole (Leisten 2003, 3–9; Northedge 2005b, especially 394–96). In two long campaigns, Herzfeld – who was not only an architect, but who also had solid training in Ancient Near Eastern archaeology (Gunter and Hauser 2005; Hauser 2008) – uncovered what was one of the largest archaeological ruins in the Middle East. Judging by today's standards, he carried out a colossal research program, one that was not always to his liking (Kröger 2005 and forthcoming; Hauser unpublished paper).[3] While most of the time Friedrich Sarre, former director of the Museum

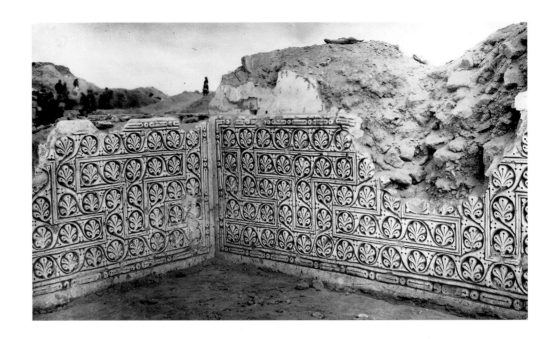

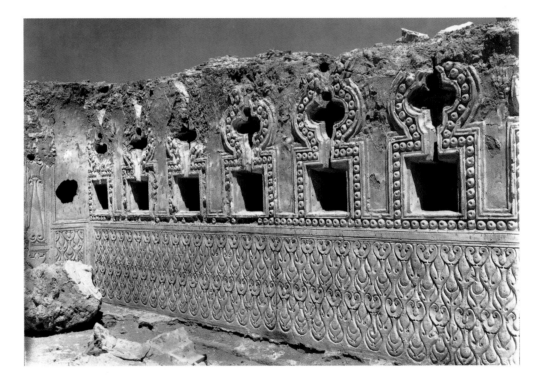

73 *(top)* Stucco decoration in the domed chamber of the so-called "Harem", Dar al-Khalifa, Samarra, photo: Ernst Herzfeld, 1911–13.

74 *(bottom)* Stucco decoration in one of the reception rooms of the Balkuwara Palace at Samarra, photo: Ernst Herzfeld, 1911–13.

of Islamic Art in Berlin and main initiator of the excavations, stayed behind comfortably in Germany, in two exhausting seasons Herzfeld unearthed or at least examined nineteen enormous sites, including the main caliphal palace or Dar al-Khalifa (pl. 73), the palace al-Balkuwara (pl. 74), the Qasr al-ʿAshiq, the Qubbat al-Sulaibiya, the two large congregational mosques, as well as fourteen "residential" houses (pl. 75). (See the detailed discussion in detail in Leisten 2003, 10–19; Northedge 2005b.)

Of course, Herzfeld was not only, nor even mainly, interested in stucco; rather, he was primarily concerned with the architecture and urban history of Samarra. With its unusual town plan and gigantic size, Samarra did not fit into what was considered a typical Islamic city. It had been founded as a royal base and a military encampment

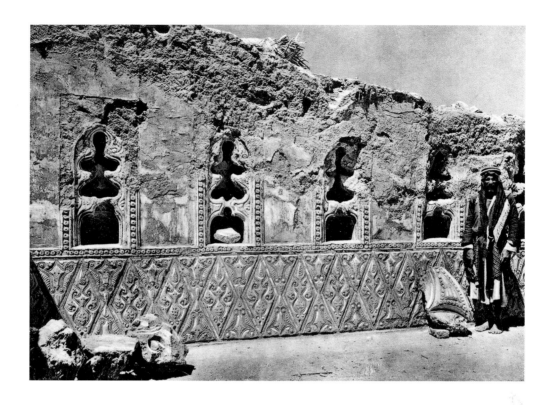

and existed only as long as the caliph and his army remained in town. But very soon Herzfeld discovered that all minor and major palaces, as well as even the residential houses, were lavishly decorated with stucco revetments. He was mesmerized by the stupendous corpus of material, which he then reserved for his own study. At the same time, Herzfeld was also pleased to have found something to take back to Berlin, being fully aware that his work would be measured in terms of the number of valuable finds fit for the exhibition in the museum there (pl. 76). The stucco revetments clearly appeared to be the most desirable *objets trouvés* of his tedious fieldwork. To quote Herzfeld: "I can say with complete confidence: we can excavate as much as we want of these things, one can fill complete rooms and museums with it . . . I am almost inclined to say you should not restrain the ideas of His Excellency von Bode: if one can raise enough funding, the whole first floor of the Kaiser Friedrich Museum can be filled." And shortly after: "Those ingenious niches [of the al-Balkuwara palace] . . . would be suited magnificently for the display of single beautiful objects, the wall surfaces in between to hang objects. I can imagine something just beautiful and novel." (Leisten 2003, 29, quoting from AP IV, Letter of 10 April 1913, and 5 August 1912). Since their first installation in 1922, the stucco finds from Samarra have always been key pieces in the museum's permanent exhibition (see also Sarre 1922).

Owing to the political upheaval in the Middle East during the World War I, the fate of the Samarra finds, however, turned out to be quite different to what Herzfeld had ever imagined. Although the first lot of finds from Herzfeld's initial archaeological season had been shipped to Berlin and Istanbul, a second lot, including "300 abgelöste Wanddecorationen" [detached wall panels] and 105 boxes of small finds from the second season, fell into the hands of the British army (Konrad 2008, 51; Kröger forthcoming), who had assumed command in the region from 1914 onwards (for details of the political developments, see Leisten 2003, 20–28; Gunter and Hauser 2005). The British army consequently redirected and shipped these finds to London. As it then turned out, they

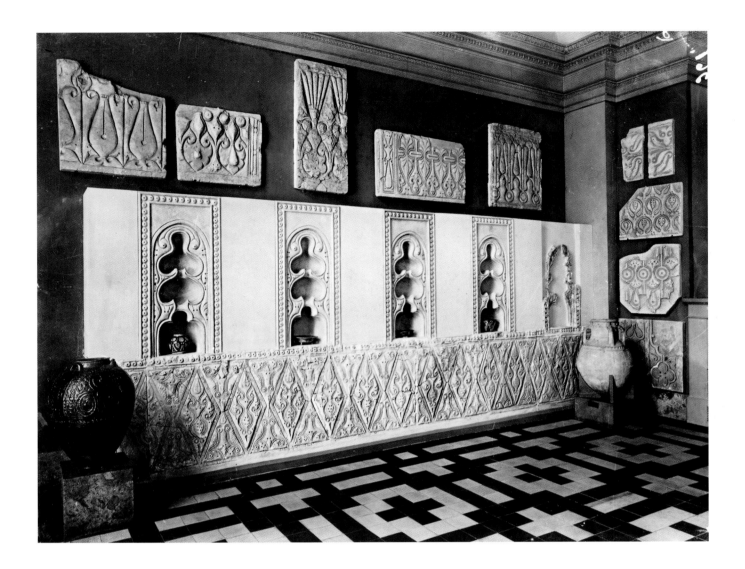

76 Reconstruction of the niche wall from House 13 as exhibited in the Kaiser-Friedrich-Museum, after 1922.

77 (*facing page, top*) Stucco decoration at the Palace of al-Huwaisilat, excavated in the late 1930s by the Directorate-General of Antiquities, Iraq.

78 (*facing page, bottom*) Stucco decoration in the Dar al-Khalifa, excavated and conserved during the 1980s by the Directorate-General of Antiquities, Iraq.

never arrived in full: neither the 300 stucco panels nor 25 of the 105 boxes ever showed up (Konrad 2008, 52). The rest of the material that did make it was eventually split up by a special commission set up at the British Museum, which, after consulting Herzfeld himself, distributed them around the world as "type-sets" (Canby 2000, 132–34; Leisten 2003, 29; Kröger 2005, 55ff; Konrad 2008, 51ff; Kadoi, forthcoming).[4] Shares were given to the Victoria and Albert Museum in London, the Museum of Islamic Art in Cairo, the French Archaeological Institute in Damascus, the Musée du Louvre in Paris, and many other institutions, above all in Berlin itself (Kröger 2005, 55). This second lot of Samarra material did not include any stucco finds except for smaller fragments (Bugio, Clark, and Rosser Owen 2007). The carved stucco revetments from Samarra today in the Museum of Islamic Art in Berlin, approximately 100 in number, belong to Herzfeld's first shipment, which had reached the Museum before the war.[5] The fate of the now missing "300 abgelöste Wanddecorationen" from the second season is still unclear. According to British rumors, they were burned by Turkish troops on German demand (Canby 2000, 134; Konrad 2008, 51).[6]

The excavations of the carved stucco revetments, of course, did not stop with Herzfeld's campaign at Samarra, and we have to bear in mind that despite his enormous work, Herzfeld had uncovered only a tiny percentage of the entire site. Later excavations were to reveal countless new examples of wall decoration, including the most

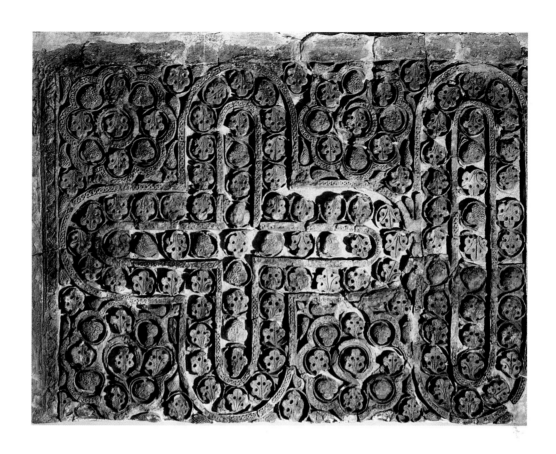

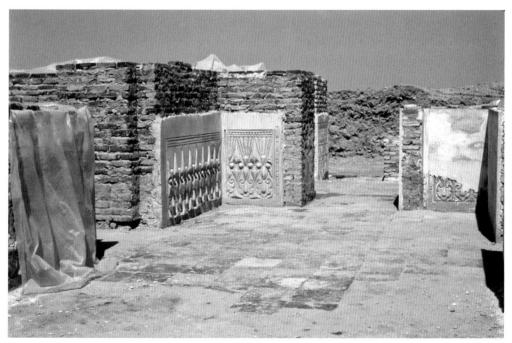

fascinating ornamentation. These were published by the Iraqi Directorate-General of Antiquities (Department of Antiquities 1940), which had reopened archaeological field-work in 1936 (Northedge 2005, 20), but were never comprehensively studied (pl. 77). In the 1970s large-scale excavations and conservations were undertaken, again by the Iraqi antiquities department, which at the same time attempted to develop Samarra as a major tourist site (pl. 78).[7]

The Three Samarra Styles and the MIA Panels

Despite the unfortunate ending of his archaeological research at Samarra, Herzfeld steadfastly carried on with publication of finds from the site (Leisten 2003, 29–32; Northedge 2005, 392–94), and his book on the stucco appeared in 1923. Initially, Herzfeld had planned to publish the Samarra stucco in a special volume on the private houses and their ornamentation. For several reasons, however, he decided to keep it as simple as possible, and "Wandschmuck [Wall decoration]" then appeared "only" as a strict classificatory work. Herzfeld had arranged the stucco according to the three famous styles (1, 2, 3), rather than according to their find site. Together with the stucco, he also published a selection of the stone and wood finds from the excavations. These too were subordinated to the respective three stucco styles, without any consideration of their different material nor of where they had been excavated originally.

Herzfeld's classification is by now classic, and it is worthwhile reiterating since it has so influenced all future art historical assessment of Abbasid art. His Style 1 is the "Beveled Style," with its distinct slant cut of carving that never produces cast shadows but only shade. It is the one dominated by the principle of total covering of the field, the perfect *horror vacui*, and here the traditional geometric and vegetal elements have been transformed into a pattern of endless rhythmic repetition. Herzfeld (1923, 6) had suggested that whereas Styles 2 and 3 had been cut out from the wet stucco by hand, Style 1 had been fashioned with a mold, a salient point that has since been repeated in all handbooks on Islamic art and one to which I shall return. The richly developed plant compositions of Style 2, on the other hand, feature no arabesque, no stalks, and therefore no plant growth. The style is comparatively anti-naturalistic, often arranged in large circular or lobed compositions with rosettes, and frequently fills square or octagonal compartments. Style 3, finally, is very similar to Style 2, as Herzfeld (1923, 183) himself had already noted: it is mainly distinguished by its mostly five-lobed vine ornament and its comparatively spare background. The British architectural historian

79 Three stucco styles from Samarra: Styles A/3 (left), B/2 (center) and C/1, the "beveled" style (right).

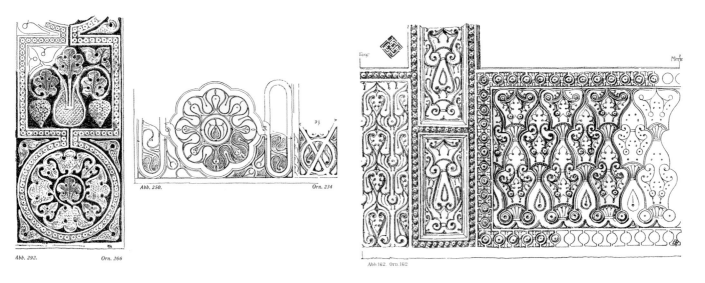

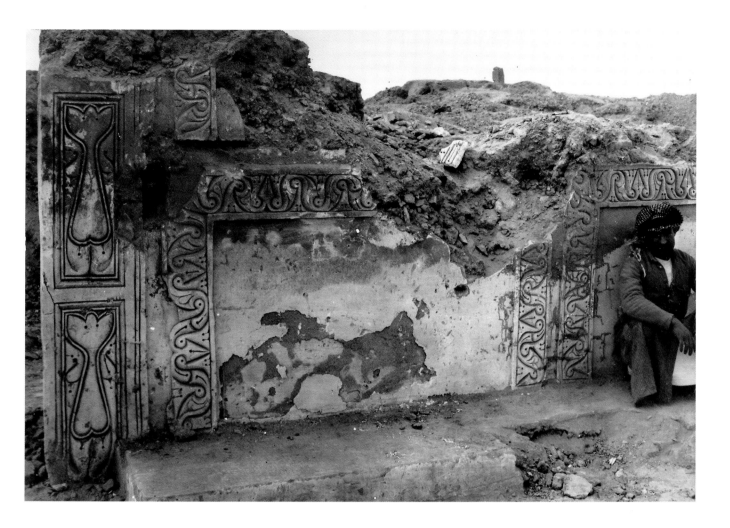

K. A. C. Creswell (1879–1974) later relabeled the styles as A, B, and C, inverting their original sequence since he believed that these three styles evolved in chronological progression, an important consideration to which I shall also return. Creswell's labeling system for the three styles of Samarra is the one by which they are generally known today (pl. 79).

Herzfeld's catalog is full of information and has become an extremely useful tool for any classification. One can look up panels such as the ones from the MIA, which incidentally do not originate from the previous share of Herzfeld's excavation finds, but have been acquired on the art market.[8] One can easily see that all three panels in the MIA (pls. 70–72 with sw.86.1999, sw.15.1999, and sw.85.1999) are cut with the distinct slant typical of Samarra Style 1/C and that at least the first two panels (sw.86.1999 and sw.15.1999; pls. 70 and 71) had evidently been part of the same original decoration scheme. The third panel (sw.85.1999; pl. 72) belongs to a group of ornaments that was particularly popular for door frames (pl. 80; Herzfeld 1923, 49–53: "Geschlossene Felder, Paneele a–c; Ornament 54–70," pls. XXIII, XXV, XXVI, etc.). According to Herzfeld (1923, 49), its main element is a bottle-shaped blossom ("vasenformige Blüte"), which theoretically can be extended on all sides into a larger infinite pattern (Herzfeld 1923, 67, ornament 94, fig. 92 and others).

Panels sw.86.1999 and sw.15.1999, with their much more elaborate star compositions, also include a similar "bottle-shaped" vegetal motif at their center. Although they have no direct equivalent in the Herzfeld catalog, which includes only one single star design

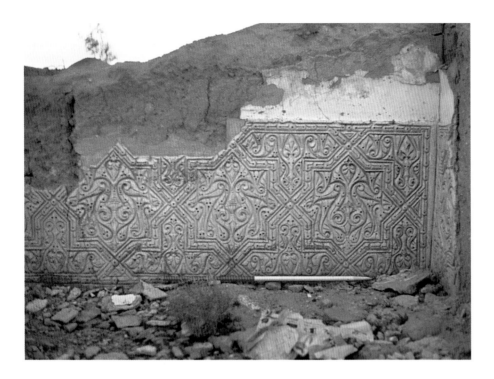

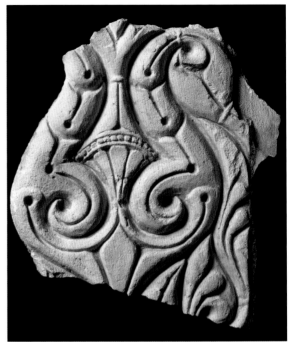

(Herzfeld 1923, 111, ornament 168, fig. 168), one can discover many comparative details, such as the little palmettes (Herzfeld 1923, figs. 157, 158, 159), pearl strings (figs. 152, 162), and the scrolling leaves. A true match in ornamentation was excavated by the Iraqi Directorate-General of Antiquities in the 1970s: a stucco revetment that had originally decorated the interior of a private house (House 10: Janabi 1983; pl. 81). Quite obviously, the MIA stuccoes and the excavated revetment are identical, as is a further stucco fragment, now in the David Collection in Copenhagen (pl. 82; inv. No. 43/1992: Folsach 1996a, 104, no. 62; Folsach 2001a, 244, no. 390).[9]

The Samarra Stucco and its Missing Context

As helpful as Herzfeld's catalog might be for categorizing art objects according to stylistic labels, it is equally inadequate for providing contextual information. Only very few entries mention the original find spots of the single revetments. Furthermore, the entries do not illuminate the archaeological context of the original discovery. Herzfeld's notes hardly include observations of the position of the stucco revetments within the architecture of Samarra, nor do they refer to their relationship with other architectural decoration, such as the wall paintings, wood, or tiles. On the contrary, Herzfeld's analysis of the stuccowork is more or less non-chronological and ahistorical. The stuccoes were published as carriers of "pure" ornament. Herzfeld's "Wandschmuck" is above all a pattern book, a little bit like Owen Jones's *The Grammar of Ornament*, a kind of wallpaper catalog from which to choose one's favorite design – the beveled style group being, of course, the top choice. This ornamental quality is forcefully underlined by Herzfeld's incredibly beautiful drawings of the stucco, which highlight the decorative character of the ornamentation (pl. 83). Herzfeld's artistic talents were exceptional (Kröger 2008), and as Eva Hoffman (2008, 109–23) has so convincingly demonstrated for the Samarra wall paintings, his drawings not only

Abb.162. Orn.162.

provided pure documentation, but also served as his interpretation of the subject-matter. Herzfeld's drawings of the stuccoes never recorded them per se, but only the ornamental repertoire, thus certainly contributing to the fact that the stucco decoration was later conceived primarily as designs.

And if one looks just at the designs, it became a natural step to look from designs in stucco to designs in other media (wood, stone, glass, etc.), and from designs at Samarra to designs from the rest of the (Abbasid) world (Egypt, Syria, Iran, Central Asia). This is surely the narrative to which later scholars such as Richard Ettinghausen (1952) and Ernst Kühnel (1977) contributed greatly, with their discussions on where the designs came from (Sasanian seals, Turkish belt ornaments, Central Asian horse fittings, wood-work, etc.) and where they went to (Egypt, Iran, Syria, Central Asia). Since its first discovery, Samarra stucco was – and still is – discussed mainly as pure ornament.

Molds

The preoccupation with the designs subsequently entailed the discussion of how they had been produced originally, and here is where the notion of the mold came in, which has been repeated uncritically over the years in most handbooks on Islamic art. No doubt the large spaces with repetitive patterns, especially in the palace of al-Balkuwara (pl. 84), must have prompted Herzfeld to conclude that Style 1 (Style c) was produced with some kind of mechanical assistance, which would have facilitated the entire decorative procedure: something was needed to help the workmen to speed up their labor. After all, there was much to be constructed and decorated in Samarra, the resplendent capital that grew by the hour.

On the one hand, Herzfeld had astonishingly specific ideas about the molds. He assumed that a master mold was made out of a wooden plank, from which one took

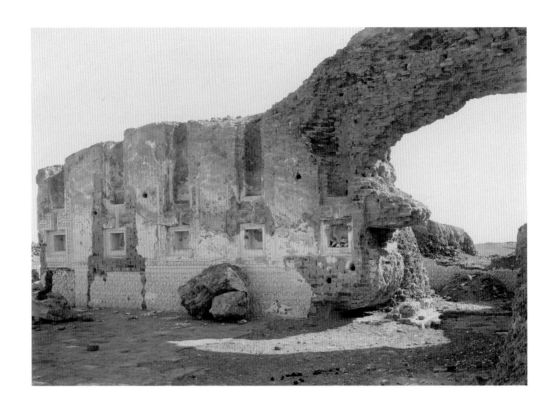

84 Excavation of the Great Iwan in the Balkuwara Palace, Samarra. Photo: Ernst Herzfeld, 1911–13. Ernst Herzfeld Papers, Freer Gallery of Art and Arthur M. Sackler Gallery Archives, Smithsonian Institution, Washington, DC. Gift of Ernst Herzfeld, 1946.

a form in clay, baked this clay mold, and used it to cast the stucco ornament (Herzfeld 1923, 10). On the other hand, Herzfeld remained amazingly obscure on the actual process. He never mentioned what he imagined the molds to have looked like exactly, nor their actual size. According to him, workmen applied the gypsum to the walls and then decorated it with molds. They then finished the joints and other details freehand, covering the entire decoration with a skim coat of gypsum ("Schlemmkreide") in order to conceal the application process. Herzfeld was obviously aware of molded Sasanian stuccoes, which, however, are square and of a completely different type to those found in Samarra (Kröger 1982a). It might also be possible that Herzfeld was thinking of woodblock prints on textiles.

Looking very carefully at the stucco panels themselves, however, it is extremely difficult to discern any traces at all that betray the use of molds. This observation was made in Berlin several decades ago (Kröger 1982b). The Berlin stuccoes show no evidence of any joints, nor of craftsmen trying to hide them. Thorough analysis also shows that no single design element is repeated exactly, something that should have happened had a mold been applied. In addition, a study of the various programs of stucco decoration in the residential units at Samarra reveals that not a single design scheme ever seems to have been repeated within one and the same house, except at the palace of al-Balkuwara. The decisive question therefore arises: what is the use of a mold? Does it make sense to use one mold for one room or even for one wall?

The only place where the technical aspects of the mold question have ever been pursued in detail is Kharab Sayyar, a smaller site in northern Syria near the Turkish border. Kharab Sayyar was excavated by the University of Frankfurt in conjunction with a Bronze Age tell, and dated – because of its stucco finds – a little later than Samarra (Meyer 1999; Haase 2007, 448ff). The excavations revealed two buildings with astonishing stucco decoration (pl. 85), some of it cut in a slant style. Here again, no signs of mold production were ever detected. On the contrary, on the panels the

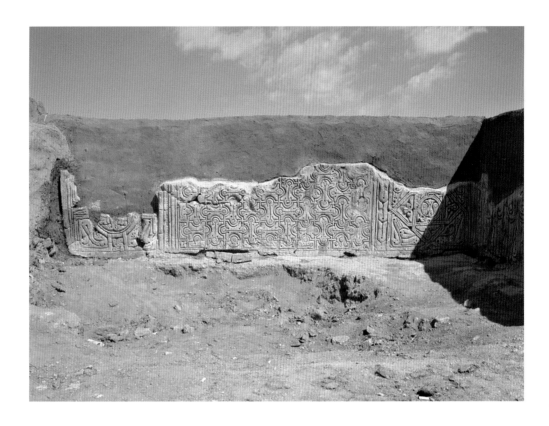

excavators identified the remains of thinly incised grid systems, which were obviously applied to help the workmen lay out the complicated patterns. These results are extremely important and will be published very soon (Koppel forthcoming). Thus the procedure of the application process has to be imagined along the following lines: the gypsum was applied in various coats on the mud-brick walls, the final coat was smoothed, and the decoration (Styles 3/A, 2/B, 1/C alike) was then cut, almost certainly with the help of a grid system, in the material that was still slightly wet. This, of course, was an ingenious way to disguise the otherwise humble building material. As one can detect the imprint of straw mats on the back of some of the stucco, it is clear that the craftsmen had made use of rougher foundation material to keep the gypsum on the wall (Herzfeld 1923, 10; see also Bugio, Clark, and Rosser Owen 2007, 757). Nevertheless, many technical questions concerning the production of the stucco panels, the actual material of the gypsum, and the organization of the craftsmen need to be pursued much further.

Color

Herzfeld's preoccupation with design, and that of later historians of Islamic art, was certainly to the detriment of the context, and it is the context that is of more interest today. It is only from some few fragments mentioned in the publication of the site that we know that stucco was found at Samarra not only on the walls but also on ceilings, such as the stucco fragments found in House XII, which obviously had originally decorated a domed roof construction (Herzfeld 1923, 115–16). Stucco was found inside residential architecture and in mosques (Herzfeld 1923, 35ff.). Most stucco seems to have been part of the interior decoration, but some was more "interior" than some

86 Fragment of a wall painting from a private house (no. XVI) in Samarra. Museum of Islamic Art, Berlin (Inv. No. Sam. o. Nr).

87 (*below*) Painted wooden panel from the Dar al-Khalifa, Samarra (h. 142.5 cm, w. 56 cm). Museum of Islamic Art, Berlin (Inv. No. Sam 874).

other, and this difference certainly has repercussions on the visibility of the decoration and the play of light and shadow, as Rudolf Schnyder (1979) had already speculated upon in a much neglected essay. But how were the stucco programs distributed within one site? For Samarra, so far this has not been studied. It is only from the Syrian town of Raqqa, the early Abbasid capital of Harun al-Rashid (r.786–809) on the Euphrates – excavated in the 1950s by Nassib Saliby and in the 1980s by Michael Meinecke – that we have more detailed information about the exact original locations of such panels (Meinecke 1991, 1998, 1999; Saliby 2004; Schmidt-Colinet, forthcoming). At Raqqa, the stucco was applied inside the building, clearly emphasizing the

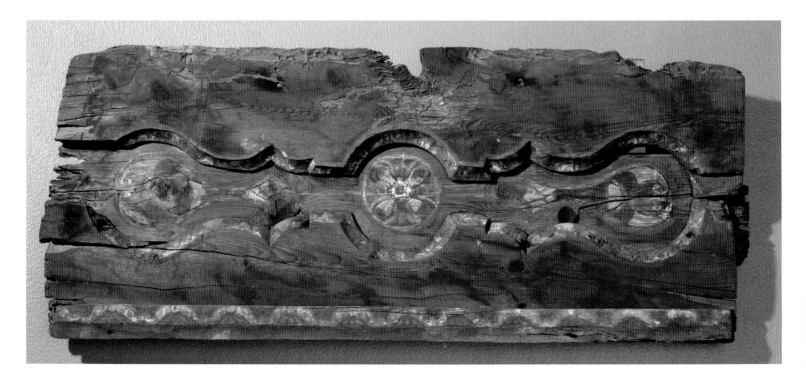

88 (*left*) Fragment of millefiori glass excavated in the Dar al-Khalifa, Samarra (h. 11 cm, w. 7.5 cm). Museum of Islamic Art, Berlin (Inv. No. Sam. o. Nr).

89 (*right*) Fragment of a luster tile excavated in the Dar al-Khalifa, Samarra (h. 28 cm, w. 28 cm). Museum of Islamic Art, Berlin (Inv. No. Sam 758a).

reception rooms (Becker 2012). Unlike Samarra, however, the stucco at Raqqa was used in narrow bands set along the doorways and never covered entire wall spaces.

One of the key questions is how the stucco related to other wall decoration, such as paintings, marble, wood, tile work, and mosaics. What was the complete decorative program, and were its elements interconnected?[10] Were there different programs in different buildings, and did they have a meaning? In the following, I would like to touch upon just one single but vital aspect of this entire issue: whether the Samarra stucco had been colored or not. The use of color certainly influences – and dramatically transforms – the perception of buildings, a reason why this topic is discussed repeatedly, and for other sites as well, as with Olga Bush (2011) on the Nasrid stuccos of the Alhambra and Martina Rugiadi (2012) on Ghaznavid marbles and stuccoes. In both these cases, the pure "white" decoration, as we have always imagined it, had originally been polychrome.

It is not very difficult to imagine polychrome stucco in Samarra as well – after all, the former Abbasid capital was full of color. Palaces and houses were decorated with lavish wall paintings (pl. 86) in shades of blue, green, red, orange, yellow, brown, as well as brilliant gold (some of these colors have been analysed by the Victoria and Albert Museum; see Bugio, Clark, and Rosser Owen 2007). In her study on the Samarra wall paintings, Hoffman (2008, 109) reminded us of the lively descriptions of colors in historical texts: "pistachio green," "iridescent peacock," "chickpea," "wax," "pearl," all names that betray an astonishing awareness of – and joy in – glorious hues and shades. Samarra wood was certainly decorated with colorful ornaments (pl. 87), tile work was polychrome, as were the artistic millefiori (pl. 88) and luster tiles (pl. 89). Even the marble came in various shades of gray, green, and rose, let alone the masses of often mentioned but long lost sumptuous textiles and draperies that

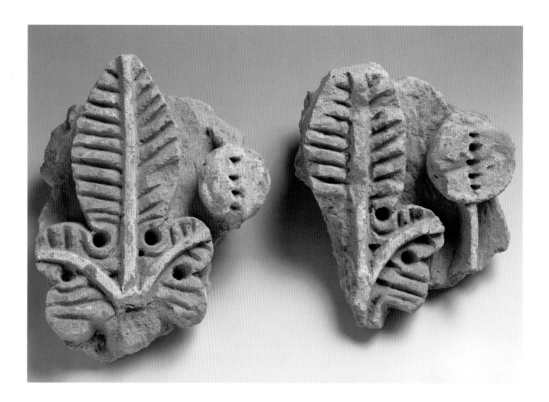

originally covered the walls and the floors of the palaces (Golombek 1988). Equally, the Syrian town of Raqqa was not the white-gray-ocher that it presents to visitors today. Excavations there yielded exquisite colored wall and floor painting, as well as colored wood and glass decoration, for both the floor and the windows (Saliby 2004; Becker 2012).

But what about the Samarra stucco? While there is undeniably some evidence for polychrome Mesopotamian stucco from the Parthian and Sasanian period (Kröger 1982a; Simpson 2012), the evidence for Samarra, and also for the other Abbasid sites, is extremely sparse. So far the Samarra panels in Berlin themselves have not been very helpful; the Museum is just about to re-examine the entire corpus.[11] One of the small remaining pieces with a few color strokes was — as museum lore would have it — evidently the work of Ernst Kühnel. He had obviously convinced his conservators to emphasize color intensity, as he had also done with Sasanian stucco.[12] Herzfeld himself noted only a few drops of color in vermilion red and light blue in some of the "holes" (Herzfeld 1923, 3, 115), of which the faintest trace can be observed even today; one of the MIA panels shows some very faded red, which needs to be analyzed. The only definite exception is the "camel frieze" from the Jawsaq palace, revealing blue as background and red and black color on and in the eyes of the animals (Bugio, Clark, and Rosser Owen 2007). From Raqqa, a stucco inscription panel with a blue background is reported, but not documented.[13] For the Syrian sites of Kharab Sayyar and Medinat al-Far, no traces of color have been noted at all.

Looking carefully at the stucco of Raqqa (pl. 90), one recognizes a distinct use of whitewash applied to the stucco. In some cases it seems to have covered the surface of the stucco completely; in other cases it was apparently used to highlight certain features, such as the stalks of the leaves or the pomegranates. And again, a second glance at some of the smaller stucco remains from Samarra reveals a similar observation: the stucco had evidently been whitened as well (pl. 91). Equally, whitewash has been noted

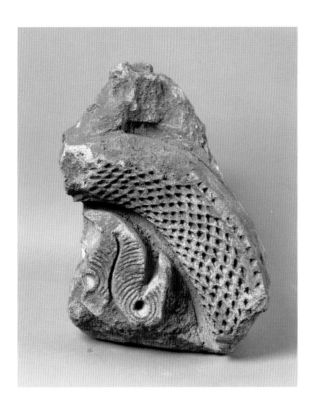

for the stucco from Kharab Sayyar.[14] If this observation turns out to be true, it would have important implications, first and foremost suggesting that the stucco probably imitated marble rather than the other way round (for this suggestion, see Schnyder 1979). "Its face shines white, and its light rises, radiant" is the beginning of a poem by the court poet al-Bukhturi (821–897), celebrating one of the former Samarra palaces, al-Ghard (cited in Meisami 2001, 73).[15] As long as the technical color analysis has not been completed, many questions remain open. We also have to decide, in turn, whether the Samarra marble was white in the first place, not polychrome, as for example in Ghazna. We then also have to consider whether the binary "white versus polychrome" is a useful distinction at all.

Date

In the entire discussion of the stuccoes, it is also important to reflect upon the date of the three Samarra styles. The date certainly touches upon extremely relevant questions, especially concerning the introduction of the beveled Style 1/c and, in consequence, whether this change marks the commencement of a new "Samarra/Abbasid" style. From the beginning there were different opinions about the chronology of the Samarra stuccoes: whereas Herzfeld believed all three styles to be more or less contemporary, Creswell assumed them to be in chronological order, the reason that he had relabeled them A, B, and C. But if there was a chronological development, why so? Did Style 1/c become fashionable at a certain moment or for a specific reason? Was it the "invention" of or for a single person – an argument recently put forward by Thomas Leisten (unpublished paper) in Berlin. Leisten considers Style 1/c to be part of a new, comprehensive artistic program, developed under the aegis of the caliph al-Mutawakkil (r.847–61), a controversial politician with an independent mind and a mania for building.

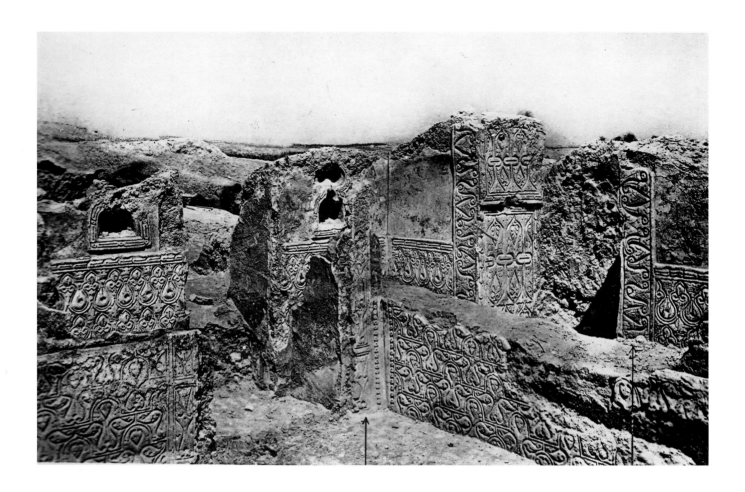

92 House XII from Samarra, showing restoration, photo: Ernst Herzfeld 1911–13.

From Herzfeld's documentation, it is extremely difficult to reconstruct the archaeological evidence. His notes do not allow any secure relocating for most of his excavated stucco panels. Furthermore, he hardly paid attention to building phases, making it impossible to date any interior decoration with certainty. One probable exception is the al-Balkuwara palace, which, according to historical sources, had been built by al-Mutawakkil for his second son, al-Muʿtazz (r.866–89). Obviously the whole complex was constructed in one go: al-Balkuwara is entirely decorated with one single decoration type (beveled Style 1/c), the reason why Creswell and lately Leisten opted for Style 1/c being a later development.

The situation, however, becomes more complicated with the Dar al-Khalifa (the House of the Caliph), the imperial palace complex founded by the first caliph of Samarra, al-Muʿtasim (r.833–42). Here stucco in Style 1/c was also discovered. This main Samarran site had been occupied at least until 884, and a considerable process of change with many additions and much rebuilding must have taken place (Northedge 1993, 145). Although Northedge succeeded in disentangling parts of the architectural chronology of this important complex, there are still major difficulties in dating the specific architectural decoration. Herzfeld's archaeological notes, a hundred years later, provide little evidence.[16]

This difficultly in dating is even more true for the reconstruction of the smaller private houses, whence the majority of the Samarra panels in Berlin originate. Over the years, several attempts have been made to relocate these panels to their original location. A preliminary list for the distribution of the various styles within the various houses established at least two houses with Styles 3/A, 2/B, and 1/C and four

houses with Styles 2/B and 1/C.[17] The existence of two, or even three, different styles within one and the same building led Herzfeld to conclude that all styles should be contemporary. Unfortunately, Herzfeld never documented the renovations of the houses. Looking carefully at some of the old photographs (and also of photographs of the later Iraqi excavations), it is clear that some houses underwent renovations and that some stucco decoration was redone (pl. 92). Without more detailed information, however, it is impossible to assess these renovations. Although we find examples of stuccoes in Style 1/C over Style 3/A, indicating a chronological order, we also find stuccoes in Style 1/C over older stuccoes of Style 1/C. It is also clear that we will never know anything about those renovations that were not photographed.

For this reason, it will remain extremely difficult to establish any sound chronology for Samarra unless new excavations are carried out. Meanwhile, one has to side with either those who cautiously prefer to leave out chronology altogether or with more daring scholars such as Leisten, who attempt to link their interpretation to a wider historical picture. One should finally mention that the chronological problem of Samarra equally affects Raqqa, where in addition to the aforementioned stucco bands of the period of Harun al-Rashid, famous beveled-style stone capitals were found, as well as remains of a beveled-style stucco mihrab in the Great Mosque (Hagen, al-Hassoun, and Meinecke 2004, 30, pl. 5). Meinecke (1999) always ascribed this group to the reign of al-Muʿtasim, who had been to Raqqa before proceeding to Samarra. However, as Heidemann (2003, 38–39) suggested, these works should rather date to the period of al-Mutawakkil instead. They were probably created under the governorship of Abu Jaʿfar Ashinas who resided in Raqqa between 839 and 845.

Conclusion

I have touched upon a few aspects I think important when studying the stucco from Samarra and left out others that are equally crucial, including the question as to how and why these magnificent stucco schemes evolved in the first place. But I certainly believe that rather than establishing pure design connections, one needs to look at the stucco in a much more comprehensive context-oriented way. I believe that Samarra decoration was very specific, and if one ever solves the riddle of the inspiration for the stucco, one will discover that it was intended to be meaningful.

It has become clear how difficult it is to study old excavation materials. At the same time, it is fascinating to see how strongly this early material shaped the entire discipline of the history of Islamic art. It remains to say that it certainly is worthwhile to have a fresh look at old sites. Amongst other things, it will, however, require painstakingly detailed archaeological and archival work.

Notes

1 This essay depends very much on personal communication and assistance. I would, therefore, like to gratefully acknowledge the extremely generous help of my colleagues in sharing information on their various excavation sites and discussing the topic with me: Andrea Becker (Raqqa/Berlin), Fatma Dahmani (Samarra/Paris), Claus-Peter Haase (Medinat al-Far/Berlin), Angela Koppel (Kharab Sayyar/Frankfurt), Jens Kröger (Samarra, Berlin), and Alastair Northedge (Samarra/Paris). I am very much indebted to Simone Struth (Munich) for helping me sort out the Samarra panels at the Berlin Museum and to the conservators Steffi Fischer, Maria Schwed, and Mariam Sonntag (all Berlin) for sharing important technical observations. In addition, I would also like to warmly thank Sheila Blair and Jonathan Bloom for inviting me to this tremendously interesting conference, Marisa Brown for her patient organization, and Aisha Al Khater and her entire staff at the MIA for their truly exceptional support there.

2 See especially the important early Abbasid stucco finds from Raqqa (Meinecke 1991, 1998, 1999; Saliby 2004), but also from Hisn Maslama (Haase 2004) and Kharab Sayyar, again in northern Syria (Moortgat-Correns 1992; Meyer 1999; Koppel forthcoming). There are many further important Abbasid stucco decorations that call for in-depth studies, especially along the Darb az-Zubayda (see, for example, the site of ʿAlwiya near Mecca; Allen 2009) as well as in Iran or Central Asia, some of which are presently being studied by Nasiba Baimatowa. Note also the Abbasid stuccoes in the Egyptian monastery of Wadi Natrun (Hunt 2003).

3 Kröger (forthcoming) will soon present a truly comprehensive record of the Samara excavations.

4 For the fate of the Samarra finds, see also the database http://www.samarrafinds.info.

5 Many of the Samarra stucco panels in Berlin are not originals but casts. A number of them had already been made on site by the field technician Theodor Bartus (1858–1941), who had specifically visited Samarra from 5 October 5 to 21 December 1911 to remove the stucco panels from the walls and to produce copies of the fragile revetments (Schwed 2004, 170ff.). In February 1912, Bartus was replaced by Karl Beger, another plaster specialist from Berlin who finished Bartus's work from the previous season (Schwed ibid.). Unfortunately, it is not clear how many casts were taken and which ones eventually reached Berlin. Further casts were later taken in Berlin. Together with the Hochschule für Technik und Wirtschaft (HTW-Berlin), the Museum für Islamische Kunst in Berlin is presently engaged in re-examining the entire find group. Mariam Sonntag will publish the results in her MA thesis.

6 The fire obviously burned only archival material and did not affect the stucco finds. For a full assessment of the fate of the panels, see Kröger forthcoming.

7 Here I would like acknowledge the essential research on Samarra carried out by Alastair Northedge, who began his comprehensive new archaeological survey of the site in 1983. Northedge has studied mainly the urban history of Samarra (Northedge 2001, 2004, 2005), but has never dealt with the stucco work. In addition Leisten, who had Herzfeld's architecture studies published in 2003, touched only upon the stucco finds from the surface.

8 The three panels in the MIA were apparently bought from the Homaizi collection, Kuwait.

9 As one can see in the excavation photograph published by Janabi (1983, pl. 20), MIA panel sw.15.1999 is presently hung the wrong way round. For the Copenhagen fragment, see also the publication of its sale at Christie's (1992, lot 84).

10 For a comprehensive treatment of this question, one eagerly awaits the doctoral dissertation by Matt Saba at the University of Chicago, who will pay specific attention to the decorative program of the Dar al-Khalifa.

11 See note 5 above. Preliminary color analysis by radioscopy by the Hochschule für Technik und Wirtschaft (HTW-Berlin) has not yet detected any color remains. Further comprehensive examinations are in preparation.

12 Personal communication, Jens Kröger.

12 Personal communication, Claus-Peter Haase.

14 Personal communication, Angela Koppel.

15 The full verses are: "Its face shines white, and its light rises, radiant / until the eyes are wearied by it and recoil: Like the pearl-bright star whose light has been purified by the pitch-black gloom, till it glisters and shines."

16 Fatma Dahmani, for example, dates the wall paintings of the palace to the period of al-Mutawakkil; personal communication. Her results will be published in her forthcoming dissertation.

17 Houses II and III, all three styles; Houses IV, V, XII, and XIII only Styles 1/C and 2/B; (mainly 1); Houses VI–IX, XIV–XVI only one style. I would like to thank Simone Struth for establishing this list.

p. 102: detail of the marble composite capital, showing the acanthus leaves and classical bead decoration. MIA, Doha (sw.54.2003).

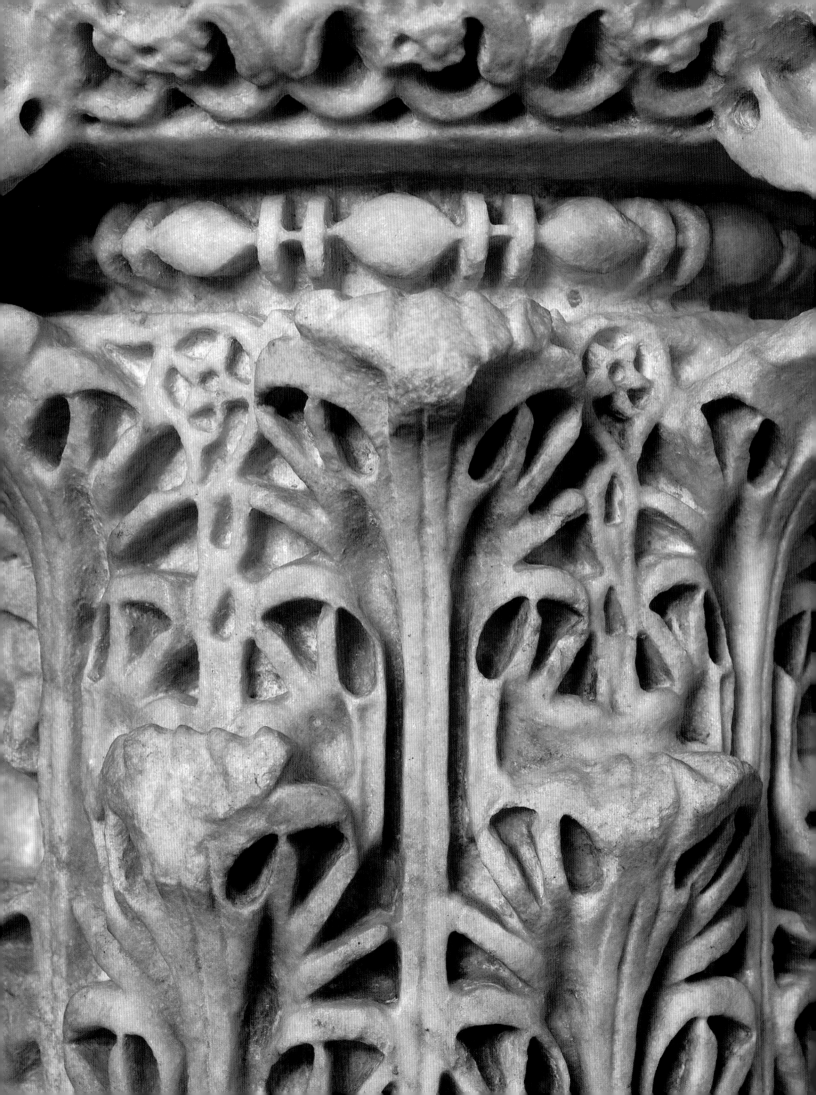

5

Two Capitals from the Umayyad Caliphate of Córdoba

رؤُوس عمودين من المندرة الأموية بقرطبة

Antonio Vallejo Triano

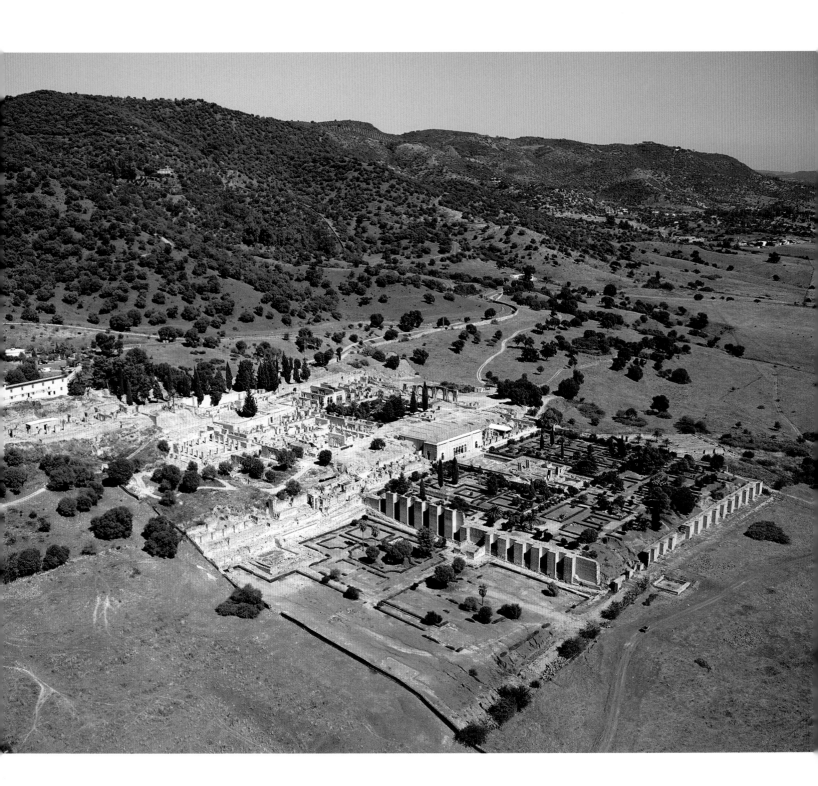

The Umayyad caliphate of al-Andalus represents one of the high points of Islamic civilization in the Mediterranean basin in the tenth century, as represented by two capitals in the collection of the Museum of Islamic Art (MIA) in Doha.[1] Among the most important aspects of its extraordinary artistic production is the architectural decoration developed within its buildings, which is clearly superior in both quantity and quality to contemporary production elsewhere. Decorated support elements such as capitals, cornices (cyma), shafts, and column bases are one of the most characteristic features of this architecture and have been considered so since the first research was undertaken on the Umayyad caliphate in Córdoba (Velázquez 1923, 3–4). Of all these elements, the capitals are most relevant because of their prominence and visibility in the decorative program, their ornamental treatment, and their occasional use as a support for inscriptions that offer precise information about patronage, chronology, and other organizational aspects of the caliphal state.[2]

From its origins, the city of Madinat al-Zahra, established near Córdoba in 936 by the first caliph of al-Andalus, ʿAbd al-Rahman III, known as al-Nasir (the victorious), was the main center for the reception, re-elaboration, and diffusion of architectural and artistic forms created by the Umayyad caliphate (pl. 93).[3] Along with other elements of material production, the capitals were subject to a process of selection and elaboration, in which they evolved from diverse types based on classical examples and used in the previous period to the two main morphological types characteristic of this period: the composite capital and the Corinthian-derived style.[4] It was in the building known today as the Hall of ʿAbd al-Rahman III, the main reception hall built between 953 and 957 CE (pl. 94) and called *al-majlis al-sharqi* (the eastern hall) in the Arab sources,

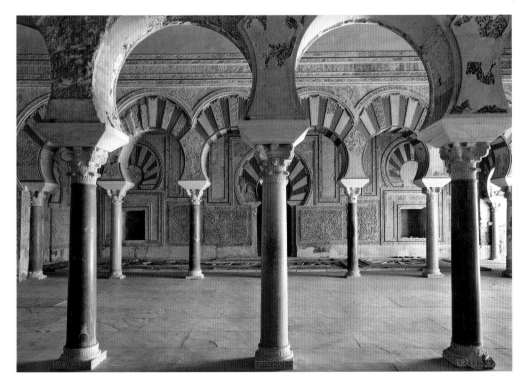

93 (*facing page*) Archeological site at Madinat al-Zahra near Córdoba, 936–1013.

94 Hall of ʿAbd al-Rahman III at Madinat al-Zahra, 953–57.

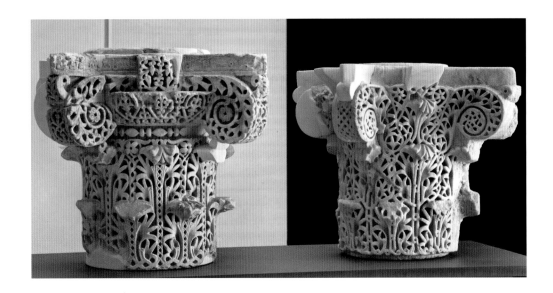

especially Ibn Hayyan (1965; see Vallejo Triano 2010, 496), where these two types of capitals acquired their canonical features, characterized by the cubic proportion of the block, the cylindrical shape of the basket, and the development of deep carving made with a trephine or drill (pl. 95). The two capitals studied here are examples of these two main morphological types.

The first is a composite capital (pl. 96a–b). It is characterized by the cylindrical form of the basket, with two acanthus crowns of eight leaves, each of which splays out into four little fingers; a secondary stem in the shape of a chain that hangs between the leaves of the upper acanthus crown and ends in a small flower; and a classical bead and reel decoration with oval beads. The echinus (the convex projecting molding of eccentric curve that supports the abacus) takes the form of a quarter circle; the big projecting volutes are shaped like discs; the abacus has two staggered levels, the upper one being flat; and the gussets, or cup-like elements, set on the axis of each of the four sides, adopt a prismatic shape, including the one with an inscription.

The acanthus leaves of the basket (*calathos*) have thick stems dividing the thinner fingers that are set on both sides, fan-shaped, and pointed (pl. 97). The stems are flat

96a–b (*left*) Marble composite capital, probably from Madinat al-Zahra. MIA, Doha (sw.54.2003); (*right*) Schematic model showing the different components of the composite capital.

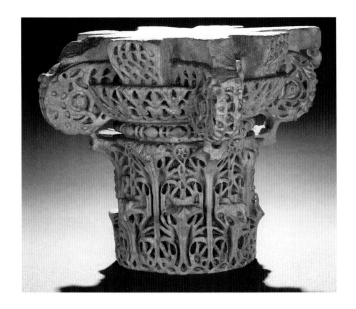

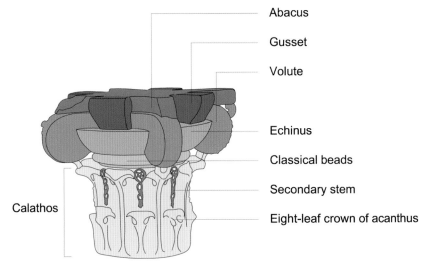

Abacus

Gusset

Volute

Echinus

Classical beads

Secondary stem

Eight-leaf crown of acanthus

Calathos

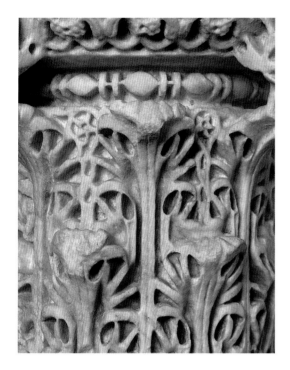

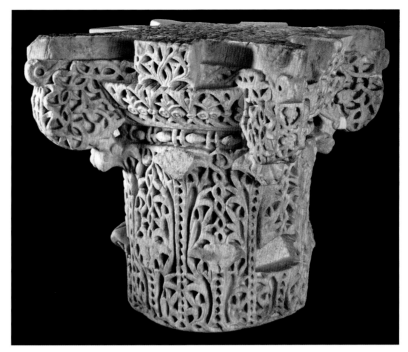

97 (*left*) Detail of the marble composite capital, showing the acanthus leaves and classical bead decoration. MIA, Doha (sw.54.2003).

98 (*right*) Marble composite capital from the hall of ʿAbd al-Rahman III, 953–57. Madinat al-Zahra Museum, Córdoba (42.24115).

and decorated with longitudinal fluting, unlike the drilled twisted decoration typically used in the capitals in the Hall of ʿAbd al-Rahman III (pl. 98). Both types of capitals are similar, however, in their classical bead and reel decoration, formed by ovals and pairs of disks, and in the secondary stems in the shape of a chain. The echinus takes the form of a crown composed of leaves in the shape of a calyx alternating with stems and double leaves with three little fingers linked with two little flowers. Except for the inscribed gusset, the other three show a mesh of intertwined stems in a diagonal shape. The volutes are formed of a scroll of leaves surrounding a little six-petaled flower in the center. The edges display a deeply incised plant decoration, and they rest on the leaves of the upper body of the basket with two small posts. It should also be pointed out that the capital has a small hole in the lower layer of leaves, in order to fit a replacement for a damaged leaf, as happened in the case of the capital shown in plate 98.

Some formal and decorative features of the capital in the MIA, as well as its dimensions, show that it is similar not only to the one from the Hall of ʿAbd al-Rahman III, but also to another example, again of a composite type (pl. 99). This capital, which is not as slender in proportion, probably belonged to the small pavilion located over the monumental entrance to the palace of Madinat al-Zahra known as the Great Portico (Escudero Aranda 2001, 120–21).

The second capital selected for study from the group in the MIA derives from the Corinthian style (pl. 100a–b). It contains several specific features that distinguish it from the better-known stereotypical examples from the Hall of ʿAbd al-Rahman III. First, and unlike most of the examples of this type, the MIA capital has two, not three, crowns of prickly acanthus leaves. The upper row has disappeared, partially replaced by a prominent gusset that has an inverted triangular shape with rounded edges and grows from a straight and stylized stem sprouting from underneath the upper layer of the acanthus leaves. In two of these gussets one can distinguish a tree fruit, specifically a pinecone, and in the third a plant with a heart shape that resembles an inverted palmette.

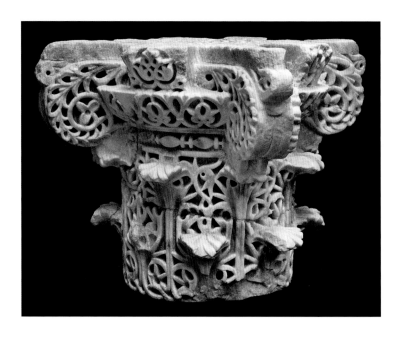

99 Marble composite capital from the pavilion on the Great Portico at Madinat al-Zahra, 953–60. Madinat al-Zahra Museum, Córdoba (34.24089).

Second, the MIA capital shows large stalks shaped like thick tree trunks, engraved with flutings, and crowned with a small leaf in the form of a calyx. From it emerge two elements: an acanthus branch, whose continuation makes up the circular volute, which ends coiled up in a prominent curl; and a very well defined fern leaf, with little heart-shaped leaves on either side of the stem, which adopts an S-shape and crosses the other half of the composition. The volutes are fully carved and rest only on one point of the leaves of the upper layer of the basket. As with the first capital, the acanthus leaves have four little fingers arranged on each side of the central veins, which are flat with vertical flutings.

One of the four faces of the MIA capital is unfinished. Its different parts have been carved only in broad strokes, without the addition of decorative details (pl. 101). The unfinished side shows that that part of the capital probably remained hidden. Therefore, it was located against the wall.

This capital may be related to a series of others, also of a Corinthian-derived style, which are characterized by the presence of fern leaves, like braids, sprouting at the

100a–b (*left*) Marble Corinthian capital, probably from Córdoba. MIA, Doha (sw.151.2008); (*right*) Schematic model showing the different components of the Corinthian capital.

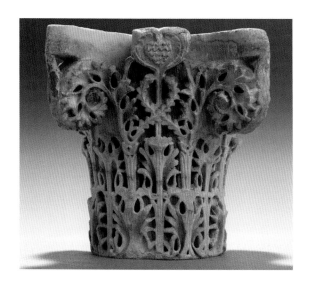

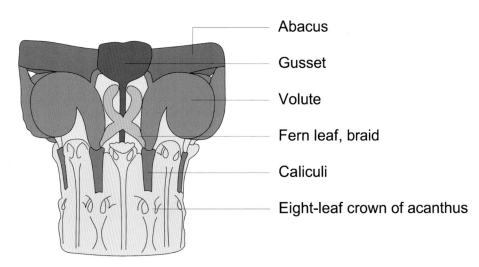

Abacus

Gusset

Volute

Fern leaf, braid

Caliculi

Eight-leaf crown of acanthus

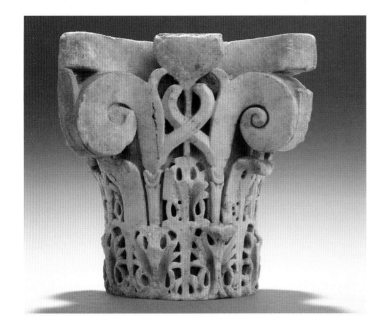 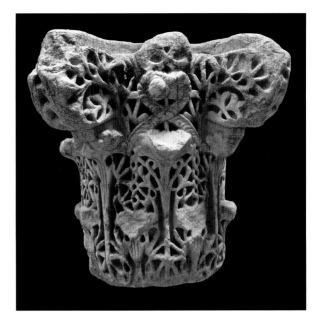

level of the volutes of the second row of the acanthus leaves, intertwining, and ending up under the gusset. The leaves sometimes coil up over themselves, overhanging from the body of the basket. Within this general type, we can identify a group of capitals (see, for example, De Montêquin 1992, 244; pl. 102), all of which show slight differences in the morphology of the fern leaves (with one or two little fingers set symmetrically), in the way the leaves are supported (with or without thick stalks), and in the various shapes of the terminals. The MIA capital exhibits a greater classicism, with elements such as the triangular shape of the gussets or the large *caliculi* closer to classical models of the Imperial Era rather than those of Late Antiquity.[5]

The extraordinary quantity and wide variety of the capitals still in the original buildings and also in public and private collections point to three key avenues of investigation: first, the architectural context; second, features related to production and patronage; and finally, the sources of inspiration for these remarkable objects.

The Architectural Context

During the eighth and ninth centuries, the mosque of Córdoba was, along with some small quarter mosques, the only basilica-type structure in al-Andalus that required a large number of column supports and, therefore, of capitals (pl. 103). As is well known, after a first stage of re-using capitals from pre-existing buildings (Roman, Late Antique, and Visigothic), the first capitals produced under Muslim patronage were made in the ninth century. But it was in the tenth century, during the Umayyad caliphate, when an extraordinary increase in the production of capitals took place, such that the number of manufactured pieces cannot be compared to any other Muslim polity in the Mediterranean, as Patrice Cressier has shown (2010, 67–82). Suffice it to point out that the buildings so far excavated in Madinat al-Zahra contained 264 capitals, an extremely large number in view of the small area of the city (around ten per cent) that has been excavated.[6]

In addition to the two types specifically created for the religious architecture of the caliphate, first for the mosque of Madinat al-Zahra (pl. 104) and then for the caliphal

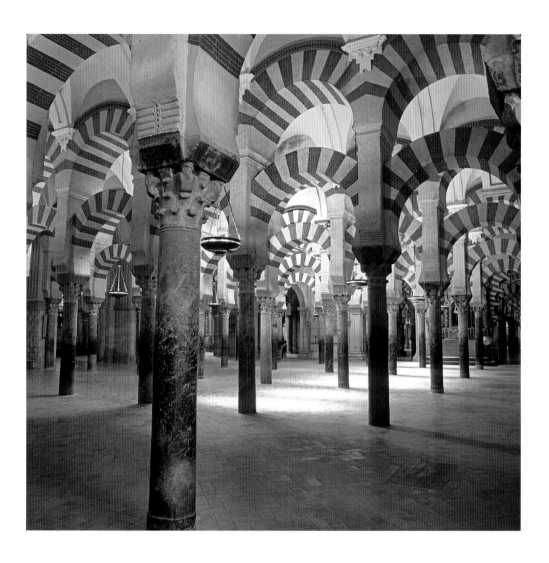

103 Arcades added to the Great Mosque of Córdoba by al-Hakam II, 961–71.

extensions of the mosque of Córdoba (pl. 105), the wide variety and the richness of types and examples are part of the extraordinary architectural development based on arch forms that took place in al-Andalus around the middle of the tenth century. This proliferation of caliphal capitals is due to two factors. First, the triple arch was introduced and developed for use in private dwellings. This type of triple arch appeared for the first time in the most important houses of Madinat al-Zahra, the residences of both the caliph and his chamberlain or *hajib* (pl. 106), and from there it spread to the private residences of the ruling elite.

Second, and much more significantly, the multiplicity of caliphal capitals is due to the introduction and development for the first time in al-Andalus of basilica-shape architecture in the civil and palatial context of Madinat al-Zahra, not in the religious context where it had already existed and would continue to be used for new caliphal mosques (Acién Almansa 2000, 51). This type of basilica became the main model for the representation of power during the caliphate.

These buildings have as a core a three-aisled basilica with a front portico, to which a group of perimeter halls are added to create a U-shape circulation space around the core.[7] The main function of this circulation belt was to provide exclusive access to the audience area to the different groups of people participating in the ceremonies that took place within it. In the case of the Hall of 'Abd al-Rahman III, these people included the caliph, his family and high-ranking civil servants, and ambassadors (pl.

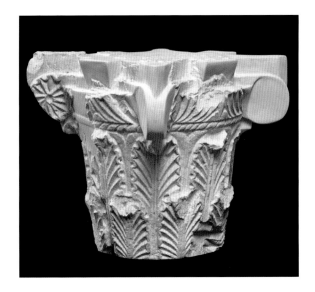

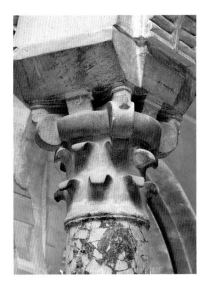

104 (*left*) Limestone caliphal capital from the congregational mosque at Madinat al-Zahra, 944–45. Madinat al-Zahra Museum, Córdoba (50.24114).

105 (*right*) Marble composite capital from the additions to the Great Mosque at Córdoba under al-Hakam II, *circa* 965.

106 (*below*) Tripartite arcade inside the house of the chamberlain Ja'far ibn 'Abd al-Rahman al-Siqlabi at Madinat al-Zahra, *circa* 961–63.

107). The setting, the activities that took place within it, and the protocol of assigning positions there are all fully described by the caliphal chroniclers (Barceló 1995, 155–75). We should remember that access from the eastern side was exclusive to the caliph. Access from the western side, by contrast, might have been used by the caliph's family and by the different groups of government employees who formed the elite administration of the caliphal state.

Finally, the embassies must have had access to the interior of the building via the facade and the main transverse aisle. Here, there is a triple foundation inscription of a monumental nature with the name of the caliph, 'Abd al-Rahman al-Nasir, designated as the sponsor and commissioner of the building, and the name of one of the two directors of the work, 'Abd Allah ibn Badr, who was, along with Sunayf, the highest political appointee responsible for building on behalf of the caliph (Martínez Núñez 1995, 116–20, 140–41).

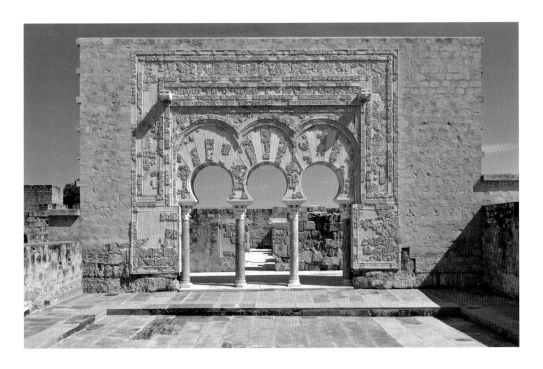

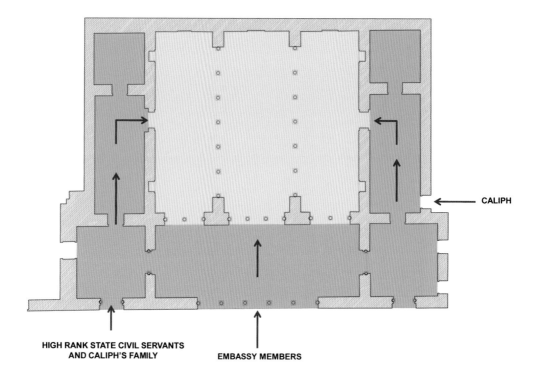

CALIPH

HIGH RANK STATE CIVIL SERVANTS
AND CALIPH'S FAMILY

EMBASSY MEMBERS

Production and Patrons

107 Schematic plan showing the entrances and circulation patterns in the hall of ʿAbd al-Rahman III at Madinat al-Zahra, 953–57.

Architectural decoration, along with the other remaining material culture, was one of the most important means of legitimization and propaganda for the caliphal state and its ruler. Therefore, the decorative programs, like the architecture, were the result of similar planning processes, from the selection of raw materials to the different phases of design and execution: choice of themes and ornamental vocabulary, supervision, implementation, and control. All of this required a complex organizational and material structure to ensure the control and achievement of its different stages by those around the caliph who were in charge of transmitting this ideology.

Raw materials were carefully chosen, as they had specific purposes. For the column bases and capitals, white marble from the Estremoz quarries in Portugal was selected. The remaining stone used for decorative and constructive elements is local, coming from within a fifty-kilometer radius of Córdoba (for details of all aspects of the origin of the raw materials, see Vallejo Triano 2010, 115–17).

Some parts of these programs were carried out *in situ*, as was the functional architectural decoration, adorning the walls and arches of the building with elements such as panels, rectangular moldings around arches (*alfices*), keystones, and friezes. All of them were carved on limestone slabs, different from the stone used for construction and superimposed onto it as if it were a skin. Generally, these panels were arranged in horizontal rows of different height, with the composition first drawn on their surface and then carved (Vallejo Triano 2006, 391–413).

This decoration, commonly known as "ataurique" (*al-tawriq*, from the Arabic *waraq*, foliage) because of the predominance of plant motifs, has been the object of investigation and reconstruction in several buildings, especially in the Hall of ʿAbd al-Rahman III, one of the most emblematic and important buildings in all caliphal architecture. The decoration there is arranged in three registers, of which the lower one is composed of an outstanding collection of more than sixty panels, all of them different and large

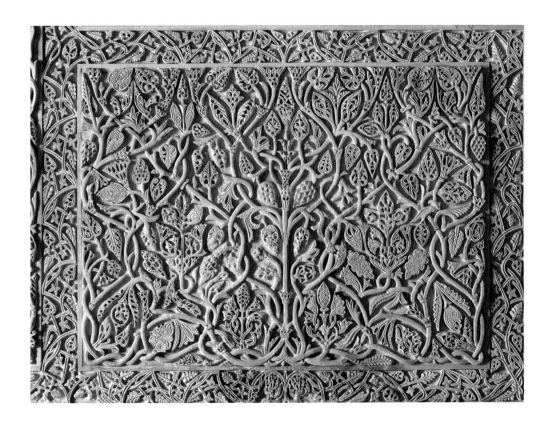

108 Carved stone panel with vegetal decoration inside the hall of ʿAbd al-Rahman III at Madinat al-Zahra, 953–57.

in size. Each one represents a tree-like structure with roots, trunk, treetop, and branches, which are articulated and sprout an exuberant flora of extraordinary richness and variety (pl. 108), including more than 1,700 different motifs, many related to vegetal forms from Samarra (Ewert 1995, 42–57). This ornament represents a new decorative language of clear Abbasid influence, which can have been produced only by teams of artisans coming from the East or trained in an artistic atmosphere directly in contact with the Abbasid world. The upper decorative registry includes a frieze with geometric shapes and stars that covers the entire building. Manuel Acién Almansa (1995, 188–91) has interpreted all of this decoration, which constituted the setting for the caliphal presence, as a cosmography, with the plant panels representing the natural and sub-lunar world and the upper frieze of stars representing the firmament.

The remaining pieces that make up the decoration, including the different elements of support such as capitals, moldings, shafts, and column bases and the other marble elements such as pilasters, small decorative arches, panels, and so on, were entirely carved throughout the various stages of the production process in a workshop, not on the building itself. This can be inferred because some pieces show an evident disconnect with their final location in the building.

The extraordinary homogeneity of these pieces in terms of type of materials, carving technique, composition, and decorative repertory (within the extraordinary richness and variety of examples, as occurs with the capitals) allows us to be certain that all of them were made in the official workshops of the *Dar al-Sina'a* (House of Trades). The written sources concur in saying that this important industrial establishment of the state was located within Madinat al-Zahra, in some part of the spacious side areas of the city, eastern or western, the only ones to have been built (Vallejo Triano 2010, 184–85). These workshops therefore not only manufactured the so-called sumptuary objects used in the court, such as the two little ivory boxes inscribed with the names

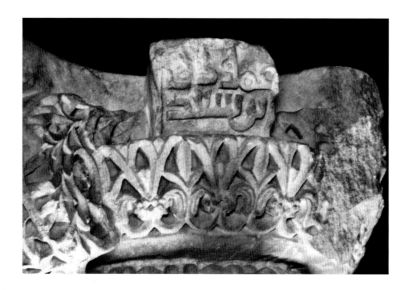

of Wallada, sister of al-Hakam II (r.961–76), and of the caliphal city (one in the Instituto de Valencia de Don Juan in Madrid and the other in the Monastery of Fitero; Ocaña Jiménez 1970, 37, pl. XXII), but also produced the different elements of the architectural decoration. This is also confirmed by the content of the messages, transmitted especially (although not exclusively) by the capitals, which provide us with invaluable information that praises the caliph as patron, with all of his formal titles, and also provides the names of some of the people who oversaw or controlled the execution and, on some occasions, the dates of the work.

In the case of the composite capital in the MIA, we have already noted that it has one epigraphic gusset (pl. 109). Its text in plain kufic, carved in relief and arranged in two lines, reads: "work of Durri ibn Sa'd."[8] Durri was a well-known name at that time, designating an important family of slaves, one of whom was called Durri al-Saghir. The officer in charge of the palace slaves (fata) for the caliph al-Hakam II, he gave the caliph the palatial estate of al-Rummaniyya, located to the west of Madinat al-Zahra, as a present (Ocaña Jiménez 1984, 367–81). This important figure is also known from epigraphy, since he is mentioned as director of some of the official works that were ordered by al-Hakam II, including the well-known pyxis from the Cathedral of Zamora and the small cylindrical one in the Victoria and Albert Museum, London; the name of Sa'd, for his part, is mentioned in the inscriptions on several works from the Hall of 'Abd al-Rahman III and its annexed rooms (Martínez Núñez 1995, 111–12, 128–29, 115–16 respectively). The Durri ibn Sa'd named on the capital in the MIA must be considered one of the workshop supervisors or artisans linked to the caliphal *Dar al-Sina'a*. This filial relation allows us to verify again in a reliable and documentary way the existence of family groups among the artisans or workshop supervisors where these caliphal works were produced.

The homogeneity demonstrated by these caliphal capitals, within the overall diversity, assures us that most of them were produced by and for the state and, therefore, in the official workshops of the *Dar al-Sina'a*. However, these works were not destined only for use by the state. The elite making up the circle of power in the caliphate, like the caliphs themselves, accumulated great fortunes in the undertaking of their administrative offices. Their profits allowed them to build large private residences, generally palatial estates, which were modeled on caliphal architecture, including such

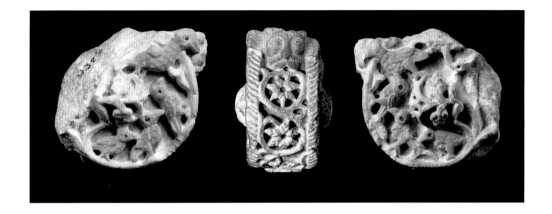

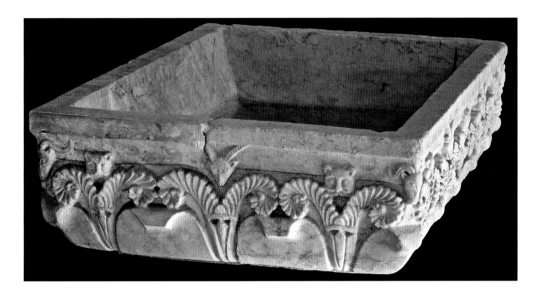

110 (*top*) Marble capital volute from the palatial estate of al-Rummaniyya near Córdoba, *circa* 965. Archeological Museum, Córdoba (CE009323).

111 (*bottom*) Marble basin from the palatial estate of al-Rummaniyya near Córdoba, *circa* 965. Archeological Museum, Córdoba (CE006418).

elements as porticos and lounges with triple arches, and hence the elite too needed column supports and their capitals.

We have been able to find evidence for this on the palatial estate of al-Rummaniyya, built by the caliph's treasurer Durri al-Saghir in the years 965–66. Al-Rummaniyya has a very large pool and three garden levels. Both spaces should be viewed from a hall with two arcades each consisting of three arches, as shown by recent excavations (Arnold, Canto García, and Vallejo Triano 2008). The quality and technical level of the decorative remains of this palatial estate are reminiscent of the work produced by the workshops that carved the decorative programs of Madinat al-Zahra, but it is obvious that the commissions were different. The formal and decorative characteristics of these objects reveal a destination different from that of an official building sponsored by the government. The capitals, for example, display an animal iconography based on bird and lion heads (marked here in a darker color; pl. 110), elements that are not found at Madinat al Zahra, neither among the official buildings nor among the residences. Elements of this same iconography can likewise be seen in other marble pieces, such as little basins, which also display a collection of animals including lion and antelope heads (pl. 111), features not found for the moment in the royal city of ʿAbd al-Rahman III (Anderson 2007, 67–69).

There also exists a series of capitals from Córdoba that must reflect a specific commission. One (pl. 112a–b) is the so-called "capital of the musicians" (studied and

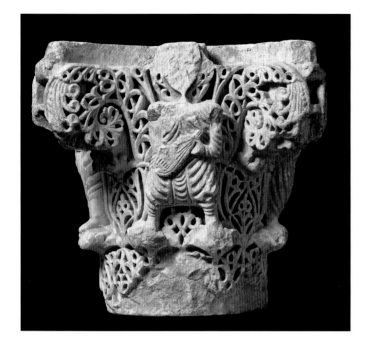 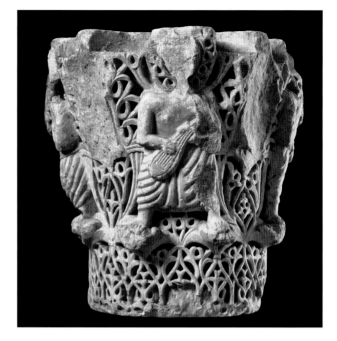

112a–b Marble Corinthian capital known as "the musicians," Córdoba, second half of the 10th century. Archeological Museum, Córdoba (DOCC133).

reproduced on numerous occasions; see, for example, Carpio Dueñas 2001, 135–36). Although its iconography corresponds to a theme typical of the court, it seems clear that it was not intended for any building at Madinat al-Zahra, nor for the Umayyad palace in Córdoba.

The material evidence thus shows a more complex reality that is not restricted exclusively to Madinat al-Zahra and official buildings. The proliferation of palaces among the members of the aristocracy linked to the state, which we know mainly from written sources, generated an increased demand for decorative materials made of marble, especially support elements and other elements about which we are little informed. Some of these materials must have been carved in non-official local ateliers,[9] but most were carved in caliphal workshops. The production of these workshops therefore was not restricted to the direct orders of the state or the caliph, but rather these workshops and artisans also supplied a commercial circuit restricted to the elite and unconnected to caliphal sponsorship.[10] The anonymous expression "blessing from God to its owner" (*baraka min allah li-sahibihi*), inscribed on the gussets of some capitals, has been related to the market and to those clients who used them not only in palaces but also in the construction of some mosques, which were sponsored by this elite as pious works.[11] In this case we may well wonder if the state controlled the hypothetical commercialization and selling of these products or if it received taxes or benefits of some kind from this activity.

Sources of Inspiration

The inspirational sources for the main architectural decoration of the caliphate, from the Byzantine, Umayyad, and Abbasid realms, have been identified.[12] For the capitals, it has also been pointed out that inspiration was taken from "diverse and complementary traditions," including the classical tradition, and that the selection of individual sources has, needless to say, implications not only for their aesthetic characteristics but

also for their political and propagandistic uses. It is known that from the moment that the first capitals were conceived for use in the expansion of the mosque of Córdoba carried out under ʿAbd al-Rahman II (r.822–52), they were inspired by, or even copied directly from, classical Roman capitals.

Various authors, including Cressier (1985, 296–313), have studied the changes and transformations made to classical models in defining prototypes for the caliphal capital. The composite capital ended up acquiring a signature role in the architecture of the period of ʿAbd al-Rahman III, and it was in the reception hall of this caliph, also known as Salón Rico, where this type of capital acquired its canonical form, one that it would maintain throughout the second half of the tenth century. The capital in the MIA (see pl. 96a–b) conforms to the model as regards its formal and aesthetic organization. In terms of chronology, it should therefore be placed between the years 953 and 960, the same date as the capital from the pavilion over the Great Portico (see pl. 99).

In contrast to the other type, the Corinthian capital shows a greater wealth of decorative formulae and variants. Some of them include recognizable elements of the classical tradition, as occurs with the Corinthian capital in the MIA (see pl. 100a–b), where the large *caliculi* and the triangular gussets stand out. However, this use of classical elements may not be measured chronologically in relation to other Corinthian capitals that do not use these elements. In fact, for several reasons, this capital in the MIA should be dated to the caliphate of al-Hakam II, without being able to pinpoint the exact moment. As with the rest of the architectural decoration, this use or recovery of elements from the earlier tradition should not be interpreted exclusively as a product of artistic evolution, but rather in terms of decisions and artistic choices of an appropriate ornamental program for each building, since these are the result of a clear political will.

I will give an example. In Madinat al-Zahra, at the same time that caliphal capitals were being used in the Throne Hall erected between the years 953 and 957, older models were also being copied for capitals in other buildings of the palace. Excavations have unearthed a capital of an extraordinary classicism (pl. 113a; this capital has been reproduced in various publications, such as Torres Balbás 1957, 682, pl. 501). In spite of its dilapidated state and its missing fragments, we are able to recognize that it is strongly inspired by the capitals used in the extension of the Great Mosque of Córdoba under ʿAbd al-Rahman II, which, as is well known, were transported and later placed in the mihrab added by the caliph al-Hakam in 961–66 (pl. 113b). The morphology of the large stalks and the existence of the large upper spirals (marked here in a darker color), which do not appear in caliphal capitals, are practically identical in both pieces. This capital must be related to a column base whose morphological features differ from those typical of the caliphate and are closer to the column base of the new mihrab added under al-Hakam II. The origin of both elements is a hall that is scarcely known as it is not yet excavated, but which is located at the foot of the caliphal residence, which has, like the mihrab, double supports in its jambs (hence its common name, Double Column Hall). All this confirms that in this building and by the choice of

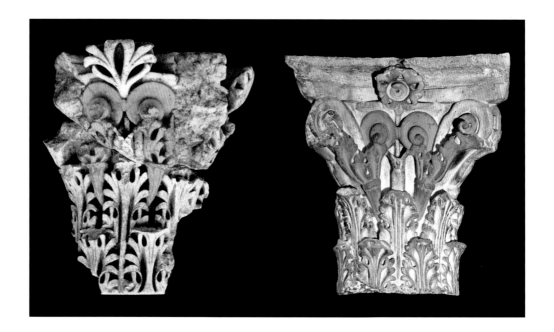

materials used, a conscious relation was sought with the period of ʿAbd al-Rahman II
via the architecture that best identified the continuity of the Umayyad dynasty, that is,
the mihrab added to the mosque in the extension undertaken by that ruler.

This use of elements and classical models as one of the sources of inspiration of the
caliphate is well documented, and we find its most emphatic evidence in the mihrab
of the mosque of Córdoba, especially its interior cornice, which copies a Roman motif
with metopes over a bead decoration, even though it introduces some plant elements
that are entirely typical of the Islamic period and derive from the Abbasid tradition.

There also exist other materials from Madinat al-Zahra (we do not know whether
they belong to the caliphate of ʿAbd al-Rahman III or of al-Hakam II) that use, main-
tain, or copy motifs from the previous tradition. Among them, a collection of moldings
from the western area of the palace stands out (Pavón Maldonado 1969, 155–83). These
moldings are decorated with different motifs such as ropes (plain or spiked), intersecting
circles, a series of star-like squares, and classical bead and reel decoration (pl. 114). They
are caliphal materials made specifically for some palatial buildings (not yet excavated,
and therefore unknown), where some common elements from the preceding local tradi-
tions were used (classical, Late Antiquity, Visigothic), although some of them are also
present in Umayyad architecture in the eastern Islamic lands. These elements were re-
elaborated for a type of work, which, like moldings, did not exist in the classical period
and which show an extraordinary development in caliphal architecture, from the quan-
titative point of view, similar to that of the capitals.

How can we explain this reuse and re-elaboration of earlier materials? This topic
has been the object of much discussion in recent years and probably there is not just
one single explanation for this phenomenon.[13] In the case of capitals and classicist
column bases of the so-called Double Column Hall, the copying of these elements
during the caliphate should be clearly interpreted as a reference to earlier architecture
and thus as the need to establish evidence for dynastic continuity in this building
through the use of these marble materials. In a general sense, the use of earlier elements
can be explained by the idea, already expressed by Acién Almansa (2000, 440), of a
"surpassing integration." In some cases this "surpassing integration" means the use of

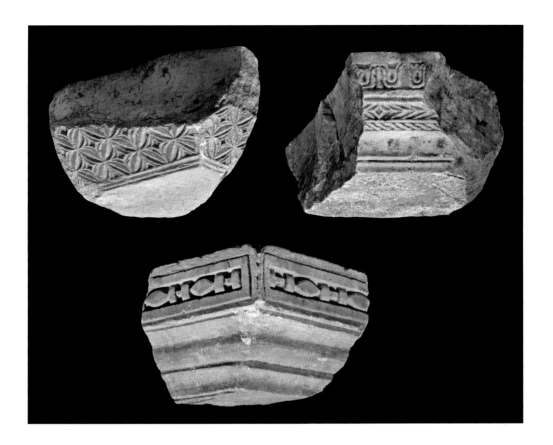

114 Marble circles and classical
beads decorated cornices from
Madinat al-Zahra, *circa* 950.
Madinat al-Zahra Museum,
Córdoba (47–48.25720,
47–48.25719, 47–48.25742).

works of the past as a reference and as a model of inspiration in order to create new objects, both beautiful and functionally efficient. But in other cases it means the direct appropriation of those elements, reusing them with a new function and within a new context. This occurs with the extraordinary collection of more than twenty figural Roman sarcophagi of different themes and sizes that were introduced into the palatial buildings of Madinat al-Zahra, together with diverse Roman portraits and other elements from that culture. The sarcophagi in particular form one of the most important collections of these elements in the Iberian peninsula, in terms of both quantity and quality (Beltrán Fortes, Ángel García, and Rodriguez Oliva 2006, 36–41, 127–52, 164–71).[14] All of them were reused as water basins and placed in the courtyards of the large administrative buildings of Madinat al-Zahra (pl. 115) at the same time that the Hall of ʿAbd al-Rahman III was being constructed, with its transcendent artistic contribution coming from the Abbasid world.

In both cases, the "surpassing integration" involves, on the one hand, the acknowledgment of the previous civilization as responsible for great works and, on the other, the "appropriation" of these works or elements, as well as, finally, their "integration" into one's culture not as trophies, but rather with the idea of placing oneself at the top of them and above the governors who created them. The borrowing from local tradition attested by these materials from Madinat al-Zahra must be interpreted as a part of a premeditated program that seeks to convey the cultural superiority of Islam and its leaders over other civilizations.

This concept is not expressed clearly in any document, although it may find certain support in the historiography of the period. We know that the caliphate undertook an important historiographical project about al-Andalus, which has been insufficiently studied. This work was carried out mainly by the chroniclers at the courts of ʿAbd

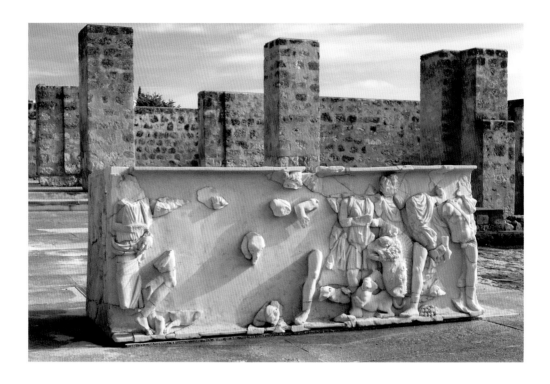

115 Marble Roman sarcophagus decorated with Meleager and Calydonian hunting boars, 1st century, reused *circa* 955 in the "Pillars Court building" at Madinat al-Zahra.

al-Rahman III and al-Hakam II, the al-Razi family (see Levi-Provençal 1955, 228–30). The first individual, Ahmad ibn Muhammad al-Razi (889–955), wrote a chronicle, the *Akhbar Muluk al-Andalus* (History of the Kings of al-Andalus), which has come down to us incomplete.[15]

This work is in reality a history of the Iberian peninsula, in some ways a "national" history, not a story of the dynasty of the Umayyads, who for different reasons ended up settling in al-Andalus. As Diego Catalán has pointed out (*Crónica del Moro Rasis* 1975), "the history of the Umayyads in Córdoba does not start in the East, but with the prehistory of al-Andalus, with the first settlers of the Peninsula." This significance given to the land, to the territory, acknowledges the singularity of the Umayyad caliphate and its identification with that territory. In other words, in the mid-tenth century, more than two centuries after settling in al-Andalus, the caliphs had a clear understanding of where they were located and presented themselves as owners of the territory and therefore as heirs, keepers, and surpassers of previous cultures there.

It is in this context of the caliphate's historic re-elaboration produced to present the Umayyads as legitimate kings of the peninsula that we find an appropriate explanation for the use and integration into their palaces and decorative programs of identifiable elements from these cultures, which were divested of their original function and put into the service of a new material and ideological purpose. The incorporation of these "minor" elements was, therefore, one of the means that the Umayyads used in order to legitimate themselves as rulers of al-Andalus.[16]

Notes

1 This contribution has benefited from the support of a research project: Plan Nacional de I+D, *Materiales de Madinat al-Zahra': producción y circulación de bienes en al-Andalus*. Ref.: HAR2009–10011. I thank my colleagues Mª Antonia Martinez and P. Cressier for the references made to this study.

2　These considerations have been pointed out by Cressier (1995, 100–01).

3　Many studies have focused on particular aspects of the history and material culture of Madinat al-Zahra', but general studies are rare, limited basically to Torres Balbás (1957, 333–788), López Cuervo (1983), Hernández Giménez (1985), and recently Vallejo Triano (2010).

4　To these two, we should add the pilaster capital, which is quantitatively less important within overall caliphal production.

5　These elements are found in some capitals from the period of the Umayyad emirate (before ʿAbd al-Rahman declared himself caliph in 929) and later during the caliphate, including the Corinthian pilaster capitals in the Hall of ʿAbd al-Rahman III, which also have a very classical appearance. For these capitals, see Cressier (1995, 96–99).

6　These capitals are grouped thus: Congregational Mosque, 68; Upper Basilical Hall, 62; Hall of ʿAbd al-Rahman III, 42; Central Pavilion, 36; rooms annexed to Salón Rico, 10; Pool House, 8; *Dar al-Mulk*, 8; Great Portico, 8; House of chamberlain (*hajib*) Jaʿfar, 6; Double Column Hall, at least 16. Logically, this number of capitals corresponds to an equal number of moldings and columns, but not of column bases, because this last element was not used in some buildings, such as the congregational mosque or the caliphal extensions to the Great Mosque of Córdoba.

7　This three-sided ambulatory structure was studied by Ewert (1987, 116–23), who proved that it had been used in both religious and palace architecture since the Abbasid period.

8　Reading by Mª Antonia Martínez Núñez.

9　This supposition seems to be confirmed by some pieces of architectural decoration, such as several panels from al-Rummaniyya, whose different technical quality places them in a production circuit unconnected to the official workshops.

10　Acién Almansa (2001, 507) has suggested the same thing for other metallic objects, "of a more standardized production," such as the bronzes of Liétor, especially oil lamps, inscribed with the name "Rasiq," which appears in other official caliphal productions such as architectural decoration and green and manganese ceramics.

11　The presence of these capitals in some official buildings as important as the Hall of ʿAbd al-Rahman III (Martínez Núñez 1995, 113) might confirm the suggestion of caliphal workshops producing objects not intended, at least in principle, for these buildings, although, for reasons we do not now know, they have ended as part of them; Cressier (2010, 70) suggests, furthermore, that these capitals could also have circulated as gifts through diplomatic exchanges.

12　Diverse opinions have been posited for these sources, depending on the viewpoint of the authors and the type of material production. For instance, Hillenbrand (2005) emphasizes Eastern and Umayyad influences, whereas Ewert (1995) and Martínez Núñez (2001) highlight the Abbasid ones.

13　Among others, two books that include several interpretations on this subject are that by Lucilia De Lachenal (1995) and that edited by Thomas Schattner and Fernando Valdés Fernández (2010).

14　It is worthwhile mentioning the sarcophagus decorated with the Meleager and Calydonian boar hunt theme, and the other one of the deceased at the Gates of Hades, or another, on a human scale, of Musas and philosophers.

15　The work has been partially preserved through a Portuguese translation made by a Muslim called Muhammad and the priest Gil Pérez at an unfixed time somewhere around the thirteenth or opening years of the fourteenth century. The Spanish version appears in *Cronica del Moro Rasis*; a critical edition by D. Catalan and Mª Soledad de Andrés was published in 1975.

16　This idea of incorporating elements from previous cultures and making clear the superiority of Islamic culture is reflected in the authors of the epoch. To give just one example, al-Maqqari (1840, 241–42) cites the statement, transmitted by the tenth-century chroniclers, that the hydraulic works associated with the aqueduct built by the caliph ʿAbd al-Rahman III to supply its palatial estate of al-Naura, and probably also Madinat al-Zahra, were of such great importance, monumental character, solidity, and magnitude that they stood out over the great buildings made by ancient kings.

p. 122: detail of the constellation of Orion as seen in the sky, from a copy of ʿAbd al-Rahman al-Sufi's *Book of Constellations* made in Baghdad in 1125. MIA, Doha (MS.2.1998, folio 126b).

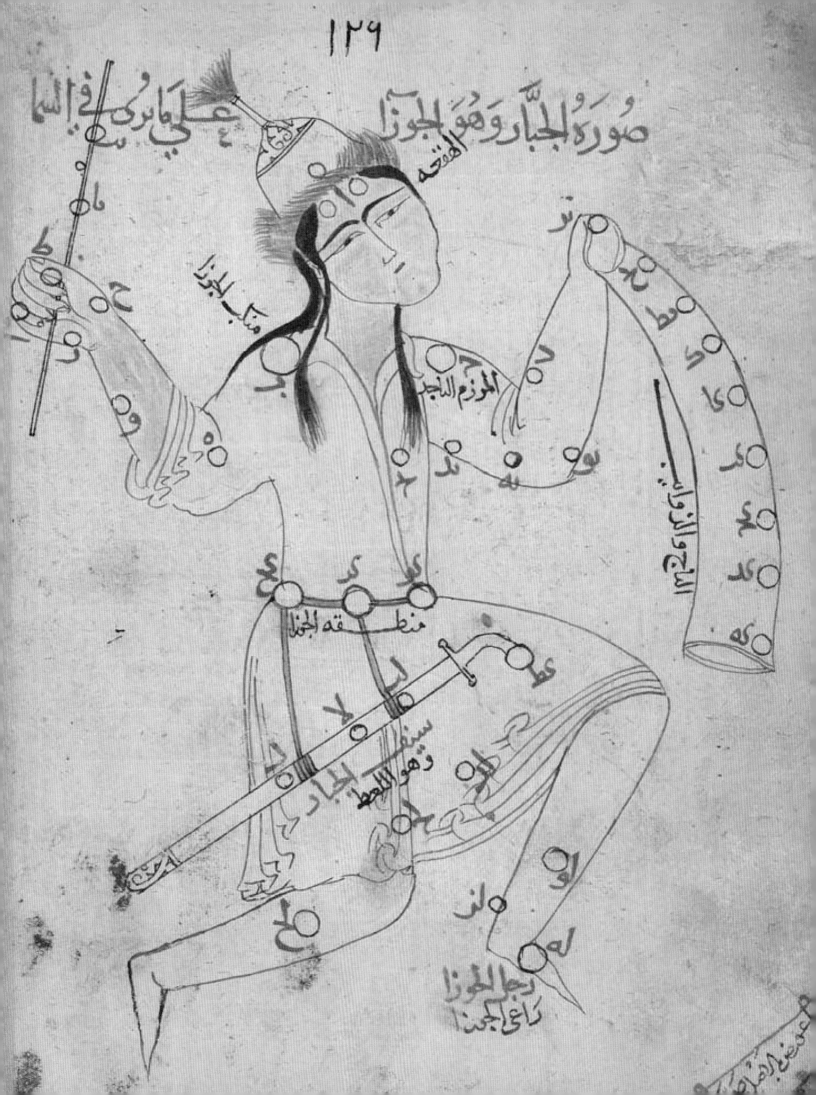

6

*The Most Authoritative Copy of
ʿAbd al-Rahman al-Sufi's Tenth-century
Guide to the Constellations*

اوقف نسخة لكتاب صور الكواكب لعبدالرحمن الصوفي

Emilie Savage-Smith

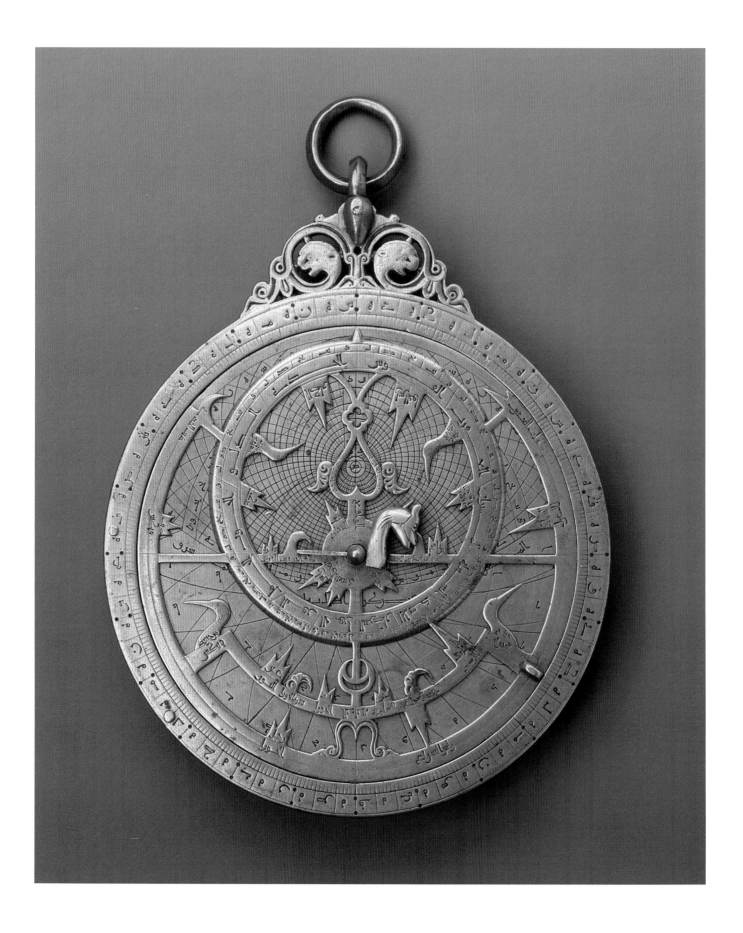

Nearly nine hundred years ago, a scholar working in Baghdad completed transcribing and annotating one of the most remarkable Arabic medieval scientific manuscripts preserved today. The result of his work now resides in the Museum of Islamic Art (MIA) in Doha as MS.2.1998.

The scholar was named ʿAli ibn ʿAbd al-Jalil ibn ʿAli ibn Muhammad, and he spent three months of 1125 (519 AH) working in Baghdad on this manuscript. He specifically states that he wrote out this manuscript "for his own use," and so he may not have been a professional copyist – though his handwriting is very good and pleasing. Because he prepared it "for his own use," he must have been particularly interested in astronomy and the constellations of stars visible in the heavens. It is also evident that he was intent upon producing the most authoritative version possible of the treatise he was transcribing.

The treatise he was copying so carefully was the most important treatise on constellation iconography to be produced in the Islamic world – and one that later was to have great influence in Latin Europe (Kunitzsch 1986; *Encyclopaedia of Islam / 3*: "ʿAbd al-Rahman al-Sufi"; *Encyclopaedia Iranica*: "ʿAbd al-Rahman b. ʿOmar Sufi"). Its title is simply the *Book of the Constellations of the Stars* (*Kitab suwar al-kawakib*). It was composed 160 years before our copyist was at work, and it was written not in Baghdad but rather in Shiraz.

The author was Abu'l-Husayn ʿAbd al-Rahman ibn ʿUmar al-Sufi – today usually referred to just as ʿAbd al-Rahman al-Sufi or simply as al-Sufi. He was an important astronomer in Shiraz at the Buyid court of ʿAdud al-Dawla (r.949–83). The book was designed to be accurate for the year 964 (353 AH) and he presumably wrote it shortly before that year. Since al-Sufi was eighty-three years old when he died in 986, it is evident that he composed this treatise somewhat late in his life, in his early sixties.[1] We also have preserved today four additional astronomical treatises by him: three on the astrolabe and one on the celestial globe.

His first treatise on the astrolabe was written for an unspecified patron while al-Sufi was still in the town of his birth, Rayy – today a few ruins incorporated into the suburbs of Tehran, but in the ninth and tenth centuries an extremely important center of learning, with much exchange of scholars with Baghdad to the west. The astrolabe (pl. 116) was made in 984 (374 AH) by a slightly younger contemporary of al-Sufi, al-Khujandi (d. *circa* 1000), who worked under the patronage of the Buyid ruler Fakhr al-Dawla at an observatory in Rayy (Allan 2002, 22–25).

All astrolabes have ten to twenty, sometimes more, major stars indicated on them. In al-Sufi's first treatise on the astrolabe the stars described as useful for placement on an astrolabe reflect the early Arabic system of star naming and not the Greek/Ptolemaic system.[2] This suggests that at this time (while he was still in Rayy) al-Sufi was not yet well acquainted with the *Almagest* written by the famous Alexandrian astronomer Ptolemy (d. *circa* 168). The *Almagest*, originally in Greek, was translated into Arabic in the early ninth century and became the major source for mathematical astronomy, as well as the source of the classical Greek system of stellar constellations (such as Orion, Cassiopeia, or Ursa Minor with the pole star in its tail) so familiar to all of us today.

116 (*facing page*) Planispheric astrolabe (diam. 15 cm), made by Hamid ibn al-Khidr al-Khujandi, Rayy or Baghdad, 984–85. MIA, Doha (SI.5.1999).

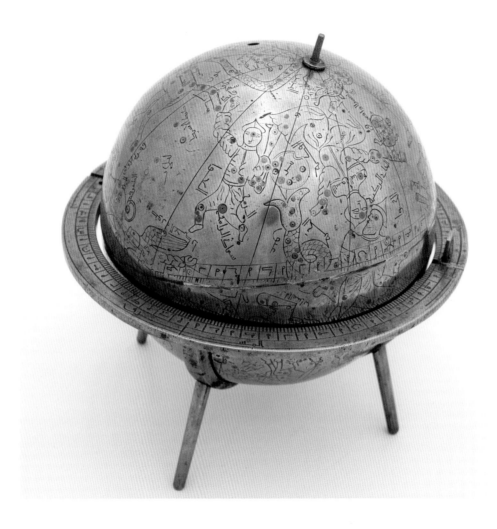

However, during the time between al-Sufi's composing in Rayy his first treatise on
the astrolabe and 964, when he was in Shiraz under the patronage of 'Adud al-Dawla,
al-Sufi had become very familiar with the *Almagest* – so much so that he could present
in the *Book of the Constellations* a description of the constellations that combines Greek/
Ptolemaic traditions with Arabic/Bedouin ones. Later, after the *Book of the Constellations*
was completed (before 964), al-Sufi prepared for 'Adud al-Dawla a completely revised
treatise on the design and use of the astrolabe (Vafea 2006, 44–53). Later yet, al-Sufi
composed a third, concise treatise on the astrolabe for a son of 'Adud al-Dawla named
Abu'l-Fawaris Shirzil (Vafea 2006, 157–231).

Finally, when he was nearly eighty years old, al-Sufi wrote a treatise on the celestial
globe, which he dedicated to a son of 'Adud al-Dawla, who, after the death of his
father, had become ruler of Kirman as well as Iraq (Vafea 2006, 2–3). Thus we see a
career curve that shows remarkable activity late in his working life, from his early sixties
to his early eighties.

The celestial globe played a fundamental role in the production of the *Book of the
Constellations*, so we need to pause to consider what such a globe looked like at this
time. Regrettably, we have no globe preserved today that was made before the time
of al-Sufi, although we know that they were produced as early as the ninth century
in Baghdad. The earliest preserved globe was made in Spain, in Valencia, in 1080 or
1085, some hundred years after al-Sufi died.[3] It has rather rubbery human figures, none
of them clothed, and the iconography bears little resemblance to the illustrations in

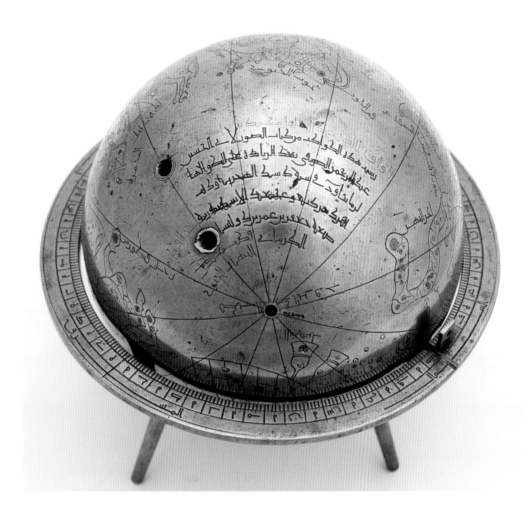

al-Sufi's treatise, except that all forty-eight of the classical Greek constellations are illustrated on the globe, just as in al-Sufi's treatise, with the stars indicated by circles.

There is a more obvious similarity between the images in the MIA manuscript and those on later celestial globes. The globe made in Kirman (not far from Shiraz) in 1362 (pl. 117; Savage-Smith 1985, 32, 221–22), besides having the instrument-maker's name and date, also has an engraved inscription (pl. 118), stating "The stars were placed (*rusimat*) according to the *Book of Constellations* by Abu'l-Husayn ʿAbd al-Rahman al-Sufi, after increasing their longitudes by 6 degrees 3 minutes to our time in the year 764 AH [1362], [which is also] 732 in the Yazdigird calendar and 1674 of the Alexandrian era."

This inscription is interesting for two reasons: it shows that al-Sufi's treatise provided the coordinates of latitude and longitude for later instrument-makers when placing their stars on a globe; and it brings up the matter of the *Book of Constellations* being "accurate for the year 964 (353 AH)."

Now you might think that star positions would not change, but indeed they do (that is, their longitudes change, not their latitudes), and this is because of the precession of the equinoxes. The Earth's axis wobbles as the Earth spins, just as a spinning top wobbles, and this produces precession (Pasachoff 2000, 488–89). This means that at the spring and autumn equinoxes the stars that are visible near the horizon just before the sun rises will appear to move over time – even within one lifetime, if a person lives to be about seventy years old. The longitudes of the stars will shift slightly; al-Sufi

stated that they shifted westward one degree every sixty-six years, while others took a value of one degree every seventy years. This shift, or precession, has great significance over time. Ultimately, about 13,000 years from now, Polaris will no longer be the Pole Star indicating North, but rather Vega will be the brightest star close to the North Pole. In more practical terms today, it means that for every astronomical instrument on which you have stars indicated as well as the ecliptic (the apparent path of the sun), after seventy years the instrument will be out of date, or inaccurate by one degree for stars near the ecliptic. In other words, all the astrolabes and globes that we see in museums today are out of date and would not function properly if you tried to use them now. This need for updating every seventy years or so may account for why there are so many astrolabes and globes preserved today. Because of this precession, or shifting, al-Sufi was able to adjust his longitudes of stars so that they were precisely correct for only one year − that is, 964.[4]

While al-Sufi did not write a treatise on the celestial globe until he was eighty years old, he did employ celestial globes in the design of his *Book of the Constellations* some twenty years earlier. There is one account that associates al-Sufi with the actual making of a celestial globe. The historian Ibn al-Qifti (d. 1248) records that in the year 1043 an Egyptian instrument-maker by the name of Ibn al-Sunbudi saw "in a library in Cairo a globe made of silver, executed by (*min ʿamal*) Abu'l-Husayn al-Sufi for the ruler ʿAdud al-Dawla, whose weight was 3,000 dirhams and whose price was consequently 3,000 dinars" (Ibn al-Qifti 1903, 440). In our historical sources, however, al-Sufi is never referred to as *al-asturlabi* (the astrolabe-maker), which was the common designation for all astronomical instrument-makers, no matter what type of instrument they made. For that reason, and because there is no corroborating evidence for this account given by Ibn al-Qifti, I am inclined to think that Ibn al-Qifti's informant confused the manufacture of a celestial globe with the reliance of a maker on al-Sufi's treatise for the coordinates and images, as stated in inscriptions similar to the one on the globe (pls. 117 and 118). This type of statement, citing al-Sufi's *Book of Constellations* as a source, is found frequently on globes of the thirteenth and fourteenth centuries preserved today (Savage-Smith 1985, 27, 31−32, 86−87; Maddison and Savage-Smith 1997, 1:123−24, 2:420).

In addition to authoring treatises on stars, astrolabes, and globes, al-Sufi was an observational astronomer, often employing instruments that were much larger than an astrolabe or globe in order to have greater precision. For example, he was well known for having made observations that enabled him to determine more accurately the obliquity of the ecliptic (Sayılı 1960, 104−07; Vafea 2006, 3). Most famously today, ʿAbd al-Rahman al-Sufi is credited with the "discovery" of the Andromeda Nebula, more accurately termed the Andromeda Galaxy (Kunitzsch 1987). It would be more precise, however, to say that he is the first to mention the Galaxy in a written treatise. In the *Book of the Constellations*, in the context of a discussion of the Bedouin constellations overlapping the area occupied by the Ptolemaic constellation of Andromeda, al-Sufi clearly described the Andromeda Galaxy (M31), which he said was "a cloudy blotch (*latkha sahabiya*) situated very close to the fourteenth star [ν *Andromedae* in modern

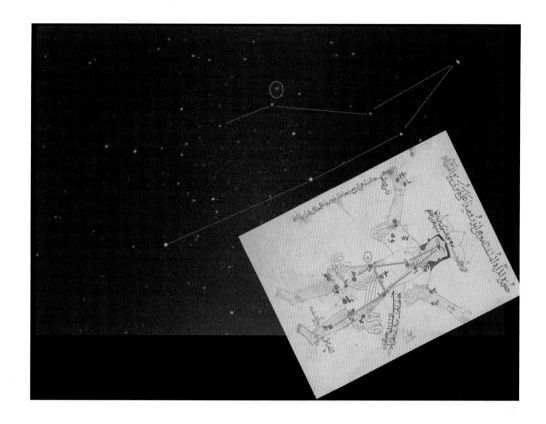

119 Area of sky including the constellation of Andromeda and the Andromeda Galaxy (circled); lower right shows the diagram of Andromeda from a copy of ʿAbd al-Rahman al-Sufi's *Book of Constellations* made in Baghdad in 1125 by ʿAli ibn ʿAbd al-Jalil ibn ʿAli ibn Muhammad; in both, the corresponding major stars have been connected by colored lines. MIA, Doha (MS.2.1998, folio 63a).

120 (*p. 130*) Constellation of Orion as seen on a globe, from a copy of ʿAbd al-Rahman al-Sufi's *Book of Constellations* made in Baghdad in 1125 by ʿAli ibn ʿAbd al-Jalil ibn ʿAli ibn Muhammad for his own use. MIA, Doha (MS.2.1998, folio 126a).

121 (*p. 131*) Constellation of Orion as seen in the sky, from a copy of ʿAbd al-Rahman al-Sufi's *Book of Constellations* made in Baghdad in 1125. MIA, Doha (MS.2.1998, folio 126b).

nomenclature], located at her right side" (ʿAbd al-Rahman al-Sufi 1954, 128). Although the Andromeda Galaxy is approximately 2.5 million light-years away, it is visible to the naked eye on moonless nights, even when viewed from areas of moderate light pollution. Plate 119 shows the area of the sky occupied by Andromeda much as seen with the naked eye, with the major stars forming the constellation connected by red lines, and the Galaxy circled in red. In the MIA manuscript the constellation of Andromeda is shown in the lower right corner, with the corresponding major stars connected by blue-green lines.[5]

It is evident from his description that it was actually the Bedouins who first observed the Andromeda Galaxy, and not al-Sufi himself. Professor Paul Kunitzsch has argued that in one copy of al-Sufi's treatise, now in the Bodleian Library in Oxford, the Galaxy is indicated on the nose of the larger of two superimposed fishes visualized by the Bedouins as lying across the Ptolemaic figure of Andromeda.[6] This particular illustration of Andromeda overlaid with the Bedouin images of fishes is not found in the MIA manuscript, although in the middle of the discussion of Bedouin images for this particular area of the sky, the copyist has made the annotation (probably added later) to the bottom of folio 64a: "Here is her picture with a fish arising from her two legs." In the MIA copy, on the Ptolemaic figure of Andromeda as seen in the sky there is – in the correct location – a small red splotch (encircled in blue-green in pl. 119), but it may simply be an accidental offset of ink from the facing page.

We must remember that all observations of the sky at this time were made by the naked eye. There were no telescopes or lenses available. From the end of the ninth or beginning of the tenth century, Islamic astronomers did occasionally use "observation tubes," particularly to view the new crescent moon on the horizon (Morelon 1996, 9–10). These were, however, tubes *without* lenses – they were simply a means of eliminating light interference.

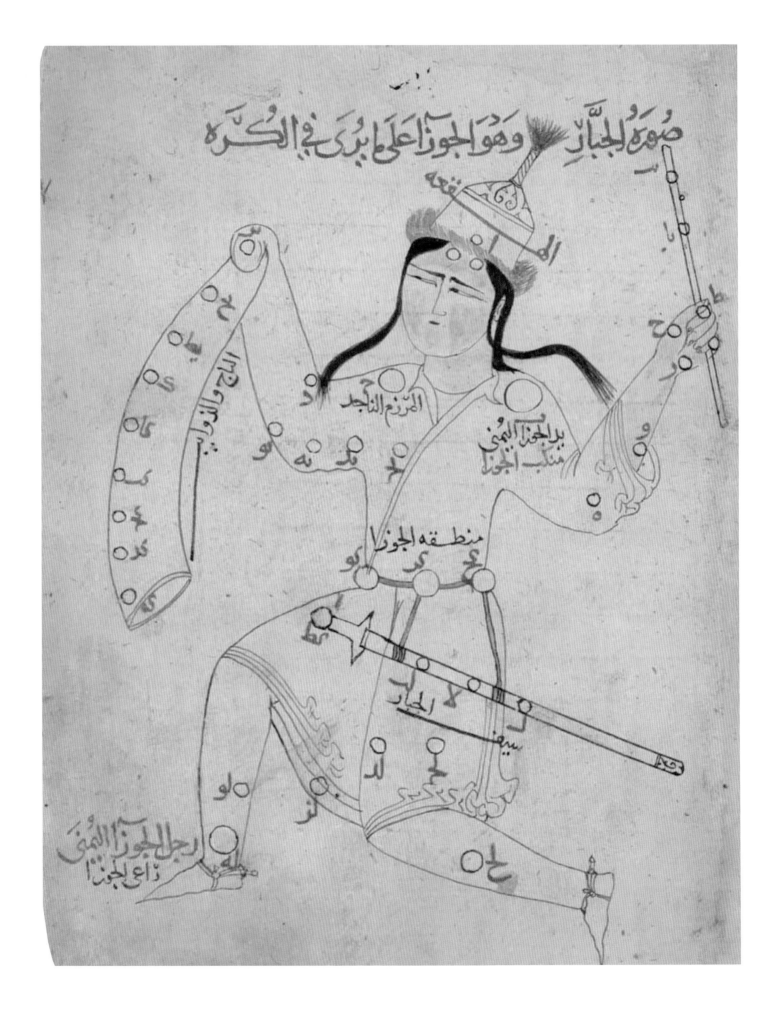

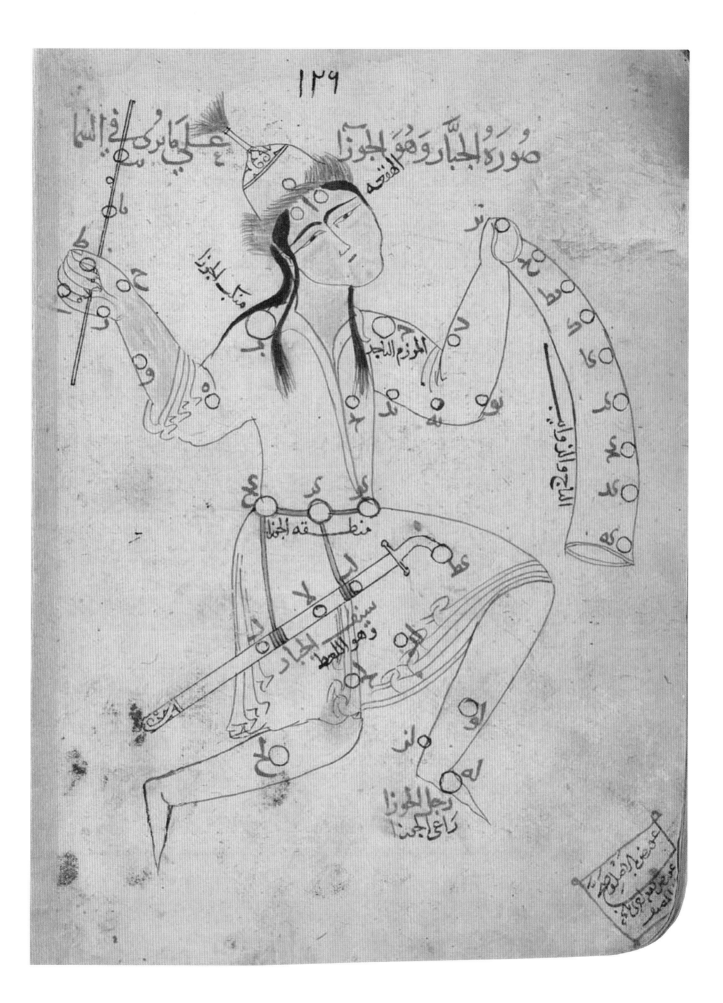

Note that to get proper alignment, the diagram of Andromeda (pl. 119) had to be tilted. This serves as a convenient reminder that the diagrams in al-Sufi's treatise were not oriented by the points of the compass. The stars comprising Andromeda, for example, can never be seen in the skies in a vertical, upright position, but this is not indicated in the manuscript diagrams (see pls. 132 and 133), where all human figures are depicted upright. In all early copies of the treatise, even the *names* of directions of the compass are omitted. In addition, the diagrams were not plotted, though I have noticed a tendency in recent discussions by art historians to speak of the plotted constellation diagrams (for example, Brend 1994). There is no grid or point of reference from which they could be plotted. In other words, the diagrams are not "scientific" diagrams in any measured or quantitative sense.

But let us look further at the contents of this remarkable treatise, as it is preserved in the MIA copy (MS.2.1998), comprising 179 folios.[7] The treatise opens with a long introduction in which al-Sufi dedicates the work to his patron in Shiraz, ʿAdud al-Dawla, and then goes on to explain the sources he used in preparing the book.

Following the introduction, all forty-eight classical constellations are discussed individually. Each constellation chapter has four sections. As an example, I will take the chapter for one of the most familiar of all constellations – Orion. It opens (fol. 123a) with a rubricated title *kawkabat al-jabbar wa-huwa al-jawzaʾ* (the constellation of the giant, also known as *al-jawzaʾ*). *Al-jawzaʾ* was the Bedouin name for an even larger giant (possibly feminine) that overlapped with the area of Orion and Gemini. Following the title, this section begins with a verbal description of the constellation and its stars (in this case thirty-eight) as presented by Ptolemy in the *Almagest*, often criticizing Ptolemy for overlooking certain stars. In classical antiquity, the constellation outlines were based on Greek mythological figures (Orion the hunter, in this instance), but al-Sufi does not attempt to recount the myths that gave rise to the original iconography. Al-Sufi describes Orion (fol. 123a, lines 3–5) as looking like "a man having a head, two arms, and two legs . . . with a stick (ʿasan) in his hand and a sword at his middle." Throughout this portion of the constellation chapter, the major stars are assigned numbers and described in terms of the general form of the constellation figure. Occasionally, distances between stars are given as multiples of a *dhiraʿ* (forearm), which is a unit of angular distance approximately equivalent to the breadth of a thumb when it is held up at arm's length against the sky and defined by al-Sufi as 2 degrees 20 minutes (Kunitzsch 1961, 118, no. 322a).

The second section presents a description of the same area of the sky, but in terms of the indigenous Arabic constellations and star-groups recognized by Bedouins. In this section, the positions of the Bedouin stars are given in terms of their distances in *dhiraʿ* from Ptolemaic stars. In the ninth century (a century before al-Sufi worked), a number of early lexicographers and grammarians had recorded the pre-Islamic Arabic poetry and rhymed proverbs that reflected the earlier Bedouin tradition of delineating the skies. In his introduction, al-Sufi provided us with the names of three such authors whose treatises he employed for his knowledge of pre-Islamic Bedouin constellation

imagery: Ibn Kunasa (d. *circa* 823), Ibn al-ʿArabi (d. *circa* 846), and Abu Hanifa al-Dinawari (d.895 or 902).

All three treatises are now lost. For that reason, al-Sufi's own *Book of the Constellations of the Stars* becomes an important source of information on this topic. The sections on Bedouin constellations are not illustrated, with the exception of the chapter on Andromeda, which in the MIA copy has an illustration of three Bedouin constellations – a camel, a horse, and a fish – that were imagined to be near Andromeda. More will be said of this shortly.

The third section of each constellation chapter presents two drawings of the Greek/Ptolemaic constellation: one as seen on a globe, one as seen in sky. The globe view (pl. 120) presents an external view as if looking from outside the sphere of stars, while the other view (pl. 121) presents it viewed as if standing on earth and looking up at the underside of the sphere of stars. The result is that the figures are reversed left to right (or east to west). The basic outlines of the Greek mythological figures were maintained, though sometimes with substantial changes. For example, Orion in Greek mythology was a hunter carrying a lion's skin over his arm. In all Islamic depictions, including this one, he is seen with an elongated sleeve rather than an animal skin.

The two illustrations of Orion (pls. 120 and 121) are a reminder that the majority of so-called "modern" star names are actually Latinised Arabic star names. The star on his left shoulder, for example, is α *Orionis*, the tenth-brightest star in the sky, whose "modern" name Betelgeuse derives from the Arabic *yad al-jawzaʾ* (arm of the giant), while the star on his right front foot, the seventh-brightest star in the sky (β *Orionis*), is called Rigel, from the Arabic for foot (*rijl*). The rightmost of the three stars forming Orion's belt, δ *Orionis*, takes it name Mintaku from the Arabic for the entire belt, *mintaqat al-jawzaʾ* (the belt of the giant). The great Nebula of Orion (M42) does not seem to have been recorded at the time.

Ptolemy's *Almagest* had no constellation illustrations, and therefore could not have served as a source for these portions of the treatise. In his introduction, however, al-Sufi gives us some clues as to his sources. He speaks of having seen an illustrated book on constellations in the handwriting of ʿUtarid ibn Muhammad al-Hasib, a ninth-century astronomer and mathematician; the book is regrettably lost today.[8] Al-Sufi also reports having seen a number of celestial globes made by instrument-makers in Harran (between the northern reaches of the Euphrates and Tigris rivers), as well as a particularly large globe made by ʿAli ibn ʿIsa, an important instrument-maker working in Baghdad in the early ninth century.[9] None of these early globes or books on constellations is known to have survived, so we cannot evaluate al-Sufi's work in terms of the specific sources he employed.

We do, however, have an important clue as to his working method. According to the eleventh-century polymath Abu'l-Rayhan al-Biruni (d.1048), al-Sufi had told the astronomer Abu Saʿid Ahmad al-Sijzi, who was working in Shiraz at the same time, that he (al-Sufi) "had placed thin paper (*al-kaghidh al-raqiq*) on the sphere [of a celestial globe] and wrapped it around its surface until it conformed very neatly (*muhandaman*) to its surface area. Then on top of it, he drew the constellations (*suwar*) and indicated

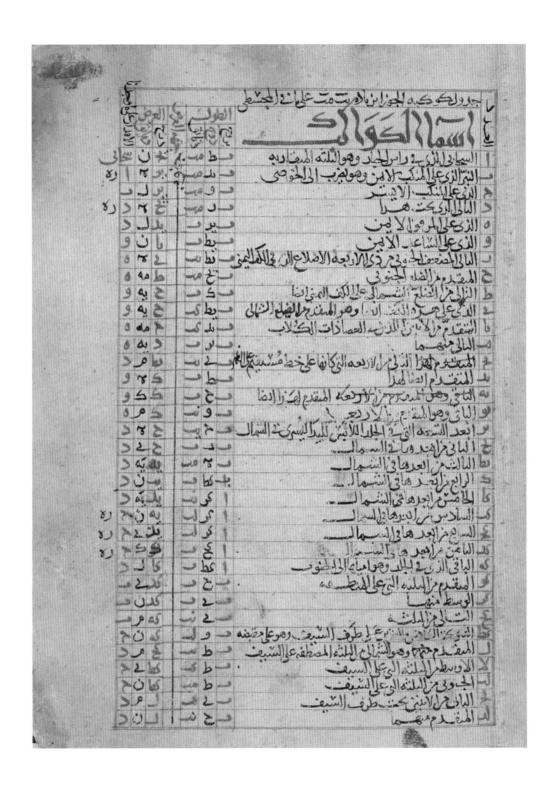

122 Star catalogue for Orion, showing the entries for the first 34 of 38 stars forming the constellation, from a copy of 'Abd al-Rahman al-Sufi's *Book of Constellations* made in Baghdad in 1125.

the stars with dots in accordance with the way they appeared through the transparency (*bi'l-shaffaf*)."[10] What globe this might have been, of course, we do not know.

What we know with certainty was that al-Sufi intended his treatise on the constellations to be of use to owners of celestial globes. For why else would he have included, for each and every constellation, a picture of how it looked on a celestial globe? The globe view, moreover, always precedes the sky view for all forty-eight constellations.

The fourth and final section in each constellation chapter reproduces the star list for that constellation given by Ptolemy in the *Almagest*, but with certain important modifications (pl. 122). Each star is numbered within the constellation and said to have

a specified position within the constellation ("on the left leg," "on the right side," etc.), all of which is derived from the *Almagest*. In the case of the entry for Orion, al-Sufi adheres strictly to the *Almagest* when describing the stars on the long sleeve, stating that the nine stars are "in the skin (*al-jild*) worn on the left arm," even though in the descriptive portion of the chapter al-Sufi had said they were on an elongated sleeve (*al-kumm*). Coordinates are then given for each star in terms of degrees and minutes of degrees. The first three columns to the left of the descriptive statement provide the longitudes, which al-Sufi took from the *Almagest* but increased by 12 degrees 42 minutes to correspond to al-Sufi's epoch of the beginning of the year 1276 of the era of Alexander (1 October 964). The next two columns give the latitudes, for the most part those of Ptolemy. Finally, the far-most left-hand column provides the magnitudes, ranging from 1 to 6 (1 being the brightest). Al-Sufi re-observed the magnitudes himself and made substantial changes from Ptolemy's list (Kunitzsch 1986, 57).

In order to appreciate fully the importance of this particular copy now in the MIA, it is necessary to examine fully the colophon of the manuscript – that is, the statement at the end of the treatise where the copyist states when and under what circumstances he made the copy. It is an unusually long and involved colophon, and to go through it line by line may be a bit tedious, but I think we must do just that. Three distinguished scholars – Barbara Brend, Robert Hillenbrand, and David King – prepared a translation of the colophon as part of their extensive sale catalogue entry (Sotheby's 1998, 33–48, lot 34), and we are all indebted to their fine work. There are places, however, where I read the text slightly differently.[11]

The colophon begins at the bottom of folio 161a (pl. 123 and Appendix), beneath the star catalogue for the final constellation, the Southern Fish (Piscis Austrinus), with the copyist speaking in the first person:

> The end of the *Book of Stars*,
> written by Abu'l-Husayn ʿAbd al-Rahman ibn ʿUmar ibn
> Muhammad al-Sufi al-Razi [that is, from Rayy].
> I copied this book from a copy that belonged to the *wazir* Qiwam al-Din [ibn]
> Nizam al-Mulk Abu ʿAli al-Hasan ibn ʿAli ibn Ishaq,[12] which he endowed as
> a *waqf*, for its everlasting preservation, to the library [*dar al-kutub*] that
> he had built in his *madrasa* in the eastern quarter

[the colophon continues overleaf on folio 161b (pl. 124), with a reference to the famous Nizamiya Madrasa built by Nizam al-Mulk in Baghdad in 1067]

> of Baghdad. ☉
> And it [that copy] was in the handwriting of Hibat Allah ibn Bishr al-Shamʿi. Its

date was Jumada I 427 H [March 1036]. Hibat Allah had said that he copied it
from a copy by Faraj ibn 'Abd Allah al-Habashi the astronomer (*al-munajjim*), a
protégé (*mawla*) and pupil of Abu'l-Husayn al-Sufi, the author of this book. And
[Hibat Allah also said] that Faraj read that copy of his to his teacher [al-Sufi] and
had gotten his signature [testifying] to its accuracy. ⊙ I transcribed this book,
copying precisely Hibat Allah ibn Bishr and imitating his method of working (*fi'l*)
in regard to the transcription (*naskh*), the drawings (*suwar*), and the illustration
(*tabyin*) of the positions of the stars. The copying of this book was done during
the beginning [*mustahall*] of Muharram of the year 519 [*circa* 7 February 1125],
and 'Ali ibn 'Abd al-Jalil ibn 'Ali ibn Muhammad copied it for his own use [*li-
nafsihi*] in Baghdad.

Praise be to God, and blessings and peace be upon our lord Muhammad
and his pure family.

As if that is not enough, the copyist then continues on the same page with eight more lines of information, writing in a hand that has slightly more ligatures (pl. 124, lower half):

> I compared this book from its beginning to end, during the month of Safar of the year mentioned earlier [March 1125], with the copy that was made for the treasury of al-Malik ʿAdud al-Dawla Abu Shujaʿ Fana-Khusraw ibn Rukn al-Dawla, may God be pleased with him, and it was a copy in an upright? (*mujallas*) script derived from Kufic, and all of the corrections and additions which were in it were in the handwriting of Abu'l-Husayn al-Sufi, the author of this book, and all the drawings (*suwar*) were the work of (*sanʿa*) Abu'l-Husayn al-Sufi in his own hand.
>
> And this copy moved about amongst the treasuries of the rulers of the Banu Buway [the Buyids] until it reached al-Sahliya, head housekeeper (*qahramana*) of the Prince of Believers [the caliph] al-Qaʾim bi-Amr Allah (d.1075),[13] and he [the caliph] bequeathed it as a *waqf*. ⊙
>
> I have confirmed the transmission [of the text; *al-riwaya*][14] and corrected this copy with utmost diligence. I improved its illustrations as much as it was possible to do so in their given position, but when this was not possible, I drew it by itself on leaves of paper which I added to the book after the poem. And in the production of the illustrations (*suwar*) I took as a model the workmanship (*sanʿa*) and draftsmanship (*rasm*) of al-Sufi. [Only] in God is there success.

From this colophon we learn that our copyist employed two copies (or what are called "exemplars") to create his own copy – one used in February and another in March of 1125. We also learn that the second copy, the one that had been made for al-Sufi's patron ʿAdud al-Dawla, had been owned by various Buyid rulers in Iraq until it finally came into the hands of a woman named al-Sahliya who held the position of *qahramana* (manageress of the women's quarters) at the court of the caliph al-Qáʾim bi-Amr Allah.

Notice also that the copyist mentioned that he added leaves of paper "after the poem." The poem immediately follows the colophon given above. The relatively short didactic poem on the stars was written by al-Sufi's son, as is evident from the title page for the poem (pl. 125), and the MIA manuscript contains the earliest preserved copy of it (Carey 2009). However, at the end of the poem there are no extra leaves of paper with drawings on them, but rather there is yet another colophon written by our copyist (pl. 126), in which the copyist again speaks in the first person:

> I desired to make clear in this poem all the types of illustrations (*ashkal al-suwar*), in keeping with what I recorded, in a number of places at its [the poem's?] beginning.[15] For when I encountered personally (*bi-yaday*) the book of illustrations that the author had composed in his own hand, and I had copied the illustration (*al-sura*), following carefully (*bi-muqtaʿa*) his work, onto the leaves added later, each illustration (*sura*) of the constellations in this book had four forms (*ashkal*). But I omitted illustrating (*tabyin*) that in this poem because the same form was often repeated. ⊙

125 Title page for the didactic poem, reading "This is a poem that the son of Abu'l-Husayn al-Sufi composed (*qala*), in which he versified what his father had written in prose in order to facilitate the memorization for whoever wishes," from a copy of ʿAbd al-Rahman al-Sufi's *Book of Constellations* made in Baghdad in 1125. MIA, Doha (MS.2.1998, folio 162a).

126 (*below*) Final colophon by the copyist, written at the end of the didactic poem, from a copy of ʿAbd al-Rahman al-Sufi's *Book of Constellations* made in Baghdad in 1125. MIA, Doha (MS.2.1998, folio 179a).

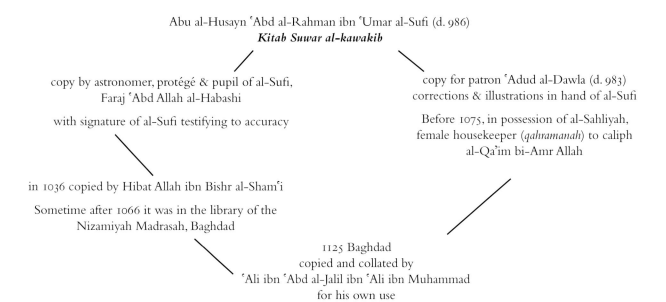

Abu al-Husayn ʿAbd al-Rahman ibn ʿUmar al-Sufi (d. 986)
Kitab Suwar al-kawakib

copy by astronomer, protégé & pupil of al-Sufi,
Faraj ʿAbd Allah al-Habashi

with signature of al-Sufi testifying to accuracy

copy for patron ʿAdud al-Dawla (d. 983)
corrections & illustrations in hand of al-Sufi

Before 1075, in possession of al-Sahliyah,
female housekeeper (*qahramanah*) to caliph
al-Qaʾim bi-Amr Allah

in 1036 copied by Hibat Allah ibn Bishr al-Shamʿi

Sometime after 1066 it was in the library of the
Nizamiyah Madrasah, Baghdad

1125 Baghdad
copied and collated by
ʿAli ibn ʿAbd al-Jalil ibn ʿAli ibn Muhammad
for his own use

127 Diagram illustrating the relationships between the exemplars used by the copyist of a manuscript copy of ʿAbd al-Rahman al-Sufi's *Book of Constellations* made in Baghdad in 1125.

The copyist appears to be saying that because each constellation is shown twice (once as on a globe and once as seen in the sky), and each constellation is discussed first in the prose treatise by al-Sufi and then again in the short didactic poem by his son, this resulted in his having four drawings for each constellation. However, since the illustrations in the poem would for the most part simply repeat those in the earlier prose treatise, he decided to omit the illustrations in the poem. As will be seen, however, he did in fact include illustrations for the first four constellations, at which point he presumably grew a bit tired. That his exemplar from which he was copying had illustrations in the poem is made clear from the sentence that follows, in which he states that he copied the label or legend "illustration of . . . (*surat . . .*)" at the point where there was an illustration for each constellation, though, as indicated above, he omitted the illustration itself:

> The placement of the illustration in this poem is under the legend at the end of each *fasl*. The illustration (*sura*) of a given constellation [here a mark in the text inserts a now nearly illegible marginal comment] . . . after the illustration (*sura*) there is written the discussion of the next constellation in accordance with what was done at the beginning of the poem. And God it is who bestows success. ⊙ The completion of the copying of this poem was during the month of Rabiʿ I . . . [? of the same year, April 1125].

Putting together all this information, we come up with the following relationship betwewen the various copies or exemplars employed by our copyist (pl. 127). It is evident that al-Sufi had direct influence on the accuracy of both exemplars (neither of which are preserved today). The exemplar our copyist used in February of 1125 was from the collection in the famous Nizamiya Madrasa library in Baghdad, and it had been copied in 1036. That, in turn, had been copied from an earlier copy made by a protégé and pupil of Sufi. That pupil, al-Habashi, had read it to his teacher and obtained al-Sufi's signature as to its accuracy. The second exemplar that he used in March to April 1125 had been made for al-Sufi's patron ʿAdud al-Dawla (sometime before 983, when the latter died), and all the corrections and illustrations (but not the text) were in the handwriting of al-Sufi himself. You could not have a better pedigree than that for a copy of the treatise.

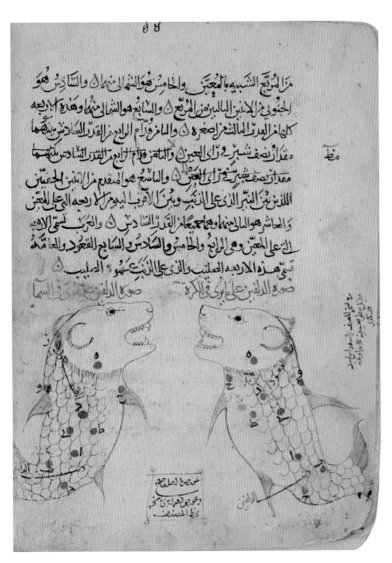

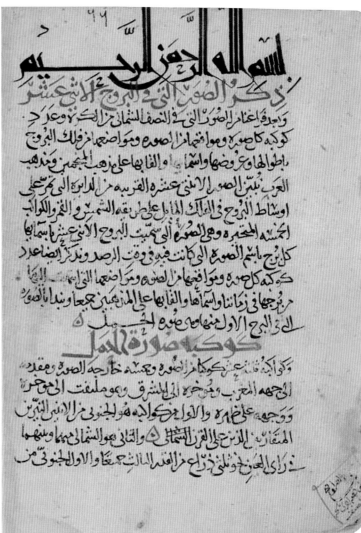

It has been suggested by the three scholars who prepared the Sotheby's sale catalogue that additions or corrections made in brown ink to the text and labels were made in February (that is, on the basis of the 1036 copy) and those in a slightly blacker ink were made in March, after finding the copy made for ʿAdud al-Dawla (Sotheby's 1998, 35). I am not convinced that this holds true consistently. There is no doubt, however, that our copyist made changes and corrections to both the text and the illustrations. But on the basis of which exemplar is anything but clear.

Furthermore, not much additional help is provided by a note that occurs periodically throughout the volume (pl. 128), which roughly translates as: "Corrected by comparison with the original and made accurate; and corrected . .[?] . . against another copy in the handwriting of the author." These are standard collation notes, placed at the end of ten-folio quires.[16] They are a means by which the copyist kept track of what he had compared and collated and what he has not. They are not to be taken to refer specifically to a nearby illustration, as Brend, Hillenbrand, and King have suggested. Rather puzzling is the fact that they are all written in the brown ink that Brend, Hillenbrand, and King assign to the earlier period of February 1125. From their contents, however, it is evident that they must have been written *after* the second copy was available. Moreover, none of these notes occur in the portion of the manuscript

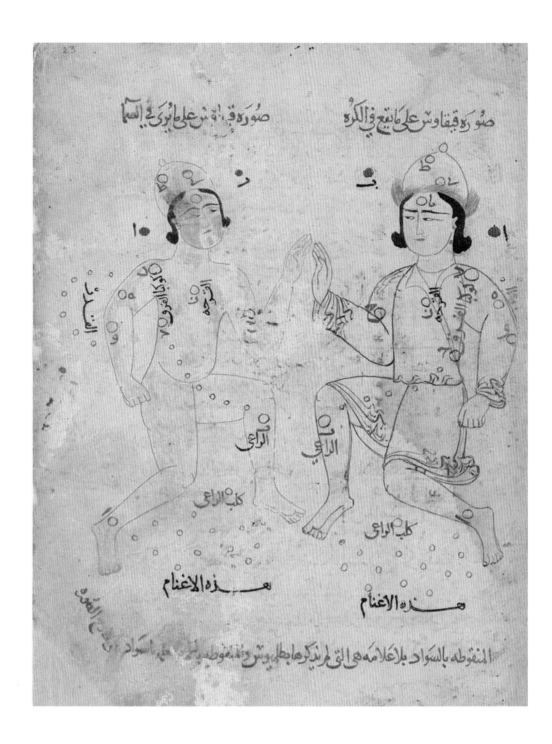

129 Constellation Cepheus, from a copy of ʿAbd al-Rahman al-Sufi's *Book of Constellations* made in Baghdad in 1125; on the right-hand side is the figure as seen on a globe, while the figure as seen in the sky is on the left-hand side. MIA, Doha (MS.2.1998, folio 23a).

that contains the poem, so we do not know if the poem was part of just one of the copies or both, and, if just one, which one. This lack of information becomes crucial when we try to explain the radically different figure of Cepheus that illustrates the poem, compared with the two figures of Cepheus that illustrate the treatise proper.

Two views of Cepheus (pl. 129) accompany the *Book of Constellations* by al-Sufi, while a single depiction of Cepheus (pl. 130) occurs in the poem written by his son. Our copyist makes no comment regarding these radically different compositions. In addition to the obvious difference in hats and clothing, the external stars between the legs of the two figures in the prose treatise (pl. 129) are not indicated on the Cepheus figure from the poem (pl. 130). These stars are labeled "These are the sheep *(al-aghnam)*" because the stars of Cepheus were traditionally viewed by Bedouins as a shepherd with

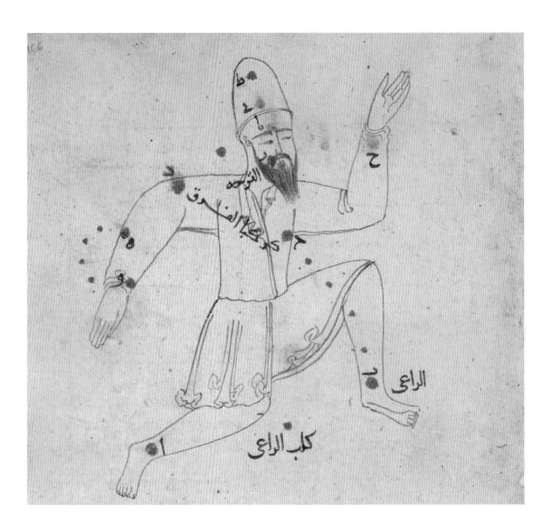

130 Constellation Cepheus in the poem written by the son of ʿAbd al-Rahman al-Sufi; only one figure is provided; it is the constellation as seen in the sky, although it is not so labeled. MIA, Doha (MS.2.1998, folio 166a).

his dog and sheep. Notice also that the two Cepheus figures illustrating the prose treatise (pl. 129) are not identical. The one on the left is drawn in red ink, unclothed, and has an ovoid helmet with no fur, while the one on the right is clothed and wears a helmet trimmed with fur. The one on the right has also been redrawn in places with a darker black ink using a stylus, perhaps suggesting revision from the second exemplar.

The northern constellation of Boötes presents a different conundrum. Only four constellations are illustrated in the poem (Ursa Major, Ursa Minor, Draco, and Cepheus, each with a single illustration, all of them a "sky view"). Therefore, for Boötes we have only one set of diagrams, those illustrating the prose treatise by the father (pl. 131). The two figures are dressed similarly, except for the headgear and hairstyles. But something is wrong here, for the star placements are the same for both figures; the globe figure should be reversed right to left, and it is not. The three-line label under the right-hand (globe) figure reads, in translation:

> This figure was in its construction incorrect because I made it exactly that way, and the reason [for doing so] is that it was reversed, with its south to the north and its north to the south, in accordance with what the author stipulated.

This statement, if I have understood it correctly, raises more questions than it answers. I think the copyist is telling us that he purposely made this figure in this way (incorrect though it is) because he was following the instructions, or illustration (which one, is not clear from the Arabic), of the author himself. Since it is written in slightly darker

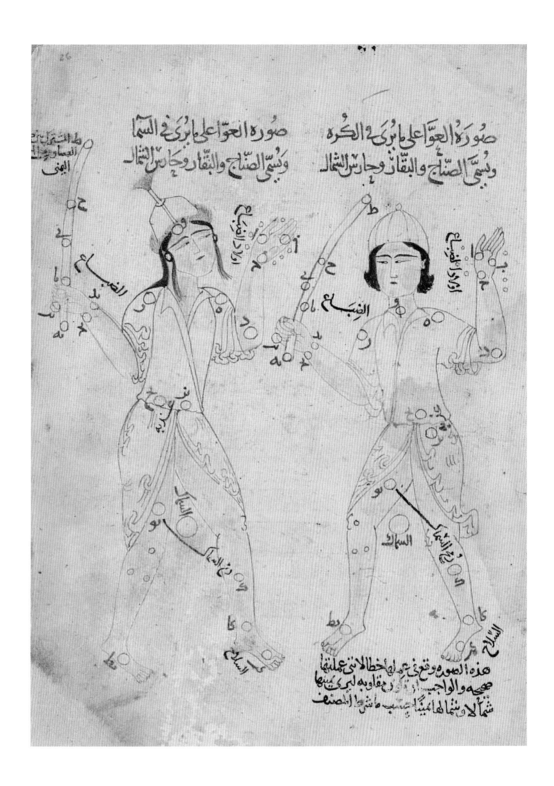

131 Constellation of Boötes, with the globe figure on the right and the sky figure on the left, from a copy of ʿAbd al-Rahman al-Sufi's *Book of Constellations* made in Baghdad in 1125. MIA, Doha (MS.2.1998, folio 26a).

ink, this would suggest – following the Brend, Hillenbrand, and King theory regarding the inks – that it was written after seeing the copy that had illustrations in al-Sufi's hand. But why would al-Sufi – or any noted astronomer – make such a basic astronomical mistake as to fail to flip or reverse the globe figure in relation to the sky figure? And if the label *was* added *after* seeing al-Sufi's autograph, then what happened to the original figure drawn before the copyist saw the autograph? Or, was it that way in *both* exemplars? Moreover, the comment about the directions is curious ("with its south to the north and its north to the south"), for it is the East–West directions that need to be reversed, not the North–South.[17]

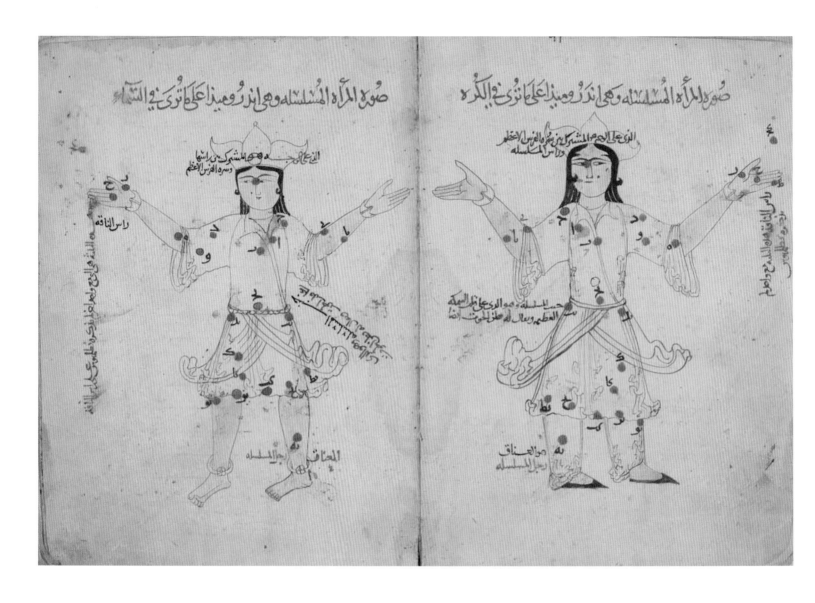

132 Constellation of Andromeda, with the globe figure on the right-hand page and the sky figure on the left, from a copy of ʿAbd al-Rahman al-Sufi's *Book of Constellations* made in Baghdad in 1125. MIA, Doha (MS.2.1998, folios 62b–63a).

133 (*facing page*) Constellation of Andromeda with three Bedouin constellations of a horse, camel, and fish, from a copy of ʿAbd al-Rahman al-Sufi's *Book of Constellations* made in Baghdad in 1125. MIA, Doha (MS.2.1998, folio 65a).

Another way in which our copyist made changes can be seen in the constellation of Andromeda (pl. 132). The two figures are fairly similar, for both wear typical three-pointed Seljuk crowns, though the globe figure wears ankle-length pantaloons and pointed black slippers, while the sky figure has bare legs and feet. Our copyist, however, went to some lengths to change the position of the feet. Initially the feet on both figures were splayed, but the right foot of the globe figure and left foot of the sky figure have been altered. It is not clear when this alteration was made, for there is no particular evidence that it was made in March after seeing the copy having drawings in al-Sufi's hand. Moreover, this alteration is of no significance in terms of the constellation design, for there are no stars in these feet. In other words, it would have no effect on the accuracy of the drawing.

The Bedouins populated the area of Andromeda with three animals: a horse, a camel, and a large fish. This copy is very rare in illustrating all three of these Bedouin images, superimposed over the classical form of Andromeda (pl. 133). This illustration is an exciting find – one that was rather overlooked in the sale catalogue. I suspect that this entire illustration, and the text on the back, may well be an addition made after seeing the second exemplar with its diagrams in al-Sufi's hand, for the quire of the manuscript has an extra folio at this point (eleven instead of ten leaves).

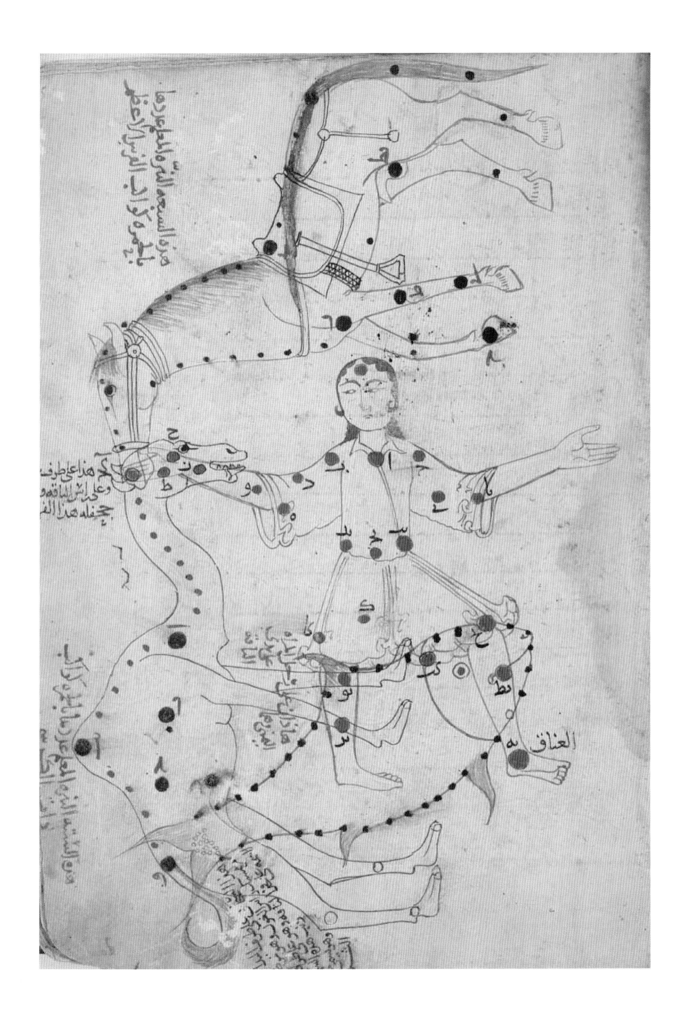

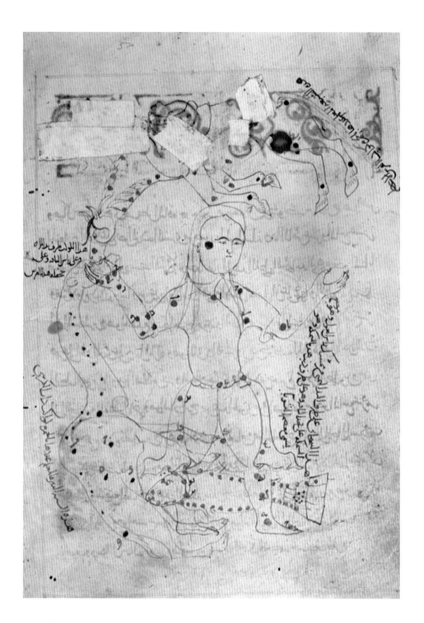

134 (*left*) Constellation of Andromeda with three Bedouin constellations of a horse, camel, and fish, from a copy of ʿAbd al-Rahman al-Sufi's *Book of Constellations* made in Mosul in 1170. Bodleian Library, University of Oxford (MS Huntington 212, folio 74b).

135 (*right*) Colophon of a copy of ʿAbd al-Raḥmān al-Sufi's *Book of Constellations* dated 400 H (= 1009–10) and signed al-Husayn ibn ʿAbd al-Rahman ibn ʿUmar ibn Muhammad. Bodleian Library, Oxford (MS Marsh 144, p. 419).

Only one other manuscript is recorded as having such an illustration (pl. 134), a manuscript now in the Bodleian, MS Huntington 212, copied in Mosul in 1170 (566 AH), forty-six years after the MIA copy.[18] This manuscript is evidently in poor condition and has been withdrawn from use. Textually, the 1170 Mosul copy appears closely related to that of the MIA copy. MS Huntington 212 also contains (on fol. 40b) an illustration of the constellation Cassiopeia overlaid with a camel, the same Bedouin camel that encroaches upon the territory of Andromeda (Wellesz 1964, 89, pl. 15; Savage-Smith 1992, 52, pl. 2.34). Unfortunately the portion of the text in the MIA copy that concerns Cassiopeia is an Ottoman replacement with only a single crude sketch of Cassiopeia made much later. It is likely, however, that the MIA manuscript did at one time include a comparable diagram of Cassiopeia with a Bedouin asterism.

Despite this defect, the manuscript copy now in the MIA is undoubtedly our most authoritative copy in terms of the age and accuracy of the exemplars from which the copyist produced it, and very valuable in terms of Bedouin imagery. But is it our earliest copy?

In the sale catalogue (Sotheby's 1998, 33), our three authorities (Brend, Hillenbrand, and King) listed the three earliest copies of al-Sufi's treatise, in chronological order, as:

1005–1011 St Petersburg, Institute of Oriental Studies, Russian Academy of Sciences, Arab. 185 [MS 85 Rosen Catalogue, MS C 724]

1009 Oxford, Bodleian Library, MS Marsh 144

1125 The present manuscript [now MIA, MS.2.1998]

We can in fact eliminate the St Petersburg copy from this list, for it is a sixteenth-century copy, probably made in Istanbul.[19] It consists of two discreet parts, each with its own colophon. One colophon states that it was based on a copy made in Cairo in 1011 (402 AH), which was said to have been made from an al-Sufi autograph; the second part states that it was based on a copy made in 1005 (396 AH) and collated with an exemplar that was copied from an autograph. Whatever the ages of the copies employed by its copyist, the St Petersburg manuscript itself is clearly not older than the MIA copy, nor more reliable.

That leaves us with the Oxford copy, and of course the one now at the MIA. The Oxford copy is a very famous manuscript that has been reproduced in facsimile and often cited as one of the earliest (if not *the* earliest) illustrated Arabic treatise preserved today.[20]

If the date given in the colophon (400 AH; 1009–10) is correct (pl. 135), it was copied within forty-five years of al-Sufi's original text. The name appearing in the colophon as the copyist is al-Husayn ibn 'Abd al-Rahman ibn 'Umar ibn Muhammad, and it has been interpreted as being al-Sufi's son (Wellesz 1959; Brend 1994; Carey 2009, 182). The poem, undoubtedly composed by the son, is not included in this copy, which is a curious omission if the son is actually the copyist and illustrator. However, there are other, more serious, problems with this colophon.

There are five particular areas of concern. First, the colophon (pl. 135) occurs on a fragmentary piece of paper, surrounded by the Latin notes of Christianus Ravius, written in 1644 while in Constantinople, stating that he copied missing parts of the manuscript from a more recent copy of the work (Wellesz 1959, 1–2). There are today about eleven folios in a slightly different hand than the rest of the volume. Second, the spacing of the lines of text on the back side of the fragment is not quite the same as the text spacing on other leaves, and the script differs in size and form from that of the rest of the volume. Third, the paper for the entire manuscript (and not just the fragmentary colophon) does not seem quite right for a manuscript of the very early eleventh century.[21] But then we have very few such ancient copies preserved with which to compare it. Fourth, the two lines of the colophon (pl. 135) read:

[1] *katabahu wa sawwarahu al-Husayn ibn 'Abd al-Rahman ibn 'Umar ibn Muhammad fi sana* ("al-Husayn ibn 'Abd al-Rahman ibn 'Umar ibn Muhammad copied it and illustrated it in the year")

[2] *arba'a mi'a sana* ("400 year")

136 (*p. 148*) Virgo as seen on a globe, from a copy of 'Abd al-Rahman al-Sufi's *Book of Constellations* dated 400 H (1009–10) and signed al-Husayn ibn 'Abd al-Rahman ibn 'Umar ibn Muhammad. Bodleian Library, Oxford (MS Marsh 144, p. 223).

137 (*p. 149*) Virgo as seen in the sky, from a copy of 'Abd al-Rahman al-Sufi's *Book of Constellations* dated 400 H (1009–10) and signed al-Husayn ibn 'Abd al-Rahman ibn 'Umar ibn Muhammad. Bodleian Library, Oxford (MS Marsh 144, p. 224).

138 (*p. 150*) Virgo as seen on a globe, from a copy of 'Abd al-Rahman al-Sufi's *Book of Constellations* made at Baghdad in 1125. MIA, Doha (MS.2.1998, folio 93a).

139 (*p. 151*) Virgo as seen in the sky, from a copy of 'Abd al-Rahmān al-Sufi's *Book of Constellations* made in Baghdad in 1125. MIA, Doha (MS.2.1998, folio 93b).

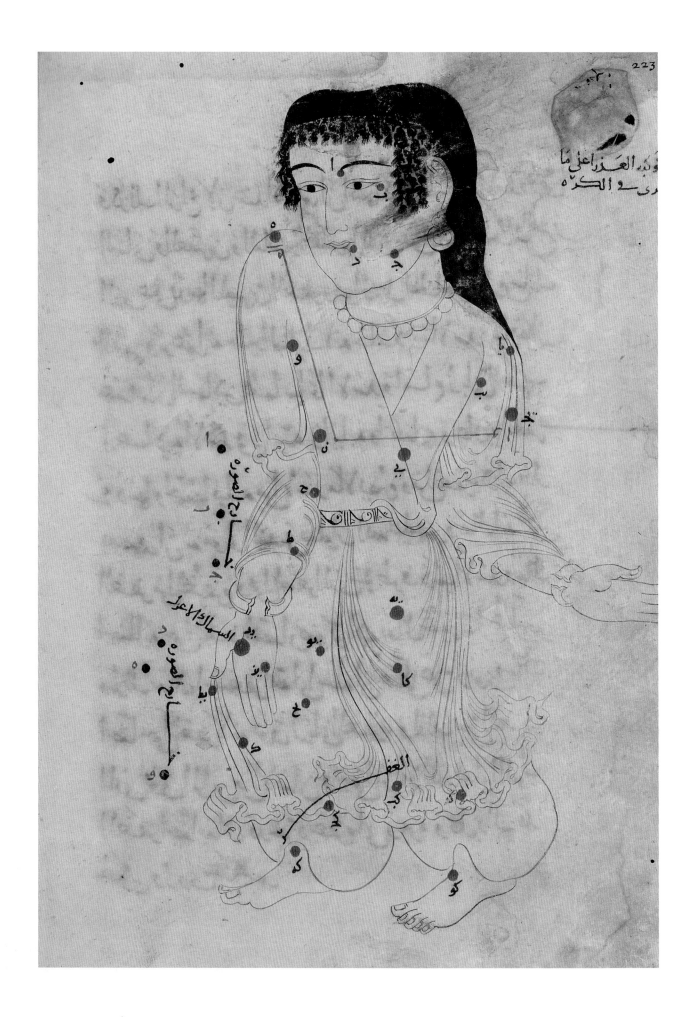

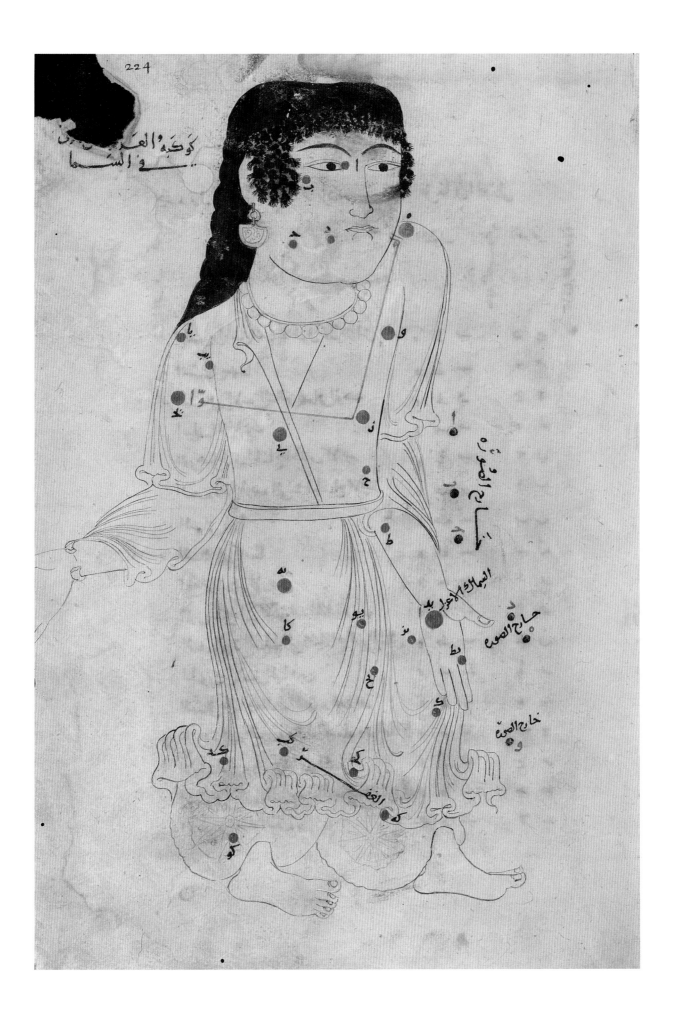

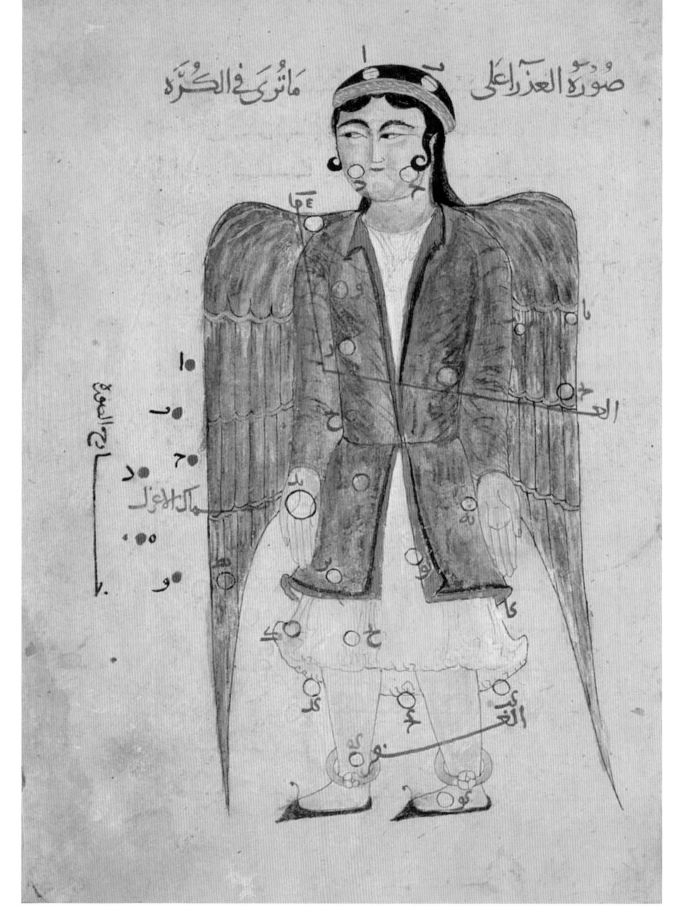

صورة العذراء على ما

ترى في السماء

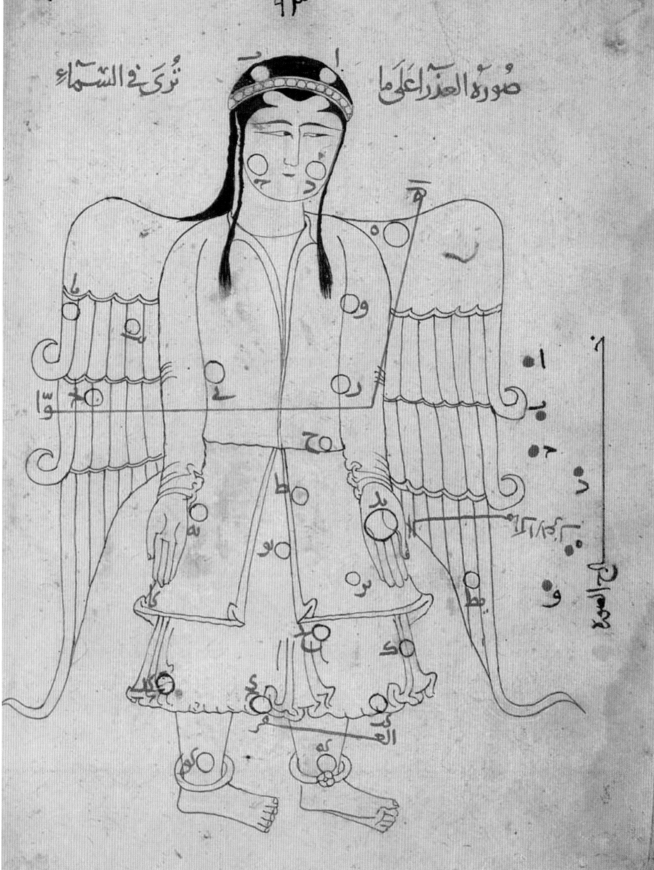

Under close examination, these two lines of the colophon do not seem to be in the same hand as the text itself, and are written in a different ink. Lastly, the final word of the second line of the colophon is very curious. It appears to be the word *sana* (year) repeated, but it is written differently from the way it is written in the previous line, and it is grammatically incorrect. It may have been added later, or it may be another word entirely that has not yet been deciphered.

In other words, the colophon appears very possibly to have been added *later*. This manuscript, MS Marsh 144, has consequently been classified as a "semi-fake" by A. Soudevar, a specialist in Islamic manuscripts, who proposed that the manuscript itself actually dates from the twelfth or thirteenth century (Soudavar 1999, 262–63). Earlier, Barbara Brend had proposed an ingenious solution to the disturbing discrepancies in this manuscript by suggesting that al-Husayn ibn ʿAbd al-Rahman ibn ʿUmar ibn Muhammad, whom she takes to be the son, began the copy, but then died. Then at a later date, possibly before the 1130s (a century and a quarter later), the manuscript was "restored" (re-copied?) and completed "in a style heavily indebted to Central Asia" (Brend 1994). The manuscript has recently been the subject of much scrutiny in Oxford, with a seminar being held for art historians and other interested parties to discuss the matter. The general conclusion was that there are serious problems with this colophon, but that the manuscript is of a respectable age, probably completed shortly before 1200, one person proposing that it may have been made in Egypt.

There is also one additional feature that convinces me, as a historian of science, that MS Marsh 144 could not have been made by the son of the astronomer al-Sufi, and that is the way the constellation of Virgo is depicted as compared to the drawings in the MIA manuscript. The two pictures of Virgo in the MIA manuscript (pls. 138 and 139) each have wings. The colored painting of Virgo as seen on a globe (pl. 138), although quite attractive, has been added much later, for both would have been line drawings without coloration. In contrast to the two in the MIA manuscript, the figures of Virgo in the Oxford manuscript (pls. 136 and 137) have lost their wings.

In al-Sufi's *Book of the Constellations*, several stars in Virgo are specified in the text as well as in the star catalogue to be on the wings, and are described with phrases such as "on the tip of the left, southern, wing" and "the foremost of the three which are on the right, northern, wing." In other words, wings are specified and required for this constellation. Their omission in the Oxford copy would never have been made by an astronomer. As a result of this omission, however, and because the Oxford manuscript carries this early date of 1009, it has entered the literature, quite erroneously I feel, that Virgo was transformed by al-Sufi into a "dancing girl" (for example, Berlekamp 2011, 123–25). Rather, it is a change produced by an aberrant, though very talented, copyist and artist, and it argues strongly against it having been made by al-Sufi's son, who was an author in his own right of a didactic poem on constellations.

In summary, then, a general consensus seems to be emerging that this famous manuscript now in Oxford was in fact produced not at the beginning of the eleventh century, but at the end of the twelfth century. If this is the case, and it seems very likely that

it is, then the manuscript now in the MIA is not only the most authoritative copy, but also the oldest copy, of what came to be one of the most influential treatises in the history of astronomy.

'Abd al-Rahman al-Sufi's illustrated book was not a treatise concerned with the mathematical technicalities of astronomy, but rather one that served a broader purpose, which no doubt accounts for its immense popularity and later influence. Because of its remarkable illustrations of all forty-eight classical constellations – each with two views – the treatise could be enjoyed by armchair astronomers who wanted to identify the constellations on their globes, for – just as in eighteenth-century Europe – every wealthy gentleman and prominent ruler would have had a globe as part of his library and collection of treasures.

At the same time, the star catalogues for each constellation served as an important direct source of star coordinates for makers of astrolabes and globes. Moreover, the accompanying text by al-Sufi provided fascinating comparisons between the star lore of pre-Islamic times (which was a prominent feature of early Arabic poetry) and the classical Greek conceptions of the skies. Whether it was 'Abd al-Rahman al-Sufi's intention or not, this treatise was instrumental in displacing the traditional Bedouin constellation imagery and replacing it with the Greek/Ptolemaic system which ultimately came to dominate all astronomy. And anyone lucky enough to be able to look through this entire manuscript will be captivated by its dual images: the globe view mirroring the sky view, and both reflecting the order and beauty of the heavens and God's creation.

Notes

1 He was born in Rayy on 14 Muharram 291 (7 December 903) and died on 13 Muharram 376 (25 May 986), completing 85 lunar years or 83 solar years (Ibn al-Qifti 1903, 227). See Sezgin 1978, 212–15.

2 The description of star positions is according to the old Arabic tradition, and when he attempts to use the Ptolemaic system errors occur. Al-Sufi later refuted certain ideas that were presented in this early treatise (Vafea 2006, 480–82, 490–91).

3 It was made in 1080 (473 AH) or 1085 (478 AH) by a well-known astrolabe maker Ibrahim ibn Saʿid al-Sahli al-Wazzan in collaboration with his son Muhammad (Florence, Istituto e Museo di Storia della Scienza, inv. no. 2712; see Savage-Smith 1985, 24, 217; Dekker 2004, 112–18). An undated and unsigned globe of essentially the same time period, and of very similar design, is now in the Bibliothèque nationale de France (Dekker and Kunitzsch 2008–09).

4 Al-Sufi adjusted the coordinates of celestial longitude (by adding 12° 42′ to those in the *Almagest*) to correspond to the beginning of the year 1276 of the Alexandrian era, which is equivalent to 964 CE.

5 Al-Sufi called the constellation of Andromeda "the constellation of the chained woman" (*surat al-marʾa al-musalsala*), adding that she was also called "the woman who never had a husband."

6 Oxford, Bodleian Library, MS Marsh 144, p. 167. This manuscript is discussed in some detail at the end of this essay. In the illustration next to star number 14, and on the nose of the larger fish, three vertical marks have been made, surrounded by a circle of dots and dashes; this is the only known example of a possible representation of the Galaxy in an Arabic copy of this

particular figure, for in other copies of this figure (such as that in Oxford, Bodleian Library, MS Huntington 212), there are no similar marks on the nose of the larger fish. Kunitzsch (1987) also provides an example of a possible representation of the Andromeda Galaxy from a Latin copy showing the two fishes over the bodice of Andromeda. The illustration of Andromeda with two overlaid fishes from MS Marsh 144 has also been reproduced in Wellesz 1959, pl. 11; Wellesz 1964, pl. 7.

7 Folios 1 (including title page), 3, and 8 of the introduction are later (Ottoman) replacement leaves, as are folios 35–44 (entries Cygnus, Cassiopeia, Perseus, and partially Auriga) and folios 68–75 (entries for Aries and Taurus).

8 ʿUtarid ibn Muhammad al-Hasib is said to have also written on the astrolabe and armillary sphere; Ibn al-Nadim 1871–72, 278; Dodge 1970, 2:658; Sezgin 1978, 161; Vafea 2006, 32–33.

9 Ibn al-Nadim 1871–72, 284; Dodge 1970, 2:671; Vafea 2006, 24–27. ʿAli ibn ʿIsa's treatise on the astrolabe is the earliest still preserved (Cheikho 1913; Schoy 1927). The modern editors of al-Sufi have erroneously added "al-Harrani" to ʿAli ibn ʿIsa's name (ʿAbd al-Rahman al-Sufi, 5, line 15); in the MIA copy, this portion of the text is an Ottoman replacement page, but it also has al-Harrani added to the name (MS.2.1998 fol. 3a, line 5).

10 Abu'l-Rayhan al-Biruni adds to this account the comment: "And that is an [adequate] approximation when the figures are small, but it is far [from adequate] if they are large." This passage occurs in al-Biruni's *The Book of the Plane Projection of Constellations and the Melon-shaped Projection of Countries* (*Kitab fi tastih al-suwar wa tabtikh al-kuwar*). The translation is that of the present author; for a slightly different translation and the Arabic text, see Berggren 1982, 53 and (Arabic) 89, lines 20–25; see also Richter-Bernburg 1982, 116.

11 I wish to thank Geert Jan van Gelder, Hugh Kennedy, Luke Treadwell, and Alasdair Watson for making suggestions regarding the reading of the colophon. All errors of interpretation, however, remain my own.

12 Celebrated minister to the Saljuk sultans Alp Arslan and Malikshah (*Encyclopaedia of Islam / 2*: "Nizam al-Mulk").

13 The twenty-sixth ʿAbbasid caliph, who ruled 1031–75, coinciding with the end of the Buyid dynasty and the beginning of the Saljuk period in Iraq (*Encyclopaedia of Islam / 2*: "al-Ka'im Bi-amr Allah"). In the ʿAbbasid caliphate, the *qahramana* was effectively the manageress of the women's quarters and second only to the queen mother among the caliph's female establishment.

14 The term *al-riwaya* was used in *ijaza*s in expressions such as *bi-haqq al-riwaya*, meaning "with right to teach on the authority of another."

15 The meaning is obscure here, but a possible interpretation is that the copyist is referring to the earlier colophon that preceded the poem.

16 Their first occurrence is on 33b (intervening Ottoman replacement leaves have disturbed the numeration), then 45b, 55b, 66b, 76b, 86b, 96b, 106b, 116b, 126b, 136b, 146b; between 66b and 76b there are also several Ottoman replacement leaves, but the foliation is not affected, while between 55b and 66b there are no replacement leaves, but there are eleven instead of ten leaves in the quire. The volume has been foliated with numbers placed on the right-hand leaves (the 'b' side of a folio).

17 Boötes is one of the few constellations that at times appears to stand upright, with the head to the North.

18 The copy was possibly dedicated (in a now partially illegible dedication) to Sayf al-Din Ghazi II, at that time the Zangid Atabeg ruler in Mosul. See Wellesz 1964, 89–90.

19 For sample illustrations and a discussion of the manuscript, see Caiozzo 2009, 118. The manuscript is bound with seventeen woodcut printed pages of an illustrated Latin constellation text, *Poeticon Astronomicon*, by Julius Higinus, which have been inserted beside each image; the copy at one time belonged to Taqi al-Din al-Misri, director of the observatory in Istanbul in the late 1570s.

20 For example, Yves Porter says of this manuscript: "The Oxford copy of the *Suwar* is one of the key monuments of Islamic painting. Indeed, it is the oldest complete illustrated manuscript that

has come to us, to this day, for the entire Islamic world" (Caiozzo 2009, 114). A facsimile edition of MS Marsh 144 was published by Fuat Sezgin (Frankfurt am Main, 1986). The basic study is still Wellesz 1959.

21 The biscuit-colored paper has laid lines that are quite wavy, though not well defined; there are irregular chain lines on many of the pages, while p. 328 has an unusual and curious very straight chain line. There is no trace of ruling, though some of the figures have indentations all around them, sometimes including the red stars (Andromeda being a good example). There are traces of catchwords, most of which have been cut off during trimming for re-binding.

Appendix

(fol. 161a)

تمّ كتاب ───────────── الكواكب

تاليف ابى الحسين عبد الرحمن بن عمر بن محمد الصوفى الرازىّ

نقلت هذا الكتاب من نسخة كانت للوزير قوام الدين [بن] نظام الملك ابى على الحسن

بن على بن اسحاق ووقفها وخلدها بدار الكتب التى عمرها بمدرسته فى الجانب الشرقي

(fol. 161b)

من مدينه السلم ⊙ وهى بخط هبة الله بن بشر الشمعى تاريخها جمدى الاولى سنه

سبع وعشرين واربع مايه للهجره وقد ذكر هبه الله انه نقلها من نسخه فرج بن

عبد الله الحبشى المنجم مولى ابى الحسين الصوفى مصنّف هذا الكتاب وتلميذه

وانّ فرج قرا نسخته تلك على استاذه واخذ خطّه فيها بالصحّه ⊙ ونقلت

هذا الكتاب مقلّدا لهبه الله بن بشر ومحتذياً فعلُه فى النسخ والصور وتبيين [=وتبيين ؟]

واضع الكواكب ووقع الفراغ من هذا الكتاب فى مستهل المحرّم سنه تسع

عشره وخمس مايه كتبه لنفسه على بن عبد الجليل بن على بن محمد بمدينه السلم

والحمد لله وصلواته على سيّدنا محمد واله الطاهرين

وسلامه

وعارضت هذا الكتاب من اوله الى اخره فى صفر السنه المقدم ذكرها بالنسخه التى عملت

لخزانه الملك عضد الدوله ابى شجاع فنا خسرو بن ركن الدوله رضى الله عنه وهى نسخه

بخط مجلِّس مولِّد من الكوفىّ والاصلاحات التى بها والالحاق جميعه بخط ابى الحسين الصوفى

مصنّف هذا الكتاب والصور جميعها صنعه [=صَنْعَة] ابى الحسين الصوفى فى بيده وهذه النسخه

تنقلت فى خزائن الملوك بنى بويه حتى انتهت الى السهليّه قهرمانه امير المؤمنين القايم بامر الله

فوقفها ⊙ واثبَّت الروايه [؟] وصحّحت هذا الكتاب بغايه الاجتهاد واصلحت من صوره ما

امكن اصلاحه فى موضعه وما لم يمكن صوّرته مفرداً فى اوراق اضفتُها الى الكتاب

بعد القصيده واحتذيتُ فى عمل الصور صنعه [= صَنْعَة] الصوفىّ ورسمه وبالله التوفيق

(fol. 179a)

اردتُ ان ابيّن فى هذه القصيده اشكال الصور جميعها حسب ما رسمتُه في عده مواضع فى

اولها فلما وقع كتاب الصور صنعه المصنف بيده ونقلتُ الصوره بمقتضى عمله فى الاوراق

المضافه فيما بعد صار لكل صوره من الكواكب فى هذا الكتاب اربعه اشكال فاهملت تبيين ذلك

فى هذه القصيده لكثره ما كان يتكرر الشكل بعينه ⊙ وموضع تبيين الصوره فى هذه القصيده تحت

المكتوب فى اخر كل فصل صوره الكوكب الفلانى[1] ويكتب بعد الصوره ذكر الكوكب الاخر حسب ما

هو

معمول [؟] فى اول القصيده والله ولى التوفيق ⊙ وفرغ من هذه القصيده فى شهر ربيع الاول [؟..]

[1] two-line marginal annotation, nearly illegible: ...بل هناك الصورة | ... ما ... ال..وا..

7

Three Ceramic Vessels from
Medieval Islamic Times

ثلاثة اواني فخارية من العصور الاسلامية الوسطى

Aimée Froom

Ceramics represent one of the most significant and enduring artistic traditions in Islamic lands. Crafted from clay, sand, quartz, and other materials, ceramics were created first for utilitarian purposes such as storage, cooking, and serving. Yet their stunning beauty often transcended their functional nature. Craftsmen made advances in materials, glazes, techniques, and decorative styles over time and geographical space. They were able to produce extraordinary objects using complex techniques that were transmitted throughout the Islamic lands and beyond.

The fourth Biennial Hamad bin Khalifa Symposium provides an opportunity to study the important collection of ceramics in the Museum of Islamic Art (MIA) in Doha.[1] This essay considers the development and spread of techniques, the transmission of knowledge, regional styles, aesthetics, and patronage through the lens of three exceptional ceramics in the MIA collection: a ninth-century Iraqi bowl with a single cobalt blue inscription (pl. 140), a tenth-century dish from the eastern Iranian world with a black-and-white inscription (pl. 141), and an early thirteenth-century Iranian bowl decorated with luster (pl. 142). Each one of these early- to middle-period ceramics marks a high point in ceramic history and reflects a harmonious union of technical and metaphorical beauty.

A Ninth-century Iraqi Bowl

Utilitarian earthenware jars, jugs, flasks, amphorae, ewers, and other containers for storage and transport are typical of pottery from the early Islamic period. Decoration was usually applied, molded, or incised, and wares could be glazed or left unglazed. A group of large-scale ceramic water jars, for instance, was left unglazed to take advantage of the natural processes of porosity and evaporation that resulted in pure and filtered cool water to drink. Examples of this group date from the ninth to fourteenth century; they have been attributed to the Euphrates river valley in Iraq, Syria, and Turkey and catalogued by Gerald Reitlinger (1951). Inscribed works are rare, but one of the later examples contains an inscription that confirms the purpose of the jar is for safe drinking water (Reitlinger 1951, 21; reprinted in Komaroff 2009, 112):

I am a *habb* of water wherein there is healing. I quench the thirst of mankind.

This I achieve by virtue of my sufferings on the day I was cast amongst the fiery flames.

140 (*facing page*) Earthenware bowl inscribed in blue on an opaque white glaze (diam. 20.5 cm), Iraq, 9th century. MIA, Doha (po.31.1999).

141 Profile view of the earthenware dish shown in pl. 35.

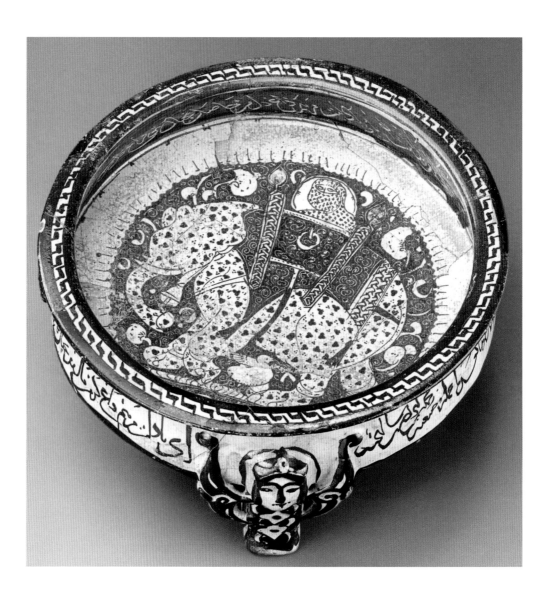

142 Fritware dish overglaze-painted with luster (diam. 20.5 cm), signed by the potter Muhammad ibn Abi Nasr al-Hasani, Kashan, February 1214. MIA, Doha (PO.285.2004).

The term *habb* (or *hubb*) mentioned in the inscription is the classical Arabic word for a large jar as defined in al-Khalil ibn Ahmad's eighth-century Arabic dictionary *Kitab al-ʿayn* (see Komaroff 2009, 112, 128, note 7). The MIA possesses a fragment of such a *habb* with barbotine decoration, dating from the ninth century or later (pl. 143).

Wares also could be glazed to render them impermeable and appropriate as containers for food and drink. The wares from the earliest Islamic era continue the use of alkaline green-blue glazes inherited from the Parthian (247 BCE–224 CE) and Sasanian (224–651 CE) periods and earlier. Yellow and green lead glazes were more common in the eighth century.

The early Islamic period was a time of great social change and nascent urban centers. Potters responded to a range of production demands using proven materials including earthenware, slip, colored pigments, and glazes and also developed new techniques and forms of decoration. Archaeological finds have revealed that fine ceramics were made for upscale markets in the nascent urban centers and on different levels for patrons in smaller cities and villages.

Beautiful vessels like the MIA bowl made in Iraq in the ninth century (Khemir 2006, 46–50) epitomize the fine ceramics of the early Islamic period (pls. 140 and 144). A single bold line of script in cobalt blue against the white surface asserts linearity and

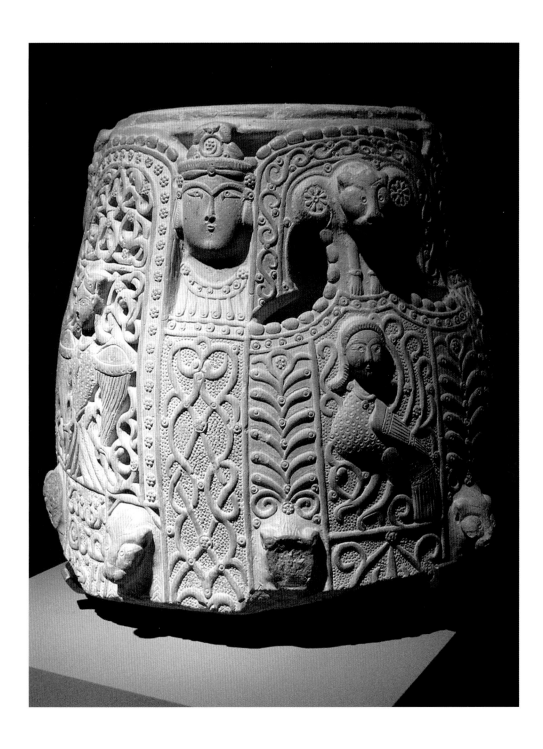

143 Unglazed earthenware *habb*, (?)Iraq, 9th century or later. MIA, Doha (PO.620.1999).

counterbalances the round form of the bowl, with its deep well and curved walls rising to a rounded, flared rim. The stark minimalism of the bowl's decoration appears resolutely modern, although it was created some twelve centuries ago. The bowl is strikingly fresh, deceptively simple, and wholly successful in form and decoration. It is also historically important: it reflects a watershed moment in the history of Islamic ceramic technology and aesthetic tradition. What makes this bowl so successful? Before considering the bowl in detail it is useful to consider the environment in which it was created.

The Canadian journalist and author Malcolm Gladwell (2008) who studied the origins of success found that it is not achieved by taking a solitary path. Rather, it results from the combination of environment, opportunities, and many hours of practice in addition to talent. Gladwell calculated that for violinists, hockey players,

144 Oblique view of the earthenware bowl shown in pl. 140.

145 (*below*) Map of the Islamic lands, 800–1500 (from Pancaroğlu 2007, pp. 8–9).

and computer geniuses it takes ten thousand hours of practice to be successful. In terms of ceramics, one might extrapolate that it took a winning combination of environment, opportunities, talented potters, many hours, and numerous wasters to create the MIA bowl.

At the time of the bowl's creation in the ninth century, Iraq was the political hub of the Abbasid caliphate (750–1258). At its height the caliphate extended over a vast geographical landscape from North Africa to Central Asia (pl. 145). Basra, a port city in southern Iraq, was an important cultural center and base for local and international

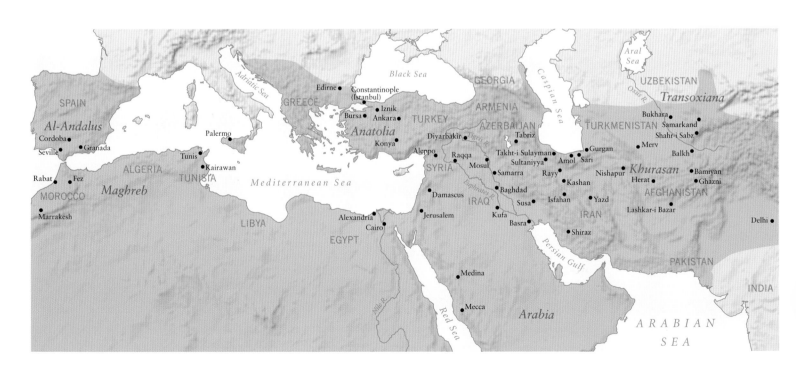

146 Porcelain bowl with transparent glaze (diam. 15.9 cm), China, Tang dynasty, 9th century. Freer Gallery of Art, Smithsonian Institution, Washington, DC (Gift of Charles Lang Freer, F1914.93).

trade. Basra also boasted many ceramics workshops, perhaps even the one that produced the MIA bowl. The ceramics workshops of Basra benefitted from the city's location as a center of vigorous international sea trade, notably with China, and its position as a cultural center of Islamic society. There was likely a concentration of talented craftsmen who had a high level of ceramic technical knowledge and who put in their ten thousand hours of practice making pots. It should be noted that Basra was not the only center of ceramic production in the region. Contemporary blue-on-white wares have been found at Hira, Kish, and Samarra in Iraq; at Siraf, Susa, Istakhr, Nishapur, Sirjan, and Rayy in Iran; and at Antioch in Syria. Portable ceramics traveled far and wide; and ongoing archaeological investigations are still revealing new aspects of provenance – where the wares were actually made.

Trade with China was not limited to one point of entry at Basra; it was widespread, and Chinese shards have been discovered in other cities and seaports such as Samarra, Susa, and Siraf (see, among others, Sarre 1925; Kervran 1977; Whitehouse 1979; Tampoe 1989; Rougeulle 1991; Hallett 1999). It was, however, the seaborne trade between Basra and China that served as the critical catalyst for monumental technological and aesthetic innovations in ceramics produced in the Muslim lands. The residents of Basra, as well as elsewhere, coveted these imports from China as luxury items. Fine ceramics were called "Chinese" (Arabic: *sini*; Persian and Turkish: *chini*), indicating the high status of imported Chinese porcelain and stoneware in medieval Islamic societies.

Many Iraqi vessels replicate the shapes of the expensive imported Chinese wares, particularly the hemispherical bowls with everted rims (pl. 146). Iraqi vessels could not, however, replicate the hard white body of the Chinese wares. The secret to fine Chinese porcelain lies in kaolin clay and minerals not available locally. Clearly not daunted by the unavailability of certain raw materials, Iraqi potters crafted their own answer in the form of a glaze made white primarily by using tin as an opacifier (Bernsted 2003, 2–7;

147 Page with Chapter 2: 34–41 from a Koran manuscript copied in gold ink on blue parchment (28 × 38 cm), North Africa, 10th century. MIA, Doha (MS.8.2006).

see also Caiger-Smith 1985; Tamari 1995; Hallett 1999; Mason 2004; Pancaroğlu 2007, 36, note 8). The opaque white glaze effectively masked the reddish-brown earthenware vessel beneath.

The white glaze covering the earthenware fabric was revolutionary for the future of Islamic and world ceramic technology. The new ceramics were popular immediately and locally. In the *Hikayat Abi'l-Qasim al-Baghdadi*, the tenth-century chronicler Muhammad ibn Ahmad Abi'l-Mutahhar al-Azdi compared the white surface of Basran cups to white pearls and their shape to the roundness of the moon (cited in Hallett 1999, 34). The white surface also acted effectively as a blank page, encouraging crafts-men to explore new horizons in decoration. The potters harnessed creative ingenuity and drew upon a repertoire of imported Chinese porcelain as well as locally produced ceramics and metalwork, and their productions reflect the wide range of possibilities: yellow and green splashed wares, mottled wares, lusterwares, molded-relief wares, and sgraffito wares. One form of decoration makes direct allusion to the white surface of a blank page: calligraphy.

Calligraphy, the art of beautiful writing, takes pride of place in ceramic decoration from this time. Calligraphy is the highest form of Islamic art, known first and foremost as the artistic form used to transmit God's word in the Koran (pl. 147). The written word was an important part of daily life. In addition to the Koran, calligraphy appears in many forms and ways. In architectural decoration, it takes on a monumental scale in the form of tiled facades or carved stucco inscriptions. Calligraphy also adorns smaller objects: it is embroidered on textiles, carved on wood, painted on enameled glass, and incised in metalwork, rendering the utilitarian objects of daily living more beautiful and a source of contemplation.

On ceramic vessels, calligraphy appears as beautifully "written" words and phrases that, when legible, often express benevolent wishes or proverbs. The calligraphers/craftsmen seem to delight in the visual possibilities of the written word/image on the ceramic fabric: letters are elongated, words and phrases are repeated, and sometimes legibility is sacrificed in favor of a pleasing combination of letters. Calligraphy on

ceramics can be written as a line of text on a page across the surface of a bowl or wrapped inside its deep contours.

The MIA bowl is a strikingly beautiful example of calligraphic decoration on a ceramic vessel. The opaque white glaze on the surface emulates luxury imported Chinese porcelain, but the decoration is Islamic and consists of an Arabic inscription in kufic script painted in cobalt blue. The inscription, which may be read as "made by Salih" ('amal salih) or "what was done was worthwhile" (ma 'umila saluha) begins at the right and finishes with a flourish at the center point of the bowl, effectively drawing a radius of the bowl.

The MIA bowl belongs to a corpus of similarly decorated Iraqi bowls. Some inscriptions are legible, but some are not, suggesting perhaps that the visual play of positive and negative space was more important than legibility. At least nine potters' names have been noted on the ceramics, usually in the form of "work of so-and-so" ('amal . . .), as on a bowl in the David Collection in Copenhagen that records the name Abu'l-Baqi (Blair and Bloom 2006, 105, no. 40). Bowls in the Louvre, Paris (Pope and Ackerman 1938–39, pl. 572D and p. 1486) and the Khalili Collection, London (POT 296; Grube 1994, no. 30) contain the phrase 'amal salih ("the work of Salih"), like the MIA bowl.

The inscriptions on blue-and-white wares are prominently placed and often comprise the vessel's sole decoration. This situation is different from lusterwares, for instance, where signatures are more discreetly located on the inside of the footring. This divergence, which has not been fully explained, has been interpreted as a peculiar feature of the blue-and-white wares. The placement of the inscription on the MIA bowl may be further distinguished from the majority of the blue-and-white wares since the inscription is not centered in the bowl; it starts at the right edge and finishes in the center, creating the impression that it is meant to be read like a line of script on a page.

It is important to note that the MIA bowl shows not only the innovation of an opaque white surface but also the second major innovation in medieval Islamic ceramics: the use of cobalt oxide. While the opaque white surface may reflect an emulation of expensive porcelain imported from China, the use of cobalt was local in origin. Cobalt, mined in the mountains near Kashan in Iran, was in the ninth century used almost exclusively by Iraqi potters, who would add cobalt pigment to the white glaze before firing. This method, which is called inglazing, allows the cobalt blue color to permeate the glaze and results in a velvety appearance after firing. Prominent forms of decoration include inscriptions in kufic script, palmettes, and abstract geometric and floral designs.

The twin innovations of an opaque white surface and cobalt blue decoration on medieval Islamic pottery had a lasting impact on the history of world ceramics. The opaque white glazed surface traveled west across the medieval Islamic world to Islamic Spain and Europe. Cobalt blue especially fascinated the Chinese when Iraqi ceramics made their way eastward (Hallett 1999). Chinese potters launched their own lines of blue-and-white porcelain wares that made their way back to the Muslim world where the porcelain was coveted and preserved, notably at the Safavid dynastic shrine at

148 Fritware flask with underglaze painting (h. 23.6 cm), Iran, 16th century. The State Hermitage Museum, St. Petersburg.

149 (*facing page*) Fritware dish painted with underglaze painting (diam. 39.1 cm), Turkey, probably Iznik, early 16th century. Victoria and Albert Museum, London (716–1902).

Ardabil in Iran and at the Topkapı Saray, the imperial palace of the Ottomans in Istanbul. The Chinese blue-and-white porcelains, in turn, inspired Safavid Persian and Ottoman Turkish potters to create their own versions, notably from the fifteenth to seventeenth centuries (pls. 148 and 149). Some of the most original and successful examples of Ottoman Turkish pottery are those that combine an understanding of Chinese blue-and-white porcelain with characteristic Ottoman motifs, style, and color palette of brilliant red, green, turquoise, and cobalt blue.

A Tenth-century Slipware Dish

The second object considered in this essay (see pls. 35 and 141) is a slip-painted, black-and-white inscribed dish from the tenth century (Khemir 2006, 50–51). The design of the dish is quite bold and strikingly modern in its minimalism: an inscription in large kufic script is painted on the flat rim of the dish; in the center is an open circular motif punctuated by small scroll motifs at the cardinal points. The central

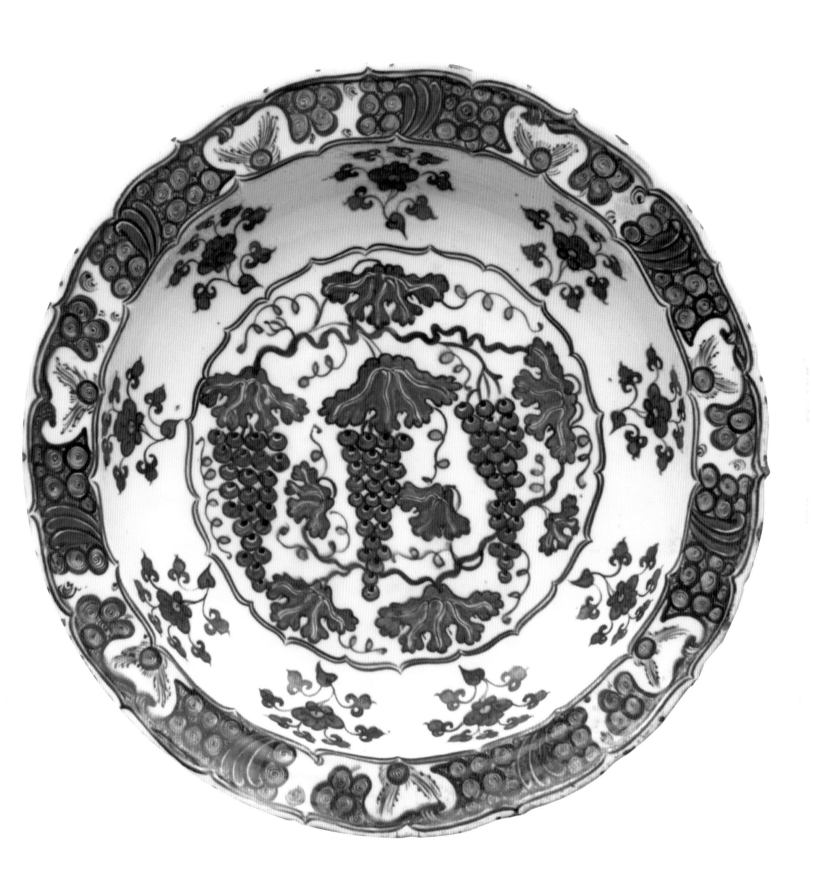

motif may be based on the Chinese yin-yang (dark-light) motif signifying opposing, yet interconnected, forces in nature. Overall, the decoration shows a harmonious use of positive and negative space that embraces the void. A characteristic feature of Islamic art may be a maximalist approach to surface decoration and a sort of *horror vacui*. But this dish, like the MIA's blue-on-white ninth-century Iraqi bowl (see pls. 140 and 144), and its extended family of inscribed ceramics represent an opposing trend and demonstrate beauty in simplicity, be it a calligraphed proverb, signature, or verse from the Koran.

While the two vessels share a similar and exceptional design aesthetic and appearance, they diverge in terms of technique, type of inscription, and tradition. The black-and-white dish belongs to an extended family of slip-painted ceramics made in the ninth and tenth centuries in the eastern Iranian world and Central Asia under the Samanids (819–1005) and hence dubbed "Samanid epigraphic ware." Before investigating the dynamic political, cultural, and commercial environment of medieval Islamic society that fostered this type of dish's technical innovations, production, and proliferation under the Samanids, let us take a closer look at the dish itself.

The dish has a wide, flat rim. Unlike the earlier Iraqi bowl, the dish's shape does not derive from Chinese porcelain, but probably stems from Islamic silver objects of similar shape and decorated with blackish niello inscriptions (Raby 1986). It has been suggested that Samanid epigraphic wares and contemporary beaten bronze objects with thin layers of silver inscriptions were lower-priced local productions that filled the gap for more expensive silverwares, which were unavailable because of a silver shortage.

Visually, the dish's wide, flat rim provides a large surface for decoration. The white surface is achieved by an application of white-colored slip, a watery semi-fluid clay mixture that covers the earthenware beneath. The inscription is slip-painted using a strong black pigment; on other examples, it can range in color from purple (manganese) to red (iron). The decoration also can be carved to sharpen the contours of the letters, with the entirety of the decorative program finished under a transparent and colorless lead glaze. Although the majority of ceramics from this family display black (or brown or red) on white slip, a number of stunning examples have white inscriptions on dark slip-covered grounds (see, for example, Makariou 2007, 197, no. 6). For a number of inscribed wares in this group, legibility also seems to have been of little concern, taking a subservient position to a harmonious decorative aesthetic. Thus, unlike the simple texts on nine-century Iraqi blue-on-white wares, the Samanid epigraphic wares can be challenging to decipher. This is not the case with the MIA dish.

Long black angular strokes of a kufic script inscription fill the entire circumference of the wide flat rim of the MIA dish. The craftsman/calligrapher took into account the width of the rim: elongated horizontal forms balance the inscription's tall vertical strokes. In this way, he skillfully guides the eye around and across the dish's surface, creating rhythm and harmony. The dish's inscription is a proverb attributed to Yahya ibn Ziyad that has been read as: "It is a fool who misses his opportunity and when the matter is over, reproaches fate."[2]

Proverbs or wise sayings in Arabic are the main subject on Samanid epigraphic wares. ʿAbdullah Ghouchani (1986), a Persian specialist of epigraphy and paleography, has done admirable research studying the inscriptions. So has the Turkish scholar Oya Pancaroğlu (2002), who identified over forty typical inscriptions and divided them into two main groups – ethics of generosity and virtues – which she noted were in line with both the function of the vessels as containers of food and the rules for polite social interactions (Pancaroğlu 2007, 67; see also Volov 1966; Bulliett 1992). Typical inscriptions include, "Generosity is a disposition of the dwellers of Paradise," "May you be well rewarded," "Eat in it with enjoyment and fulfillment," "Knowledge is the most honorable of values," "Blessing and good-fortune and joy and wellbeing," and, simply, "Blessing."

In what kind of environment were the MIA dish and Samanid epigraphic wares in general produced, and for what type of patron were they destined? The Samanids oversaw a wide variety of ceramic production including the epigraphic slipwares ascribed to centers of production such as Nishapur and Afrasiyab (old Samarqand) and apparently for local consumption; they are not found in excavations west of central Iran or at Rayy. The northeastern Iranian provinces of Khurasan and Transoxiana were populated by a multi-cultural society. Persians, Arabs, and Turks circulated in the main cities of Nishapur, Samarqand, Herat, and Bukhara under the auspices of the local Persian dynasty, the Samanids, who ruled first as governors for the Abbasids. The Samanids promoted Persian artistic and literary traditions alongside new Islamic elements such as the Arabic language. Out of this culture was born one of the great philosophical thinkers, Ibn Sina (also known as Avicenna; b.980 in Khurasan, d.1037), whose master-work, *Canon of Medicine*, is the most important encyclopaedic corpus of medieval medical knowledge in the Islamic world. Although his native tongue was Persian, he wrote in Arabic.

The MIA dish and related epigraphic wares were destined for such a multicultural and multilingual clientele. Created to serve food and drink, these vessels transcend their basic purpose and reflect the culture for which they were produced. The proverbs and sayings in Arabic on the vessels recall medieval *adab* literature on generosity, hospitality, and table etiquette (van Gelder 2000 gives many primary sources) and reiterate the importance of writing in a daily context. The fineness of the potting and the variety of kufic-style scripts seen on the vessels attest to the very high skill level of the crafts-men/calligraphers and to local pottery production in general.

An Early Thirteenth-century Luster Bowl

Figural imagery forms the main decorative program on the third ceramic discussed in this essay (see pl. 142), an Iranian luster-painted tripod bowl from the early thirteenth century (Watson 1985, pl. 74; Khemir 2006, 58–63). A veiled lady with large almond-shaped eyes sits in an elaborately detailed howdah atop an elephant. Leaves, a bird with flapping wings between the elephant's legs, and a snake-filled pond below fill out the

circumference of this rounded composition, which is a masterwork of painting in copper luster. Three winged sphinxes support the tripod bowl with its slightly concave walls and wide flat rim, a shape likely derived from cast metalwork incense burners. Calligraphy is present, but unlike the previous vessels, beautiful writing is not the sole form of decoration, and it occupies a less prominent position, being more discretely placed on the side walls of the vessel.

The appearance and decorative technique of the footed bowl are not the only differences between this vessel and the two previous ones studied: the very fabric of the ceramic vessel is different. For the footed bowl, the earthenware of the earlier objects, the most common ceramic fabric until the eleventh century, has been replaced by fritware (also called stonepaste). Fritware is an artificial body made from crushed quartz, local white clay, and other materials finely ground together. The technique likely came to Iran from Syria or Egypt. More versatile and malleable than earthenware, resembling the coveted white Chinese porcelain, and with a surface receptive to glazes, the development of fritware production set in motion a technical revolution. An unparalleled expansion in ceramic decorative techniques led to a golden age for Iranian ceramics in the twelfth and early thirteenth centuries, not only before the Mongol invasions but also under the Mongol Ilkhanid dynasty (1256–1353) in Iran and Iraq. Potters experimented with fritware for vessels and architectural tiles in an unprecedented number of ways: decoration is incised, molded, carved, and applied creatively. In addition to monochrome glazes, there was a new interest in testing a range of colors painted under or over a transparent glaze. The most luxurious and expensive wares are the overglaze-painted enamels (*mina'i*) and lusterware, as in the MIA footed bowl. These wares required the ten thousand hours of practice Gladwell mentioned as well as technical knowledge, great precision, precious materials, and an expensive second firing in the kiln. The footed bowl belongs to the third apex of middle-period Islamic ceramic production and is a watershed moment for Islamic ceramics and the history of world ceramics, as the luster technique was transmitted to Spain and on to Renaissance Europe, where it had a lasting impact over the centuries (Caiger-Smith 1985).

The footed bowl's rich copper-brown color and lustrous sheen that seem to imitate precious metals are characteristic of lusterware. The luster effect is produced by painting copper and silver oxides suspended in a solution containing sulfur onto a fired and glazed object and then re-firing the object in a lower temperature, oxygen-reducing kiln. During this costly second firing the metallic compounds bind to the surface of the glaze and, after polishing, reveal an exquisite, lustrous finish.

Kashan, a pottery production center for six thousand years, was the main site of production for luster ceramics in Iran. It is unclear exactly how the technique came to Iran. Luster ceramics had been produced in Abbasid Iraq in the ninth and tenth centuries as well as in Syria and Egypt. Scholars previously thought that Egyptian potters had brought the technique to Iran near the end of the Fatimid caliphate (1171) but this scenario is being questioned; for one thing, the artistic styles are too dissimilar. The luster technique also was used in another media, that of glassware decoration, before the advent of Islam in Egypt and during the ninth and tenth centuries in Iraq,

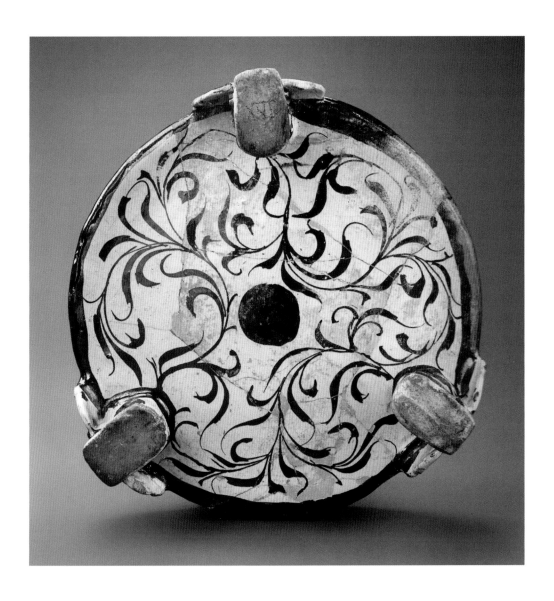

150 Underside of the fritware
dish shown in pl. 142 showing
the waterweed motif. MIA, Doha
(PO.285.2004).

as shown by written and material evidence (for Iranian lusterware see, among others,
Watson 1986, 1994, 2004; Porter 2003, 2004; Mason 2004; Pancaroğlu 2007; Blair 2008).

The MIA luster bowl is thought to belong to a hoard found at Gurgan, a site near
modern-day Gunbad-i Qabus in eastern Iran. This cache of ceramics, including luster-
ware, was found at this Caspian regional town, but their attribution to Gurgan is
complicated by unscientific excavations and quick dispersion onto the market. As a
group, the Gurgan wares are generally in good condition, as many were found in large
storage jars, and of excellent quality. They are painted with a wide range of decorative
programs. In addition to the lady, the MIA bowl features leaves, spirals, and so-called
waterweed motifs that fill the rest of the background and the base of the bowl (pl.
150). The iconography, type, and disposition of motifs are familiar from the other vessels
in the Gurgan group and from the third style, the "Kashan style," of luster painting
(Watson 1985).

What is extraordinary about the MIA dish is the masterful manipulation of the
decorative program and luster technique to create a glowing, almost three-dimensional
effect to the composition. How is this achieved? The protagonists of the figural
program – the veiled lady and the elephant – are depicted in reserve against the white
ground. They appear to stand out in relief against the dark copper luster background.

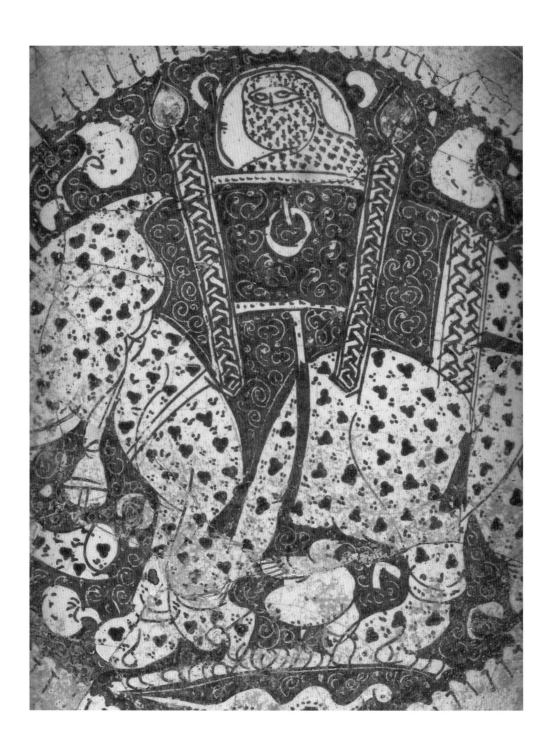

151 Detail of the fritware dish shown in pl. 142 showing a lady in a *howdah*. MIA, Doha (PO.285.2004).

Furthermore, the white scrolls etched out on the luster background and the elephant's howdah add another layer of texture, nuance, and depth. The reserve painting is complemented by the positive copper luster details of the lady's dress and veil and the elephant's all-over pattern of *çintimani*, a triple-ball motif of Buddhist origins that was often interpreted as a heraldic symbol in Turkic societies and became a prominent decorative motif on Ottoman Turkish ceramics, tiles, and textiles (pls. 151 and 152).

The richly decorated and dressed lady, elephant, and *howdah* suggest an official ceremonial context. A similar scene, this time with the addition of an elephant driver and a half-clothed black attendant at the back, is found on a contemporary lobed bowl in the Freer Gallery in Washington, DC (Atıl 1973, no. 39). The Freer bowl was painted over the glaze in enamel colors and gold highlights (*mina'i*), a very costly technique

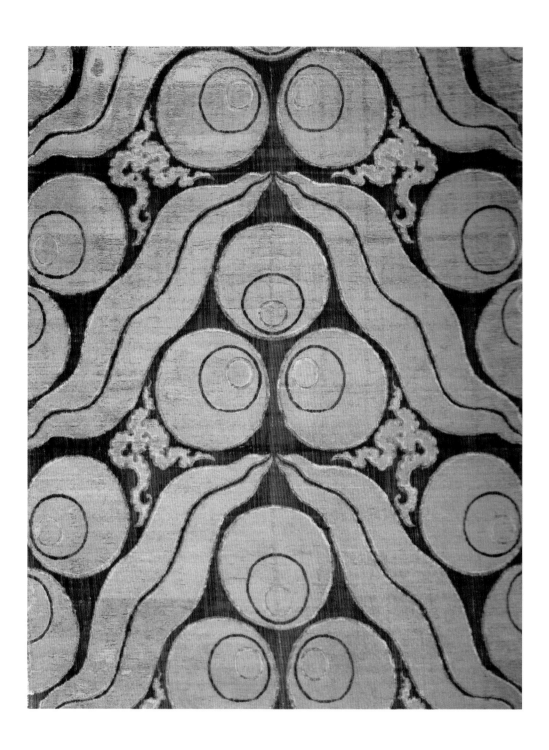

along with luster and the one closest to medieval book painting. The scene on the Freer bowl has been interpreted as an illustration of an episode from Firdawsi's *Shahnama* ("Book of Kings," written *circa* 1000) with the central rider as Sapinud, the Indian bride of Bahram Gur. The scene on another fritware bowl produced in Iran in the late twelfth or early thirteenth century, this time in champlevé and incised under-glaze slip decoration and transparent turquoise glaze, so-called "silhouette ware," has been identified as the arrival of an Indian princess promised to Alexander (Louvre OA 6473, available on their Atlas database at http://cartelen.louvre.fr/cartelen/visite?srv=car_not_frame&idNotice=21108&langue=en). Furthering the ceremonial references, the MIA bowl is supported by three feet fashioned into winged sphinxes (pl. 153), another princely motif that appears frequently in Iranian art of the twelfth and thirteenth

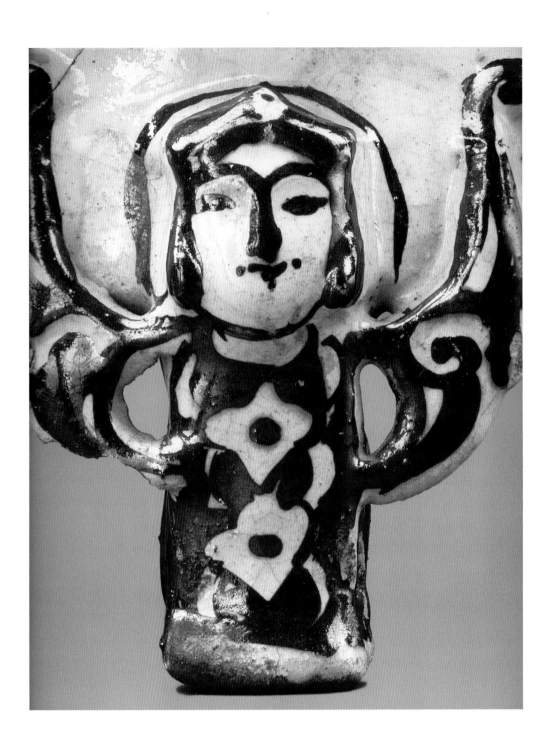

153 Detail of the foot of the fritware dish show in pl. 142.

centuries. Among other examples, sphinxes are represented on three lusterware objects in the Khalili collection (Grube 1994, figs. 243, 260, 263) and on contemporary bronze mirrors, such as one in the Louvre (OA 3945) attributed to twelfth- or thirteenth-century Khurasan or Anatolia, which have celestial iconographic associations that stretch back to pre-Islamic Achaemenid times.

Given the detailed attention to the MIA bowl's decoration, it is not surprising that the potter signed and dated his work: Muhammad ibn Abi Nasr al-Hasani in Shawwal 611 AH (February 1215 CE). What is interesting is that he indicated he made ('amila) and decorated (sana'a) it, revealing a level of precision and specialization shared by Abu Zayd Kashani, the most important potter of medieval Iran (Blair 2008, 162). It was a time of political instability before Saljuq power ended in Iran in 1194 and the Mongol

invasions of Kashan in 1224, but there was an active, sophisticated milieu of lusterware vessel and tile production controlled mainly by leading Shiʿite multi-generational families of potters. Numerous dated examples survive from this period, and specialists of medieval Persian literature have recognized nearly one hundred verses by a dozen poets (Blair 2008, 162; for epigraphic lusterware and ceramics in general, see Bayani in Pancaroğlu 2007; and for epigraphic ceramics, see Ghouchani 1986). The inscriptions, written in cursive script, mainly come from Persian love poetry but also include moralizing proverbs, benedictory blessings, and good wishes to the vessel's owner in Arabic, as on the earlier Samanid epigraphic wares. The inscriptions on the MIA bowl have yet to be fully deciphered. In addition to the marketplace, vessels were made on commission for high-level patrons. The inscription on the Freer *mina'i* lobed dish, for example, reads, "Glory to the most illustrious amir, the learned, the just . . . Abu Nasr Kirmanshah . . ." It was an environment of erudite patrons and potters, where the potter could be a scribe, a scholar, and a poet, as shown in the example of Abu Zayd, and communicate with the patron via verbal and visual metaphors to, in the apt and eloquent words of Sheila Blair (2008, 169), "evoke and provoke beauty in the minds of the beholders."

In conclusion, ceramic technology, decoration, form, and patronage in the Islamic lands evolved dramatically between the ninth and thirteenth centuries. The impact of the innovations was long-lasting and extended far beyond the borders of the Islamic world. Three exceptionally beautiful ceramic objects in the MIA collection – a ninth-century Iraqi bowl with a single cobalt blue inscription, a black-and-white inscribed tenth-century dish from the eastern Iranian world, and an early thirteenth-century Iranian luster bowl – provide a lens into this active, significant period of ceramic history. Each one of these ceramic objects marks a high point in the history of ceramics not only in the Muslim lands but also across the globe. Each vessel also represents a harmonious union of technical, aesthetic, and metaphoric beauty. The MIA houses many other representative examples in a wide range of media. There we are surrounded by beauty from the past and encouraged to create and preserve beauty for the future.

Notes

1 It is with sincere gratitude that I acknowledge Sheila Blair and Jonathan Bloom, Marisa Brown, and the staff of the MIA for their kind assistance, especially since I was unable to present this paper at the Symposium in Doha.

2 The Arabic text reads: *wa ʿajizu al-ra'yi midya'un lifursatihi hatta itha ma faata amrun ʿataba al-qadara.*

p. 176: detail of the decorative pattern on the inlaid brass ewer made for Mahmud ibn Sanjar Shah, early 13th century. MIA, Doha (MW.466.2007).

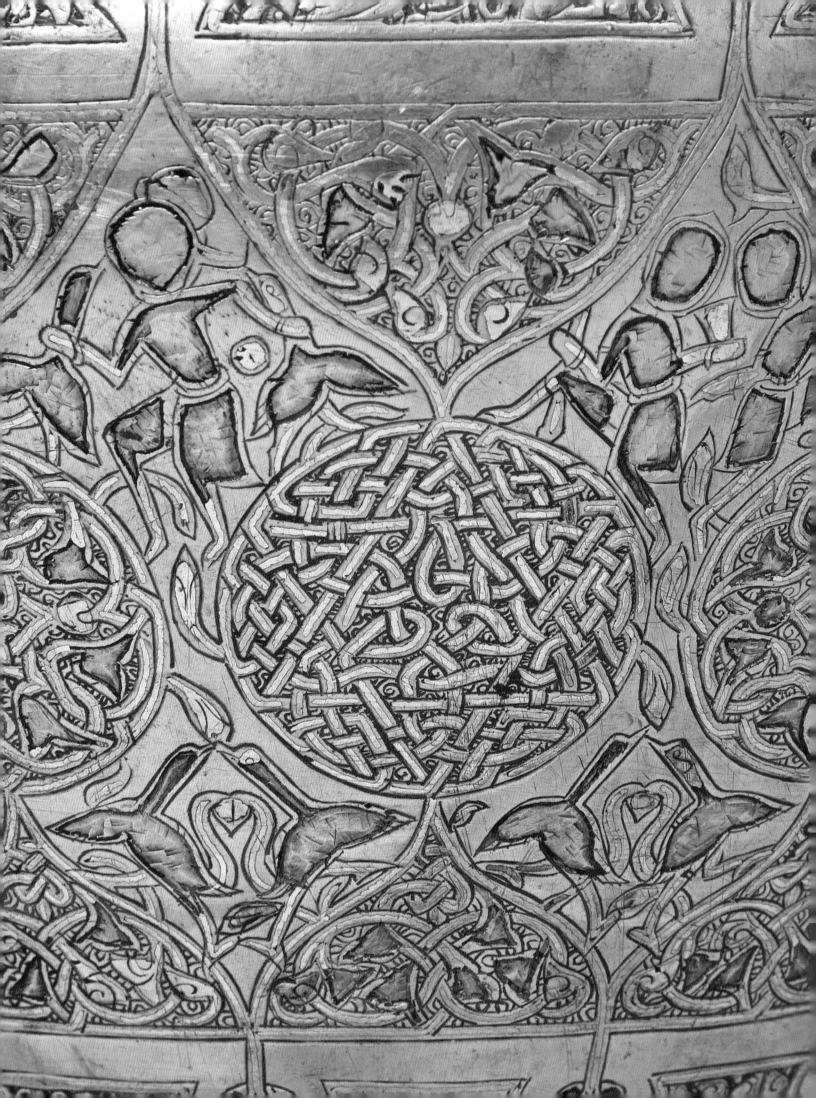

8

The Biography of a Thirteenth-century Brass Ewer from Mosul

حكاية الابريق نحاسى من القرن الثالث عشر من الموصل

Ruba Kana'an

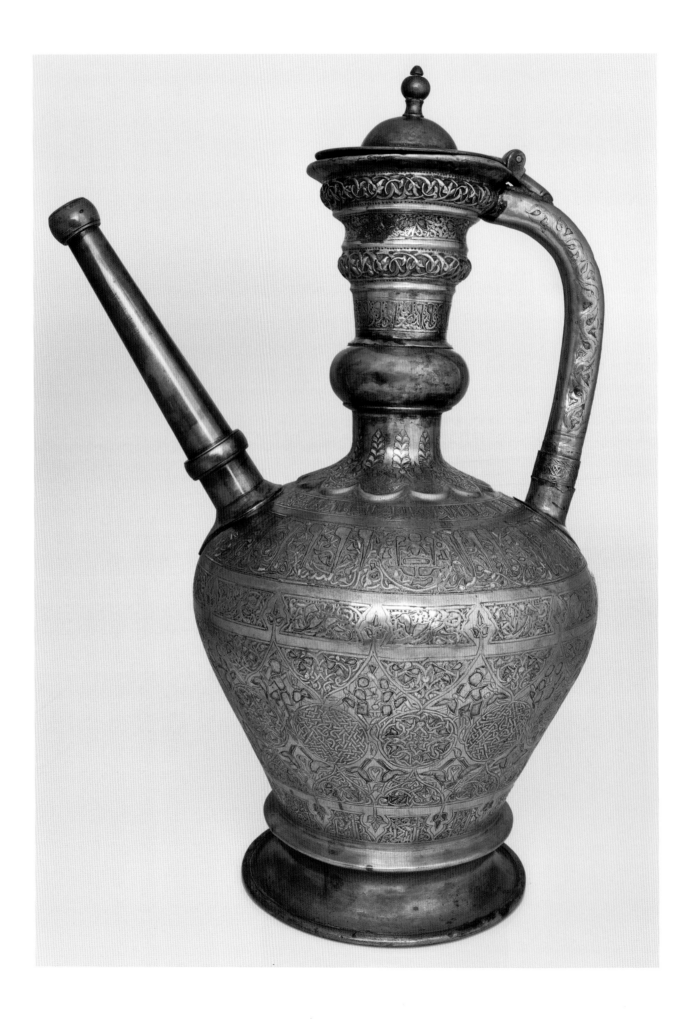

I first encountered this brass ewer (pl. 154) when it was on display at the former Reitlinger gallery at the Ashmolean Museum in Oxford as part of the outstanding collection of the late Nuhad es-Said (d.1982). In 2000 the collection moved to the Arthur M. Sackler Gallery of Art in Washington, DC and remained there until 2007, when it found a permanent home in the Museum of Islamic Art (MIA) in Doha. When I was a graduate student at the University of Oxford, I heard numerous inspiring lectures from James Allan on Islamic metalwork, particularly on the Mosul school to which the MIA ewer belongs.[1] These lectures frequently used examples from the Nuhad es-Said collection, including the MIA ewer. Allan's study of it (1982, 54–57) remains a seminal contribution to the field of Islamic metalwork, and the present article engages with his initial findings. Whereas he approached the ewer from a stylistic perspective, however, the present essay examines the ewer from a biographical perspective and as a cultural object that was produced within a particular historical context. More particularly, it focuses on what the ewer can tell us about people and events associated with its production and the social and geopolitical circumstances in which the ewer was made and exchanged. Such information provides insight into the ewer's possible uses and offers a new interpretation of its iconographic program. I draw upon primary historical sources and build upon established studies of Islamic metalwork, particularly the work of David Storm Rice (d.1962), published between 1949 and 1958 (full bibliography in Segal 1962, 669–71), and modern scholars who have engaged with Rice's scholarship, most recently Julian Raby (2012).

The MIA Ewer

The form, size, and general decorative features of the MIA ewer relate it to a group of lavishly decorated and sumptuously inlaid brass ewers attributed to the city of Mosul in northern Iraq and dated to the early thirteenth century (Raby 2012, especially 67–68, Table 1.2). These ewers follow a typical Late Antique type, in which the spout and handle issue from the shoulder of the main body, and reflect a Mediterranean-influenced cultural style.[2] Where these ewers differ from their Byzantine/Fatimid predecessors is in their predominantly inverted-pear body shape that typically culminates with raised scallops at the base of the vessel's neck. At least twelve ewers of this type are known to have survived and are now part of museum collections, including the undated ewer in the Louvre signed by Ibrahim ibn Mawaliya (pl. 155); the ewer in the Cleveland Museum of Art signed by Ahmad ibn ʿUmar al-Dhaki and dated 1223 (pl. 156); the ewer in the Metropolitan Museum of Art, New York signed by ʿUmar ibn al Hajj Jaldak and dated 1226 (pl. 157); the ewer in the Museum of Turkish and Islamic Arts in Istanbul signed by Iyas, the *ghulam* (servant or slave) of ʿAbd al-Karim ibn al-Turabi, and dated 1229 (pl. 158); the ewer in the Freer Gallery of Art signed by Qasim ibn ʿAli and dated 1232 (pl. 159); the undated ewer in the Musée des Arts Décoratifs, Paris (pl. 160); the ewer in the Museum für Islamische Kunst, Berlin signed by ʿAli ibn ʿAbdallah al-ʿAlawi and datable 1220–40 (pl. 161); and the ewer in the Walters Art

154 (*facing page*) Inlaid brass ewer made for Mahmud ibn Sanjar Shah (h. 44 cm), Mosul, early 13th century. MIA, Doha (MW.466.2007).

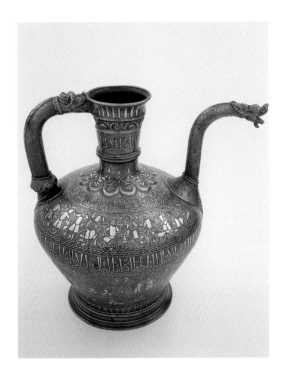

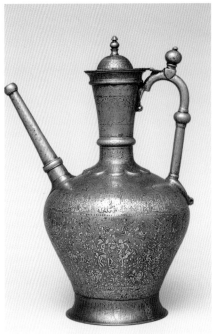

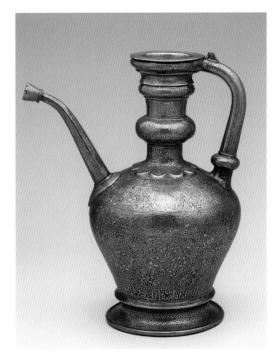

155 (*above left*) Inlaid brass ewer signed by Ibrahim Ibn Mawaliya (h. 30.8 cm), Mosul, early 13th century. Musée du Louvre, Paris (K3435).

156 (*above center*) Inlaid brass ewer with later lid and base (h. 38 cm), Mosul, 1223. Cleveland Museum of Art (John L. Severance Fund 56.11).

157 (*above right*) Inlaid brass ewer signed by ʿUmar ibn al-Hajj Jaldak (h. 30.6 cm, diam. 21.3 cm), Mosul, 1226. Metropolitan Museum of Art, New York (91.1.586).

158 (*right*) Inlaid brass ewer signed by Iyas (h. 39 cm), *ghulam* of ʿAbd al-Karim ibn al-Turabi, Mosul, 1229. Museum of Islamic Art, Istanbul (217).

159 (*far right*) Inlaid brass ewer made by Qasim ibn ʿAli for Amir Shihab al-Din (h. 36.7 cm), Mosul, 1232. Freer Gallery of Art, Smithsonian Institution, Washington, DC (Purchase, F1955.22).

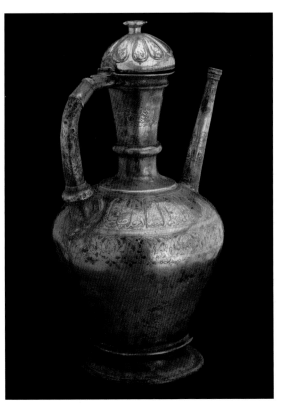

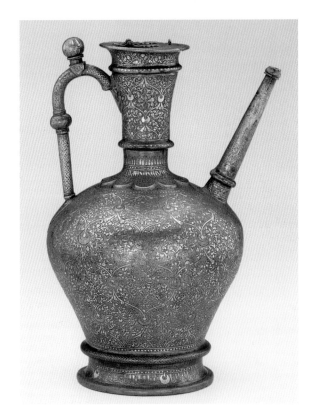

Museum signed by Yunus ibn Yusuf and dated 1246 (pl. 162). Closely related to these ewers in form, provenance, and decorative characteristics are the faceted Blacas ewer in the British Museum signed by Shujaʿ ibn Manʿa and dated 1232 (pl. 163); the Homberg ewer in the Keir Collection signed by Ahmad al-Dhaki and dated 1242 (pl. 164); and the ewer in the Louvre signed by Husayn ibn Muhammad and dated 1258 (pl. 165). The MIA ewer's height of 44 centimeters is also typical of the group, whose

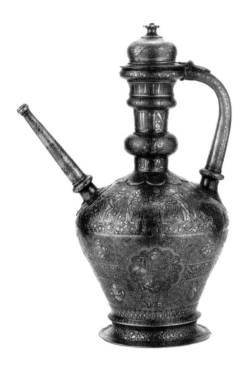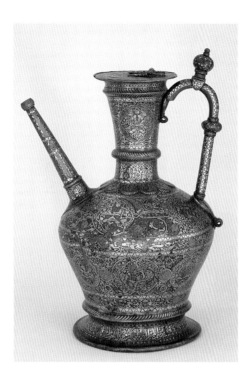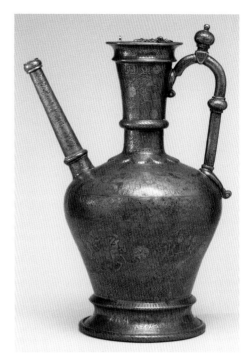

160 (*left*) Inlaid brass ewer, Mosul, early 13th century. Musée des Arts Décoratifs, Paris (4413).

161 (*center*) Inlaid brass ewer signed by ʿAli ibn ʿAbdallah al-ʿAlawi (h. 35 cm), Mosul, 1220–40. Museum of Islamic Art, Berlin (I.6580).

162 (*right*) Inlaid brass ewer signed by Yunus ibn Yusuf (44.5 × 31.8 × 16.5 cm), Mosul, 1246. Walters Art Museum, Baltimore (54.456).

reported heights range between 36 and 45 centimeters depending mostly on restored or missing lids and bases.[3]

The MIA ewer is closest in size, weight, and general characteristics to the Freer ewer of 1232. Radiographic images of the MIA ewer (pl. 166) demonstrate the similarities between its body shape and that of the Freer ewer of 1232 (pl. 167).[4] The images show that both ewers are made of sheet brass that was hammered and spun, with the upper part of the neck soldered just below the lower collar of the neck. The images also suggest that the differences between the ewers were most likely found in the treatment of the solder line that separates the ewer's body from its neck. For example, whereas the lower neck of the Freer ewer is separated from the cylindrical upper part with a narrow molded ring, the MIA ewer has a torus-shaped broad ring that covers the solder line between the body and the neck. Although the current ring on the MIA ewer is clearly part of a later restoration that included the replacement of the spout, pre-restoration photographs after its purchase at a Paris auction in the 1970s (pl. 168) and the radiographic image suggest that the current ring is a modern replacement of an original now-missing ring that was probably of the same shape and dimensions.[5] Torus-shaped rings are common in some, but not all, Mosul ewers, including the Cleveland Museum of Art's ewer of 1223, the Metropolitan Museum of Art's ewer of 1226, and the undated ewer at the Musée des Arts Décoratifs.

Less prevalent than the torus ring in the lower part of the MIA ewer's neck is the repoussé work on the upper parts of the neck (pl. 169). Two finely undulating and interlacing meanders of split palmettes worked in repoussé decorate the neck of the MIA ewer. The only known repoussé work on a Mosul ewer is the single band on the neck of the Louvre ewer datable to the late twelfth or early thirteenth century and signed by Ibrahim ibn Mawaliya and another band around the handle of the same ewer. But the repoussé band on Ibrahim ibn Mawaliya's ewer is a single undulating stem with alternating kidney-shaped leaves. The same decorative composition of the interlacing and undulating split-palmette rings decorates the undated ewer in the Musée

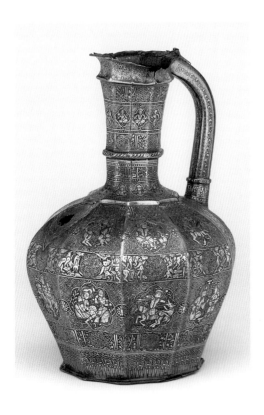

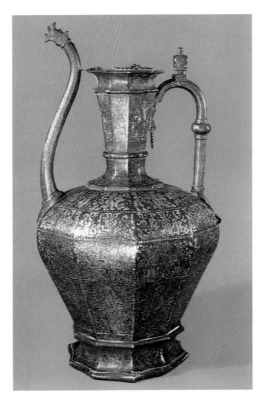

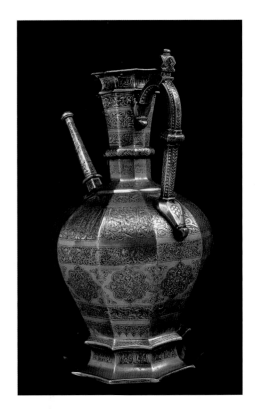

163 (*above left*) Blacas ewer signed by Shujaʿ ibn Manʿa (h. 30.4 cm), Mosul, 1232. British Museum, London (OA 1866.12–29.61).

164 (*above center*) Homberg ewer signed by Ahmad al-Dhaki (h. 39.5 cm), Mosul, 1242. Keir Collection.

165 (*above right*) Inlaid brass ewer signed by Husayn ibn Muhammad; Mosul, 1258. Musée du Louvre, Paris (7428).

166 (*right*) Radiographic image of the MIA ewer (pl. 154).

167 (*far right*) Radiographic image of the Freer ewer (pl. 159).

des Arts Décoratifs, but this time in silver inlay. On the basis of general form and some clear similarities with the Louvre ewer by Ibn Mawaliya, then, one can suggest that the MIA ewer dates to the first quarter of the thirteenth century, a proposition to which I will return toward the end of this essay.

The decoration of the MIA ewer's body also combines the typical and the distinctive. Both the form and the content of the four bands of inscription are typical. General good wishes are conveyed alternately in human-headed *naskh* inscriptions and ornate

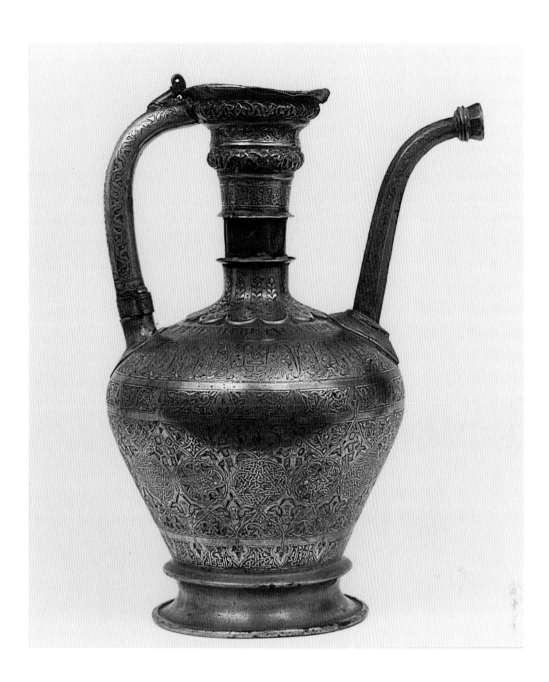

168 Inlaid brass ewer made for Mahmud ibn Sanjar Shah before the replacement of the spout and neck ring (pl. 154).

kufic in seamless elegance. The main decorative program on the body of the ewer, however, portrays an orderly and quite sober repetition of a limited number of patterns and motifs. Two plain bands frame a series of alternating roundels inlaid with interlacing geometric patterns, framed above and below with inlaid split palmettes (pl. 170). Both the roundels and the split-palmette composition are clearly delineated with a thin silver inlay border that elegantly protrudes into the flanking plain bands in the form of a pointed finial. The diamond areas left between the densely decorated roundels are also filled with repetitive elements, here on a plain background. All the lower diamonds are filled with depictions of two ducks, each symmetrically aligned and facing each other. The diamonds above the roundels, in contrast, are filled with alternating motifs (pl. 171): a man capturing two ducks by their necks, followed by two men facing each other depicted in two variations (drinkers and musicians). In sum, the MIA ewer is decorated with a repertoire of geometric patterns, split-palmette scrolls, inscriptions, ducks, and men who appear to be hunting those ducks.

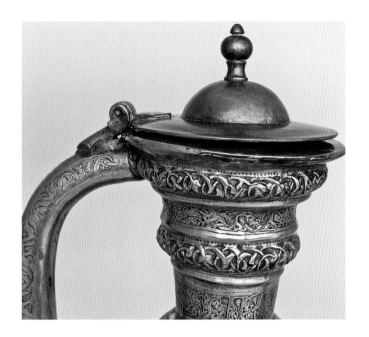

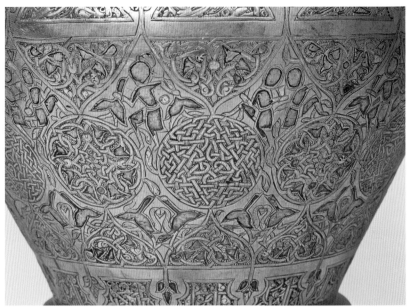

169 (*left*) Repoussée rings on the upper neck of the ewer made for Mahmud ibn Sanjar Shah, detail of pl. 154.

170 (*right*) Detail of the decorative pattern on the ewer made for Mahmud ibn Sanjar Shah, detail of pl. 154.

171 (*facing page, top*) Detail of the interlaced roundels on the ewer made for Mahmud ibn Sanjar Shah, detail of pl. 154.

172 (*facing page, bottom left*) Detail of the bird hunt with a blowpipe on the body of the ewer signed by Ibrahim ibn Mawaliya (pl. 155). Drawing from Rice 1957, fig. 22.

173 (*facing page, bottom right*) Detail of the hunt with a blowpipe and a bow from the Barberini vase. Drawing from Rice 1957, fig. 23.

The theme of hunting is, of course, typical on Islamic metalwork. However, the depiction of fowling, or bird hunt, is rare in metalwork decoration more generally, yet it appears to be common on Mosul metalwork (Baer 1977, 327–32 and 1983, 232–34; for the relationship to Jaziran manuscript illustration, see Rice 1957). Fowling is distinctively represented on Mosul metalwork, both in hunting parties and as part of the broader theme of the princely hunt. The sport is usually depicted in different forms. These include hunting by hand, as in the repetitive scene in the medallions of the MIA ewer and in the upper band on the body of the Homberg ewer; hunting with a blowpipe (blowtube), as in a medallion on the body of the Cleveland ewer, the body of the Ibrahim ibn Mawaliya ewer (pl. 172), and the Homberg ewer; and hunting with a bow, as on the Blacas ewer in the British Museum, a brass cup from the tomb of Sayyid Battal Ghazi now in the Museum of Turkish and Islamic Arts in Istanbul, the shoulder and main medallions of the Cleveland ewer of 1226, and both inside and outside the basin signed by Ahmad al-Dhaki and dedicated to the Ayyubid sultan al-ʿAdil II (r.1238–39), now at the Louvre (OA 5991) or with both a blowpipe and a bow, as on the Barberini vase in the Louvre (OA 4090; pl. 173). The *tadbiq* method, or hunting little birds by using a stick covered with a sticky substance, is more difficult to discern visually, but it is most probably represented twice in the panels in the upper part of the body of the Homberg ewer, along with the other methods of bird hunting (Rice 1957, pl. 12; Baer 1977, pl. 14). It follows that inlaid Mosul brasses are perhaps best characterized by the abundance of bird depictions that include a ubiquitous fowling theme, the use of birds as common space fillers in pairs and in groups, as well as specific types including ducks, falcons, and peacocks.[6]

The abundance of bird hunt and fowling depictions on Mosul metalwork is also reflected in the historical chronicles of the period, including Ibn al-Athir (d.1233), Ibn Shaddad (d.1285), and al-Dhahabi (d.1348). These chronicles include various narratives of fowling not only as part of the princely cycle, but more importantly in relationship to the *futuwwa* order that was reformed and encouraged by the Abbasid caliph al-Nasir (r.1180–1225) and aspired to by the rulers of the Jazira. Al-Nasir is reported to have utilized the *futuwwa* movement as an apparatus of government that allowed him to create

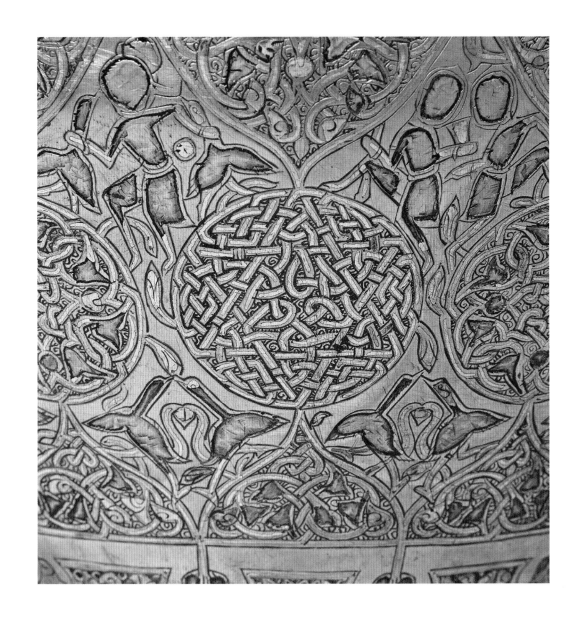

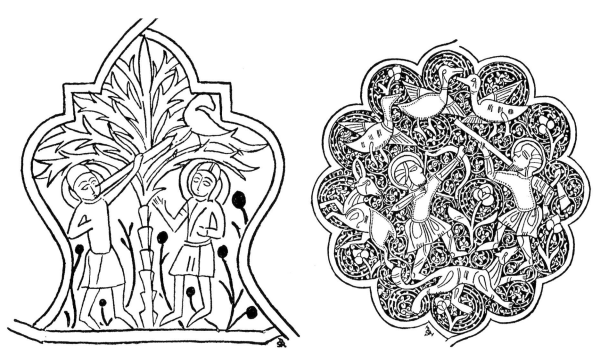

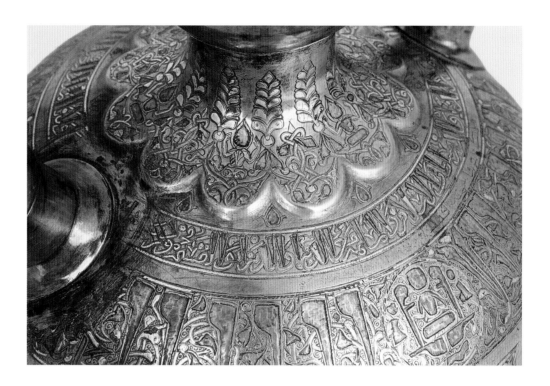

174 Detail of the inscription naming the recipient on the ewer made for Mahmud ibn Sanjar Shah, detail of pl. 154.

a sense of joint purpose with the ruling emirs of the various principalities in his realm.[7] Historians of the thirteenth century mention the initiation of various rulers of Syria, the Jazira, and west Iran into the *futuwwa* movement, including the Ayyubid ruler of Damascus, al-Malik al-ʿAdil I (r.1196–1218); the Zangid ruler of Mosul, Nur al-Din Arslan Shah I (r.1193–1211); the Zangid ruler of Shahrazur, Nur al-Din Arslan Shah III (r.1233–45); the Seljuq ruler of Rum, Kay Kavus (r.1211–20); the Khawarazmshah Jalal al-Din Mengubirti (r.1220–31); the Salgurid atabek of Fars ʿIzz al-Din Saʿid I (r.1198–1226 or 1231); and an anonymous ruler of Oman.[8] The caliph al-Nasir, and al-Mustansir after him, initiated the ruling princes as well as the religious and military elites into the *futuwwa* movement and rewarded them with certain privileges, including "*futuwwa* trousers" (Cahen 1953). One of these privileges is the monopoly of certain sports such as the shooting of birds (*ramy al-bunduq*). In his account of the events of the year 634 AH (1236), for example, al-Dhahabi mentions an event where Badr al-Din Luʾluʾ's son al-Salih Ismaʿil was engaged in a ritual hunting of birds that was permitted only to *futuwwa* initiates.[9] All of this suggests that the bird hunt motif on the MIA ewer and other Mosul metalwork may have a broader iconographic significance that needs to be explored further.

The "Patron" of the MIA Ewer

In addition to the typical repertoire of benedictions and good wishes common on Mosul metalwork, the MIA ewer bears an inscription with the name of Abu'l-Qasim Mahmud ibn Sanjar Shah, the Zangid ruler of Jazirat Ibn ʿUmar (modern day Cizre on the border between Turkey and Iraq), who ruled from 1208 until his death in 1250/51 (pl. 174).[10] Understanding the patron's history and the geopolitical context of his rule is the next step in unfolding the biography of the MIA ewer.

The full name of Abu'l-Qasim Mahmud is Muʿizz al-Din Mahmud ibn Muʿizz al-Din Sanjar Shah ibn Sayf al-Din Ghazi ibn Qutb al-Din Mawdud ibn ʿImad al-Din

'Imad al-Din Zangi Ibn Qasim
al-Dawla Aqsunqur
1127–46

Sayf al-Din Ghazi I
1146–49

Qutb al-Din Mawdud
1149–70

Nur al-Din Mahmud Zangi
(Aleppo) 1146–74

Sayf al-Din Ghazi II
1170–1180

'Imad al-Din Zangi II
d. 1236

'Izz al-Din Mas'ud I
1180–93

al-Malik al-Salih Isma'il
d. 1181

Mu'izz al-Din Sanjar Shah
(Cizre)

Nur al-Din Arslan Shah III
d. 1245

Qutb al-Din Muhammad

Nur al-Din Arslan Shah I
1193–1211

Mu'izz al-Din Mahmud
(d. 1251)

'Izz al-Din Mas'ud II
1211–1218

Badr al-Din Lu'lu'
1211–1259

Al-Mas'ud Shahanshah
(d. 1251)

Nur al-Din Arslan Shah II
1218–1219

Nasir al-Din Mahmud
1219–1234

175 Zangid family tree.

Zangi ibn Qasim al-Dawla Aqsunqur (pl. 175). His grandfather, Sayf al-Din Ghazi II (r.1170–80), was the fourth atabek of Mosul and nephew to the famous atabek of Aleppo, Nur al-Din Mahmud Zangi (d.1174). Sayf al-Din II was also married to the daughter of his uncle Nur al-Din, thus making Mahmud ibn Sanjar Shah a descendant of one of the most prestigious Zangid lines, with direct lineage from the founder of the Zangid line in Mosul and his son Nur al-Din of Aleppo. Mahmud ibn Sanjar Shah's grandfather, Sayf al-Din Ghazi II, was the ruler of Mosul and the head of the Zangid house (of Mosul), but during his prolonged final illness his emirs convinced him that if he died, his young children would be better protected not as rulers, but rather if rule were transferred to his brother 'Izz al-Din Mas'ud (Ibn al-Athir 1963, 181; Ibn Shaddad 1978, 228). That same year 'Izz al-Din Mas'ud I (r.1180–93) became ruler of Mosul, and the children of Sayf al-Din Ghazi II were given Jazirat ibn 'Umar as a principality, which they ruled for seventy years, from 1180 until the death in 1251 of Mahmud ibn Sanjar Shah's son al-Malik al-Mas'ud Shahanshah. This transfer of power, ostensibly to protect the Zangid line from the rising power of the Ayyubids, led to the continuation of the Zangid rule of Mosul in the progeny of 'Izz al-Din Mas'ud until power was usurped by Badr al-Din Lu'lu', who became regent in 1211 and ended the Zangid line of Mosul in 1233/4 and of Jazirat ibn 'Umar in 1251.

Surprisingly, chroniclers ignore Mahmud ibn Sanjar Shah's impressive family tree and his forty-year rule in Jazirat ibn 'Umar, mentioning little beyond his birth, ascent to

176 Inlaid brass basin with the name of Mahmud ibn Sanjar Shah (diam. 41 cm), Mosul, early 13th century. Museum of Islamic Art, Berlin (I.3570).

rule, and death.[11] Mahmud ibn Sanjar Shah, however, seems to have maneuvered his way around the turbulent politics and switching alliances between the Zangids and the Ayyubids that dominated the first half of the thirteenth century in Syria and the Jazira. More importantly, he maintained good relationships with the Abbasid caliphs in Baghdad, the Ayyubids of Syria, and the strong man of Mosul, Badr al-Din Lu'lu'. In fact, Mahmud ibn Sanjar Shah and Badr al-Din Lu'lu' sealed an alliance, in a manner typical of the period, by the marriage of Mahmud ibn Sanjar Shah's son, al-Malik al-Mas'ud Shahanshah, to Badr al-Din Lu'lu's daughter.[12] This marriage, however, served its political purpose only until the death of Mahmud in 1251. That same year, Badr al-Din Lu'lu' got rid of his son-in-law. He captured him and put him on a boat from Jazirat ibn 'Umar to Mosul. The Zangid prince never made it to his destination, thus ending the life of the last remaining heir to the Zangid line.[13]

Notwithstanding their impressive pedigree, Mahmud ibn Sanjar Shah and his father before him were less than admired by the chroniclers of their time. In his chronicle *al-Kamil fi'l-tarikh*, for example, Ibn al-Athir quotes the Ayyubid sultan Salah al-Din (r. 1169–93), saying: "I never received a bad report about anyone without my finding him not as bad as was said, except for Sanjar Shah, for things were repeated about him that I thought terrible but when I saw him, the reports were nothing in my eyes." (Ibn al-Athir 1982, 12:61; see also Richards 2007, 385). This damning account of Mahmud's father is also reflected in the narration of Sanjar's cruelty and his terrible death at the hands of his own son Ghazi, as well as the ascent of his second son Mahmud to power. When Mahmud became the ruler of Jazirat ibn 'Umar in 1208, Ibn al-Athir (1982, 12:281; Ibn Shaddad 1978, 233) recounts that he had his brother Ghazi's body thrown to the dogs before he gave his remains a decent burial. Mahmud is also reported to have drowned most of his father's concubines upon coming to power. Ibn al-Athir also reported (1982, 9:300), that his slave girl had worked previously for Mahmud ibn Sanjar Shah and saw him burning the faces of several of his father's concubines before throwing them into the river. Mahmud ibn Sanjar Shah, the man mentioned on the MIA ewer, was clearly regarded by the chroniclers as a despicable human being.

Ironically, despite his reputation, Mahmud ibn Sanjar Shah's name is found on several important metalwork objects: the MIA ewer, a basin, a door, and several coins. A brass basin measuring 41 centimeters in diameter and 16 centimeters in height, previously in the Sarre collection and now in the Museum für Islamische Kunst in Berlin (pl. 176), bears his name and full titles (Sarre and Mittwoch 1906, 12–13 and pl. 6; Gladiss 2006, 80 no. 31). Beyond a broad silver-inlaid inscription in *naskh* that is interspersed with interlaced knots, the rounded sides of the basin are plain and do not seem to provide us with additional information about provenance or patron. Nor does the Berlin basin relate in form or style to the decorative program of the MIA ewer or to the typical basin style attributed to Mosul.

The best-known object bearing Mahmud ibn Sanjar Shah's name is the double-door (pl. 177) of the Friday Mosque of Cizre, built in 1155, with the bronze knocker in the form of two dragons, now in the Museum of Turkish and Islamic Arts in Istanbul (nos 4282, 3749, 3750; Roxburgh 2005, 130–31, 399). The door's wooden frame is overlaid with brass elements forming twelve-pointed stars. Conservation work on the door in 1984 to 1986 revealed various repairs, including one in the first half of the thirteenth century in which fragments of brass vessels with figurative images and decoration were hammered flat as a background for the cast brass decorative elements. The inscription in *thuluth* bears the name of Mahmud ibn Sanjar Shah, clearly representing the time when the mosque was restored and the doors added. The designs of the door and the cast doorknockers were based on the door of the Artuqid palace of Diyarbakir as illustrated by Isma'il ibn al-Razzaz al-Jazari in his Automata of 1206 (Hill 1974, 136).

Finally, a number of copper coins bearing Mahmud's name, minted in Jazirat ibn 'Umar, have survived. In his discussion of the figural coins of the Jazira, Nicholas Lowick (1985, 185–86) demonstrates that the Zangids (of both Jazirat ibn 'Umar and Sinjar) used an emblem or *tamgha* of the atabek house in the shape of a double-ended anchor on their coins. This is also true of the coins minted by Mahmud's father and for Mahmud himself, as shown by a coin minted in Jazirat ibn 'Umar in 1241. What is interesting, though, is that prior to this coin, in the early part of his rule (between 1209 and 1218), Mahmud's coins depicted a seated figure holding a crescent – the astrological depiction of the moon – a motif typical on coins from the Mosul mint. According to Ibn al-Fuwati, author of an important biographical dictionary of the thirteenth century, the relationship between Mosul and the two weaker Zangid principalities of Jazirat ibn 'Umar and Shahrazur was clearly reflected by the image and legend on their coins. This explains, perhaps, the two different iconographic programs on Mahmud's coins.

Mahmud ibn Sanjar Shah, then, was not just one of the many Zangid princes of the Jazira. He was a prince of a noble descent whose inheritance was clearly usurped as a child and who grew up to form a continuous threat to the formidable Badr al-Din Lu'lu''s regency of his minor cousins in Mosul. He and his son were the last ruling Zangids.

Conclusions

Having explored the decorative program of the MIA ewer and the political context of the individual whose name is mentioned on it, how can we elaborate upon the ewer's biography?

Based on the fact that the body of the MIA ewer has a similar profile to and general dimensions as other Mosul ewers, especially the Freer ewer of 1232, it can be suggested that the body of the MIA ewer was a ready-made, mass-produced object bought in a market before it was decorated. Thus, if it was indeed Mahmud ibn Sanjar Shah who ordered the ewer, it is likely that he ordered only its decoration. Based on the kinds of objects that bear his name and their beauty and elegance, it may be tempting to regard him as the benevolent and inspired patron of the MIA ewer. But we must be cautious of such a straightforward reading because, as I have argued elsewhere (Kana'an 2009, 2012), interpreting the names of persons of influence inscribed on objects as an object's "patron" can be misleading because it does not reflect the complex nature of the medieval Islamic market or the multiple networks of craft relationships and object circulation systems that operated in the market. Attributing the MIA ewer to the patronage of Mahmud ibn Sanjar Shah does not address the obvious stylistic differences between the two brass objects that bear his name: the MIA ewer and the Berlin basin. Either piece may well have been a gift to him, and not ordered by him. In this regard, it is also important to recall the location of the name and titles of Mahmud ibn Sanjar Shah in the dedication inscription on the MIA ewer. The inscription starts to the right of the handle and ends with Mahmud's name squashed before the left side of the handle (see pl. 174), hardly the place for a signature of a patron celebrating his commission or demonstrating his magnificence. If we assume, then, that Mahmud is most probably not the MIA ewer's patron, then it might be prudent to consider other individuals in his circle of relations who would have had the motives and means to produce this object.

While certainly inconclusive, important consideration must be given to the marriage alliance between the families of Mahmud ibn Sanjar Shah and Badr al-Din Lu'lu' (for which we do not seem to have a date). This marriage provides evidence for a direct relationship between the person whose name is on the MIA ewer and the city of Mosul in which it is known that similar ewers were made and decorated (Raby 2012, 24; Kana'an 2012, 69–70). As such, the MIA ewer could have been part of the wedding presents that Badr al-Din Lu'lu' sent to his many in-laws.[14] In a recent article on the Freer ewer dated to 1232 (Kana'an 2012), I argue that the Freer ewer with an inscription in the name of Shihab al-Din Tughrul, the Atabek of Aleppo, was made in Mosul, not Aleppo, and that it was a "diplomatic" gift most probably commissioned by Badr al-Din Lu'lu' himself. This raises the question that if Badr al-Din Lu'lu' was sending inlaid ewers as gifts to other rulers in the region (as was mentioned by the thirteenth-century Andalusian geographer Ibn Sa'id), could he have sent the MIA ewer to Mahmud ibn Sanjar Shah in Jazirat ibn 'Umar as a gift?

It is fairly certain that we can place the MIA ewer in Mosul. In his publication of the Nuhad es-Said collection, James Allan (1982, 54–57) was the first to locate the MIA

177 (*facing page*) Double-door from the Friday Mosque at Cizre, Turkey, with bronze knocker in the form of two dragons, 1155. Museum of Islamic Art, Istanbul (4282, 3749, 3750).

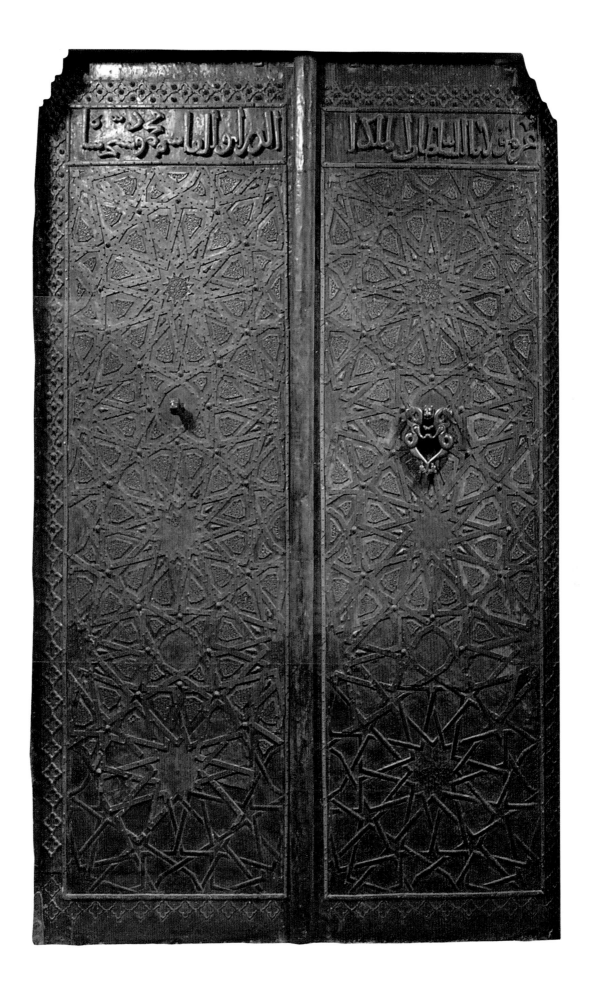

ewer on stylistic grounds both in Mosul and specifically at the workshop of Ibrahim ibn Mawaliya, whose name is on the Louvre ewer (see pl. 155). Allan based his argument on the presence of repoussé work on the neck of the ewer, the use of a plain background for a significant part of the decorative composition, and the similar way in which the irregular areas between the main motifs were filled. Allan also identified the location of Ibn Mawaliya's workshop as Mosul based on two signed objects by Ibn Mawaliya's *tilmidh* (pupil) Isma'il ibn Ward: the Benaki Museum box of 1220 (Rice 1953, 61–65) and a manuscript of *Hadith* copied in 1249 (James 1980).

Three additional points can be added to Allan's argument: first, the depiction of the two ducks as a repetitive motif, with the proviso that on the Ibrahim ibn Mawaliya ewer the ducks face away from each other, while in the MIA ewer they face each other; second, before the silver inlay was picked out of the MIA ewer, its brilliant effect would have been quite similar to the Ibrahim ibn Mawaliya ewer, as both use relatively larger pieces of silver than those of other (and later) Mosul ewers; and third, perhaps most intriguing, the knotted interlace roundels decorating the body of the MIA ewer are also found, albeit in a miniature scale, in the interlace pattern on the base of the small box in the Benaki Museum signed by Isma'il ibn Ward, the *tilmidh* (pupil) of Ibrahim ibn Mawaliya, and dated 1220 (Rice 1953, especially 64, pl. 3; James 1980). In the case of the Benaki box and the MIA ewer, there is a narrow silver band framing the roundel extending on both sides to enclose a split-palmette motif. This narrow silver band can also be linked to the silver inlay that outlines the continuous mesh pattern on the Freer ewer of 1232 made by Qasim ibn 'Ali, the *ghulam* of Ibrahim ibn Mawaliya, whose name it bears. One can perhaps postulate that the limited number of motifs and repetitive patterns on the MIA ewer represent an earlier stage that led to the development of the overall design on the Freer ewer. In addition, the use of the torus band on the ewer's neck and the use of a plain background for a significant part of its decorative program, as argued earlier, suggest the 1220s as the date for the decoration of the ewer. This range of factors confirms that the MIA ewer was most probably decorated in Mosul, specifically in the workshop of Ibrahim ibn Mawaliya where Isma'il ibn Ward, Qasim ibn 'Ali, and the decorator of the Doha ewer trained and produced their magnificent brasses.

Placing the MIA ewer in this way again raises the question of its patronage: did Mahmud ibn Sanjar Shah order the decoration of the ewer, or was the ewer a gift ordered for him by his once ally, competitor, and relative by marriage, Mosul's lord Badr al-Din Lu'lu'? Given the similarities in style, provenance, and context between the MIA ewer of the 1220s and the Freer ewer of 1232, it would be conceivable that the ewer was indeed part of a group of gifts that Badr al-Din Lu'lu' sent to several princes of the Jazira in his continuous effort to secure their allegiance. Such a re-reading of the biography of the MIA ewer and the broader group of ewers to which it belongs provides a tantalizing portrait of the Jazira in Zangid times and of the production and patronage of Mosul metalwork.

Notes

1 For a comprehensive discussion of the Mosul school of metalwork see Raby 2012 where he argues for the role of the city of Mosul as a center of production, patronage, and dissemination of inlaid metalwork on the basis of signed objects, prevalent motifs, and the conscious sense of solidarity and tradition displayed by the acknowledgment of chains of training and apprenticeship amongst craftsmen.

2 For the Byzantine/Fatimid influence, see Allan 1985, 127–40; this ewer form is clearly distinguishable from the ewers attributed to the Herat and eastern Iran, whose ewers have cylindrical necks and high spouts reflecting a different evolutionary tradition.

3 The only way to ascertain whether the ewers were mass-produced to a specific size and with specific characteristics is by carrying out detailed measurement and analysis of the group as a whole as part of a single research initiative.

4 I thank Susan Reese from the MIA's conservation department for providing me with this image. For a more recent discussion of the similarities to the Freer ewer, see Kana'an 2012.

5 I thank David Sulzberger for providing me with the pre-restoration photograph. Ahuan Islamic Art acquired the MIA ewer at a Paris auction prior to 1977, around which time it was restored by Plowden and Smith in London, UK.

6 Wild ducks remained a popular motif on Mamluk metalwork well into the first quarter of the fourteenth century, but mostly in the form of flocks encircling medallions or paired ducks in cartouches. See, for example, a brass ewer of *circa* 1300 inlaid with silver and gold in the Museum of Islamic Art in Cairo (15089), in Atıl 1981, 72–73.

7 The definitive work on al-Nasir remains Hartmann 1975.

8 In his *Tarikh al-islam*, al-Dhahabi (1998, 453) narrates that Jalal al-Din Khawarazmshah sent an envoy to the Abbasid caliph al-Mustansir seeking from him *futuwwa* status (mentioned by the chronicler as asking for the *futuwwa* trousers [*sirwal*]) and that upon receiving that privilege he committed himself to the service of the caliph. Cahen (1952, 36), on the other hand, mentions the caliph al-Nasir sending envoys to al-ʿAdil II initiating him into the *futuwwa*, suggesting that al-*futuwwa* was both granted as a privilege by the caliph and sought after by the emirs.

9 On the influence of the *futuwwa* movement on Badr al-Din Luʾluʾ and the initiation of members of his family into it, see Patton 1991, 49, 67–69.

10 Allan 1999, 56 gives two dates for the death of Mahmud: 1242 or 1250. Ibn Shaddad (1998, 2:235) and Ibn al-Athir's *al-Kamil* confirm that he died in 1250.

11 The most important chronicler of the region in this period is Ibn al-Athir, whose history written under the patronage of Badr al-Din Luʾluʾ naturally does not contain favorable accountsof Sanjar Shah and the other Zangid princes.

12 Chroniclers commonly refer to diplomatic marriages. For the marriages of Badr al-Din Luʾluʾ's children see Patton 1991, especially 48–49.

13 Most chronicles of the period conclude that he was drowned on the orders of Badr al-Din Luʾluʾ.

14 Badr al-Din Luʾluʾ's relations by marriage include two daughters who were married to high-ranking emirs in the court of the Abbasid caliph al-Nasir, and a marriage proposal attempted with ʿIzz al-Din Aybak.

p. 194: detail of glass bowl, mid-14th century. Toledo Museum of Art (Purchased with funds from the Libbey Endowment, Gift of Edward Drummond Libbey, 1944.33).

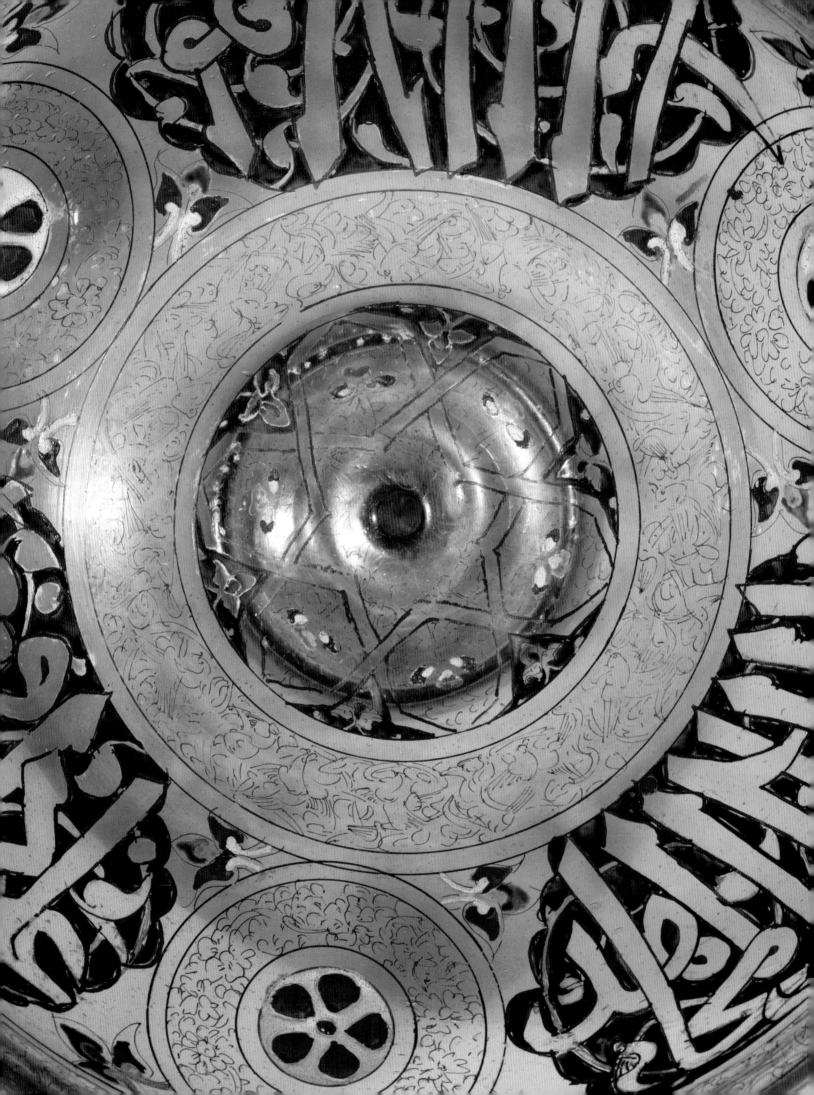

9

A Mamluk Enameled Bucket and Experiments in Glass Production

دلو مطلي بالمينا من العصر المملوكي وتجارب في أنتاج الزجاج

Rachel Ward

This bucket (pl. 178) is one of the stars in the collection of Mamluk enameled glass in the Museum of Islamic Art (MIA), Doha. The bucket was first published in 1884 when it was in the Spitzer collection in Paris (Garnier 1884, 297, pl. 1). At the sale of the Spitzer collection in 1893, it was catalogued as "travail oriental (XIVe siècle)" and was acquired by Baron Alphonse de Rothschild for the considerable sum of 14,500 francs (perhaps equivalent to $500,000 today). He had a special case (pl. 179) made to contain the bucket and the enameled blue glass bottle that he bought at the same sale (Spitzer, Chevallier, and Mannheim 1893, lot 1975 and pl. XLIX). Both objects remained in the possession of the Rothschild family until the sale of the collection of the late Baroness Batsheva de Rothschild in December 2000, when the bucket was catalogued as a nineteenth-century French copy of Mamluk glass (Christie's 2000). It was acquired with a small collection of nineteenth-century French glass in "Mamluk style by a private individual" who thought it an unusual example of such glass – and so it was! At the XVIth Congress of l'Association Internationale pour l'Histoire du Verre held in London in 2003, I gave a paper titled "Big Mamluk Buckets," in which I provided reasons – technical, analytical, stylistic, epigraphic, and historical – for believing the bucket to be fourteenth century (Ward 2005). In 2009 the bucket was again offered for sale, this time as a fourteenth-century Mamluk vessel,

178 (*facing page*) Doha Bucket (h. 21 cm), Egypt or Syria, 1350–75. MIA, Doha (GL.516.2009).

179 The Doha Bucket and bottle in the case made for them by Baron Alphonse de Rothschild in 1893 (after Christies 2000, 47).

180 (*top*) Interior of the Doha
Bucket (pl. 178) showing domed
base.

181 (*bottom*) Drawing of the
inscription on the Doha Bucket.

and was acquired by the MIA – where it was reunited with the Spitzer bottle, which
had been acquired by the museum at the Rothschild sale in 2000 (Sotheby's 2009,
94–99, lot 96).

The bucket stands 21 centimeters high and is made of thick glass with a brownish
tinge and many fine bubbles. It was blown and tooled to shape, and a separate glass
disk was applied to its base. The disk has caused the interior base to dome slightly
around the dimpled center, and the glass within the created vacuum of air has gone
milky white (pl. 180).[1] A cursive Arabic inscription in blue enamel is set against a
winding white scroll with red leaves and animal head terminals in green, yellow, white,

182 (*top*) Detail of the inscription on the Doha Bucket (pl. 178).

183 (*bottom*) Detail of the inscription of the Doha bucket (pl. 178), seen from the inside.

and black (pl. 181). The inscription indicates that the function of the bucket was to receive the water poured over the hands of its owner and his guests:

> My reward falls from the tips of fingers
> I contain cool water.[2]

The design was outlined in gold before the application of the enamels; gold lines run beneath the enamels in several places: for example, under the animal head (pls. 182 and 183). The thick red enamel ground and border of the inscription are gilded. Below this band are, alternately, lion roundels and double-headed birds. The roundels are

184 Kassel Bucket (h. 26.5 cm), Egypt or Syria, *circa* 1375–1400. Museumslandschaft Hessen Kassel (NT 396).

framed in red with gold lobes as an outer edge and a gold ground. The lion, in blue enamel, is shown striding to the left, with its right paw raised and its long tail doubling back over its rump. The double-headed eagle is outlined in red and filled with gold. Its heads are in profile, its wings outstretched and its claws clasping the dragon-headed terminals of its tail. Around the base and rim of the bucket are friezes of red palmettes, once gilded all over, with small green enamel dots decorating alternate palmettes on the lower frieze. A narrow twisted and knotted cable, outlined in red and filled with gold, runs around the vessel just above the flange.

The workshop that produced the Doha bucket made other vessels of the same distinctive shape. A bucket in Kassel (pl. 184) measures 26.5 centimeters and is decorated with a large pseudo-kufic inscription, lotus roundels, and leafy scrolls (Schmoranz 1899, pl. xxxii; Lamm 1929–30, ii, pl. 182, no. 3).[3] A second, in the Museum of Islamic Art in Cairo (pl. 185), was acquired from the Prince Yusuf Kamal collection (Lamm 1929–30, ii, pl. 182, no. 2). It measures 26.5 centimeters and is decorated with anonymous royal titles with a frieze of triangles above and below, double palmettes in roundels, and other floral designs. A third (pl. 186) was in the collection of Madame Edouard André in 1929 when mentioned by Lamm, but its present location is unknown to me (Schmoranz 1899, 33, pl. 30, profile drawing, pl. G; Lamm 1929–30, ii, pl. 179, no. 11 repeats Schmoranz's drawing). It measures about 28 centimeters and is very similar to the last

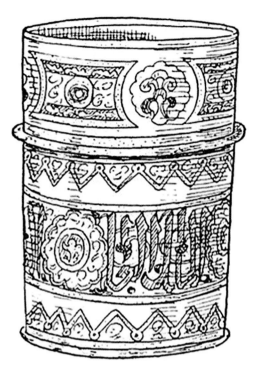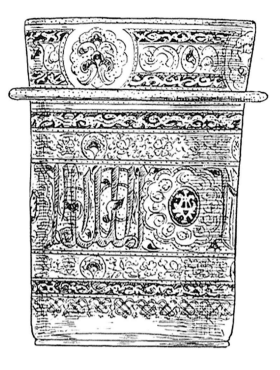

185 (*left*) Glass bucket from the collection of Prince Yusuf Kamal (h. 26.5 cm), Egypt or Syria, 1375–1400. Drawing from Lamm 1929–30, vol. 2, pl. 182, 2.

186 (*right*) Glass bucket once in the collection of Madame Edouard André (h. 28 cm), Egypt or Syria, 1375–1400. Drawing from Lamm 1929–30, vol. 2, pl. 179, 11.

one, with anonymous royal titles, double palmettes in roundels, and other floral designs. A fourth in the Gulbenkian Museum in Lisbon (inv. no. 2377; pl. 187) measures 27.5 centimeters and is decorated with anonymous royal titles and a Koranic inscription (17: 111), birds, lotus flowers and double palmettes in roundels, and other floral designs (Ribeiro and Hallet 1999, no. 8).

A fifth vessel, in the MIA, is published here for the first time (pl. 188). It is 13.5 centimeters high with a diameter of 9.2 centimeters and is blown from very green glass with a high kick under its base and a trailed foot rim. The decoration is in blue, red, white, green, and yellow enamels and gold. Around the rim is an inscription in gold on a blue ground between two rows of white dots. The inscription is very poorly written and remains undeciphered, but it does appear to be copying a real text. The body has three roundels framed by a gold leafy scroll on a blue ground; within the roundels and between them are debased versions of the double palmette motif seen on three of the four vessels described above.

Two candlesticks that are the same shape as the Doha bucket (turned the other way up and with a neck and socket attached) must also be products of the same workshop. The first (pl. 189a–c), from the Eumorfopoulos collection, was recently offered for sale in London (Sotheby's 2011, lot 26, 70–75). It is missing its original neck and socket (it now has a modern replacement) and measures 13.5 centimeters to the top of its body. It is decorated with a palmette and arabesque design in gold with drops of colored glass (many missing) and a benedictory inscription. The second (pl. 190a–b), in the Corning Museum of Glass (no. 90.1.1), measures 21 centimeters and is decorated with a complex geometric design on the body and anonymous royal titles around the foot (Schmoranz 1899, figs. 34–36; Carboni and Whitehouse 2001, no. 134).

In addition to these complete vessels, some fragments can be positively identified to come from buckets or candlesticks. A fragment of rim and flange in the Museum of Islamic Art in Cairo (pl. 191) has interlacing arches similar to those on the Corning

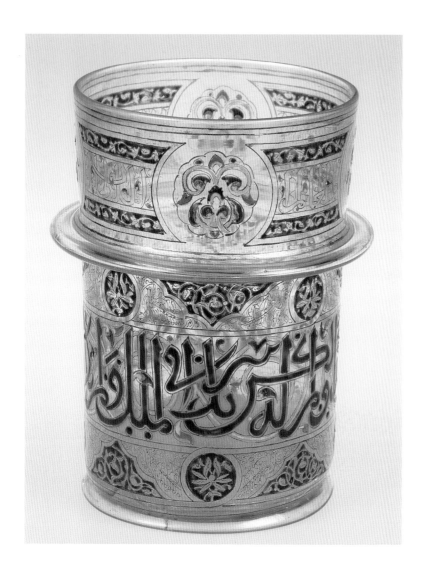

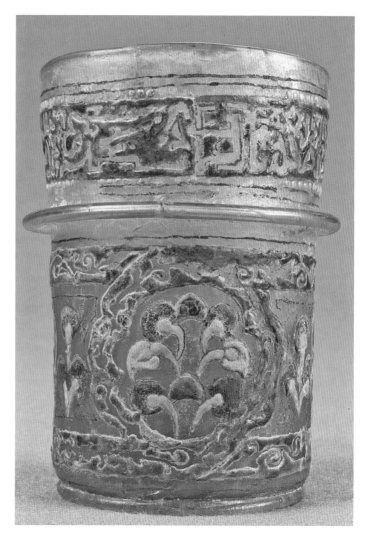

187 (*left*) Glass bucket
(h. 27.5 cm), Egypt or Syria,
1375–1400. Calouste Gulbenkian
Foundation, Lisbon (no. 2377).

188 (*right*) Glass bucket
(h. 9.2 cm), Egypt or Syria,
1390–1400. MIA, Doha
(GL.140.2003).

candlestick, but the pattern suggests that it comes from a bucket with a low rim like the Doha bucket (Lamm 1929–30, II, pl. 132, no. 26). A fragment of rim and flange from a bucket also in the Museum of Islamic Art in Cairo (no. 6075[2]) has one of a series of flying storks around the rim; the height of the rim is comparable to the Kassel bucket (pl. 192). Another fragment with a tall rim in the Ashmolean Museum (no. 6.67) is also likely to come from a bucket (pl. 193). A fragment of rim and flange from a bucket in the Antaki Collection, Aleppo, is the only example decorated with human figures to have survived (pl. 194). Between a series of roundels it has seated revellers painted in gold with red outlines and small patches of colored enamel (similar revellers occur on contemporary glass beakers and bowls, linking them to the bucket workshop). A fragment of rim and flange from a bucket with gilded frames outlined with red enamel (pl. 195) was excavated on the citadel of Aleppo (no. 19/19/1470). A fragment from the shoulder of a candlestick in the Louvre (MAO 490/100; pl. 196) has palmettes in geometric strapwork, a design very similar to that on the Corning candlestick (see pl. 190a–b). A fragment of the rim and flange of a candlestick in Cairo (pl. 197) repeats the decoration around the foot rim of the Eumorfopoulos candlestick (see pl. 189a–c). A fragment of body and flange from a candlestick in Stockholm (pl. 198) has a gold inscription on a red ground painted within the vessel similar to the inscription on the Corning candlestick (see pl. 190a–b).

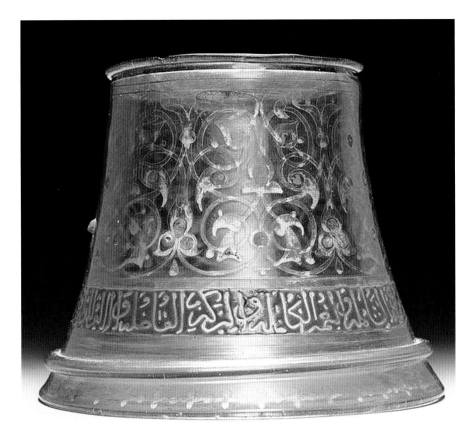

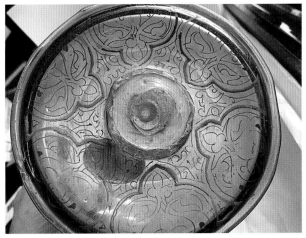

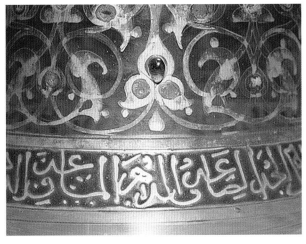

189a–c (*above*) Eumorfopoulos candlestick (h. 13.5 cm), Egypt or Syria, 1350–75. Private collection; (*top right*) Shoulder of the Eumorfopoulos candlestick (pl. 189a); (*top, bottom right*) Detail of the inscription and glass boss on the Eumorfopoulos candlestick (pl. 189a).

190a–b (*right*) Glass candlestick once in the Rothschild Collection (h. 21 cm), probably Egypt, 1340–65. Collection of the Corning Museum of Glass, Corning, New York, Clara S. Peck Endowment Fund purchase (90.1.1.); (*far right*) Shoulder of the former Rothschild candlestick (pl. 190a).

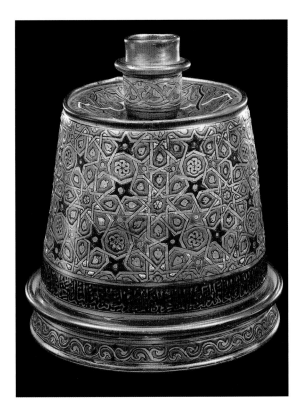

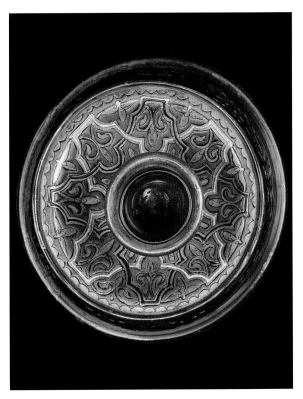

191 (*top left*) Fragment from the rim, flange, and body of a bucket decorated with lobed arches and palmettes, Egypt or Syria, 1350–75. Museum of Islamic Art, Cairo. Drawing from Lamm 1929–30, vol. 2, pl. 132, 26.

192 (*top right*) Fragment of rim and flange of a bucket with one of a series of flying storks, Egypt or Syria, 1350–75. Museum of Islamic Art, Cairo (no. 6015,2). Sketch by Rachel Ward (6075(2)).

193 (*above right*) Fragment of rim and flange of a bucket, Egypt or Syria, 1350–75. Eastern Art Department, Ashmolean Museum, Oxford (G. 67).

194 (*above far right*) Fragment of rim and flange of a bucket with figural decoration; probably Syria, 1350–75. Antaki Collection, Aleppo.

195 (*right*) Fragment of rim and flange from a bucket excavated on the citadel of Aleppo, probably Syria, 1390–1400 (19/19/1470).

196 Fragment from the shoulder of a candlestick; Egypt or Syria, 1350–75. Musée du Louvre, Paris (MAO 490/100).

197 (*below left*) Fragment of rim and flange, probably from a candlestick, Egypt or Syria, 1350–75. Museum of Islamic Art, Cairo. Drawing from Lamm 1929–30, vol. 2, pl. 132, 28.

198 (*below right*) Fragment of flange in the C. J. Lamm collection, Egypt or Syria, 1350–75. Drawing from Lamm 1929–30, vol. 2, pl. 119, 17.

The style of the vessels and fragments suggests a continuous production from about 1360 to the end of the fourteenth century. The Doha bucket and the two candlesticks are very similar in shape, and they each have a disk of glass applied to their flat base/ shoulder. The decoration of these three vessels suggests a date in the third quarter of the fourteenth century.[4] At first sight the gilded arabesque decoration on the Eumorfopoulos candlestick is markedly different from the thickly enameled geometric design on the Corning candlestick, but both designs recur on a dish in the Metropolitan Museum of Art, New York (pl. 199), confirming that the styles were contemporary and coexisted in the workshop. The inscription on the Doha bucket recurs on several metal vessels, undated but of a type attributed to the mid- and later fourteenth century (pl. 200). The arabesque design in gold with small areas of color on the Eumorfopoulos candlestick closely resembles the decoration on some of the lamps made for Sultan Hasan's mosque and dating to the 1360s, such as one in the Museum of Islamic Art in Cairo (no. 284; Wiet 1929, pl. XXVIII). The lobed arch frames that encircle the socket of the Eumorfopoulos candlestick first became popular in the 1320s, but the shoulder of the Corning candlestick has a more complex variant with overlapping arches, a design not seen on Mamluk objects until the second reign of Sultan Hasan (1354–61),

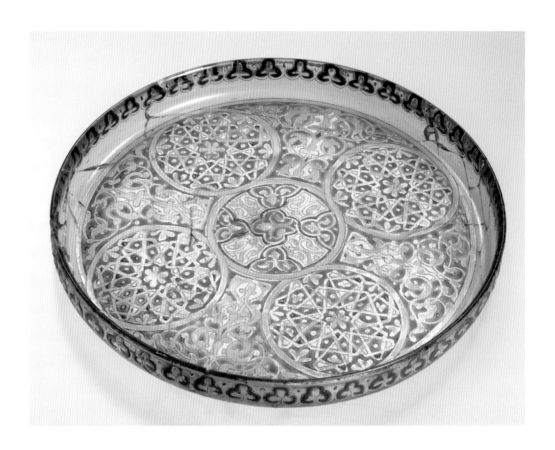

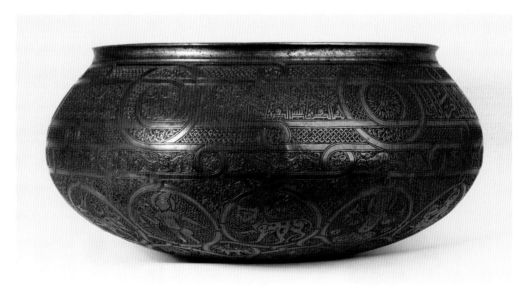

199 (*top*) Glass dish (diam. 21.6 cm), Syria or Egypt, 1350–75. Metropolitan Museum of Art, New York (91.1.1533).

200 (*bottom*) Water basin decorated with zodiac signs (h. 12.5 cm, diam. 24 cm.) Iraq/Syria, second half of 14th century. Museum of Islamic Art, Berlin (I.3590).

when it appears on enameled glass lamps and also on other glass and inlaid brass vessels. For example, several lamps made for the mosque of Sultan Hasan in the 1360s and now in the Museum of Islamic Art in Cairo (nos. 272, 289, 290, 305) feature overlapping lobed arches (Wiet 1929, pls. XXIV, XXXIV, XXXV, XLI). So does the inlaid brass sprinkler inscribed to Sultan Hasan in Cairo's Museum of Islamic Art (no. 15111; Atıl 1981, 98, no. 31). The geometric design on the Corning candlestick is first seen in Koranic illumination in the second quarter of the fourteenth century, but it became popular in other media and was widespread by the middle of the fourteenth century. It is not common on glass – such precise work was difficult to do – but an enameled

201 Glass bowl (h. 17.8 cm; diam. 36.8 cm, probably Egypt, mid-14th century. Toledo Museum of Art (Purchased with funds from the Libbey Endowment, Gift of Edward Drummond Libbey, 1944.33).

bowl made for the Rasulid Sultan ʿAli ibn Dawud (r.1322–63) in the Toledo Museum of Art (no. 1944.33; Carboni and Whitehouse 2001, 266–68, no. 132) has a smaller version of the design (pl. 201), which is almost identical to the design on the candlestick fragment in the Louvre (see pl. 196).

The Kassel, Cairo, André, and Gulbenkian vessels are all taller (26.5–28 centimeters), with a straighter profile, narrower aperture, and higher rim. They do not have the applied disk; instead the foot is finished with a high kick and a trailed or pinched foot rim. In style these vessels are closer to mosque lamps from the last decades of the fourteenth century. For example, the decorative kufic on the Kassel bucket is similar to that on lamps made for Sultan Barquq's funerary complex in Cairo, which was finished in 1386 (Cairo, Museum of Islamic Art, no. 277; Wiet 1929, pl. LXVII).

The second bucket in the MIA is similar to this last group in shape, manufacture, and style but is considerably smaller (height 13.5 centimeters; rim diameter 9.2 centimeters) and the enamels are of lower quality. A bucket fragment from the excavation on the citadel in Aleppo (no. 19/19/1470; pl. 195) is also made from green glass and comes from a vessel that is smaller than others in the group (the estimated diameter of its rim is 12 centimeters). It is part of the debris associated with Timur's invasion of Aleppo in 1399, and so is likely to date to the 1390s.

Large quantities of inlaid brass candlesticks were produced during the Mamluk period to furnish the religious foundations built by the sultans and their amirs. The

202 Brass candlestick made for the Mamluk sultan al-Nasir Ahmad (h. 17.5 cm, diam. 33.5 cm), later cut down and base added for use as a bucket, Egypt or Syria, 1342. Samuel Courtauld Trust, Courtauld Gallery, London (0.1966.GP217).

glass candlesticks and candlestick fragments are a small and cohesive group and may have been made together as experimental samples to try and break into this lucrative market. They did not become popular and were discontinued, but rather than reject the form altogether, the glassmakers removed the neck and socket and turned it over to create a bucket. The bucket shape is unparalleled in contemporary glass or other media, and it is tempting to see here the influence of European patrons who had little use for the large Mamluk candlesticks and often adapted them by removing the necks and sockets and turning them over for use as buckets (pl. 202). The bucket-shaped finger bowl does not appear to have become popular either, because the later ones have a significant change in their proportions, becoming taller and narrower with small apertures that would have been inappropriate for finger bowls. The Koranic inscription on the Gulbenkian bucket excludes a domestic function, and both the Gulbenkian and the second bucket in the MIA have the remains of a wick holder within them, suggesting that these later vessels were used as lamps, either suspended from their wide flange or placed on a flat surface.

The vessels in the group, especially the Doha bucket and the two candlesticks, have technical features that show that they are amongst the most innovative and sophisticated products of the Mamluk enameled glass workshops, overcoming many of the particular difficulties that faced enameled glassmakers in the medieval period.

Because Mamluk enamels consist largely of the same glass as the body of the vessel and become fluid at a similar temperature, they had to be fired on a pontil in a furnace, unlike modern enamels, which have a substantially lower melting point than their body glass and so can be fired, like glazed ceramics, in a kiln.[5] This was a skilled operation that risked the vessel softening and losing its shape before all of the enamels had melted and bonded with the surface of the glass. Furthermore, the enamels were colored by

203a–b (*left*) Glass lamp made for the Mamluk sultan al-Muzaffar Baybars (h. 29 cm), Egypt or Syria, 1309–10. Victoria and Albert Museum, London (322–1900); (*right*) Details of the lamp made for the Mamluk sultan al-Muzaffar Baybars showing failed enamels, detail of pl. 203a.

the addition of different agents that affected their melting point. Red, blue, and white were hard enamels, melting at around the same temperature as the body of the vessel – some had even higher melting points than the glass itself. Yellow and green were soft enamels, melting at a much lower temperature.[6] Despite the variation in their melting temperatures, the enamels were all fired together rather than risk multiple re-entries into the furnace. Great skill and experience were required to fire enamels with different melting points simultaneously. If too little time was allowed, the hard enamels would not adhere or would remain a dirty gray color or appear bubbly because the organic matter in the glass had not had sufficient time to burn off. If too much time was taken, the soft enamels "overcooked" or spattered.

The lamp made for Sultan Baybars II (r. 1309–10) is a splendid object (pl. 203a–b), but it has various faults that illustrate these challenges. The vessel has slumped badly to one side during the firing of the enamels (much more noticeable in life than in the photo-graph – museum photographers always arrange the object to look its best). The enamels

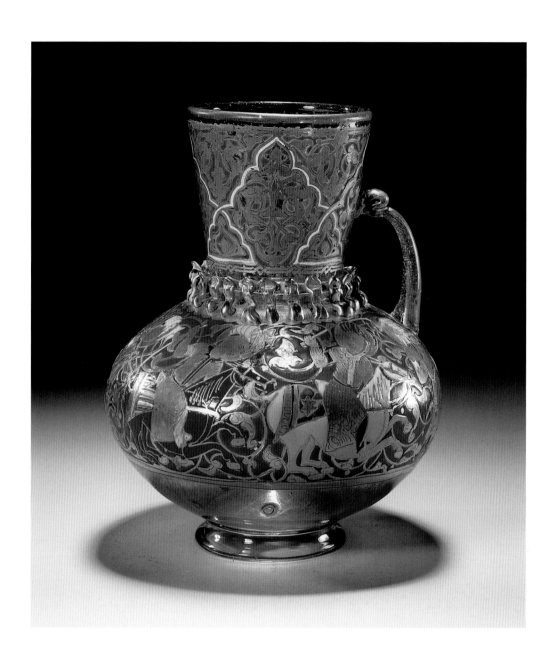

204 Rothschild tankard (h. 18.4 cm), Egypt or Syria, 1350–75. Present whereabouts unknown.

themselves are not all successfully fired. Bits of the blue inscription are missing, and the tiny areas of yellow and green enamels are reduced to gray bubbles on the surface of the glass (pl. 203a). The glassmaker did not even attempt to enamel the underside of the lamp, which faced out towards the glassmaker and so received less direct heat.

Half a century later, the craftsmen responsible for the two candlesticks and the Doha bucket had overcome these difficulties and produced vessels that have retained their shape and are decorated with a full range of colors, including both hard and soft enamels, thickly applied and well fired. Experience and skill may explain their success, but glass-makers were also experimenting with the chemical constituents of the individual enamels. Analyses of some yellow and green "soft" enamels suggest that they have been purposely "hardened" by halving the levels of lead and doubling that of silica, to bring their melting point closer to other enamels.[7] The experiments also enabled them to expand their range of colors. The Doha bucket has a new color, dark brown, seen first on lamps made for Sultan Hasan in the 1360s. The same color is used for the boots and parts of the costume of the rider on the Rothschild tankard (pl. 204).

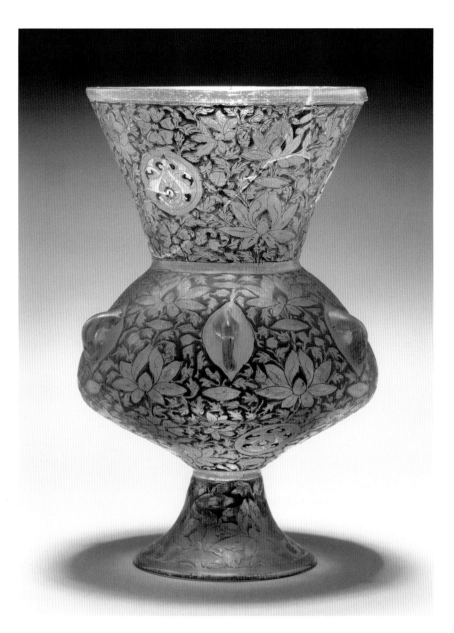

205a–b (*left*) Glass lamp made for the Mamluk sultan al-Nasir Hasan (h. 38.5 cm), Egypt, 1360s. British Museum, London (OA 1881.9–9.3); (*right*) Detail of the lamp made for al-Nasir Hasan (pl. 205a).

Designs on glass were usually drawn in gold suspended in a liquid medium such as gum arabic. The fluid gold drawing can still be seen inside the vessels.[8] To increase their visibility, small inscriptions and fine designs needed a colored ground to contrast with the gold. But it was a laborious process to surround these fine lines with enamels, difficult to do accurately and with a high risk that the enamel mixture would flood the fine lines by dripping down the side of the vessel when applied or by spreading out when fired. Such detail was a less important issue for mosque lamps, which hung too high for close inspection. The blue enamel on a lamp made for Sultan Hasan's mosque is so uneven and inaccurate in its application that the gilded floral design would be unintelligible without the red lines sharpening the outlines (pl. 205a–b). But secular vessels, made to be handled and admired at close quarters, required more intricate designs than mosque lamps. Glassmakers evolved different methods of achieving them.

One method can be seen in the gold inscription around the base of the Eumorfopoulos candlestick (see pl. 189c). The blue enamel ground is so thick that it bulges around the gold letters and their small diacritical points, yet they remain crisply legible.

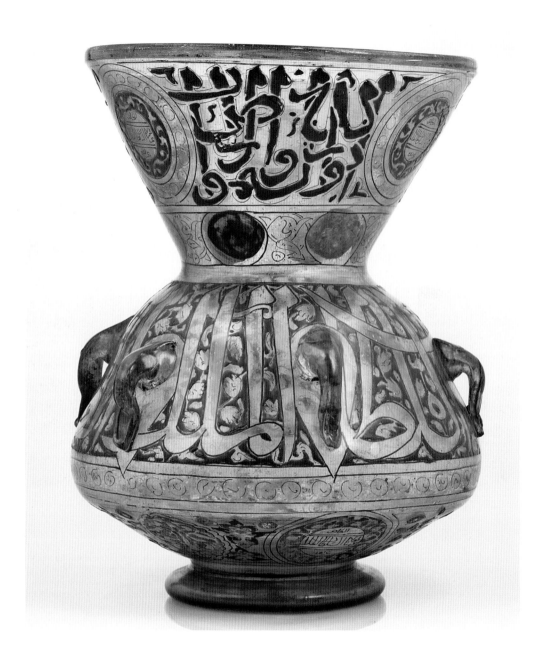

206 Lamp made for the Mamluk sultan al-Zahir Barquq, Egypt, *circa* 1386. MIA, Doha (GL.52.2002).

The only way to achieve such accuracy was to use some sort of resist on top of the gold, perhaps an oil or waxy product that burned off during the firing of the enamels. Close inspection of the edges of the letters reveals a hairline crack where blue enamel abuts the gold script. This crack is not present at the top or bottom of the band of blue enamel, suggesting that some resistant substance was mixed with the gold of the inscription, or applied on top of it, to hold back the enamel. A similar technique seems to have been used on some of the lamps made for Barquq's complex completed in 1386, including the lamp in the MIA (pl. 206; for a discussion and illustrations of the use of a resistant on this mosque lamp, see Ward 2012, 70 and pl. 9). The frieze of colored horsemen on the Rothschild tankard would have been impossible to achieve without a resist to hold back the enamels to protect the thin gold lines separating horse from ground, boots from horse, etc. (see pl. 204). A related technique known as *cuerda seca*, in which a waxy mixture is used to separate colored glazes on tiles, evolved in Iran in the third quarter of the fourteenth century (for a new discussion of the

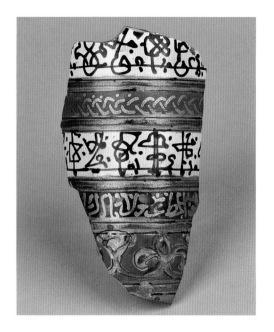

207a–b (*left*) Fragment from a beaker decorated on both exterior (a) and interior (b) with gilded red enamel (h. 17.8 cm), Egypt, 1350–75. Museum of Islamic Art, Berlin (1.2435); (*right*) interior of the fragment shown in pl. 207a.

evolution of *cuerda seca*, see O'Kane 2011). The timing suggests that there may have been some technical exchange between the glass and ceramic industries.

Another method of placing a colored ground behind intricate gold designs can be seen on the Corning candlestick (see pl. 190a–b) and on the candlestick fragment in Stockholm (see pl. 198). A thin layer of enamel has been painted inside the glass, behind the gold inscription, allowing the calligrapher to write freely in a loose and busy style that would have been impossible to outline successfully with enamel, even if a resist had been used. This solution was possible only after the enamelers had learned how to lower the melting point of the interior enamels (which received no direct heat as the body glass was between them and the furnace) by the addition of 35–45 per cent lead (Freestone and Stapleton 1998). This labor-saving technique first appears in the decoration of mosque lamps in the 1340s, but became popular very fast and is seen on many later lamps.[9] For example, red and green roundels are painted within the mosque lamp made for Barquq (see pl. 206). The presence of this technique enables many undated vessels, such as the Corning Candlestick, to be dated to the 1340s or later.

Understanding how lead could reduce the melting point of enamels lies behind another innovation: the use of a thick impasto enamel, modeled to give a relief effect and then gilded. The Doha bucket uses this technique for the palmettes around the base and rim, the frames of the decoration, and the background of the inscription. The red impasto enamel on the Doha bucket has not been analyzed, but unpublished analyses of similar impasto red enamel on fragments reveal it to be rich in lead (50 per cent on one object), a fact that explains how such thick enamels could be used alongside thinner enamels.[10] The impasto technique probably evolved around the same time as high lead enamels painted within the vessel, in the 1340s or later. Some of the most sophisticated examples of this technique survive only in fragments. No doubt they were a popular choice for Mamluk banquets – not an environment that would have maximized their chances of survival. The fragment from a beaker in Berlin (Museum für islamische Kunst, 1.2435), which was found at Fustat, combines the impasto technique with high-lead red enamel painted behind the glass to give contrast to the gold inscription (pl. 207a–b).

A Mamluk Enameled Bucket and Experiments in Glass Production　　213

The application of trails or spots or bosses of molten glass is a more traditional way to create a relief effect on the surface of a glass vessel, but the second firing for the enamels complicated the use of molten glass. If the trails or bosses were applied before the second firing, their shape might be distorted by the heat of the furnace, but if they were applied afterwards, it was difficult to heat the vessel sufficiently for them to bond with the body glass without damaging the enamels. The Rothschild tankard has numerous trails applied around the base of its neck and later gilded (see pl. 204). They were applied before the enamels and have collapsed slightly during this second firing, but still make a strong visual effect. The colored glass bosses on the Eumorfopoulos candlestick were applied after the enamel decoration had been fired and most have dropped off (see pl. 189a–c). It is significant that the glass behind the inscription has been slightly distorted as the thick blue enamel fused with the wall of the vessel, but the glass behind the bosses is smooth, presumably because the heat did not penetrate far enough into the wall of the vessel. The difficulty of combining enamels and applied glass on the same vessel may explain why so few of them do so.

Returning the completed and decorated vessel to the pontil to fire the enamels in the furnace put great strain on the glass body where the pontil was attached. As Stefano Carboni has pointed out, the base of the Cavour vase was broken when the pontil was cracked off after firing the enamels and had to be hastily fitted with a random dollop of glass (Carboni and Whitehouse 2001, 260–63, no. 129). Disks of glass were applied to the bases of thin-walled vessels, such as beakers and jugs, to reinforce that area. The three earliest vessels in the sequence, the Doha bucket and both candlesticks, all have this applied disk of glass. The application of the glass pad results in a distinctive domed interior with the apex of the dome (part of the inner wall of the vessel) coming down to join with the center of the outer pad of glass (Tait 1998, 52–53, describes with a series of diagrams how the disk of glass was applied).

The later buckets/lamps do not have this pad of glass. On these vessels, the base is finished with a high kick, and its outer edge is protected with a trail of glass. A similar development can be seen in the manufacture of enameled glass beakers. Early beakers have the additional disk of glass to strengthen their base, but later examples do not. Apparently, toward the end of the fourteenth century glassmakers were more confident in their handling of the vessel when firing the enamels in the furnace. This confidence might indicate that the differential between the melting points of the body glass and enamels had been increased, either by raising the melting point of the body (I have noticed a trend towards higher silica in the body glass of later vessels but more analyses are needed to confirm this) or lowering the melting point of all of the enamels (by the addition of lead), or both.

These candlesticks, buckets, and lamps contradict the long-established view that the best and most sophisticated enameled glass was produced in the thirteenth century and that the enameled glass industry was in decline in the fourteenth century.[11] The workshop that produced them was at the forefront of developments in enameled glass, experimenting with technology in order to achieve more successful results. Even the

latest vessels, clearly produced with speed and less attention to detail, include technical innovations that show that glassmakers were still honing their skills at the end of the fourteenth century.

Notes

1 Tait 1998, 52 gives diagrams illustrating how the pad of glass was attached to the base of the vessels like this.

2 The same verse recurs on some fourteenth- and fifteenth-century Mamluk metal bowls and there have been various suggested readings, but they all refer to the object as a fingerbowl. Sarre (Sarre and Mittwoch 1906, 103) translated the inscription on the Berlin bowl as "Die zehn Finger haben mich zum Gefass gebildet, ich umfasse kuhles Wasser" (Ten fingers made me. I contain cool water.) In 2005 I translated the bucket inscription as "Indeed, dust of the fingers is my reward, I contain pleasant water" (Ward 2005). In Sotheby's 2009 (lots 96, 98) Doris Behrens Abouseif translated it: "I am a toy for the fingers shaped as (in the form of) a vessel, I contain cool water." The exact reading and translation remain elusive.

3 The Kassel bucket may have been collected by the Landgrave princes in the medieval period. It features in the original museum inventory of 1770, but was moved to the Lowenburg display later in the eighteenth century.

4 Carboni suggests that the Eumorfopoulos candlestick is several decades earlier than the Corning candlestick, but does not give reasons for this difference in date (Carboni and Whitehouse 2001, 270).

5 Practising glassmaker William Gudenrath was the first to demonstrate that medieval enameled glass had to be returned to the furnace for a second firing on the pontil.

6 Analyses of Mamluk enamels by scientists such as Ian Freestone, Colleen Stapleton, Julian Henderson, Marco Verita, and James Peake have made a huge contribution to our knowledge of the technology of Mamluk glassmaking. For a discussion of the properties of soft and hard enamels, see Freestone and Stapleton 1998, especially 126–27.

7 For published examples, see the analyses of glass fragments in the Ashmolean, Oxford in Henderson and Allan 1990, 176–77, Table 1, particularly the results for G66 and G68. More analyses are needed to establish that this was a trend.

8 It was hard to achieve that fluidity with powdered enamel unless it was very dilute; red lines used in the design have an uneven scratchy appearance like writing with a ballpoint pen that is running out of ink.

9 The lamp in the Bargello, Florence, which was made for Tughaytimur's *khanaqah* and finished in 1345, is the earliest datable vessel to use high lead enamels: it has red bands and bright green medallions (Ward 2012, 66, pl. 6).

10 Non-destruction x-ray fluorescence analysis of the red impasto enamel on a beaker in the British Museum (Waddesdon Bequest, no. 53) revealed that it had very high lead levels, as documented in an internal report by Ian Freestone, 18 May 1992.

11 C. J. Lamm (1929–30) first outlined a chronology for Ayyubid and Mamluk enameled glass in his two-volume work on Islamic glass, arguing that enameled and gilded glass was produced from the late twelfth to the early fifteenth century but that the most sophisticated enameled vessels were made during the thirteenth century and that the industry entered a long decline in the fourteenth century and finally collapsed in the fifteenth century.

p. 216: detail of silk-and-gold tapestry-woven medallion, first half of the 14th century. David Collection, Copenhagen (30/1995).

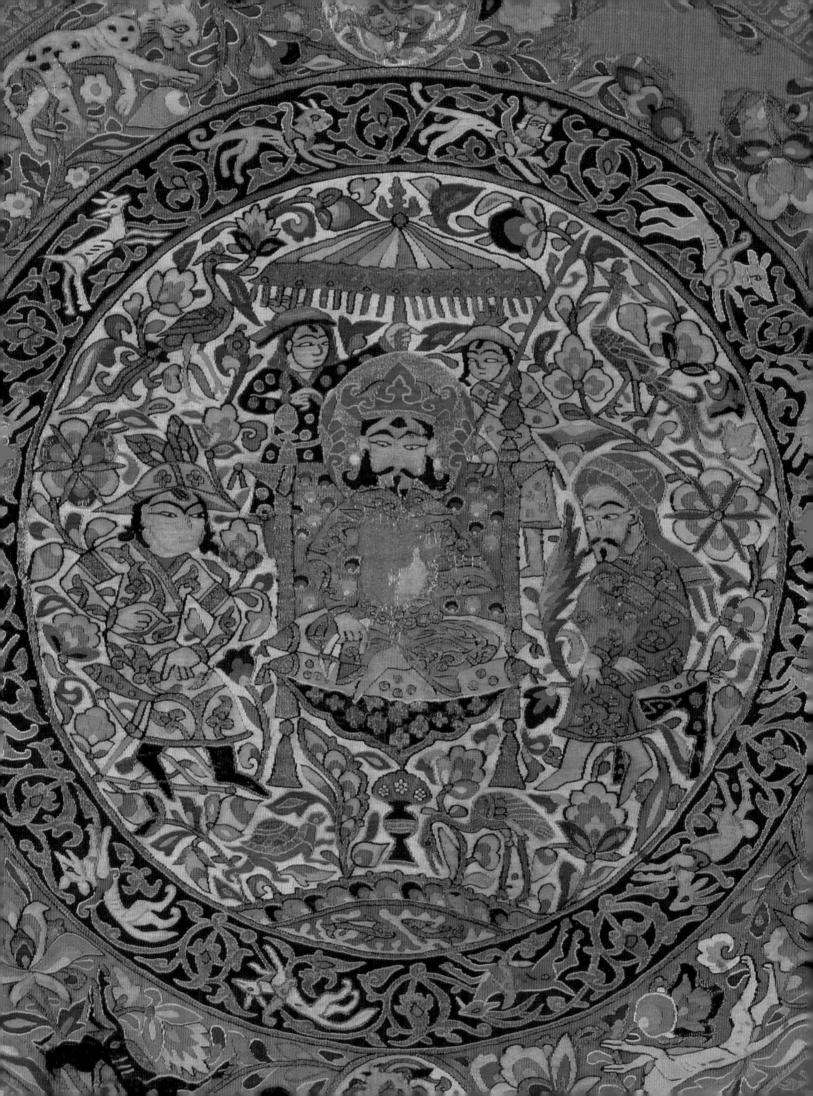

10

*A Set of Silk Panels from
the Mongol Period*

مجموعة من لوحات الحرير من عصر المغول

Kjeld von Folsach

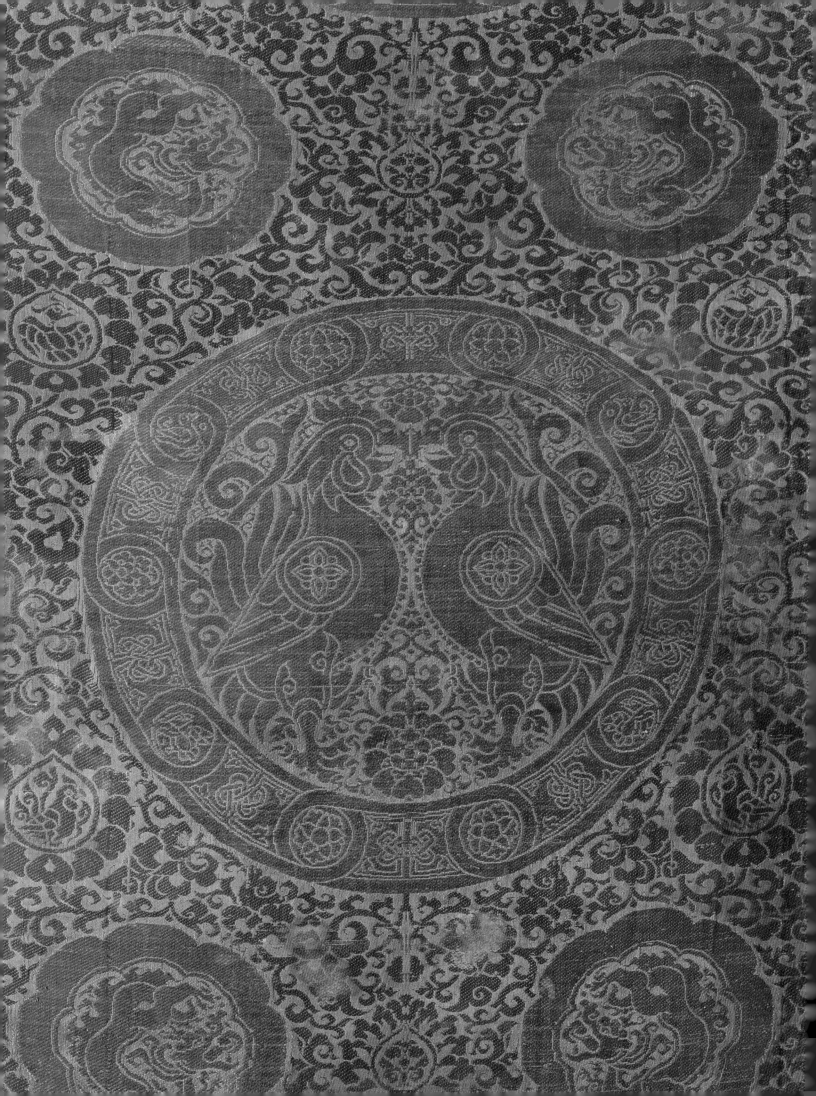

Beauty is one of the keywords for this volume of essays and the Symposium on which it is based, and I can hardly think of a group of objects of Islamic art that embraces this concept more convincingly and graciously than textiles. Besides their aesthetic qualities, textiles – especially early and medieval ones – played a highly important role, whether social, political, or utilitarian, in the society and culture that Lisa Golombek (1988) once very much to the point described as "the draped universe of Islam."[1]

Among the different world civilizations, the Islamic is perhaps the one that is influenced to the highest degree by the culture of the nomads – whether Arab, North African, Persian, Central Asian, or Mongol. Portable goods therefore played a significant role even in the minds and daily life of the sedentary strata of Muslim societies. Among these goods, textiles were some of the most prominent, be they clothing, tents, draperies, carpets, bags, or cushions.

For a person living in our industrialized world, it can be difficult to understand why luxury textiles were so greatly admired and why they were so costly in the pre-modern world. At least I had not considered it when I started at the David Collection in 1984, coming as I did from a background in European, post-Renaissance studies. My predecessor there as director, André Leth, took me around the collection to educate me. He told me of the high level of artistic and technical skill needed to create these complex works of art; about the costly materials and dyes brought in from all parts of the civilized world; and about the great esteem in which textiles were held in medieval society – a fact conveyed to us through innumerable contemporary sources.

When I asked Leth somewhat impertinently why, then, there were so few medieval textiles in the David Collection, he replied with some resignation that except for fragments found in the dry sand of Fustat (old Cairo), textiles from before 1500 were incredibly rare. He pointed out that most of them had survived in Europe in church treasuries or in princely tombs, and that most of these pieces had found their way long ago to the famous old museums.

History, and indeed the collection of the Museum of Islamic Art (MIA) in Doha, luckily proved Leth wrong. I am certainly not mocking my predecessor. Perhaps he could have predicted that there would still be fine textiles in private hands, but there was no way he could have foreseen the wealth of fabrics and robes that would come out of Tibetan monasteries from the 1980s, owing to changed political circumstances, or out of the arid lands of the Asian steppes.

One group of historical textiles that has expanded dramatically through these discoveries comprises fabrics woven in the Mongol Empire, stretching from China in the east, across Central Asia and the Islamic world as far as Mamluk Syria, Byzantium, and Eastern Europe in the west. This new material has found its way into museums and collections, public as well as private, and it has generated a substantial amount of new research focusing on the Mongol period, roughly from the early part of the thirteenth century to the middle of the fourteenth.

In the 1980s and 1990s, Anne Wardwell published a series of groundbreaking articles on Mongol textiles, or *panni tartarici*, as they were called in contemporary Western

208 (*facing page*) Detail of silk-and-gold lampas panel decorated with cockerels (pl. 213), Central Asia, *circa* 1300. David Collection, Copenhagen (40/1997).

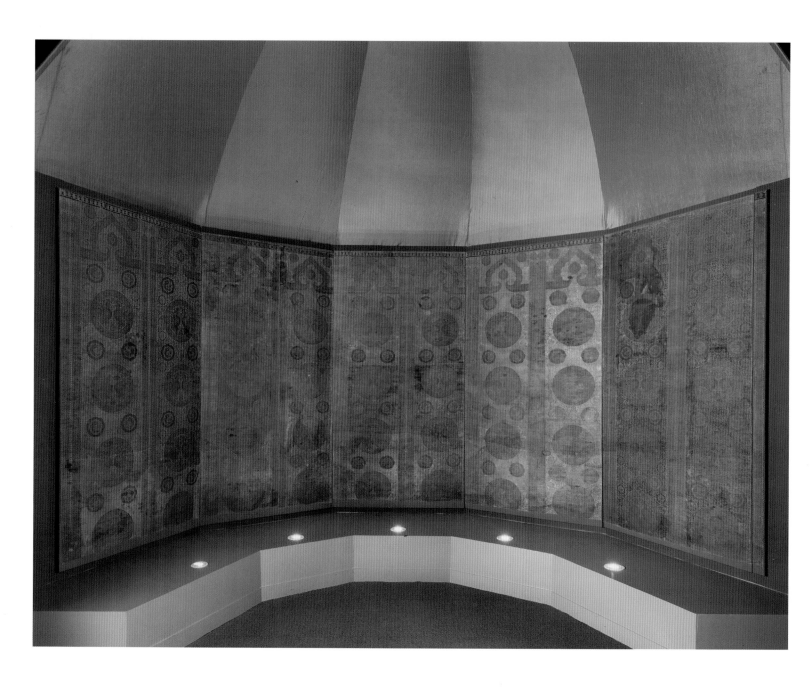

209 Silk-and-gold lampas panels decorated with cockerels, seven individual pieces, Central Asia, *circa* 1300. MIA, Doha (TE.40.2002).

inventories (Wardwell 1987, 1989, 1992, 1992–93). Her research culminated in 1997 with the exhibition *When Silk was Gold*, held at the Metropolitan Museum of Art, New York and co-curated with James Watt (Watt and Wardwell 1997). The same year, Thomas Allsen published his brilliant book *Commodity and Exchange in the Mongol Empire*, in which he explored the cultural history of the period's textiles (Allsen 1997). In 1993, in collaboration with our conservator, Anne-Marie Bernsted, I myself had written on the Mongol textiles then found in the David Collection (von Folsach and Bernsted 1993). In 2002, Linda Komaroff and Stefano Carboni presented *The Legacy of Genghis Khan*, a fine exhibition in New York and Los Angeles that highlighted the whole period and put the textiles into context (Komaroff and Carboni 2002). Around the same time, several other scholars dealt with the topic, for example, Feng Zhao (1999), Yuka Kadoi (2009), and Markus Ritter (2010). At the end of 2010, *The Legacy of Genghis Khan* was followed up by *The World of Khubilai Khan* exhibition (Watt 2010), and in 2011 just before I left for the conference in Doha, I received a new publication by Karel

210 Map of the Mongol Empire (from Carboni and Komaroff 2002).

Otavsky and Anne Wardwell on medieval textiles between Europe and China in the Abegg-Stiftung (Otavsky and Wardwell 2011). In addition to this wealth of publications, new textiles and robes from the Mongol period are still turning up frequently, so it will probably take a long time before the last word has been said on this group – if it ever is.

In this essay I will concentrate on a set of magnificent lampas-woven textiles that is shared between the MIA and the David Collection in a very uneven proportion: ten "arches" in the MIA (pl. 209) and one "arch" in the David Collection (see pl. 213).[2] I will begin with a short note on the Mongols, then return to the panels, make a few digressions, present a surprise, and finally try to sum up.

Around 1206 the Mongol leader Genghis (or Chingiz) Khan unified the many tribes of his nomadic people. By the time of his death in 1226, he had created a vast empire that included Mongolia, northern and western China, Central Asia beyond the Aral Sea, and also northern Iran and Afghanistan. This huge area was further expanded by his successors, and for the first and only time, eastern and western Asia were joined in one empire (pl. 210). Since the Mongols had no given rules of succession, they had to choose new leaders, quite often after heated debate or fighting. Genghis Khan had four sons, each of whom directly or through successors would become Great Khans, or leaders, in one of the four khanates into which the empire would eventually divide: the Empire of the Great Khan (Yuan China); the Chaghatay Khanate of Central Asia; the Golden Horde in Russia; and the Ilkhanate in Afghanistan, Iran, and Iraq. Before

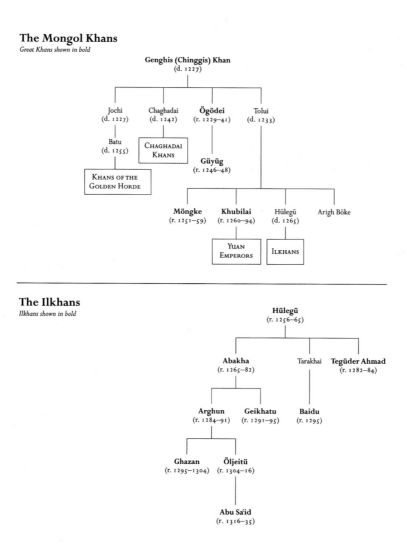

The Mongol Khans
Great Khans shown in bold

Genghis (Chinggis) Khan
(d. 1227)

Jochi (d. 1227) — Chaghadai (d. 1242) — **Ögödei** (r. 1229–41) — Tolui (d. 1233)

Batu (d. 1255)

CHAGHADAI KHANS

KHANS OF THE GOLDEN HORDE

Güyüg (r. 1246–48)

Möngke (r. 1251–59) — **Khubilai** (r. 1260–94) — Hülegü (d. 1265) — Arigh Böke

YUAN EMPERORS

ILKHANS

The Ilkhans
Ilkhans shown in bold

Hülegü (r. 1256–65)

Abakha (r. 1265–82) — Tarakhai — **Tegüder Ahmad** (r. 1282–84)

Arghun (r. 1284–91) — **Geikhatu** (r. 1291–95) — **Baidu** (r. 1295)

Ghazan (r. 1295–1304) — **Öljeitü** (r. 1304–16)

Abu Saʿid (r. 1316–35)

211 Genealogy of the Mongols (from Carboni and Komaroff 2002).

the empire began to disintegrate completely, four of the Chingizids ruled as Great Khans: Ögödey, third son of Genghis; Ögödey's son Güyüg; Möngke, the oldest son of Genghis's fourth son Toluy; and Möngke's brother Kublai (Qubilay), the conqueror of Song China (pl. 211). Toluy's younger son Hülegü is of special interest for the Islamic world, as he was sent by his brother Möngke to finalize the conquest of the Islamic west, culminating in the sack of Baghdad in 1258. Later, Hülegü and his successors governed Iraq and Iran as Ilkhans – "subservient khans" – until the middle of the fourteenth century.

The Mongols have a nasty reputation as merciless destroyers of cities and entire populations unless the conquered submitted to their power immediately. This is largely true, but the Mongols also created an immense empire where trade and ideas could move freely under the aegis of the Pax Mongolica. Open-minded and less self-centered than dynasties in many of the older cultures, they were aware that they needed the knowhow of the sedentary peoples they had conquered. As a result, artists and craftsmen were often spared execution and forcibly removed from their homelands to different centers in the empire to work for their new masters. The Mongol capital of Karakorum (Qara Qorum), built between 1251 and 1259 during the reign of Möngke Khan, for example, featured architecture and decoration that took inspiration from both

East and West, and archaeological excavations and literary sources prove that craftsmen came there from all the lands conquered at that time (Allsen 1997, 34–35). This interchange resulted in a fairly unorthodox culture where people from all religions or cultural backgrounds were taken seriously if they could contribute something. In the arts, this meant that motifs and techniques from East and West were joined in an eclectic or synthesizing way, and new expressions were created.

Textiles were a commodity of the highest importance for nomads, and this was certainly true of the Mongols, both before and after they became rulers of any empire They were particularly fond of textiles woven with gold thread – a type they called *nasij*, from the Arabic verb *nasaja*, to weave. In time, *nasij* became synonymous with cloth of gold and silk (Allsen 1997, 2–3). In the beginning, these complex textiles were traded, looted, or received as tribute, but later they were also produced in Mongol centers by foreign weavers.

At court, luxury textiles were naturally used as an expression of power and splendor, and demand was enormous. Tents and other forms of architecture were draped in *nasij*. The entire court was clad in golden robes presented by the ruler, while other garments were bestowed upon visitors. The Mongol princes also gave uncut bolts of *nasij* as gifts (Allsen 1997, 23), perhaps one explanation for the many untailored pieces originating from Tibetan monasteries. Gold in general is associated in many societies with kingship, but it would appear that the Mongols in particular considered gold an imperial color, just as purple was associated with the Byzantine emperors and black with the Abbasid caliphs (Allsen 1997, 60–70; von Folsach and Bernsted 1993, 18). The quantity of gold thread in preserved, high-quality Mongol textiles to some extent speaks for itself.

Most sedentary societies paid serious attention to architecture and its decoration. So did nomadic societies, but their dwellings were made not of stone or brick, but of textiles. The traditional Mongol tent was the *yurt* or *ger* – a wooden trellis supporting a felt cover. In general, the tents from western Asia had pole constructions covered by fabric stabilized by external guy ropes (pl. 212). Neither the pictorial nor the many written sources give us an exact idea of what the great imperial tents looked like in the period, but they could be huge, holding up to one thousand people and lined with golden silks (Allsen 1997, 13–15). They were as impressive as "real" architecture, and magnificent tent cities were the rule rather than the exception among the great Islamic dynasties in the east for centuries to come (von Folsach 1996b). The panels we are going to examine now were most probably woven to decorate the interiors of such tents.

As far as I am aware, the history of the panels is as follows: in January 1997, the Hong Kong-based art dealers Plum Blossoms offered the David Collection one complete panel – that is, two arches supported by two columns on the left side, two in the middle, and none on the right side. In May of the same year, this group had grown by four pieces: a complete panel, a complete panel cut in two halves vertically, and a narrow strip consisting of one column. A year later, two more complete panels were added (see pl. 209).[3] In the meantime, still during 1997, the David Collection had bought half a panel from another art dealer, Jeremy Pine (see pl. 213). This makes a total of eight pieces, seven of which are in the MIA today. All panels originally came from the same

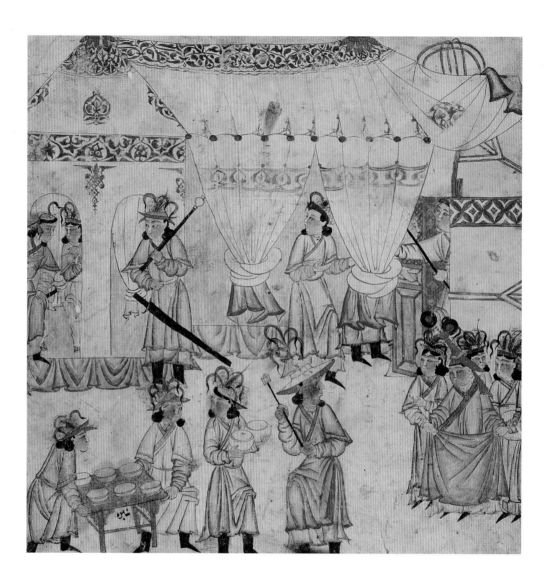

212 Colored drawing of an imperial tent from a copy of Rashid al-Din's *Compendium of Chronicles* (25.8 × 25.8 cm) Iran, early 14th century. Bildagentur für Kunst, Kultur und Geschichte, Berlin (Diez A fol. 70, S. 18, no 1).

dealer, and all panels had come from Tibet, where they had reportedly served as a baldachin. As far as I know, no further panels of this group have surfaced since.

A full panel from selvedge to selvedge is approximately 124 centimeters wide, and all are between 220 and 228 centimeters high. All the panels have been cut at the top and some at the bottom, though a few, including the one in the David Collection, have their original starting or finishing band preserved (pl. 214). As with most Mongol lampas-woven textiles, the selvedges end in a fringe formed by weft loops (see pls. 214 and 215).

Here I shall not – and cannot – present an in-depth technical analysis of these very complex lampas-woven textiles, but I would like to draw the reader's attention to a few details using the David panel as an example.[4] The main colors in the textile are coral red and gold. The background for the coral-red and golden ornaments is yellowish beige with a pink tone, but it is an optical effect obtained by mixing red and yellow silk threads. At the top, in and around the pearl border, aubergine-colored silk is used in the upper part, but, rather surprisingly, the aubergine-colored silk is mixed with a greenish-yellow silk in the lower part of the border and in the stripe below (pl. 215).

The gold threads are even more unusual (pl. 215). All the gold thread below the pearl border and its frame consists of fairly thin paper strips gilded on the outside and wrapped around a yellow silk core. The pearls in the pearl border and the four narrow

bands constituting a framework over and under them, however, have gold strips woven flat. This is a refinement that is seen in a small group of Mongol textiles, one that brings the fabric to life, since light is reflected differently off wrapped and flat gold. But what is quite inexplicable and unique here is that while the lower part of the pearls and three of the surrounding bands are woven with rather thick and wide paper strips gilded on both sides, the top of the pearls and the lowest band are woven with narrower gilded strips of animal substrate, also gilded on both sides. I am not sure if this observation is valid for the MIA pieces as well; it will have to be confirmed when the panels are not on display. Before the Mongols, paper-based gold thread was normally associated with China (Wardwell 1992, 364), whereas animal substrate was most common in the West. A mixture of both in the same textile is highly unusual, especially in the same pattern type. Flat-woven gold was first used in China, but its usage moved westward in the Mongol period (Watt and Wardwell 1997, 134–35). It is incidentally interesting to note how in this case paper has survived much better than animal substrate.

Although the group of panels was most probably produced as one commission, the pieces were woven on different drawlooms, and the split MIA panel shows minor differences. Whereas all the other panels, including the one in the David Collection, have five pearls between the interlocking elements in the golden framework, the split MIA panel has four (pl. 216). It is also the only one to have wrapped, not flat, gold thread in the pearls and the framework; another difference is that the cockerels in the big medallions have red pupils. On art-historical grounds, the David panel and the rest of the group can be attributed to the late part of the thirteenth century or the first half of the fourteenth century, a date partly supported by carbon-14 testing carried out in 1993.[5]

As expected, the individual motifs in these magnificent textiles belong to the synthesizing type

213 Silk-and-gold lampas panel decorated with cockerels (228 × 63.5 cm), Central Asia, *circa* 1300. David Collection, Copenhagen (40/1997).

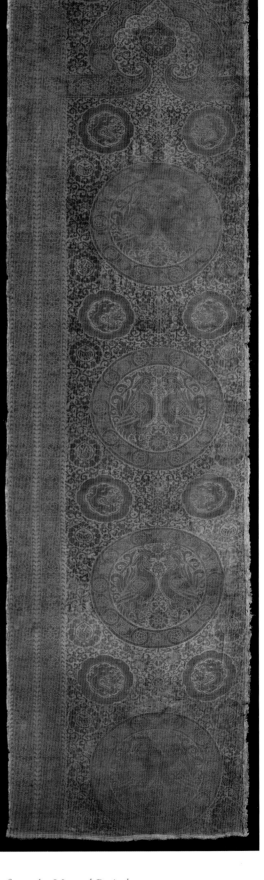

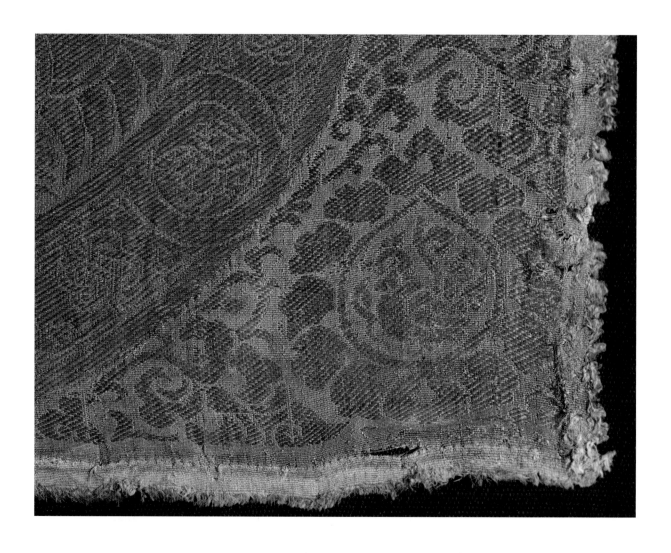

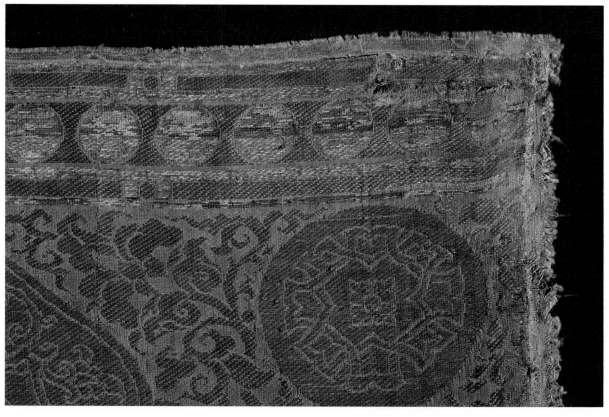

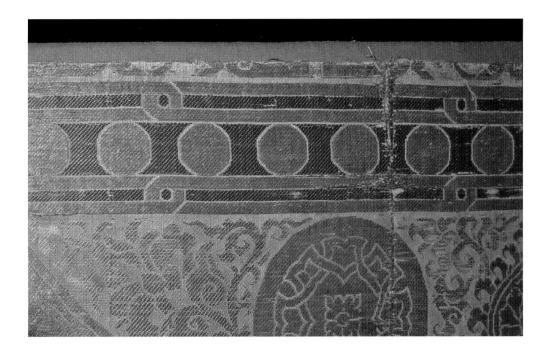

216 Top of the split panel
(see pl. 209).

characteristic of the Mongol period, but two features – the overall architectural layout and the fact that the panels were so obviously designed to be joined and sewn together to form an entity, with no columns on the right side – are quite unusual in the period. The niche as such – and indeed the mihrab – is a leitmotif in Islamic art, but even as an architectural phenomenon, whether structural or decorative, or as a decoration on objects, the niche, arch, and arcade are major motifs in the West. Admittedly, the somewhat eccentric arch, lintels, and spiky columns here have a flavor of their own that is not easily paralleled.[6]

The vegetal motifs display influences from East and West. The stylized lotuses and peonies point to the East, while the dense overall design with split leaves points to the West. The somewhat unusual vine on the arch appears to be a hybrid. The vine has its origins in the West, but here it has a strong Far Eastern flavor.

The medallions – plain or lobed roundels or slightly teardrop shapes – are the dominant elements in these textiles, apart from the architectural framework. The small medallions under the pearl border contain interlacing reminiscent of similar patterns in Islamic art, and this is true to an even greater extent of the borders of the large roundels (see pl. 213 and detail in pl. 208). They have a calligraphic, kufesque character,[7] and the interlocking bands forming ten little medallions have many parallels in metalwork from eastern Iran (von Folsach 2001, no. 487).

The swimming ducks, the flying birds – whatever species they might be – and the coiled dragons all originate in the East. The cockerels, on the other hand, especially the big confronted ones with a stylized "tree of life" between them, have obvious roots in Western art, including what we could call their Royal Air Force wings and quite unique beaded breasts.[8]

Actual cockerels in medallions are found in late Sasanian silks (von Falke 1913, I, fig. 98) and also on a robe currently on the market that I would tend to place in twelfth-century Iran or Afghanistan.[9] Real or fabulous beasts are abundant on Mongol textiles: ducks, cockerels, parrots, falcons, lions, various felines and dog-like animals, rabbits, horses, deer, and ibexes (pl. 217a–f), in addition to harpies, griffins, double-headed

214 (*facing page, top*) Bottom right corner of the silk and gold lampas panel decorated with cockerels, detail of pl. 213.

215 (*facing page, bottom*) Top right corner of the silk and gold lampas panel decorated with cockerels, detail of pl. 213.

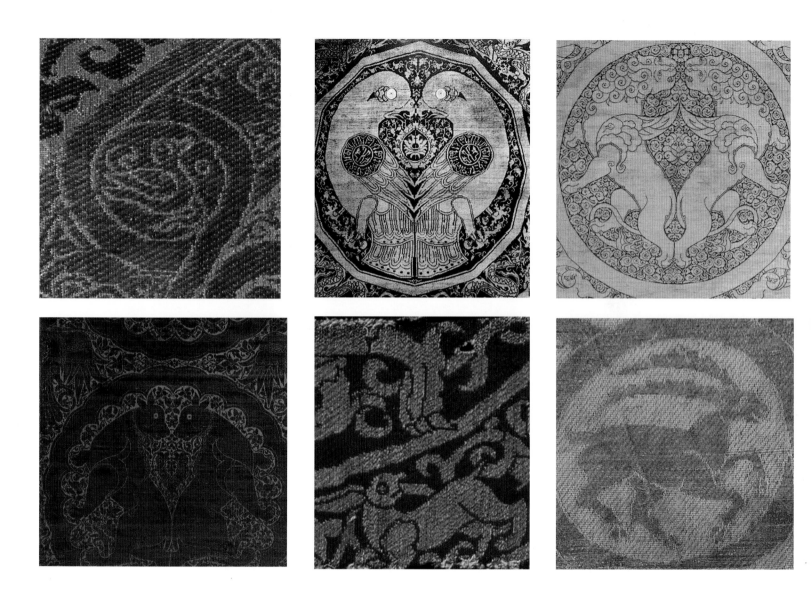

217a–f Animals depicted on Mongol silk-and-gold textiles
top row: a) duck, detail of pl. 208; b) parrots, detail of textile in Museum für Kunst and Kulturgeschichte der Hansestadt Lübeck (MI); c) lions, detail of textile in MIA, Doha (TE.202).
bottom row: d) dog-like creature, detail of textile in David Collection, Copenhagen (32/1989); e) rabbit, detail of textile in David Collection, Copenhagen (69/1998); f) ibex, detail of textile in MIA, Doha (CO.159.2002).

eagles, phoenixes, dragons, and makaras (pl. 218a–f). Did these creatures have a specific symbolic meaning to the Mongols? Probably not, except that they and similar beasts had always populated the textiles of the mighty in both East and West, where they at some point did have or might have had a special significance.

We do, however, have one interesting comment on this subject. According to Peng Ta-ya, who visited Mongolia with a Chinese embassy in the 1230s, "As for designs [the Mongols] use the sun and moon and dragon and phoenix. There is no difference between the elevated and the humble." This situation changed under Kublai Khan, and in 1270 according to the *Yuanshi*, the official history of the Yuan dynasty, it was forbidden to have designs with the sun, moon, dragons, tigers, and rhinoceros outside the court (Allsen 1997, 108). The rules were made even stricter in 1314, when it was decided that dragons with five claws could only be used on imperial costumes (Kadoi 2009, 22). It seems as if the Mongol court became more conscious of symbols when it was exposed to old imperial Chinese etiquette. Whether these bans had any effect outside Yuan China is highly questionable, and, as witnessed on the panels and other textiles, dragons did exist and also spread to other media in the Ilkhanid west.[10]

Medallion designs containing different motifs – human figures, beasts, or plants, alone or mirrored over a central axis – have a long history that goes back several

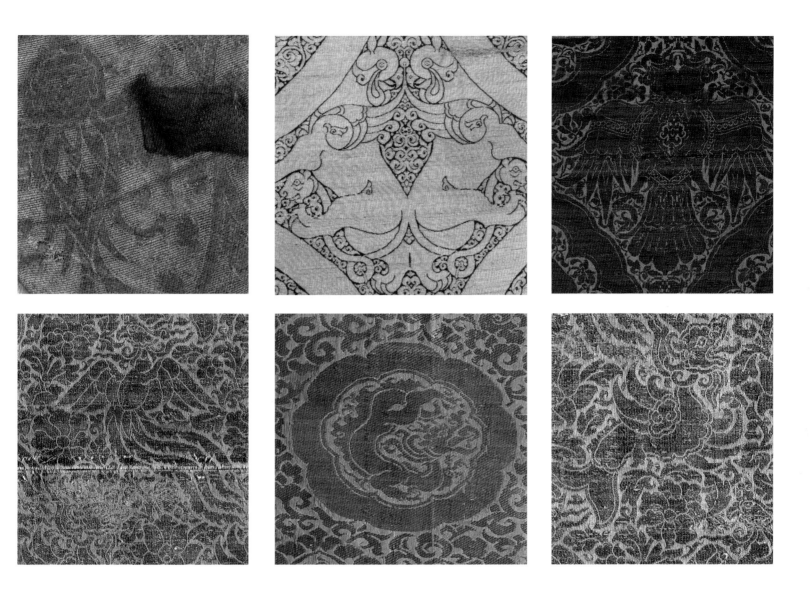

218a–f Fabulous beasts depicted on Mongol silk-and-gold textiles *top row:* a) harpy, detail of textile in MIA, Doha (CO.93.2000); b) griffins, detail of textile in MIA, Doha (TE.202); c) double-headed eagles, detail of textile in David Collection, Copenhagen (32/1989).
bottom row: d) phoenix, detail of textile in David Collection, Copenhagen (46a-b/1992); e) dragon, detail of textile in David Collection, Copenhagen (40/1997); f) makara, detail of textile in David Collection, Copenhagen (46a-b/1992).

centuries before the advent of Islam. By far the majority of them appear already in the Byzantine and Sasanian west, but they are also frequent in Soghdiana or Central Asia and are even found as Western-influenced exotica in Tang China (von Falke 1913, I, figs. 68, 99, 110). In Byzantium, they continued to be popular in the thirteenth and fourteenth centuries (*Byzance* 1992, 457, 463). In Islam, however, they seem to have disappeared or become very old-fashioned by the beginning of the thirteenth century.

In China, such medallion designs were more or less absent after the Tang period, so it is rather surprising that medallions play such a prominent role in Mongol textiles from the middle of the thirteenth and well into the fourteenth century (pl. 219a–d). We see them in many variations in the panels discussed here, and they achieve monumental scale in some of the textiles (see pls. 213, 219a–b, 226). They also appear in many small variations (see pls. 214, 218a, 219c, and 229) and again in a large and complicated fashion in the impressive lady's robe in the MIA (pl. 228a). One could claim that a unique textile in the David Collection is the king of the Mongol medallions (pl. 220), but it is neither part of a larger design nor does it belong to the lampas-woven textiles discussed here. It was woven in a completely different technique: tapestry or *kesi*. It is worthwhile noting that this roundel, probably manufactured in one of the

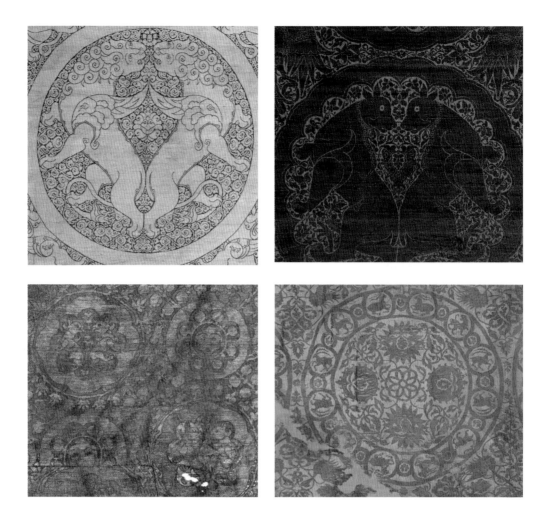

219a–d Medallions enclosing various motifs on Mongol silk-and-gold textiles:
top row: a) lions; MIA, Doha (TE.202); b) dog-like creatures; David Collection, Copenhagen (32/1989)
bottom row: c) griffins and moon faces; MIA, Doha (TE.31.1999); d) plants and animals, MIA, Doha (CO.159.2002).

220 (*facing page, top*) Silk-and-gold tapestry-woven medallion (diam. 69 cm), western Iran, first half of the 14th century. David Collection, Copenhagen (30/1995).

221 (*facing page, bottom*) Mural from the audience hall at Laskhari Bazar, Afghanistan; first half of the 12th century (after Sourdel-Thomine 1978).

Ilkhanid centers in western Iran, also displays the same mixture of elements from East and West, so much so that the Mongol ruler is flanked by his Mongol heir or general and his Persian or Arab vizier (von Folsach 1996a, 80–87).

In pre-Mongol Islamic painting, I have only been able to find one depiction of a textile with a proper medallion design, namely the one worn by a guardsman from the Ghaznavid palace at Lashkari Bazar, datable to the first half of the twelfth century (pl. 221). But painting is scarce before 1200. What is more surprising is that I have not been able to find a single medallion design in the many paintings from the Mongol period. There are dots or rosettes, but no true roundels like the ones on the actual textiles.

As mentioned above, all the silk panels under discussion are cut at the top just above the pearl border. Above it, however, there are minute remnants of a design that can be seen especially on the MIA split panel (see pl. 216), the one that is slightly different from the rest. It can also just be glimpsed on the piece in the David Collection (see pl. 215), and probably on the other MIA textiles as well. It is worthwhile noting that parts of that pattern in the David piece have gilded paper strips woven flat, while the rest have wrapped gilded paper strips. The sparse fragments of flat gold are seen at an interval that indicates a repeated design.

Several people have proposed that this missing design would have been an inscription or pseudo-inscription frieze.[11] This suggestion does make sense if we look at the split panel (see pl. 216), and it is certainly supported by the evidence provided by many other Mongol textiles, such as these three examples from the David Collection (pl.

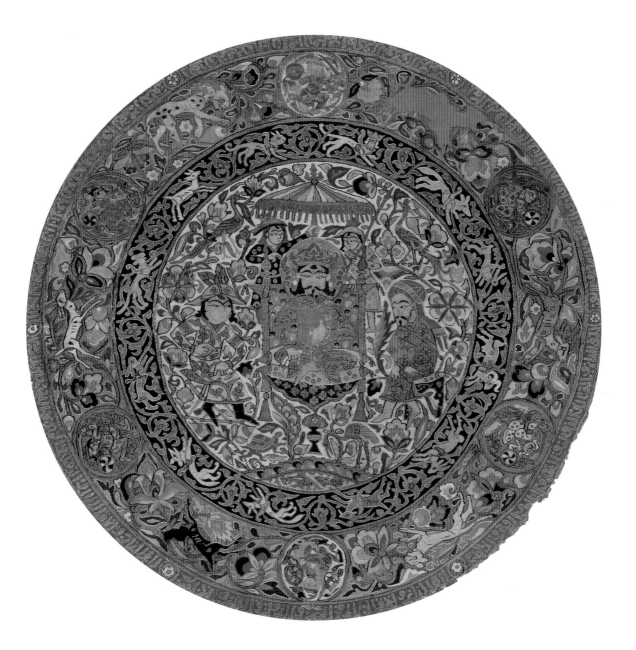

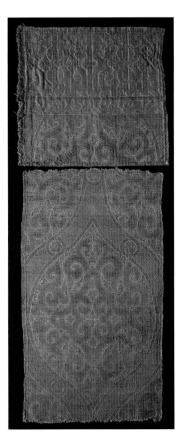
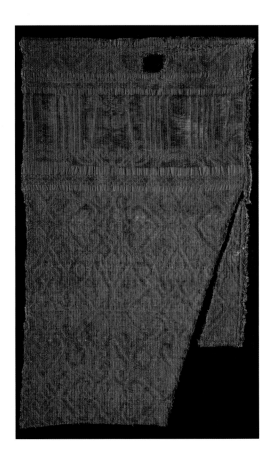

222a–c Three Mongol gold and silk textiles in the David Collection, Copenhagen (*left to right*): a) geometric design (14/1992); b) oval (4/1993 and 15/1989); c) *tiraz* naming the Salghurid sultan Abu Bakr ibn Sa'd (20/1994).

223 Detail of silk-and-gold textile with oval, showing coloristic effects achieved with gold thread, David Collection, Copenhagen (4/1993).

222a–c). All of them have the same coloristic effect in the "calligraphic" bands. In a detail of the central textile (pl. 223), one can appreciate the difference between the lower background with gold thread woven flat and the slightly raised areas with wrapped gold thread forming the "letters" outlined by coral-red silk. Anne Wardwell identified this rich effect years ago in the world history of Rashid al-Din as a special, luxury technique called "gold on gold" (Raschid-eldin 1968, 149).

A layout like this, with a band at the top and a larger uniform field below, led me to suggest in 1993 that this kind of design was probably made specifically for draperies

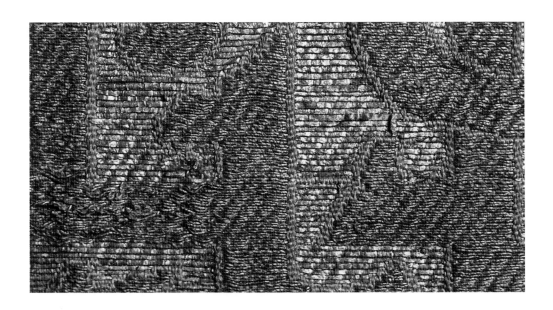

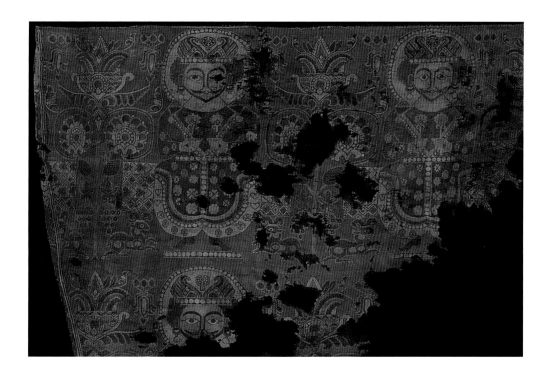

or tent hangings (von Folsach and Bernsted 1993, 47). With the later discovery of many Mongol robes, this turned out to be true, but only with very serious reservations. As can be seen in plate 228a–c, bands with calligraphy or calligraphy-like ornaments were also placed on the shoulders of many robes that turned up later.

This observation brings me to another digression: the *tiraz* phenomenon, a subject that I cannot deal with in depth here, but one that is well known to many of my readers. I would, however, like to quote the North African historian Ibn Khaldun's *Muqaddima* from the 1370s. "The pre-Islamic non-Arab rulers used to make a *tiraz* of pictures and figures of kings, or (other) figures and pictures specifically (designed) for it [pl. 224]. The Muslim rulers later on changed that and had their own names embroidered together with other words of good omen and prayer" (Ibn Khaldun 1958, ii, 66). Ibn Khaldun stated that there was a change from pictures to text in princely textiles when the Muslims took over. To make it short and very simple, in the heyday of Islamic *tiraz* under the Umayyads, Abbasids, and Fatimids, these textiles were produced by and for the Islamic ruler and distributed according to strict rules.[12] The receiver wearing such textiles could demonstrate that he had the favor of the ruling prince. For the prince, these fabrics with his name were an advertisement for his sovereignty on a par with having his name mentioned in the *khutba*, the Friday prayer, or the *sikka*, the right to have his name inscribed on coins. Even when the political importance of *tiraz* diminished during the eleventh and twelfth centuries, inscriptions with good wishes still enjoyed a high level of prestige in the Arabic-speaking world. Even pseudo-inscriptions were appreciated and obviously echoed real *tiraz*.

From the Mongol period, we know of three textiles that could be considered *tiraz* because they carry the names or titles of princes. The first one is from the tomb of Rudolf IV, who died in Vienna in 1365 (pl. 225). The textile carries the titles and name of the Ilkhanid sultan Abu Sa'id, and can be dated to between 1319 and 1335 based on these titles (Ritter 2010, 111). The striped pattern, however, is very different from the other textiles discussed here, and it is also the only example woven with

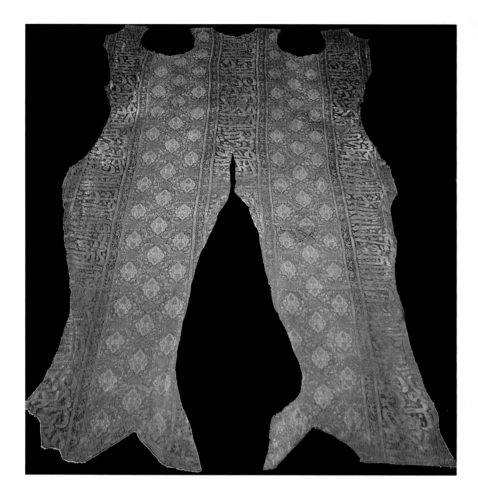

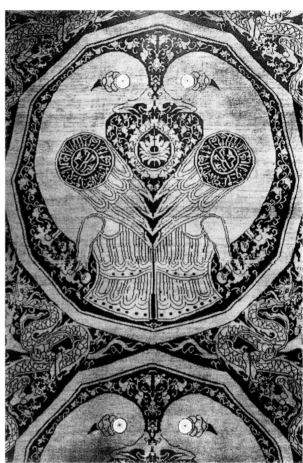

225 (*left*) Silk-and-gold *tiraz* in the name of the Ilkhanid Abu Saʿid; Western Iran, 1319–35. Dom und Dïozesanmuseum, Vienna.

226 (*right*) Silk-and-gold *tiraz* naming Nasir al-Din Muhammad (71 × 22 cm), Central Asia, first half of the 14th century. Museum für Kunst und Kulturgeschichte der Hansestadt, Lübeck (TE.40).

real metal strips. It was undoubtedly produced in another part of Asia, most probably western Iran.

The second Mongol *tiraz* is in the David Collection and was woven in the name of Abu Bakr bin Saʿd, Salghurid ruler of Fars between 1226 and 1260 (pl. 222c). In contrast to the Abu Saʿid *tiraz*, this lampas-woven textile clearly belongs to the Eastern group under discussion and is even an especially extravagant kind, in that both the calligraphic band and the larger field below belong to the "gold-on-gold" type, with wrapped and flat-woven gold thread, this time on animal substrate. It is not a *tiraz* in the traditional sense; it could hardly have been woven in Fars at the command of Abu Bakr himself for him to bestow on others. It was more likely from the East, a gift to him from his Mongol overlords, either Möngke Khan or his younger brother Hülegü (Watt and Wardwell 1997, 135). This practice was not unusual in the period. Although we do not know what the garments looked like, we know from written sources that Möngke, for example, gave robes of honor to the local rulers of Herat and Kirman and also to his brother Hülegü after he had defeated the Assassins in 1253 (Allsen 1997, 80). And in 1323, according to the Mamluk historian Abu'l-Fida, the aforementioned Ilkhanid sultan Abu Saʿid sent the Mamluk sultan Nasir al-Din Muhammad ibn Qala'un (r.1293–1341, with interruptions) 700 pieces of cloth that had the Mamluk ruler's name woven in them. A lampas-woven silk with parrots in twelve-sided medallions, dragons, and Arabic script (pl. 226) could fit this description, although it includes only the titles of the sultan, not his actual name (Wardwell 1989, 101–02; von Wilckens 1992, 47–48; von Folsach and Bernsted 1993, 29–30; Kadoi 2009, 25; Ritter 2010, 123).[13] With that

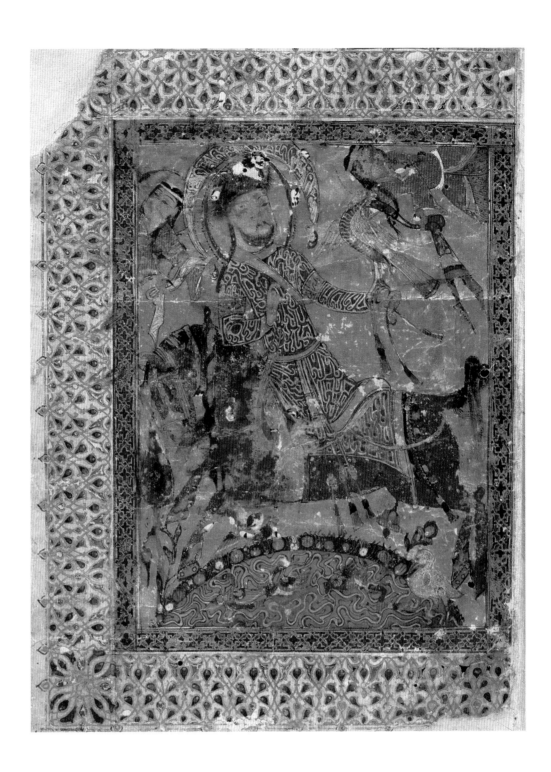

reservation, the textile, which used to be in the Marienkirche in Danzig and now is in Lübeck, can be considered the third "*tiraz*" we know from the Mongol period.

In most early and medieval depictions of *tiraz* inscriptions, they are placed around the arms of the owner, as in the frontispiece painting showing the atabeg of Mosul, Badr al-Din Lu'lu', in 1219 (pl. 227). This was also the case in the Mongol period, as seen on a number of paintings from the Great Mongol *Shahnama* (Grabar and Blair 1980, pls. 12, 14, 17, 28, 36, etc.) or from Rashid al-Din's world history *Jami' al-Tawarikh* (Blair 1995, figs. 38, 46, etc.). Even in the tapestry roundel in the David Collection, the general, the vizier, and one of the guards have stylized *tiraz* bands around their arms (see pl. 220). None of the many figures seem to have calligraphic or pseudo-calligraphic

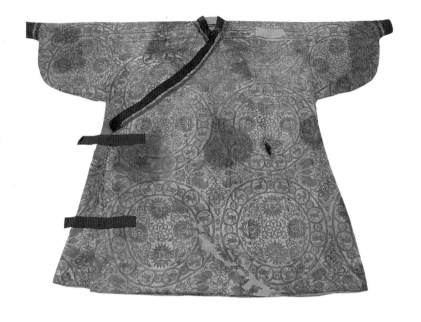

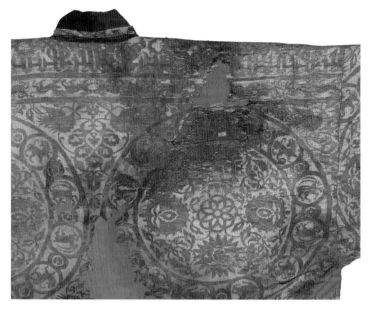

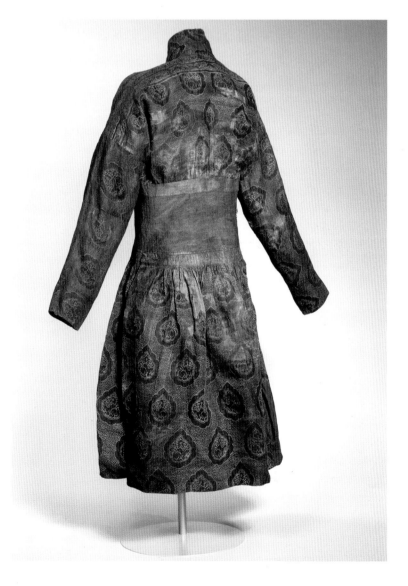

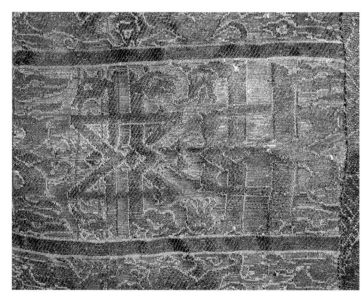

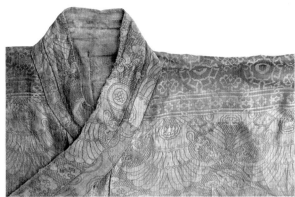

bands on their shoulders, as so many of the preserved robes do. But none of the robes have any traces of woven, embroidered, or stitched *tiraz* bands on the sleeves, as far as I have been able to observe. So again, as is the case with the medallion designs, contemporary depictions and the actual textiles and robes do not seem to match.

Let me leave these contradictions unresolved for the time being and turn to the surprise that I promised. I demonstrated – as suggested by others before me – that the cockerel panels in the MIA and the David Collection could very well have had a calligraphic or pseudo-calligraphic band at the top where they were cut. But there might also be another possibility. The design of a tailored textile in a private collection is very similar to the one in the panels (pl. 229).[14] There are, however, some differences. The pearl border has no frame, and the two lobed dragon roundels at the top of the tent panels are missing, thereby moving the first of the large cockerel roundels closer to the arch. Another difference is that I could find no traces of metal thread, if indeed there had ever been any.

The fabrics seen on the outsides of the columns and below the dragon medallions were added by sewing, but the weaving continues at the top over the pearl border, and here the real surprise appears. Plate 229 shows the robe from the back, and just below the shoulders between two pearl borders, instead of a calligraphic band, there are two confronted dragons flanked by two mirrored half dragons. The fierce, undulating creatures with four claws are obviously flying, as witnessed by the small clouds, and they are both chasing the same flaming pearl in the center (pl. 230). At the top there is a frieze of lobed palmettes, and over that a starting or finishing band just like the one seen at the bottom of some of the big panels (see pl. 214). To the left of the left columns and the half dragon farther up, there is a selvedge of the usual loop type, and the fabric has been cut on the right side, indicating that this textile would originally also have consisted of two arches, like the complete tent panels.

It has not been possible for me to verify whether the small design remnants at the top of the large panels in the MIA and the David Collection could fit the dragon design on the robe in private hands. But it actually seems most likely to me that the panels had a decoration of a different type – most probably bands of calligraphy, despite

229 Back panel from a silk-and-gold Mongol robe with cockerels and dragons; Central Asia, *circa* 1300. Private collection.

the evidence of the robe. The design on the robe seems to be an interesting variation of the design used in the MIA and the David Collection panels.

⌐

I once read a very serious German book on European architecture in which the title of the last chapter was "Kein Schlusswort" – freely translated as "no conclusion." Although tempted to follow this path, I shall try to end this essay with some concluding remarks. There is no doubt that these complicated and highly sophisticated textiles woven of silk and plenty of gold – *nasij* – were very costly in their day. They were worn and used by the very top echelon of Mongol society. They were distributed to the court and given away as robes and uncut cloth to foreign princes, ambassadors,

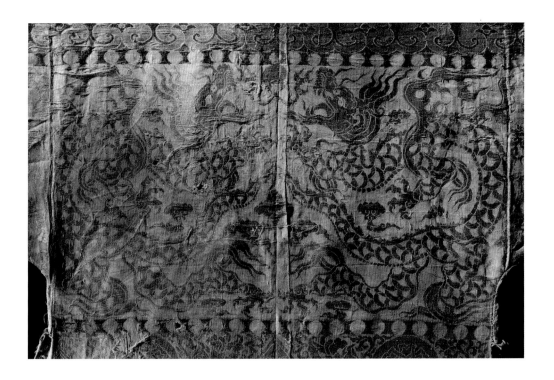

230 Detail of the silk-and-gold Mongol robe with cockerels and dragons shown in pl. 229.

religious institutions, and others that the Mongol leaders found it worthwhile to honor. They were rare and highly prized treasures as far away as Europe, where they were known as *panni tartarici*.

The Mongols were *homines novi*, new people, among the old sedentary cultures in the Middle and Far East. They were aware of it, and this was one of the reasons why they were so eager to spare the lives of and abduct foreigners who had artistic and technical knowledge. I believe that this is probably also the reason why they were so eclectic and relatively archaic in their taste, at least in the thirteenth and early fourteenth centuries. When medallion designs with heraldic animals, and so on, and *tiraz* inscriptions – real or pseudo – had disappeared or were about to disappear in the Islamic world, the Mongols fell back on these two decorative but also highly symbolic elements, which, in the words of Ibn Khaldun, had been the privilege of pre-Islamic and Islamic princes for many centuries. The Mongols were not interested in following the newest fashions in China or Greater Iran; they wanted to be regally dressed like the princes of earlier times. Only gradually did they adopt the new customs and fashions of the peoples they had conquered.

A great deal of well-spent energy has gone into suggesting where this rather homogeneous and yet varied group of textiles was woven. Based on historical sources, an analysis of artistic motifs, material (not least the gold thread), and weaving techniques, they have been moved east or west. All agree that these textiles were produced in an area covering the eastern Iranian world, Central Asia (whatever this area covers), Mongolia, and northern and western China. This is admittedly a great expanse, and some scholars have subsequently been more audacious and specific in their attributions, for many good reasons (Wardwell 1992, especially 369–71; Watt and Wardwell 1997, 127–38; Kadoi 2009, 15–33; von Folsach and Bernsted 1993, 44–61). I still believe, as I did in 1993, that one should be careful with overly narrow attributions. Before the unity of the conquered lands disintegrated, the Mongol empire had been an area of migration and cultural exchange for a long time. Raw materials, finished goods, technical knowhow,

and artistic motifs traveled freely under the Pax Mongolica. People moreover moved or were moved against their will from one end of Asia to the other.

Several facts, nevertheless, speak for production sites east of Ilkhanid Iran. First, as far as I am aware, none of these textiles has been found in Muslim lands. Even the *tiraz* of Abu Bakr came from Tibet and never reached Fars. But this situation could be accidental, and some eastern textiles actually were found as far away as Europe in the medieval period (see pl. 226). Another indication of the same provenance might be the lack of depictions of shoulder inscriptions or designs with big roundels in the fairly rich repertoire of Islamic painting from Ilkhanid lands, and the corresponding fact that none of the preserved caftans has any traces of *tiraz* or even decorative bands on the arms seen so often on Mongol paintings from the west.

Although I will probably disappoint most of my readers, I will rather timidly suggest an origin for these synthesizing Mongol textiles in the area between the Islamic and Chinese heartlands – a vast expanse often described vaguely as Central Asia, an area which, like a rubber band, can be stretched here and there. Future finds and the publication of archaeological reports might be helpful, although textiles certainly did travel.

The gold and silk panels that are shared between the MIA and the David Collection have a decoration that draws upon both East and West; they have flat and wrapped gold threads, and the base material of the gold thread is both paper and animal substrate. But wherever they were manufactured, they are among the most impressive lampas-woven textiles from the medieval period. Apart from that, they are the earliest surviving group of woven panels that with a very high degree of certainty were designed to decorate the magnificent tents of the Asian nomads. This was a tradition that was carried on over the ensuing centuries until it reached its zenith in the splendid tent camps of the Great Mughals – a dynasty that was very proud to be descended from the golden line of Genghis Khan.

Notes

1 I would like to thank the staff of the MIA, especially Konstatinos Chatziantoniou and Franak Hilloowala, for help during my stay in Doha. I would also like to thank Martha Gaber Abrahamsen for revising this article for style.

2 The Doha panels TE.40.2002 were published in Zhao 1999, 198; Thompson 2004, 13, 76–81. The panel in the David Collection 40/1997 was published in von Folsach 2001, no. 641; Komaroff and Carboni 2002, no. 73; Kamansky 2004, 81; Kadoi 2005, 231; Blair 2005, 31; Blair and Bloom 2006, no. 12; Kadoi 2009, 31.

3 For the dimensions of the seven Doha pieces, see Thompson 2004, 76. There are slight variations from these to the ones presented by Anne Wardwell in her sales report from 1998 (see the following note).

4 The textile in the David Collection was analyzed by Anne-Marie Bernsted when it was acquired by the museum in 1997, and the seven Doha pieces were analyzed by Anne E. Wardwell in a sales report made for Plum Blossom International in 1998, both unpublished. A related but not identical lampas weave was analyzed and drawn by Anne-Marie Bernsted in von Folsach and Bernsted 1993, 75–78.

5 The testing (Institute of Physics and Astronomy, University of Aarhus, sample AAR–4023) yielded

a date between 1290 and 1400 at the 95.4 per cent confidence level and between 1295 and 1315 (25 per cent) and 1345 and 1395 (75 per cent) at the 68.2 per cent confidence level.

6 For a related eastern Islamic mihrab, see von Folsach 2001, no. 393. A similar eccentric arch can be seen in an embroidered Central Asian panel sold at Christie's, London, 6 October 2011, lot 97. Yuka Kadoi calls the arch a "four-lobed motif" and links it to the cloud collar, which might very well have been introduced to China by the Mongols (Kadoi 2009, 32). She also mentions that this accessory was often woven into the robe or attached to the shoulders. This is not the case in the robe of pl. 229, and I believe that in the context of these panels, the lobed motif should be considered an architectural element related to the ones on many panels from the Mughal period (von Folsach 2001, nos 663 and 680).

7 Kufesque ornaments are found on many of the Mongol silks under discussion and are also seen on contemporary carpets, such as the famous group from Kyoto (Watt 2010, 34 and figs. 46, 47).

8 For example, von Folsach 2001, no. 472. For the beaded breast, see a number of pots in Ilyasov forthcoming.

9 The robe, which belongs to the dealer Carlo Cristi, has a dense medallion design with confronted cockerels. The border of the medallions consists of an unreadable (according to Will Kwiatkowski) mirrored and repeated cursive inscription.

10 For example, the luster tiles that may have decorated the Ilkhanid palace at Takht-i Sulayman constructed in the 1270s (Kadoi 2009, 51).

11 Written communication from Jacqueline Simcox, 4 May 1998. Anne Wardwell, who studied the Doha panels before they were mounted, states in her unpublished report from 1998 that the missing top band clearly consists of a repeat of stylized *alif* and *lam* forms, with the letters woven with wrapped gilded paper against a background of flat strips of animal substrate gilded on both sides. This is not clear in the David Collection piece, where, according to Anne-Marie Bernsted, both the flat-woven and the wrapped gold thread at the top are paper. Wardwell's description is repeated in Komaroff/Carboni's description of the David panel (Komaroff and Carboni 2002, 261).

12 See, for example, Folsach and Bernsted 1993, 12–16. The literature on the subject is extensive.

13 The inscription does not make it completely clear if it refers to Abu Saʿid's contemporary, the Mamluk sultan Nasir al-Din Muhammad ibn Qalaʾun. However, a date in the first half of the fourteenth century seems right. The fragment fits into the group of lampas-woven textiles from the eastern part of the Mongol empire, not the above-mentioned *tiraz* of Abu Saʿid from the tomb of Rudolf IV.

14 I am indebted to Michael Franses for pointing out this important textile to me and for giving me access to study it.

p. 242: detail of the Cagan animal carpet, probably late 14th century. Metropolitan Museum of Art, New York (1990.61).

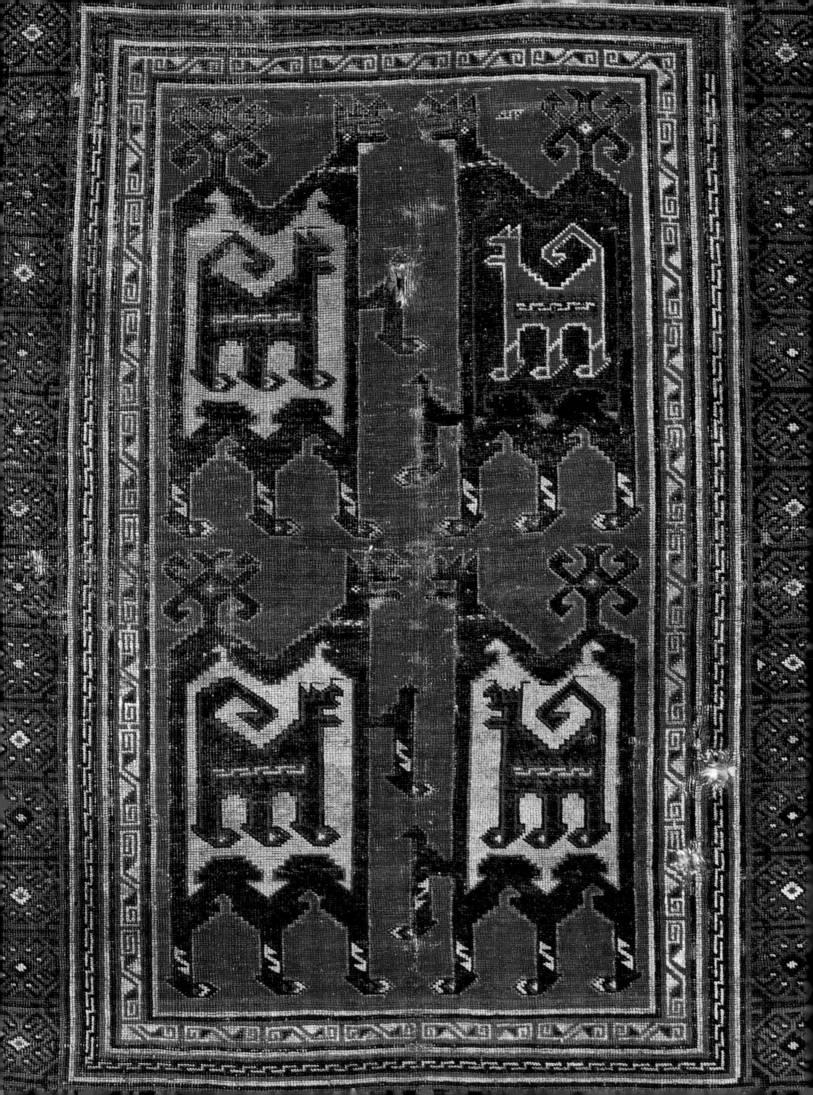

II

An Early Anatolian Animal Carpet
and Related Examples

سجادة اناضولية برسوم حيوالية وّنماوخ مشابهة

Michael Franses

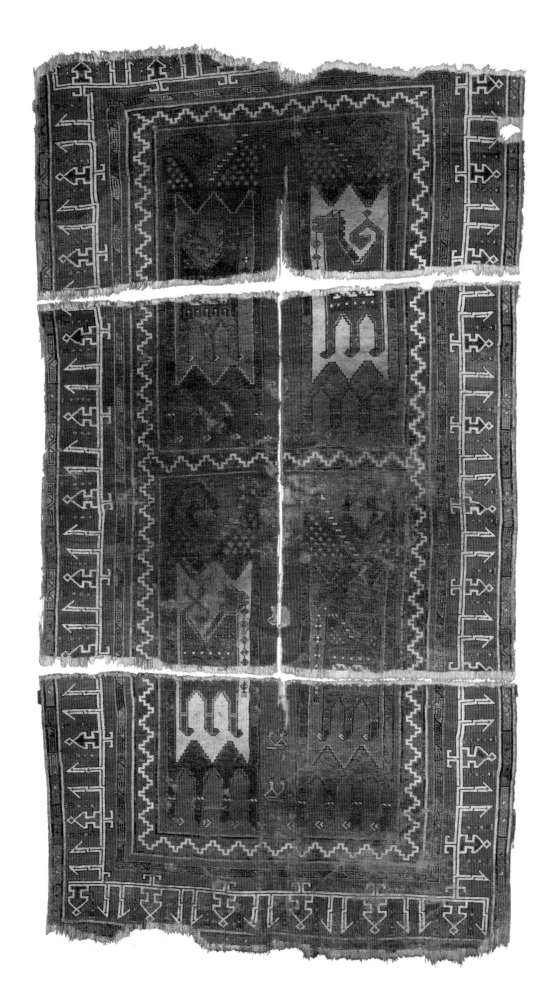

When one considers the textile arts of the East, an image comes to mind of the most glorious colors, sensual textures, intriguing patterns, and sublime beauty. The textile arts in general – and carpets in particular – rarely disappoint and have dazzled onlookers for thousands of years.[1] The most magnificent examples were the ultimate symbols of affluence, power, and culture and were fundamental in the expression of artistic talent across much of Asia.

For more than 10,000 years, tribal symbols have been portrayed through woven items and on costume, animal trappings, tents, and carpets. These motifs were the very language of the peoples who created them, bestowing fertility, warding off evil sprits, bringing joy in life or richness to the land, and carrying the soul to the afterlife. The more isolated the people, the longer the basic forms of ornaments continued unaltered, perhaps for hundreds of years, simply being copied from one generation to the next. Yet over this same period their meanings may well have changed many times.

Studying these works of woven art today provides an opportunity to delve into the histories of mankind, to contemplate both the simplicity and complexity of thought that achieved such intriguing patterns, to marvel at the glorious creations, and to ponder their meanings. One can also gain an appreciation of the outstanding and inventive skill required for the construction of complex weaving techniques and glimpse the development of the entire grammar of ornament.

Images exist of patterned textiles from 9,000 years ago, and surviving examples go back at least 4,500 years. A significant number of 3,000-year-old textiles – including carpets – survive today, yet from the time of the first literature on the subject more than a century ago, the study of their patterns, development, and history has never commanded the respect accorded to other types of works of art.

For the 2011 Hamad bin Khalifa Symposium, I was invited to discuss one carpet from Qatar's Museum of Islamic Art (MIA). This was certainly a challenge, as the museum is filled with the most wonderful works of art – it is a treasure house of beauty and a doorway to the history and culture of the peoples of the Islamic world. I selected a carpet that embraces diverse cultures, a carpet from Anatolia depicting mysterious creatures (pl. 231), a work so intriguing that we might never properly understand it.

At the Symposium, it was possible to present images of most of the surviving early animal carpets – many shown in public for the first time – alongside numerous examples depicted in paintings. This enabled me to place the MIA carpet in its historical context, demonstrating its rarity and significance, and to present a summary of the current knowledge on the origins of animal designs depicted on oriental carpets made between 500 and 2,800 years ago.[2]

The subject needs to be approached differently in written form, as a full study of early animal carpets would require a large, dedicated volume. In any case, such a task should really only be undertaken once the carpets have been more fully researched and scientifically tested. This challenging subject can only be truly understood by physical examination and comparison of similar works side by side, and a written paper is a very blunt instrument in this regard. Consequently, the much narrower focus of this essay is the MIA animal carpet and related examples.[3]

231 (*facing page*) The Qatar animal carpet (170 × 310 cm; incomplete), Anatolia, probably second half of the 14th century. MIA, Doha (CA.77).

Discoveries from Tibetan Monasteries

During the 1980s and 1990s, two sources provided a continuous stream of fascinating carpets, both piled and flat-woven, which in some instances have necessitated the rewriting of the history of early weaving. The first source was old Turkish collections (Balpinar and Hirsch 1988; Alexander 1993; Kirchheim et al. 1993; Ölçer and Denny 1999); the second was Tibetan monasteries. It is well known that rugs had traveled along the ancient Silk Road since Roman times: in the early twentieth century Sir Aurel Stein discovered pile carpet fragments preserved in the deserts of Central Asia (http://ipd.bl.uk). The caravan routes of the Silk Road also passed the Buddhist monasteries of Greater Tibet, whose culture spread far beyond the present-day boundaries of the Tibet administrative region of China. Chinese emperors and dignitaries would visit and take retreat in the Himalayan monasteries, and travelers would bring as gifts a wealth of silk and textiles, the currency of the Silk Road (Watt and Wardwell 1997). Thus, over a period of 2,000 years, these monasteries became some of the greatest treasure houses of the world.

After the Chinese occupation of Tibet in 1959, and particularly during the Cultural Revolution in the late 1960s and early 1970s, most of the physical evidence of the culture of ancient Tibet was deliberately and systematically destroyed. The monasteries were torn down or put to secular uses. The art objects that they had preserved for centuries were largely burnt, defaced, or stolen, although the monks did manage to hide some. Others survived because a practical purpose was found for them: the enormous Yuan period tapestry-woven mandala in the Metropolitan Museum of Art, New York (1992.54), for example, was reportedly being used in the 1970s as a ceiling canopy in a grain mill, in what was originally a small monastery. A number of monastic treasures were also publicly distributed to local residents, with the admonition that these were their possessions, in essence stolen from them by the monks during centuries of predation. Some of the recipients chopped up the textiles they were given and put them to use, while others stored them away.

The dealer Jeremy Pine related an account of an incident that took place in the 1970s at the Potala Palace in Lhasa. A large group of old carpets, which had been folded up for centuries and in some cases were worn or damaged, were gathered together from a storeroom by Chinese troops. They were loaded onto three lorries (one carpet alone is said to have required eight men to lift it) and dumped into a nearby river. A Tibetan fisherman managed by chance to catch one fragment and took it home. Some years later he moved to Kathmandu and discovered that it was part of an extremely rare twelfth- or thirteenth-century carpet from Anatolia (see pl. 236b).

Between 1959 and 1990, many thousands of Tibetans left their country in fear of persecution. Often reliant on aid from international organizations to support themselves, these refugees consequently sold off the treasures they had acquired or saved from the monasteries. These included several carpets and textiles, among them masterpieces of textile art from Spain in the west to China in the east, some dating back more than 2,000 years. The Dalai Lama, writing about works of art from Tibet in a western

collection (1998), said: "When so much of the Tibetan cultural heritage has been destroyed in its own land, I am very happy to know that so many fine works of art from Tibet have been preserved [in collections throughout the world] . . . We Tibetans would regard most of these artifacts as sacred . . . All of them are a source of inspiration."

The MIA Anatolian Animal Carpet

Before it was acquired by a previous owner in Kathmandu, Nepal, the MIA animal carpet had reportedly been in a Tibetan monastery. In 1991, it was sent to Longevity Conservation Studio in London for washing and conservation, an event that allowed me the opportunity to examine it thoroughly over eight months. The process was lengthy because much of the carpet was heavily impregnated with wax. This situation is typical of carpets and textiles from the monasteries, which were once illuminated by thousands of yak-butter candles. These gave off a vapor of grease that over centuries covered the contents of the buildings. Because the carpets were out of reach of sunlight, however, the colors were perfectly preserved.

Looking at this extraordinary carpet, one is immediately fascinated by the abstracted animal forms that fill the center. The patterns embrace aspects of Islamic art as well as iconography derived from earlier traditions and show how the peoples of the Islamic world adopted and adapted symbols. We are confronted by creatures within creatures, possibly symbolizing fertility, or perhaps by mythological beasts, summoned to carry the soul to the afterlife. These strange creatures are probably ancient totemic symbols that can be traced back to some of the oldest civilizations of the ancient Near East. Or maybe they represent an abstraction, with elements derived from once naturalistic designs on silk textiles, possibly from Sasanian Persia, that were passed down and evolved over a thousand years. The carpet clearly tells a story, of which there have been many interpretations, but here I will merely attempt to shed light on its rarity and significance.

It is estimated that the complete carpet would have measured 170 by 310 centimeters. The fact that it had been divided at some point (in this case into four sections of equal size) was typical of the many thousands of textiles that arrived in London from Nepal between 1970 and 2000. For example, most of the Northern Song period (960–1127) tapestry-woven Chinese silks that came out of Tibet were probably complete when donated to the monasteries but were later cut to a similar size, as they made perfect sutra covers; other cloths were cut up to serve as banners. The function that the pieces of the MIA carpet served in a Himalayan monastery for over 600 years is unknown, but what is quite remarkable is that they all survived and remained together.

A sample of warp thread was removed prior to washing and in 1992 sent to the Institute of Particle Physics (ETH) in Zurich for radiocarbon dating; the test returned a date of 1190–1300. Because equipment has improved and the science has developed over recent years, resulting in increasingly more reliable tests, a second sample was tested in 2001: the mean of two runs gave a date of 1319–1440 (see Appendix).

In March 1993, the carpet was exhibited at the European Fine Art Fair in Maastricht, where it was purchased by Mr. and Mrs. Heinrich Kirchheim, private collectors from Stuttgart. The carpet became the highlight of their magnificent collection, which was published in *Orient Stars* (Franses 1993, 15) and exhibited at the VIIth International Conference on Oriental Carpets in Hamburg the same year. The carpet remained in the Kirchheim Family Collection until February 1998, when it was acquired by the MIA.

A Brief Background to Early Carpets

A full historical survey of oriental carpets in general, and of those with animal designs in particular, would need to start at the very beginning. The first surviving carpets were made more than 4,500 years ago. Over the past thirty years, the subject has advanced in quantum leaps with the continuing discovery of so many knotted pile carpets made 1,600 to 2,800 years ago from Central Asia, Persia, and China, making it a topic of on-going research that is not ready for publication at this stage.

I will therefore start some 1,300 years ago, with the discovery of the oldest complete, or almost complete, carpet from the Near East, which was reportedly found in Fustat, former capital of Egypt and now part of Old Cairo. The Fustat lion rug (pl. 232), carbon-dated in 1983 to 580–920, was purchased by Mrs. McCoy Jones in 1987 for the Fine Arts Museums, San Francisco. Since there are no other early carpets related either in design or color for which the place of production or the culture of the weavers is certain, this rug could have been made almost anywhere, though it was probably made in the Near East, possibly in Anatolia. Following the Fustat rug, there is a gap of 200 to 400 years before the next Anatolian carpets that survive in a sufficiently intact state for the design to be discernable.

In 1959, Dr. Richard Ettinghausen, director of the Islamic Department of the Metropolitan Museum and a distinguished historian of Islamic art, published his fascinating article "New Light on Early Animal Carpets." He pointed out that much of what we know about thirteenth-century carpets has been learned from their depiction in European paintings, a subject reviewed in considerable depth by Kurt Erdmann (1929; 1941). Ettinghausen noted that the next important contribution to the subject was made by Carl Lamm (1937; 1985), who presented many of the early carpet fragments that he found in Fustat together with reconstructions of the designs.

Ettinghausen illustrated three small fragments of carpets depicting semi-naturalistic birds in roundels that were all probably found in Fustat. He explained their techniques and pointed out that their designs are in the style of Sasanian silk cloths. He reviewed animal carpets in Italian paintings and then illustrated an outstanding carpet depicted in an early fourteenth-century Persian miniature in the Freer Gallery of Art, Washington, DC, showing "Zahhak Enthroned," from the Great Mongol *Shahnama*, attributed to northwest Iran in the 1330s (see pl. 246). Ettinghausen (1959, 99, note 16) noted another animal carpet depicted in a Mamluk manuscript dated 1337 and showed other examples in miniatures. His work provides a clear foundation for deeper study of these

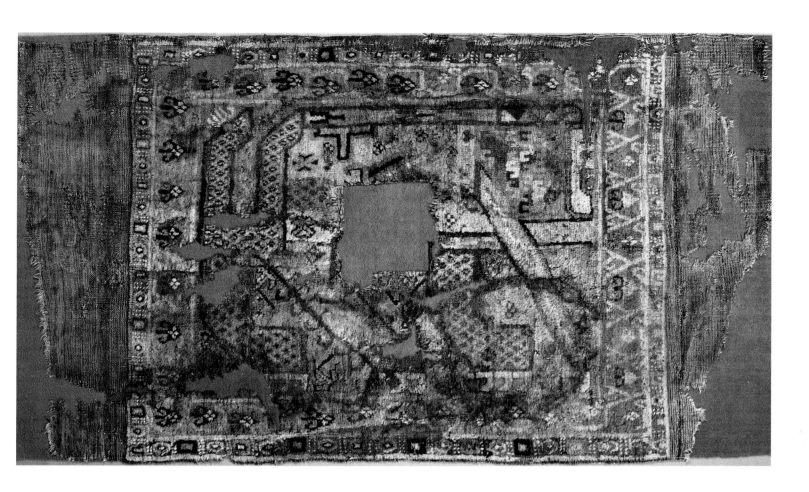

232 The Fustat lion carpet (drawing) (165 × 91 cm; incomplete), Near East, possibly Anatolia, 7th–9th century. Fine Arts Museums of San Francisco (1986.4).

carpets. I will return to the Zahhak carpet later, as it is fundamental to the understanding of the recent carpet discoveries.

John Mills (1978) considerably enlarged upon the research of Erdmann and Ettinghausen and listed sixty early Italian paintings with animal and bird carpets, categorizing them into seven design groups. Mills's comments have made his article one of the key sources for the study of early carpets. A number of the carpets depicted in the paintings resemble Byzantine silks. Their field designs are mostly divided into tile patterns of octagons with small diamonds filling the corners. Some of them have a repeat design within the octagons showing large double-headed eagles, two fairly naturalistic birds facing a tree, or standing animals. In other paintings the figures are more abstract. At first, these figures were considered to be misrepresentations by the artists, but they are now believed to represent another school of carpet design, which ran parallel to a more naturalistic Byzantine and Persian school. This abstract style, which is possibly far older than the naturalistic style, depicted animals in a schematic way as symbols of mythological creatures.

The "Early Konya" Carpets

The first examples of early knotted-pile carpets to be found in Anatolia were discovered in 1905 by the Swedish scholar Fredrik Martin at the Alaeddin Mosque in the city of Konya in central Anatolia. It has often been suggested that six of these eight carpets might have been woven locally as part of the building's original furnishings when it

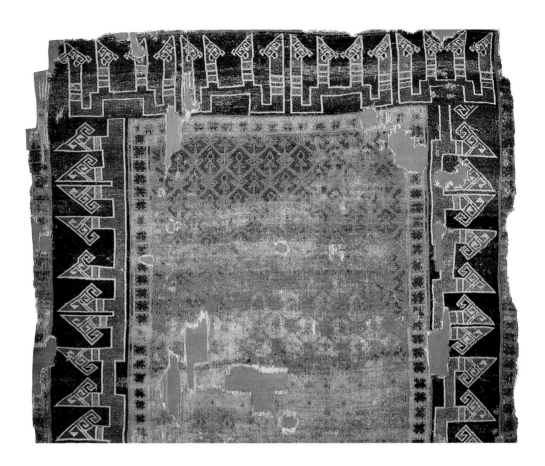

233 Early Konya carpet with diamond lattice (detail) (294 × 512 cm; incomplete), Anatolia, probably 13th century. Museum of Turkish and Islamic Art, Istanbul (681).

was constructed in 1218–20 (Martin 1908). There is no proof of this, however, and neither the time nor the place of origin of these carpets has ever been agreed upon unanimously.

The evidence for the manufacture of the "Early Konya" carpets in or around Konya is purely circumstantial, based largely upon the fact that some were found there and others were found nearby. Almost all of the literature published since the rediscovery of these carpets has attributed them to the Seljuks, the dynasty that ruled Konya in the thirteenth century. Part of the evidence for the Seljuk attribution is that one of the Konya carpets has a repeat design of four inward-pointing arrows in octagons, reminiscent of eighteenth- and nineteenth-century Turkmen carpets from Central Asia. The Turkmen, reputedly descendants of Oghuz Khan, belong to the Seljuk tribes, and among the many varied peoples of present-day Anatolia are Turkmen who bear the same tribal names as their "cousins" in Turkmenistan. There are also similarities between the patterns of the carpets and ornaments in Seljuk architecture. In fact, however, the archaic style of the carpets is far closer to patterns used in the ancient Near East than to the sophisticated and ornate designs of the Seljuk buildings; and the technical characteristics of the "Early Konya" carpets suggest that not all of them were made in the same place. I do not reject the idea that these carpets might have been made by Seljuk Turks, but would certainly question it. It is quite likely that these carpets were made at a time when the Seljuks were in power, but in the absence of firm evidence, we can only speculate as to exactly who made them. The reason to consider this here is that later I will be posing similar questions with regard to the origins of the Anatolian animal carpets.

Whatever their origins, the "Early Konya" carpets are undoubtedly among the most magnificent carpets extant. They have spectacular colors and a boldness of composition

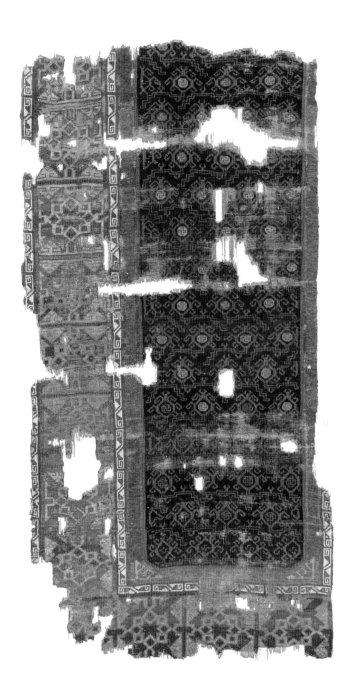

234 Early Konya carpet with clouds (121 × 240 cm; incomplete), Anatolia, probably second half of the 14th century. Museum of Turkish and Islamic Art, Istanbul (688).

and form that set them apart from all others. One (pl. 233) has a wide kufic-style border filled with hook motifs that resemble the heads of highly stylized confronted birds, perhaps symbols of protection. Thus the lines between traditional designs associated with the formal practice of Islam and patterns associated with more ancient beliefs might have become blurred. Whatever the case, these carpets were certainly not created by the peoples who designed the more formal Alaeddin Mosque, on which the patterning is much more refined and has little to do with the symbolic iconography seen on the rugs that were found there.

Another "Early Konya" carpet has a geometric border pattern more in the style usually associated with Islamic art (pl. 234) and was probably made in the second half of the fourteenth century (the carbon-14 result from Oxford should be considered unreliable because techniques have improved). It has a field design of rows of what could be interpreted as stylized creatures with hooks and long tails. A stylistic study

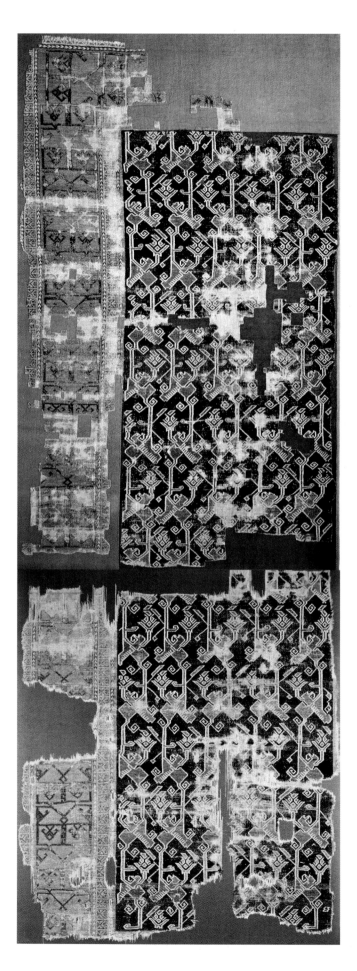

might well suggest a later date for this fragment than the others, as certainly the handle and colors appear different to the other "Early Konya" carpets. Louise Mackie (1977) thought that the motifs were probably derived from a Chinese cloud-palmette silk pattern of the Yuan dynasty. She illustrated an early fourteenth-century fragment excavated in Egypt and now in the Metropolitan Museum (46.156.20), which has a design remarkably similar to that of the carpet. Similar Yuan silks are in Doha, London, Berlin, Brussels, and St Petersburg. A number of other carpets survive that show the same field pattern, but come from different places of origin.[4]

In 1929, twenty-four years after Martin's great discovery, the American scholar Rudolf Riefstahl (who was himself highly skeptical of the claims that the Alaeddin Mosque carpets had been made for its opening; Riefstahl [1931]) found a further seven early carpets in the Eşrefoglu Mosque, built in 1240 at Beyşehir, southwest of Konya. At least four of these are probably contemporary with those from the Alaeddin Mosque. Since their rediscovery, these carpets have been declared Turkish national treasures, although one did leave Turkey: the upper part is now in the David Collection in Copenhagen and the lower part in the Keir Collection (pl. 235).

It is perhaps surprising that the majority of surviving thirteenth- and fourteenth-century Anatolian carpets have been rediscovered largely in just two places, apart from some tiny fragments unearthed over the years from the rubbish dumps of Fustat. One fragment with a hooked medallion motif, possibly from Fustat, which stands out as being related to the "Early Konya" carpets, was acquired in 1974 by the Metropolitan Museum (pl. 236a).

A related rug fragment, acquired in Nepal by Jeremy Pine and now with the Kirchheim Family Collection in Hannover, reportedly came from the Potala Palace in Lhasa (pl. 236b). Just a corner section survives, but it is possible to deduce that the pattern was composed of a number of rectangular compartments, either two or three arranged horizontally and an unknown number vertically. Inside the compartments are repeated a series

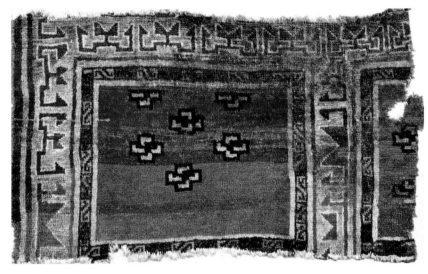

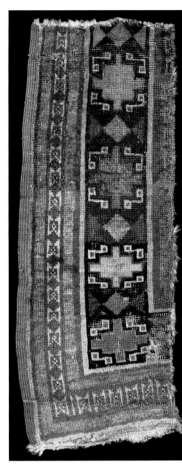

236a–c Three early carpets,
Anatolia, 12th–13th century (*left
to right*): a) Hooked medallion
carpet (22 × 29 cm, section).
Metropolitan Museum of Art,
New York (1974.227);
b) Compartment design rug (73
× 43 cm, section), possibly
western Anatolia. Kirchheim
Family Collection, Hannover;
c) Stepped medallion border
fragment (29 × 75 cm),
probably western Anatolia.
Private collection.

235 (*facing page*) Early Konya
carpet with floral design (upper
section: 187 × 302 cm, lower
section: 207 × 185 cm), Anatolia,
probably 14th century. Upper:
David Collection, Copenhagen
(3/1991); lower: Keir Collection.

of overlaid rectangles, rather like Chinese cash motifs. Each compartment is surrounded by a small band filled with "S" serif motifs and the primary border has stylized kufic patterns. Almost twenty years ago samples from this fragment were carbon-dated to 1189–1283 (although this testing should be repeated for confirmation).

Two border fragments also acquired by Pine in Nepal are survivors from a carpet probably made in western Anatolia that may well be as old as the "Early Konya" carpets (a sample tested almost twenty years ago was radiocarbon dated to 1040–1300, but again this should probably be re-tested). The side section (pl. 236c) is in remarkable condition, its selvedge intact, and in handle it is not dissimilar to nineteenth-century Melas rugs from western Anatolia. It displays the concept of a design overlaid against a continuous red background, a feature common on rugs made before 1600. It has a minor border with a repeating kufic-style pattern associated with rugs made from the thirteenth to fifteenth century. Related kufic designs can be seen on several Fustat carpet fragments, including one in the Metropolitan Museum knotted on single warps and attributed to the ninth century (Aslanapa 1988, 11, fig. 1) and another, probably from the late fourteenth or early fifteenth century, in the National Museum, Stockholm (43/1936; Lamm 1985, fig. 6).

Over the past fifty years, Turkish authorities have scoured every mosque in Anatolia, and so the chances of an unknown example now coming to light are slight. While many fifteenth-century carpets have been discovered in this way, none has been found that can be attributed with any confidence to the thirteenth or fourteenth century, apart from two in Divriği (Balpinar and Hirsch 1988, pls. 1, 2), and certainly none has

matched the earlier finds in magnitude or significance. Thus, some sixty years after Riefstahl's finds in Konya, considerable excitement was caused when news came of early Anatolian rugs emerging from monasteries in Tibet.

The Cagan Animal Rug

The first Anatolian animal rug discovered in Kathmandu in the 1980s was found by Fred Cagan (pl. 240). A Buddhist monk had reportedly saved it from a Tibetan monastery. In 1990, the Cagan rug, which probably dates from the late fourteenth century (again, the early carbon-14 result should be considered unreliable until the carpet has been re-tested), was purchased by the Metropolitan Museum. In the museum's *Bulletin*, Daniel Walker (1990) wrote that "no group of Oriental carpets has aroused as much interest and speculation as the early animal rugs of Anatolia," comparing the museum's acquisition with the famous Marby bird-and-tree rug in Stockholm and the Bode dragon-and-phoenix rug in Berlin (see pl. 250c–d):

> The animal rug . . . with its bold coloring and highly stylized design and in its structural and material features, conforms to the general characteristics of this small group. . . . A field design of animals or birds, often in square or octagonal compartments, is known from actual rugs and from numerous representations in paintings. The style must have grown out of the designs of medieval textiles with single or paired animals in roundels; the roundels became octagonal in the transfer of technique. Animals with raised forelegs are also seen in many medieval textiles. . . . In a specific sense, however, the iconographic treatment is unusual. The device of an animal within an animal . . . is not otherwise known except in a rug appearing in a Sienese painting. . . . The assembled figures in *The Marriage of the Virgin* [see pl. 245] stand on a rug whose field design . . . had not been comprehensible until the appearance of the Museum's rug.

Three Carpets with Abstracted Animal Motifs

Another early rug has remained an exciting curiosity since it was discovered in Tibet in the 1980s: the so-called "Faces" carpet, carbon-dated to 1042–1218, which was first published in 1992 (Herrmann 1992, pl. 1), and immediately acquired by the Kirchheims (pl. 237). The top and bottom of the field are both missing, so we cannot know how many repeats there were originally. The "Faces" carpet is quite different from the MIA carpet in weave, color, and handle. Two complete creatures can be seen, along with almost all of two more above, grouped in overlaying pairs. They have faces with rosy cheeks that look almost human. The field is enclosed by three borders: a narrow band repeating a small triangular motif in a number of different colors; a middle border of hexagons with a cut-out star motif (not so different from a pattern common on

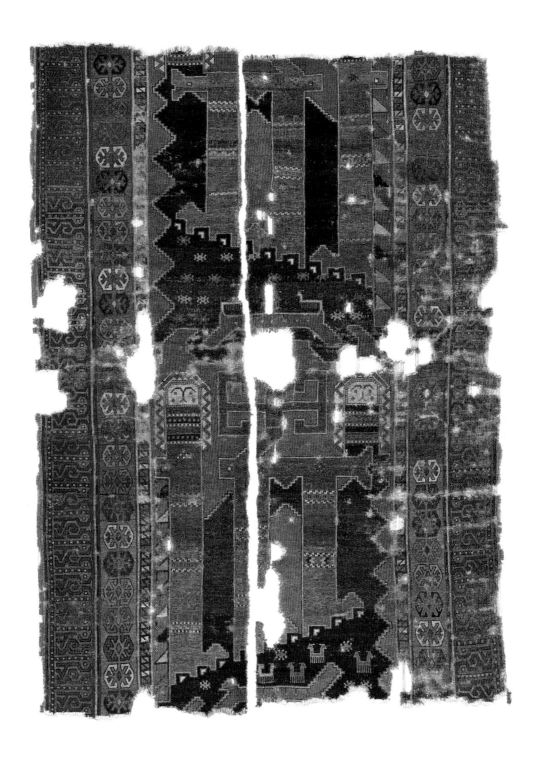

237 Early animal carpet with faces (170 × 235 cm; incomplete), probably Kurdish, probably 12th century. Kirchheim Family Collection, Hannover.

small Kurdish saddle bags of the nineteenth century); a graceful outer border with a "unique" stylized kufic border that includes large "S" serifs with an extension on top between the vertical strokes. Rather than containing the field, the borders appear to free-float on a continuous red background. This highly abstracted design must have developed from a long tradition. Unlike the other animal carpets, this one is piled extensively with offset knotting,[5] a feature commonly found on nineteenth-century Kurdish carpets from eastern Anatolia and western Persia.

A rug that is often overlooked, and may turn out to be one of the most significant early animal carpets, was acquired by Wilhelm von Bode from Carl Zuber in Venice and is now in the Museum für Islamische Kunst in Berlin (pl. 238). It has a narrow

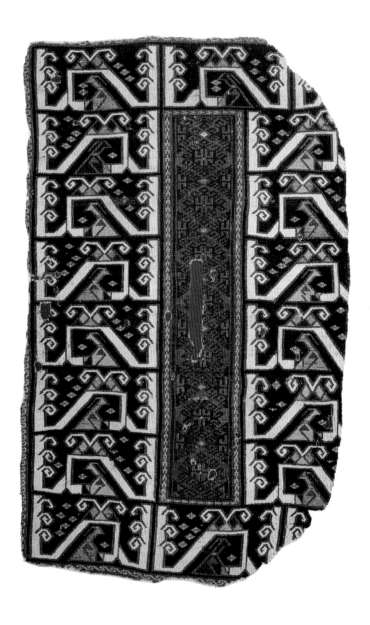

238 Early animal carpet with lattice and hooked diamonds (86 × 184 cm; incomplete), east Anatolia, probably Kurdish, possibly 14th or 15th century. Museum of Islamic Art, Berlin (KGM 1888,112).

field, worked mostly in only two colors, depicting a grid of hooked diamonds and giving the appearance of a panel that has been placed upon the dark blue background. A narrow "tuning-fork" border surrounds the field; outside this is a spectacular primary border of rows of kufic-style ornaments, between which are bird-like forms and a large hooked wing motif that resembles the Great Bird seen in ancient Mesopotamian art (Pinner 1980). The combination of narrow field and wide border is often associated with rugs specifically made to cover coffins, in this case possibly a child's coffin. As with the "Faces" carpet, the Zuber rug is made with offset knotting, and the hooked diamond motifs again bring to mind later Kurdish rugs. Lamm (1985, nos 15, 16) found two fragments in Fustat that have both a similar style to the Zuber rug and offset knotting (National Museum, Stockholm, 229/1939). The age of the Lamm fragments is unknown; samples from the Zuber rug were carbon-dated in Zurich in 1999 to 1468–1636. A further test might confirm the date, but it is possible that these three could all prove to be from the fourteenth century.

A larger fragment, not in offset knotting but very similar in color and wool to seventeenth-century carpets found in eastern Anatolia and northwest Persia, has a

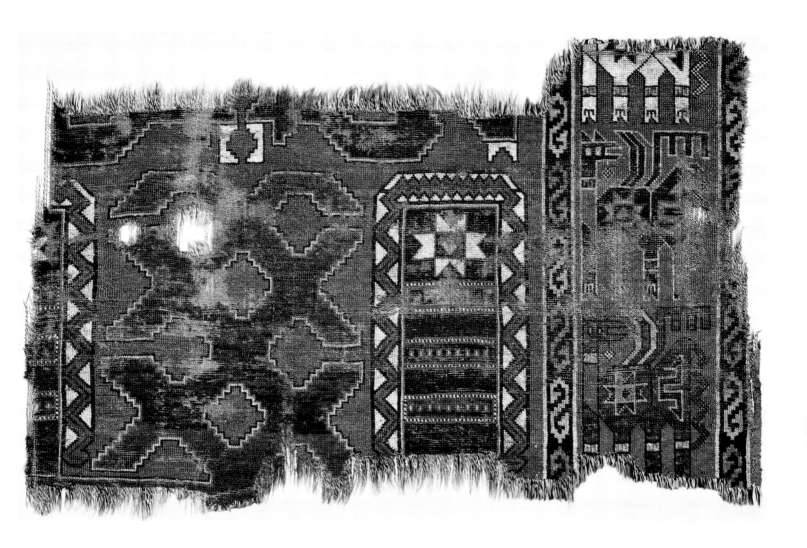

239 Early animal carpet with
strange beasts (122 × 73 cm),
probably eastern Anatolia,
possibly Kurdish, probably 13th
or 14th century. George and
Marie Hecksher Collection,
San Francisco.

pattern reminiscent of the "Faces" rug. It came from Nepal in the late 1980s and was
subsequently acquired by George and Marie Hecksher in San Francisco (pl. 239). While
it is very different from the "Faces" carpet, in many ways it is the closest to it: the
central field shows traces of possibly four strange beasts; the double-crosses in the center
with the wing design on top are doubtless another interpretation of the tail seen as
two inward-pointing "E" motifs on the "Faces" carpet. The tiny parts of snake-like
creatures visible at the top edge are equally intriguing. More naturalistic four-legged
creatures with wings and tails are placed in the borders. This fragment underwent two
separate carbon-14 tests in Zurich, with results 1228–1391 and 1249–1382.

A Specific Group of Early Anatolian Animal Carpets

What makes the MIA and Cagan carpets of special interest is that they form part of
a small but very definite group of five survivors sharing many similar characteristics
(pls. 240–44). The other three – the Genoa, Pine, and Kirchheim carpets – also emerged
from Tibetan monasteries and appeared on the market in Kathmandu between 1985
and 2000. Together with the examples with more abstracted creatures discussed imme-
diately above, these represent one of the greatest discoveries in the history of carpets
since Martin came across the "Early Konya" carpets in 1905 and Rudenko (1970)

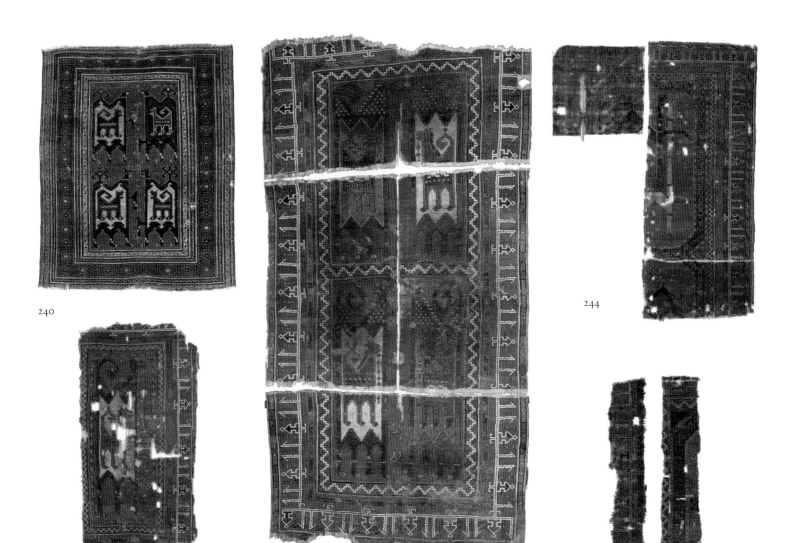

240

242

241

244

243

discovered the Pazyryk carpet (carbon-dated to 383–200 BCE) in the Altai Mountains of Siberia in 1947.

These early Anatolian animal carpets from Tibet partially fill the huge gap between the "Early Konya" carpets made about 800 years ago and carpets of the type most famously represented by the Bode dragon-and-phoenix rug, made about 500 years ago (see pl. 250d). Carpets of this intervening period were a prime area of study for Kurt Erdmann, who was excluded from the storerooms of the Museum of Turkish and Islamic Arts in Istanbul even though he taught at the university there for many years. In 1957 he wrote *Der Türkische Teppich des 15. Jahrhunderts*, and examination of his notes some twenty years later revealed his fascination for the lost carpets of the fourteenth century. Sadly the other great scholar of Turkish carpets, May Beattie, also died before these treasures from Tibet came to light, and Charles Ellis only caught a glimpse of them in his final years. Thus these and other recent finds have prompted the almost complete rewriting of this part of carpet history.

Comparison of the five carpets reveals remarkable similarities and differences. The animals are strikingly alike on the Genoa and the MIA carpets, with slightly more differences on the Cagan carpet, and the animals on the Kirchheim rug are quite

dissimilar (little remains of the field of the Pine carpet). The tail of the outer creatures on the Cagan rug is more akin to that on the border animal in the Hecksher fragment (see pl. 239), but the inner creatures have the curled-back tail of the MIA and Genoa animals. The outer creatures on the Cagan and Genoa rugs have three legs on the ground and one foreleg raised, albeit not as elegantly as the creature on the Kirchheim carpet. The cord hanging from the mouths of the inner creatures of the MIA carpet should be noted, as well as the necklace that also appears on some of the Cagan and Genoa animals (bringing to mind the necklaces on samite-woven silks from China, Sogdiana, Persia, and the Byzantine empire). On three – the Genoa, Pine, and Kirchheim – of the five carpets the creatures stand in elongated octagons placed just inside the rectangular field borders. The animals on the Kirchheim carpet are substantially different from the others, in a more curvilinear style, with long elegant necks and high-kicking forelegs that bring to mind, as Kirchheim noted, the legs of horses at the Spanish Riding School in Vienna. In the upper octagon a tail feather extends from the blue creature in the foreground, and the yellow creature is set behind; in the lower octagon the creatures must be facing in the opposite direction.

The patterns of all these early animal carpets are set against a red background. The border designs give the appearance of floating on top of the field, and the patterns seem to be overlaid, providing a sense of perspective. The well-conceived spaces between the various patterns and borders lend these carpets a special majesty. This subtle concept continued to be used in Anatolian carpets through the sixteenth and seventeenth centuries, but died out later.

The design of the kufic-style main border is one of the most significant features of this group. Various pseudo-kufic borders appear on many carpets, but this one is quite particular. The following features should be noted: the lines within the vertical strokes that break to create the partial illusion of interlace or different levels; the lower hooks at the base of the script; and the candelabra-like ornament with tree diamonds and a trident tail. It is not surprising to find border patterns often continuing unaltered for centuries, so the fact that four (the MIA, Genoa, Kirchheim, and Pine carpets) have almost identical borders is not an indication of a shared age; the similarities in the materials and weave of these four suggest, however, that they were probably made in the same place. In 1940, in a comprehensive article on geometric carpets depicted in Timurid miniature paintings, Amy Briggs listed fifty-seven Persian manuscripts, in which she counted 122 carpets, and presented an insight into the variety of kufic-style borders that were in use 600 to 700 years ago in Persia (no actual examples of these carpets are known to have survived). A variety of kufic borders continued to be used in Anatolia, albeit in a more stylized form, through the fifteenth and sixteenth centuries (Pinner and Stanger 1978). Only one carpet with a kufic-style border is currently attributed to Syria (Mills 1997).

The similarities that exist in the minor borders should also be noted carefully. Adjacent to the central field of the Cagan rug is the typical "S" serif border found on the Marby rug and other examples. It also forms the outer perimeter of the MIA and Genoa rugs. Of particular relevance are the white zigzag lines that surround the fields

Facing page (approximately to scale):
240 The Cagan animal carpet (126 × 153 cm), Anatolia, probably late 14th century. Metropolitan Museum of Art, New York (1990.61).

241 The Qatar animal carpet (see pl. 231).

242 The Genoa animal carpet (98 × 198 cm; incomplete), Anatolia, probably second half of the 14th century. Private collection, Genoa.

243 The Pine early animal carpet (24 × 110 cm and 22 × 109 cm), Anatolia, probably second half of the 14th century. Private collection.

244 The Kirchheim early animal carpet (84 × 163 cm, 85 × 45 cm, 70 × 67 cm; adjoining sections), Anatolia, probably mid-14th century. Kirchheim Family Collection, Hannover.

of the MIA, Genoa, Pine, and Kirchheim rugs and the patterns within the narrow bands that form the octagons on the Pine and Kirchheim rugs. These exact borders can be found on other rugs, discussed below, and indicate the likelihood that examples with similar patterns traveled widely across Asia.

The Animals

My initial impression was that the smaller creatures inside larger ones might suggest pregnancy, but I soon realized that there were in fact three levels of animal (the middle one more rudimentary, without defined head, tail, and legs). After consulting the art historian Joachim Gierlichs, who felt that the creatures most closely resembled a *senmurv* (or *simurgh*, the winged creature of Persian legend) and described how this motif found its way from Sasanian into Islamic art (Gierlichs 1993), I spent some time researching the subject. Prudence Harper (1961), for example, refers to the Avesta, the great book of the Zoroastrian religion that flourished in Iran through the Achaemenian and Sasanian periods. The earliest depictions she found (p. 96) dated from considerably earlier, a seal from the Akkadian period some 4,300 years ago "decorated with two such lion-griffins, bird-tailed, footed and winged, their roaring leonine heads lowered and sur-mounted by figures wearing the horned crowns that are always the mark of divinity."

I will not, however, attempt to definitively identify the creatures here, but merely comment that the highly schematic style of drawing suggests that they were the result of a long development and that much earlier representations may well exist on textiles, silver, stone, and other media. Images of *senmurv*s tend to be curvilinear and "natural-istic"; I am unaware of depictions in other media of creatures within creatures, a fact that surely must be significant. In some of the earliest carpets that have survived — such as the Pazyryk carpet — the creatures also tend to be fairly naturalistic in their drawing, and such abstraction as can be seen in these animal carpets may have taken many years to evolve. The MIA creatures probably thus represent the end of a design tradition rather than the beginning.

Early Animal Rugs in Paintings

This fascinating group of Anatolian animal carpets comes into much sharper focus when put alongside similar rugs depicted in two paintings. Walker (1990) drew atten-tion to the remarkable similarity of the Cagan rug to the carpet depicted in Gregorio di Cecco di Luca's *The Marriage of the Virgin* of 1423 (pl. 245): the pattern of three creatures one inside the other, the inner dog-like creature with its foreleg raised, and the shaping of the legs. The carpet in the painting, however, has a different arrange-ment of these motifs from all the surviving examples. The Cagan rug has four large animals in the field, undivided; the MIA carpet has the upper two animals in one compartment and the lower two in another; the Genoa carpet has only one large

245 (*facing page*) *Marriage of the Virgin*, attributed to Gregorio di Cecco di Luca, *circa* 1423 (41 × 33.2 cm). National Gallery, London (NG1317).

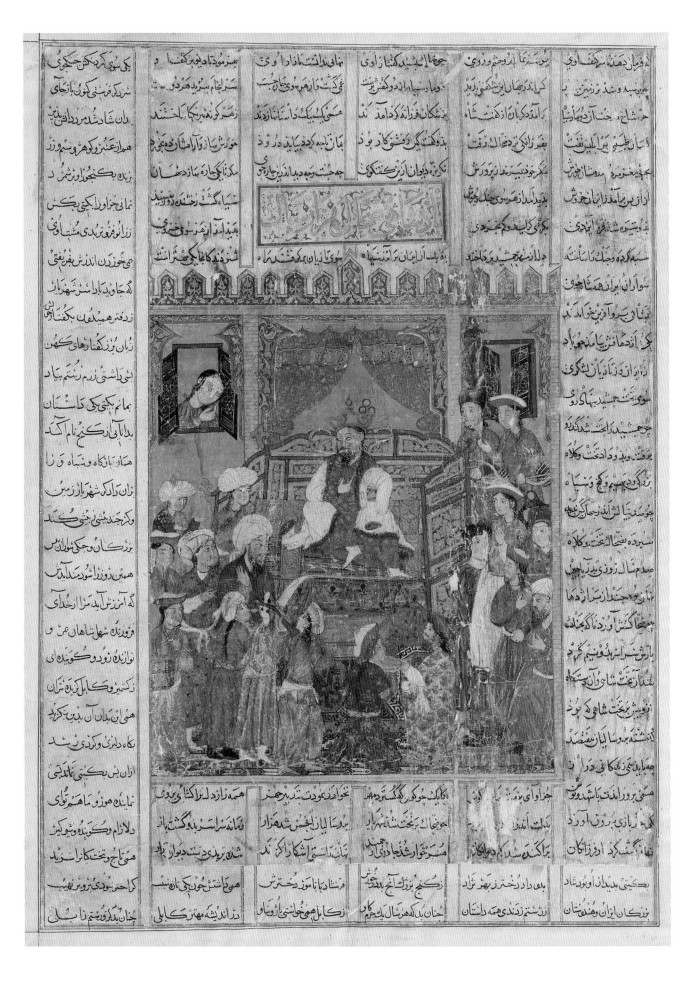

247 Doris Brian's drawing of the carpet in "Zahhak Enthroned" (from Ettinghausen 1959, pp. 93–116).

animal; and the Kirchheim carpet has two or more octagons enclosing the creatures; the rug in the painting probably has an arrangement of two columns of three of the large creatures. Its border pattern is certainly quite different from the Cagan rug and indeed unlike those on any others in the group. This specific type of kufesque border is more similar to the earlier Pine fragments from west Anatolia (see pl. 236c). Similar borders can also be seen on the hems of costumes portrayed in several Italian paintings of the thirteenth and fourteenth centuries, but there are no direct comparisons. The arrangement of the border at the ends of the rug in the Sienese painting, with the design on the sides cut off by the upper and lower borders with no flowing corner resolution, is a common feature on Anatolian carpets.

Much closer to these Anatolian animal carpets in general and to the MIA carpet in particular is the rug that was identified by Ettinghausen in the Persian painting showing "Zahhak Enthroned" (pl. 246) from the Great Mongol *Shahnama* (Grabar and Blair 1980, no. 1). Doris Brian's drawing of this rug (pl. 247) clearly reveals the relationship between it and the surviving Anatolian group. The primary kufic-style border with its candelabra motif is remarkably similar. The interlocking "T" border and the double wavy line do not appear on the five Anatolian carpets; but the border that immediately surrounds the field, with what appears like a zigzag ivory line formed by offset small blocks, can be seen in all but the Cagan rug. The bands that form the octagons in the Zahhak carpet with their inverted "S" forms can be seen in a rather clumsy manner in the octagon bands on the Pine and Kirchheim fragments. It is also interesting to see that the space between the diagonal sides of the octagons and the corners of the field on the Kirchheim fragment echoes the design of the Zahhak carpet and to note the more regular octagons and far more realistic animal on the Zahhak carpet. Might one assume from these features that the carpet depicted in the painting from a royal manuscript is a perfectly composed court carpet, possibly from western Persia, whereas the surviving Anatolian animal rugs are a "naive" village interpretation? Or is it not equally possible that an ancient abstracted design was "sophisticated" in a court workshop?

246 (*facing page*) "Zahhak Enthroned," from the Great Mongol *Shahnama*, Tabriz or Baghdad, *circa* 1330. Freer Gallery of Art, Smithsonian Institution, Washington, DC. Purchase, FI923.5.

The Mongolian Connection

248a–b Two Monoglian carpets with rows of rosettes in the field and kufic and candelabra border (*left to right*): a) the Pine carpet (117 × 210 cm), probably 14th or 15th century. Private collection; b) the Naginataboko carpet (99 × 177 cm), probably 14th or 15th century. Naginataboko Preservation Association, Kyoto.

Two other rugs acquired by Pine in Nepal, also from Tibetan monasteries, appear to be Mongolian in origin but have the specific kufic-style border pattern seen on the Anatolian animal carpets. One, carbon-dated to 1294–1480, has a field pattern of two columns of large rosettes (pl. 248a). The lack of a neat corner resolution in the borders is a feature shared with rugs from Anatolia.

A similar rosette field design can be seen on some of the group of twenty-one rugs from the Mongol Yuan period that are among the many carpets, tapestries, and textiles exhibited on 17 July each year on a parade of floats in the Gion Festival in Kyoto, Japan. This festival, which has taken place annually since 669, is funded by local merchant guilds, each of which has a storeroom of treasures brought out solely for the

event. Initially the rugs were erroneously attributed to the eighteenth or nineteenth century (Walker 1992), the time they were first recorded in the guild lists. They have since been reassessed as being contemporaneous with the Anatolian animal rugs, and one Kyoto rosettes rug (pl. 248b) has been carbon-dated to 1293–1447. Other field designs on the Kyoto Mongol rugs include lion-dogs, tigers, and prunus blossoms. Three of them have an identical primary border to that on the MIA animal carpet, and on some the outer border has the same pattern as the band forming the octagon on the Pine and Kirchheim animal fragments and on the Zahhak rug.

Some Fifteenth-century Anatolian Rugs with Animals in Octagons

By the second half of the fifteenth century, many of the carpets depicted in European paintings form very close relationships with surviving Anatolian examples. For instance, a fragment with a dragon-and-phoenix pattern in octagons and a kufesque border (pl. 249a) relates directly to the carpet in the Domenico di Bartolo's fresco of the *Marriage of the Foundlings* from *circa* 1440 in the Spedale di Santa Maria della Scala, Siena ("Auction Reports" 1992, 150). This fragment was discovered in Cairo in 1939, published by Erdmann in 1955, and then not seen again until 1992, when an Italian collector acquired it in New York. A much more stylized dragon-and-phoenix design is found on a fragmented rug in the Kirchheim Collection (pl. 249b). Carbon-dated to 1432–1632, it is possibly from the mid-fifteenth century. It is interesting that such an abstracted version of this pattern could be made not long after a more naturalistic one.

Four other complete or almost complete Anatolian animal rugs survive from the fifteenth century. The most unusual of these, possibly from the first half of the fifteenth century, is in the Vakiflar Museum in Istanbul (pl. 250a). A stylized Great Bird sits over a pair of confronted creatures that can be related in their underside and infill ornaments to certain Turkman carpets from Turkmenistan. Below are comb-like creatures also seen on some of the oldest surviving Persian pottery (Pinner 1980).

A rug probably dating from the second half of the fifteenth century and once in the Bernheimer Collection in Munich displays two octagons, each containing a mirrored design of a pair of confronted phoenixes interspersed with small octagons (pl. 250b). The hooked heads of the phoenixes can be seen on a two-octagon rug in Jacopo Bellini's *Annunciation* of 1444 in the church of S. Alessandro, Brescia (Franses and Eskenazi 1996, 4).

The Marby bird rug in Stockholm (pl. 250c) and the Bode dragon-and-phoenix rug in Berlin (pl. 250d) have been the great icons of early Anatolian animal rugs for the past hundred years, both published countless times. The field of the Marby carpet, which dates from the fourteenth or early fifteenth century (radiocarbon dated to 1300–1420), is divided in half, each one containing an octagon with a tree flanked by two birds. On top of the tree is a hooked device, probably the symbol of a Great Bird. Several carpets with a design of two birds facing a tree are depicted in Italian paintings, but none seem to be drawn in the schematic manner of the Marby rug; in contrast,

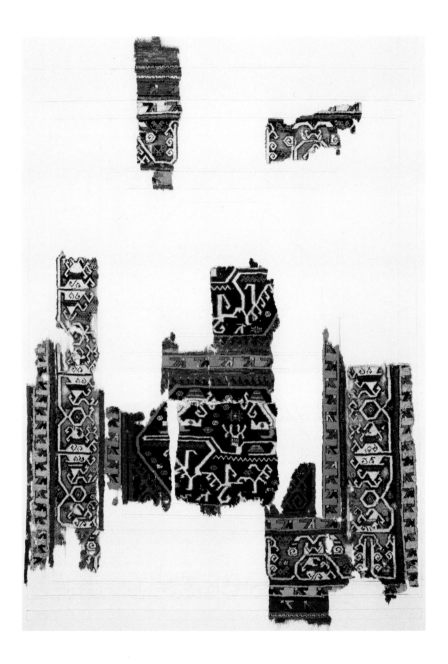

249a–b Two Anatolian animal carpets with octagons (*left to right*): a) Cairo dragon and phoenix carpet (49 × 65 cm), probably early 15th century. Private collection, Genoa; b) the Kirchheim stylized dragon and phoenix carpet, assembled sections (originally approximately 155 × 230 cm), possibly mid-15th century. Kirchheim Family Collection, Hannover.

the border patterns of the latter can be seen in many paintings (the major border, for example, is similar to the minor border of the rug in the Brescia *Annunciation*). The minor border of the Marby rug appears on several of the Anatolian animal carpets. The Marby rug may represent a more archaic rendering that existed, largely unaltered, for many centuries in more provincial areas. It has been suggested that it might have reached Sweden with the Vikings, who are known to have traveled down the Volga to the Black Sea where they traded with Byzantine merchants.

The Bode dragon-and-phoenix rug may date from around 1490 (in 1999 it was carbon-dated in Zurich to 1486–1645). Two paintings by Bartolomeo degli Erri depict a rug with a similar pattern: *Scene from the Legend of St Vincent Ferrer, circa* 1470 (Kunsthistorisches Museum, Vienna, GG 6696) and *The Birth of St Thomas Aquinas* of 1475 (Yale University Art Gallery, New Haven, 187.41). A third painting, *Christ Before Pilate*, 1469–80, by the Master of the Schottenaltar, in the Schottenstift Museum, Vienna, shows a phoenix tail similar to that on the Bode rug. The primary border of the Bode is akin to that of the Brescia painted rug, but with the colors reversed.

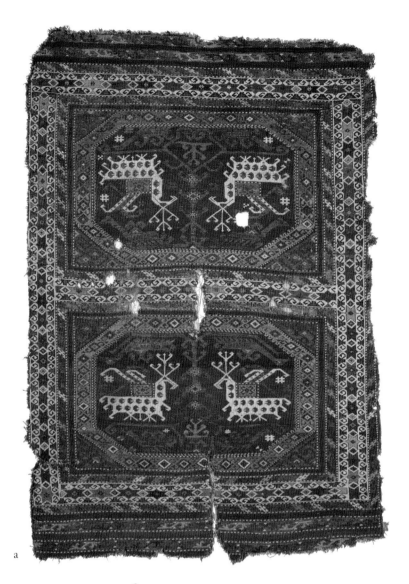

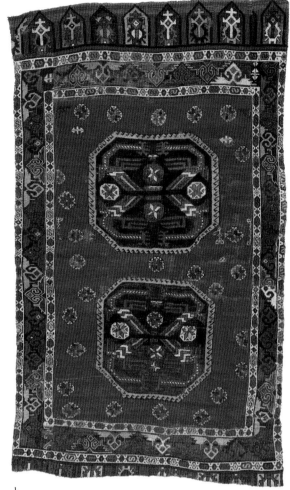

250a–d Four Anatolian animal carpets with octagons:
a) the Vakiflar carpet with confronted animals and tree (154 × 227 cm; incomplete in width), *circa* 1500 or later. Vakiflar Museum, Istanbul (E-1);
b) the Bernheimer carpet with dragon and phoenix (119 × 200 cm; incomplete in length), second half of the 15th century. Private collection, Padua;
c) the Marby carpet with confronted birds and tree (109 × 145 cm), 14th or early 15th century. National Historical Museum, Stockholm (17 786);
d) the Bode carpet with dragon and phoenix (91 × 161 cm; incomplete in width), probably late 15th century. Museum of Islamic Art, Berlin (I.4).

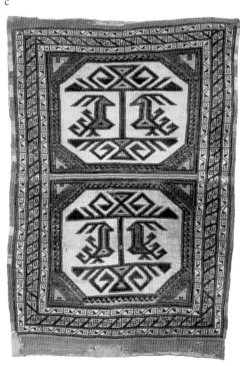

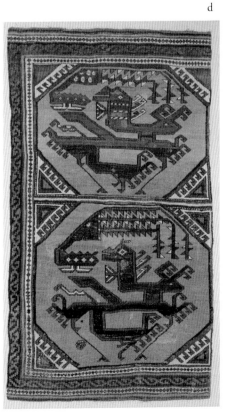

A Summary of the Anatolian Animal Carpet Group

Technically, these five animal carpets are all reasonably similar. They are woven on wool foundations with symmetrical knots and two wefts between each row of knots.[6] The warps are all Z2S and vary occasionally in thickness, sometimes with dark wool twisted with light wool. All the examples examined have "lazy lines" in their construction.[7] Their condition is extraordinarily good in view of their great age. Their pile is evenly worn down to the knots, except for the MIA carpet, of which much of the original pile survives. The Cagan, MIA, Genoa, and Kirchheim rugs have parts of the original side selvedge. The selvedge on the Cagan rug differs from the others in the method used to secure it and in its color, being blue rather than red. The Genoa rug, which is in part worn and is missing some borders, is the only example with the original end finish at the lower end. It establishes that the warps were left uncut, with each alternate warp returning up the carpet. Between the end of the pile and the uncut fringes are five lines of blue kilim, and the uncut warps naturally twist. At the end of this is a heavy cord that must have continued along the entire lower end. This cord is made up of six pairs of threads twisted together, each part composed of one brown and one ivory thread.

I propose that all five of these carpets are from Anatolia. There is no proof for this, apart from their similarity, both in technique and in the nature of the materials used and particular hues of color, to carpets dating from the late fifteenth century onwards that are attributed to Anatolia, and their differences from carpets assumed to have been made elsewhere. In addition, we do have some idea of what a number of Persian carpets of the fourteenth and fifteenth centuries may have looked like from depictions in Timurid paintings.

This returns us to the question of where the carpet in the Zahhak miniature was made. Could it have been imported from Anatolia to Persia? Or is it not more likely that the inspirations for these Anatolian animal carpets were in fact Persian, and that these five survivors from Tibetan monasteries were simply Anatolian interpretations? We probably will never know. Another curiosity is provided by a Sasanian rug recently acquired by the MIA (CA.91.2011) that was carbon-dated to 380–600 and shows naturalistic lions depicted on the tapestry-woven sections at each end. It has technical features more akin to Anatolian carpets than to Persian, although the type of wool used would seem to be more Persian than Turkish.

With regard to their age, each of the five carpets has been dated using carbon-14 testing (see Appendix) – although it would be useful now to compare these results with other methods currently becoming available, such as protein analysis. In the early years of carbon-14 analysis, the results appeared to be less reliable, but more recent tests, including those organized by Jürg Rageth for Heinrich Kirchheim and undertaken at ETH in Zurich, have produced far more consistent results, although they still provide quite a wide range of dates in many cases.

Aside from the scientific methods currently available, the only reference point available for works such as these carpets, which carry no in-woven dates and have no

documentation, is comparison with examples bearing similar patterns that are depicted in datable paintings. Of course, it is impossible to determine whether a rug was new when portrayed, whether a design that appears on a rug is the first depiction of that pattern, or whether a particular pattern was used for centuries. It is possible to trace design development through paintings, but one may unwittingly compare examples from different weaving centers whose designs evolved at different rates. These are just some of the many pitfalls that show that until more accurate scientific methods of dating become available, all conclusions need to be treated with extreme caution.

Bearing these points in mind, it is likely that the MIA, Genoa, and Pine rugs are contemporary and probably date to the second half of the fourteenth century. The Kirchheim fragments are possibly the earliest, from the mid-fourteenth century, and the Cagan rug might be a little later, from the late fourteenth century. If these datings are correct, then it is likely that the rugs arrived in Tibet over a considerable time span.

In any case, even without knowing exactly when and where these five rugs were made, we can still grant these creations the admiration they deserve. Used carpets are often worn and torn, and regardless of their age, color, and design, they have tended to be treated as disposable utilitarian objects. Consequently, it is not always easy to view them as works of art, unlike Tutankhamen's gold or Emperor Qin Shi Huang Di's terracotta army at Xi'an. But these particular carpets also have a historical resonance and a depth and beauty that are immediate in their appeal and make them worthy of much wider appreciation.

Notes

1 This article is dedicated to the memory of Richard Ettinghausen (Frankfurt am Main, 1906– Princeton, NJ, 1979). I would also like to acknowledge to the assistance of Carole Bellon, Annette Beselin, Sheila Blair, Jonathan Bloom, Alessandro Bruschettini, Fred Cagan, John Eskenazi, Ben Evans, Kjeld von Folsach, Joachim Gierlichs, Nobuko Kajitani, the late Heinrich Kirchheim and the Kirchheim family, Jens Kröger, John Mills, Jeremy Pine, Julian Raby, Jürg Rageth, William Robinson, Daniel Shaffer, Richard de Unger, Daniel Walker, Rupert Waterhouse, Stefan Weber, and of course Richard Ettinghausen.

2 These images can be seen in the podcast of the lecture (http://www.islamicartdoha.org/) and will form the basis for an exhibition being planned for Doha, possibly in 2016.

3 The comparative images are reproduced here mainly in black and white because the ornaments can be more readily appreciated in this way.

4 A complete fifteenth-century Spanish carpet in the Textile Museum, Washington, DC (1976.10.3); a small Spanish fragment in the Museo Nacional de Artes Decorativas, Madrid (1.742; Arraiza 2002, 96, pl. 24); and two sections of a late fifteenth-century carpet possibly from the Ushak region of west Anatolia, now with the Bardini Estate in Florence (7880; Boralevi 1999, 74–75, no. 22) and in the Museum für Islamische Kunst in Berlin (1885.985; Beselin 2011, 81).

5 Offset knotting: the symmetrical knots tied on two warps are not placed above one another in each row but are offset using an adjacent warp.

6 The MIA carpet: 755 knots per dm², 9 colors (J. Vernon, Longevity Textile Conservation, 1991). The Cagan carpet: 1320 knots per dm², 7 colors (after Walker 1990). The Genoa carpet: 755

knots per dm², 8 colors (J. Vernon, Longevity Textile Conservation, 1991). The Kirchheim carpet: 890 knots per dm², 8 colors (A. Thompson, Longevity Textile Conservation, 2000).

7　These are small diagonal lines that can be seen on both the front and the back of certain carpets. After each row of knots, two or more shoots of weft are passed between the warps and beaten down in order to hold the knots in place and to act as a base on which to tie the next row of knots. Lazy lines are created by the weaver not passing the weft threads across the full width of the loom, but reversing them at a certain point, and then bringing another weft across from the opposite side of the rug. At the point where these two wefts meet is a gap. In the next row, the wefts meet slightly to one side of that gap. When continued over several rows of pile, this creates a diagonal line.

Carbon-14 dating results for early Anatolian carpets

Pl.	Lab/ref.	Test date	Radiocarbon age	95% probability
232	HAR–5003/5522	29/1/1986	1,290 ± 90 (mean of 2 runs)	580–920 (100%)
233	OxA–6801	17/3/1997	695 ± 40	1250–1320 (72%) 1340–1400 (28%)
234	OxA–6551	19/3/1997	1,025 ± 65	880–1170 (100%)
235	AAR–8450	3/3/2004	515 ± 30	1330–1350 (7.4%) 1390–1450 (88.0%)
236b	ETH★			1189–1283
236c	OxA★			1040–1300
237	RCD–203	23/11/1990	630 ± 55	1270–1420 (100%)
	ETH–21307	25/2/2000	900 ± 30	1042–1110 (37.2%) 1110–1149 (21.3%) 1150–1218 (41.5%)
238	ETH–20873	1/11/1999	330 ± 30 (mean of 2 runs)	1468–1636 (100%)
239	ETH–16397	7/11/1996	720 ± 45	1228–1317 (78.6%) 1344–1391 (21.1%)
	ETH–16397	11/9/1998	715 ± 30	1249–1309 (89.6%) 1356–1382 (10.4%)
240	OxA–2144	10/11/1989	800 ± 70	1040–1290 (100%)
241	ETH–9003	18/6/1992	740 ± 45	1190–1300 (100%)
	ETH–23549	2/3/2001	540 ± 30 (mean of 2 runs)	1319–1342 (9.8%) 1392–1440 (90.2%)
242	RCD–729	3/2/1992	740 ± 55	1205–1375 (100%)
	ETH–23548	2/3/2001	535 ± 30	1322–1339 (6.1%) 1393–1441 (93.9%)
243	ETH–24277/24278	2/3/2001	555 ± 30	1312–1352 (26.1%) 1387–1435 (73.9%)
244	ETH–18653/18976	1/10/1998	580 ± 25	1308–1359 (55.1%) 1380–1420 (44.9%)
248a	IGNS★			1294–1480
248b	OxA–5342	5/5/1995	530 ± 55	1293–1447 (100%)
249b	ETH–21325	15/8/2000	410 ± 40	1432–1526 (69.9%) 1555–1632 (30.1%)
250c	★★			1300–1420
250d	ETH–20877	1/11/1999	330 ± 30 (mean of 2 runs)	1486–1645 (100%)

★ No further information available
★★ From Nockert 2011
AAR = AMS Dating Centre, University of Aarhus;
ETH = Eidgenössische Technische Hochschule, Zurich;
HAR = Low Level Measurements Laboratory, Harwell; IGNS = Institute of Geological and Nuclear Sciences, New Zealand; OxA = Research Laboratory for Archaeology, University of Oxford; RCD = Radiocarbon Dating, Wantage

لسقمك وفر

فَرَاغَكَ لِشُغَلِكَ

12

*An Ottoman Murakkaa
and the Birth of the International Style*

المرقعة العثمانية ونشأة الاسلوب العالمي

Mohamed Zakariya

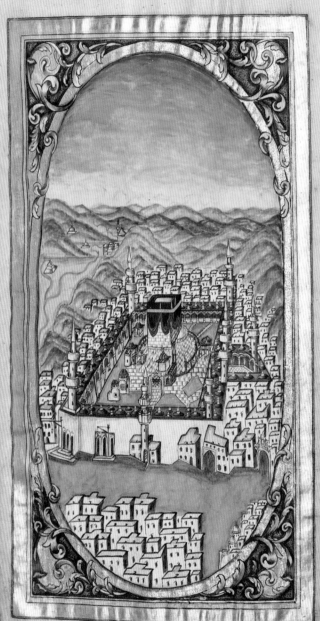

To understand an artifact like the Ottoman album or *murakkaa* in the Museum of Islamic Art (MIA),[1] you have to begin at the beginning, with the origins of calligraphic writing in Arabic. I would like to take the reader back, in a symbolic way, to the cities of Mecca and Medina (pl. 251), the points from which the Islamic religion and the Arabic language radiated. We cannot go back to the way these cities were, but we can return to places remembered in art and idealized in memory, not so much for what they were, but for what they are in the imagination.

The first time I saw these pictures was in 1964, in a Moroccan copy of a *Dala'il al-Khayrat*, but in its schematic form. I was intrigued. Later, I saw the Ottoman versions, both painted and printed, which evolved up to the late nineteenth century. This genre of illumination succeeds as artworks are supposed to. Can we imagine an Ottoman traveler, looking at these pretty, generic, Turkish-looking towns, perhaps on his way there, maybe even singing the litanies of the *Dala'il*, feeling as if he is going to the heart of his faith?

In Mecca and Medina the art of calligraphy found its beginnings, shrouded in legend, the province of only a handful of accountants, scribes, and other literate people. It was a simple way of writing, not yet fully understood but poised to take off on a flight that continues today.

Many have hypothesized about where this writing came from, and some have come close to solving the riddle. We know that at the time of the Prophet of Islam, an early form of writing was functioning. If we look at the samples from the Holy Relics Room at the Topkapı Palace in Istanbul, I think we can get an idea of how writing was being done in those years. Plate 252 shows a page with a full, short sura, *al-Takathur*, the 102nd chapter of the Koran (Aydın 2005, 89). Perhaps it was written for

251 (*facing page*) Facing pages showing the Ka'ba and the Prophet's tomb in a compilation of Koran surahs copied by al-Hajj Ahmad Na'ili (14.8 cm × 10 cm; text area 10 cm × 5.5 cm), Ottoman Empire, dated 1223/1808. MIA, Doha (MS.391.2007).

252 Leather page with Sura 102 in kufic script, preserved in the Holy Relics Room in the Topkapı Palace, Istanbul, possibly 7th century or a later copy. Topkapı Palace Museum, Istanbul.

memorization. There are also prophetic letters in the Holy Relics Room. Perhaps they are real, perhaps not, but the writing seems consistent with some of the authentic papyri from this early period. If the letters are fakes, they may be copies of originals and should not be ignored.

The story of how the art of calligraphy, or *fann al-khatt*, went from these elementary states to the pinnacle of achievement in the nineteenth and early twentieth centuries is one of the extraordinary examples of the evolution of an art. To call it an art at this early stage is premature, however, since its practicality as a writing system transcends its identification as a vehicle of beauty. The development of calligraphy took place over a period of roughly fourteen centuries, with peaks and plateaus, periods of stable progress and of stagnation, but always recovering and moving higher. It is its evolution that is fascinating.

From Writing to Calligraphy, Kitaba *to* Khatt

Before I discuss the progression that led up to the Ottoman *murakkaa* and how albums like this helped pave the road of development, let us note some roads that led elsewhere. The two distant worlds of Chinese Islam and North African/Andalusian Islam were also areas where great calligraphic art was created.

Plate 253 is an example of the calligraphy of Chinese Islam. It is simply one of the most innovative and stunning pieces of the art that I've ever seen. It is both fully Islamic and fully Chinese, a perfect amalgam, alchemy in ink. The composition of this masterpiece is totally unintuitive to those who see Arabic structure only from the standard viewpoint. The text is *nun wa'l-qalam* (Koran 68: 1). Most striking is the *lam* of *qalam*, which descends like a thunderbolt from heaven, piercing the heart of the word. This strong vertical stroke gives the composition its drama and impact.

The other geographic and cultural extreme, the counterbalance, is the North African/Andalusian branch of calligraphy. An example of it at its most original and expressive is a manuscript comprising the last thirtieth (*juz'*) of the Koran (or the last two sixtieths or *hizb*s) in the MIA (pl. 254). This piece, with its unique writing and layout, gives us a picture of the rich and continuous field of innovation that developed out on the west wing of Islam – perhaps freer from an artistic viewpoint than the more official and regulated styles of the Islamic heartlands. Although the artists and crafts-people occasionally played with eastern themes, perhaps with a touch of parody, at its best the calligraphy of western Islam owes little to the east save its early origins. It is the perfect vehicle for transcribing the Koranic *riwaya* (reading) of Imam Warsh, the style of Medina favored by proponents of the Maliki school. This *riwaya*, with its complex orthographic demands, does not work gracefully in the "eastern" scripts.

Unlike the eastern scripts, the western ones are not proportional (*mansub*); that is, the letters are not regulated by criteria of size, dimension, proportional relationships, and the effects created by the movement of the sharp chisel edge of the pen and the free-flowing black ink on the specially prepared and polished surface of the paper.

253 (*facing page*) Scroll with Koran 68: 1, China, 18th century. Qatar Calligraphy Museum, Doha.

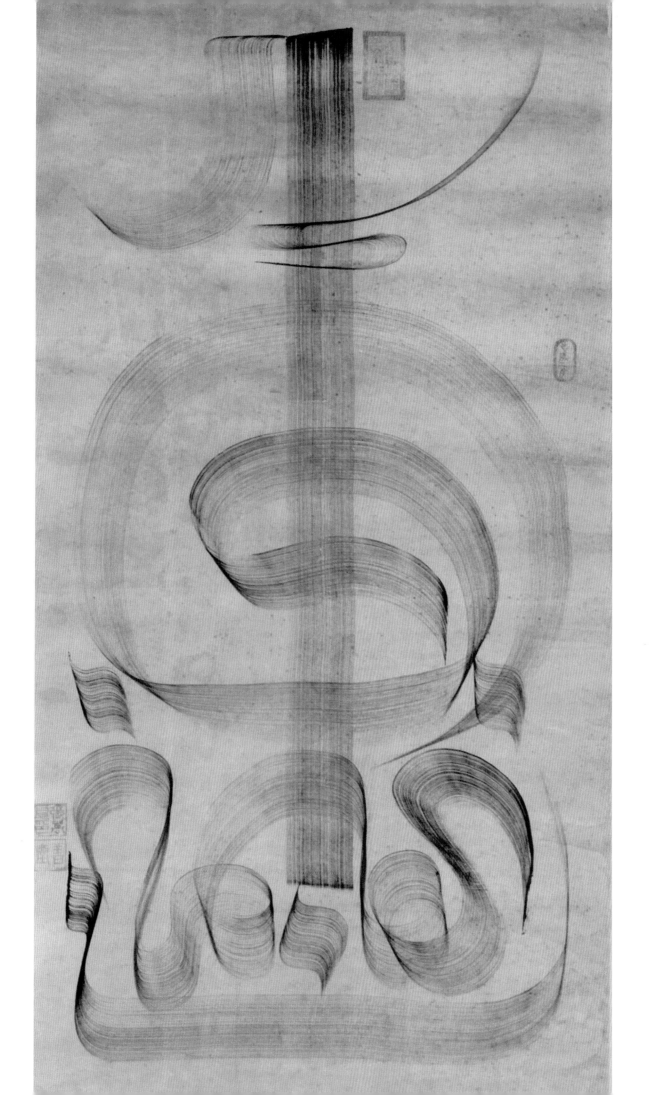

254 Double page from a Maghribi Koran with the heading and opening nine verses of Sura 78, Andalusia or North Africa, 14th century. MIA, Doha (MS.11.1999).

255 (*facing page*) Two pages from an early Koran manuscript in kufic script with the chapter headings for Suras 33 (*top*) and 34 (*bottom*); MIA, Doha (MS. 233.1999 and 36.2007).

Moreover, the western scripts are written with a blunt-tipped pen. The ink is applied heavily and is expected to run out before the end of the letter, leaving just enough to write the thin parts of the letter.

That said, the writing art and scribal practice were part of most Muslim societies wherever they were. By looking at early works, we can see this split-level vision – practical, scribal writing on the one hand, and various approaches to artistic, calligraphic writing on the other. This is an oversimplification of a complex subject, of course, and we do not yet know the true names of the important early scripts. Most extant early manuscripts are written in ways that do not conform to the canonical styles but are often influenced by them, so it is useful to consider the official styles – the canon – in comparison to the more or less vernacular, individual ways of writing. This then leads to other issues, such as how new scripts evolved from old ones and how to read sloppy writing.

With writing like that shown in plate 255, we begin to see the artistic and masterly control of the pen. The reed pen can be simply a marking stylus, or it can become an instrument that takes as much time and skill to master as a musical instrument. In this kind of work, we see the birth of Arabic-script penmanship. Unlike the Maghribi scripts from North Africa with their individuality, these are the harbingers of the classic scripts from Iraq. Almost every letter is manipulated by the pen. In lesser hands than those that wrote this, we see minimal or uninspired manipulation. The aesthetics of these works gives us a deeper understanding of the social milieu and the artistic motivations

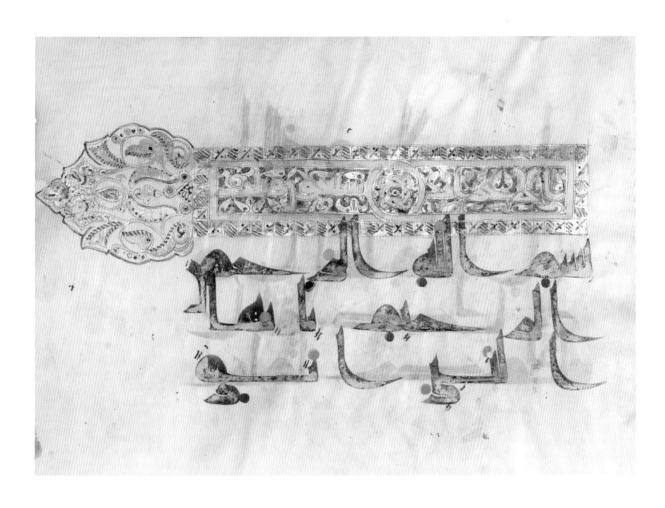

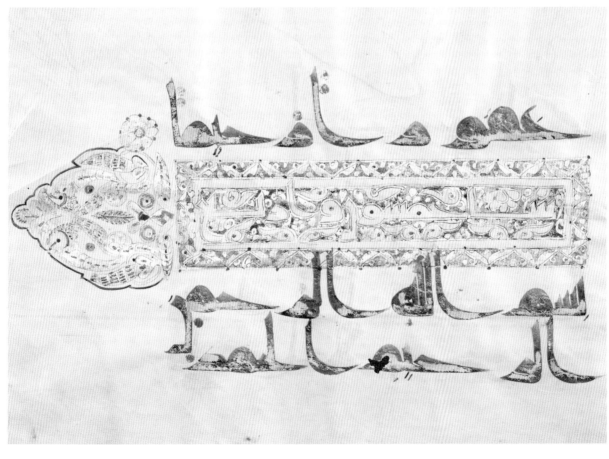

of the writers themselves. Without consideration of these factors, the works become as if cut adrift from their time.

I'm not talking about fiddly decoration here, but structural design engaged to impose visual concepts of motion and stasis, weight and weightlessness, flow, muscularity, texture, surprise, joy, and, of course, legibility, transforming mere writing into something bigger. This was a process that was repeated again and again. Here the work is not micro-perfect, but fast and subtle. The thickened sweep of the *alif*'s hook, normally the width of a pen, imparts resolve and drive. Other such moves abound. The writing was quick enough that we can read the writer's moves almost as though we were watching him.

To highlight some of the characteristics of this elegant script, I selected letter groups from the front and back of the folios shown in plate 255, which come from the same writer and probably the same volume. I wrote the letter groups randomly on genuine parchment to get the right visual effect (pl. 256); as a text, however, they have no meaning. To understand the diagram, first observe that the writing was done in brown ink with a chisel-edge reed pen. Originally, modifications to these letterforms would have been done with the same pen and the same ink, either while it was still wet or after it dried – most likely the latter, considering the weather. I identified four areas where the writer would make modifications and added them here in black ink for emphasis. A red arrow with a letter shows the type of modification:

A – putting the *tarwis* or head on the beginning or end of a stroke
B – rounding a letter form
C – thickening a stroke
D – forming a corner

Operations B, C, and D could have been done with the pen when the piece was being written or added later. If done while writing, the pen can be held at various contrary angles to achieve the thickening. The little "eyes" are drawn and filled in after the basic shape of the letter has been made.

There seems to have been some way to indicate a baseline for the writing in these manuscripts; the method is not obvious but could possibly be rubbing it over a string-board (Arabic: *mistara*, Turkish: *mıstar*). Or it could have been done by eye, which is by no means impossible. In any case, the writing does not sit on a flat base but occupies a subtle, spontaneous relation to the line, giving it energy and loveliness. The writer probably supported his parchment on his right knee, as was the practice later, and wrote holding the parchment at a steep angle to the ground. This allows the ink to flow downwards by gravity, giving the bottom parts of the letters more density.

In these examples, the orthography of the older recension, the one generally associated with the third caliph 'Uthman (r.644–56), can be seen in the form *ya ayyuha*, but on the back of the page, the text continues with the "rationalized" spelling of *al-kafirun wa'l-munafiqun*; that is, with long *alifs* written out. Another interesting feature of the manuscript is the use of a yellow dot over, on, or under a consonant to indicate the vowel that relates to a doubled consonant.

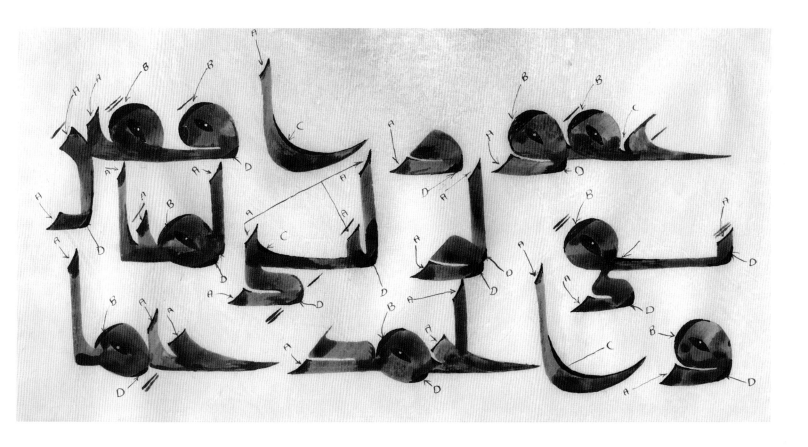

256 Schematic drawing showing the area of the original pen strokes that are modified by retouchings, as was done in the two pages shown in pl. 255.

These folios have to be counted among the highest examples of this kind of writing. By the ninth century writing had developed a high-end version, written by noted people, which we will call calligraphy – in Arabic *san'at al-khatt*, *fann al-khatt*, or just plain *al-khatt*. In short, some writers were becoming calligraphers, and calligraphy was becoming an art in its social context.[2] Obviously the presence of a high-end product, written by known specialists producing sumptuous manuscripts of the Koran (*mushafs*), demonstrates the burgeoning presence of a connoisseur culture that understood and appreciated it and paid for it in some way.

While all this writing of so-called kufic manuscripts was spreading through the cities, another concept of writing existed for non-Koranic uses, and presumably such scripts had developed from the kind of writing we see in the Arabic papyri. It is entirely possible that the so-called "Eastern Kufic" scripts or "New Style" (Déroche 1992, 132–84), which had a prolific life in the tenth to twelfth centuries, emerged from the simple, supple scripts of the papyri, and that even the Maghribi family of scripts did as well. It is likely that in the courts, bureaucracies (*diwans*), and businesses of the central zone, especially in Baghdad and the Syrian cities, these new forms were being arranged into a hierarchy of value and prestige, becoming *muhaqqaq*, *thuluth*, *rayhan*, *tawqi'*, *riqa'*, and *naskh*[3] – the so-called six scripts – and the forty or so derivative scripts that had some currency at an early stage.

In the early history of calligraphy, three names are pivotal. Ibn Muqla (d.940) is conspicuous and legendary, but no sample of his work has been identified. We know so little about him and his contributions that some skepticism about his inventions and especially his measuring and proportional system is in order. Ibn al-Bawwab (d.1022), as so many later calligraphers, was a respected figure in the religious establishment of his day. A man of humble birth (his name literally means "son of the doorman"), he

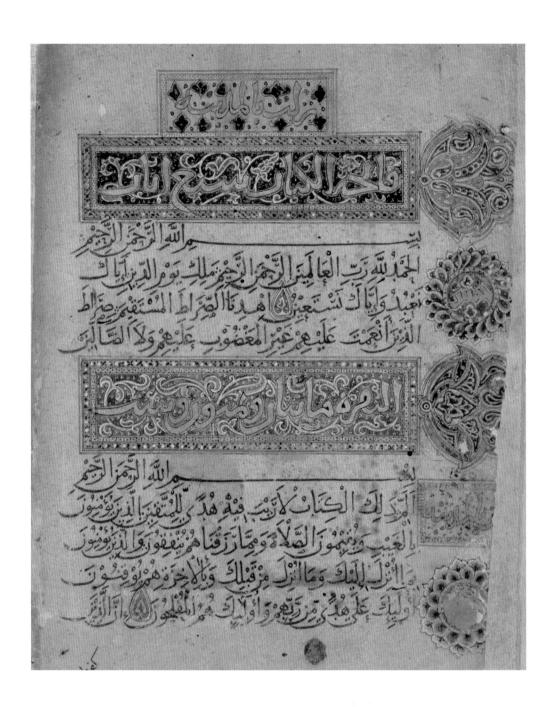

257 Opening page from the Koran manuscript copied by Ibn al-Bawwab (17 × 13 cm), Baghdad, 1000–1. Chester Beatty Library, Dublin (MS.1431, folio 9b).

was mocked by courtiers and wags of the "nobility" because of his origins. Today it makes more sense to consider him less as an inventor than as an artistic writer who was far ahead of his peers, an artist by nature who had a distinct vision for defining the characteristics of the different scripts, albeit in an early way. This is clear from his famous Koran manuscript in the Chester Beatty collection – possibly the earliest example of a hundred per cent delineation of the *rayhan* script (pl. 257).

Rayhan is basically a small *muhaqqaq* (usually one-third the size) in which the *alif*, *lam*, and independent *kaf* all bear the *tarwis* (*tarwisa*), the small blob or hook at the beginning of the letter (pl. 258). All the letters like *raʾ*, *zaʾ*, *waw*, and *mim* are *mursala* – that is, longish, with pointed tips. Most letter shapes are *muhaqqaqa*, that is, with fewer variations, except for the occasional "hooked *ra*." The "eyes" of *faʾ*, *qaf*, *mim*, and medial and final *ʿayn* are open. Notably, the vowels (*harakat*) for short *a* and *i* are written with the same pen and stroke style used for the basic writing. *Rayhan* forms a

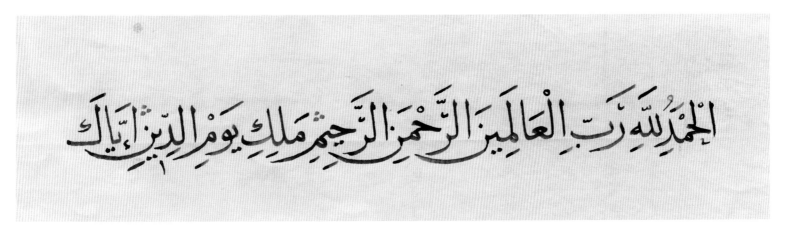

pair with its sister script *muhaqqaq*, just as *riqaʿ* does with its sister *tawqiʿ* and *thuluth* with its sister *naskh*. (*Thuluth* and *naskh* in no way resemble each other, but they are complementary.)

Note that the Chester Beatty manuscript is written in the "rationalized" orthography in a very consistent way. This was the most common spelling after the orthography changes of the ninth to the eleventh centuries and was used until King Fuad I became interested in reviving ʿUthmanic orthography in the early twentieth century (Tabbaa 2002 gives an overview of these developments).

This Koran manuscript is entirely the work of Ibn al-Bawwab's hand, including the illumination – in short, a masterpiece of art. He had the distinction of being a highly intelligent observer of human psychology, as seen in his trenchant work "Rhyming in R."[4] It is possible that Ibn al-Bawwab was teaching his views on the power of line and flow, as described by the shaykh Muhammad ibn al-Hasan al-Sinjari (fl. *circa* 1442) in his poem *Bidaʿat al-mujawwid fiʾl-khatti wa usulih*, "The Equipment of the Perfectionist in Calligraphy and Its Principles" (cited in Habib 1305, 278–80). In the section on holding the pen, Sinjari writes: "Let the writer use his thumb, index, and middle finger only, and make the middle finger a horse that carries the reed like the breath." In any case, I think Ibn al-Bawwab's importance to the art is vastly underrated and overshadowed by the third pivotal figure, Yaqut al-Mustaʿsimi (d. 1298), who died nearly three hundred years after his predecessor.

We see in Yaqut's work the culmination of the evolution of the six scripts during the Baghdad period. With him, many features of later writing and book production became established – writing crisply with the slant-cut pen, writing successfully in larger sizes, confining writing within borders, using both large and small writing on the same page, and using free-flowing black soot ink. It may be, however, that his primary achievement was as a teacher.

When Yaqut's six famous students – among them Arghun Kamili and Ahmad Ibn al-Suhrawardi (d. *circa* 1320) – left Baghdad after the destruction of the city, they spread out to teach his methods. The two great movements in six-script calligraphy began to take shape, the Iranian and the Turkish. Since my specialty is the Ottoman/Turkish approach, I will confine myself to that development.

About 150 years after the death of Yaqut, another star rose in the north-central Anatolian city of Amasya. Amasya was the home of many distinguished calligraphers, as were the surrounding towns of the region, Çorum, Merzifon, and Tokat. But it was Şeyh Hamdullah (d. 1520) – Hamdullah ibn Mustafa Dede, also known in Turkish as

Ibnüş-Şeyh (Arabic *shaykh*, elder, exemplar) – who was to make the most indelible marks in the annals of the art. The Şeyh himself – he was the *şeyh* of the archery guild – studied with the well-known calligraphers of his time and location. His work was of a high but not extraordinary caliber until Sultan Bayazid II encouraged him to develop a new way to write and appreciate calligraphy – an experience that made him legendary. In 1481, when Şeyh Hamdullah was fifty-two, Bayazid invited him to Istanbul, where he soon began his revision and reconstruction of Arabic script writing that earns him the rank we would call godfather of the modern international style.

The Album and the Book Trade

Albums have played a role in the art of the book in Muslim cultures from an early period. Most of them are assemblages of separate works. The Ottoman calligrapher's *murakkaa* is something else – a specialty, a teaching and collection book, and an object in itself. Such albums seem to have come into existence in their present form in the latter part of the fifteenth century, based on Persian concepts, primarily collection albums. The Ottoman *murakkaa*s may have been connected to the calligraphy being undertaken in Amasya, a town that has been called the alembic of Ottoman culture.

By this period, Ottoman preferences in books and texts were being developed – complete manuscripts of the Koran (*mushaf*s), collections of often-used suras named after the sixth sura of the Koran, al-An'am (Livestock) and hence known in Turkish as *En'am*s, other manuscripts of all kinds, short specimens, and albums (*murakkaa*s). The *levha* (a large piece intended for display) had not yet been accomplished. The book arts were fully underway, including cultivating, seasoning, and selecting reeds for pens; paper and ink making; and procuring pigments and adhesives – the whole apothecary of book chemistry. In addition, the arts and trades of book production were in full swing, including gold-beating, illumination, borders, design, binding, restoration, and repair. The tools for these trades were also manufactured, at various levels of utility and luxury – items such as penknives, slabs against which to trim pens, burnishers, scissors, and inkwells. Also active were the designers (sing. *nakkaş*), who produced work for large architectural settings. In short, Istanbul boasted the whole industry, producing everything from prestige books to those for wider circulation.

Significantly, the protocols of calligraphy education also took shape here in the fifteenth century. Part of the curriculum was the making and use of the *murakkaa*. In essence, the *murakkaa* is a collection of calligraphy that is organized around a concept. *Murakkaa*s can be collections of small works by a single calligrapher or collections of works by various calligraphers, as is the one in the MIA. A *murakkaa* can have a random sequence of individual pieces (*kit'a*s) or it can be designed for a specific purpose, like the lesson *murakkaa*s (*meşk murakkaası*) that contain the exercises known as *müfredat* (in which the letters of the Arabic alphabet are written in sequence as an exemplar) and *mürekkebat* (words or phrases, often poems or sayings from the Prophet), the basic curriculum for the beginner. A student might collect the teacher's lessons and have them

bound; these collections are often dated consecutively, so we can judge how quickly a student was progressing (pl. 259).

These albums take two basic forms: the book form (*kitap murakkaa*) and the bellows form (*körüklü murakkaa*). Both look like books, but their pages are joined in quite different manners. The book *murakkaa* for *thuluth* and *naskh* is held with the spine at the top, and each page is opened one by one. The bellows *murakkaa* is held the same way, but the pages (*kit'as*) are joined edge to edge in such a way that they can all be opened at once, in a strip, or folded so that two can be seen at the same time. The *ta'lik* (Arabic *ta'liq*) *murakkaa* is vertical in format, bound on the right-hand edge, and read page by page like a book. The writing can be horizontal or diagonal in format.

Each page of a *murakkaa* is called in Turkish a *kit'a*, from the Arabic *qit'a*, a fragment or piece. The *kit'a* form probably has its origins in Persianate culture. Sometimes the *kit'as* in a *murakkaa* become separated and are simply individual specimens. When we see a *kit'a* whose text is not completed on the page, we can assume it was once part of an album whose text carried on from *kit'a* to *kit'a*. In addition to its use in *murakkaas*, the *kit'a* is such a cherished and beloved format that calligraphers made countless examples, each with an integral text without any connection and never joined in a *murakkaa*.

A *murakkaa* can be categorized by the scripts used – *thuluth-naskh*, *muhaqqaq-rayhan*, or *tawqi'-riqa'*, the related pairs of the six scripts – or by the texts, which are often mixed. Among the common texts are Koranic verses, hadith, aphorisms, and poetry. One famous type is the *kaside murakkaa*, which contains an entire poem. Sometimes the text is on a theme, such as the *murakkaa* by Ahmed Karahisari in the Museum of Turkish and Islamic Art in Istanbul, which condemns Sufism. *Ta'lik murakkaas* can include the *müfredat* and *mürekkebat* lessons, *kaside* texts, and Ottoman, Arabic, or Persian poetry, especially for quatrains.

Specially made *murakkaas* can be read straight through from beginning to end, script to script. In other *murakkaas*, the lines in *thuluth* script can be read one after another, before returning to the beginning and reading the lines in *naskh* through to the end. These are called *müteselsil*, or sequential albums. Before Şeyh Hamdullah and during his lifetime, cylindrical *murakkaas* were made by attaching *kit'as* edge to edge, laminating them on paper or fabric, and then rolling them like scrolls, to be kept in leatherbound gilded tubes. Owing to its awkward proportions, this format was supplanted by book and bellows *murakkaas*.

It is rare to find longish format *murakkaas*, in which there is only one line of script per page, often in the script known as *celi ta'lik* (Arabic *jali ta'liq*). One example by Yesari Mehmed Es'ad is in the Abdul Hamid II collection in the Hatcher Library at the University of Michigan, Ann Arbor (no. 402). These *murakkaas* are bound parallel to the writing. This style, called *cönk* (Persian *jung*), has a long precedent in Persian book making.

The calligraphy for a *murakkaa*, as for calligraphy in other formats, is done on *ahar* paper – that is, paper that is varnished with egg white and alum and then burnished. It is written only on one side. The cardboard support for these pages is made by

وفيه واقضاهم على · صدق رسول الله

إن لا قينا · إنّا لا أين قد بغوا علينا إذا أرادوا فتنةً أبينا

يرفع بها صوته ابنا أبينا · قال رسول الله صلى الله عليه وسلم

إنّ شرّ الناس عند الله منزلةً يوم القيامة من تركه الناس اتقاء

فحشه · قال النبي صلى الله عليه وسلم · من ترك الكذب

وآله المنتجبين المنتخبين الطاهرين أجمعين

إذا وعدار جلاً وأخاه ومن نيته أن يفي · قال ربيت ولم يفي للميعاد

فلا إثم عليه · عن شراء من مال · والخطيئة بين الله صلى الله

عليه وسلم · ضمن كفّ المدافع عن عشيرته ثم تلا الآيات

wet-laminating three to five sheets of paper stuck down on a wooden panel. The cardboard dries and shrinks tight as a drumhead; it will retain its flatness when the finished *kit'a* is cut from the wood panel.

Before it is cut, the writing is pasted down on the cardboard, followed by the border strips, which can be marbled paper (Turkish *ebru*, Persian *abri*, cloudy), dyed paper, or plain paper that is later painted. When all this is dry, the gold work and outlines are added, and any painting is done. Finally, the gold work can be stippled with a tiny hemispherical point to give it visual texture and articulation. Since the time of Şeyh Hamdullah, the design of illumination has become simpler: as a modernist would say, "less is more." Over time, both colors and design have also become much less stereotypically "Islamic," diverging from the so-called traditional blue and gold color scheme and delicate illumination.

To compile the *murakkaa*, the *kit'a*s – from two to occasionally more than one hundred – are assembled, in pairs, in order and joined by thinly skived leather bands. The unbound edges are then usually covered with leather bands for protection. The book block is bound, sometimes awkwardly, with covers but without a flap known as a *sertab* and *mıkleb*. Occasionally, used book covers are recycled into *murakkaa* covers. Any final touches are then added, such as gilding on the leather bands, doublures, endpapers, and covers.

The *murakkaa* form preserves calligraphic works and serves as a portable exhibition. Most importantly, it serves as a model for tyro calligraphers to study. The fact that the *murakkaa* can be held near at hand under various light sources so that the writing can be examined closely adds to its utility as a teaching tool and its critical role in maintaining standards and transmitting artistic values. To copy from a master's *murakkaa* is an amazingly effective learning experience. Only by seeing and handling genuine work, not reproductions, can the student understand the fine points of the master's style. The great albums of Şeyh Hamdullah have been copied countless times by later students and artists, some imparting their own characteristics to the work and some few successfully achieving *taklid*, an almost photographic copy of an original done by eye, a rare tour de force.

*Murakkaa*s were passed from calligrapher to calligrapher for study and inspiration; they were inherited, sold, and collected, and many found their way into museums. Some received so much use that they had to be re-bordered and re-bound, which sometimes gives an anachronistic look to an album. Sometimes, too, a collection is made into a *murakkaa* centuries after the individual *kit'a*s were written.

As a result, the *murakkaa* can be a curator's nightmare and a collector's godsend. A fine *murakkaa* is something to be sought, admired, and, I believe, used. The fit and finish of a good one is revealing of the inherent quality of the work. Some twentieth-century *murakkaa*s are too fussy, with anachronistic illumination and binding design. They don't feel good in the hand – they are too "technique-y" and feel awkward and fragile. Less modern albums feel good in the hand and are tougher. You are not afraid to handle them; in fact, they should be handled.

259 (*facing page*) Concertina or bellows album (*körüklü murakkaa*) by Mehmed Abdulaziz Rifa'i Efendi, 1900 (Derman 2009, 253).

A Critical Theory of Calligraphy

But let us digress and take a look at the characteristics of writing that specialists look for in judging calligraphic work. In the flow of calligraphic history, certain masters at certain times have been associated with revolutionary flashes of creativity and invention. Ibn al-Bawwab and Şeyh Hamdullah are prominent among them, but there were many others who have been forgotten. The work of such people formed the axis around which new concepts developed.

To explain some of these concepts, I paraphrase Mahmud Yazır (d.1952) in his recondite work *Kalem Güzeli* or *Beauty from the Pen* (1981 and 1989).[5]

1. *Mekteb*: school. This includes the type of script, the calligrapher, the era, and the place. A school has a life and a history, and it evolves. The six styles of Ibn al-Bawwab, the *ta'liq* of the famous Safavid calligrapher Mir 'Imad (d.1615), the *naskh* of Şeyh Hamdullah, and the *celi* of Rakim Efendi are first and foremost schools, the starting-point.

2. *Kol*: branch. This refers to an artist's contribution to the script and the school. Calligraphers of a certain *kol* form a successive chain that carries common features. These commonalities function as a bridge between the style/script and the personal features of the artist's work. When we analyze a *kol*, the style and the methodology should be considered separately. One can say, for example, that a work by Şefik Bey is a *kol* of his teacher Kadiasker Mustafa Izzet Efendi's school.

3. *Üslub*: methodology. This refers to the ways and means by which an artist works to achieve the look, rendering it a *kol*. The way a pen is cut, the ink and paper used, and the artist's technique and approach factor in here.

4. *Tarz*: style or type. Sometimes specific features distinguish one written work from another. For instance:, one can say, "Nefeszade wrote in the *vadi* [valley] or *tarz* of Şeyh Hamdullah. Although his work is in the *üslub* of Şeyh Hamdullah, there are differences."

5. *Tavır*: mode or manner. When one calligrapher's writing exhibits the characteristics of another's, that is *tavır*. For example, we might say a Koran manuscript written by Ismail Zühdi has the *tavır* of the Şeyh, implying that although some elements of the work belong to Ismail Zühdi, the writing mainly reflects the *üslub* and *tarz* of Şeyh Hamdullah.

6. *Şive*: accent. Regardless what script, school, branch, methodology, style, or manner a piece reflects, many specific details and elements in it are unique and belong completely to the calligrapher. These elements are the *şive*, which may not exist in every example of an artist's work. If a work is a *taklid*, it has no *şive* of the artist at all.

7. *Hal*: state. *Hal* is more distinctive than *şive*. When the *şive*s of different works are the same, it may be that the *hal* will distinguish them. Every piece of calligraphy has a *hal*. The *hal* of a work must be understood to assess its aesthetic value. *Hal* also denotes different instances of a particular letter in a text and how they differ. I think that Yazır is referring here to the state of the calligrapher at the

260 Page attributed to Ahmad Ibn al-Suhrawardi but probably not in his hand. MIA, Doha (MS.643).

moment of writing and how his or her tools were functioning, both of which give a unique look to a work.

We can approach these seven arcane concepts with some skepticism – indeed, my hat is off to anyone who can isolate and recognize all of these characteristics of writing – but they are part of the intellectual structure of calligraphic analysis and criticism. We should not, however, put the theory before the calligraphy itself. There is little critical analysis of the early texts, aside from rather gushing encomiums about beauty, and it is not apparent what, if any, critical theory may have existed. How much did a scribe attend to what his skill created? Formal criticism came much later and probably developed out of accumulated observations by a multitude of artisans.

Mahmud Yazır's descriptions are subtle. The eye has to perceive the forms for them to have effect and meaning. Otherwise, calligraphy is just ink on paper, legibility at best. So the eye must be trained and must work to see in order to take perception to

a higher level. I don't mean to imply that I have been able to come close to these ideals. In fact, most calligraphers today are unaware of these concepts and work as they see fit. So beauty is not just in the eye of the beholder in this art; it is also, and even especially, in the eye of the educated beholder.

Yazır's precepts are a distillation of the observations of great teachers and the formulations of observant professionals, gleaned over many years. They can help us understand what is and what isn't beautiful. No calligrapher practiced ugly calligraphy intentionally. This critical approach can challenge misleading notions, such as the derivation of a page at the MIA (pl. 260), which features similar writing characteristics as are found in other manuscripts that have been falsely identified as being by Ibn al-Suhrawardi. These manuscripts feature sumptuous illumination and first-class production values, although the MIA page suffers from a much later mounting that deprived it of its burnish. The manuscripts are written in lushly decorated attempts at *muhaqqaq* script, but script analysis shows that the writing only approximates the rules of *muhaqqaq*. The letterforms are in no way proportional or consistent and are jammed together in a cramped and manic fashion.

Ibn al-Suhrawardi has provided us with many examples of his *muhaqqaq*, which is everything that *muhaqqaq* should be – stately, dignified, magnificently proportioned, with every letter in its correct dimension and sitting in its best location in relation to the line. There are certain quirks that identify Ibn al-Suhrawardi's work, and he was not averse to signing it. The puzzle, then, is why the page in the MIA and others like it were signed by the illuminator but not the calligrapher. Whoever wrote the text must have been affluent enough to afford lavish illumination – perhaps a royal. Whoever this calligrapher was, he seems to have made more than one copy of the Koran.

Deconstructing the Murakkaa *in the MIA*

The *murakkaa* in the MIA (pl. 261) is an interesting example of the genre. First, it is both a *körüklü murakkaa*, a bellows or concertina album, and a *toplama murakkaa*, a collection album. It consists of seventeen *kit'as*. Two are by the great Derviş Ali (d.1673) and six are by Ismail – certainly Nefeszade Seyyid Ismail (d.1679). These six comprise a *murakkaa* in themselves. Both of these artists were teachers of the illustrious Hafız Osman (d.1698). There are two pieces thought to be by Hafız Osman in this album, one of which is signed, but in a way consistent with his earliest work. In addition, there are a few unsigned *kitas* and, almost as afterthoughts, a *ta'liq kit'a* by Mir 'Ali Haravi (d.1545) and three by the découpage specialist Fahri of Bursa (d.1618).

Derviş Ali was a very learned man who studied calligraphy with Halid Erzurumi (d.1631). He wrote more than fifty Koran manuscripts, plus many *en'ams* and *evrads* (from the Arabic *anvad, sing, wird*, religious recitations, and referring to collections of daily recitations in book form) and many *kit'as* and *murakkaas*. He is considered the second proponent (*üstad-i sani*) of the school of Şeyh Hamdullah.

261 (*facing page*) Two *kit'as* by Nefeszade Seyyid Ismail in a concertina album, Istanbul, 17th century. MIA, Doha (MS.279.1999).

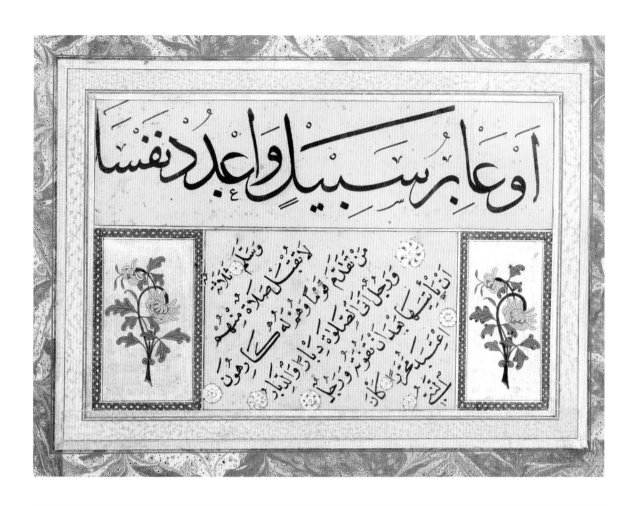

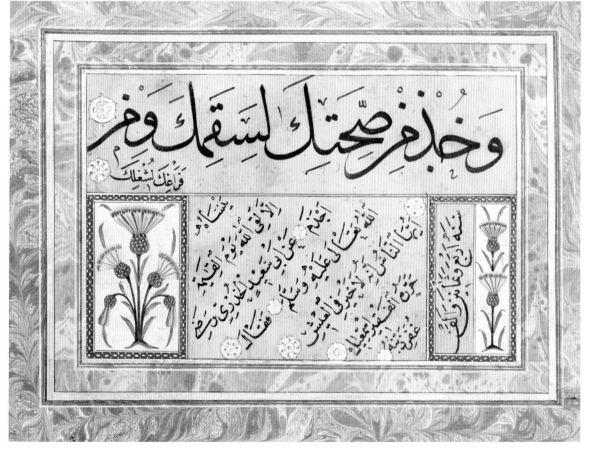

About Nefeszade, Mustakimzade (1928, 129) had this to say in his masterwork *Tuhfe-i hattatin* (*The Rare and Wonderful Work on the Calligraphers*):

He is from the city [Istanbul]. He is well known as Nefeszade [Son of the Breath]. . . . The tally of breaths a person takes in his life is mentioned by people of insight. It is a concept the point of which is that the one who holds his breath while moving the pen will seek to have the best acquisition of calligraphy.

He learned his *thuluth* and *naskh* from Halid Erzurumi and took his license [*icaze*] and "breath" [*nefes*] from him and became unique in following the Şeyh's style. Even after learning calligraphy from him [Nefeszade], Hafız Osman went back to him a second time, starting all over again to learn the style of the Şeyh. If [Nefeszade] didn't have such a fat belly, he would have been able to hold the *altlık* [writing pad] on his knee for work and practice, and it would have been impossible to distinguish his work from that of the late Şeyh. In the year 1090 [1679], he used up all his allotted breaths and, holding his breath, he dove into the sea of reunion with the lord of mankind.

Both of these calligraphers – Derviş Ali and Nefeszade – learned from Halid Erzurumi. They were the living representatives of the Şeyh school, and both were the teachers of Hafız Osman, who is considered author of the next foundational stage of Ottoman calligraphy. Every good or great calligrapher is also a teacher. From the Şeyh to Hafız Osman, there is a chain of transmission – Şeyh Hamdullah, Sükrullah Halife, Pir Mehmed, Hasan Üsküdari, Halid Erzurumi, Nefeszade, Derviş Ali, Suyolcuzade Mustafa Eyyubi, to Hafız Osman.

It would seem that the MIA *murakkaa* was assembled with the intention of demonstrating that transmission takes place in a small way and over a short period of the calligraphers' working lives. Many of the *kit'a*s are worth noting:

Kit'a 1 is in *thuluth* and *naskh* scripts. Could it be by Suyolcuzade Mustafa Eyyubi?
Kit'a 2 is a good Derviş Ali piece in *thuluth* and *naskh*.
Kit'a 3 is another good Derviş Ali piece in *naskh*.
*Kit'a*s 4–9 are mediocre *thuluth* and *naskh* pieces by Nefeszade; these six *kit'a*s make up a *müteselsil murakkaa*.
Kit'a 10 is a *basmala* in Şeyh Hamdullah's style of *muhaqqaq* with what looks like Hafız Osman's *naskh*. But there is such rawness in it that if this is the work of Hafız Osman it comes from an early period of his study, but later than *kit'a* 11.
Kit'a 11. The *thuluth* line is a version of a line famous since at least the time of Şeyh Hamdullah, but it is normally written in *tawqi'*, a more compact, less geometric member of the *thuluth* family. This one is very inept, like a student's writing. At first glance, the *naskh* looks like Hafız Osman's, but on closer inspection we see a strong influence by Derviş Ali, to the point that it looks like his work. But the careful control of the ink makes it likely to be Hafız Osman. It is said that Hafız Osman only began to write in his famous style after 1679, so *kit'a*s 10 and 11 both precede that date.
Kit'a 12 is a redo of a *muhaqqaq* line from a Şeyh Hamdullah six-script scroll, but altered. It is followed by four lines of a script that is supposed to be a very small *muhaqqaq* or *rayhani*, but is inept. The writer makes a common mistake on the

alif-lam-ha-alif of *al-hashimi*, showing that he wasn't paying much attention to Şeyh Hamdullah's *muhaqqaq*. Yet he has a good, firm control of his pen and ink and may well have become a known calligrapher.

Kit'a 13 is a famous line in *thuluth* that may have its origins in the work of Yaqut al-Musta'simi. The *naskh* is a shapeless and languid style that does not seem professional.

The album itself, despite its oddities, is a true collector's item, with interesting illuminations and some very attractive marbled paper (*ebru*). If *kit'a*s 10 and 11 are indeed early work of Hafiz Osman, we can think of the album as showing the influence of his teachers. If would be nice if *kit'a* 1 were by Suyolcuzade, his other teacher, as he may have been the one who had the most effect on Hafiz Osman. The famous calligrapher Sami Efendi (d. 1912) once said of him, "I believe that Hafiz Osman became Hafiz Osman only after meeting Suyolcuzade" (cited in Derman 1998b, 68 and 2009, 58).

While the calligraphic works in the album are not exceptional examples of writing and illumination – in fact, they are far from being these calligraphers' finest work – they still have a rugged and unpretentious beauty. Who knows when these pieces were first collected, who did the binding, reformatting, and perhaps rebinding, or who did the illumination (this seems to have been, to some degree, the work of one specialist). Except for the *ta'liq* pieces, all the work, including the two anonymous *kit'a*s, shows some characteristics of Şeyh's style. But the inclusion of the Mir 'Ali *kit'a* and the three découpage pieces appears to have been an afterthought. They add nothing to the importance of the thirteen primary *kit'a*s. Nevertheless, as an object, the album has a good deal of presence.

The streams and branches of calligraphy, then, run from the Şeyh to Hafiz Osman and on to others, branching out into other schools and *kol*s. Yet the whole enterprise was under the shadow of the great Şeyh. Derviş Ali, Nefeszade, and Hafiz Osman can be said to have helped revive the Şeyh Hamdullah school (*mekteb*) and set the scene for Hafiz Osman's breakthrough in forming his own school. By the sixteenth century, Istanbul had become the hub of calligraphy and book production in the central Islamic world. Students came to Hafiz Osman and radiated out from him, teaching and working.

If we look at another item from the MIA collection (pl. 262), we can see why his achievement is so radical and spectacular. This *kit'a* is from an album for teaching the *thuluth* script only. Hafiz Osman was known to prepare his own, highly regarded *ahar* paper, which is probably used in this specimen. He is at the height of his powers here. The calligraphy shows all the characteristics of great *thuluth* writing – the "breath-like flow of the pen" is omnipresent, along with strength, drive, crispness, softness, precision, proportion, balance, and elegance. Not all of Hafiz Osman's work achieved this level, but here it is at its highest.

In fact, this work is so good it actually reminds one of recreations of Hafiz Osman's other late work by Mahmud Celaleddin (d. 1829). As an example of a return to origins, consider these *kit'a*s from a *murakkaa* by Celaleddin (pl. 263). In this *murakkaa*, he took a few extant pages from a *müfredat* collection by Şeyh Hamdullah and then added the

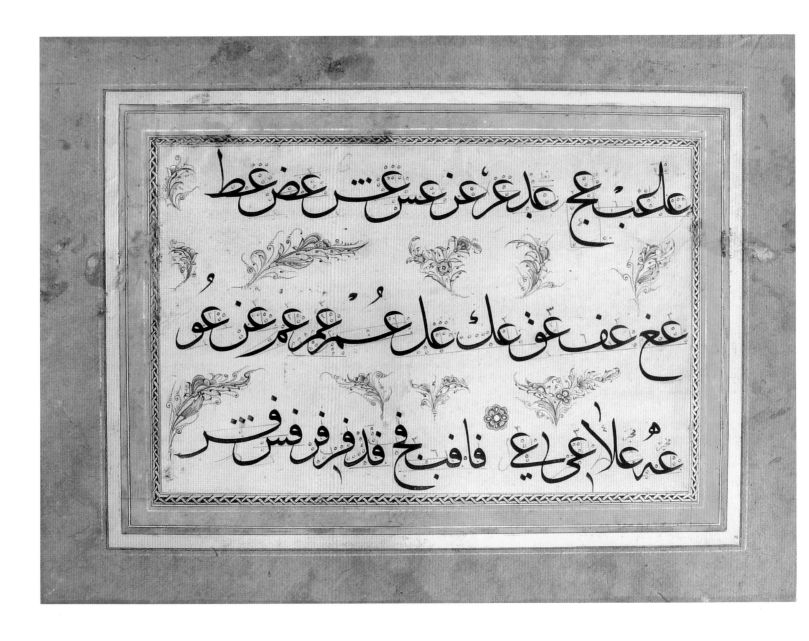

262 *Müfredat* exercises on the letters *ayn* and *fa'* in *thuluth* script, by Hafiz Osman, Istanbul, 17th century. MIA, Doha (MS.726.2011).

263 (*facing page*) Two *kit'as* from an album in *thuluth* by Mahmud Celaleddin: Şeyh Hamdullah's müfredat exercises for the letters *fa'* and *kaf*, early 16th century (*bottom*); Mahmud Celaleddin's reconstruction of the exercises for the letter *sad*, early 19th century (*top*) (Derman 2009, pp. 132 and 129).

missing six pages himself, although, oddly, he did not do the whole necessary set of exercises. These pages can be easily distinguished – the cumulative teaching and technical improvement have become naturalized in the work of Mahmud Celaleddin, a refugee from the Russian usurpation of Daghistan and one of the few self-taught masters. In the pages by Mahmud, we see the same breath-like flow as in the Hafiz Osman album. A brilliant follower of Hafiz Osman, Mahmud no doubt used *murakkaa*s by the masters to learn their style. When he devised his own kind of *thuluth*, however – at a slightly larger than normal size and the even larger *celi* – he created what no one wants, stasis of line. The style was forced into accepted use for a while, but was not favored and fell into oblivion.

The Ta'lik Murakkaa

The name *ta'lik* – actually the name of an ancient script, the ancestor of *shikasta* and *divani* – was an Ottoman shortening of the Persian *nasta'liq*. Mir ʿImad al-Hasani is credited as being the model for the script and the most consistently elegant

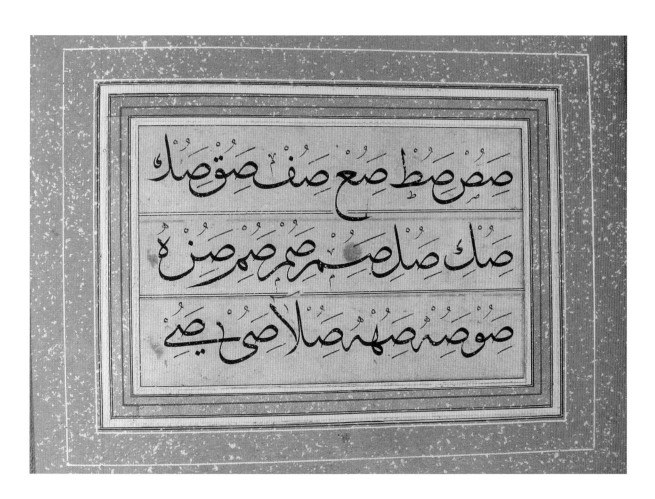

264 *Kit'a* in *ta'lik* by Yesari
Mehmed Es'ad, Istanbul, 18th
century (Derman 2009, p. 105).

of the Persian masters, in the same way that Yaqut was the model for Şeyh
Hamdullah's innovations.

A young genius in Istanbul, the profoundly disabled Yesari Mehmed Es'ad Efendi
(d.1798), devised a new way to write and experience this script (pl. 264). Under the
development of his son, the extraordinary Yesarizade (d.1849), the script achieved its
famous look, less romantic and flamboyant than the Persian (pl. 265). It became flatter,
more under the control of the writer, more vigorous, muscular, and precise in line. In
short, it was almost impossibly difficult to write. Many have tried, but few have mas-
tered *ta'lik* – perhaps twenty in two centuries, only six of whom were great masters.

It is worth noting an aspect of the teaching process. When a student has finished
the required curriculum, augmenting this study with *murakkaa*s, both original and
good printed copies, he or she receives the *icaze* or license giving the calligrapher
permission to sign his or her name to works, along with the document attesting to
his or her competence, the *icazetname* (pl. 266).

The International Style

In 1922, King Fuad I of Egypt invited Mehmed Abdulaziz Rifa'i (d. 1934) to come to Cairo and establish the Royal School of Calligraphy. He remained there for eleven years and taught an entire generation of Egyptian calligraphers, who then spread the style. The Royal School published a short-lived periodical and survived until the end of the monarchy, when, in a diminished state, it became a quasi-governmental school. Nevertheless, the style deriving from Şeyh Hamdullah became ubiquitous, with other contenders, such as the Karahisari and Mamluk schools, long forgotten.

In Arabic and Ottoman typography, *thuluth* never became a printable script, but some very elegant and legible *naskh* fonts existed for movable type. Books were printed in these fonts during the late years of the Ottoman empire and in Egypt through the 1950s. They set a standard that has not been improved on to this day.

266 License (*icazetname*) given to Mehmed Hayri by his teacher Hakki (right cartouche) and substantiated by Hakki's student Fahri (left cartouche); Istanbul, 1880. MIA, Doha (ms.762.2011).

Of the six scripts, three are essentially obsolete now – *muhaqqaq*, *rayhani*, and *tawqiʿ*. The remaining three – *thuluth*, *naskh*, and *riqaʿ* – absorb the imagination and creative spirit of modern calligraphers, along with *taʿliq* and *celi taʾlik*. Minor scripts such as *divani*, *celi divani*, and *riqʿa* are still quite popular. A few *murakkaa*s are still made – in fact, I have made two myself – although the format is being explored today primarily in sumptuous printed versions from Turkey.

The flowering of the Ottoman *murakkaa* was from the time of Şeyh Hamdullah to 1920, with the album's peak during the eighteenth, nineteenth, and twentieth centuries. Representing the dominant political power, the evanescent Ottoman state, calligraphers, teachers, writers, scholars, and consumers ensured that the standards remained intact, that experiments in ornament were made, that production was high – in short, that this style became the international norm for the central Muslim lands.

But it was not power alone that gave the international style precedence. The style and its advocates were supported by biography, literature, philosophy, aesthetics, and methodology. Calligraphy was an institution. It had big names. It had critics. It had an audience. For many, possession of one of these wonderful Ottoman *murakkaa*s must have been a burning desire, as it is for museums today.

Notes

1 There is a good deal of spelling overlap between Arabic and Turkish terms. When I use a word in a Turkish context, I have used modern Turkish spelling.

2 While types of calligraphy are a matter of taste, the jury is still out on whether calligraphy is an art form at all. Nevertheless, the notion of a golden age that ended around 1500 is simply romantic preference masquerading as science. It totally disregards the textual and manuscript evidence, as well as the long view – the amazing linearity of calligraphy's evolution. It belongs to an earlier time, when scholars had little access to the Arabic, Persian, and Turkish literature we have now, not to mention the presence of modern scholars such as M. Yazır, M. Uğur Derman, and, of course, Oleg Grabar.

3 Note that in Ottoman calligraphy, the Turkish names and spellings of the scripts are used: *muhakkak, sülüs, reyhânî, tevkî, rıkâ*, and *nesih*.

4 Translated on the Resources & Papers page of my website, www.zakariya.net.

5 I am indebted to my student Kuntay Çelik for his help in translating this difficult material, which is summarized here.

p. *300*: detail of a folio from the Jahangir Album with calligraphy by *al-faqir* Mir ʿAli, Iran, *circa* 1540 and marginal decorations attributed to Madhu, Mughal, *circa* 1610. MIA, Doha (MS.157.2000).

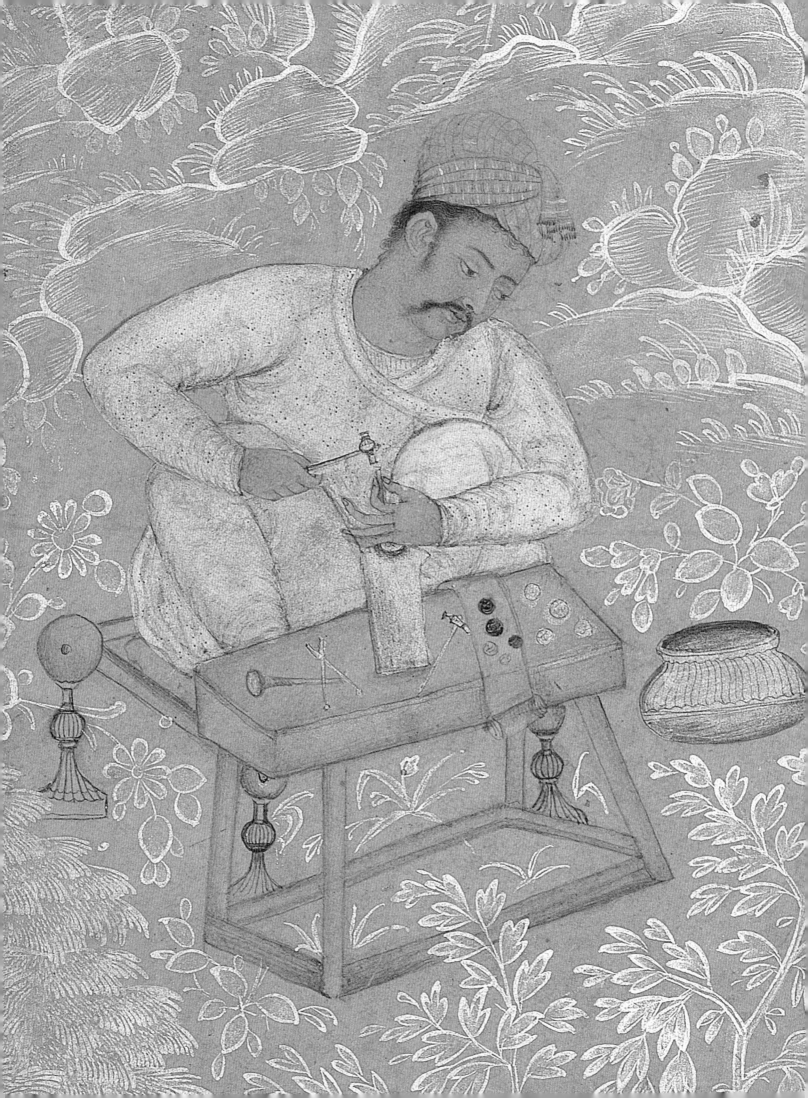

13

Five Folios from the
Jahangir Album

خمسة اوراق من البوم الشاه جهانكير

John Seyller

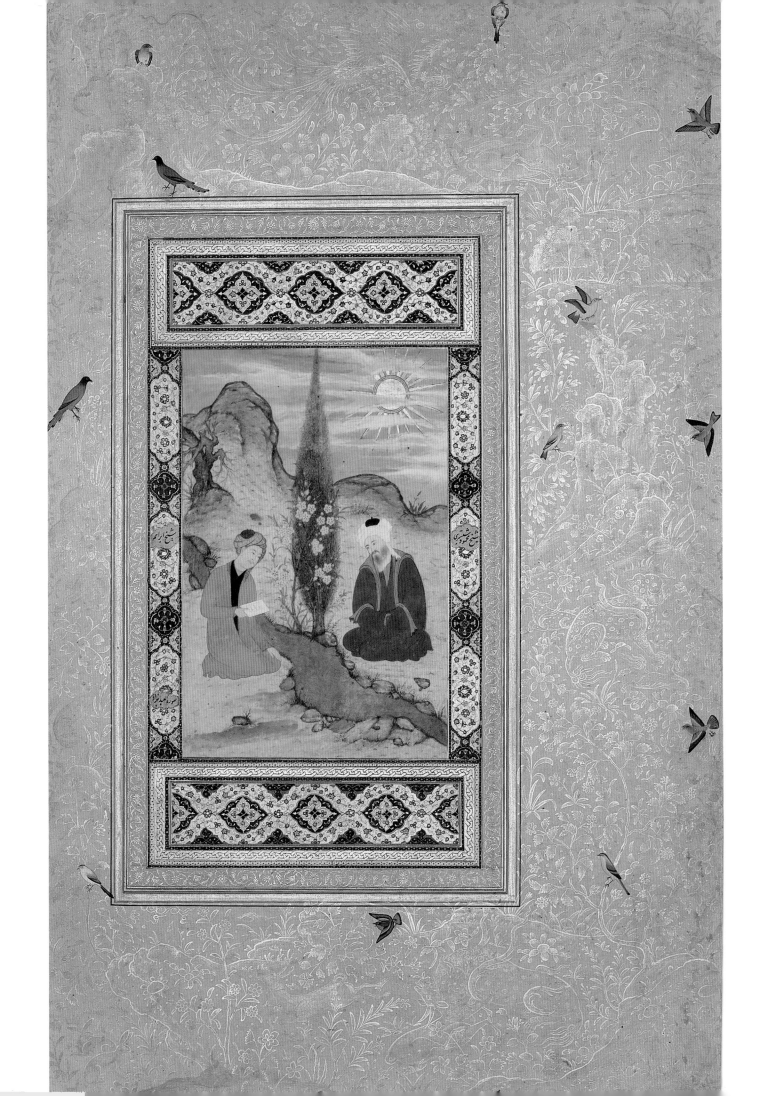

Among the Mughal treasures of the Museum of Islamic Art (MIA) in Doha are five little-known folios from the Jahangir Album, a magisterial book compiled under the auspices of Emperor Jahangir (r.1605–27).[1] The project began shortly before 1599, when Jahangir was still Prince Salim, and continued apace until 1610, a period that spanned both his rebellious years at Allahabad and the first few years of his reign. Work on the album had largely wound down by 1620, but picked up again briefly in the early years of Shah Jahan's reign (1628–58).[2] The album, parts of which are also known as the Gulshan Album and the Berlin Album, is dispersed, with 330 of the 379 extant page sides in Tehran and Berlin. The five double-sided folios in the MIA follow the format used throughout the album. One side of the folio typically has a central field featuring a late sixteenth- or early seventeenth-century Mughal or Persian painting as well as wide borders decorated with discreet golden designs of animals in landscapes and colored birds flying about or roosting in trees. The other side has a central panel filled with specimens of writing by eminent calligraphers and borders filled with lightly colored vignettes of figures engaged in royal and genre activities. In this essay, I aim to identify the subjects and artists of the MIA paintings as well as those of the folios' marginal decorations. Such a comprehensive examination of five folios is one important step toward the forthcoming definitive study of the Jahangir Album.

The most intriguing painting among the five Jahangir Album pages in the MIA has a gray-bearded sage and a younger man seated on either side of a rock-lined stream (pl. 267). Two inscriptions within small lobed cartouches set across flanking illuminated gold panels assign their imaginative identities. The older figure is labeled as Shaykh Mahmud Shabistari (1288–1340), a Sufi poet born near Tabriz, and the younger is named as Shaykh Ibrahim, a disciple to whom he dedicated his now-lost *Shahidnama* (Lewisohn 1995, 121). The roles of master and pupil are borne out by their positions and ages, and by the faintly inscribed sheet of paper held by Shaykh Ibrahim. Further down the left side is a more significant inscription written in the same hand in a similar cartouche; it reads *sawwarahu al-'abd bihzad* ("work of the slave Bihzad"), suggesting that when the album was compiled in the early seventeenth century the painting was at least nominally accepted as the work of that eminent Persian master (*circa* 1460–1535). This historical attribution is significant because Jahangir prided himself on his firsthand knowledge of Bihzad's work, as is evident from his inscription on the flyleaf of the copy of the *Khamsa* of Nizami made in 1494–95 (British Library Or. 6810), in which he remarks that sixteen paintings in the manuscript are by Bihzad while the six others are by the artist's contemporaries, Mirak and 'Abd al-Razzaq (Seyller 1997, 292 and pl. 8). Indeed, the legacy of Bihzad can be discerned in the late fifteenth-century Persianate figure style, the composition dominated by an undulating and stony horizon, indistinctly outlined rocks, and regular tufts of grass.

Yet the ascription to Bihzad is now readily recognized as inaccurate, for other features are out of keeping with that artist's work. The faces differ conspicuously in proportion and shape, in the greater smoothness of the skin, and particularly in the shape and articulation of the eyes. Moreover, an extraneous thick blue line runs along the ridge's

267 (*facing page*) Folio from the Jahangir Album (42.1 × 26.5 cm) with "Shaykh Shabistari converses with Shaykh Ibrahim" attributed to Mir Sayyid 'Ali (18.9 × 6.7 cm), Mughal, 1560–65, and marginal decorations. MIA, Doha (MS.155.2000).

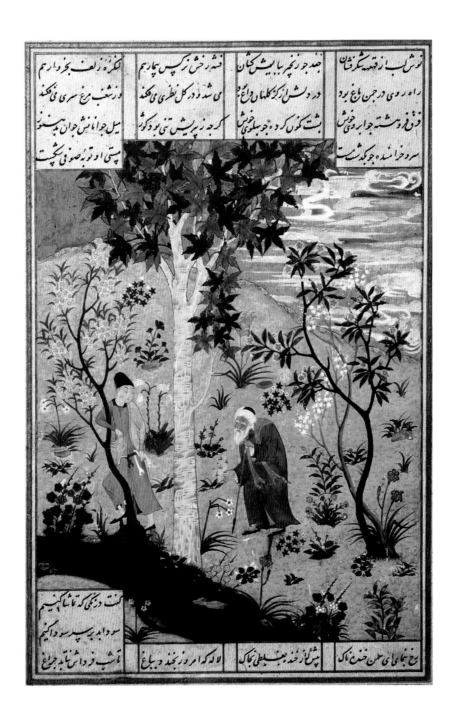

268 "Old Sufi laments his lost youth" by Bihzad from a *Khamsa* of Amir Khusraw (13.4 × 10.7 cm), Iran, July 1485. Chester Beatty Library, Dublin (MS.163, folio 38a).

edge, a feature absent in Bihzad's own paintings. The desiccated tree trunk in the upper left is more substantial in form and nuanced in texture than any of Bihzad's lifeless stumps (Bahari 1997, pls. 44, 49, 77, 100, 109). Finally, there is the thickly painted sky, which is streaked with salmon and white clouds that partially obscure a radiant sun. Such a sky is found in only one painting ascribed or attributed to Bihzad (pl. 268). Yet even in this case, there is a pronounced difference between the soft-edged clouds blended here into the light blue sky and the discrete, ribbon-like clouds overlaid on the darker blue sky in Bihzad's original. In sum, this painting (pl. 267) appears to be by someone consciously imitating Bihzad's style while inadvertently introducing some minor Mughal traits.

It turns out that that artist is Mir Sayyid ʿAli, a Safavid painter who accompanied Humayun from his exile in Iran, first to the temporary Mughal court at Kabul from

269 *(left)* Self-portrait of Mir Sayyid ʿAli (16.8 × 9.7 cm), Iran, *circa* 1540. Arthur M. Sackler Gallery, Smithsonian Institution, Washington, DC. (Purchase–Smithsonian Unrestricted Trust Funds, Smithsonian Collections Acquisition Program, and Dr. Arthur M. Sackler, s1986.291).

270 *(right)* Self-portrait of Mir Sayyid ʿAli (19.1 × 10.5 cm), Mughal, *circa* 1555–56. Los Angeles County Museum of Art (M.90.141.1, Bequest of Edwin Binney, 3rd).

September 1549 to November 1554, and then a year later to Delhi, where Humayun regained the Mughal throne and Mir Sayyid ʿAli assumed a dominant role in the Mughal atelier under Humayun and Akbar (r.1556–1605). There is ample evidence to support this attribution. The face of Shaykh Ibrahim – an oval with a slightly protruding chin joined to an incipient heavy jaw – is akin to those of Mir Sayyid ʿAli's youths, including his own self-portraits of the early 1540s and mid-1550s (pls. 269 and 270). Moreover, the rendering of the hands and the calligraphic treatment of the folds, sleeves, and hem of his robe are absolutely identical in all three paintings. Mahmud Shabistari's face and distinctive squat cap (*kulah*) also have many counterparts in other works by Mir Sayyid ʿAli, notably in the muezzin and schoolmaster in the signed "School Scene" of *circa* 1540 (pl. 271) and several figures in "Nomadic Encampment" (Welch 2004, pl. 3). A similar treatment of the undulating horizon appears in an attributed painting in the copy of the *Shahnama* made for the Safavid ruler Shah Tahmasp in the early 1530s (fol. 135b; Canby 2003, pl. 4.10) and an ascribed work in the copy of the *Khamsa* of Nizami produced 1539–43 (fol. 157b; Meisami 2011, pl. 87). The latter already has a

horizon accentuated with an extraneous outline, but that feature becomes wetter and more emphatic a decade later in the signed self-portrait made for the Mughal emperor Humayun in 1555–56 (pl. 270). The contorted tree trunk in the upper left is a more developed version of a form seen in "School Scene" (see pl. 271), "Nomadic Encampment," and the Los Angeles "Self-Portrait" (pl. 270). A thickly painted sky of the same hue is used in a painting attributed to Mir Sayyid ʿAli in the Tahmasp *Shahnama* (Canby 2003, pl. 4.10), and again with an identical radiant sun in a detached illustration from the 1539–43 *Khamsa* of Nizami (Welch 1979, no. 66). Finally, the inscribed sheet displayed prominently in Shaykh Ibrahim's hand is yet another instance of the artist including poetical verses in his paintings, a habit he adopted from his father, Mir Musawwir (Melikian-Chirvani 1998, 32–33, 36–37, 44).

This attribution matters for several reasons. First, there are perhaps only a dozen paintings ascribed or attributed to Mir Sayyid ʿAli, so any addition to this master's oeuvre is valuable in its own right.[3] Second, because this painting most closely

resembles the Los Angeles "Self-Portrait" (pl. 270), which it must postdate by at least five years, it fleshes out the artist's little-known work in Lahore and Delhi, where he worked from 1555 through the mid-1560s before leaving the Mughal court to undertake the pilgrimage to Mecca. Third, this painting is an early Mughal example of a historicizing style, albeit one that looks to a model furnished by an artist who remained active, if only in a primarily administrative capacity, in the Safavid workshop even during Mir Sayyid ʿAli's youth. Such a conscious archaism occurs several times elsewhere in the Jahangir Album, most strikingly in Nanha's 1608 copy of Bihzad's "Camel Fight" of *circa* 1525 (Semsar 2000, pls. 187–88).[4] This kind of art historical exercise naturally interested Jahangir, a self-proclaimed connoisseur of painting with an abiding taste for Persianate styles. It is, however, somewhat unexpected that such historicism was also manifested in the first decade of Akbar's reign even as the atelier began to move toward a new empiricism under the influence of European art. Since Akbar's chronicler Abu'l Fazl (1977, 1: 113) later singled out Bihzad as setting the standard for masterpieces, it seems likely that Bihzad alone engendered this type of art historical tribute during Akbar's reign.

A different approach to the past is evident in a second Jahangir Album painting that depicts a mounted prince, accompanied by two horsemen and five footmen, addressing a supplicant standing before him (pl. 272). Two riders – one on a galloping horse – and a footman carrying a polo mallet arrive from opposite directions, while two small figures peer over a curving ridge that defines the high horizon. It is obvious from the discoloration around all the figures but the two distant onlookers, where a fresh layer of gold on the sky has obscured the alterations to the figures' contours, that a Mughal artist has lightly repainted the ground and trees and replaced all of the original figures and horses with his own. There are remarkably few vestiges of the original figures: the outlines of the Safavid turban baton of the white-turbaned onlooker at the horizon, the lappets on the robe (*jama*) of the footman directly below the horse, the turban plume of the foreground attendant in dark blue carrying a polo mallet, and the polo mallet of the figure in red who now clutches a bow with both hands. The presence of two footmen with polo mallets in hand, the approach of a rider at full gallop, and the absence of the standard parasol above the prince together suggest that the original work was a polo-themed illustration, probably an early sixteenth-century painting in a manuscript of the *Guy u Chawgan* (Ball and Polo Stick) of ʿArifi. It follows, then, that the present supplicant was once a dervish smitten by a prince (Soudavar 1992, pl. 32). Yet the two panels of text at the top of the painting field belong not to ʿArifi's text but are independent poems (*qasida*s) by Saʿdi and Muhtasham Kashi.[5]

The painted additions are attributed here to Mukund, a senior and somewhat old-fashioned Mughal artist active from about 1570 to 1606. Many figures can be matched exactly to those in ascribed paintings in luxurious manuscripts dating from 1595 to 1606. The ungainly facial types, compact bodies, angular gestures, and blotchy ground seen here are presaged in two illustrations in the 1595 copy of the *Khamsa* of Nizami (pl. 273 and fol. 184b; Brend 1995, pl. 23). In particular, the attenuated supplicant with a further eye protruding beyond his profile relates closely to an astonished onlooker

در صفی از لشکر که در نظارت پاشد بود از نظر شاه بر روی جسته بود شاه بدان صید خیان صید کش همی کشید آن کشیده

زخش هی چون پک کش کم کرد پشت کمان چین سکن کرد تیرران هاپ زورد کرد شت زش ان هی کوشش

273 "Faridun hunts gazelles" by Mukund from a manuscript of the *Khamsa* of Nizami (folio 30.2 × 19.5 cm; painting 17.5 × 10.9 cm), Mughal, 1595. British Library, London (Or. 12208, folio 19a).

272 (*facing page*) Folio from the Jahangir Album (42.3 × 26.6 cm) with "Dervish approaches his beloved on the polo field" (20.5 × 13 cm), Iran, *circa* 1530–40, repainting attributed to Mukund, *circa* 1606, and marginal decoration attributed to Ikhlas. MIA, Doha (MS.158.2000).

in a copy of the 1595 *Baharistan* of Jami (fol. 29a; Topsfield 2008, no. 15), and the rider with a blunt profile has an almost identical counterpart among the overpainted figures in a manuscript of the Royal Library *Diwan* of Nawa'i (fol. 137a; Seyller 2011c, pl. 2). The last of these comparisons occurs in a Timurid manuscript refurbished about 1606, suggesting that this painting, too, was made under the auspices of Jahangir. Corroborating this date is the figure of the gold-turbaned prince, whose face is rendered in Mukund's distinctive manner,[6] but whose features are those of Jahangir, demonstrating again the patron's fondness for this kind of literary conceit.[7] The juxtaposition of two verses extolling the beloved's beauty with Jahangir's interpolated likeness seems merely coincidental, for although the emperor was keen to have his image inserted in the album's border decoration, he never expresses any physical vanity in his memoirs.

A third Jahangir Album painting demonstrates the breadth of the Mughals' visual sources (pl. 274). It depicts a woman praying to a gleaming sun, a Hindu custom

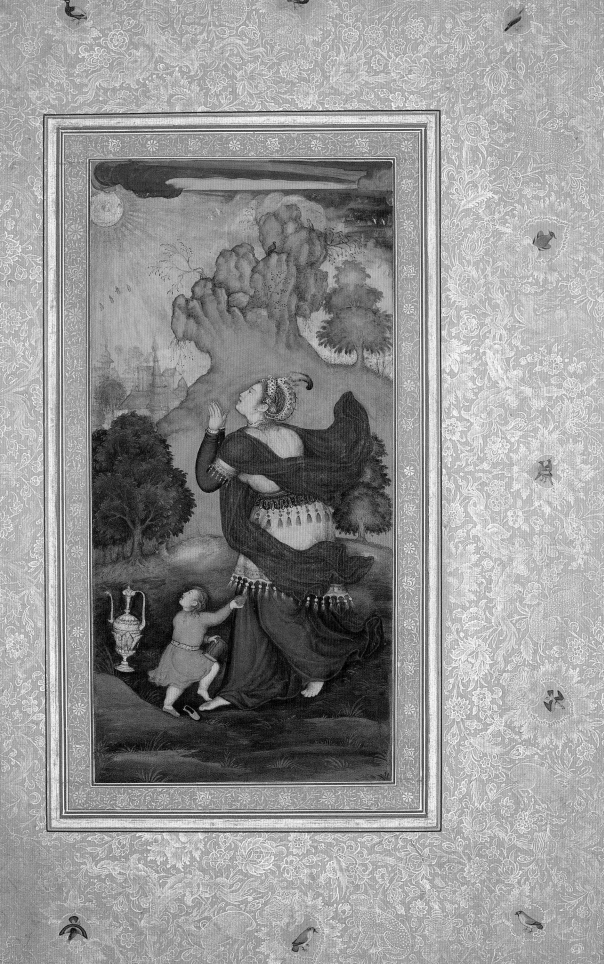

275 *Crucifixion* by Albrecht Dürer (13.3 × 9.8 cm), Germany, 1508. Metropolitan Museum of Art, New York (19.73.30).

adopted by the ecumenically inclined Akbar because he perceived the sun as a symbol of oneness revered in all religions. The painting is readily attributed to Basawan (active 1565–98), who became the most innovative and highly esteemed artist of Akbar's atelier in large part because of his creative adaptation of European motifs and visual effects. While the figure's stout physique, exotic tunic, and light brown hair all point to a European model, the gesture of upraised hands allows the source to be identified precisely as the distraught figure of St. John in the 1508 *Crucifixion* by Albrecht Dürer (1471–1528), an artist well represented in the engravings available at the Mughal court in the 1590s (pl. 275). Basawan renders the customarily androgynous youth as a woman, binding up the originally tangled locks into an elaborate braid and crowning the head with a fanciful tiara. Transforming the figure's facial expression from anguish to fervor, he lowers her joined hands slightly, and animates the robes that drape about her bulky torso and flare up at her feet, a detail that showcases his extraordinary ability to render pliant cloth furrowed by shadows. Basawan adds an unrelated figure of a boy holding a book, and introduces an ornate ewer that is featured in a number of Mughal paintings made about this time.[8] He complements the figures' solidity and immediacy with painterly trees, a hazy cityscape, and a softly articulated outcrop with delicate pastel coloring.[9] Basawan's original sunbeam-streaked atmospheric sky gives way to a cursorily painted passage covering the narrow strip that was added when the painting was mounted in the Jahangir Album.

274 (*facing page*) Folio from the Jahangir Album (42.3 × 26.6 cm) with "Woman worships the sun," attributed to Basawan (22.8 × 11.3 cm), Mughal, *circa* 1595. MIA, Doha (MS.157.2000).

A fourth page in the MIA represents a type seen numerous times in the Jahangir Album, in which four individual portraits conceived and executed independently were brought together within the central panel of the page (pl. 276). In some cases, the customary plain green background of each small portrait was extended slightly to standardize the painting size; each portrait was then framed separately (for example, Stronge 2010, pl. 83). In others, the four paintings were conjoined freely, with trees and flowers added both to obscure the seams where sheets of paper adjoined and to suggest a continuous environment.

In this example, five figures of great historical importance are presented in the latter manner. In the upper right, Akbar is depicted holding a falcon while a boy prince with a bow stands nearby. This portrait is attributed to Basawan's son, Manohar (active 1582–1624), the leading portraitist of Jahangir's reign. As in similar images, also by Manohar, Akbar wears a lavish robe (*jama*), this time a rich purple brocade with gold medallions adorned with flowers, accented by a short black waist sash, and complemented by golden leggings (*paijama*). The profile format of Akbar's portrait points to a date before his death in 1605 or soon thereafter, for after 1614, Akbar's posthumous image became fixed as an aged figure depicted in three-quarter view. The date can be narrowed further to *circa* 1606 by also excluding the Allahabad period (1600–04), when the estranged prince was disinclined to commission portraits of his father. Stylistic considerations argue against a date in the 1590s, for the heavier shape and finer detailing of Akbar's face and the very naturalistic description of the falcon are refinements of these elements in comparable imperial portraits by Manohar from 1590 and 1597 (Goswamy and Bhatia 1999, no. 40; Seyller 2011b, pl. 3). The boy beside Akbar can be identified as Prince Danyal, born in 1572, three years after his eldest brother, Salim. Danyal appears in two illustrations in the *Akbarnama* showing events of 1577 and 1578, when he would have been five or six years old (see pl. 278; Leach 1995, pl. 41), and again in an independent portrait made by Manohar in the late 1590s (Welch et al. 1987, no. 18). In the last of these, the blunt profile and heavy jaw observed already in his childhood likenesses have become the distinguishing features of his adult visage. Thus, it seems that the deaths of both Akbar and Danyal in 1605 and Jahangir's long-awaited accession that year occasioned the commemorative portraits of members of the royal family in less troubled times.

In the upper left is Raja Man Singh of Amber (1550–1614), who, after serving Akbar as a stalwart Rajput ally from 1569, became in 1605 a *mansabdar* (titled officer) of seven thousand, the highest rank attainable for one born outside the imperial family. Although he was Jahangir's brother-in-law, their relationship was cool, in part because of Man Singh's support for Khusraw, Prince Salim's son and Man Singh's nephew and ward, in the struggle for succession in 1605. Nonetheless, on the occasion of a major *darbar* (audience) held in 1606, Jahangir gave Man Singh the honor of personally attending him with a flywhisk (Seyller 2011b, pl. 11), and at another *darbar* held *circa* 1611 (Losty 1986, no. 32) allowed him to stand in the premier rank. In several independent portraits, Man Singh is endowed with the same dark complexion, rotund body, and white mustache seen here.[10] Although quartets of portraits are sometimes all by one artist, in this

276 (*facing page*) Folio from the Jahangir Album (42.2 × 26.3 cm) with four portraits (25.2 × 14 cm) and marginal decorations attributed to Khizr, Mughal, *circa* 1610. MIA, Doha (MS.156.2000).

God Is Beautiful and Loves Beauty

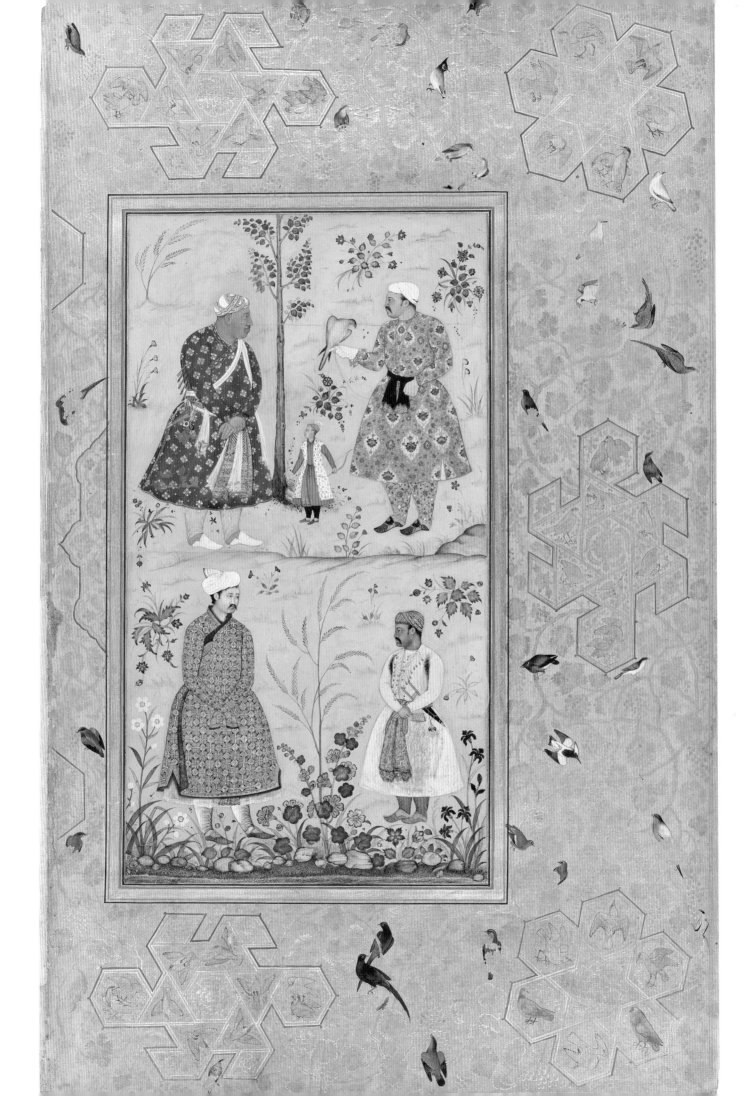

case several features establish the painter as Bishandas (active 1589–1644) rather than Manohar. Man Singh's eye is not as narrow as it is in Manohar's 1617–18 (and thus posthumous) portrait of him in the 1606 *darbar*, and his thinly painted, well-modeled face generally lacks the surface tautness that characterizes Manohar's work. Conversely, Bishandas's personal style is evident in the relaxed treatment of the eye, the highly detailed but softly drawn hands – note the rendering of the knuckles – and especially the loosely painted (and perhaps unfinished) streaks of white that constitute the narrow sashes falling across Man Singh's torso and over his *patka* (waist sash). Then there is the figure's stance. Here, Bishandas depicts the venerable general standing upright, not leaning on a staff as he is usually shown, but supported by feet set evenly on the ground; the shoes, however, are inexplicably left unfinished. By contrast, Manohar's figures are typically imbued with a rocking motion that is created by a voluminous body balanced precariously on feet that are set at an angle and shod in luxurious shoes with curving soles. This portrait of Man Singh was almost certainly produced between 1608, the date recorded on a similar portrait in the Berlin portion of the Jahangir Album (Das 1998, pl. 3), and August 1613, when the artist, who was lauded by Jahangir as "unequalled in his age for taking likenesses," was assigned to an ambassadorial mission to the Safavid court at Isfahan that returned only in 1620.

In the lower right is a portrait of another important noble, Zayn Khan Koka (1542–1601). The son of Akbar's childhood wet-nurse, he was affectionately deemed Akbar's foster-brother (*koka*). He is known from a series of other portraits, including one on a page in the Tehran portion of the Jahangir Album that is again paired with a portrait of Raja Man Singh, a personage of comparable status.[11] The finest of the other portraits of Zayn Khan Koka (Losty 1986, no. 24) is inscribed by Jahangir, who identifies the figure and adds mistakenly that he was granted the title of Mughal Khan, a title actually given to his son.[12] The inclusion of the word *'inayat* in the phrase *'inayat shud* ("was bestowed") in the inscription has mistakenly been used to attribute that painting as well as a practically identical third copy in the Victoria and Albert Museum to an artist named 'Inayat (Falk and Archer 1981, 49–50; Losty 1986, no. 24), but all three paintings should be attributed instead to Nanha (active 1577–1620), an accomplished artist whose painterly manner is emulated and heightened by Bishandas, his nephew. Apart from the series of small brush marks used to create a sensitively modeled face, the most telling indication of Nanha's work is the slightly chalky quality he imparts to sheer muslin, most evident where it hangs over the orange *paijama* and bunches up on the sleeves. The blotchy rendering of the dark musk stains at the armpits and the inventive wriggling arrangement of the lappets are equally distinctive. The striking consistency among the multiple portraits of Zayn Khan Koka – some made during his lifetime, others posthumously – underscores the fact that the Jahangir Album contains a number of copies of existing Mughal paintings.

The final noble, whose distinctive mustache and sloping nose are recognizable in an earlier portrait by Mansur in the Salim Album (Beach 2011, pl. 12), has not been identified definitively.[13] This painting can be attributed to Mansur (active 1589–1626), a renowned painter and illuminator. His personal style is recognized in the small, dark

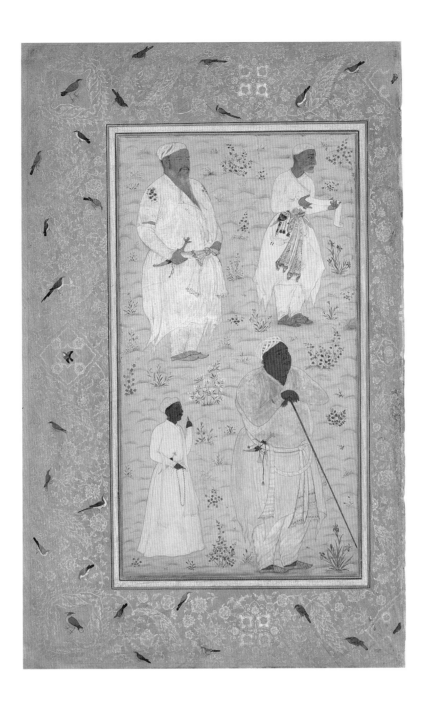

277 Folio from the Jahangir Album (46.2 × 26.5 cm) with four portraits (29.2 × 16 cm), Mughal, *circa* 1610. MIA, Doha (MS.159.2000).

facial features, the dappled modeling of the skin, and the streaky rendering of the pink *paijama*.[14] This attribution of an independent portrait to Mansur underscores the breadth of the activities of this versatile artist in the Jahangir Album, a project to which he also contributed independent floral and natural history studies; figural, animal, and landscape elements to several borders; illuminations; and an endpaper with a spectacular full-page design (pls. 286 and 187; Beach 2011, figs. 4–7 and no. 21).

The fifth folio from the Jahangir Album in the MIA has four portraits joined together on a common ocher background, which is anchored by a single ground line and relieved with flowers and tufts of grass (pl. 277). The figures, whose uniformly white clothing helps minimize the discordant effect of their two different scales, include a Hindu figure with a scroll in hand and writing implements tucked into his waistband, two burly figures, and a dark-skinned Hindu endowed with a bushy mustache, a *tilak* (devotional mark) on his forehead, and a rosary in his grasp. None is immediately

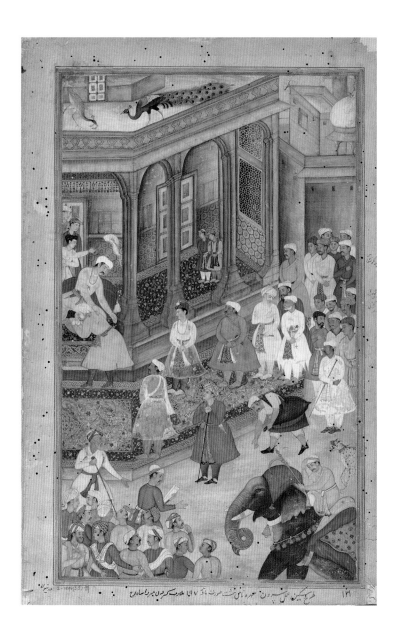

278 "Ambassadors of Mirza Shahrukh pay homage to Akbar in 1577," designed by Miskin and painted by Shravan, with eight portraits by Madhu, from a copy of the *Akbarnama* (folio 37.4 × 24.7 cm; painting 33.1 × 20 cm), Mughal, *circa* 1586–87. Victoria and Albert Museum, London (IS.2:114-1896).

recognizable, but the two smaller figures appear prominently in an *Akbarnama* court scene of 1577, in which they are among the eight special portraits added by Madhu (pl. 278). The white-bearded figure has eluded identification,[15] but the dark-skinned figure is probably Raja Bhagwan Das of Amber (r.1573–89), Akbar's ally and the father of Man Singh, whose portrait is discussed above.[16]

Far more compelling are the two large-scale, portly figures in the upper left and lower right. The former's facial features, beard, and turban match those of one uninscribed figure in a *darbar* scene of 1617, suggesting that he is a prominent noble, though his unkempt appearance – including a tear in his right sleeve and dark smudges on both shoulders – is quite anomalous for one of that station.[17] Whatever his identity, he is portrayed by Bishandas with extraordinary sensitivity, especially in the pensive gaze and remarkably tactile beard. His counterpart below can be identified as the eminent *vina*-player (a stringed instrument) Mishri Singh, better known as Nawbat Khan. The son-in-law of the famous singer Tansen, he converted to Islam and in 1607 was named supervisor of the *naqqara-khana* (drum-house; Wade 1998, 118–21). He appears in a Victoria and Albert Museum *Akbarnama* scene of 1573 (Wade 1998, pl. 1), and is the

279 Folio from the Jahangir Album (42.3 × 26.6 cm) with calligraphy (20.5 × 8.7 cm) by ʿAli *al-sultani* dated 1541–42 and marginal decorations including figures attributed to Nanha, Mughal, *circa* 1604. MIA, Doha (MS.158.2000).

subject of three other independent portraits (Crill and Jariwala 2010, no. 11; Goswamy with Bhatia 1999, no. 29; Wade 1998, pl. 73). Standing here with his old-fashioned four-pointed *jama* tied in the Muslim manner, that is, under the right arm, he is visibly older, his hair thoroughly gray and the thin mustache sported at an earlier age now abandoned altogether. The painting is again the work of Bishandas, who renders Nawbat Khan's facial features with remarkable softness and human warmth. The artist highlights the translucency of the gauzy muslin as it is alternately bunched up or stretched tight over his subject's dark skin, and meticulously describes the delicate pattern of the bands that mark the collar, shoulders, and cuffs. In light of the figure's age and Bishandas's development as an artist, it likely that the painting was made between 1607 and 1613.

 On the reverse of each of these five folios is a calligraphic specimen or two written in *nastaʿliq*, often mounted on an attractive oblique angle against a gold field ornamented with a dense floral scroll; illuminated bands and ornamental birds are enlisted to fill out the remaining space. One page (pl. 279) has two particularly important specimens, the larger one signed by the "poor ʿAli *al-sultani* in the months of the year

280 Detail of the upper
marginal decorations showing
Prince Salim receiving two slain
ducks, attributed to Nanha. MIA,
Doha (MS.158.2000).

948 [1541–42]," and the smaller by Mir ʿAli of Herat (d. *circa* 1550), one of two cal-
ligraphers whose work was avidly collected by the Mughals. The verses themselves offer
only standard tropes of Persian poetry.[18]

Surrounding this elegant writing are elaborate border decorations rendered in different
shades of gold. The scenery, which was designed to complement the nine lightly tinted
figures, includes fanciful buildings, a hermit's cave, tilled fields with animals grazing
nearby, and assorted ridges and trees. As usual, the figures are set at irregular intervals in
the upper, outer, and lower margins, but seem to look and move across the spaces among
them as if they are interacting with one another. In this case, the activity that links them
together is the hunt. Thus, one figure carrying a musket drags his kill, an antelope buck,
to the left. There, a seated prince is presented with two ducks brought down by the
royal falcon perched on his gauntlet (pl. 280). The prince is Jahangir, here depicted so
young that it is almost certain that the folio dates from the Allahabad years, when he
would have been in his early thirties. This dating is also supported by the image of Akbar
hunting with bow and arrow that is unexpectedly relegated to the lower left corner – an
area secondary in importance – and by the style of the border figures, whose detailing
surpasses that of the border figures in the deluxe manuscripts of the mid-1590s (Seyller
2001, 123–36) and whose clothing is rendered with both the red and green tints and the
deep, European-inspired folds characteristic of Jahangir Album borders produced in the

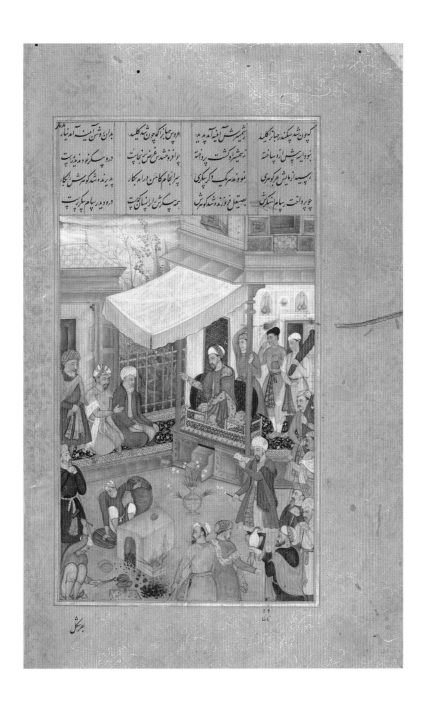

281 "Ironsmiths cast and polish round mirrors in the presence of Iskandar" by Nanha from a copy of *Khamsa* of Nizami (folio 33.8 × 20.8 cm; painting 15.8 × 10.7 cm), Mughal, 1595. Walters Art Museum, Baltimore (w.613, folio 16b).

Allahabad atelier. Various facial types allow the painter to be identified as Nanha, who worked for Salim at Allahabad and whose portrait of Zayn Khan Koka appears in plate 276. The most distinctive figure is the fur-cloaked sage seated before a cave; his long face and beard and narrow-set eyes, for example, repeat exactly those features of a retainer in a court scene ascribed to Nanha in the 1595 *Khamsa* of Nizami (pl. 281).[19] Likewise, the figure of Akbar, identified by his boxy face and short mustache as well as by his ornate plumed turban, matches the emperor's portrait in an illustration ascribed to Nanha in the Victoria and Albert Museum *Akbarnama* (Sen 1984, pl. 36). That many of the most accomplished painters in Jahangir's employ contributed both independent paintings and increasingly elaborate border figures underscores the unprecedented emphasis placed on these marginal areas of the Jahangir Album.

Two other pages with very different marginal imagery (pls. 282–85) can be attributed to Madhu, a senior artist who executed a single illustration as well as numerous

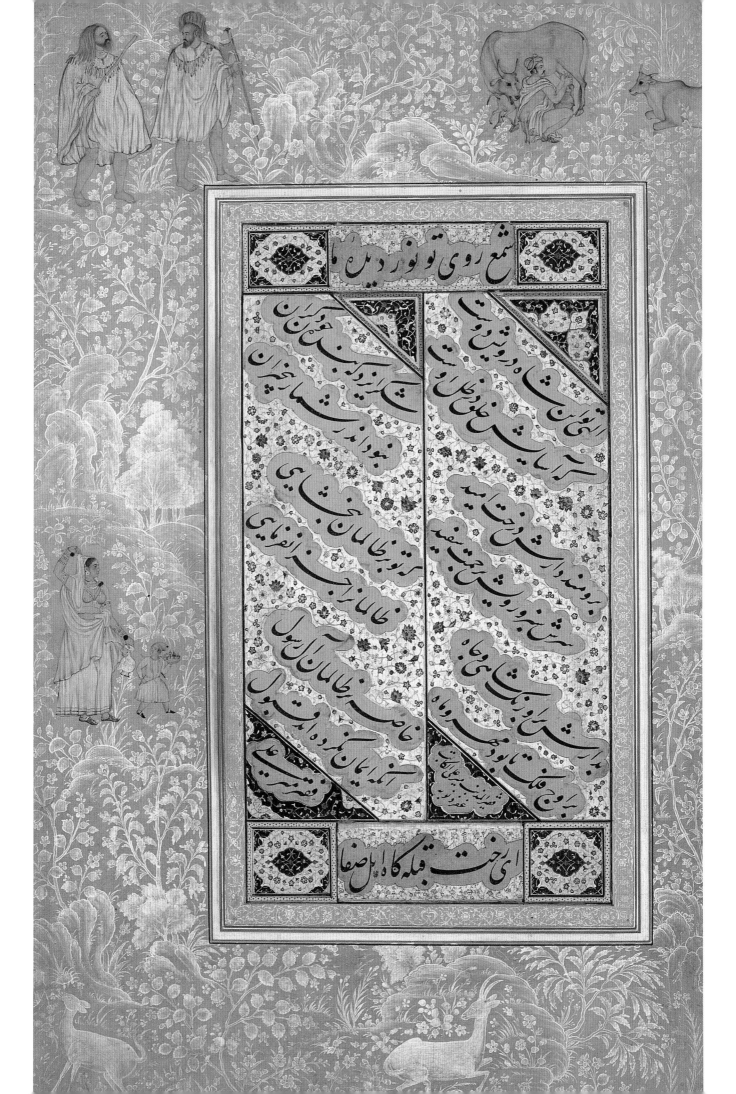

283 Detail of the upper marginal decoration showing two *sadhus*, attributed to Madhu. MIA, Doha (MS.155.2000).

282 (*facing page*) Folio from the Jahangir Album (42.1 × 26.5 cm) with calligraphy by *faqir* Mir ʿAli, Iran, *circa* 1540, and marginal decorations attributed to Madhu, Mughal, *circa* 1604. MIA, Doha (MS.155.2000).

borders in both the 1595 *Baharistan* and 1597–98 *Khamsa* of Amir Khusraw; thereafter, he joined Salim in Allahabad, and worked for a few years in the imperial atelier upon Jahangir's accession. Each of the folksy vignettes in the first example (pl. 282) has elements developed elsewhere in Madhu's work. The two well-modeled full-grown cows in the milking scene, for example, are rendered with exaggeratedly dark muzzles and eyes, features found in his *Baharistan* border animals (Losty 1985, figs. 17–18).[20] The cowherd, naked but for a loincloth and a palpably weighty shawl over his shoulders, is depicted with particularly muscular limbs, a trait shared by the two itinerant sadhus to the left (pl. 283), who have equally well-articulated feet and hands (Titley 1983, pl. 39; Leach 1995, no. 2.174). And while the woman carrying a golden vessel in the outer margin has the rounded facial features and sturdy physique of many of Madhu's characters, the squat boy beside her practically repeats in reverse a figure used in the artist's ascribed painting in the 1596 97 *ʿIyar-i Danish* (Krishnadasa 1999, pl. 11). Even the squarish outcrops and compact trees with dense foliage in the upper border have counterparts in both the aforementioned painting and his border designs in the *Baharistan*.

A second set of border figures by Madhu returns to courtly life, and begins with two rotund characters wearing subtly tinted clothing seated opposite one other with assorted golden vessels between them (pl. 284). The face of the princely figure resembles a figure in Madhu's aforementioned *ʿIyar-i Danish* painting, while his corpulent

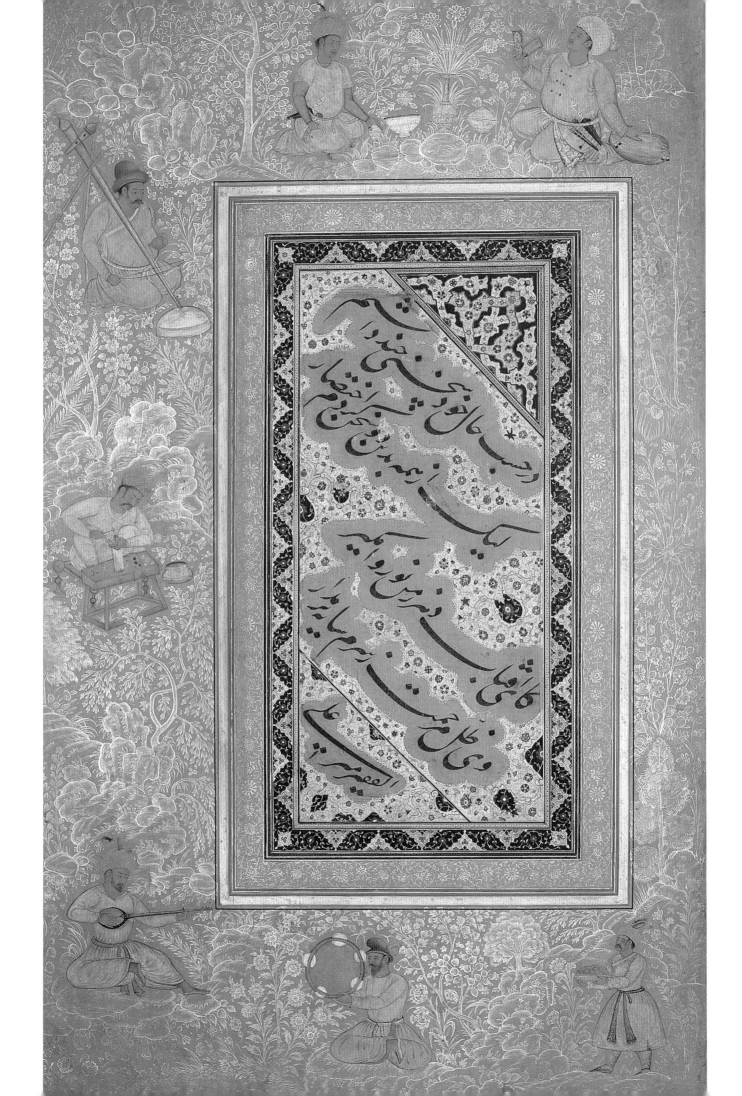

companion has more strongly characterized features and actions as well as highly detailed accessories. A servant in the lower margin carries a platter of fruit, apparently destined for his superiors above, while three musicians arrayed around the outer margin serenade them. The lower two play the *da'ira* (frame drum with cymbals) and the fretted instrument known as the *tambur*, two instruments commonly depicted in Mughal painting, even as the third plies an *ektara*, a rudimentary single-stringed instrument documented only once elsewhere in contemporaneous painting.[21] Still more interesting is the activity carried out by a craftsman seated behind a workbench (pl. 285). Using a ball-peen hammer, the craftsman attaches a slender metal stem onto a seal. The seal-mounting process is suggested by the completed piece and two tools that appear immediately below, and implied even more by four loose seals on the right, but is established definitively by the black seal impressions – with fragments of legends visible – on the paper scroll overhanging the workbench. Madhu returns to a close-up presentation of the technical aspect of art-making in one of the best-known folios from the Jahangir Album, in which he decorates the margins with six similar artisans engaged in various bookmaking activities ranging from burnishing paper to tooling manuscript covers (Seyller 2005, pl. 1).

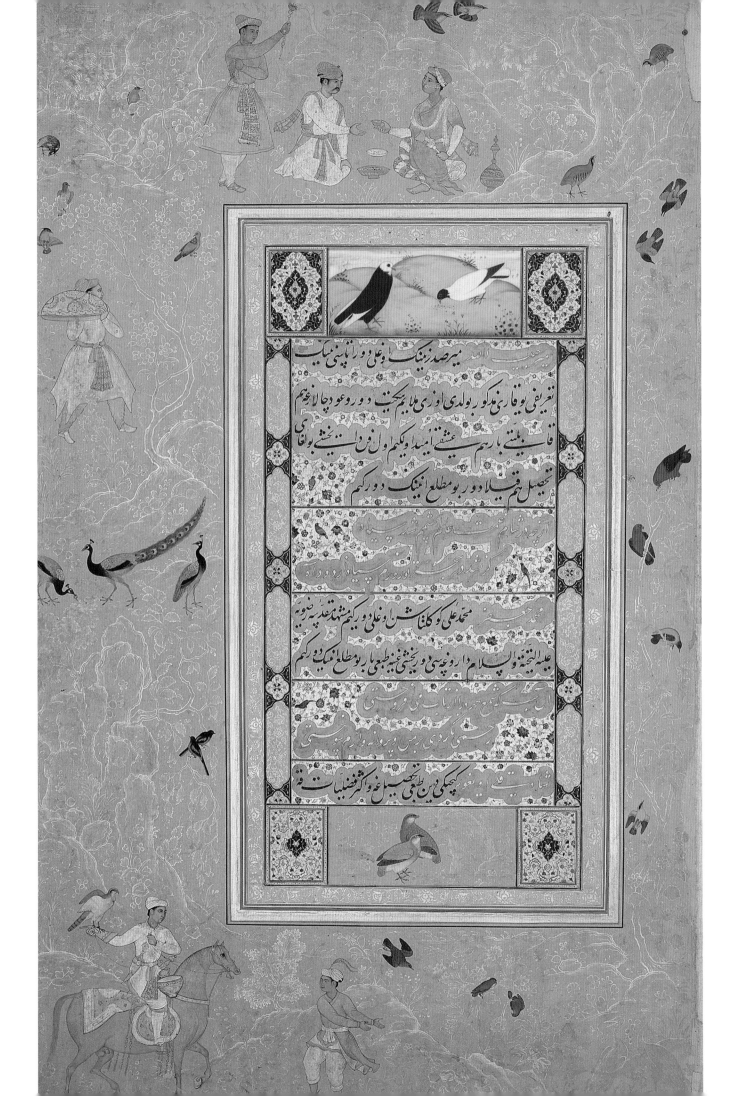

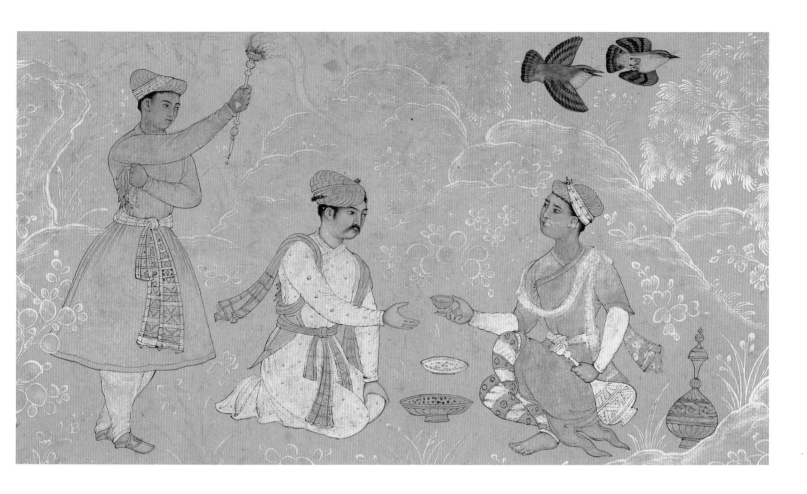

287 Detail of the upper margin attributed to Mansur. MIA, Doha (MS.156.2000).

Mansur's many talents are evident on another Jahangir Album folio (pl. 286). His unparalleled ability to impart lifelike qualities to natural history subjects comes through in two independent paintings of pairs of birds set above and below the central panel of calligraphy. The two pigeons display the same combination of naturalistic poses, detailed plumage, and solid coloring as the sixteen pigeons in a painting ascribed to Mansur, yet the black-and-white markings on the closest specimens diverge just enough to indicate that the artist does not resort to type but describes different birds (Falk and Digby 1979, no. 22; now in a private collection, the painting should be dated *circa* 1600–05 rather than *circa* 1660). Likewise, his meticulous description of the two Grey Francolins in the lower panel distinguishes them physically from the pair of Chukar partridges in the upper right border, though both are celebrated in Persian poetry as creatures with an ideally graceful gait. Astonishingly, many of the tiny birds in the border are depicted with a precision that matches the level of detail seen in full-scale paintings, so that the peacock and two peahens in the outer margin rival their larger counterparts in a painting attributed to Mansur (Beach 2011, pl. 15), and the Grey Francolins in the lower margin of an ascribed border (Beach 2011, pl. 7) compare well with the framed specimens here. Even the outcrops in these two areas are given the same elegant profile and compound lobes as others in Mansur's work.

Juxtaposed with Mansur's natural history elements are six figures in the margins, who relate closely in facial type, clothing, and rendering to characters in the artist's ascribed paintings and borders. The faces of the youth and attendant in the upper margin (pl. 287), for example, correspond to two of the courtiers seated opposite Timur in an ascribed illustration of the 1596 British Library *Akbarnama* (pl. 288), and the man

286 (*facing page*) Folio from the Jahangir Album (42.2 × 26.3 cm) with calligraphy, Bukhara, *circa* 1540, and two pigeons, two Grey Francolins, and marginal decorations attributed to Mansur, Mughal, *circa* 1600–05. MIA, Doha (MS.156.2000).

288 "Bayazid I captured and brought before Timur, who gives him the honor of a seat above the princes," ascribed *ʿamal-i Mansur Naqqash*, from a copy of the *Akbarnama* (folio 41.2 × 27.1 cm; painting 16.2 × 12.4 cm), Mughal, 1596. British Library, London (Or. 12988, folio 35b).

accepting a cup of wine in plate 287 strongly resembles the groom on the bottom left in plate 288. Similarly, the *paijama*s of the flywhisk-bearer and the attendant carrying a platter in the outer margin have both the exaggerated taper and lumpy contours of ones worn by his other figures (Beach 2011, figs. 7 and 12). The combination of fully colored faces and opaque clothing rendered in several shades of gold is one seen in other borders by Mansur assigned to the Allahabad period (Beach 2011, pl. 7).

The last of the five Jahangir Album folios in the MIA is decorated with six marginal figures drinking and relaxing; here, however, this common activity is distinguished by the thumb-sized characters' exquisite draftsmanship and coloring, which command sustained visual attention and project the figures forward to an unprecedented degree from a background lightly detailed in gold (pls. 289–91). The most inventive individual is surely the casually attired one in the upper right, who, having drained a cup of wine, now seems about to let it slip from his hand as he throws his arm over a bolster and tilts his head back in tipsy reverie (pl. 290). The carefully observed pose and hands, the raised wide-set eyes, and the gauzy *jama* all indicate the work of an artist well versed

289 Folio from the Jahangir Album (46.2 × 26.5 cm) with text from Mir ʿAli Shir Nawaʾi's *Majalis al-nafayis* and marginal decorations attributed to Manohar, Mughal, *circa* 1609. MIA, Doha (MS.159.2000).

in the nuances of the human body and behavior. That artist is Manohar, whose contributions to the Jahangir Album consist largely of portraits and European-flavored images of the emaciated Majnun. Called upon to decorate some margins of the Jahangir Album, in which freer and more personal imagery seems to have been encouraged, Manohar presents figures in three-quarter view and sheds much of the impassiveness that he habitually brings to courtly portraiture (for example, pl. 276).

One unexpected point of overlap between the two types of painting occurs in the upper right corner, where a youth pours wine so ostentatiously that Manohar renders the stream of wine in mid-air (pl. 291). The figure's pearl and ruby earrings and purple *jama* woven with gold thread are two indications that this is no ordinary youth, but the occurrence of the same seated figure with identical attributes in a marginal painting by Govardhan on another Jahangir Album folio (Pal 1993, cat. 55B) and an independent portrait of the same figure standing – again dressed in purple and holding flask and cup (Rogers 1993, pl. 37) – leave no doubt that he is a royal personage. His identity is established conclusively as Prince Shah Murad (1570–99) on the basis of an

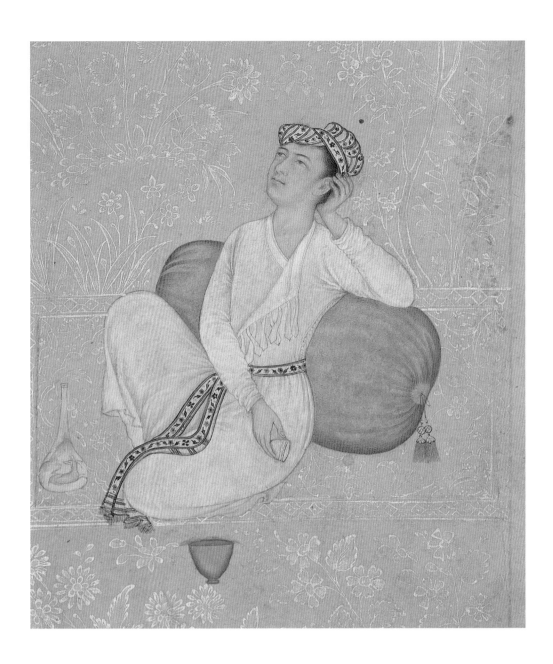

290 Detail of the outer margin showing a youth relaxing, attributed to Manohar. MIA, Doha (MS.159.2000).

291 (*facing page*) Detail of the upper margin depicting Prince Shah Murad pouring wine, attributed to Manohar. MIA, Doha (MS.159.2000).

inscribed double portrait of Murad seated opposite his brother Danyal in a pavilion (Losty 2011, no. 1). Moreover, Murad's likeness in both paintings is absolutely consistent with that of the princely figure in two other paintings by Manohar (Beach 1981, no. 22 and pl. 41). More striking is the fact that Manohar's marginal posthumous portrait of Murad is a reprise of a passage from his double portrait of a decade earlier. The artist dispenses with the prince's dagger and nascent mustache even as he adds earrings and full coloring, but retains the pose, the configuration of the turban and *patka*, and the nearby dish of the earlier version. His inclusion of the detail of wine being poured is both amazing and poignant, for alcoholism precipitated Murad's early demise.

Although figures are the most telling element in marginal decoration, some border designs without figures can be associated with individual artists on the basis of several ascribed marginal decorations in the 1595 *Baharistan* (Seyller 2001, 123–36) and the Jahangir Album itself (pages 185, 189, 220, 245). Plate 276, for example, has in its upper and lower margins an oblong medallion with a carefully drawn golden bird swooping about or attacking a rival in each of its geometric units. While these complex

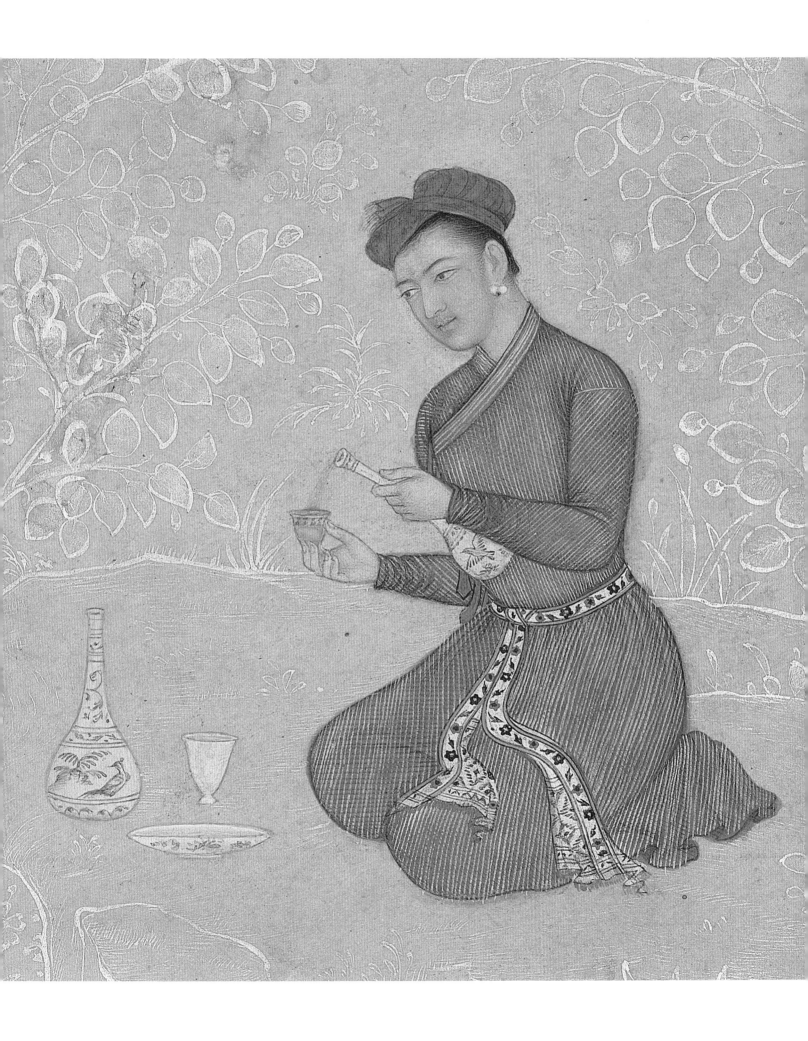

292 Detail of the upper margin of pl. 276 showing animal interlaces within a geometric medallion, attributed to Khizr; Mughal, *circa* 1610. MIA, Doha (MS.156.2000).

medallions and motifs are ostensibly too generic to support an attribution, they are paired with two others in the outer corners that are surprisingly distinctive (pl. 292). The six-pointed star at the center of each of these corner medallions is surrounded by six hexagons containing yellowish or greenish golden birds. In the upper example, the star contains one pinwheel ring of six leopard heads encircled by a second ring of five wolf and one deer terminal heads; in the lower example, it encloses an outer ring of three deer alternating with three *qilin* (the fantastic Chinese creature, often called a unicorn), each biting a vine in turn, and an inner ring of six cheetah heads similarly engaged. Such interlaced animal motifs are found only in late Akbari borders ascribed or attributed to Khizr (for example, Seyller 2001, figs. 53, 62), who also shows a predilection for medallions and birds of similar complexity and articulation; hence, it is very probable that Khizr brought his stock-in-trade to the same decorative role he played in the Jahangir Album.

Although any individual folio from the dispersed Jahangir Album is unfailingly impressive, the true achievement of the album is revealed only over an extended series of folios, when the variety of visual strategies and technical brilliance become apparent. The modes range from historicizing to avant-garde, with a few existing paintings or portraits extended, repainted, or conjoined with others in quite inventive ways. Some border vignettes excerpt earlier Mughal paintings that appear either elsewhere in the album or in a given artist's own work. Many different elements are distinctive enough to be attributed to individual masters. These attributions build up the well-documented body of work for the approximately forty Mughal artists active at the Allahabad and imperial courts at the beginning of the seventeenth century, in some cases filling in a decade-long gap in an artist's career. Together with the scores of new attributions that will be featured in the forthcoming comprehensive study of the Jahangir Album, they also alter one key feature of the prevailing understanding of Mughal painting, which has posited a sea change at Akbar's death in 1605, with Jahangir formulating and then asserting a newly refined set of visual interests upon his accession. As one realizes the dearth of manuscripts illustrated for Akbar from 1600 to 1605, and recognizes in hitherto little-studied manuscripts and albums the work of the large numbers of imperial artists who defected to Salim's service during this period, one gradually reaches the conclusion that it was Salim who was the primary Mughal patron from as early as 1600. There surely is no greater testament to the depth and sophistication of his patronage than the Jahangir Album, the pre-eminent project of the age.

Notes

1 Three sides are published in Seyller 2011a, fig. 12.10 and Beach 2004, figs. 4–5.

2 I am grateful to Milo Beach for sharing his thoughts on the scope and duration of the Jahangir Album as well as the attribution of some paintings.

3 Melikian-Chirvani 1998, 47 admits only seven or eight paintings to his oeuvre, but discards several works for which there is a general consensus. In this case, Wheeler Thackston reports that the inscription is real, but remains not quite legible in reproduction.

4 Another copy of Bihzad's "Camel Fight" was made *circa* 1599 by ʿAbd al-Samad (Seyller et al. 2002, no. 18). See also "Shaykh Majd al-Din Baghdadi receives homage from his pupil Sultan Muhammad" (Staatsbibliothek zu Berlin-Preussischer Kulturbesitz, Orientabteilung, Libri pict. A 117, fol. 19b), labeled in the same manner as pl. 1 and ascribed in the cartouche below as ʿamal-i bihzad ("work of Bihzad"). A painting of Majnun apparently regarded as Bihzad's work was both included and replicated in the Gulshan Album (Canby 2011, figs. 2, 4).

5 The short passages above on the right and left, respectively, have been identified by Wheeler Thackston as excerpts from the *Kulliyyat* of Saʿdi (ed. Muhammad ʿAli Furughi [Tehran: Amir Kabir, 1363], 705), and a *ghazal* (ode) by Muhtasham Kashi (no. 418). Thackston has kindly provided the following translations: "If they produce a form like this on the day of resurrection, lovers will have to make a thousand excuses for their sins." The left panel reads: "To control one's sighs in the face of his form – I doubt the creator of form would have the fortitude." The fact that vestiges of the tree in the upper right cross over the panel border and intrude upon the writing itself suggests that the panels were either part of the original composition or were taken from another painted page.

6 See, for example, the equestrian portrait of Akbar in the 1597 *Akbarnama* in the Chester Beatty Library (Ms. 3), fol. 202b.

7 For examples of this phenomenon in manuscripts made in Allahabad, see Seyller 2004, figs. 4 and 8. The insertion of Jahangir's likeness in literary contexts continues sporadically through 1611.

8 The same boy and vase appear in a drawing of Minerva by Basawan (Freedman 2009, no. 1). This suggests that he is probably based on a figure of Cupid. Similar vases occur in the work of Kesu (Brand and Lowry 1985, no. 63), and Manohar (Seyller 2011b, fig. 12.6).

9 Compare the rocks in Basawan's two inscribed and attributed works in the 1597–98 *Khamsa* of Amir Khusraw (Seyller 2001, pls. I, XXII).

10 Gulshan Album (Golestan Palace Museum, Ms. 1663), fol. 10a, attributed here to Nanha; Metropolitan Museum of Art, New York 1982.174 (Welch 1985, no. 107); Chester Beatty Library, Ms. 11A.1, ascribed to Payag (Leach 1995, no. 3.31); British Museum 1920 9–17 013 (38).

11 Gulshan Album, fol. 10a; Musée Guimet no. 7179 (Okada 1989, no. 52); British Library, India Office Collections, Johnson Album 18, no. 18 (Losty 1986, no. 24); Victoria and Albert Museum I.S. 91–1965 (Crill and Jariwala 2010, fig. 12.3); Musée Guimet no. 7179 (Bibliothèque nationale 1986, no. 3); Israel Museum no. 901.69 (Milstein 1984, no. 174); and Fondation Custodia no. 1973–T.4, no. 53 (Crill and Jariwala 2010, no. 10).

12 The inscription properly reads *shabih-i zayn khan koka ba mughal khan ʿinayat shud* ("Portrait of Zayn Khan Koka. He was awarded [the title of] Mughal Khan"). Mughal Khan is mentioned in Khan 1979, vol. 2, 107. I am grateful to Wheeler Thackston for his reading of this inscription.

13 He may be the figure in the lower right corner of a Jahangiri *darbar* scene in the National Library of Russia (Dorn 489, sheet 8; Thackston 1999, 88). Thackston has tentatively read the fragmentary name written on his collar as Mukhlis Khan.

14 See comparable figures in Mansur's ascribed works in the 1596 *Akbarnama* in the British Library (fol. 110a); the 1597–99 National Museum *Baburnama* (fol. 8b; Beach 2011, fig. 12.10); the Gulshan Album, p. 246 (Beach 2011, fig. 12.7), and the *circa* 1605–07 *Kulliyyat* of Saʿdi (Aga Khan Museum Collection, fol. 94b). The ascription on the last of these paintings is reported here for the first time.

15 He bears a strong resemblance to a labeled figure identified by Thackston (1999, 252) as Mirmiran Khan in a *Jahangirnama* illustration; the significant difference in date, however, diminishes the likelihood that they are the same individual.

16 Sen 1984, 156. The name of Raja Bhagwan Das is written in the right margin, albeit further up the folio.

17 Dressed in a fur-trimmed orange tunic, he stands along the left edge of the Royal Library *Padshahnama*, fol. 49a (Beach, Koch, and Thackston 1997, pl. 9).

18 I am indebted to Wheeler Thackston for his translations of all the text on this and other Jahangir Album pages in the MIA, which are presented in full in the Appendix.

19 The relevant figure is dressed in brown and appears in the lower right corner.

20 Moreover, all the dogs in Madhu's ascribed painting (f. 263a) in the 1605 *Nafahat al-uns* have the same dark muzzle and eyes.

21 Gulshan Album, fol. 68b; in that example, the instrument is played by a female musician.

MIA MS.155.2000

Top and bottom cartouches:

<div dir="rtl">

شمع روی تو نور دیدهٔ ما

ای رخت قبله‌گاه اهل صفا

</div>

Sham'-i rōy-i tu nūr-i dīda-i mā

ay rukhat qiblagāh-i ahl-i safā

The candle of your face is the light of our eyes.
Your cheek is the direction to which the people of purity turn.

Right-hand column:

<div dir="rtl">

الهی تو این شاه درویش‌دوست * که آسایش خلق در ظل اوست

برومند دارش درخت امید * سرش سبز و رویش برحمت سفید

بدارش بر اورنگ شاهی و جاه * بر اوج فلک تا بود مهر و ماه

فقیر المذنب میر علی الکاتب غفر ذنوبه

</div>

Ilāhī tu īn shāh-i darvēsh-dōst

ki āsāyish-i khalq dar zill-i ōst

Burōmand dārash dirakht-i umēd

sarash sabz u rōyash ba raḥmat safēd.

Bidārash bar awrang-i shāhī u jāh

bar awj-i falak tā buvad mihr u māh.

Faqīr Mīr ʿAlī al-Kātib ghafara dhunūbah

O God, keep this dervish-loving king, in whose shadow is the repose of the people,
as a flourishing tree of hope – his head green and his face white with mercy.
Keep him on the throne of kingdom and majesty as long as the sun and moon are at the apex of the celestial sphere.
The poor Mir Ali the Scribe, may [God] pardon his sins.

Left-hand column:

<div dir="rtl">

شکر ایزد که بنده چون دگران * نبود اندر شمار بیخبران

که تو بر ظالمان ببخشایی * ظالمانرا جزا نفرمایی

خاصه بر ظالمان آل رسول * آنکه ایمان نکرده اند قبول

فقیر میر علی

</div>

Shukr-i Īzad ki banda chun digarān ★ *nab'vad andar shumār-i bēkhabarān*

Ki tu bar ẓālimān bibakhshāyī ★ *ẓālimānrā jazā nafarmāyī*

Khāṣṣa bar ẓālimān-i āl-i rasūl ★ *ānki īmān nakardaand qabūl.*

Thank God that this servant is not, like others, among the number of those ignorants

Who think that you pardon wrongdoers and do not requite the unjust,

Particularly those who are unjust to the family of the Apostle, those who have not accepted faith.

The poor Mir Ali.

MIA MS.156.2000

Text (from Mir ʿAli-Sher Navaʾi's *Majālisuʾn-nafāyis,* in Chaghatay Turkish):

میر حبیب الله میر صدرنینک اوغلی دور اتاسینینک تعریفی یوقاری مذکور بولدی. ملایم ییکیت دور و عود چالارغه هم قابلیتی

بار. هم عشقی امید اولکیم اول فندا یخشی بولغای تحصیل هم قیلادور. بو مطلع انینک دور کیم

از چه در شام غمت عالم بچشمم شد سیاه * گر نشد در هجر تو روزم سیاه از دود آه

محمد جعفر محمد علی کوکلتاش اوغلی دور کیم مشهد مقدسه رضویه (علیه التحیة والسلام) داروغه‌سی دور. یخشی‌غینه طبعی بار.

بو مطلع انینک دور کیم

آن شب که شمع چهره‌را از تاب می‌افروختی * رحمی نکردی بر من و پروانه‌وارم سوختی

شاه‌قلی اویغور کیچیکی‌دین طبع تحصیل‌غه و اکثر فضلیاتقه

Mīr Ḥabībullāh Mīr Ṣadr'ning oghlï dur. Atasïnïng taʾrīfi yuqarï mazkūr boldï. Mulāyim yigit dür u ʿūd chalargha ham
qabiliyyatï bar ham ʿishqï. Umēd olkim ol fanda yakhshï bolghay. Taḥṣīl ham qiladur. Bu maṭlaʾ anïng dur kim:
Az chi dar shām-i ghamat ʿālam ba chashmam shud siyāh
gar nashud dar hajr-i tu rōzam siyāh az dūd-i āh.

Muḥammad Jaʿfar Muḥammad ʿAlī Kükältash oghlu dur kim Mashhad-i muqaddasa-i Rizaviyya (ʾalayhiʾt-taḥiyyatu waʾs-
salām) dārūghasï dur. Yakhshïghïna ṭabʾi bar. Bu maṭlaʾ anïng dur kim:
Ān shab ki shamʾ-i chihra-rā az tāb mēafrōkhtī ★ raḥmē nakardī bar man u parvānavāram sōkhtī.

Shāhqulï Uyghur kichikidin ṭabʾ taḥṣīlgha u aksar faḍliyyātqa

Mir Habibullah was the son of Mir Sadr. A description of his father has been given above. He is a mild youth, and he has talent for playing the lute and for minstrelsy. It is hoped that he will be good in that art. He studies. this line is by him:

In the evening of your grief why did the world turn black in my eyes if my day did not turn black from the smoke of sighing in separation from you?

Muhammad Jaʿfar is the son of Muhammad Ali Kükältash who is the overseer of the shrine of Imam Riza at Mashhad. He has fairly good poetic talent. This line is by him:

The night when you lit the candle of your countenance
You had no mercy on me, and I burned like a moth.

Shahqulï Uyghur has from childhood had a nature attuned to study and [he has acquired] most of the accomplishments . . .

<div dir="rtl">

در حسب حال خود سخنی چند داشتم

لیک از همه بدین دو سخن کردم اختصار

کای آفتاب دهر ز من نور وا مگیر

وی ظل مرحمت ز سرم سایه بر مدار

الفقیر میر علی

</div>

Dar ḥasb-i ḥāl-i khwad sukhanē chand dāshtam
līk az hama badīn du sukhan kardam ikhtiṣār:

K'ay āftab-i dahr zi man nūr vāmagīr
v'ay ẓill-i marhamat zi saram sāya barmadār.

al-faqīr Mīr ʿAlī

I had a few things to say about my condition,
But I confined myself to these two thoughts:
O sun of the age, do not take your light from me,
And, O shadow of mercy, do not remove your shadow from my head.

The poor Mir Ali.

Text is Chaghatay Turkish from Mir Ali-Sher Nava'i's *Majālisu'n-nafāyis:*

<div dir="rtl">

اهلی انی مولانا شرف الدین یزدی مقابله‌سیدا مذکور قیلورلار ایردی

فقیر سمرقندقه بارغاندا ایاغی سینیب صاحب فراش ایردی

عیادتیغه باردیم الیدا اولتوروب بو معمانی کیم اندین علا

حاصل بولور بیتیب انکا توتا بیردیم کیم

دور باد از تو درد و زحمت پا ٭ دشمنت‌را بلا مصیب و عنا

قاشی‌دین چیققاندا فقیرنینک حالاتین سوروب کیم ایرکانیمنی معلوم

قیلغاندین سونکرا بو معمانی کیم فقیرنینک اتی اندین حاصل بولور ایتیپ

بیتیب بر شاگردیدین وثاقیمغه یباریب ایردی معا بودورور کیم

چشم تو مرا دید و منش نیک ندیدم ٭ چون سیر به بینم ز تو اینست امیدم

و مولانا همول ضعف بیله عالمدین اوتتی و قبری سمرقنددا اوق دورور

گویا انی تلف قیلغاندا سونکاکین تاپادیلار که بیر یبردا قویغایلار

میر عماد مشهدی موسوی تخلص قیلور ایردی دانشمند و خوش‌محاوره

و خوش خُلق و خوش‌طبع ییکیت ایردی مشهد شعراسی اننک خدمتیغه ییغیلورلار

و هرنی دیسه اطاعت قیلورلار ایردی معا فنی‌دا هم محارق

</div>

Ahlī: anï Mawlānā Sharafuddīn Yazdī muqābalasida mazkūr qïlurlar erdi. Faqīr Samarqandqa barghanda ayaghï sinip
ṣāḥib-farāsh erdi. ʿIyādatïgha bardïm. Alïda olturup bu muʾammānï kim andïn ʿAlā ḥāṣïl bolur bitip anga tuta berdim kim:
Dūr bād az tu dard u zaḥmat-i pā ★ dushmanatrā balā muṣīb u ʿinā.

Qashïdïn chïqqanda faqïrnïng ḥālātïn sorup kim ergänimni ma'lūm qïlghandïn songra bu mu'ammānï kim faqïrnïng atï andïn ḥāṣil bolur aytïp bitip bir shāgirdidin visāqïmgha yibärip erdi. Mu'ammā budurur kim:

Chashm-i tu marā dīd u manash nēk nadīdam ✶ chun sēr bibīnam zi tu īnast umēdam.

va mawlānā hamol za'fdïn 'ālamdïn öttï ve qabrï Samarqandda oq durur. Gōyā anï talaf qïlghanda süngäkin tapmadilar ki bir yerdä qoyghaylar.

Mīr 'Imād Mashhadī Mūsavī takhalluṣ qïlur erdi. Dānishmand ve khwashmuḥāvara ve khwashkhulq ve khwashṭab' yigit erdi. Mashhad shu'arāsï anïng khidmatigha yïgilurlar ve harne desä iṭā'at qïlurlar erdi. Mu'ammā fannïda ham mahārati . . .

Ahli: He used to be mentioned as being on a par with Mawlana Sharafuddin Yazdi. When I went to Samarkand he had broken his foot and was confined to bed, so I went to visit him. Sitting in front of him, I wrote this riddle, from which the name Ala can be derived, and gave it to him:

"May pain and inconvenience of foot be far from you. May disaster and travail afflict your enemy."

After I left him, he asked about me, and when he had ascertained who I was, he sent the following riddle, from which my own name can be derived, with an errand boy to my quarters. The enigma is this:

"Your eye saw me, but I did not see it well. When I see it fully, this is my hope of you."

The mawlana passed away of that same illness, and his grave is somewhere in Samarkand. You would think that when they lost him they couldn't find his bones to put them in one place. (?)

Mir Imad Mashhad had the pen name of Musavi. He was a learned man, a good conversationalist, good-natured, and poetically talented. The poets of Mashhad used to gather in his presence and do anything he said to do. He had expertise in the art of riddles.

Poetry on sides:

ما مست و خراب و رند و عالم سوزیم ✶ با ما منشین وگرنه بدنام شوی

نه قصّه آن شمع چگل بتوان گفت ✶ نه حال من سوخته‌دل بتوان گفت
غم در دل تنگ من ازانست که نیست ✶ یک دوست که با او غم دل بتوان گفت

هر دوست که دم زد ز وفا دشمن شد ✶ هر پاکروی که بود تردامن شد
گویند شب آبستن غیبست ولی ✶ چون مرد ندید از چه آبستن شد

Mā mast u kharāb u rind u 'ālamsōzēm
bā mā manishīn vagarna badnām shavī.

Na qiṣṣa-i ān sham'-i Chigil bitavān guft
na ḥāl-i man-i sōkhtadil bitavān guft.
Gham dar dil-i tang-i man azānast ki nēst
yak dōst ki bā ō gham-i dil bitavān guft.

Har dōst ki dam zad zi vafā dushman shud
har pākrōy ki būd tardāman shud.
Gōyand shab ābistan-i ghayb ast, valī
chun mard nadīd az chi ābistan shud?

We are dead drunk, rascals, and world-burners.
Do not sit with us; otherwise you'll get a bad name.

Neither can one tell the story of that candle of Chigil nor can one speak of the condition of forlorn me.
The grief in my distressed heart comes from the fact that there is no friend to whom I can tell the sorrow in my heart.

Every friend who speaks of fidelity becomes an enemy.
Every pure person there is becomes sullied.
They say the night is pregnant with what is to be, but
since it has never seen a real man, how can it be pregnant?

MIA MS.158.2000

<div dir="rtl">

ای دل غم یار و نالهٔ زار خـــوش اســـت سوز جگر و دیدهٔ خونبار خوش است

غیر از غم یار هـرچـه حـاصـل کردی حاصل همه هیچ است غم یار خوشست

</div>

Ay dil, gham-i yār u nāla-i zār khwash ast
Sōz-i jigar u dīda-i khūnbār khwash ast.
Ghayr az gham-i yār harchi ḥāṣil kardī
Ḥāṣil hama hēch ast; gham-i yār khwash ast.

O heart, grief inflicted by one's beloved and pitiful moaning are pleasant.
Agonizing and eyes filled with bloody tears are pleasant.
Aside from grief from your beloved, everything you have acquired
Is nothing. Only grief from the beloved is pleasant.

<div dir="rtl">

کاشکی خـاک حـریم حرمـت می‌بـودم می‌خرامیدی و من در قدمت می‌بودم

بی‌غم عشق تو صد حیف ز عمری که گذشت پیش ازین کاش گرفتـار غمـت می‌بـودم

</div>

Kāshkī khāk-i ḥarīm-i ḥaramat mēbūdam.
Mēkharāmīdī u man dar qadamat mēbūdam.
Bē gham-i ʿishq-i tu ṣad ḥayf zi ʿumrē ki guzasht
Pēsh azīn kāsh giriftār-i ghamat mēbūdam.

Would that I were the dust of your inviolable sanctuary.
You would strut, and I would be at your feet.
Alas for all of my life that passed without grief from you
before now. I wish I had been afflicted by grief for you then.

<div dir="rtl">

الفقیر علی السلطانی فی شهور سنهٔ ۹۴۸

</div>

al-faqīr ʿAlī al-Sulṭānī fī shuhūr-i sana-i 948
The poor Ali al-Sultani in the months on the year 948 [1541–42]

Left-hand panel:

لـب داد بـاو شراب بـســــیـار چشم تو که کرد خواب بسـیـار

خورد از جگرم کبـاب بـسـیـار آن غمزه که مست ازین شرابست

تـو یـافـتـهٔ صـواب بـسـیـار گر کشـتـن عـاشقـان صوابست

از نـاز پـر و عـتـاب بـســـیـار هرگز نشـود دو چشـم تو سیـر

از چـشـم کـمـال آب بـســـیـار از دوری عـارض و لبـت رفـت

کتبه میر علی

Chashm-i tu ki kard khwāb-i bisyār
Lab dād ba ō sharāb-i bisyār.
Ān ghamza ki mast azīn sharāb ast
Khward az jigaram kabāb-i bisyār.
Gar kushtan-i ʿāshiqān savābast
Tu yāftaī savāb-i bisyār.
Hargiz nashavad du chashm-i tu sēr
Az nāz pur u ʿatāb-i bisyār.
Az dūrī-i ʿāriz u labat raft
Az chashm-i Kamāl āb-i bisyār.

Katabahu Mīr ʿAlī.

To your eye, which has slept too much, the lip has given much wine.
The glance that is drunk on this wine made much kebab of my liver.
If killing lovers is rewardable, you must have received a lot of reward.
Never will your two eyes have enough of coquettishness and rebuke.
Far from your cheek and lips many tears flowed from Kamal's eyes.

Written by Mir Ali.

Facing page: detail of pl. 286.

p. *340*: detail of *A Georgian Youth*, circa 1670–90. MIA, Doha (PA.73.2011).

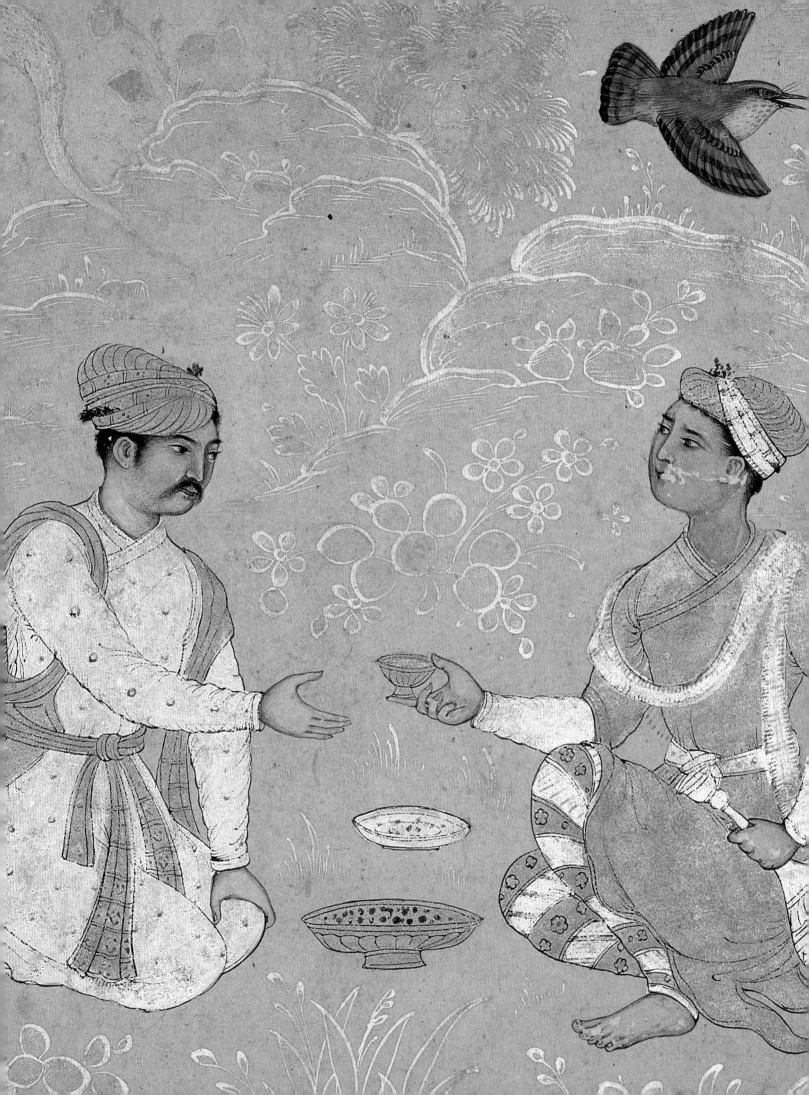

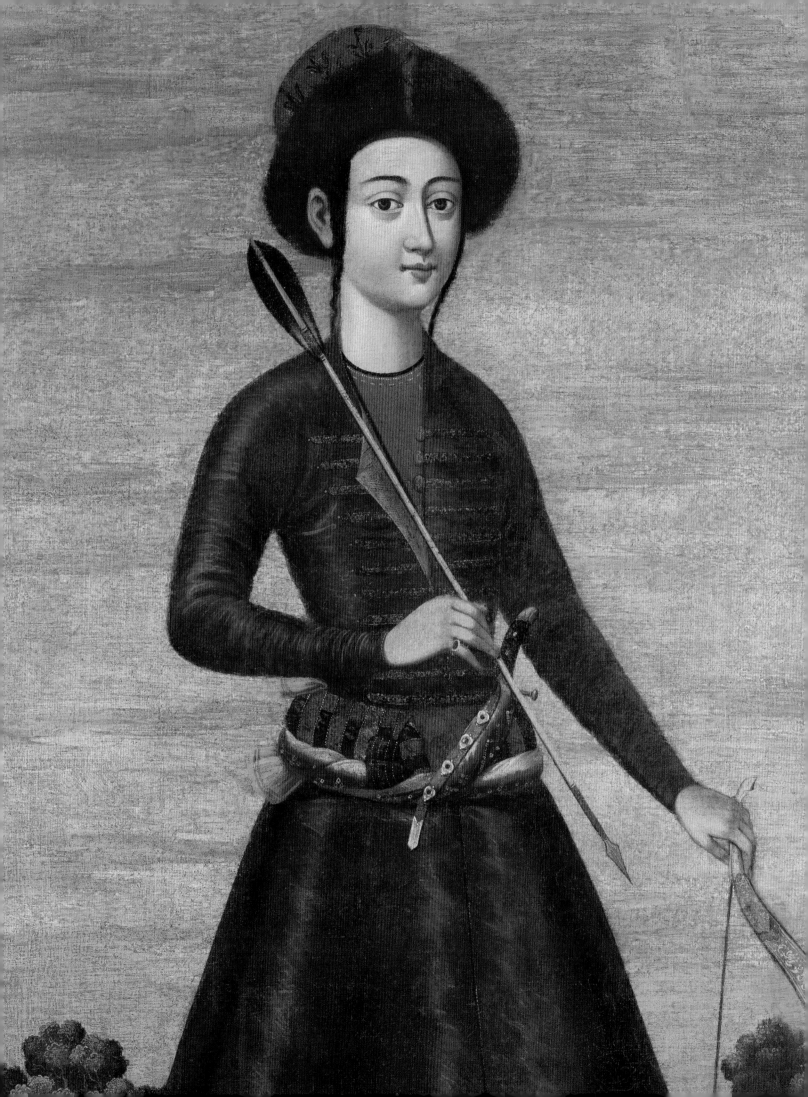

14

Six Seventeenth-century Oil Paintings
from Safavid Persia

ستّ لوحات زيتية من القصر السابع عشر من بلاد وفارس الصفوية

Eleanor Sims

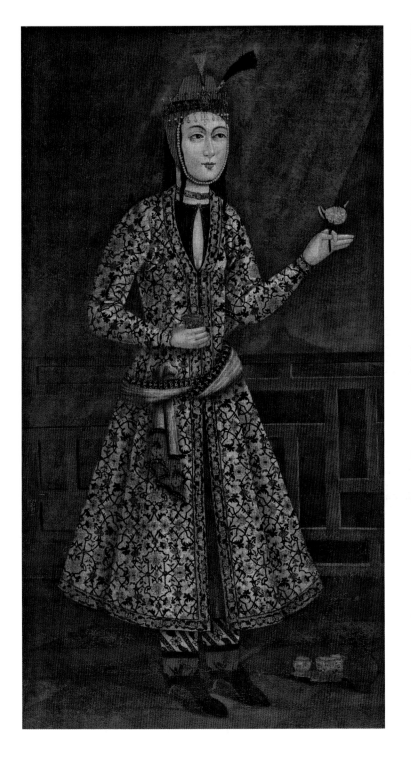
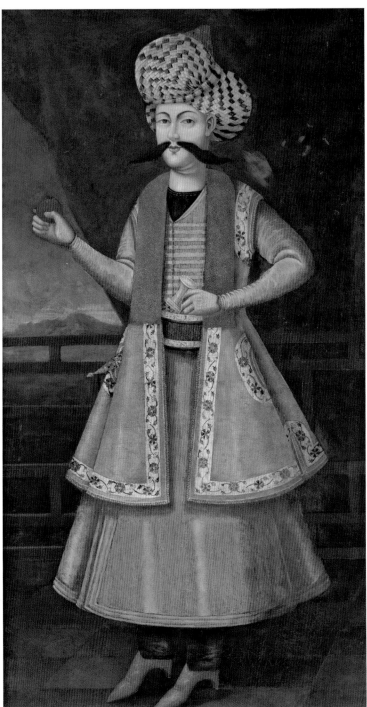

In a landmark exhibition of the arts of Persia at the Royal Academy in London in 1931, a pair of oil paintings on canvas, nearly life-size pictures of a man and a woman in rich seventeenth-century Persian dress (pls. 293 and 294), was "placed in a position of honour" (Arnold-Forster [1949], 148, pls. 28, 29). At that period, such pictures must have seemed highly unusual in size, technique, and medium; nonetheless, they elicited no comment in a subsequent exhibition publication, nor did they merit even a catalogue entry; in fact, they engendered almost nothing but silence for another four decades. When they emerged from deepest Wiltshire in 1974, they had – according to family tradition – quietly resided there for nearly 300 years. But then they began to travel (Christie's, London, 11 July 1974, Lots 42–43; Lissauer 1974, 216–17). Since 1974, they have been sold, separated, and relodged, each more than once, and each has again journeyed eastward – separately. Exactly eighty years from their first public (if unremarked) appearance, they have rejoined each other in the Museum of Islamic Art (MIA) in Doha, together with no fewer than four other "members" of their generic "clan" (pls. 295–98).

These six pictures constitute the best of the genre, as well as the rest of its qualitative range. Among them is also the single known exception to the generic type: rectangular late-Safavid paintings of "Orientals" executed in oil on canvas, nearly life-size pictures of men and women, almost always presented as pairs and attired in the garb of either upper-class Persians or the Oriental Christians who dwelled among them. Such people would all have looked wonderfully "exotic" to the many Europeans who visited the Safavid court throughout the seventeenth century. And as these visitors so often recorded what they saw in words, so some also wished to have a visual record, both to recall for themselves and to show to others the exotic peoples of those unfamiliar parts of the world from which they were returning.

Whether such paintings will strike every eye as beautiful is a different matter: they may instead seem unsettling, even bizarre, in their use of European techniques and materials for the representation of non-European subjects. Among the many ways in which the overall group is unusual is that it includes the largest and the most striking examples of the eclectic mode of seventeenth-century Safavid Persian paintings that have so far survived the troubled centuries since they were painted. When I first saw some of them in the autumn of 1975, I also felt that they were odd in the extreme. Decades later, with time to cogitate, both in private and in print (Sims 1976, 221–48; Sims 1979a, 408–18; Sims 1998, 121; Sims 2006, 135–40), I note with some rue that there is much, still, to learn about these large oil paintings. The most frequently asked, but still unanswered, question is "who painted them?" and then "from what background did he" – or, more likely, they – "come?" I had originally believed, and do still, that they are not the work of Europeans but of persons who learned the technique from Europeans, and worked hard at learning it. For as we shall later see, when less well-trained Persian painters first reproduce Europeans, and European fashions, as murals and on a monumental scale, the images will also strike the inexperienced eye as, frankly, inept. By contrast, bizarre though the Persian oil paintings on canvas of the later seventeenth century may still appear, they are not ineptly painted, even though already in

293 (*facing page, left*)
The Basset Down Lady,
oil painting on canvas
(163 × 86.5 cm), Isfahan,
circa 1665. MIA, Doha
(PA.16.2009).

294 (*facing page, right*)
The Basset Down Gentleman,
oil painting on canvas (164
× 86 cm), Isfahan, *circa* 1665.
MIA, Doha (PA.72.2011).

1975 – as now – they seemed not to come from "any established school of painting." Nor has there been much advance in knowing for whom most of them were painted, let alone precisely when. But if none is dated – at least, to the best of my knowledge – I am also still convinced both that they date from no earlier than the second half of the seventeenth century and that they are almost surely no later than the end of that century. Uncertainties notwithstanding – or perhaps because of them – these unusual pictures continue to exercise a fascination, of which the six paintings in the MIA represent virtually all of the primary subgroups of the genre, as well as the single known exception. We shall look at them all, beginning with the most visually complex of the six.

This lady (pl. 295) is not the first of the group I encountered so many years ago, but I did already "know" her from published pictures (Jullian 1964; Anonymous 1969); as she was then in Paris, she has retained the sobriquet "The Paris Lady." She is a "member" of the most impressive suite of Persian seventeenth-century oil paintings on canvas to which, for working purposes, I refer as the "Prospect Suite," after a type of seventeenth-century painting, the "portrait with a prospect" (Piper 1963, xiii–xv). The type was particularly popular for paintings in England around 1630, even if the painters who most frequently executed such pictures were often Flemish or Dutch. A finely dressed figure, of either a man or a woman who faces either left or right, stands on a marble floor, often checkered rusty-red and white. The space is implicitly the terrace of a grand structure, for behind the figure is often a balustrade, while at either the right or the left background of the picture is the "prospect": a spacious, distant, and indistinct landscape with water in the background – or at least the suggestion that, were the subject to turn his back to us, he would gaze over water lying under an atmospherically charged sky. The leading practitioner of this portrait type in London was the Dutch painter Daniel Mytens (or Mijtens) (Turner 1996, 21: 508–09). Coming to England from Holland in about 1618, by 1624 he had won the favor of King James I and, after 1625, of his son and successor, King Charles I. Paintings of the type whose subjects are royal also include the older feature of the draped table next to the figure on which repose royal regalia – a crown, sometimes a scepter (Piper 1963, 61, pl. 1d); pictures of non-royal figures, for instance, van Dyck's portrait of the 2nd Earl of Warwick (Wheelock et al. 1990, 267) or Mytens's of the first Duke of Hamilton (Turner 1996, 21: 509), have neither table nor royal attributes.

How clearly *The Paris Lady* adheres to this model should now be evident (Sotheby's, London, 15 October 1998, Lot 69; Sims 1998, 121). I have no doubt that the source of the model is seventeenth-century oil paintings themselves, and not illustrated books or reproductive prints: Charles I had himself ordered that oil-painted portraits of "Or selfes, or Queene and children" (Ferrier 1970, 51) be sent to Shah Safi I (r.1629–42); these were presented to the Shah in April 1638. Nor is there much doubt of the nature of the portraits; although no trace of them in Iran has ever come to my attention, they have nonetheless left their ghostly visual echo in Persian painting of all styles from that date throughout the seventeenth century (Sims 2001, 183–84 and 196, notes 10–11). Thus, the elaborate setting in which *The Paris Lady* stands can be paralleled by much

295 (*facing page*) *The Paris Lady* (from the first "Prospect Suite"), oil painting on canvas (163.5 × 90 cm), Isfahan, *circa* 1650–60. MIA, Doha (PA.66.1998).

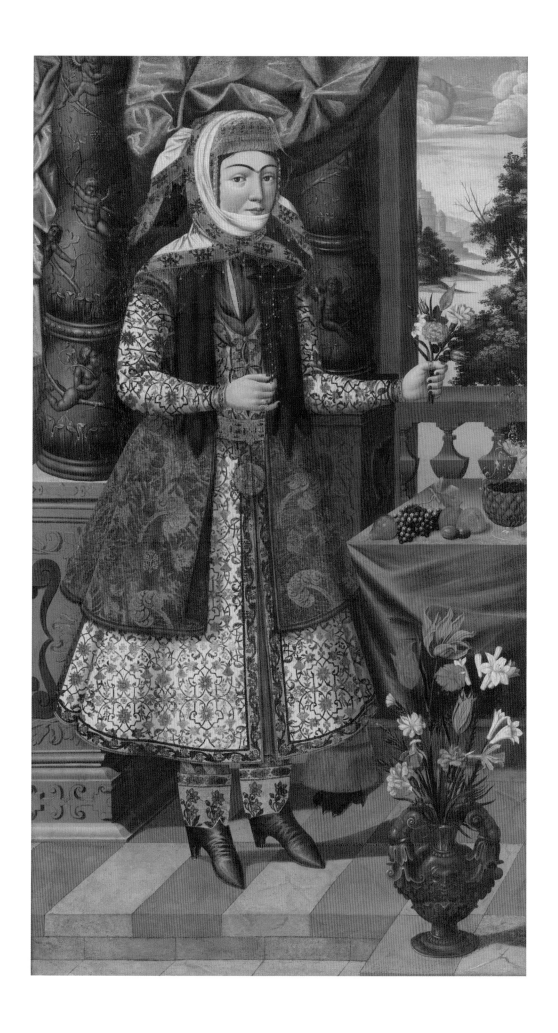

in the background of Mytens's *King Charles I* in the National Portrait Gallery, London (no. 1246; Piper 1963, pl. 1d), of which numerous copies, and related versions, were made. She too stands on a terrace paved with large squares of red and white marble slanting from lower left to upper right (offering the chance to attempt an essay at European four-point perspective); behind her is a pair of high pedestals supporting carved, gray, twisted columns wreathed with laden vines in which large putti disport; farther behind her is a lower balustrade of red stone, and beyond that, at the right, is the "prospect": a view of a large, classically appearing round structure in the distance, with a shorter tower beside it; the view is fringed with foliage and overhung with puffy white clouds in a blue sky. Between the columns is a heavy curtain of green velvet with long, thick golden fringes. The lady faces right, and beside her, to the right, is also a table: draped in red, though laid not with royal regalia but with fruit, sweet-meats, and a Venetian clear glass decanter partly filled with red wine; in one hand she holds a mixed nosegay and in the other a Venetian wineglass with a wide, shallow bowl, an elaborately shaped and exaggeratedly long stem, and no apparent foot. At her own feet, on the terrace to the right front of the picture, stands a large, apparently metal vase with a bulbous body, a narrow neck, and thick acanthus-like handles; it is filled with flowers – roses, lilies, tulips, and carnations. Between her feet and the vase can be seen one foot of the table: large, black-haired, and clawed – truly a large, black, hairy beast's foot. These features are all found in other versions of the Mytens "portraits with a prospect" and many other contemporary portraits as well.

Her clothing calls for comment. The silvery-white robe is densely patterned with a curvilinear floral trellis scrolling through elongated cartouches with elaborate ends; the front closing and the hem are edged in a thin golden fabric with a black-stemmed arabesque and, above the waist, the robe is tied with red bows; a red undergarment is seen above the bosom, and over the robe is a shorter, open, fur-lined, and fur-collared sleeveless jacket, of a different red with a pattern of large golden and darker red blooms. Two white scarves wrap her head: a large one, with a wide golden border sprigged with floral sprays and fringed with delicate gold-tied clumps of ball-tassels; a smaller sheer one covers the chin, positioned to pull over the mouth at appropriate moments and also securing both the larger scarf and the golden headdress hung with golden coins on the forehead; a few strands of dark hair emerge at the brow and the side of her face. The angled stripes of her trousers can just be seen above the wide golden cuffs with growing flowers, in the Indian manner, and her high-heeled slippers are green. Golden bracelets at her wrists, a number of rings on her hands, and a wide golden belt set with red stones and a large hanging disk complete the rich ensemble; her short fingernails are also red.

While *The Paris Lady* has no true companion in the MIA, the lady we first looked at offers a fascinating and suggestive comparison (see pl. 293). As she and her mate were, in 1974, consigned for auction as coming from the Wiltshire house called Basset Down, the name *The Basset Down Lady* clings usefully. She too faces right and stands on a checkered floor – this time of red and black; she too wears a dress of the very same fabric, with a similar golden edging; she too wears trousers, diagonally striped,

that end in wide, golden floral-patterned cuffs over high, dark slippers; a loose sash with wide flowered ends, like the Mughal *patka*, is wound around her hips. The only real difference in their costume is her headdress. A highish, narrow-crowned cap in red fabric covers both head and ears; it is ringed above the brow with a delicate golden diadem, fixed with a string of pearls under the chin and surmounted by two aigrettes, one the black heron-feather spray characteristic of Safavid princely headgear. She too holds a flower in one hand and a drinking vessel in the other, but the flower is single and the cup is small; on the floor at her feet are only several blue-and-white cups and a small, globular metal bottle. The railing behind her appears to be rusty-red painted wood in what has been called a "Chinese" pattern; a landscape stretches indistinctly behind her; and she seems to cast a faint shadow behind her, to the left. The canvas on which she is painted is almost the same size as that of *The Paris Lady* – but the effect is of a much smaller image, perhaps because the setting is so very simplified.

Her male pendant (see pl. 294) faces left and stands on the "same" terrace, a draped green curtain falling behind him to leave only a small triangular glimpse of landscape at the horizon. The pavement displays the same attempted perspective, in its red-and-black checkers and – curiously – slants in the same direction as that on which the lady stands: from lower left to upper right. His clothing seems simpler, pattern being largely absent: a long orange coat with welted edging and golden frogging, over a dark undergarment seen only at the neck, is clasped at the waist by a wide fabric belt into which a short white (for ivory?)-handled dagger is thrust. Over this is a fawn-yellow jacket, short, shaped, and sleeveless, edged with floral trim and lined and collared with gray karakul. His huge turban is of striped cloth, wound in the classical seventeenth-century Safavid shape; he is clean-shaven but wears the exaggeratedly enormous mustaches of the style favored by Shah ʿAbbas I, so often depicted throughout the century and well into the eighteenth (Grube and Sims 1995, 178, 182–84; Sims 2003, 796). With one hand he touches his dagger and with the other he holds a fruit, as if offering it to the lady whom he faces. Indeed, the faces are a notable feature of this couple, albeit that his mustaches – they have the appearance of being merely pasted onto the visage – and her close-fitting red cap, in addition to the more obvious differences of gender and position, tend to obscure the similarity in the way both are executed: light, egg-shaped, with shortish noses and small but full underlips, and a pursing line at each side of the mouth. One expert I consulted, very early in my study of these paintings, observed that the brush-strokes in all the visages (of the group of five in the initial study, in addition to the Basset Down pictures) are pure cliché, with no freedom in the execution of either faces or hands.

Yet that the Basset Down paintings are a unit is evident from positions, gestures, and the setting: in this unified space – however simply it may be executed – each figure reaches out to the other – however stiff may be the representation.

For contrast, let us turn to another man (pl. 296) also in the MIA: I call him *The Gentleman with a Cane* (Sotheby's, London, 15 October 1997, Lot 35). He has blue eyes and reddish-blond ʿAbbasi-style mustaches, the head is peculiarly set on a torso with misaligned shoulders and arms that – apparently – differ in length; one signet-ringed

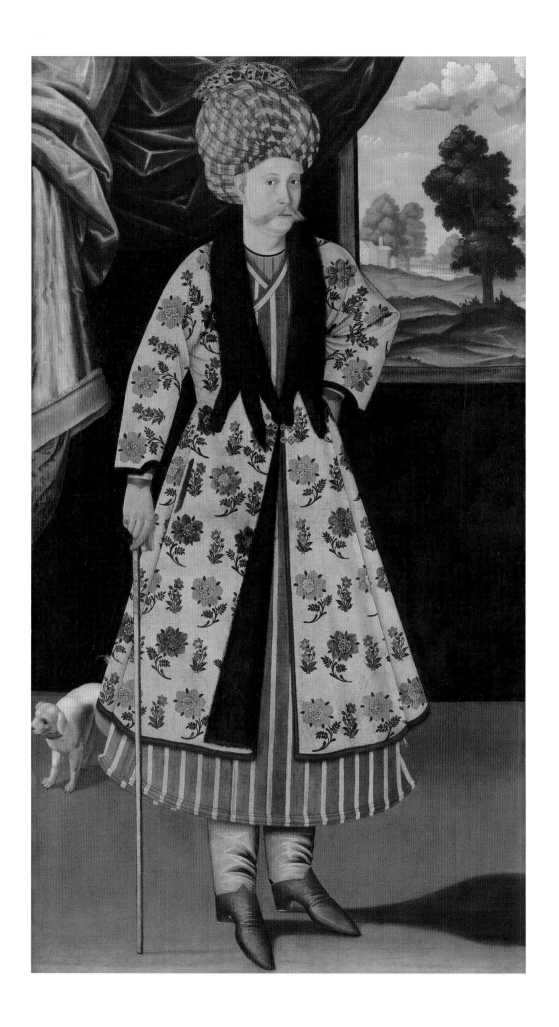

hand rests on that longish cane, and his Safavid garments are both well observed and well painted. He stands facing right, in an indistinct interior, with a luxuriant green curtain fringed in gold looped up behind him and partly falling over the window, at the upper right, through which a single tree, with full green foliage, marks the middle ground and a more distant grove marks the farther distance. At the bottom left of the painting a little white dog peers out from behind him.

From the moment the gentleman appeared for sale, in 1997, he conveyed the sense of an individual: the head, so I noted in March of 2011, was compelling, and the garments painted by someone who really knew such clothing, down to the fine, barely visible black-and-white cording at the hem and wrists. He is also considerably larger than the other three MIA paintings (and, indeed, than most of the other rectangular paintings of the overall Persian group). His long robe, striped in blue and gold, shows the weight of the fabric at its welted hem; the under-robe, of red and visible only at the neck, and the red trousers both seem simply rendered in comparison with the handsome gold-ground floral pattern of his long-sleeved shorter coat, lined and collared with black marten. The striped textile of the turban seems similar to that of *The Basset Down Gentleman*, even if less expert winding results in a turban of rather different shape; the golden coat recalls the celebrated van Dyck portrait of Sir Robert Sherley, executed in Rome in the summer of 1622 (Brown et al. 1999, 160–63). And while the size of the van Dyck painting – 2 × 1.334 meters – would not at first seem especially relevant, the van Dyck being unequivocally European, *The Gentleman with a Cane* – who is unequivocally uncertain in all identifying features – measures over two meters in height and a meter and a quarter in width. This is notably close to the van Dyck Sherley, and even to the anonymous Berkeley Will Trust Sherley portrait (195 × 105 cm; Tromans 2008, 62, fig. 49). In other words, in shape and size, as well as in the compelling head, this painting conforms to the European intention of capturing likeness implicit in the commissioning of a portrait. I would concur with the original cataloger that this picture is a portrait, albeit remaining, still, an unidentified subject anonymously executed, if almost surely in Persia. As such, it appears to be unique among the surviving rectangular Safavid paintings in oil on canvas: it seems to be the only true portrait of the entire primary group of thirteen paintings.

The last of the rectangular pictures in the MIA (pls. 297 and 298) are two I have also known since the mid-1970s (Sims 1979a, 408–18, fig. 4). Smaller than any of the others so far discussed (157.5 × 80.6 cm), one shows a maiden with a large metal bottle in one arm and a shallow cup filled with red liquid in the other hand; the other a beardless youth holding a strung bow and an arrow. On the ground beside each, at the lower left, is a platter bearing three pomegranates and – beside the youth – a bulbous glass bottle visibly full of red liquid. Both stand facing right but gaze out at us, in an open green landscape with a fairly low horizon; and both cast shadows to the right. They offer a number of features upon which to reflect. The fur-brimmed hats suggest that they are Caucasian, if not also specifically Georgian: thus, they are *The Georgians*. In size, style, placement of figure, and landscape they are clearly similar but, equally clearly, they are not a pendant pair, for both face the same way. Implicit,

296 (*facing page*) *An Unidentified European Gentleman With a Cane*, oil painting on canvas (218 × 125 cm), Isfahan, *circa* 1660–70. MIA, Doha (PA.2.1997).

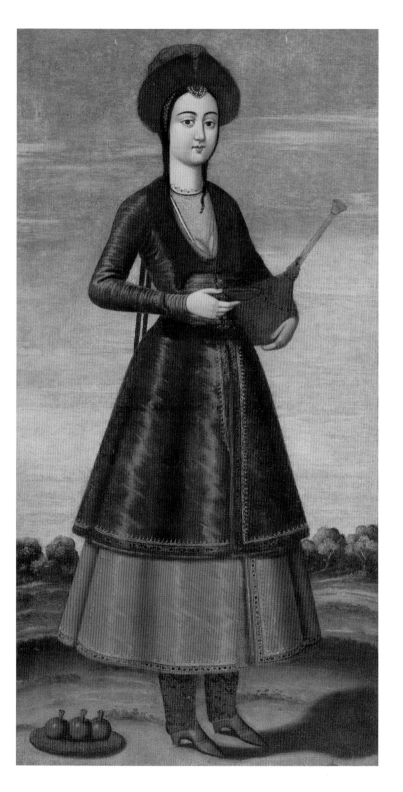
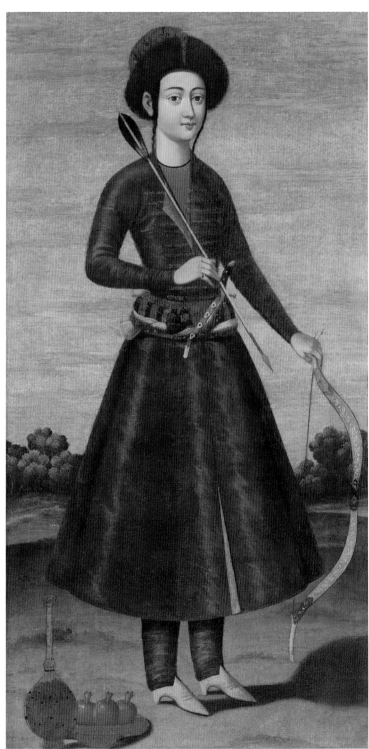

therefore, is that there did, once, exist another such "pair" of pictures equally similar in size, style, in the placement of figures of different genders – but both looking to the left, to face this youth and maiden; they, too, would have stood in the same simple landscape with a low horizon and a pink-touched pale blue sky. Considering what their subjects may have been, and for what function they were painted, raises a host of questions about them both, and a number of others, to which I shall now turn.

The six paintings in the MIA, let me reiterate, constitute almost half of the presently known pictures of the overall type, the primary grouping at the moment; and the other seven have important connections to the MIA six. One group among them comprises more pictures from the "Prospect Suite": another lady and a man, both in Tehran (pls. 299 and 300). Their settings include precisely the same elements: the red-and-white marble checkered floor, the gray column on the high pedestal, the shorter red stone balustrade beyond which – at either right or left – is the "prospect," framed by a heavy curtain, either red or green; the red-draped table laid with European objects or fruit, and the European (or European-style) metal vase with its fleshy acanthus handles, either standing on the floor or cradled in one arm of *The Tehran Lady*, whose stance, position, and even the cut and the silvery fabric of her dress are virtually the same as that of both *The Paris Lady* and *The Basset Down Lady*. The differences lie in minor variations of pose and accessories but primarily in the headdress – so often, in the East as also in medieval and Renaissance Europe, an indicator of nationality, status, religion, civil state, or all of these. Thus, *The Paris Lady* in the MIA is Armenian: compare her head-dress with its golden coins at the brow with an early twentieth-century painting of an Armenian girl by Arshag Tolvanian (pl. 301). *The Tehran Lady* is Georgian: evident not only from her headdress but also from the large drinking-horn she raises in one hand. Note that both face right; thus, one possible pairing would be *The Tehran Man* who faces left: his garb is unmistakably seventeenth-century Safavid Persian, from his huge striped turban to his dark-green slippers.

Given three good pictures of similar size and style, setting, and content and quality, each an ideally beautiful member of the three principal national or religious groups a European visitor would most likely encounter in any sojourn in Isfahan, each posed to face an absent, but implicit, pendant, it is hard to escape the conviction that they were executed as part of a suite of matching pairs, a large decorative ensemble picturing the typical denizens of the realm of the "Great Sophy," when "Isfahan," as the Persian saying goes, was "half the world." Moreover, repeating elements, or ensembles, suites, or sets – in other words, multiples, be they images or ornament – are a fundamental of the Persian aesthetic and had been for millennia: multiple projecting ornaments on Luristan bronze sockets and finials (Pope and Ackerman 1938–39, pls. 42, 43); multiple projecting bosses on medieval Persian metalwork (Pope and Ackerman 1938–39, pls. 1321–23); multiple tiny units of a decorative revetment of reflecting mirror-glass (Morris, Wood, and Wright 1969, fig. 64); symmetrical numbers of multiple niches in an interior (Babaie 2008, 147); and, perhaps, paintings to fill those niches.

Speaking of architectural decoration leads quite naturally to matters of size: it is, of course, useful in making connections between various objects but hardly an infallible

297 (*facing page, left*)
A Georgian Maiden, oil painting on canvas (157.5 × 80.6 cm), Isfahan, *circa* 1670–90. MIA, Doha (PA.74.2011).

298 (*facing page, right*)
A Georgian Youth, oil painting on canvas (157.5 × 80.6 cm), Isfahan, *circa* 1670–90. MIA, Doha (PA.73.2011).

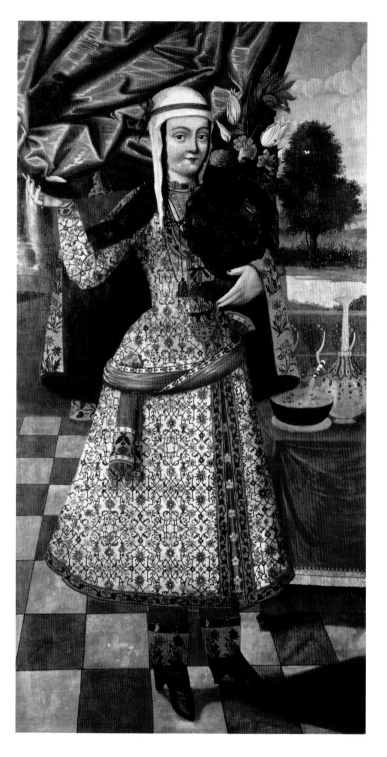
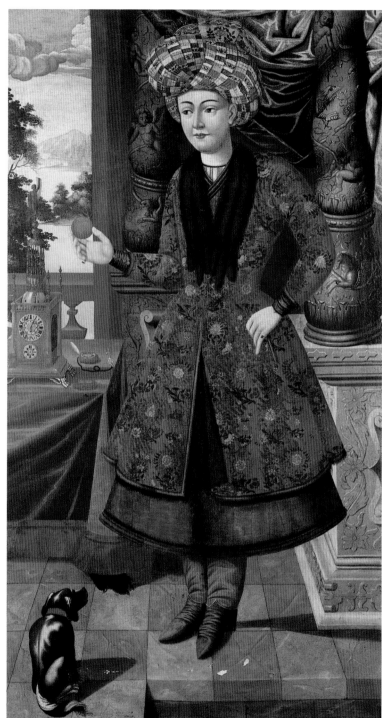

diagnostic, since independent paintings on canvas are so easily cut down. Shape is quite another matter. And so I now turn, for some background, to the larger setting in which I have long proposed these oil-painted images of seventeenth-century Persian types were created, some of the royal buildings of Isfahan, and their mercantile counterparts in some of the houses of the Armenian community of New Julfa, across the Zayanda River.

That the pavilion-cum-entry to the seventeenth-century garden zone lying behind the great new *maydan* of Shah 'Abbas I, the 'Ali Qapu – the Lofty Gateway – had painted figural decoration in many places is by now well-known (Zander 1968, 133–292; Grube 1974, 514–15; Galdieri 1979; Sims 2002, 73–76; Babaie 2008, 85–86, and chapters 4–5 *passim*). Its interior audience-halls, exterior audience-porches, and of course the so-called "Music Box" in the topmost story all included painted figural decoration (Sims 2002, 233, pic. 147). If the figural paintings are technically dateless, most can be dated by comparison in the first several decades of the century, up to perhaps 1630 or so (Sims 2002, 232–33). Towards mid-century, Shah 'Abbas II built for himself an audience-palace deep within the garden zone of Isfahan. Called the Chihil Sutun – the Palace of the Forty Columns – it bears only one date (an eighteenth-century copy of the original inscription), which is, moreover, in a chronogram: "1057," equivalent to 1647 (Zander 1968, 293–382; Honarfar [1350] 1971, 566–79; Babaie 2008, 186–97). The date of both building and paintings has been much discussed but may now be simply summarized in the statement that the Chihil Sutun was built in the reign of 'Abbas II, between 1642 and 1666, while its figural mural decoration is datable in those years but probably closer to the latter part of his reign (Sims 1974, 523; Babaie 1994, 125–42; Sims 2002, 73–77, 120, 273; Babaie 2008, 196–97).

For the Chihil Sutun is really a key document for the primary group of oil-painted pictures of which, let us recall, the MIA six are almost half the group: its walls are covered with figural decoration practically all over, inside and out, in all the styles current in the Safavid capital and elsewhere in that period (Grube 1974, 515; Sims 1979a; Robinson, Sims, and Bayani 2007, 216–20, 222–28). The great audience-hall of the interior has been well studied and much reproduced; the series of "exotic"-looking Europeans on its exterior *talars* (columnar porches) less so, especially because during the periods of greatest tourist accessibility – in the 1970s – they were largely covered in scaffolding (but see Zander 1968, 329, figs. 1–3). Among the most evocative of the many figures painted in niches with pointed tops on the south *talar* is a dark-haired lady who wears a Safavid Persian heron-feather aigrette but clothing of uncertain origin and also – for the middle of the seventeenth century – archaic. Indeed, her first published identification was merely as "a lady in Western clothing" (Schuster-Walser 1970, pl. 3). In the square neckline, the necklaces of pendant jewels, and the split skirt over a contrasting underskirt, I find a suggestive parallel in a mid-sixteenth-century standing, full-length portrait of Catherine Parr (last wife of Henry VIII) in the National Portrait Gallery, London (no. 4451; Foister et al. 1988, 27; James 1996, 20ff.). The anonymous Persian painter, no doubt working from a print that reproduced the painting, suited the lady's costume according to his coloristic notions, for he could never have known

299 (*facing page, left*) *The Tehran Lady* (also from the first "Prospect Suite"), oil painting on canvas (180 × 110.5 cm), Isfahan, *circa* 1650–60. The Saad Abad Cultural-Historical Complex, Museum of Fine Arts, Tehran, Iran.

300 (*facing page, right*) *The Tehran Man* (also from the first "Prospect Suite"), oil painting on canvas (180 × 110.5 cm), Isfahan, *circa* 1650–60. The Saad Abad Cultural-Historical Complex, Museum of Fine Arts, Tehran, Iran.

301 *L'Armenienne* by Arshag
Tolvanian (1880–1969), oil
painting on canvas (61 × 50 cm).
Present whereabouts unknown.

the color of the more unified Tudor fabric. Another "exotic" image in a pointed-top
niche on the same *talar* is a European gentleman (pl. 302; Schuster-Walser 1970, pl. 2).
Here the Persian painter included every single detail from his model – painted, printed,
or even living – he could possibly find, even if he did not always understand the cut
or function of what he was painting: black, wide-brimmed hat on shoulder-length dark
hair, white lace collar and cuffs, waist-length jacket with slit sleeves, short cape draped
over one arm, baggy breeches tied at the knees with extravagant bows; straight sword
as well as short staff; and a small white hound at the feet. Nor is he alone on the
Chihil Sutun porch (Schuster-Walser 1970, pl. 1) and, surely, such men are French:

354 *God Is Beautiful and Loves Beauty*

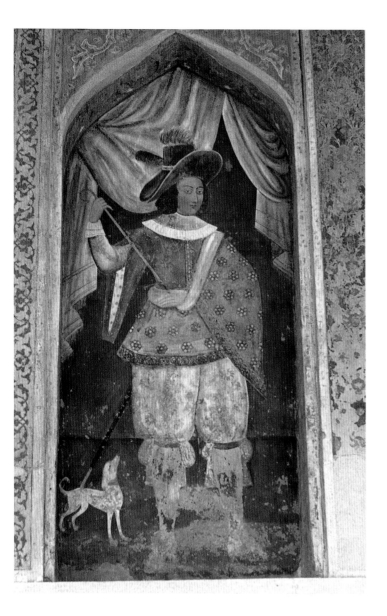

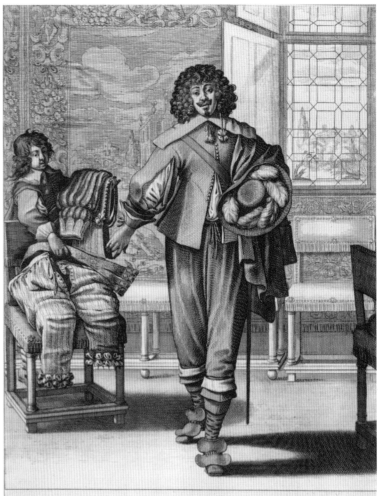

LE COVRTISAN SVIVANT LE DERNIER EDIT LE LACQVAY
Bien que sans mentir ie cheriße Puis que le luxe m'incommode, Sur ma foy cette broderie
D'auoir du clinquant deßus moy; J'aprouue fort ce changement ; N'a desormais plus d'entregent,
Il faut pourtant que j'obeiße Lacquay sers moy donc a la mode, Si ce n'est a la friperie.
Aux defences qu'en fait le Roy. Et serre cet habillement Ou l'on en tire de l'argent.
le Blond excud Auec Priuilege du Roy.

302 (left) *A French Gentleman,*
mural on the south *talar* of the
Chihil Sutun, Isfahan, *circa* 1650.

303 (right) *Le Courtisan Suivant
le Dernier Edit* (The Courtier
Who Follows the Latest Fashion)
by Abraham Bosse (1603–1676),
etching and engraving on paper
(29 × 19.7 cm), 1633.
Metropolitan Museum of Art,
New York (The Elisha Whittelsey
Collection, The Elisha Whittelsey
Fund 1951 51.501.2287).

compare the somewhat earlier "courtisan suivant le dernier edit" – the courtier who
follows the latest fashion – in Abraham Bosse's etching of about 1633 (pl. 303; Filipczak
1998, 135). And while a good deal more is known about Italian and English goods and
persons in Isfahan in the first third of the century than of French, these French-
appearing persons suggest that there is rather more to the secular French presence in
Persia than so far appears to be documented (Schuster-Walser 1970, 77–79; *Le Perse et
la France* 1972, 11–12). One relevant image, tantalizing in the extreme even if it reverses
the direction of locale, subject, and maker, is a fine French chalk drawing signed and
dated in 1627 by one of the finest of Louis XIII's court artists, Daniel Dumonstier (pl.
304). Clearly a portrait of a Persian man, with a full, hennaed beard and a splendidly
wrapped white turban, both his identity and the reason for his presence in Paris at this
date remain unknown. What this very beautiful drawing does confirm, however, is the
veracity of the rendering of clothing and textiles, at least in the "Prospect Suite" and
The Gentleman with a Cane. The textures of fur and fine undergarments, the welting
of edges, the gold fitting for the heron-feather aigrette: Dumonstier so wonderfully
conveys them, but the painters of our oil-painted figures are reasonably equal to the

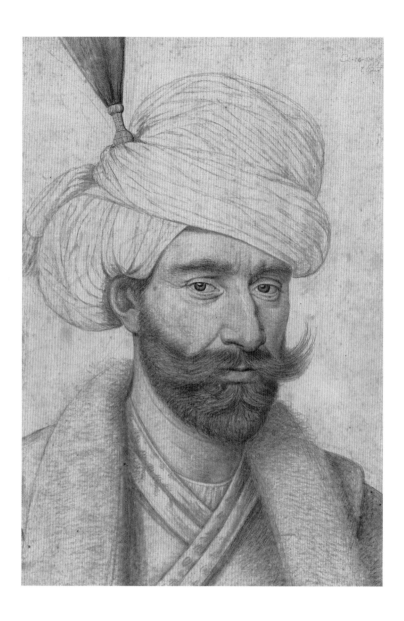

304 *A Safavid Persian Man,*
Daniel Dumonstier (1574–1646),
chalk-drawing on paper, Paris,
1627. Private collection.

task; the Chihil Sutun mural painters were not. On the other hand, these charmingly
clumsy paintings on the Chihil Sutun *talars* include the heavy swathes of velvet curtain
at one side of the picture; it had come to be de rigueur in Persian painting of the
eclectic mode, no matter the quality of the image or whatever might be its technique,
scale, or purpose, as it is also so prominent a feature of the oil paintings – by now
abundantly evident.

Moreover, the Chihil Sutun's many, eclectically rendered "exotic" figural paintings
were not unique in Shah ʿAbbas II's capital. Similar pendant images, a man and a
woman, are to be seen in a drawing of the slightly earlier Ayina Khana (it stood near
the bank of the Zayanda River but was destroyed in the nineteenth century) (pl. 305;
Welch 1973, 117, cat. 70): one, each, in the middle register, among the panels of mir-
rored revetment on the walls of the entrance *talar*. And they could also be found in
New Julfa, across the river. The Dutch traveler Cornelis de Bruyn describes the house
of Khwaja Sarfraz, having ". . . all the walls . . . painted and full of figures as big as the
life . . . a Turkish man . . . and woman . . . other figures dressed after the Persian and
Spanish manner . . ." (Carswell 1968, 66). From some other house a large fragment still
survives, large enough to show a group of three persons, one lady in the white

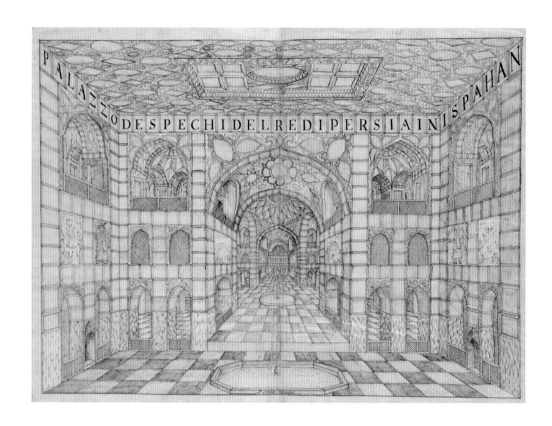

305 *Entrance-Talar of the Ayina-Khana, the Palace of Mirrors,*, drawing by G. J. Grélot, 1671–75, from *The Journal and Travels of Ambrosio Bembo in Asia.* James Ford Bell Library, University of Minnesota, Minneapolis (Bell 1676 fBe).

headdress of certain Georgian women, together with the piglets in a large dish (Diba and Ekhtiyar 1998, 128–29, cat. 16) that so emphatically identify the subject as non-Muslims. And an entire gallery of such pictures still survives in the mid-century "House of Sukas," both on the walls of its entry-*talar* and in the main rooms (pls. 306 and 307; Carswell 1968, 65–67, pls. VI, 70, 72, 73; Karapetian 1974, figs. 84, 87; *Ganjnameh* 1998, 86–99, figs. 65, 67). Again, they show figural types that would have been "exotic" to its Armenian owners: European and Persian men and women, Georgian women, and Indian men, in company with Christian religious images. Surely they were all created in imitation of the painted princely structures across the river – then, as still, the sincerest flattery.

Exterior or interior, such Safavid images were subject to the "slings and arrows" of time and weather, war and urban deterioration, benign neglect – and also restoration. Nonetheless, as they remain today it is evident that the mural subjects on the walls of buildings in Isfahan, as in New Julfa, are essentially the same as the oil-on-canvas subjects: in conception, presentation, and execution. That some among them so clearly represent the Christian minorities dwelling alongside the Muslim majority of Safavid Isfahan has long provided "ammunition" for some of my oldest and dearest of colleagues, who have argued for the uniquely Armenian "authorship" of these eclectic figural types of the later seventeenth century, not only painted onto plastered walls but also onto primed canvas – just as other old and dear friends and colleagues have equally argued for their uniquely Georgian "authorship" (Adle et al. 1996, 352–57). But does an Armenian context, or even an Armenian subject, *ipso facto* necessarily argue for an Armenian painter? Or a Georgian context or subject for a Georgian painter? Of this I remain skeptical, as others have also long been uncertain of their painterly paternity: I find, in consulting my earliest notes on the paintings I saw in 1975, the comment that while the painters in question had surely learned their techniques from Europeans,

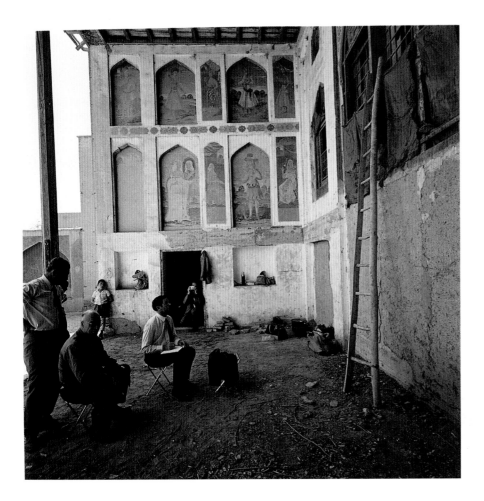
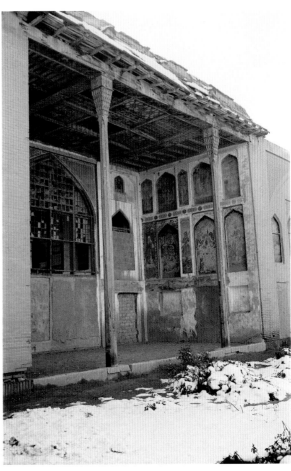

306–07 Two views of the *talar* of the House of Sukas, New Julfa (Isfahan), *circa* 1655.

none of the pictures appear to be "from any established school of painting." What they do seem to demonstrate, at least the "finest" – the most elaborate and carefully painted – among them, is that the ideal composition of such a suite of rectangular oil paintings on canvas was a pair of native Persians, male and female, together with an Armenian couple and a Georgian couple.

One more oil painting on canvas must now enter the discussion; it differs only slightly from better-known paintings of the "Prospect Suite," similar in setting but slightly smaller in size (pl. 308; Sotheby's, New York, 26 May 2005, Lot 110). Wherever its original European home may have been (for it is now in a North American private collection), I have come to consider it as a kind of chronological and stylistic fulcrum on which turns the larger gathering of all the later seventeenth-century rectangular oil paintings on canvas, for reasons soon to be apparent.

I must first correct its most recently published title, *Portrait of a Nobleman*: it is neither. Instead it is another painting of a Persian lady in the rich and complex setting of a second and smaller "Prospect Suite." She too wears diagonally striped trousers, and a sash loosely draped around her hips; her earrings are a pair, as opposed to a single one, her coiffure is of multiple braids; the bosom, it is true, is small and indistinctly rendered (and may have misled the cataloger). On the white-draped table beside her are fruits, rather than coins and timepieces, as is also the case with the Georgian and the Armenian ladies of the first "Prospect Suite." Moreover, the painting is rectangular – as have been all the other oil-painted pictures here under consideration: this is not without significance.

358 *God Is Beautiful and Loves Beauty*

This should be evident from a strikingly similar canvas (pl. 309; Christie's, London, 27 April 2004, Lot 85). True, the setting is far simpler, having only a draped curtain and a view through a window at one side of the picture. What is also notable is that its top is pointed and that the shape perfectly accommodates the lady's head. The garments are again almost devoid of pattern but in pose, gaze and face, coiffure and earrings, even the splendid fur-lined, gold-brocaded 'Abbasi hat, the two images are otherwise the same: the figure has simply been reversed. She was flipped, simplified, and here used for a painting expressly made for the more traditional Persian pointed niche – or at least, to echo that shape, as it hung on a wall. Which I am proposing it did, and did so in the company of companions having exactly the same faces but attired differently, who also stand and gaze out at us from pictures with similarly simple settings and similarly pointed tops (pl. 310): for instance, a dancing-girl (Christie's, London, 7 April 2011, Lot 146) dressed in a gauzy overgarment, short red jacket, and striped Persian leggings, with thonged clogs on her feet. And as both ladies face right, it is hard to imagine that there would not also have been a "matching" pair of men who would have faced left, and the ladies.

What, then, may we conclude from all this? I would suggest that in the rectangular full-length Safavid Persian paintings in oil pigments on canvas we are looking at a later seventeenth-century phenomenon with a relatively short life – I think it would have lasted, in Persia, no later than about 1700. Its origin is surely complex but, equally surely, it acquired its very particular profile in seventeenth-century Isfahan. Developed in the earlier seventeenth-century presence of Europeans and European works of figural art – reproductive prints (Diba and Ekhtiyar 1998, 108–10, cat. 5), printed books (Ferrier 1970, 55–56), and oil paintings, as gifts or for sale (della Valle 1672, 3: 37), but especially as princely gifts, especially the oil paintings of monarchs that came to Persia with so many of the embassies of trade or diplomacy sent by the crowned heads of Europe to the "Great Sophy" – emerged in a context in which the representation of foreigners became a fashion favored by royalty (Richard 2007, 78–79) that would, then, have been widely imitated all over Isfahan. They acquired fuller shape in the presence of a certain number of European painters – if of little talent, then with much sense of adventure (Sims 1976, 226–28) – who knew how to paint in oils on rectangular stretched canvas supports and who then appear to have taught their craft to willing non-European painters, including the Shah of the day (Sims 1976, 227). They were nourished at a moment when Armenians from Julfa built new churches in their new city of New Julfa and decorated them with literally acres of indifferent European paintings in oil on canvas (Carswell 1968, pls. 4–67 passim), while Georgians, especially of the Undiladze family, had been established at high levels of power and prestige in Safavid Isfahan for the better part of the century (Babaie et al. 2004, 34–36, 88, 93). And then they matured in the presence of Europeans who were struck by the "exotic" human variety they found in Isfahan, wished to recall it when they returned to their European homes, and so commissioned big pictures from local painting ateliers – which must have been few but which also must have operated in full knowledge of what their colleagues and rivals were doing.

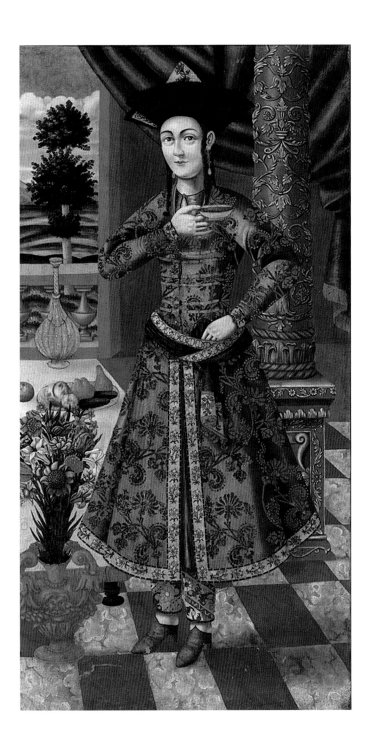

308 *A Maiden Standing in an Elaborate Interior,* oil painting on canvas (158.1 × 82 cm), Isfahan, *circa* 1665–75. Private collection.

In such a milieu, I would suggest, a kind of critical mass was reached in the second half of the seventeenth century. From it emerged a striking, bizarre, but sometimes brilliant vogue for large rectangular oil paintings on canvas in the European manner, showing men and women in the fine and fashionable garments to be seen in the capital, whether Muslim Persian, Armenian, or Georgian. That such paintings are figural types, and virtually never true portraits – the single recorded exception so far being *The Gentleman with a Cane* – should now be clear. And that they are the work of interrelated studios should also now be more than clear: from the similarity of faces that overrides differences in gender; from the utter sameness of the silvery, trellis-patterned dress on three ladies of the primary group and still others of secondary quality (Sotheby's, London, 13 October 1999, Lot 14); from the reuse of figures

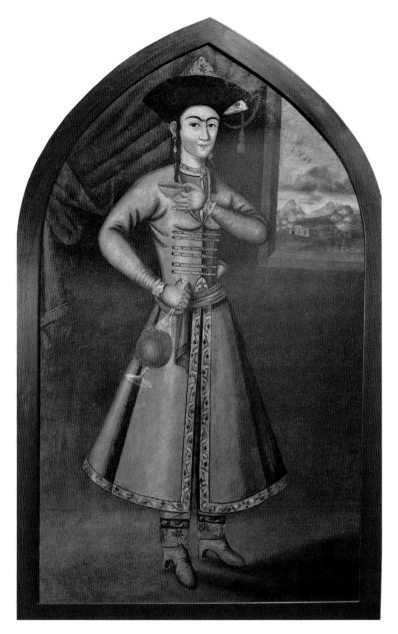

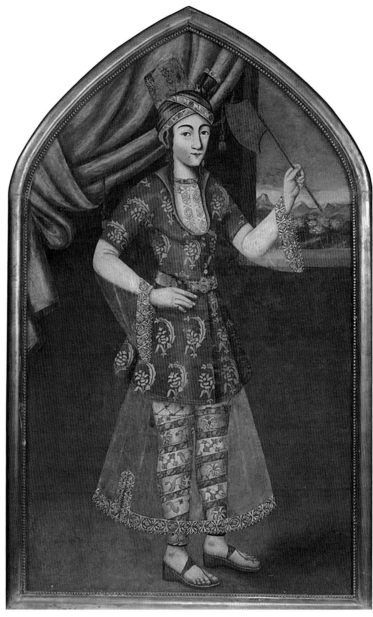

309 (*left*) *A Maiden Standing in an Unadorned Interior*, oil painting on canvas (154 × 89 cm), Isfahan, *circa* 1665–75. Present whereabouts unknown.

310 (*right*) *A Dancing-Girl Standing in an Unadorned Interior*, oil painting on canvas (153 × 91.4 cm), Isfahan, *circa* 1665–75. Present whereabouts known.

and the repeated faces, even for paintings of different shapes; and from the repetition of settings not only seen in different stylistic groups but also furnished with what can, in the end, be thought of as mere studio-props – astonishing as these may sometimes be.

Consider one last pair of images, late nineteenth-century photographs from a studio in Tbilisi (pls. 311 and 312): one showing a princess of the Cholokashvili family, the other an unknown nobleman, but both accompanied by that large and extraordinary Umayyad ewer dated 69 AH (688–89 CE) now in the Georgian National Museum (Inv. I–V: D'yakonov 1947, 5–8; Ettinghausen and Grabar 1987, 71–72 [where it is mistakenly said to be in the Hermitage]) and about which the late Oleg Grabar once speculated in such tantalized frustration. May these photographs, of Georgian aristocrats in fancy photographers' studio settings, not be seen as the formal and functional nineteenth-century equivalent of our seventeenth-century oil paintings of Persians, Armenians, and Georgians from Isfahan? I suggest they may.

311 (*left*) *Princess Cholokashvili*, black-and-white studio photograph by Alexander Roinashvili (1846–1898), Tbilisi, 1887–98.

312 (*right*) *An Unknown Nobleman*, black-and-white studio photograph by Alexander Roinashvili (1846–1898), Tbilisi, 1887–98.

As I also suggest that the still small primary group represents a European taste for what such envoys had seen in the East but rendered in the grandest version of European images, the large oil-painted canvas. And as always, Persians and Armenians alike then followed the vogue for "pictures in niches, as big as the life; they are of men and women" (Carswell 1968, 66); intended for their Isfahan dwellings, however, the newer kind of picture – the independent oil painting on stretched canvas – was shaped to accord with the prevailing Isfahani taste for pointed niches and windows (Zander 1968, 329, figs. 1–3; Carswell 1968, pl. VII; Grube 1974, figs. 2, 4; Diba 2001, figs. 114, 220, 223, 225; Sims 2002, 120, pic. 36): "arched all about," as Olearius had already written in 1637 (Carswell 1968, 66). What the Persian patrons of such independent oil paintings with pointed tops seem not – ever – to have desired was the exotic and unusual, the frankly foreign, so striking a characteristic of the primary group of the oil-painted canvases that are rectangular in shape: for those having pointed tops all seem to

represent only Persians. In fundamental – and short-lived – contrast, the MIA six and their seven recorded companions, life-size rectangular oil paintings on canvas showing standing men and women in Persian and related attire of the second half of the century are truly typical images of people from parts unknown. They were commissioned, I would suggest, by European travelers in Persia to take back to Northamptonshire or Wiltshire – or to elsewhere, and earlier in the century, to Greillenstein in Austria (Sims 1988, 20–40) – when they themselves returned to their own familiar parts, carrying home with them the visual flavor of the exotic East and of "parts unknown."

Postscript

In my mind's ear, I hear the sardonically sympathetic observation from the now-empty chair on the other side of our paired desks: "One should read the books in one's library." Preparing the published version of this essay, I reread the chapter on the "Persian Pictures" in Mary Arnold-Forster's volume on Basset Down and found two remarkable references relating to the pair that for so long hung in that house but are now in the MIA (pls. 293 and 294; Arnold-Forster [1949], 147–49). One is to Persian garments said to have been presented to the Arnold-Forster ancestor by Shah ʿAbbas II "in which dress the young man was painted after his return to England" (Arnold-Forster [1949], 147). The second is that, by 1949, the canvas of this later seventeenth-century English painting was "tattered" beyond repair but had been copied in a watercolor "sketch." It was not illustrated in Mrs. Arnold-Forster's book, but I am in the process of trying to establish whether it has been preserved and, if so, where it may presently be.

As proofs of this article were in preparation, I was shown pictures of another pair of large, rectangular oil-painted pictures, a man and a woman, both dressed in seventeenth-century Safavid Persian garb. They hang at Eastnor Castle in Herefordshire (UK). I have not yet seen them in person, but the photographs suggest that they come from another suite entirely, one that is otherwise presently unrecorded.

Speakers and Fellows at the Symposium, from left to right:

Front row: Emilie Savage-Smith, Paul Goldberger, Sheila Blair, Jonathan Bloom, Ruba Kanaan, Wafaa Abdulaali

Second row: Marisa Brown, Eleanor Sims, Simon Rettig, Kjeld von Folsach, Laura Parodi, Vivienne S. M. Angeles, Sandra Aube, Filiz Yenişehirlioğlu, Adel Adamavoa, Elizabeth Ettinghausen, Emily Neumeier

Third row: Said Ennahid, Michael Franses, Mohamed Zakariya, Ahmed Wahby, Abdul Lateef Usta, Fernando Martinez Nespral, Mandy Ridley, Rebecca Bridgman, Antonio Vallejo Triano, Khaled Tadmori

Back row: Simon O'Meara, François Déroche, John Seyller, Alexandra Van Puyvelde, Julia Gonnella, Peter Wandel

Missing: Nourane Ben Azzouna, Aimée Froom, Mahnaz Shayestehfar, Rachel Ward

Contributors

SHEILA BLAIR and JONATHAN BLOOM, the editors of this volume and organizers of the 2011 Symposium on which it is based, are shared holders of the Hamad bin Khalifa Endowed Chair of Islamic Art at Virginia Commonwealth University and the Norma Jean Calderwood University Professorship of Islamic and Asian Art at Boston College. A wife and husband team, they are the authors and editors of over twenty books and hundreds of articles on all aspects of Islamic art and architecture, including *Rivers of Paradise: Water in Islamic Art and Culture* and *And Diverse are Their Hues: Color in Islamic Art and Culture*, the beautiful volumes of papers from the previous two symposia.

FRANÇOIS DÉROCHE teaches about the history and codicology of the Arabic manuscript at the École Pratique des Hautes Études in Paris. He has investigated various aspects of the handwritten book across the Islamic lands, with a special interest in the early period.

KJELD VON FOLSACH is Director of the David Collection in Copenhagen. He has published extensively on the museum's splendid collection, including a monograph on their textiles.

MICHAEL FRANSES is currently Director of Special Cultural Projects at the Qatar Museums Authority. He has written and published many books and periodicals on various aspects of the textile arts of Asia.

AIMÉE FROOM is an independent scholar. She has written on many aspects of the decorative arts from the Islamic lands, including a survey of the ceramics in the collection of the Asian Art Museum in San Francisco.

PAUL GOLDBERGER holds the Joseph Urban Chair in Design and Architecture at the New School in New York City. He is also the Architecture Critic for *The New Yorker*, and has written their celebrated "Sky Line" column since 1997.

JULIA GONNELLA is Curator at the Museum für islamische Kunst (SMPK) in Berlin. For many years she has directed the Islamic section of the Syrian-German excavations on the Citadel of Aleppo in Syria.

RUBA KANA'AN is head of education and special programs at the Aga Khan Museum in Toronto. From 2008 to 2011 she held the Noor Chair of Islamic Studies at York University there. She has written several articles on trade and craftspeople in medieval Islamic times.

EMILIE SAVAGE-SMITH is retired Professor of the History of Islamic Science in the Oriental Institute at the University of Oxford. She has written extensively about the history of anatomy, surgery, dissection, and ophthalmology in the medieval Islamic lands.

JOHN SEYLLER is Professor of Art History at the University of Vermont. He specializes in the book arts produced under the Mughals in India and has written several monographs and articles on individual manuscripts and their painters.

ELEANOR SIMS is editor of the journal *Islamic Arts*. She has written extensively on Persian painting in all media, ranging from manuscripts to murals and oils.

ANTONIO VALLEJO TRIANO is Curator of Cultural Heritage for the Junta de Andalucía (the Andalusian regional government). Since 1985, he has served as the director of the archeological site at Madinat al-Zahra. His research focuses on architecture from the Umayyad caliphate, especially Madinat al-Zahra and the decorative elements there.

RACHEL WARD is an independent scholar. She publishes extensively on metalwares and glass from the Mamluk period in Egypt and Syria.

OLIVER WATSON, formerly Director of the Museum of Islamic Art in Doha, is the I. M. Pei Professor of Islamic Art and Architecture at the Khalili Research Centre for the Art and Material Culture of the Middle East, University of Oxford.

MOHAMED ZAKARIYA is a practicing calligrapher who received diplomas under the auspices of the Research Centre for Islamic History, Art, and Culture in Istanbul. He concentrates on classical Arabic and Ottoman Turkish styles.

Bibliography

Abbott, Nabia. 1939. *The Rise of the North Arabic script and its kur'ânic development, with a full description of the Kur'an manuscripts in the Oriental Institute.* The University of Chicago Oriental Institute publications, vol. 50. Chicago: University of Chicago Press

ʿAbd al-Raḥmān al-Ṣūfī. 1954. *Ṣuwaru'l-kawākib or Uranometry (Description of the 48 Constellations), with the urjūza of Ibn uʾṣ-Ṣūfī, based on the Ulugh Bēg Royal Codex, Arabe 5036 of the Bibliothèque Nationale, Paris.* Hyderabad: Osmania Oriental Publications Bureau

Abu'l Fazl. Reprint 1977. *A'in-i Akbari*, trans. Henry Blochmann. 3 vols. New Delhi: Oriental Books Reprint Corporation

Acién Almansa, Manuel. 1995. "Materiales e hipótesis para una interpretación del Salón de ʿAbd al-Raḥmān al-Nāṣir," in *Madīnat al-Zahrāʾ. El Salón de ʿAbd al-Raḥmān III.* Córdoba: Junta de Andalucía, Consejería de Cultura, pp. 179–95.

———. 2000. "La herencia del protofeudalismo visigodo frente a la imposición del Estado islámico", in *Visigodos y Omeyas. Un debate entre la Antigüedad tardía y la Alta Edad Media.* Ed. Luis Caballero and Pedro Mateos. *Anejos de Archivo Español de Arqueología* XXIII, pp. 429–41

———. 2001. "Del estado califal a los estados taifas. La cultura material," in *Actas del V Congreso de Arqueología Medieval española.* Vol. 2. Valladolid: Junta de Castilla y León, Consejería de Educación y Cultura, pp. 493–513

Adle, Charyar, et al. 1996. "Peintures géorgiennes et peintures orientales, Musée Géorgien d'Art Chalva Amiranachvili à Tbilissi," *Archéologie et arts du monde iranien, de l'Inde et du Caucase d'après quelques recherches récentes de terrain, 1984–1995*, V, pp. 347–65

Alexander, Chris. 1993. *A Foreshadowing of 21st Century Art.* New York and London: Oxford University Press

Ali, Mustafa. 1926. *Menâkib-i Hünerverân.* Istanbul: Matbaa-i Amire

Allan, James W. 1973. "Abu al-Qasim's Treatise on Ceramics," *Iran* 11, pp. 11–20

———. 1982; Reprint 1999. *Islamic Metalwork. The Nuhad es-Said Collection.* London: Philip Wilson Publishers

———. 1985. "Concave or Convex? The Jaziran and Syrian Metalwork in the Thirteenth Century," in *The Art of Syria and the Jazīra 1100–1250.* Ed. Julian Raby. Oxford Studies of Islamic Art 1. Oxford: Oxford University Press, pp. 127–40

———. 1991. *Islamic Ceramics.* Oxford: Ashmolean Museum

———, and Francis Maddison. 2002. *Metalwork Treasures from the Islamic Courts.* Doha: Museum of Islamic Art/London: Islamic Art Society

Allen, Terry. 1988. "The arabesque, the bevelled style, and the mirage of an early Islamic Art," in *Five Essays on Islamic Art.* Occidental, Calif.: Solipsist Press, pp. 1–15

———. 2009. "An ʿAbbasid fishpond near Makka." Occidental, Calif.: Solipsist Press, (http://sonic.net/~tallen/palmtree/fishpond/fishpond.htm)

Allsen, Thomas T. 1997. *Commodity and Exchange in the Mongol Empire: A Cultural History of Islamic Textiles.* Cambridge: Cambridge University Press

Alofsin, Anthony. 2009. *A Modernist Museum in Perspective.* New Haven and London: Yale University Press

Altıkulaç, Tayyar, ed. 2009. *Al-muṣḥaf al-šarīf al-mansūb ʿilá ʿUthmān ibn ʿAffān (nuskhat al-Mashhad al-Ḥusayni bi'l-Qāhira).* Vol. 1. Istanbul: IRCICA

Anderson, Glaire D. 2007. "Villa (*munya*) Architecture in Umayyad Córdoba: Preliminary Considerations," in *Revisiting Al-Andalus. Perspectives on the Material Culture of Islamic Iberia and Beyond.* Ed. Glaire D. Anderson and Mariam Rosser-Owen. Leiden and Boston: Brill, pp. 53–79

Anonymous. July 1969. "Un penchant pour la blancheur," *Maison et Jardin* 155, pp. 92–93

Appadurai, Arjun, ed. 1986. *The Social Life of Things: Commodities in Cultural Perspective.* Cambridge: Cambridge University Press

Arnold, Félix, Alberto Canto García, and Antonio Vallejo Triano. 2008. "La almunia de al-Rummāniyya. Resultados de una documentación arquitectónica," *Cuadernos de Madīnat al-Zahrāʾ* 6, pp. 181–204

Arnold-Forster, Mary. [1949]. *Basset Down: An Old Country House.* London: Country Life Ltd

Arraiza, Alberto Bartolomé. 2002. *Alfombras Españolas de Alcaraz y Cuenca, Siglos XV–XVI*. Madrid: Museo Nacional de Artes Decorativas

Aslanapa, Oktay. 1988. *One Thousand Years of Turkish Carpets*. Istanbul: Eren

Atıl, Esin. 1973. *Ceramics from the World of Islam*. Washington, DC: Smithsonian Institution

——. 1981. *Renaissance of Islam, Art of the Mamluks*. Washington, DC: Smithsonian Institution

"Auction Reports: Dragon & Phoenix Rises from the Ashes." 1992. *Halı* 65, p. 150

Aydın, Hilmi. 2005. *Pavilion of the Sacred Relics: The Sacred Trusts: Topkapı Palace Museum, Istanbul*. Somerset, NJ: Light.

Babaie, Sussan. 1994. "Shah ʿAbbas II and the Wall Paintings of the Chihil Sutun," *Muqarnas* 11, pp. 125–42

——. 2008. *Isfahan and its Palaces: Statecraft, Shiʿism and the Architecture of Conviviality in Early Modern Iran*. Edinburgh: Edinburgh University Press

——, et al. 2004. *Slaves of the Shah: New Elites of Safavid Iran*. London and New York: I. B. Tauris

Baer, Eva. 1965. *Sphinxes and harpies in medieval Islamic art, an iconographical study*. Israel Oriental Society, *Oriental Notes and Studies*, no. 9. Jerusalem: Israel Oriental Society

——. 1977. "A Brass Vessel from the Tomb of Sayyid Battal Ghazi. Notes on the Interpretation of Thirteenth-century Islamic Imagery," *Artibus Asiae* 39, no. 3/4, pp. 299–335.

——. 1983. *Metalwork in Medieval Islamic Art*. Albany: State University of New York Press

Bahari, Ebadollah. 1997. *Bihzad. Master of Persian Painting*. London and New York: I. B. Tauris

Bahrami, Mehdi. 1949. Reprint 1988. *Gurgan Faiences*. Cairo: Le scribe égyptien. Costa Mesa: Mazda

Balpinar, Belkis, and Udo Hirsch. 1988. *Carpets of the Vakıflar Museum, Istanbul*. Wesel: Uta Hülsey

Barceló, Miquel. 1995. "El Califa patente: el ceremonial omeya de Córdoba o la escenificación del poder," in *Madīnat al-Zahrāʾ. El Salón de ʿAbd al-Raḥmān III*. Córdoba: Junta de Andalucía, Consejería de Cultura, pp. 155–75

Beach, Milo Cleveland. 1981. *The Imperial Image: Paintings for the Mughal Court*. Washington, DC: Freer Gallery of Art

——. 2004. "Jahangir's Album: Some Clarifications," in *Arts of Mughal India: Studies in Honour of Robert Skelton*. Ed. Rosemary Crill, Susan Stronge, and Andrew Topsfield. Ahmedabad: Mapin Publishing in association with Victoria and Albert Museum, pp. 111–18

——. 2011. "Mansur," in *Masters of Indian Painting, 1100—1650*. Ed. Milo Beach, Eberhard Fischer, and B. N. Goswamy. Zürich: Artibus Asiae Publishers, pp. 243–58

——, Ebba Koch, and Wheeler Thackston. 1997. *King of the World. The Padshahnama. An Imperial Manuscript from the Royal Library, Windsor Castle*. London: Azimuth Editions

Becker, Andrea. 2012. "Colour and Light in Abbasid Palaces: Interior Decoration for Harun ar-Rashid," in *Proceedings of the 7th International Congress on the Archaeology of the Ancient Near East* 7 (12–16 April 2010, British Museum and UCL, London). Wiesbaden: Harrassowitz, pp. 391–404

Beltrán Fortes, José, Miguel Ángel García and Pedro Rodríguez Oliva. 2006. *Los sarcófagos romanos de Andalucía, Corpus Signorum Imperii Romani-España*. Vol. I, fasc. 3. Murcia: Tabularium

Berggren J. L. 1982. "Al-Bīrūnī on Plane Maps of the Sphere," *Journal for the History of Arabic Science* 6, pp. 47–112

Berlekamp, Persis. 2011. *Wonder, Image, & Cosmos in Medieval Islam*. New Haven and London: Yale University Press

Bernsted, Anne-Marie. 2003. *Early Islamic Pottery: Materials and Techniques*. London: Archetype Publications

Beselin, Anna. 2011. *Geknüpfte Kunst, Teppiche des Museums für Islamische Kunst*. Berlin: Museum für Islamische Kunst – Staatliche Museen zu Berlin

Bibliothèque Nationale. 1986. *À la Cour du Grand Moghol*. Paris: Bibliothèque Nationale

Blair, Sheila. 1995. *A Compendium of Chronicles: Rashid al-Din's Illustrated History of the World*. The Nasser D. Khalili Collection of Islamic Art, 27. London and Oxford: The Nour Foundation in association with Azimuth Editions and Oxford University Press

——. 1998. *Islamic Inscriptions*. New York: Columbia University Press

——. 2005. "East meets West under the Mongols," *The Silk Road* 3/2, pp. 27–33

——. 2006. *Islamic Calligraphy*. Edinburgh: Edinburgh University Press

——. 2008. "A brief biography of Abu Zayd," *Muqarnas* 25, pp. 155–76

——, and Jonathan Bloom. 2006. *Cosmophilia: Islamic Art from The David Collection, Copenhagen*. Chestnut Hill, Mass.: McMullen Museum

——, and Jonathan Bloom. 2009. *Rivers of Paradise: Water in Islamic Art and Culture*. Proceedings of the Second Biennial Hamid bin Khalifa Symposium on Islamic Art. New Haven and London: Yale University Press

Bloom, Jonathan, and Sheila Blair. 2011. *And Diverse Are Their Hues: Color in Islamic Art and Culture*. Proceedings of the Third Biennial Hamid bin Khalifa Symposium on Islamic Art. New Haven and London: Yale University Press

Boralevi, Alberto, ed. 1999. *Oriental Geometries, Stefano Bardini and the Antique Carpet*. Livorno: Sillabe

Bothmer, Hans-Caspar von. 1987. "Architekturbilder im Koran: Eine Pracht-handschrift der Umayyadenzeit aus dem Yemen," *Bruckmanns Pantheon* 45, pp. 4–20

——, Karl-Heinz Ohlig, and Gerhard-Rüdiger Puin. 1999. "Neue Wege der Koranforschung," *Magazin Forschung, Universität des Saarlandes* 1, pp. 33–46

Brand, Michael, and Glenn Lowry. 1985. *Akbar's India: Art from the Mughal City of Joy*. New York: Asia Society Galleries

Brend, Barbara. 1994. "A Reconsideration of the Book of Constellations of 1009–10 in the Bodleian Library," in *The Art of the Saljūqs in Iran and Anatolia: Proceedings of a Symposium Held in Edinburgh in 1982*. Ed. Robert Hillenbrand. Costa Mesa, Calif.: Mazda Publications, pp. 89–93

——. 1995. *The Emperor Akbar's Khamsa of Nizami*. London: The British Library

Briggs, Amy. 1940. "Timurid Carpets, I, Geometric Carpets," *Ars Islamica* 7/1, pp. 20–54.

——. 1946. "Timurid Carpets, II, Arabesque and Flower Carpets," *Ars Islamica* 11–12, pp. 146–58

Brown, Christopher, et al. 1999. *Van Dyck 1599–1641*. London: Royal Academy Publications and Antwerpen Open

Bugio, Lucia, Robin J. H. Clark, and Mariam Rosser Owen. 2007. "Raman Analysis of Ninth-century Iraqi Stuccoes from Samarra," *Journal of Archaeological Science* 34, pp. 756–62

Bulliett, Richard W. 1992. "Pottery styles and social status in medieval Khurasan," *Archaeology, Annales and Ethnohistory*. Ed. A. B. Knapp. Cambridge: Cambridge University Press, pp. 75–82

Bush, Olga. 2011. "Designs Always Polychromed or Gilded," in *And Diverse Are Their Hues. Color in Islamic Art and Culture*. Ed. Jonathan Bloom and Sheila Blair. New Haven and London: Yale University Press, pp. 53–76

Byzance: L'art byzantin dans les collections publiques françaises. 1992. Louvre. Paris: Réunion des musées nationaux

Cahen, Claude. 1953. "Notes sur les debuts de la futuwwa d'an-Nāṣir," *Oriens* 6/1, pp. 18–22

Caiger-Smith, Alan. 1973. *Tin-Glaze Pottery in Europe and the Islamic World: The Tradition of 1000 Years in Maiolica, Faience, and Delftware*. London: Faber

——. 1985. *Lustre Pottery: Technique, Tradition and Innovation in Islam and the Western World*. London: Faber

Caiozzo, Anna. 2009. "Iconography of the Constellations," in *Images of Islamic Science: Illustrated Manuscripts from the Iranian World*. Ed. Ziva Vesel, Serge Tourkin, and Yves Porter. Teheran: Institut Français de Recherche en Iran, pp. 106–33

Canby, Sheila. 2000. "Islamic Archaeology: By Accident or Design?," in *Discovering Islamic Art: Scholars, Collectors and Collections 1850–1950*. Ed. Stephen Vernoit. London and New York: I. B. Tauris, pp. 128–37

——. 2003. "Safavid Painting," in *Hunt for Paradise. Court Arts of Safavid Iran, 1501–1576*. Ed. Sheila Canby and Jon Thompson. New York: Asia Society, pp. 73–134

——. 2011. "ʿAbd al-Samad," in *Masters of Indian Painting, 1100–1650*. Ed. Milo Beach, Eberhard Fischer, and B. N. Goswamy. Zürich: Artibus Asiae Publishers, pp. 97–110

Carboni, Stefano. 2001. *Glass from Islamic Lands*. London: Thames & Hudson

——, and Tomoko Masuya. 1993. *Persian Tiles*. New York: Metropolitan Museum of Art

——, and David Whitehouse. 2001. *Glass of the Sultans*. New York: Metropolitan Museum of Art

Carey, Moya. 2009. "Al-Sufi and Son: Ibn al-Sufi's Poem on the Stars and its Prose Parent," *Muqarnas* 26, pp. 181–204

Carpio Dueñas, Juan Bautista. 2001. "Capitel con cuatro músicos," in *El esplendor de los omeyas cordobeses. La civilización musulmana de Europa occidental. Catálogo de piezas*. Granada: Junta de Andalucía, Consejería de Cultura, Fundación El legado andalusí, pp. 135–36.

Carswell, John. 1968. *New Julfa: The Armenian Churches and Other Buildings*. Oxford: The Clarendon Press

Cheikho, Louis. 1913. "*Kitāb al-ʿamal bi-al-aṣṭurlāb* li-ʿAli ibn ʿIsá," *al-Mashriq* 16, pp. 29–46

Christie's, London, 7/11/1974, Lots 42–43

Christie's, London, 20/10/1992. *Islamic Art, Indian Miniatures, Rugs and Carpets*. London: Christie's

Christie's. 2000. *The Collection of the Late Baroness Batsheva de Rothschild*. London: Christie's

Christie's, London, 4/27/2004, Lot 85

Christie's, London, 4/7/2011, Lot 146

Cressier, Patrice. 1985. "Les chapiteaux de la grande mosquée de Cordoue (oratoires dʿAbd al-Raḥmān I et dʿAbd al-Raḥmān II) et la sculpture de chapiteaux à l'époque émirale. Deuxième partie," *Madrider Mitteilungen* 26, pp. 257–313

——. 1995. "Los capiteles del Salón Rico: un aspecto del discurso arquitectónico califal," in *Madīnat al-Zahrāʾ: El Salón de ʿAbd al-Raḥmān III*. Córdoba: Junta de Andalucía, Consejería de Cultura, pp. 85–106.

——. 2010. "Le chapiteau, acteur ou figurant du discours architectural califal? Omeyyades dʿal-Andalus et fatimides dʿIfriqiya," *Cuadernos de Madīnat al-Zahrāʾ* 7. [*Homenaje a Maryelle Bertrand*], pp. 67–82

Creswell, K. A. C. 1940. *Early Muslim Architecture. II. Early ʿAbbasids. Umayyads of Cordova, Aghlabids, Tulunids, and Samanids. a.d. 751–905*. Oxford: Oxford University Press

Crill, Rosemary, and Kapil Jariwala, eds. 2010. *The Indian Portrait, 1560–1860*. London: National Portrait Gallery

Crónica del Moro Rasis. 1975. Ed. Diego Catalán y Mª Soledad de Andrés. Madrid: Gredos

Crowe, Yolande. 1975–77. "Early Islamic Pottery and China," *Transactions of the Oriental Ceramic Society* 41, pp. 263–78

——. 2002. *Persia and China: Safavid ceramics in the Victoria and Albert Museum, 1501–1738*. London: Victoria and Albert Museum

Dalai Lama. 1998. "Message from His Holiness the Dalai Lama," in *On the Path to Enlightenment: The Berti Aschmann Foundation of Tibetan Art at the Museum Rietberg Zurich*. Ed. Helmut Uhlig. Zurich: Museum Rietberg, p. 7

Das, Asok Kumar. 1998. "Bishandas: 'Unequalled in his Age in Taking Likenesses,' " in *Mughal Masters: Further Studies*. Ed. Asok Kumar Das. Mumbai: Marg Publications, pp. 112–33

De Lachenal, Lucilia. 1995. *Spolia: uso e reimpiego dell'antico dal III al XIV secolo*, Milan: Longanesi

De Montêquin, François-Auguste. 1992. "Capital of Cordoba or Madīnat al-Zahrāʾ," in *Al-Andalus: The Art of Islamic Spain*. Ed. Jerrilyn Dodds. New York: Metropolitan Museum of Art, p. 244

Degeorge, Gérard, and Yves Porter. 2002. *The Art of the Islamic Tile*. Paris: Flammarion

Dekker, Elly. 2004. *A Catalogue of Orbs, Spheres and Globes*. Florence: Instituto e Museo di Storia della Scienza

——, and Paul Kunitzsch. 2008–09. "An Early Islamic Tradition in Globe Making," *Zeitschrift für Geschichte der Arabisch-Islamischen Wissenschaften* 18, pp. 155–211

Department of Antiquities (of Iraq). 1940. *Excavations at Samarra 1936–1939, I. Architecture and mural decoration* (in Arabic). Baghdad: Matbaʿ al-Hukuma

Derman, M. Uğur. 1998a. *The Art of Calligraphy in the Islamic Heritage*. Istanbul: Research Center for Islamic History, Art, and Culture (IRCICA)

——. 1998b. *Letters in Gold: Ottoman Calligraphy from the Sakıp Sabancı Collection, Istanbul*. New York: Metropolitan Museum of Art

——. 2009. *Eternal letters from the Abdul Rahman Al Owais Collection of Islamic Calligraphy*, trans. Irvin Cemil Schick, Sharjah: Sharjah Museum of Islamic Civilization

——. 2010a. *Edebi ve Hattı ile Ali Alparslan*. Istanbul: Yapı Kredi Yayınları

———. 2010b. *Emin Barın ve Koleksiyonu*. Istanbul: Boyut

———. 2011. *Ömrümün Bereketi*, vol. 1. Istanbul: Kubbealtı

Déroche, François. 1983. *Les Manuscrits du Coran: Aux origines de la calligraphie coranique*. Bibliothèque Nationale, Catalogue des manuscrits arabes, 2ᵉ partie, Manuscrits musulmans, I/1. Paris: Bibliothèque Nationale

———. 1992. *The Abbasid Tradition, Qurʾans of the 8th to the 10th Centuries AD*. The Nasser D. Khalili Collection of Islamic Art 1. London and Oxford: Nour Foundation in association with Azimuth Editions and Oxford University Press

———. 1999. "Un critère de datation des écritures coraniques anciennes : le *kâf* final ou isolé," *Damaszener Mitteilungen* 11 [Gedenkscrift für Michael Meinecke], pp. 87–94

———, et al. 2006. *Islamic codicology. An Introduction to the Study of Manuscripts in Arabic Script*, London: al-Furqan Islamic Heritage Foundation

———. 2009. *La transmission écrite du Coran dans les débuts de l'islam. Le codex Parisino-petropolitanus*. Texts and studies on the Qurʾān 5. Leiden and Boston: Brill

al-Dhahābī, Muḥammad ibn Aḥmad. 1998. *Tārīkh al-islām wa wafayāt al-mashāhīr waʾl-āʿlām: Ḥawādith wa wafayā 631–40 H.* Ed. ʿUmar ʿAbd al-Salam al-Tadmuri. Beirut: Dar al-Kitab al-ʿArabi

Diba, Darab, et al. 2001. *Maisons d'Ispahan*. Paris: Maisonneuve et Larose

Diba, Layla S., and Maryam Ekhtiyar, eds. 1998. *Royal Persian Paintings: The Qajar Epoch, 1785–1925*. Brooklyn: I. B. Tauris in association with the Brooklyn Museum of Art

Dimand, Maurice. 1952. "Studies in Islamic Ornament, II. The origin of the Second Style of Samarra Decoration," in *Archaeologica orientalia in memoriam Ernst Herzfeld*. Ed. George C. Miles. Locust Valley, NY: J. J. Augustin, pp. 64–68

Dodge, Bayard. 1970. *The Fihrist of al-Nadīm: A tenth-century Survey of Muslim Culture*, 2 vols. New York and London: Columbia University Press

D'yakonov, Mikhail M. 1947. "Ob odnoi rannei arabskoi nadpisi (An Early Arabic Inscription)," *Epigrafica Vostoka* 1, pp. 5–8

Erdmann, Kurt. 1929. "Orientalische Tierteppiche auf Bildern des XIV und XV Jahrhunderts. Eine Studie zu den Anfängen des orientalischen Knüpfteppichs," *Jahrbuch der Preussischen Kunstsammlungen* 50, pp. 261–98

———. 1937. "Evidence for the identification of Kashan pottery," *Ars Islamica* 3, pp. 44–75

———. 1941. "Neue Orientalische Tierteppiche auf Abendländischen Bildern des XIV und XV Jahrhunderts," *Jahrbuch der Preussischen Sammlungen* 63, pp. 121–26

———. 1955. "Zu einem anatolischen Teppichfragment aus Fostat," *Istanbul Mitteilungen* 6, pp. 42–52

———. 1957. *Der Türkische Teppich des 15. Jahrhunderts*. Istanbul: Istanbul University

Escudero Aranda, José. 2001. "Capitel compuesto," in *El esplendor de los omeyas cordobeses. La civilización musulmana de Europa occidental. Catálogo de piezas*. Granada: Junta de Andalucía, Consejería de Cultura, Fundación El legado andalusí, pp. 120–21

Ettinghausen, Richard. 1952. "The bevelled style in the Post-Samarra period," in *Archaeologica Orientalia in Memoriam Ernst Herzfeld*. Ed. George C. Miles. Locust Valley, NY: J. J. Augustin, pp. 72–83

———. 1959. "New Light on Early Animal Carpets," in *Aus der Welt der Islamischen Kunst. Festschrift für Ernst Kühnel*. Berlin: Gbr. Mann, pp. 93–116

———, and Oleg Grabar. 1987. *The Art and Architecture of Islam 650–1250*. Harmondsworth: Penguin Books

Ewert, Christian. 1987. "The Mosque of Tinmal (Morocco) and some new aspects of Islamic Architectural Typology," *Proceedings of the British Academy* 72, pp. 115–48.

———. 1995. "Elementos de la decoración vegetal del Salón Rico de *Madīnat al-Zahrāʾ*: los tableros parietales," in *Madīnat al-Zahrāʾ. El Salón de ʿAbd al-Raḥmān III*. Córdoba: Junta de Andalucía, Consejería de Cultura, pp. 43–57

Falk, Toby, and Mildred Archer. 1981. *Indian Miniatures in the India Office Library*. London: India Office Library

———, and Simon Digby. 1979. *Paintings from Mughal India*. London: P & D Colnaghi & Co Ltd

Falke, Otto von. 1913. *Kunstgeschichte der Seidenweberei*, 2 vols. Berlin: Wasmuth

Farhad, Massumeh, and Marianna Shreve Simpson, eds. 2012. *Ars Orientalis* 42 [Proceedings of the Second Biennial Meeting of the Historians of Islamic Art Association]

Ferrier, Ronald. 1970. "Charles I and the Antiquities of Persia: The Mission of Nicholas Wilford," *Iran* 8, pp. 51–56

———, ed. 1989. *The Arts of Persia*. New Haven and London: Yale University Press

Fogg, Sam. 2003. *Islamic Calligraphy*. Sam Fogg Catalogue no. 27. London: Sam Fogg

Folsach, Kjeld von. 1996a. "Pax Mongolica: an Ilkhanid tapestry-woven roundel," *Hali* 85, pp. 80–87

———. 1996b. "The Great Mughal Journeys Forth," in *Sultan, Shah and Great Mughal. The History and Culture of the Islamic World*. Ed. Kjeld von Folsach, Torben Lundbæk, and Peder Mortensen. Copenhagen: National Museum, pp. 348–53

———. 2001. *Art from the World of Islam in The David Collection*. Copenhagen: David Collection

———, and Anne-Marie Keblow Bernsted. 1993. *Woven Treasures – Textiles from the World of Islam*. Copenhagen: David Collection

———, Torben Lundbæk, and Peder Mortensen, eds. 1996. *Sultan, Shah, and Great Mughal. The History and Culture of the Islamic World*. Copenhagen: National Museum

Franses, Michael. 1993. "The Appreciation of an Art Form," in *Orient Stars, A Carpet Collection*. Stuttgart and London: E. Heinrich Kirchheim/Hali Publications, pp. 11–23

———, and John Eskenazi, eds. 1996. *Turkish Rugs and Old Master Paintings*. London: The Textile Gallery

Freedman, Aaron. 2009. *Darshan. Paintings from the Collection of Subhash Kapoor*. New York: Subhash Kapoor

Freestone, Ian C. 2002. "The Relationship Between Enamelling on Ceramics and on Glass in the Islamic World," *Archaeometry* 44/2, pp. 251–55

———, and Colleen P. Stapleton. 1998. "Composition and Technology of Islamic Enamelled Glass of the Thirteenth and Fourteenth Centuries," in *Gilded and Enamelled Glass from the Middle East*. Ed. Rachel Ward. London: British Museum, pp. 122–27

Froom, Aimée. 2008. *Persian Ceramics from the Collections of the Asian Art Museum*. San Francisco: Asian Art Museum

Gacek, Adam. 2006. "The Copying and Handling of Qur'âns : Some Observations on the *Kitâb al-Masâhif* by Ibn Abî Dâʾûd al-Sijistânî," *Mélanges de l'Université Saint-Joseph* 59 [Actes de la conférence internationale sur les manuscrits du Coran (Bologne, 26–28 septembre 2002)], pp. 229–51

Galdieri, Eugenio. 1979. *Esfahan: ʿAli Qapu: An Architectural Survey*. Rome: ISMEO

Ganjnameh: Cyclopedia of Iranian Islamic Architecture 4. 1998. Tehran: Faculty of Architecture and Urban Planning, Documentation and Research Center

Garnier, Édouard. 1884. "Collections de M. Spitzer – La Verrerie," *Gazette des Beaux-Arts*, 2nd period, 29, pp. 293–310

Gelder, Geert Jan van. 2000. *Of Dishes and Discourse: Classical Arabic Literary Representations of Food*. London: Curzon Press

George, Alain. 2010. *The Rise of Islamic Calligraphy*. London: Saqi

al-Ghazali. 2000. *Al-Ghazali on the Manners Relating to Eating*: Kitab adab al-akl. Trans. and annotated D. Johnston-Davies. Cambridge: Islamic Texts Society

Ghouchani, Abdullah. 1986. *Katībahā-yi sufāl-i Nīshabūr* (Inscriptions on Nishapur Pottery). Tehran: Muze-yi Reza ʿAbbasi

Gierlichs, Joachim. 1993. *Drache-Phönix-Doppeladler, Fabelwesen in der Islamischen Kunst*. Bilderhefte der Staatlichen Museen zu Berlin, 75/76. Berlin: Gbr. Mann

Gladiss, Almut von. 1986. *Islamische Kunst Verborgene Schätze, Ausstellung des Museums für Islamische Kunst, Berlin*. Berlin: Staatliche Museen, Preussischer Kulturbesitz

——, and Kjeld von Folsach. 2006. *Die Dschazira: Kulturlandschaft zwischen Euphrat un Tigris*. Berlin: Museum für islamische Kunst, Staatliche Museen zu Berlin

Gladwell, Malcolm. 2008. *Outliers: The Story of Success*. New York: Little, Brown

Golombek, Lisa. 1988. "The Draped Universe of Islam," in *Content and Context of Visual Arts in the Islamic World*. Ed. Priscilla P. Soucek. University Park, Penn.: Pennsylvania State Press, pp. 25–49

Goswamy, B. N., and Usha Bhatia. 1999. *Painted Visions. The Goenka Collection of Indian Paintings*. New Delhi: Lalit Kala Akademi

Grabar, Oleg. 2009. "When is a Bird a Bird?," *Proceedings of the American Philosophical Society* 153, pp. 247–53

——, and Sheila Blair. 1980. *Epic Images and Contemporary History: The Illustrations of the Great Mongol Shahnama*. Chicago and London: University of Chicago Press

Grube, Ernst J. 1974. "Wall Paintings in the Seventeenth Century Monuments of Isfahan," *Iranian Studies* 7 [Studies on Isfahan, ed. Renata Holod], pp. 511–22, 528–42

——. 1976. *Islamic Pottery of the Eighth to the Fifteenth Century in the Keir Collection*. London: Faber and Faber

——. 1994. *Cobalt and Lustre: The First Centuries of Islamic Pottery*. The Nasser D. Khalili Collection of Islamic Art 9. London and Oxford: The Nour Foundation in association with Azimuth Editions and Oxford University Press

——, and Eleanor Sims. 1995. "The Representations of Shah ʿAbbas I," in *L'Arco di Fango che Rubò la Luce alle Stelle: Studi in onore di Eugenio Galdieri per il suo settantesimo compleanno*. Ed. Michele Bernardini, et al. Lugano: Edizioni Arte e Moneta SA, pp. 177–208

Gueit, E., E. Darque-Ceretti, and M. Aucouturier. 2010. "Glass gilding process in medieval Syria and Egypt (13th–14th century)," *Journal of Archaeological Science* 37/7, pp. 1742–52

Guest, Grace D., and Richard Ettinghausen. 1961. "The Iconography of a Kashan Luster Plate," *Ars Orientalis* 4, pp. 25–64

Gunter, Ann C., and Stefan R. Hauser, eds. 2005. *Ernst Herzfeld and the Development of Near Eastern Studies 1900–1950*. Leiden and Boston: Brill

Haase, Claus-Peter. 2004. "Frühabbasidischer Stuckdekor eines Nischenraums in Madinat al-Far/Hisn Maslama und seine östlichen und westlichen Bezüge," in *Al-Andalus und Europa zwischen Orient und Okzident*. Ed. J. Gierlichs, K.-H. Golzio, C. Kothe, and M. Müller-Wiener. Petersberg: M. Imhof, pp. 49–58

——. 2007. The Development of Stucco Decoration in Northern Syria of the 8th and 9th Centuries and the Bevelled Style of Samarra," in *Facts and Artefacts: Art in the Islamic World. Festschrift for Jens Kröger on his 65th Birthday*. Ed. Annette Hagedorn and Avinoam Shalem. Leiden and Boston: Brill, pp. 439–60

Habîb. *Hat ve Hattâtân*. 1305. Constantinople: Matbaa-i Ebuz-Ziya

Hagen, Norbert, Mustafa al-Hassoun, and Michael Meinecke. 2004. "Die Große Moschee von ar-Rāfiqa," in *Raqqa III. Baudenkmäler und Paläste I*. Ed. Verena Daiber and Andrea Becker. Mainz: Ph. von Zabern, pp. 25–40

Hallett, Jessica. 1999. "Trade and Innovation: The Rise of a Pottery Industry in ʿAbbasid Basra." D.Phil. thesis, University of Oxford

Harper, Prudence. 1961. "The Senmurv," *The Metropolitan Museum of Art Bulletin*, series 20/3, pp. 95–101

Hartmann, Angelika. 1975. *Al-Nasir li-Din Allah (1181–1225): Politik, Religion, Kultur in der spaten ʿAbbasidenzeit*. Berlin: Walter de Gruyter

Hauser, Stefan R. 2008. "Ernst Herzfeld, professeur de l'archéologie orientale a l'Université de Berlin," in *Beiträge zur Islamischen Kunst und Archäologie, 1*. Ed. Ernst-Herzfeld-Gesellschaft. Wiesbaden: Dr. Ludwig Reichert, pp. 21–40

——. Forthcoming. "Die Ausgrabungen in Samarra im Kontext der Grabungstätigkeiten im Osmanischen Reich im frühen 20. Jh.," in *Hundert Jahre Grabungen in Samarra. 7. Kolloquium der Ernst Herzfeld Gesellschaft, Museum für Islamische Kunst Berlin, 30. June–2. July 2011*. Ed. Julia Gonnella. Wiesbaden: Dr. Ludwig Reichert

Heidemann, Stefan. 2003. "Die Geschichte von ar-Raqqa/ar-Rāfiqa," *Raqqa II. Die islamische Stadt*. Ed. Stefan Heidemann and Andrea Becker. Mainz: Ph. von Zabern, pp. 9–56

Henderson, Julian, and J. W. Allan. 1990. "Enamels on Ayyubid and Mamluk Glass Fragments," *Archeomaterials* 4, pp. 167–82

Hernández Giménez, Félix. 1985. *Madīnat al-Zahrāʾ. Arquitectura y decoración*. Granada: Patronato de la Alhambra.

Herrmann, Eberhart, ed. 1992. *Asiatische Teppich und Textilkunst, Band 4*. Munich: Herrmann

Herzfeld, Ernst. 1912. *Erster vorläufiger Bericht über die Ausgrabungen von Samarra*. Berlin: D. Reimer

——. 1923. *Der Wandschmuck der Bauten von Samarra und seine Ornamentik, Die Ausgrabungen von Samarra 1, Forschungen zur islamischen Kunst 2, 1*. Berlin: D. Reimer

——. 1927. *Die Malereien von Samarra, Die Ausgrabungen von*

Samarra III, Forschungen zur islamischen Kunst 2, 3. Berlin: D. Reimer

———. 1948. *Die Geschichte der Stadt Samarra, Die Ausgrabungen von Samarra VI, Forschungen zur islamischen Kunst 2, 6* Hamburg: D. Reimer, Andrews, and Steiner

Hill, Donald R. 1974. *The Book of Knowledge of Ingenious Mechanical Devices* (Kitāb fī maʿrifat al-ḥiyal al-handasiyya) *by Ibn al-Razzāz al-Jazarī.* Trans. and annotated Donald R. Hill. Dordrecht and Boston: D. Reidel

Hillenbrand, Robert. 1994. "The Relationship Between Book Painting and Luxury Ceramics in 13th-century Iran," in *The Art of the Saljuqs in Iran and Anatolia.* Ed. Robert Hillenbrand. Costa Mesa: Mazda, pp. 134–45

———. 2005, "The Syrian Connection: Archaic Elements in Spanish Umayyad Ivories," *Journal of the David Collection,* 2/1, pp. 49–73

Hoffman, Eva. 2008. "Between East and West: the Wall Paintings of Samarra and the Construction of Abbasid Princely Culture," *Muqarnas* 25, pp. 107–32

Honarfar, Luṭfallah. [1350] 1971. *Ganjīna-yi Āthār-i tārīkhi-yi Iṣfahān* [*A Treasure of the Historical Monuments of Isfahan*]. 2nd ed. Tehran: Markaz-i forush va intashar

Hunt, Lucy-Ann. 2003. "Stuccowork at the Monastery of the Syrians in the Wadi Natrun: Iraqi – Egyptian Artistic Contact in the ʿAbbasid Period," in *Christians at the Heart of Islamic Rule: Church Life and Scholarship in ʿAbbasid Iraq.* Ed. David Thomas. Leiden and Boston: Brill, pp. 93–127

Hyman, Isabelle, and Marvin Trachtenberg. 1986. *Architecture: From Prehistory to Post-Modernism/The Western Tradition.* New York: Harry N. Abrams

Ibn al-Athīr, ʿIzz al-Dīn. 1963. *Al-tārīkh al-bāhir fīʾl-dawla al-atabikiyya biʾl-Mawṣil.* Ed. A. A. Tulaymat. Cairo: Dar al-kutub al-haditha

———. Reprint 1982. *Al-Kāmil fīʾl-tārīkh.* Ed. C. J. Tornberg. Beirut: Dar Sader (orig. pub. 1853)

Ibn al-Fuwaṭī, ʿAbd al-Razzaq. 1932. *Al-Ḥawādith al-jāmiʿa waʾl-tajārib al-nāfiʿa fiʾl-miʾa al-sabiʿa.* Ed. Mustafa Jawad. Baghdad: Matbaʿat al-Furat

Ibn al-Nadīm. 1871–72. *Kitāb al-Fihrist.* Ed. Gustav Flügel. Leipzig: F. C. W. Vogel

Ibn al-Qifṭī. 1903. *Taʾrīkh al-ḥukamāʾ.* Ed. Julius Lippert. Leipzig: Dieterich'sche Verlagsbuchhandlung

Ibn Ḥayyān. 1965. *Muqtabis.* Vol. 7. Ed. ʿAbd al-Raḥmān al-Ḥajji. Beirut: Dar al-thaqafa. Trans. 1967 E. García Gómez as *El Califato de Córdoba en el "Muqtabis" de ibn Ḥayyān: Anales Palatinos del califa de Córdoba al-Ḥakam II, por ʿĪsā ibn Aḥmad al-Rāzī, 360–364 H = 971–975 JC, traducción de un ms. árabe de la Real Academia de la Historia.* Madrid: Sociedad de Estudios y Publicaciones

Ibn Khaldun. 1958. *The Muqaddimah: An Introduction to History.* Trans. Franz Rosenthal. 3 vols. Bollingen series, 43. London: Pantheon Books

Ibn Shaddād, Muḥammad ibn ʿAlī. 1978. *Al-aʿlāq al-khaṭīra fī dhikr umarāʾ al-Shām waʾl Jazīra.* Ed. Yahya ʿAbbāra. Damascus: Wazarat al-Thaqafah waʾl-Irshad al-Qawmi

Ilyasov, Jangar Ya. Forthcoming. "Exotic Images: On a New Group of Glazed Pottery of the 10th and 11th Centuries," *Journal of The David Collection* 4

Inal, Ibnülemin Mahmud. 1955. *Son Hattatlar.* Istanbul: Maarif Basımevi

Jahdani, A. 2006. "Du *fiqh* à la codicologie. Quelques opinions de Malik (m. 179/796) sur le Coran-codex," *Mélanges de l'Université Saint-Joseph* 56 [Actes de la conférence internationale sur les manuscrits du Coran (Bologne, 26–28 septembre 2002)], pp. 269–79

James, David. 1980. "An Early Mosul Metalworker: Some New Information," *Oriental Art* 26/3, pp. 318–21

James, Susan E. 1996. "Lady Jane Grey or Queen Kateryn Parr?," *Burlington Magazine* 138, no. 1114, pp. 20–24

al-Janabi, Tariq. 1983. "Islamic Archaeology in Iraq: Recent Excavations at Samarra," *World Archaeology* 14/3, pp. 305–27

Jeffery, A., and I. Mendelsohn. 1942. "The Orthography of the Samarqand Qurʾān Codex," *Journal of the American Oriental Society* 62, pp. 175–95

Jodidio, Philip. 2008. *Museum of Islamic Art: Doha, Qatar.* Munich: Prestel Publishing

Jullian, Philippe. January 1964. "Tableaux autour de Tiepolo," *Connaissance des Arts,* p. 51

Kadoi, Yuka. 2005. "Aspects of Frescoes in Fourteenth-Century Iranian Architecture: The Case of Yazd," *Iran* 43, pp. 217–40

———. 2009. *Islamic Chinoiserie: The Art of Mongol Iran.* Edinburgh: Edinburgh University Press

———. Forthcoming. "The Samarra Finds in the New World: A Fragment of ʿAbbasid Artistic Legacy in American Museums," in *Hundert Jahre Grabungen in Samarra. 7. Kolloquium der Ernst Herzfeld Gesellschaft, Museum für Islamische Kunst Berlin, 30. June–2. July 2011.* Ed. Julia Gonnella. Wiesbaden: Dr. Ludwig Reichert

Kamansky, David, ed. 2004. *Wooden Wonders: Tibetan Furnitures in Secular and Religious Life.* Chicago: Serinda

Kana'an, Ruba. 2009. "The *de jure* 'Artist' of the Bobrinski Bucket: Production and Patronage in pre-Mongol Khurasan and Transoxiana," *Islamic Law and Society* 16, pp. 175–201

———. 2012. "Patron and Craftsman of the Freer Mosul Ewer of 1232: A Historical and Legal Interpretation of the Roles of *Tilmīdh* and *Ghulām* in Islamic Metalwork," *Ars Orientalis* 42

Karapetian, Karapet. 1974. *Isfahan, New Julfa: Le Case Degli Armeni /The Houses of the Armenians.* Rome: ISMEO, pp. 67–78, 119–56

Keall, E. J., and Robert B. Mason. 1991. "The Abbasid Glazed Wares of Siraf and the Basra Connection: Petrographic Analysis," *Iran* 29, pp. 51–66

Kervran, Monique. 1977. *Les niveaux islamiques du secteur oriental du Tépé de l'Apadana.* Paris: Cahiers de la D.A.F.I.

al-Khamis, Ulrike. 1990. "The Iconography of Early Islamic Lusterware from Mesopotamia: New Considerations," *Muqarnas* 7, pp. 109–18

Khan, Shah Navaz. Reprint 1979. *Maʾathir-ul-Umara.* 3 vols. Trans. Henry Beveridge. Patna: Janaki Prakashan

al-Khemir, Sabiha. 2006. *From Cordoba to Samarqand: Masterpieces from the Museum of Islamic Art in Doha.* Paris and Doha: Musée du Louvre

Kirchheim, E. Heinrich, et al. 1993. *Orient Stars, A Carpet Collection.* Stuttgart and London: E. Heinrich Kirchheim/ Halı Publications

Komaroff, Linda. 2009. "Sip, Dip, and Pour: Toward a Typology

of Water Vessels in Islamic Art," in *Rivers of Paradise: Water in Islamic Art and Culture*. Ed. Sheila Blair and Jonathan Bloom. New Haven and London: Yale University Press, pp. 105–30

——. 2011. *Gifts of the Sultan: The Arts of Giving at the Islamic Courts*. Los Angeles: Los Angeles Museum of Art

——. 2012. *The Gift Tradition in Islamic Art*. New Haven and London: Yale University Press

——, and Stefano Carboni, eds. 2002. *The Legacy of Genghis Khan: Courtly Art and Culture in Western Asia, 1256–1353*. New York: Metropolitan Museum of Art

Konrad, Christoph B. 2008. "Die Funde der Grabung Ernst Herzfelds 1911–1913 aus Samarra'," in *Beiträge zur Islamischen Kunst und Archäologie*, 1. Ed. Ernst-Herzfeld-Gesellschaft. Wiesbaden: Dr. Ludwig Reichert, pp. 51–54

Koppel, Angela. Forthcoming. *Der Stuck aus Kharab Sayyar*. Wiesbaden: Dr. Ludwig Reichert

Krishnadasa, Rai. 1999. *Anwar-e-Suhaili (Iyar-i-Danish)*. Varanasi: Bharat Kala Bhavan

Kröger, Jens. 1982a. *Sasanidischer Stuckdekor. Ein Beitrag zum Reliefdekor aus Stuck in sasanidischer und frühislamischer Zeit nach den Ausgrabungen von 1928/9 und 1931/2 in der sasanidischen Metropole Ktesiphon (Iraq) und unter besonderer Berücksichtigung der Stuckfunde vom Taht-i Sulaiman (Iran), aus Nizamabad (Iran) sowie zahlreicher anderer Fundorte*. Mainz: Ph. von Zabern

——. 1982b. "Werkstattfragen iranisch-mesopotamischen Baudekors in sasanidisch-frühislamischer Zeit," in *Künstler und Werkstatt in den orientalischen Gesellschaften*. Ed. Adalbert J. Gail. Graz: Akademische Druck- u. Verlagsanstalt, pp. 17–30

——. 2005. "Ernst Herzfeld and Friedrich Sarre," in *Ernst Herzfeld and the Development of Near Eastern Studies 1900–1950*. Ed. Ann C. Gunter and Stefan R. Hauser. Leiden and Boston: Brill, pp. 45–99

——. 2008. "Ernst Herzfelds künstlerische Begabung," in *Beiträge zur Islamischen Kunst und Archäologie, 1*. Ed. Ernst-Herzfeld-Gesellschaft. Wiesbaden: Dr. Ludwig Reichert, pp. 41–50

Kühnel, Ernst. 1931. "Dated Persian Lustred Pottery," *Eastern Art* 3, pp. 221–36

——. 1977. *Die Arabeske. Sinn und Wandlung eines Ornaments*. Graz: Verl. für Sammler

Kunitzsch, Paul. 1961. *Untersuchungen zur Sternnomenklatur der Araber*. Wiesbaden: O. Harrassowitz

——. 1986. "The Astronomer Abu 'l-Ḥusayn l-Ṣūfī and His Book on the Constellations," *Zeitschrift für Geschichte der Arabisch-Islamischen Wissenschaften* 3 (1986), pp 56–81. Reprinted 1989. *The Arabs and the Stars: Texts and Traditions on the Fixed Stars and their Influence in Medieval Europe*. Northampton: Variorum Reprints no. XI

——. 1987. "A Medieval Reference to the Andromeda Nebula," *The ESO Messenger* 49, pp. 42–43

Lamm, Carl Johann. 1929–30. *Mittelalterliche Gläser und Steinschnittarbeiten aus dem Nahen Osten*. Berlin: D. Reimer

——. 1937. "The Marby Rug and Some Fragments of Carpets Found in Egypt," in *Svenska Orientsällskapets, Årsbok 1937*. Stockholm: Bokförlags Aktiebolaget Thule, pp. 51–130

—— (ed.). 1985. *Carpet Fragments, The Marby Rug and Some Fragments of Carpets Found in Egypt*. Stockholm: Nationalmuseums skriftserie NS 7. Stockholm: National Museum

Landin, Bo, and Sterling van Wagenen. 2009. *Learning From Light: The Vision of I. M. Pei*. Slickrock Films

Lane, Arthur. 1947; Reprint 1965. *Early Islamic Pottery: Mesopotamia, Egypt and Persia*. London: Faber

Leach, Linda York. 1995. *Mughal and Other Indian Paintings from the Chester Beatty Library*. 2 vols. London: Scorpion Cavendish

Leisten, Thomas. 2003. *Excavations of Samarra, vol. I, Architecture: Final Report of the First Campaign 1910–1912*. Mainz: Ph. von Zabern

——. Forthcoming. "Al-Mutawakkil und der 'neue Stil': Historismus, Avantgarde und Kunst als Metapher im Samarra des 9. Jahrhunderts," *Hundert Jahre Grabungen in Samarra. 7. Kolloquium der Ernst Herzfeld Gesellschaft, Museum für Islamische Kunst Berlin, 30. June–2. July 2011*. Ed. Julia Gonnella. Wiesbaden: Dr. Ludwig Reichert

Lévi-Provençal, Evariste. 1955. "Sur l'installation des Rāzī en Espagne," *Arabica* II, pp. 228–30.

Lewisohn, Leonard. 1995. *Beyond Faith and Infidelity: the Sufi Poetry and Teachings of Mahmud Shabistari*. Richmond, Surrey: Curzon Press

Lissauer, Frank. 1974. *Christie's Annual 1974*. London: Christie's

López Cuervo, Serafín. 1983. *Medina Az-Zahra. Ingeniería y formas*. Madrid: Ministerio de Obras Públicas y Urbanismo

Losty, Jeremiah. 1985. "The 'Bute Hafiz' and the Development of Border Decoration in the Manuscript Studio of the Mughals," *Burlington Magazine* 127, pp. 855–71

——. 1986. *Indian Book Painting*. London: The British Library

——. 2011. *Indian Miniatures from the Lloyd Collection and Other Properties*. London: Oliver Forge and Brendan Lynch

Lowick, Nicholas. 1985. "The Religious, the Royal and the Popular in the Figural Coinage of al-Jazira," in *The Art of Syria and Jazīra 1100–1250*. Ed. Julian Raby. Oxford Studies of Islamic Art 1. Oxford: Oxford University Press, pp. 159–74

MacGregor, Neil. 2010. *A History of the World in 100 Objects*. London: Allen Lane

Mackie, Louise W. 1977. "Two Remarkable Fifteenth Century Carpets from Spain," *Textile Museum Journal* 4/4, pp. 15–27

Maddison, F. R., and Emilie Savage-Smith. 1997. *Science, Tools and Magic. Part I: Body and Spirit, Mapping the Universe, Part II: Mundane Worlds*. 2 vols. The Nasser D. Khalili Collection of Islamic Art, 12. London and Oxford: The Nour Foundation in association with Azimuth Editions and Oxford University Press

Makariou, Sophie, ed. 2007. *Chefs-d'œuvre islamiques de l'Aga Khan Museum*. Paris: Musée du Louvre

al-Maqqarī. 1840. *The History of the Mohammedan Dynasties in Spain, Extracted from the Nafhu-T-Tib . . .* Trans. D. Pascual de Gayangos, vol. I. London: W. H. Allen

Martin, Fredrik R. 1908. *The History of Oriental Carpets Before 1800*. Vienna: Printing Office of the Imperial Austrian Court

Martínez Núñez, Mª Antonia. 1995. "La epigrafía del Salón de ʿAbd al-Raḥmān III," in *Madīnat al-Zahrāʾ. El Salón de ʿAbd al-Raḥmān III*. Córdoba: Junta de Andalucía, Consejería de Cultura, pp. 109–52

——. 2001. "Sentido de la epigrafía omeya de al-Andalus," in *El esplendor de los omeyas cordobeses. La civilización musulmana de Europa occidental. Estudios*. Vol. 1. Coord. Mª Jesús Viguera and Concepción Castillo. Granada: Junta de Andalucía,

Consejería de Cultura, Fundación El legado andalusí, pp. 408–17

Mason, Robert. 1994. "The Beginnings of Islamic Stonepaste Technology," *Archaeometry* 36/1, pp. 77–91

——. 1995. "New Looks at Old Pots: Results of Recent Multidisciplinary Studies of Glazed Ceramics from the Islamic World," *Muqarnas* 12, pp. 1–10

——. 1997a. "The Beginnings of Tin-opacification of Pottery Glazes," *Archaeometry* 39/1, pp. 41–58

——. 1997b. "Mediaeval Iranian Lustre-painted and Associated Wares: Typology in a Multidisciplinary Study," *Iran* 35, pp. 103–35

——. 2004. *Shine Like the Sun: Lustre-painted and Associated Pottery from the Medieval Middle East.* Costa Mesa: Mazda

Meinecke, Michael. 1991. "Early Abbasid Stucco Decoration in Bilad al-Sham," in *Bilad al-Sham during the Abbasid Period (132 a.h./750 a.d.–451 a.h./1059 a.d.). Proceedings of the Fifth International Conference on the History of Bilad al-Sham.* Amman: History of Bilad al-Sham Committee, pp. 226–37

——. 1998. "From Mschattā to Sāmarrāʾ: the Architecture of ar-Raqqa and its Decoration," in *Colloque international d'archéologie islamique (Le Caire, 3–7 février 1993).* Ed. Roland-Pierre Gayraud. Textes arabes et études islamiques 36. Cairo: Institut français d'Archéologie orientale, pp. 141–48

——. 1999. "Abbasidische Stuckdekorationen aus ar-Raqqa," in *Rezeption in der Islamischen Kunst.* Ed. B. Finster and Ch. Fragner [Bamberger Symposium, 26–28 June 1992]. Beirut: Fr. Steiner, pp. 247–67

——, and Andreas Schmidt-Colinet. 1993. "Palmyra und die frühislamische Architekturdekoration von Raqqa," in *Syrien. Von den Aposteln bis zu den Kalifen.* Ed. Erwin M. Ruprechtsberger. Mainz: Ph. von Zabern

Meisami, Julie Scott. 2001. "The Palace Complex as Emblem. Some Samarran *Qaṣīdas*," in *A Medieval City Reconsidered: an Interdisciplinary Approach to Samarra.* Ed. Chase F. Robinson. Oxford Studies in Islamic Art 14. Oxford: Oxford University Press, pp. 69–78

——. 2011. " 'I Guess That's Why They Call It the Blues': Depictions of Majnun in Persian Illustrated Manuscripts," in *And Diverse Are Their Hues: Color in Islamic Art and Culture.* Ed. Jonathan Bloom and Sheila Blair. New Haven and London: Yale University Press, pp. 120–51

Melikian-Chirvani, Assadullah-Souren. 1982. *Islamic Metalwork from the Iranian World, 8th–18th Century.* London: Victoria and Albert Museum

——. 1998. "Mir Sayyed ʿAli: Painter of the Past and Pioneer of the Future'," in *Mughal Masters: Further Studies.* Ed. Asok Kumar Das. Mumbai: Marg Publications, pp. 30–51

Meyer, Jan-Waalke. 1999. "Die zweite Grabungskampagne in Kharab Sayyar 1999," *Mitteilungen der Deutschen Orient-Gesellschaft zu Berlin* 132, pp. 303–09

Mills, John. 1978. "Early Animal Carpets in Western Paintings – A Review," *Halı* 1/3, pp. 234–43

——. 1997. "The Chihil Sutun 'Para-Mamluk' Prayer Rug," *Halı* 93, pp. 72–76

Milstein, Rachel. 1984. *Islamic Painting in the Israel Museum.* Seattle: University of Washington Press

Moortgat-Correns, Ursula. 1992. *Charāb Sējār. Eine frühabbasidische Ruinenstätte in Nordmesopotamien.* Berlin: Geb. Mann

Morelon, Régis. 1996. "General Survey of Arabic Astronomy," in *Encyclopedia of the History of Arabic Science.* 3 vols. Ed. Roshdi Rashed. London: Routledge, 1:1–19

Morris, James, Roger Wood, and Denis Wright. 1969. *Persia.* London: Thames & Hudson

al-Munajjid, Salah al-din. 1972. *Dirāsāt fī tārīkh al-khaṭṭ al-ʿarabī mundhu bidāyatihi ilā nihāyat al-ʿaṣr al-umawī – Etudes de paléographie arabe.* Beirut: Dar al-Kitab al-Jadid

Müstakîmzâde. 1928. *Tuḥfe-i Hattâtîn.* Istanbul: Devlet Matbaasi

Newhouse, Victoria. 2006. *Towards a New Museum.* New York: The Monacelli Press

Nockert, Margareta. 2011. "The Marby Rug," in *Oriental Carpet and Textile Studies* 7, pp. 77–82

Northedge, Alastair. 1993. "An Interpretation of the Palace of the Caliph at Samarra (Dar al-Khilafa or Jawsaq al-Khaqani)," *Ars Orientalis* 23, pp. 143–71

——. 2001. "The Palaces of the Abbasids at Samarra," in *A Medieval City Reconsidered: an Interdisciplinary Approach to Samarra.* Ed. Chase F. Robinson. Oxford Studies in Islamic Art 14. Oxford: Oxford University Press, pp. 29–67

——. 2005a. *The Historical Topography of Samarra.* London: British School of Archaeology in Iraq/Fondation Max van Berchem

——. 2005b. "Ernst Herzfeld, Samarra and Islamic Archaeology," in *Ernst Herzfeld and the Development of Near Eastern Studies 1900–1950.* Ed. Ann C. Gunter and Stefan R. Hauser. Leiden and Boston: Brill, pp. 385–403

al-Nuwayrī, Aḥmad ibn ʿAbd al-Wahhāb. 1923. *Nihāyat al-arab fī funūn al-adab.* Cairo: Dar al-kutub al-misriya

Ocaña Jiménez, Manuel. 1970. *El cúfico hispano y su evolución.* Madrid: Instituto Hispano-Árabe de Cultura

——. 1984. "Las ruinas de "Alamiria", un yacimiento arqueológico erróneamente denominado", *Al-Qanṭara* v, pp. 367–81.

Okada, Amina. 1989. *Miniatures de l'Inde impériale. Les peintres de la cour d'Akbar.* Paris: Editions de la Réunion des Musées Nationaux

O'Kane, Bernard. 2011. "Tiles of Many Hues: the Development of Iranian *Cuerda Seca* Tiles and the Transfer of Tilework Technology," in *And Diverse Are Their Hues: Color in Islamic Art and Culture.* Ed. Jonathan Bloom and Sheila Blair. New Haven and London: Yale University Press, pp. 174–203

Ölçer, Nazan, and Walter B. Denny. 1999. *Anatolian Carpets, Masterpieces from the Museum of Turkish and Islamic Arts.* Bern: Ertug and Kocabiyik

Otavsky, Karel, and Anne E. Wardwell. 2011. *Mittelalterliche Textilien. II: Zwischen Europa und China.* Riggisberg: Abegg-Stiftung

Pal, Pratapaditya. 1993. *Indian Painting.* Los Angeles: Los Angeles County Museum of Art

Pancaroğlu, Oya. 2002. "Serving Wisdom: the Contents of Samanid Epigraphic Pottery," in *Studies in Islamic and Later Islamic Art from the Arthur M. Sackler Museum, Harvard University Art Museums.* Cambridge, Mass.: Harvard University Press, pp. 59–75

——. 2007. *Perpetual Glory: Medieval Islamic Ceramics from the Harvey B. Plotnick Collection*. Chicago and New Haven: Art Institute of Chicago and Yale University Press

Pasachoff, Jay M. 2000. *A Field Guide to the Stars and Planets*. 4th ed. The Peterson Field Guide Series. Boston and New York: Houghton Mifflin Company

Patton, Douglas. 1991. *Badr al-Din Lu'lu': The Atabeg of Mosul, 1211–1259*. Seattle: University of Washington Press

Pavón Maldonado, Basilio, con la colaboración de Felisa Sastre. 1969. "Capiteles y cimacios de *Madīnat al-Zahrā'* tras las últimas excavaciones (Hacia un corpus del capitel hispano-musulmán)," *Archivo Español de Arte* 166, pp. 155–83

Le Perse et la France: relations diplomatiques et culturelles du XVII au XIX siècle. 1972. Paris: Musée Cernuschi

Philon, Helen. 1980. *Early Islamic Ceramics: Ninth to Late Twelfth Centuries*. London: Islamic Art Publications

Pinner, Robert. 1980. "The Animal Tree and the Great Bird in Myth and Folklore," in *Turkomen Studies I*. Ed. Robert Pinner and Michael Franses. London: Oguz Press, pp. 204–48

——, and Jackie Stanger. 1978. "Kufic Borders on 'Small Pattern Holbein' Carpets," *Hali* 1/4, pp. 335–38

Piper, David. 1963. *Catalogue of Seventeenth-Century Portraits in the National Portrait Gallery 1625–1714*. Cambridge: Cambridge University Press

Pisarev, S. I. 1905. *Samarkandskii kuficheskii Koran, po predanii'u' pisannyi sobstvennoruchno tre'tim khalifom Osmanom (644–656) i nakhodi'a'shchiisiy'a v Imperatorskoi S-Peterburgskoi publichnoi biblioteki'e' = Coran coufique de Samarcand: écrit d'après la tradition de la propre main du troisième calife Osman (644–656) qui se trouve dans la Bibliothèque Impériale Publique de St. Petersbourg*. Saint Petersburg: St Petersbourg Arkheologicheskii institut

Pope, Arthur Upham, and Phyllis Ackerman, eds. 1938–39. *A Survey of Persian Art From Prehistoric Times to the Present*. Oxford: Oxford University Press

Porter, Venetia. 1995. *Islamic Tiles*. London: British Museum

Porter, Yves. 2003. "Les techniques du lustre métallique d'après le *Jowhar-Nâme-ye Nezâmi* (A.D. 1196)," in *VIIe Congrès international sur la céramique médiévale en Méditerranée*. Ed. Ch. Bakirtzis. Athens: Éd. de la Caisse des Recettes Archéologiques, pp. 427–36

——. 2004. "Textes persans sur la céramique," in *La science dans le monde iranien à l'époque islamique*. Ed. Z. Vesel and H. Beikbaghban. Tehran: Institut français de recherche en Iran, pp. 165–89

al-Qalqashandī, Aḥmad ibn ʿAlī. 1920. *Ṣubḥ al-aʿshá fī ṣināʿat al-inshā'*. Cairo: al-Matbaʿa al-Amiriya

Raby, Julian. 1986. "Looking for Silver in Clay: a New Perspective on Samanid Ceramics," in *Pots and Pans: A Colloquium on Precious Metals and Ceramics in the Museum, Chinese and Graeco-Roman Worlds*. Ed. Michael Vickers. Oxford Studies in Islamic Art 3. Oxford: Oxford University Press, pp. 179–203

——. 2012. "The Principle of Parsimony and the Problem of 'the Mosul School of Metalwork'," in *Metalwork and Material Culture in the Islamic World: Art, Craft and Text. Essays Presented to James Allan*. Ed. Venetia Porter and Mariam Rosser-Owen. London: I. B. Tauris, pp. 11–85.

Raschid-eldin. Reprint 1968. *Histoire Des Mongols de la Perse*. Trans. Étienne Quatremère. Amsterdam: Oriental Press

Rawson, J., M. Tite, and M. J. Hughes. 1987–88. "The Export of Tang *sancai* Wares: Some Recent Research," *Transactions of the Oriental Ceramic Society* 52, pp. 39–61

Reitlinger, Gerald. 1951. "Unglazed Relief Pottery from Northern Mesopotamia," *Ars Islamica* 15–16, pp. 11–22

Ribeiro, Maria-Queiroz, and Jessica Hallet. 1999. *Os vidros da dinastia Mameluca no Museu Calouste Gulbenkian/Mamluk Glass in the Calouste Gulbenkian Museum*. Lisbon: Calouste Gulbenkian Museum

Rice, D. S. 1953. "Studies in Islamic Metalwork II," *Bulletin of the School of Oriental and African Studies* 15/1, pp. 61–79

——. 1957. "Inlaid Brasses from the Workshop of Aḥmad al-Dhakī al-Mawṣilī," *Ars Orientalis* 2, pp. 283–326

Richard, Francis. 2007. *Le siècle d'Ispahan*. Paris: Gallimard

Richards, D. S. 2007. *The Chronicle of Ibn al-Athir for the Crusading Period, Part 2, The years 541–589/1146–1193: the Age of Nur al-Din and Saladin*. Aldershot: Ashgate

——. 2008. *The Chronicle of Ibn al-Athir for the Crusading Period, Part 3, The years 589–629/1193–1231: the Ayyubids after Saladin and the Mongol Menace*. Aldershot: Ashgate

Richter-Bernburg, Lutz. 1982. "Al-Bīrūnī's *maqāla fī tasṭīḥ al-ṣuwar wa-tabṭīkh al-kuwar*," *Journal for the History of Arabic Science* 6, pp. 113–22

Riefstahl, Rudolf Meyer. 1931. "Primitive Rugs of the 'Konya' Type in the Mosque of Beyshehir," *The Art Bulletin* 13/2, pp. 177–220

Ritter, Markus. 2010. "Kunst mit Botschaft: Der Gold-Seide-Stoff für den Ilchan Abu Said von Iran (Grabgewand Rudolfs IV. In Wien) – Rekonsruktion, Typus, Repräsentationsmedium," in *Beiträge zur Islamischen Kunst und Archäologie*, vol. 2. Ed. Markus Ritter and Lorenz Korn. Wiesbaden: Ludwig Reichert, pp. 105–35

Robinson, B. W., and Eleanor Sims, with contributions by Manijeh Bayani. 2007. *The Windsor Shahnama of 1648*. London: Azimuth, for the Roxburghe Club

Rogers, J. Michael. 1993. *Mughal Miniatures*. New York: Thames & Hudson

Rougeulle, Axelle. 1991. "Les importations de céramiques chinoises dans le Golfe arabo-persique (VIIIe–XIe siècles)," *Archéologie islamique* 2, pp. 5–46

Roxburgh, David, ed. 2005. *Turks. A Journey of a Thousand Years*. London: Royal Academy of Arts

Rudenko, S. I. 1970. *Frozen Tombs of Siberia – the Pazyryk Burials of Iron Age Horsemen*. London: Dent

Rugiadi, Martina. 2011. "Carved Marble in Medieval Ghazni: Function and Meaning," *Hadeeth ad-Dar*, 34, pp. 5–11

——. 2012. " 'As for the colours, look at a garden in spring': Polychrome Marble in the Ghaznavid Architectural Decoration," in *Proceedings of the 7th International Congress of the Archaeology of the Ancient Near East (12–16 April 2010, British Museum and UCL, London)*. Wiesbaden: Harrassowitz, pp. 425–44

Safadi, Yasin H. 1978. *Islamic Calligraphy*. Boulder, Colo.: Shambala

Safwat, Nabil F. 1996. *The Art of the Pen: Calligraphy of the 14th to 20th Centuries*. The Nasser D. Khalili Collection of Islamic

Art, 5. London and Oxford: The Nour Foundation in association with Azimuth Editions and Oxford University Press

Saliby, Nassib. 2004. "Les fouilles du Palais B 1950–1952, Les fouilles du Palais C 1953; Les fouilles du Palais D 1954 et 1958," in *Raqqa III. Baudenkmäler und Paläste I*. Ed. Verena Daiber and Andrea Becker. Mainz: Ph. von Zabern, pp. 77–130

al-Samhūdī. 1984. *Wafāʾ al-wafā bi-akhbār dār al-muṣṭafā*. Ed. M. ʿAbd al-Hamīd, vol. 2, rééd. Beyrouth: Dar al-Kutu al-ʿAlamiya

Sarre, Friedrich. 1922. "Die Aufstellung der Ergebnisse der Ausgrabungen von Samarra im Kaiser-Friedrich-Museum, Berliner Museen," *Berliner Museen. Berichte aus den preußischen Kunstsammlungen* 43, pp. 49–60

———. 1925. *Die Keramik von Samarra*. Berlin: D. Reimer

———, and Eugen Mittwoch. 1906. *Erzeugnisse islamischer Kunst*. Berlin and Leipzig: Hiersemann

Savage-Smith, Emilie. 1985. *Islamicate Celestial Globes: Their History, Construction, and Use*. Smithsonian Studies in History and Technology, no. 46. Washington, DC: Smithsonian Institution Press

———. 1992. "Celestial Mapping," in *The History of Cartography, Volume 2, Book 1, Cartography in the Traditional Islamic and South Asian Societies*. Ed. J. B. Harley and David Woodward. Chicago: University of Chicago Press, pp. 12–70

Sayılı, Aydın. 1960. *The Observatory in Islam and its Place in the General History of the Observatory*. Publications of the Turkish Historical Society, ser. 7, no. 38. Ankara: Türk tarih Kurumu Basimevi

Schattner, Thomas G., and Fernando Valdés Fernández, eds. 2010. *Spolien im Umkreis der Macht: Akten der Tagung in Toledo vom 21. Bis 22. September 2006 = Spolia en el entorno del poder: Actas del coloquio en Toledo del 21 al 22 de septiembre 2006*. Mainz: Ph von Zabern

Schimmel, Anne-Marie. 1984. *Calligraphy and Islamic Culture*. New York: New York University Press

Schmidt-Colinet, Andreas. Forthcoming. "Der Stuckdekor von ar-Raqqa," *Raqqa V. Die Bauornamentik*. Ed. Andrea Becker. Mainz: Ph. von Zabern

Schmoranz, Gustav. 1899. *Old Oriental Gilt and Enamelled Glass Vessels Extant in Public Museums and Private Collections*. Vienna and London: G. Norman

Schnyder, Rudolf. 1979. "Zur Frage der Stile von Samarra," in *Akten des VII. Internationalen Kongresses für Iranische Kunst und Archäologie*, München (7–10 September 1976). Berlin: D. Reimer, pp. 371–79

Schoy, Carl. 1927. "ʿAlī ibn ʿIsá, Das Astrolab und sein Gebrauch," *Isis* 9, pp. 239–54

Schuster-Walser, Sybilla. 1970. *Das Safawidische Persien im Spiegel Europäischer Reiseberichte (1502–1722): Untersuchungen Zur Wirtschafts- und Handelspolitik*. Baden-Baden and Hamburg: Bruno Grimm/Helmut Buske Verlag

Schwed, Jutta Maria. 2004. "Von der Grabung ins Museum. Grabungsfunde und ihre museale Präsentation am Beispiel der Stuckornamente aus Samarra," in *Islamische Kunst in Berliner Sammlungen*. Ed. Jens Kröger and Désirée Heiden. Berlin: Parthas, pp. 169–72

Sears, Elizabeth, and Thelma K. Thomas, eds. 2002. *Reading Medieval Images: The Art Historian and the Object*. Ann Arbor: University of Michigan Press

Segal, J. B. 1962. "Obituary: David Storm Rice," *Bulletin of the School of Oriental and African Studies* 25, pp. 666–71

Semsar, Mohammed-Hasan. 2000. *Golestan Palace Library – Portfolio of Miniature Paintings and Calligraphies*. Trans. Karin Emami. Tehran: Zarrin and Simin Books

Sen, Geeti. 1984. *Paintings from the Akbar Nama. A Visual Chronicle of Mughal India*. Varanasi: Lustre Press

Serin, Muhittin. 1992. *Hattat Şeyh Hamdullah*. Istanbul: Kubbealtı

———. 1999. *Hat Sanatı ve Meşhur Hattatlar*. Istanbul: Kubbealtı

Seyller, John. 1997. "The Inspection and Valuation of Manuscripts in the Imperial Mughal Library," *Artibus Asiae* 57, nos 3/4, pp. 243–349

———. 2001. *Pearls of the Parrot of India. The Walters Art Museum Khamsa of Amir Khusraw of Delhi*. Baltimore: Walters Art Museum

———. 2004. "The Walters Art Museum *Diwan* of Amir Hasan Dihlawi and Salim's Atelier at Allahabad," in *Arts of Mughal India: Studies in Honour of Robert Skelton*. Ed. Rosemary Crill, Susan Stronge, and Andrew Topsfield. Ahmedabad: Victoria and Albert Museum and Mapin Publishing, pp. 95–110

———. 2005. "Painting Workshops in Mughal India," in *Karkana: A Contemporary Collaboration*. Ed. Hammad Nasar. Ridgefield, Conn.: The Aldrich Contemporary Art Museum and Green Cardamon, pp. 12–17

———. 2011a. "Basawan," in *Masters of Indian Painting, 1100–1650*. Ed. Milo Beach, Eberhard Fischer, and B. N. Goswamy. Zürich: Artibus Asiae Publishers, pp. 119–34

———. 2011b. "Manohar," in *Masters of Indian Painting, 1100–1650*. Ed. Milo Beach, Eberhard Fischer, and B. N. Goswamy. Zürich: Artibus Asiae Publishers, pp. 135–52

———. 2011c. "A Mughal Manuscript of the *Diwan* of Nawaʾi," *Artibus Asiae* 71, no. 2

———, et al. 2002. *The Adventures of Hamza. Painting and Storytelling in Mughal India*. Washington, DC: Freer Gallery of Art and Arthur M. Sackler Gallery, Smithsonian Institution

Sezgin, Fuat. 1978. *Astronomie bis ca 430 H*. Geschichte des arabischen Schrifttums 6. Leiden: Brill

Shebunin, A. N. 1891. "Kuficheskij Koran Imperatorskoj Sankt-Petersburgskoj publichnoj biblioteki," *Zapiski Vostochnogo Otdelenija imperatorskogo russkogo arkheologicheskogo obshchestva* 6, pp. 69–133

———. 1902. "Kuficheskij Koran Khedivskoj Biblioteki v Kaire," *Zapisok Vostochnago Otdvlenia Imperatorskogo russkago arkheologicheskago obshestva* 14, pp. 117–54

Simpson, St. John, Janet Ambers, Giovanni Verri, Thibaut Deviese, and Jo Kirby. 2010. "Painted Parthian Stuccoes from Southern Iraq," in *Proceedings of the 7th International Congress on the Archaeology of the Ancient Near East* (12–16 April 2010, British Museum and UCL, London). Wiesbaden: Harrassowitz, pp. 209–20

Sims, Eleanor G. 1974. "Remarks on the Paintings in a Europeanizing Style in the Chihil Sutun," *Iranian Studies* 7 [*Studies on Isfahan*, ed. Renata Holod], pp. 522–42

———. 1976. "Five Seventeenth-Century Persian Oil Paintings," in *Persian and Mughal Art*. Ed. Michael Goedhuis. London: P & D Colnaghi & Co Ltd, pp. 221–48

———. 1979a. "Late Safavid Painting: the Chehel Sutun, the Armenian Houses, the Oil Paintings," in *Akten des VII. Internationalen Kongresses für Iranische Kunst und Archäologie, München, 7.-10. September 1976*. Archäologische Mitteilungen aus Iran, Ergänzungsband 6. Berlin: Dietrich Reimer Verlag, pp. 408–18

———. 1979b. "The 17th Century Safavid Sources of Qajar Oil Painting," in *Islam in the Balkans/Persian Art and Culture of the 18th–19th Centuries*. Ed. Jennifer Scarce. London: Royal Scottish Museum, pp. 99–102

———. 1988. "Hans Ludwig von Kuefstein's Turkish Figures," in *At the Sublime Porte: Ambassadors to the Ottoman Empire (1550–1800)*. London: Hazlitt, Gooden & Fox, pp. 20–40

———. 1998. "Auction Report: Portrait of a Lady (Persian Oil Painting in Islamic Rug Sales)," *Hali* 102, p. 121

———. 2001. "Towards a Monograph on the 17th-Century Iranian Painter Muhammad Zaman ibn Haji Yusuf," *Islamic Art* 5, 183–99

———. 2002. *Peerless Images: Persian Painting and its Sources*. London and New Haven: Yale University Press

———. 2003. "Images and Their Afterlives: Four Safavid Reception-Scenes in the Čihil Sutun," in *Studi in Onore di Umberto Scerrato per il suo settantacinquesimo compleanno*. Ed. Maria Vittoria Fontana and Bruno Genito. Naples: Università degli Studi di Napoli "L'Orientale"/Istituto Italiano per l'Africa e l'Oriente, pp. 791–804

———. 2006. "The 'Exotic' Image: Oil-Painting in Iran in the Later 17th and the Early 18th Centuries," in *The Phenomenon of "Foreign" in Oriental Art*. Ed. Annette Hagedorn. Weisbaden: Reichert Verlag, pp. 135–40

Sotheby's, London, 15 October 1997, Lot 35

Sotheby's, 29 April 1998. *Oriental Manuscripts and Miniatures* [sale catalogue]. Entry for Lot 34 prepared by Barbara Brend, Robert Hillenbrand, and David King

Sotheby's, London, 15 October 1998, Lot 69

Sotheby's, London, 13 October 1999, Lot 14

Sotheby's, New York, 26 May 2005, Lot 110

Sotheby's, 1 April 2009. *Arts of the Islamic World including fine carpets and textiles; auction in London* [sale catalogue]

Sotheby's, 4 October 2011. *Arts of the Islamic World. Evening Sale, including the Harvey B. Plotnik Collection of Islamic Ceramics*

Sotheby's, 5 October 2011. *Arts of the Islamic World. Day Sale, including Fine Carpets and Textiles*

Soudavar, Abolala. 1999. "The Concepts of 'al-aqdamo aṣaḥḥ' and 'Yaqin-e sābeq', and the Problem of Semi-fakes," *Studia Iranica* 28, pp. 255–73

———, with contribution by Milo Cleveland Beach. 1992. *Art of the Persian Courts*. New York: Rizzoli

Sourdel-Thomine, Janine. 1978. *Lashkari Bazar: Une résidence royale ghaznévide et ghoride. 1B: Le décor non figuratif et les inscriptions*. Paris: Boccard

Spitzer, Frédéric, Paul Chevallier, and Charles Mannheim. 1893. *Catalogue des objets d'art et de haute curiosité antiques, du moyen-âge & de la renaissance, composant l'importante et précieuse Collection Spitzer, dont la vente publique aura lieu à Paris . . . du . . . 17 avril au . . . 16 juin, 1893 . . . Paris, 17 April–16 June 1893*. Paris: Imprimerie de l'Art, E. Ménard

Stchoukine, Ivan. 1964. *Les Peintures des manuscrits de Shah Abbas Ier à la fin des Safavis*. Paris: Geuthner

Stronge, Susan. 2002. *Painting for the Mughal Emperor. The Art of the Book, 1560–1660*. London: V&A Publications

———. 2010. *Made for Mughal Emperors. Royal Treasures from Hindustan*. London and New York: I. B. Tauris

Suleman, Fahmida. 2003. "The Lion, the Hare and Lustreware: Studies in the Iconography of Lustre Ceramics from Fatimid Egypt." D.Phil. thesis, University of Oxford

Tabbaa, Yasser. 1987. "Bronze Shapes in Iranian Ceramics of the Twelfth and Thirteenth Centuries," *Muqarnas* 4, pp. 98–113

———. 2002. *The Transformation of Islamic Art During the Sunni Revival*. Seattle: University of Washington Press

Tait, Hugh. 1998. "The Palmer Cup and Related Glasses Exported to Europe in the Middle Ages," in *Gilded and Enamelled Glass from the Middle East*. Ed. Rachel Ward. London: British Museum Press, pp. 50–55

Tamari, Vera. 1995. "Abbasid Blue-on-White Ware," in *Islamic Art in the Ashmolean*. Ed. James W. Allan. Oxford Studies in Islamic Art 10. Oxford: Oxford University Press, pp. 117–46

Tampoe, Moira. 1989. *Maritime Trade between China and the West: an Archaeological Study of the Ceramics from Siraf (Persian Gulf), S.D. 8th–15th Centuries*. Oxford: B. A. R.

Tashköprüzâde. *Miftāḥ al-saʿāda wa miṣbāḥ al-siyāda fī mawḍūʿāt al-ʿulūm*. Cairo: Dar al-kutub al-haditha

Thackston, Wheeler M., trans. and ed. 1999. *The Jahangirnama, Memoirs of Jahangir, Emperor of India*. New York: Oxford University Press

Thompson, Jon. 2004. *Silk: 13th to 18th Centuries: Treasures from the Museum of Islamic Art, Qatar*. Doha: National Council for Culture, Arts and Heritage

al-Ṭībī, Muḥammad ibn Ḥasan. 1962. *Jāmiʿ maḥāsin kitābat al-kuttāb*. Ed. Salahuddin Al-Munajjid. Beirut: Dar al-kitab al-jadid

Tilden, Scott. 2004. *Architecture for Art: American Art Museums*. New York: Harry N. Abrams

Titley, Norah. 1983. *Persian Miniature Painting and Its Influence on the Art of Turkey and India*. Austin, Texas: University of Texas Press in association with The British Library

Topsfield, Andrew. 2008. *Paintings from Mughal India*. Oxford: Bodleian Library

Torres Balbás, Leopoldo. 1957. "Arte hispanomusulmán hasta la caída del Califato de Córdoba," in *España musulmana hasta la caída del califato de Córdoba (711–1031 de J.C.)*, vol. 5 of the *Historia de España*, dir. by R. Menéndez Pidal. Madrid: Espasa-Calpe, pp. 333–788.

Tromans, Nicholas, ed. 2008. *The Lure of the East: British Orientalist Painting*. London: Tate Gallery

Turner, Jane, ed. 1996. *Grove Dictionary of Art*. 34 vols. London: Oxford University Press

Vafea, Flora. 2006. "Les traités d'al-Ṣūfī sur l'astrolabe." Thèse de doctorat, Université Paris 7 – Denis Diderot

Valle, Pietro della. 1672. *Viaggi di Pietro della Valle Il Pellegrino*. 3 vols. Bologna: Gioseffo Longhi

Vallejo Triano, Antonio. 2006. "Consideraciones generales

sobre los programas decorativos de *Madīnat al-Zahrāʾ*," in *Escultura decorativa tardorromana y altomedieval en la Península Ibérica*. Ed. L. Caballero Zoreda and P. Mateos Cruz. Anejos de Archivo Español de Arqueología 41, pp. 391–413

——. 2007. "*Madīnat al-Zahrāʾ*: Transformation of a Caliphal City," in *Revisiting Al-Andalus. Perspectives on the Material Culture of Islamic Iberia and Beyond*. Ed. Glaire D. Anderson and Mariam Rosser-Owen. Leiden and Boston: Brill, pp. 3–26

——. 2010. *La ciudad califal de Madīnat al-Zahrāʾ. Arqueología de su arquitectura*. Jaén: Almuzara

Velázquez Bosco, Ricardo. 1923. *Excavaciones en Medina Azahara. Memoria sobre lo descubierto en dichas excavaciones*. Madrid: Junta Superior de Excavaciones y Antigüedades.

Volov, Lisa. 1966. "Plaited Kufic on Samanid Epigraphic Pottery," *Ars Orientalis* 6, pp. 107–34

von Wilckens, Leonie. 1992. *Mittelalterliche Seidenstoffe*. Bestandskatalog des Kunstgewerbemuseums, 18. Berlin: Staatliche Museen zu Berlin. Kunstgewerbemuseum

Wade, Bonnie. 1998. *Imaging Sound. An Ethnomusicological Study of Music, Art, and Culture in Mughal India*. Chicago and London: University of Chicago Press

Walker, Daniel. 1990. "Animal Rug," *Metropolitan Museum of Art Bulletin*, n. s. 47/2, pp. 12–13

——. 1992. "Rugs in the Gion Matsuri Preservation Associations," in *Gionmatsuri 'Yama' 'Hoko' Kensohin Chosa Hokokusho: Torai Senshokuhin no Bu*. Ed. Nobuko Kajitani and Kojiro Yoshida. Kyoto: Gion Festival Committee, pp. 173–88

Ward, Rachel. 1998. "Glass and Brass: Parallels and Puzzles," *Gilded and Enamelled Glass from the Middle East*. Ed. Rachel Ward. London: British Museum Press, pp. 30–34

——. 2005. "Big Mamluk Buckets," in *Annales du 16e Congrès de l'Association internationale pour l'Histoire du Verre, London 7–13 Septembre, 2003*. Ed. Marie-Dominique Nenna. Nottingham: AIHV, pp. 182–85

——. 2012. "Mosque Lamps and Enamelled Glass: Getting the Dates Right," in *The Arts of the Mamluks in Egypt and Syria – Evolution and Impact*. Ed. Doris Behrens-Abouseif. Göttingen: Vandenhoeck & Ruprecht, pp. 55–75

Wardwell, Anne E. 1987. "Flight of the Phoenix: Crosscurrents in Late Thirteenth- to Fourteenth-Century Silk Patterns and Motifs," *Bulletin of The Cleveland Museum of Art* 74/1, pp. 2–35

——. 1989. "Panni Tartarici: Eastern Islamic Silks Woven With Gold And Silver (13th and 14th Centuries)," *Islamic Art* 3, pp. 95–173

——. 1992. "Two Silk and Gold Textiles of the Early Mongol Period," *Bulletin of The Cleveland Museum of Art* 79/10, pp. 354–78

——. 1992–93. "Important Asian Textiles Recently Acquired by The Cleveland Museum of Art," *Oriental Art*, n.s. 38/4, pp. 244–51

Watson, Oliver. 1985. *Persian Lustre Ware*. London: Faber

——. 1986. "Pottery and Metal Shapes in Persia in the 12th and 13th Centuries," in *Pots and Pans: a Colloquium on Precious Metals and Ceramics in the Museum, Chinese and Graeco-Roman Worlds*. Ed. Michael Vickers. Oxford Studies in Islamic Art 3. Oxford: Oxford University Press, pp. 205–12

——. 1994. "Documentary *Mināʾi* and Abu Zaid's Bowls," in *The Art of the Saljuqs in Iran and Anatolia*. Ed. Robert Hillenbrand. Costa Mesa: Mazda, pp. 170–80

——. 2004. *Ceramics from Islamic Lands*. London: Thames & Hudson

Watt, James C.Y. 2010. *The World of Khubilai Khan: Chinese Art in the Yuan Dynasty*. New York: Metropolitan Museum of Art

——, and Anne E. Wardwell. 1997. *When Silk Was Gold: Central Asian and Chinese Textiles*. New York: Metropolitan Museum of Art

Welch, Anthony. 1973. *Shah ʿAbbas & the Arts of Isfahan*. New York: Asia Society

Welch, Stuart Cary. 1979. *Wonders of the Age. Masterpieces of Early Safavid Painting, 1501–1576*. Cambridge, Mass.: Fogg Art Museum, Harvard University

——. 1985. *India: Art and Culture, 1300–1900*. New York: Metropolitan Museum of Art

——. 2004. "Zal in the Simurgh's Nest: A Painting by Mir Sayyid ʿAli for a *Shahnama* Illustrated for Emperor Humayun," in *Arts of Mughal India. Studies in Honour of Robert Skelton*. Ed. Rosemary Crill, Susan Stronge, and Andrew Topsfield. Ahmedabad: Mapin Publishing in association with the Victoria and Albert Museum, pp. 36–41

——, et al. 1987. *The Emperors' Album. Images of Mughal India*. New York: Metropolitan Museum of Art

Wellesz, Emmy. 1959. "An Early al-Ṣūfī Manuscript in the Bodleian Library in Oxford: a Study in Islamic Constellation Images," *Ars Orientalis* 3, pp. 1–26

——. 1964. "Islamic Astronomical Imagery: Classical and Bedouin Tradition," *Oriental Art*, n.s., 10, pp. 84–91

Wheelock, Arthur, et al. 1990. *Van Dyck Painting*. Washington, DC: National Gallery in association with Thames & Hudson

Whitehouse, David. 1979. *Maritime Trade in the Arabian Sea: the 9th and 10th Centuries ad*. Naples: Istituto universitario orientale

Wiet, Gaston. 1929. *Lampes et bouteilles en verre émaillé*. Cairo: Institut français d'archéologie orientale

Wilkinson, Charles K. 1973. *Nishapur: Pottery of the Early Islamc Period*. New York: Metropolitan Museum of Art

Williamson, Andrew. 1987. "Regional Distribution of Medieval Persian Pottery in Light of Recent Investigations," in *Syria and Iran: Three Studies in Medieval Ceramics*. Ed. James Allan and Caroline Roberts. Oxford Studies in Islamic Art 4. Oxford: Oxford University Press, pp. 11–22

Wiseman, Carter. 1990 [rev. ed., 2001]. *I. M. Pei: A Profile in American Architecture*. New York: Harry N. Abrams

al-Yaḥṣūbī, Al-Qāḍī ʿIyāḍ. N.d. *Al-Shifā*. Lebanon: Dar Al-Kutub Al-ʿIlmiya

Yazır, Mahmud. 1981. *Kalem Güzeli*. Vols. 1 and 2. Ankara: Ayyıldız Matbaasi A. Ş.

——. 1989. *Kalem Güzeli*. Vol 3. Ankara: Gaye Matbaacılık A. Ş.

Zander, Giuseppe, ed. 1968. *Travaux de restauration de monuments historiques en Iran*. Rome: ISMEO

Zhao, Feng. 1999. *Treasures in Silk*. Hong Kong: ISAT/Costume Squad

Photograph Credits

© Museum of Islamic Art, Doha: 1, 3–6, 28, 30–31, 33–34, 116, 120–26, 128–33, 138–39, 142–44, 150–53, 169–71, 174, 178, 180, 182–83, 209, 216, 217f, 219d, 228a, 255, 260, 262, 266

Map by Martin Brown: 2

Image © Getty Images. Photographer: John Lamb: 7

Image © Getty Images. Photographer: Christopher Capozziello: 8

Photograph courtesy of the High Museum of Art: 9

Image © Getty Images. Photographer: Eduardo Barcellos: 10

Image © Getty Images. Photographer: John Harper: 11

Getty Images. Photographer: Charles Cook: 12

Image © Architekturfoto Staatsgalerie Stuttgart, Foto: Staatgalerie Stuttgart: 13

Image © The National Gallery, London: 14

Image © Getty Images. Photographer: Ben Pipe Photography: 15

Image © Getty Images. Photographer: Barry Winiker: 16

Image © University Corporation for Atmospheric Research: 17

Image © Getty Images. Photographer: El Huang Photography: 18

Image © Courtesy Syracuse University: 19

Image © Courtesy Everson Museum of Art, Syracuse, NY: 20

Image © Philip Greenspun; photo courtesy http://philip.greenspun.com: 21

Image © Getty Images. Photographer: Sean Gallup: 22

Image © Getty Images. Photographer: Bloomberg: 23

Image © Getty Images. Photographer: Alan Copson: 24

Image © Courtesy Miho Museum: 25

Image © Getty Images. Photographer: Forestgan Shanghai: 26

Image © Getty Images. Photographer: Ellen Rooney: 27

Image © Institut du Monde Arabe / Getty Images. Photographer: Rudi Sebastian: 29

© Museum of Islamic Art, Doha: Photo: Lois Lammerhuber: 32, 36–37, 96a, 97, 100a, 109, 228c, 267, 272, 274, 276–77, 279–80, 282–87, 289–92

© Museum of Islamic Art, Doha: Photo Marc Pelletreau: 35, 70–72, 140–41, 188, 206, 217c, 219a, 254, 293–98

Alan Russell, ClickNetherfield: 38–43

Photo courtesy Sheila Blair and Jonathan Bloom: 44

© Museum of Islamic Art, Doha: Photo Samar Kassab: 45–46, 48–51, 53–59, 62–67, 154, 218a, 219c, 251

Image © Museum für Islamische Kunst, Staatliche Museen zu Berlin: 69, 73–76, 79–80, 83, 90, 92, 161, 200, 250d

Image © Museum für Islamische Kunst, Staatliche Museen zu Berlin, photo Barbara Brunewald: 77

© Margarete van Ess, Berlin: 78

© Alastair Northedge (Paris): 81

Image © The David Collection, Copenhagen. Photography Pernille Klemp: 82, 208, 213–15, 217a, 217d–e, 218b–f, 219b, 220, 222–24, 227, 228b

Photographer: Ernst Herzfeld, Photo File 19, image 65a, A1259: 84

© Kharrab Sayyar Project, Institute for Archaeological Sciences, Goethe-University, Frankfurt/Main: 85

Image © Museum für Islamische Kunst, Staatliche Museen zu Berlin; photo: Jürgen Liepe: 86

Image © Museum für Islamische Kunst, Staatliche Museen zu Berlin; photo: Georg Niedermeiser: 87–89, 238

Image © Museum für Islamische Kunst, Staatliche Museen zu Berlin, photo: Ingrid Geske: 91, 207a–b

Image © paisajes@paisajesespanoles.es, picture 993563: 93

Image © Manuel Pijuan: 94, 103, 105–08

Madinat al-Zahra Museum, Córdoba: 95, 98–99, 104, 114–15

Image © Jorge Forne: 96b, 100b

© Museum of Islamic Art, Doha: Photo: Nicolas Ferrando: 101, 147, 261

Photograph Antonio Vallejo Triano: 102

© Archaeological Museum, Córdoba: 110–12

© Mas Archive, Barcelona: 113a–b

© Museum of the History of Science, Oxford: 117–18

Bodleian Library, University of Oxford: 134–37

Freer Gallery of Art, Smithsonian Institution, Washington: 146, 159, 246

Image © The State Hermitage Museum / photo by Alexei Pahomov: 148

Index

Index created by Meg Davies (Fellow of the Society of Indexers)

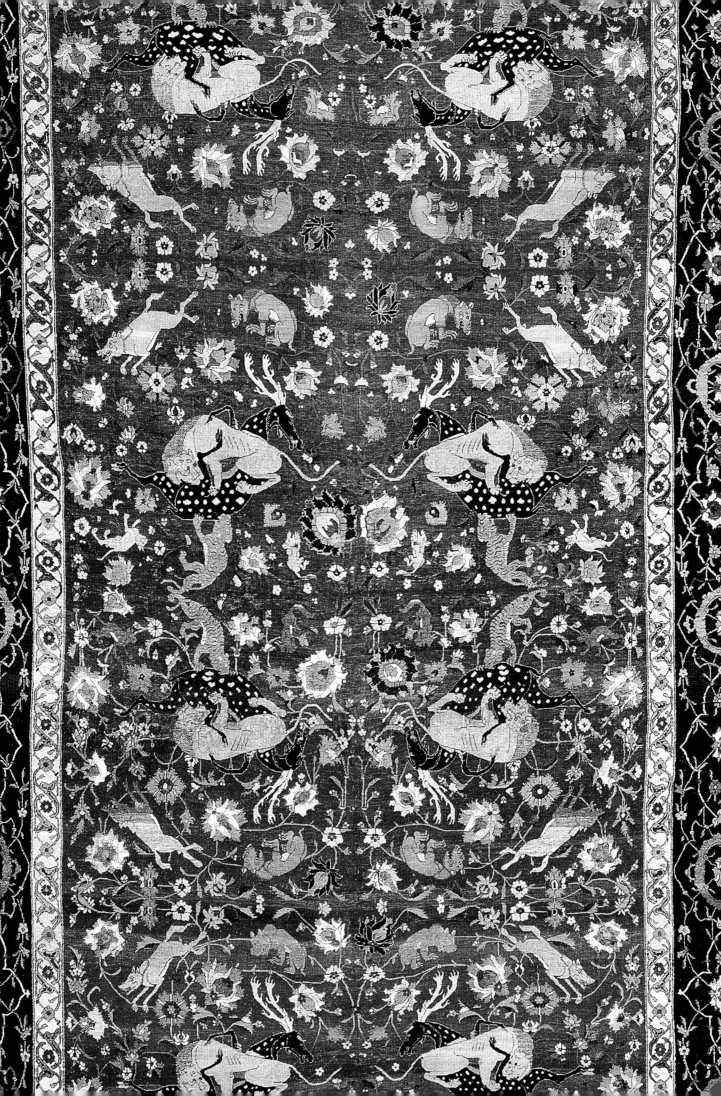

ان الله جميل يحب الجمال: التحفة والفن والثقافة الإسلامية

شيلا بلير وجوناثان بلوم

تحقيق شيلا بلير وجوناثان بلوم

دار النشر بجامعة يبل - نيوهافن ولندن

بمشاركة

مؤسسة قطر للتربية والعلوم وتنمية المجتمع

وجامعة فرجينيا كومنولث

وجامعة فرجينيا كومنولث - كلية فنون التصميم في قطر

سنة ٢٠١٣

ان الله جميل يحب الجمال : التحفة زف النفس والثقافة الاسلامية